Living with Art

*I am so happy in the house and in my work
that I even dare to think that the happiness
will not always be limited to one,
but that you will have a share in it
and good luck to go with it.*

VINCENT VAN GOGH,
letter to his brother, Theo,
about September 18, 1888

REPRODUCED ON THE COVER:

Vincent van Gogh. *Vincent's House at Arles,* detail
(entire work page 4). 1888.
Oil on canvas, 30 × 37".
Vincent van Gogh Foundation,
Rijksmuseum Vincent van Gogh, Amsterdam.

Living with Art

Second Edition

Rita Gilbert

William McCarter
University of North Texas

Alfred A. Knopf, Inc. New York

This is a Borzoi Book
Published by Alfred A. Knopf, Inc.

Acquiring Editor: Roth Wilkofsky
Project Editor: Eleanor Castellano
Production Controller: Karen Lumley
Photo Editors: Dana Dolan and Kathy Bendo
Designer: Lorraine Mullaney
Copyeditor: John Sturman

Manager of Production Operations: Della Mancuso
Managing Editor: Suzanne Thibodeau
Marketing Manager: Liz Israel
Assistant Editor: JoAnn Rush
Editorial Assistant: Laura Ralston

Line illustrations by Bill Evans, Denton, Texas; Vantage Art Studios, Massapequa, New York
Composition and camera work by York Graphic Services, Inc., York, Pennsylvania
Color separations by York Graphic Services, Inc., York, Pennsylvania
 and Chanticleer Company, Inc., New York/Switzerland
Printing and binding by Arcata Graphics/Kingsport Press, Kingsport, Tennessee

Second Edition
9 8 7 6 5 4 3 2

Library of Congress Cataloging in Publication Data

Gilbert, Rita, 1942–
 Living with art/Rita Gilbert, William McCarter.—2nd ed.
 500 p. 27.75 cm.
 McCarter's name appears first on the earlier edition.
 Bibliography: p. 484
 Includes index.
 ISBN 0-394-37401-0
 1. Art appreciation. I. McCarter, William, 1939– II. Title.
N7477.G55 1988
701'. 1—dc19 87–35307

Manufactured in the United States of America

Preface

Living with Art is a basic art text for college students and other interested readers. As such, it offers a broad introduction to the nature, vocabulary, media, and history of art, drawing on examples from many cultures.

Structure of the Book

The book is divided into five major parts. Part I serves as a general overview of the subject of art and its study. In the opening chapter are discussions about what it means to live actively with art and the importance of art in today's world; the basic impulse for art as exemplified in children's art and folk art; and the roles of the three essential participants in art: the artist, the patron, and the observer. Chapter 1 also presents material about creativity and perception, and it concludes with a set of basic guidelines for art criticism and understanding. Chapter 2 poses the question "What Is Art?" and gives readers criteria for answering it within their own frames of reference. The chapter considers "motel" or "sofa" art; style and iconography; form and content; and the relationship art has to the audience, to the artist's intention, to beauty, and to the "real" world. Chapter 3 introduces several broad themes that run through the entire history of art and notes the various purposes art has served and continues to serve.

Part II is a thorough analysis of the elements and principles of design in art, with detailed explanations and many illustrations. The part concludes with a more comprehensive list of guidelines for art criticism. Part III covers the two-dimensional media, and devotes a full chapter to each of the major categories—drawing, painting, prints, the camera arts, and graphic design. In Part IV the same detailed coverage is applied to three-dimensional media—sculpture, crafts, architecture, and environmental design. No comparable text, we believe, gives such in-depth treatment to these important modes of expression. Techniques and materials are explained in relation to their expressive possibilities and, wherever possible, in relation to the visual elements and principles.

Part V is a brief, but complete, chronological history of art from earliest times to the present. The final chapter in this part compares works of art from widely separated parts of the globe—Asia, Africa, South America, Europe, and North America—that were produced in approximately the same time periods.

Illustrations and Biographies

Illustrations are the "meat" of any art text; there can be no meaningful words without the pictures. *Living with Art* has 650 illustrations, 190 of them in full color. The book has been printed entirely on a four-color press, thus allowing placement of the color reproductions alongside their textual references. Because our publisher believes (and we agree) that quality is at least as important as quantity, great care has been taken to ensure that the color reproductions are as nearly faithful to the original works of art as four colors of ink on paper can be.

Such a large number of illustrations permits flexibility. Readers will find works of art from many different cultures, works made by women and by men, works as old as civilization and others barely dry. Historical periods have been

documented thoroughly. However, because we feel that students connect particularly well with the art of our own time, more than one hundred of the works shown in *Living with Art* date from the 1970s and 1980s. No work of art is discussed without being illustrated, and nearly every illustration falls on the page where it is discussed.

Students often are fascinated by the lives of artists they study. We are fascinated, too, and that interest prompted a unique feature in *Living with Art*. Spotted throughout are thirty-six brief biographies of artists, positioned near the text discussion of each artist's work. Set off from the text, the biographies include an image of the artist (usually a self-portrait), a brief life history, and a quotation from the artist. The preparation of these biographies has been perhaps the most rewarding work on *Living with Art*. We have learned anew that artists are interesting people; we have speculated about which artists we would like to invite to dinner, which we would rather admire from afar. The individual personalities of the artists have resulted in a rich and complex heritage of art, and we in turn are enriched by learning who they are, who they were.

New to This Edition

This revision of *Living with Art* has been exceptionally thorough. Readers familiar with the previous edition will find much new material, set within the existing framework. First of all, 140 illustrations, 70 of them in color, are new to this edition; these new works comprise more than 20 percent of the total illustrations. Some of the new pictures are up-to-the-minute art, while others are better examples we have found to illuminate points made in the text.

Chapters 1 and 2 have been completely reorganized and rewritten with the help of numerous reviewer suggestions. These chapters include new sections on style and creativity, an expanded treatment of the artist's role in society, and a discussion of art patronage, from popes to PepsiCo. Chapter 2 also addresses the controversial topic of who decides what is art, and why, with reference to Richard Serra's *Tilted Arc* and a deattributed Rembrandt. Guidelines for art observation and criticism have now been provided at two points in the book—in Chapter 1, when the student is just beginning to study art; and in Chapter 5, when the student has acquired more information.

Chapter 8, "Prints," has a new section on the monotype, or monoprint. Chapter 9, previously called "Photography," is greatly enlarged to cover "The Camera Arts" of photography, film, and video. A history of film from its origins to the present, along with a capsule treatment of video arts, now puts this chapter in tune with modern times—the times when pictures move. Chapter 13, "Architecture," includes new material on the Greek Orders and on balloon-frame construction. Chapter 14, "Environmental Design," has also been expanded to present analyses of environments readers of this book will know well—the college campus and the mall.

Part V, the history section, offers new and/or expanded discussions of Aegean art (Chapter 15) and Dada and Surrealism (Chapter 17). Chapter 17, "The Modern World," has been brought up to the minute of going to press, with coverage of the artists currently making news in the galleries and art journals.

This edition of *Living with Art* introduces a wholly new feature—end-of-chapter brief life stories of "Art People," or people who usually are not professional artists but who have had major impact on the world of art. The Art People include several collectors, a dealer, a biographer, an artist's relative (Theo van Gogh), a patron of the arts, even a forger and a thief. Besides this, there are four new artists' biographies: Henri Rousseau, Georgia O'Keeffe, Jacob Lawrence, and Alfred Hitchcock.

Finally, this revised edition of *Living with Art* has allowed us to explore a topic we consider urgent in today's world—keeping the art we live with. In the Epilogue we address the complexities of conservation and restoration, drawing on such examples as the *Laocoön Group*, Leonardo's *Last Supper*, and the Sistine paintings of Michelangelo.

Additional Resources

A number of additional resources have been provided for *Living with Art*. Extensive chronologies offer students both a geographical and a historical perspective. The chronologies are cross-cultural, listing periods and styles, important political and social events, and major artists. There is a bibliography with suggestions for further reading. A glossary of terms summarizes definitions given in the text. An Instructor's Manual is available, providing teaching strategies, sample tests, student projects, suggestions for further illustrations, and a list of teaching resources. A set of 250 slides of illustrations in the book can be purchased from an independent supplier, either as a set or individually.

Living with art is something everyone does. In today's world we are surrounded, inevitably, by an amazing treasure house of art. To ignore that art, to let it pass before our eyes without our noticing, is like walking into the treasure house and turning off all the lights. By this book we have tried to turn on the lights.

Acknowledgments

In Chapter 9 of this book we point out that a major motion picture nowadays requires a huge number of creative people to pull it together. This is no less true of a major art textbook. All the following have made important contributions.

First, we must thank the hundreds of museums, galleries, private collectors, and photographers who have provided the illustrations for *Living with Art*. They make a life filled with art possible—and joyful.

Numerous reviewers have helped to shape this text. They have corrected our mistakes, changed our emphases, identified our omissions, and offered creative suggestions. The following people reviewed all or part of the manuscript for this second edition: Douglas George, University of New Mexico; Larry Gleeson, University of North Texas; Paul Grootkerk, Mississippi State University; Janice Hardy, Georgia College; Kathleen Lobley, Butler University; Joseph Molinaro, Broward Community College; Jo Anne Nix, Georgia College; Christie Nuell, Middle Tennessee State University; Helen Phillips, University of Central Arkansas; Dominic Ricciotti, Winona State University; and Thomas Turpin, University of Arkansas.

Seventeen people acted for us in the all-important role of "Monday-morning quarterback." They reviewed the first edition after it was published, and their comments and criticisms were tremendously helpful in shaping the second edition. They are: Mary Alice Arnold, Appalachian State University; Ross Beitzel, Gloucester County College; Carole Calo, University of Massachusetts; Jerry Coulter, James Madison University; Lynn Galbraith, University of Nebraska; Susan Jackson, Marshall University; Jan Koot, California State University, Long Beach; Kathleen Lobley, Butler University; Carolyn Loeb, Central Michigan University; Joseph Molinaro, Broward Community College; Tim Morris, University of Central Arkansas; Christie Nuell, Middle Tennessee State University; Helen Phillips, University of Central Arkansas; Dominic Ricciotti, Winona State University; Barbara Kerr Scott, Cameron University; Thomas Turpin, University of Arkansas; and Kenneth Weedman, Cumberland College.

Finally, we must once again thank the people who got us through the first stage, the first edition reviewers. They include: Michelle R. Banks, Memphis State University; George Arnott Civey, III; Richard T. Doi, Central Washington University; Henry Drewal, Cleveland State University; Betty Disney, Cypress College; Steve Eliot, Broward Community College; Robert N. Ewing, California State University, Fullerton; Paul Grootkerk, Mississippi State University; Sharon K. Hopson; Nell Lafaye, University of South Carolina; John C. Riordan, State University of New York, College at Potsdam; Claire Selkurt, Mankato State University; Michael J. Smith, Southern Illinois University; Barbara von Barghahn, George Washington University; and Randy Wassell, Colorado State University.

Artist Joan Curtis again worked with us throughout the manuscript preparation of this edition, serving as first-round critic and reviewer. As before, she demonstrated her exceptional ability to suggest precisely the right illustration for a particular spot in the text.

Special thanks are due to the highly professional staff and free-lancers at Alfred A. Knopf: Karen Lumley, Della Mancuso, Kathy Bendo, Dana Dolan, Laura Ralston, JoAnn Rush, Liz Israel, Suzanne Thibodeau, Lorraine Mullaney, Eleanor Castellano, and John Sturman. Kathy Bendo and Dana Dolan tackled the immense and thankless task of gathering illustrations as though it were a challenge and even fun. Karen Lumley brought great sensitivity, professionalism, and calm to the exacting job of production controller.

As usual, we have no adequate way to thank our editor, Roth Wilkofsky, nor to characterize what he is and what he does. Perhaps the simplest is best: Without him there would be no book.

North Salem, New York R. G.

Denton, Texas W. McC.

Contents

part one
INTRODUCTION

1
Living with Art

*L*ate in the summer of 1888 the artist Vincent van Gogh rented a little yellow house on a street corner in the southern French town of Arles. Even before he moved into the house Van Gogh had begun to sketch it and its surroundings, and in September he turned his sketches into an important painting now called *Vincent's House at Arles* (1). Perhaps as much as anyone ever, Van Gogh lived with art, for he spent most of his adult life painting images *of* his life—his own likeness, his friends, the landscape he inhabited, his room, his house, his special chair. For Van Gogh, *living* and *art* were practically the same.

Relatively few of us will commit a lifetime to art, as Van Gogh did, but that doesn't mean we are not involved with art. Who lives with art? You do. Everybody does. It would be impossible *not* to live with art, because art is inextricably connected to human existence. Art has been with us since the earliest cave dwellers made their first tentative steps toward civilization, and will be with us as long as civilized life continues on our planet.

You probably have a lot more art in your life than you realize. If you live in a city or town, artists have designed almost everything in your environment. The buildings in which you live and work, the furniture inside those buildings, the clothes you wear—all were designed by artists in specialized fields. Very likely the walls of your home are decorated with posters, prints, photographs, maybe original paintings, that you have hung to give personal meaning to your world. Perhaps your school or office building has a large-scale sculpture out front, or a fabric hanging or mural inside. In the homes of friends you will see different kinds of art. One person may collect antique furniture, another Mexican pottery, yet another stamps or drawings or historical maps. Even this book you are reading was designed by an artist, a graphic artist whose task was to make it visually appealing and easy to read.

Whether we know it or not, all of us make choices—every day, every minute—with respect to art. We choose one product over another, one garment

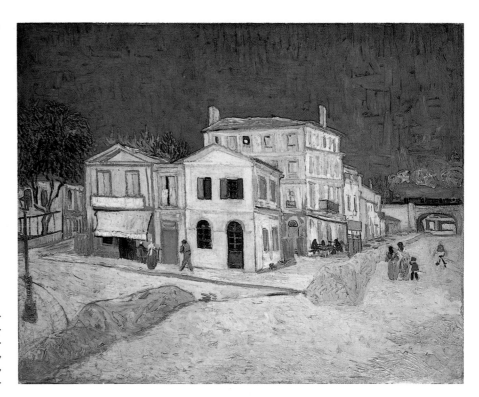

1. Vincent van Gogh.
Vincent's House at Arles. 1888.
Oil on canvas, 30 × 37".
Vincent van Gogh Foundation,
Rijksmuseum Vincent van Gogh,
Amsterdam.

over another, one way to walk from place to place, basing our decisions largely on the visual attractiveness of the preferred option. We choose to study and enjoy particular works of art or to ignore them. We choose to plan encounters with art, as in museums and galleries, or not to do so. Some people choose to devote their entire lives to the pursuit of art, thereby acquiring the designation of "artist."

Whatever our degree of involvement with art, we must remember that it *is* a choice. We can go through life like sleepwalkers, ignoring or taking for granted the art around us. Or we can enrich our lives by developing a more active appreciation of the art we live with. This book is about the appreciation of art, which means a combination of understanding and enjoyment. It is possible to heighten our appreciation of art, to learn to see, to take an active interest in the visual world. When we do so, we are only following a basic *aesthetic impulse*—an urge to respond to that which we find beautiful.

The Impulse for Art

The second paragraph of this chapter stated that art is inextricably connected to human existence. Before going on, we might challenge this statement. Is it true? Do we really need art in the same way that, say, we need language? In fact, why is there art? Are such things as paintings and sculptures absolutely necessary to human life?

The history of civilization suggests that we do need art, that it is basic to human expression. This seems to be equally true for those who make art, those who buy or support it, and those who simply admire it. The earliest people made art—whether they called it that or not—as evidenced by the cave paintings found in various parts of the world (**2**). Archaeologists tell us that in the Ice Age, about 35,000 years ago, Cro Magnon peoples in Europe "suddenly" began making objects that we would describe as art. (The word "suddenly" must be understood in the context of thousands of years, the point being that all the earliest known works date from roughly the same time.) They painted the walls of their

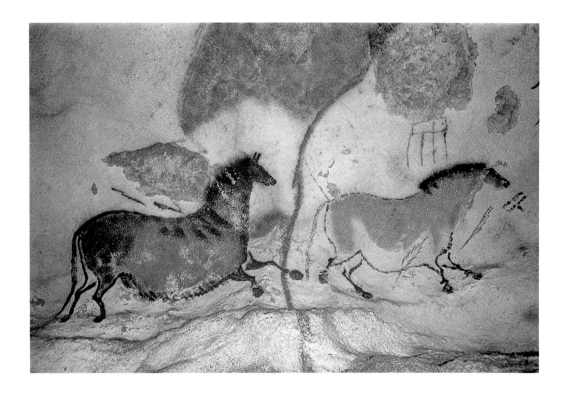

caves, carved figurines, decorated their tools and everyday implements with fine designs (3), and even made musical instruments.

 As primitive peoples advanced and learned to make more sophisticated objects for their daily use, they nearly always embellished them with artwork. A pot will hold water or cook food over the fire just as well if it is plain. Why decorate it? A plain garment will keep the wearer warm. Why make it fancy? A shelter needs only to keep out the rain and wind. Why ornament it? Nevertheless,

2. Cave painting of horses.
c. 15,000–10,000 B.C.
Lascaux, France.

3. *Romping Ibexes,*
detail of a spear-thrower.
c. 20,000 B.C.
Carved reindeer horn, length 3⅝".
Musée de l'Homme, Paris.

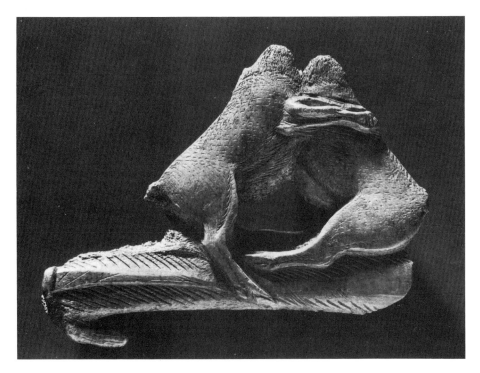

our long-ago ancestors did all these things. A partial explanation assumes that the life-and-death struggle for survival had eased off just enough to allow time for artistic expression, but it does not tell us why the spare time was actually used for artistic expression. We like to think that Cro Magnon humans "suddenly" developed a sense of themselves as being human, of being unique in the order of the universe, different from animals or trees. A work of art declares to the world: "I am here. I am unlike anyone else. I am special." If true, this theory supports the conclusion that there is an inborn human urge to create and enjoy art, to be "special."

There are two areas we might consider to see how this artistic impulse works. In neither case are the artists always aware that they are making "art." They are simply doing what seems to them perfectly natural, and it remains for others, outsiders, to declare that their efforts constitute art. The first of these areas is children's art, and the second is folk art.

CHILDREN'S ART

All of us begin to play with art as children, but in our teens most of us turn away from that kind of free expression in order to concentrate on learning the numerous rules of success in our complicated society. By looking at children's art we can get some idea of how an individual's power of expression grows. The book *Heidi's Horse*[1] follows the progress of one child, Heidi Scheuber, from age two to age nine.

At two Heidi began with random scribbling that expressed her joy in making marks (**4**). At three she made organized circular swirls, and at four separate shapes and shapes within shapes. At four years and three months human and animal figures appeared, made of circles and straight lines (**5**). A few months later Heidi produced a horse composed of the same elements (**6**). Heidi's progress reflects the normal pattern of human development, from formless marks to forms with meaning. This gradual expansion of form and meaning is the story of art, both for the individual artist and for civilization as a whole.

Heidi's drawings of horses when she was between five and nine years old show the burst of creative development we all go through at that age (**7,8**). This

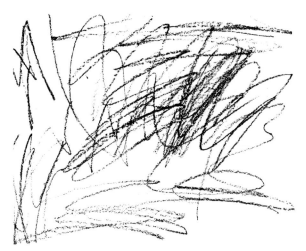

4. Drawing at age 2.

5. Drawing at age 4 years, 3 months.

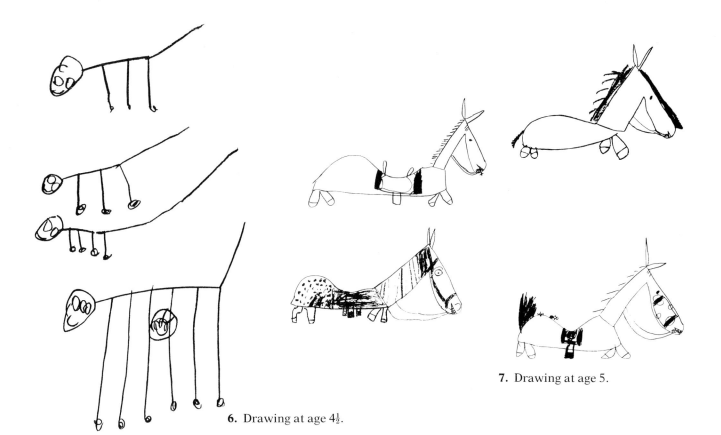

7. Drawing at age 5.

6. Drawing at age 4½.

urge, however, often is lost between age nine and the teens. The creative freedom of the younger child is overwhelmed by the desire, experienced by most older children, for realism and accuracy. Awareness of the world has expanded tremendously, and the set of marks that once seemed so satisfactory is suddenly inadequate. At this stage many children become so critical of their own efforts that they give up and never draw again. The ones who don't give up, who persevere and retain their ability to play freely with forms, become the people we call "artists."

We might speculate that there is something of the child in all artists—not in the sense of immaturity or lack of intellectual development, but in the ability to experiment, uncensored by conventional standards of good and bad. Pablo Picasso was an immensely sophisticated artist, and certainly he knew that what he

8. Drawing at age 6.

4–8. Horse drawings by Heidi Scheuber, over a period of four years. From *Heidi's Horse* by Sylvia Fein, published by Exelrod Press.

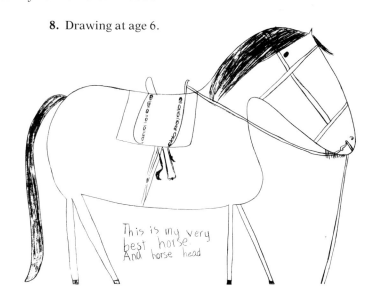

made was called art—by himself and by the world. Yet throughout his life he retained this ability to play, even to "draw" joyfully in the air with a flashlight (**9**). Could it be that the artist lives in all of us until and unless something destroys it? Further evidence for this idea can be found in the expression of folk art.

FOLK ART

Folk art is a term applied to works made by individuals with no academic training in art and often with little or no formal education. Folk art exists outside the mainstream of Western art; you will rarely find it included in official surveys of art history, such as the one comprising Part V of this book, nor occupying the main galleries of important museums. Nevertheless, this art has a living current of its own. Some folk artists work within a longstanding tradition. Skills are handed down from parent to child over many generations. Other such artists are true "originals" who begin to make art even though it might be considered a strange pursuit by their families and friends.

We tend to think of folk art as a country art, uncorrupted by slick urban values, but some folk art has been made in cities. There is folk painting and sculpture, even folk architecture. Much of this art, however, consists of objects for daily life, embellished to make them beautiful. In other words, everyday people take everyday objects and turn them into a special art form.

So much about folk art is appealing. Like the art of children, it often reveals a quite direct expression. Most folk painters and sculptors would become impatient if someone tried to tell them how art is "supposed" to look. They form images of what they see, colored by their feelings about what they see, and they are satisfied. They invent, they play with forms, they delight in colors and shapes, they decorate—free of the inhibition that comes from being told "That's not *real* art."

Another aspect of folk art, especially of functional items, is that it tends to be exceptionally well crafted. Pleasure is in the making, in the handling of materials, in taking the time to be sure the work is as perfect as it can be. No wonder "sophisticated" art lovers have begun to collect this work avidly.

What impulse causes folk artists to create? There seem to be a variety of motives. Vermont folk artist Stanley Marcile, who began drawing in his seventies, claims he did so because he had nothing else to do. He says, "I saw these pencils in the store, so I bought them and started drawing. I couldn't go hunting no more, so I just started inventing." Marcile's drawing of a house (**10**) shows an instinctive flair for composition, especially in the way the tree curves above the roof. Like most folk art, the drawing is decorative—full of patterns and lines and curls that please the eye as much as they must have pleased the hand in drawing

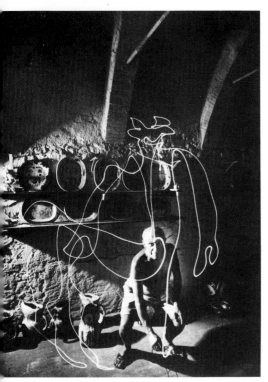

9. Gjon Mili.
A Centaur Drawn with Light,
Pablo Picasso
at the Madoura Pottery
in Vallauris, France, 1949.
Life Magazine © Time Inc.

10. Stanley Marcile. *Untitled.* 1981.
Ballpoint and felt pen on paper,
11 × 14″. Courtesy the artist.

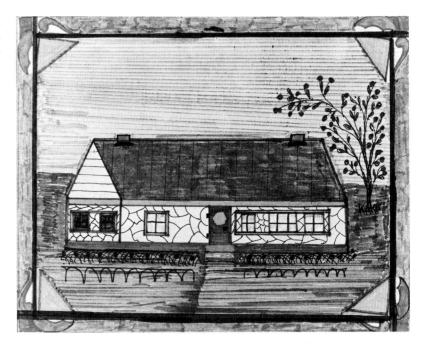

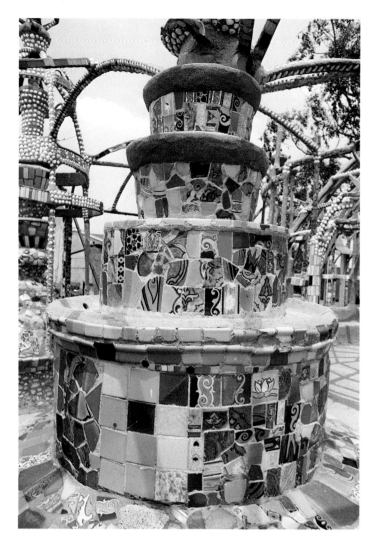

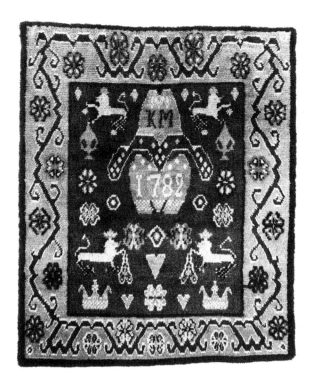

left: 11. Simon Rodia. Watts Towers,
Los Angeles, detail.
c. 1921–54 (now partially destroyed).

above: 12. Rya rug, from Finland. 1782. Wool.
National Museum of Finland, Helsinki.

them. This last might be considered a major (or *the* major) characteristic of folk art: it pleases the eye.

Similar concerns must have motivated Simon Rodia, an immigrant tile-setter from Italy, who built, in the depressed area of Los Angeles known as Watts, a fantasy-land construction that has come to be called the Watts Towers (**11**). Working with bits of bottle glass, broken dishes, shells, pieces of mirrors, and other debris from the streets, Rodia patiently created a thing of beauty—a very personal expression of art, in monumental form—in his backyard. He labored over the towers for about thirty years, feeling that he thus paid a debt to the country that had given him a home and a living. But the Watts Towers are not just the obsession of an eccentric laborer. They are the product of a creative artist who has found a unique way to use his gift.

Whole cultures have established folk-art traditions because, for certain periods of time, they had little else to do. Before the advent of television or VCRs, before radio, before modern transportation made social contact easy, people were left to their own devices for long stretches of time. In rural areas, and particularly in cold climates, the winter months dragged on interminably. Shut inside their houses, people turned to making functional objects, and, since time was their greatest asset, they lavished attention on craftsmanship and decoration. In Scandinavia—where winters are among the coldest and darkest on earth—a tradition of weaving and rug-making sprang up, and it continues to this day. Certainly the rugs were needed for warmth, but they didn't need to be fancy. A rug hand-knotted in Finland in 1782 (**12**) has a typical folk quality of allover decorative plant and animal forms. Characteristic, too, is the working into wool

of the maker's initials and the date, for folk weavers take great pride in their accomplishments.

Time, therefore, seems to be an important element in the urge to make folk art, but it does not completely explain the phenomenon. The same people, faced with time on their hands, could equally have taken up gymnastics or dancing or indoor horticulture or games (and possibly they did all these as well). It seems evident that there is an inborn compulsion to make something wonderful, something that will last.

As suggested earlier, the inventiveness of folk art stems largely from a lack of knowledge or concern about how things "should" look, and this is true not only of drawings and paintings, but of handcrafted objects as well. Toys serve as a good example. In our day most children's toys are turned out by the identical millions, geared to a child-consumer market that responds eagerly to television advertising. Before mass production, however, a toy was usually a one-of-a-kind item, its form determined only by the ingenuity of the maker. In mid-19th-century England a wood-carver fashioned an elaborate butcher shop (13), complete with hanging meats, butcher, and customers—an enchanting variation on the doll house. This piece shows the lengths to which an interested and creative toy-maker might go in constructing a plaything to delight a child.

During the 18th and 19th centuries in the United States, the folk arts enjoyed an especially rich outpouring. All sorts of objects—furniture, toys, gateposts, trade signs, tableware, weathervanes (14)—were potential subjects for the folk artist's imagination. The great variety of styles can be explained partly by the ethnic diversity of the new nation. Settlers from Europe brought along their own folk traditions and transplanted these traditions to the new country. Some of these traditions continue even today, in areas heavily settled by particular groups.

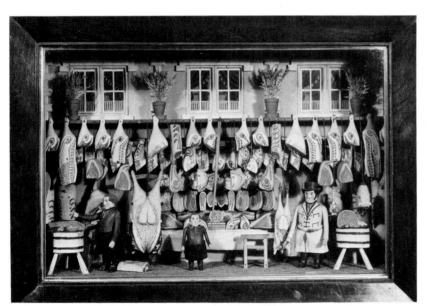

13. Toy butcher shop, from England. c. 1800. Carved and painted wood with stained glass, height 19⅝". Cooper-Hewitt Museum, Smithsonian Institution, New York (gift of Maude K. Wetmore).

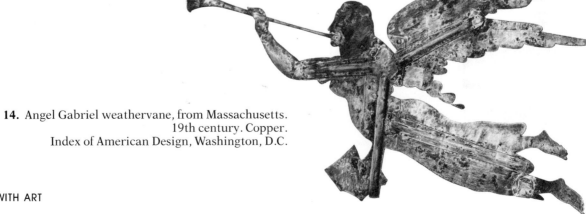

14. Angel Gabriel weathervane, from Massachusetts. 19th century. Copper. Index of American Design, Washington, D.C.

To sum up, then, it seems that the conditions favorable for the development of a folk art are time, separation from the mainstream of art, and the desire to make something extraordinary out of the ordinary. Does this mean that, in our fast-paced world with global communication and mass production, the folk arts will die out? Apparently it does not. Thanks to the machine, leisure time is, if anything, more available than ever before. The mainstream of art, if known, can be disregarded; some contemporary folk artists know very well what is being shown in the galleries of New York, Chicago, and Los Angeles but don't care. Above all, the desire to make something wonderful appears to be basic and will not go away, no matter how our world changes. Indeed, our changing world has fostered the expansion of folk art into different realms. Perhaps there is a new "folk art," in tune with modern times.

MODERN "FOLK ART"

If there is a contemporary folk art, we may seek it wherever people take something ordinary and make it extraordinary. Across the bay from San Francisco, in a spot bordered by the highway that daily carries commuters into the city, lie the depressingly named Emeryville mud flats. Prevailing winds and tides continually strew the mud flats with garbage—driftwood, old automobile parts, tin cans, junk of all sorts. But what might have been an ugly trash pile has turned into something quite different—a constantly changing folk-art gallery. Artists, many anonymous, take the junk and turn it into sculptures of animals, human figures, fanciful creatures, abstract constructions—whatever the imagination can conjure from battered castoffs (15). Some of the sculptures do not stand for long. When they fall, other artists come along and recycle the material into new works of art. Motorists driving by the mud flats are treated to an ongoing, vital art exhibition.

The mud-flat artists do not get any money for their efforts, and they seldom get recognition as individual artists. Then why do they do it? They do it for

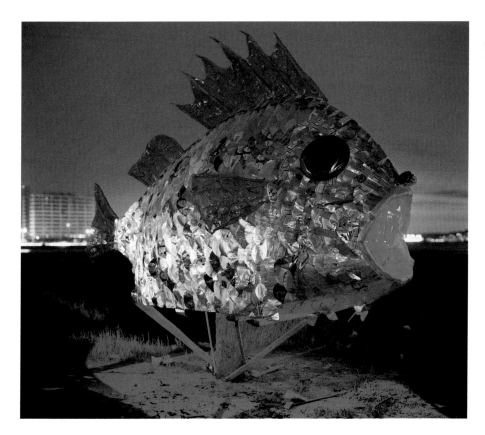

15. Anonymous. *Fish.*
Aluminum cans and mixed media.
Emeryville mud flats, California.

pleasure, for the sheer joy of creating something out of almost nothing. They make the extraordinary out of the ordinary. In a very real sense, they are today's folk artists.

So we have considered two groups of people—children and folk artists—for whom art seems to be a basic element of human expression, a natural part of life. We might add to this list a third group, ancient artists who decorated their implements and the walls of their caves. All three groups are practitioners, makers of art. This discussion began, however, with the premise that *everybody* lives with art, and some people simply do not choose to devote their time to artistic creation. As suggested earlier, there are three different ways in which people can live with art—by making it, by supporting it, and by observing and enjoying it. The balance of this chapter considers these three roles: artist, patron, observer.

The Role of the Artist

Nobody questions the role farmers play in society. They produce the food necessary to sustain life. Much the same is true of furniture makers, car and clothing manufacturers, and nowadays computer programmers and bankers. But what of artists? What role do they fill? What do they contribute to society, and do we really need them? Would our world be seriously diminished if there weren't any artists? To answer these questions, let us focus briefly on those people who live actively with art every day of their lives—the artists themselves.

We should first consider who the artist is. Thanks to Hollywood movies and popular fiction, many people have a stereotype in mind. (The two artists whose biographies appear in this chapter were both subjects of sensationalized Hollywood films, thus contributing to the stereotype.) According to this idea, the artist is a free spirit, unbridled by any moral code; poorly dressed and not very well washed; high nearly all the time on drugs or drink or both; housed in a drafty but picturesque studio, surrounded by paint cans, nude models, and bohemian friends; apt to dash off at any moment to Majorca or the South Pacific to live

16. Rembrandt Peale.
Thomas Jefferson. 1805.
Oil on canvas, 28 × 23½".
New-York Historical Society,
New York.

primarily on peeled grapes, pausing every now and again to splash onto canvas the tortured outpourings of an Intense Inner Turmoil. The artist's death comes tragically early, usually by suicide or overindulgence in strong drink. Is this image romantic? Absolutely. Is it accurate? Almost never. The fact is that most great artists become great by channeling their personal vision into hard work and discipline.

This picture of the artist—a charming one, to be sure—really applies only to a few artists, influenced by Romantic ideals of the late 19th century. Throughout history artists have filled many different kinds of social roles. In ancient Egypt, Greece, and Rome, artists usually had very low social status, and some were actually slaves whose task was to carry out the artistic requirements of their masters. During the Middle Ages the artist moved into the realm of the craftsman, occupying a social level roughly equivalent to that of today's fine cabinetmaker. Only by the time of the Renaissance, the 15th century, were artists accepted in "good" society, and still their creations were under the rigorous control of wealthy patrons. Today's artists in most countries enjoy a social status like that of Renaissance artists—a special elite apart from class—but their freedom of expression is greater than that of artists even a few generations ago.

The social role of artists has changed over time, but their function remains basically the same. Like their counterparts in earlier times, contemporary artists fulfill a practical function, designing virtually every structure and object in the environment. Today this practical role is carried out by artists with specialized, often technical, training—industrial and graphic designers, architects, craft artists, and fashion designers, among others. But what about the painters and sculptors, the photographers and cinematographers? What needs do they meet in our computer age? We can identify at least four basic functions for the artist—all of them age-old, all expanding in complexity.

First, artists *record*. They give us visual images that can be preserved for historical reference. This idea is so obvious that we take it for granted, forgetting how overwhelming our ignorance otherwise would be. Were it not for artists, we would have no idea what people from the past looked like. Thomas Jefferson was one of the founders of our country, principal author of the Declaration of Independence, and third president of the United States. He is well known to us from his extensive writings. His splendid architecture (**443**) stands today and is still admired. But Jefferson died more than a decade before the invention of photography, and were it not for artists' portraits, including the sensitive one by Rembrandt Peale (**16**), we would have no visual image of the man to match the achievement. Nor could we form any visual image of historical places and events. Before the invention of the camera in the early 19th century, artists recorded images mainly through painting and sculpture. Today we rely more heavily on photography, cinema, and television to keep our history, but of course the people behind these media are also artists. Even with the prevalence of mechanical recording, there is a renewed interest in the painted portrait, and a great many well-known artists are thriving on portrait commissions.

Second, artists *give tangible form to the unknown*. In other words, they attempt to record what cannot be seen with the eyes or what has not yet occurred. This role has been important throughout the history of art, and it is no less vital today. Ancient artists had a somewhat different list of unknowns to contend with. They puzzled over and feared such things as tornadoes, floods, eclipses, and the wrath of spirits. Even in an age when satellites predict the weather and spirits have been tamed, there still are certain unknowns, and artists still are struggling to give them tangible form. What would a nuclear holocaust be like? We do not know and dare not find out. What exists at the edge of our universe? Scientists will know eventually, but not soon. What do our dreams and nightmares really mean? None of us can analyze them definitely. These unknowns are frightening to us, just as the Thunder God must have been to our ancestors. If artists can present them to us in some concrete form, we can tame them and go about our business.

Third, artists *give tangible form to feelings*. These may be the artist's own feelings that are expressed in paint or marble or whatever the medium. But surely they are feelings shared by many people—love, hate, despair, fear, exhila-

ration, anger, admiration, the terror of nightmares (**17**). When we respond to a work of art, when we pay attention to the emotions it evokes, we are communicating in a way with the artist and with other people who share these responses.

Fourth, artists *offer an innovative way of seeing*, a unique visual perspective. When we experience a work of art, we confront the artist's perspective, compare it to our own, and take note of both the similarities and the differences. Art encourages us to think, to question, to imagine, to explore, to dream. It stretches our own horizons by confronting us with someone else's.

To sum up, then, artists perform at least four important functions in society: they record, they visualize the unknown, they portray feelings, and they stretch one's ability to see. All of these functions have to do with communication. Artists are able to fill these roles because they *create* new visual images. The words *creative* and *creativity* will come up often in this book, so it might be well to pause a bit and consider what they really mean.

CREATIVITY

Who is creative? Are artists more creative than other people? If so, how did they get that way? What is creativity? Does everyone start out having it and do some people then lose it? Is there any way to get it if you don't have it? Can a person become more creative? Less creative? These are fascinating questions to which, unfortunately, there are no definite answers. We can approach the problem by looking at examples and perhaps gain some insight, but nobody will ever write the rules of creativity.

The illustration (**18**) shows a work by Pablo Picasso entitled *Bull's Head*, which consists entirely of the seat and handlebars of a bicycle. No doubt every one of us has seen a bicycle, and we are familiar with the shapes of seat and handlebars. Picasso, however, looked at these shapes and saw something else— saw it in his creative imagination. He saw the head of a bull. By putting the two shapes together in a special way, he made something of them that had not been there before. In other words, he created. What's more, he created so persuasively that, if you hadn't been told what the shapes were and had not read the caption, you might not recognize the bicycle seat and handlebars for what they are. You would instead see a bull's head, because that is what Picasso has caused us to see. It is important to note that Picasso was a great fan of the bullfight. His creativity in this instance was filtered through his life's experiences and interests—his own *references*. Another creative artist might have combined the two shapes into

left: 17. Phyllis Bramson. *Metaphysical Drama 2.* 1983. Oil on canvas, 5' × 6' × 4". Courtesy Dart Gallery Incorporated, Chicago.

right: 18. Pablo Picasso. *Bull's Head.* 1943. Bronze, height 16⅛". Courtesy Chevojon Frères, Paris.

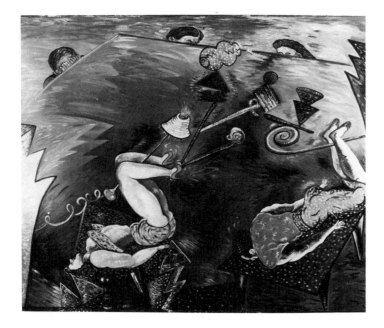

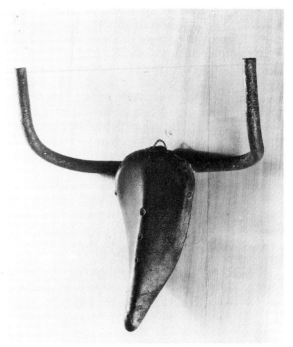

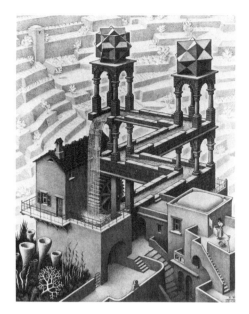

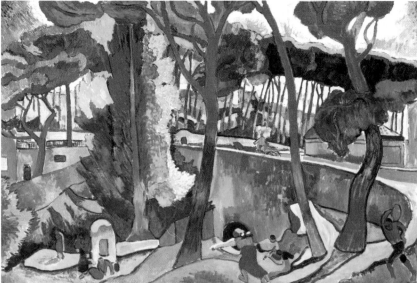

something very different. (Numberless other creative artists have seen bicycle seats and handlebars and paid no attention to them.)

The Dutch artist M. C. Escher was a lover of visual puzzles. He enjoyed tricking the viewers of his art. In *Waterfall* (**19**) we see an elaborate, fantastic structure and landscape; the trick comes when we look more closely. The water-fall of the title spills down normally in the center of the picture. Then the water proceeds back and forth, somehow running uphill to the top! We stare at the drawing, trying to figure out what is wrong with it. At any given point it *looks* all right, but we know it cannot be. Our brains are sure that water does not flow uphill; our eyes see that the water gets to the top, flows down, then goes around again. Escher has created an intriguing image. His creativity makes us see some-thing that could not possibly be true. More to the point, his creativity let him imagine that water might run uphill, then figure out a way to make it happen.

The last example in this section is a painting by André Derain, called *The Turning Road, l'Estaque* (**20**). In every respect but one this seems a fairly straight-forward landscape. The one exception, needless to say, is the color. Trees and grass in our world are not blood red, nor are people. Clouds and shadows are not vivid purple. Roads seldom are bright yellow. Derain, a member of the Fauve group in France at the early part of this century (Chapter 17), painted in *arbitrary colors, or colors unrelated to the natural world.* He chose to depict nature not as we see it through the window, but as he wanted to see it in his painting. Such disregard of natural colors requires a creative leap of the imagination that was shocking to art viewers of the time.

These three works—the Picasso, the Escher, and the Derain—have certain characteristics in common. All three involved the making of something that had not been before. All three resulted from the artists' suspending judgment about what should be or actually is, in favor of what might be. All three developed as they did because of certain personal preoccupations: for Picasso, the bullfight; for Escher, a puzzle; for Derain, color as pure color. Taken together, they give us clues about the nature of creativity.

The literature on creativity is plentiful. Many writers and educators have tried to analyze creativity and to determine what makes a person creative.[2] While the exact nature of creativity remains elusive, there is general agreement that creative people tend to possess certain traits, including:

- *Sensitivity*—heightened awareness of what one sees, hears, and touches, as well as responsiveness to other people and their feelings.
- *Flexibility*—an ability to adapt to new situations and to see their possibilities; willingness to find innovative relationships.

left: **19.** M. C. Escher.
Waterfall.
1961. Lithograph,
$14\frac{7}{8} \times 11\frac{3}{4}''$.
Escher Foundation,
Haags Gemeentemuseum,
The Hague.

right: **20.** André Derain.
The Turning Road, l'Estaque.
1906. Oil on canvas,
$4'2\frac{1}{2}'' \times 6'4\frac{5}{8}''$.
Museum of Fine Arts, Houston
(John A. and Audrey Jones Beck
Collection).

- *Originality*—uncommon responses to situations and to solving problems.
- *Playfulness*—a sense of humor and ability to experiment freely.
- *Productivity*—the ability to generate ideas easily and frequently, and to follow through on those ideas.
- *Fluency*—a readiness to allow the free flow of ideas.
- *Analytical skill*—a talent for exploring problems, taking them apart, and finding out how things work.
- *Organizational skill*—ability to put things back together in a coherent and logical order.

Are artists more creative than other people? Maybe, maybe not. The profession of artist is not the only one that requires creativity. Scientists, mathematicians, writers, teachers, business executives, doctors, lawyers, librarians, computer programmers—people in every line of work, if they are any good, look for ways to be creative. The football coach who invents a new play is being creative, as is the plumber who devises an innovative way to keep the washing machine from leaking. Artists occupy a special place in that they have devoted their lives to opening the channels of *visual* creativity.

Can a person become more creative? Almost certainly, if one allows oneself to be. Being creative, as we said, means making something new. It means learning to trust one's own interests, experiences, and references, and to use them to enhance life and work. Above all, it means discarding rigid notions of what has been or should be in favor of what *could* be. For both the artist and the observer of art, creativity develops when the eyes and the mind are wide open, when the brain is operating on all its channels.

LEFT BRAIN, RIGHT BRAIN

A theory popular in the 1960s and 1970s suggests that the right half of the human brain is more creative than the left half, or at least that the right brain has greater responsibility for *visual* creativity. This idea is based on studies having to do with brain-hemisphere differentiation. Scientists have known for many decades that the two halves of the human brain have some different functions, and that the left side of the brain largely controls verbal abilities. People who survive injuries to the left brain may lose their verbal skills, whereas those who suffer right-brain injuries do not. This knowledge paved the way for experiments, beginning in the 1960s, that seemed to establish specialized roles for the two sides of the brain.

According to this theory, the left brain is the custodian of words and logic; the right brain, the keeper of images and analogies. The left brain gives names to things and describes them. It reasons sequentially, from one step to the next, and bases its conclusions on reason and facts. The right brain does not use words but relies on images. It is intuitive rather than logical, it lacks a sense of linear time, and it tends to seek relationships and associations between things. From these conclusions, it would seem to follow that the right half of the brain is the "artistic" side, since visual art deals in images and relationships. Researchers theorized that artists, when they set about working, could somehow "turn on" the right brain, blocking out the verbal and logical activities of the left brain. This theory is appealing and may have some validity, but it seems now to have been somewhat overstated.

New research indicates that the two halves of the brain are more *interdependent* than had been believed.[3] Rather than having sole responsibility for a particular set of functions, they are specialists, using each other's abilities as needed. If indeed, as seems apparent, the right brain is more image-oriented, the left brain more word-oriented, it stands to reason that the artistic experience will be heightened if one uses *both* sides of the brain to their fullest potential, allowing them to interact naturally, to complement one another.

Whether one is making art or looking at it, the experience is bound to be richer if one brings to it the fullest participation of sensory, intellectual, and aesthetic capacities. That is the key to truly *living* with art. We should keep this in mind as we consider our next two categories—the patrons and the observers.

The Role of the Patron

A patron is a person who buys or commissions works of art. Without patrons, artists could not prosper, for there would be no one to finance their endeavors. The first section of this chapter presented the idea that people have an inherent impulse to make art. It seems equally true that people have an inherent impulse to collect and support art. The patron of art may be a private individual, a political or religious leader, a business or government body, even a whole culture.

Patrons may have any number of motivations for supporting art. Perhaps art is meant to show the patron's wealth or prestige. Perhaps the patron simply loves the experience of being surrounded by art and can afford to indulge that love. In the case of an establishment—a monarchy, a government or religious body, or a business firm—art may embody the ideals and principles of that establishment, may express what it feels about itself and wishes to communicate to the world. The same may be true when art is integral to a whole culture.

Looking back into history, we find that many of the cultures we admire as high points in the world's progress also were great patrons of art. Among them we could include the Classical civilizations of Greece and Rome, the Gupta period in 5th- and 6th-century India, the Song dynasty in China, and the Renaissance in 15th-century Europe. History tells us that art thrives in an atmosphere fostering the highest ideals and the greatest energy. Art grows alongside achievements in science, government, and commerce.

There are records to show how highly art was valued in some of these exemplary cultures. For instance, in 15th-century Italy, in the prosperous city-state of Florence, one family reigned supreme for three generations—the Medici. The Medici were bankers and, although not of noble blood, ruled as virtual kings. They were also great patrons of art and supported Raphael, Michelangelo, Sandro Botticelli, and many other artists whose works appear in this book. Botticelli's *Primavera* (**21**), one of the loveliest paintings from the Renaissance, originally was created to hang in a villa belonging to the Medici. Lorenzo de' Medici had this to say about his vast expenditures for art: "Many deem that it would

21. Sandro Botticelli. *Primavera.* c. 1478. Tempera on panel, 6'8" × 10'3¾". Uffizi, Florence.

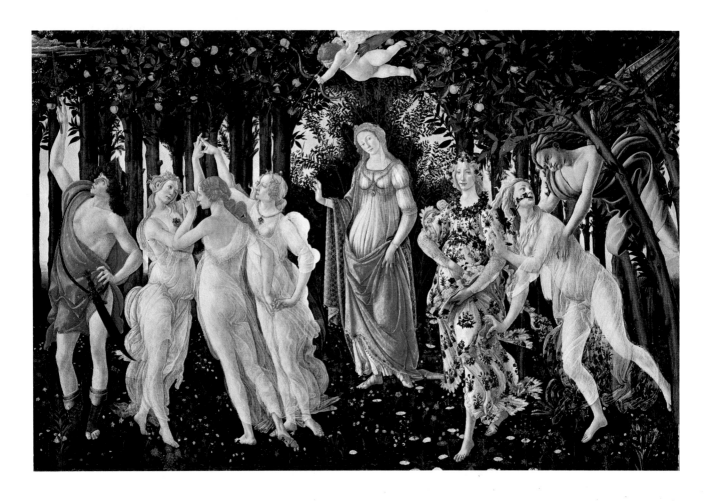

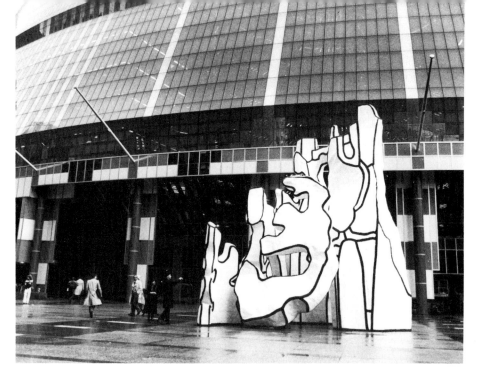

22. Jean Dubuffet.
Monument with Standing Beast.
1984. Fiberglass, height 29'.
Commissioned by the Illinois
Capital Development Board;
given by the Leonard J.
Horowich Family Foundation
in memory of Leonard J. Horowich
with additional funding by
the Graham Foundation
and an anonymous donor.

have been preferable to keep part of the funds in the treasury; I think that our patronage was the great splendor of our regime and, in my opinion, the money was well spent."[4] Five centuries later we can only agree: the money was *very* well spent. Our artistic heritage would be much the poorer without works commissioned by the Medici.

We can find a surprisingly true echo of Lorenzo's ideals in our own more recent national history. Writing for *The New York Times*, historian Arthur Schlesinger, Jr., tells us:

> In the third year of the Civil War, President Abraham Lincoln ordered that construction of the Capitol dome be completed. When critics objected to the diversion of labor and money from the prosecution of the war, President Lincoln said, "If people see the Capitol going on, it is a sign that we intend this Union shall go on."

Nearly a century later, Schlesinger continues, "President Franklin D. Roosevelt recalled this story in 1941 when, in a world ablaze with war, he dedicated the National Gallery of Art in Washington." We can only marvel at these stories. Why should political leaders, fighting for the very survival of their nations and people, pay attention to art? Perhaps they felt that, somehow, art is important *for* survival. Perhaps they understood that art will endure long after the details of battle and politics are forgotten. As Schlesinger says, "If history tells us anything, it tells us that the United States, like all other nations, will be measured in the eyes of posterity less by the size of its gross national product and the menace of its military arsenal than by its character and achievement as a civilization."[5]

From the words and actions of Lorenzo, of Lincoln and Roosevelt, of many other government leaders like them, we may conclude that the purpose of official art patronage is to show contemporaries "This is who we are," and to show future generations "This is who we were." No doubt the same purpose underlies support of the arts by a new breed of patrons—the corporate giants.

Once a sculptor's masterpiece might have adorned the private sitting room of a king or dictator or cardinal. Today it is more likely to rest in the lobby of an office building or in the street outside (**22**). Some corporations, such as IBM and Pepsico, invest very heavily in art, particularly contemporary art (**23**). Their reasons for this patronage are diverse. Certainly prestige is among their motivations; the chief executive of Pepsico Inc., which maintains a large sculpture garden at its headquarters, has said, "I don't think anybody could walk away from here without being impressed."[6] Another reason may have to do with productivity—productivity of the most inventive sort. We said earlier that art stretches

people's horizons, encourages them to think and explore. Apparently, the large corporations of the United States agree. Listen to their chief executives:[7]

AMERICAN REPUBLIC INSURANCE COMPANY: We are in the think business here. . . . Whenever you expand an employee's intellectual horizons, you make him a better employee.—Watson Powell 3d

PAINEWEBBER: Most of us spend a substantial amount of our lives in our place of work. At PaineWebber, the art collection puts us in touch with the best our culture produces in the visual arts. It underscores the value of creative human endeavor and offers us another way of looking at our own time.—Donald B. Marron

What these executives are saying is that displaying creative art in the workplace will help to make their workers more creative. But the kind of intellectual and emotional stimulation afforded by art need not be restricted to our working lives. Art can give us new ways of seeing in our social, leisure, and personal lives. There are gains for the self, not just for the employer, in becoming an active observer of art.

The Role of the Observer

There is a difference between being merely an observer and being an intelligent, *informed* observer. Observers walk through the world letting their eyes record art while their brains are occupied elsewhere. Informed observers, by contrast, have spent the time and energy needed to educate themselves so that their exposure to art will be meaningful. They don't just coexist with art; they live with it.

23. Alberto Giacometti. *Large Standing Woman II (Grande femme debout II).* 1960. Bronze, height 9'1½". *Large Standing Woman III (Grande femme debout III).* 1960. Bronze, height 7'8⅞". Courtesy PepsiCo Inc., Purchase, N.Y.

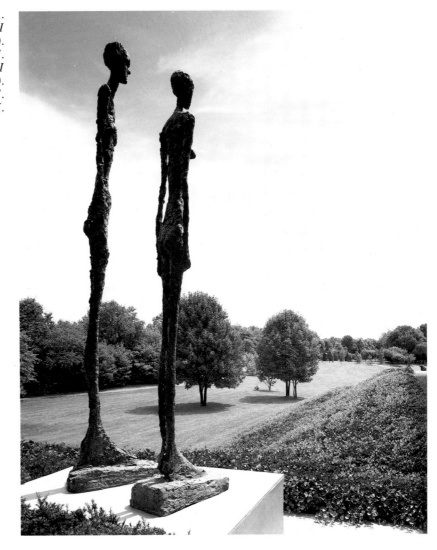

How, then, do observers of art proceed to educate themselves? As with most areas of life, the more one puts into it, the more one will get out of it. You can observe and enjoy art at many different levels. Some art is "easy." Advertising layouts, magazine covers, record-jacket designs—these make good examples. The graphic design is bright, colorful, and attractive. Its main purpose is to appeal superficially to the eye—and to encourage you to buy the product. Nearly anyone can admire the cleverness of the design without spending a lot of time studying it.

Others kinds of art are more "difficult" for the untrained observer. This could be said of the two paintings illustrated next (**24,25**). If you are not familiar with works of art in these particular styles, you may think that the first, a painting by Alma Thomas, is little different from a computer printout, perhaps in Arabic; and the second, a painting by Alex Katz, may strike you as resembling a poster or magazine advertisement. If you turn away from them quickly, the paintings may communicate nothing to you. On the other hand, if you have seen other works in these styles, if you have learned the process by which the two artists arrived at these kinds of expressions, then you may find some thread of communication.

In other words, there are two specific things that can enhance your appreciation of art: exposure and study. *Exposure* means looking at art, as much as possible, and really seeing it. You should be familiar with this process from your experience with music. The first time you hear a song or a symphony you may find it appealing. But when you have listened to the same piece of music over and over, you begin to greet it like an old friend. You hear patterns and rhythms and harmonies that you didn't notice before. Whereas the first exposure gave you sensory pleasure, repeated exposures bring emotional and perhaps intellectual pleasure. This in turn gives you greater appreciation of similar music by the same composer and by others.

Another benefit of exposure to art—of looking at art and really seeing it—is that we heighten our perceptions of art. Perception is a complicated process, and if we do not understand its intricacies, a lot of our visual world can slip past us.

24. Alma Woodsey Thomas. *Light Blue Nursery.* 1968. Acrylic on canvas, 4'2" × 4'. National Museum of American Art, Smithsonian Institution, Washington, D.C. (gift of Alma W. Thomas).

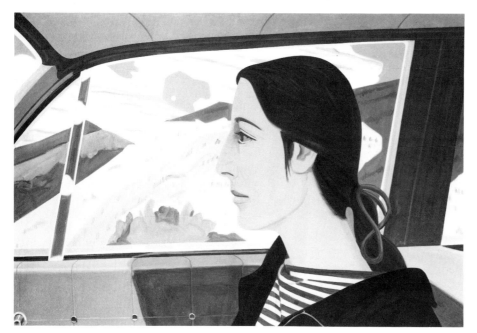

25. Alex Katz. *Impala*. 1968.
Oil on canvas, 6 × 8'.
Cleveland Museum of Art
(Mr. and Mrs. William H. Marlatt
Fund and gift of the
Eppler Family Foundation
and Agnes Gund Saalfield).

PERCEPTION

Our appreciation of art is directly tied to our individual *patterns of perception*—
the specific ways in which we experience the world around us. In most cases art
depends primarily on visual perception—the process by which our minds inter-
pret the information that we collect with our eyes.

In visual perception our eyes take in information in the form of light pat-
terns. Through a complex interaction that scientists do not entirely understand,
the brain processes these visual images to give them meaning. The mechanics of
perception work in much the same way for everyone, yet in a given situation, we
do not all see the same things. The human eye simply cannot take in all available
visual information. Our world is too complex, and we are constantly bombarded
with an incredible range of visual images. If the mind recorded all the visual
detail that our eyes see at any given moment, it would "blow a fuse." To avoid
overloading our mental circuits, the brain responds only to that visual informa-
tion required to meet our needs at one moment.

Suppose you are driving along a busy street, assailed on all sides by de-
manding visual images. Your eyes "see" everything. But what does your brain
register? If you are behind the wheel of the car, you will see the traffic signs and
lights, because awareness of such details is necessary to survival. If you are very
hungry, your attention may be attracted by fast-food signs and restaurants. But
if you are looking for a specific address—the home of a friend or the place where
you have a business appointment—then you will focus on building numbers and
block out nearly everything else. It is easier to cope with life and with our com-
plex visual world if we simplify our perceptions and see according to our imme-
diate needs.

At the same time, if we habitually allow ourselves to see *only* in terms of
immediate needs, we miss many satisfying visual experiences. On a treacherous,
icy day we may concentrate so hard on the problem of getting to class or to work
that we do not see how beautiful the ice-covered tree branches are. Always busy,
always preoccupied, we do not notice the striking design of a house or the beauti-
ful cut of a garment. We walk past paintings and sculptures without ever really
seeing these works of art. To enjoy fully the aesthetic experiences offered by our
world, we must occasionally put aside immediate needs and really *look*. A quick
glance is not enough.

Studies indicate that the brain is often more important than the eyes in
determining what each of us sees as we move through the world. The brain's

ability to control perception is obvious when we study ambiguous figures, such as the classic one reproduced here (**26**). When you first look at this drawing, you may see a young woman turning away from you so that only her cheek line, the top of her nose, and her eyelashes are visible. Or you may see a toothless old woman with a large, warty nose, whose chin is buried in a dark collar. For you to be able to see both images, your brain must reorganize the lines in the drawing.

Even after you have been made aware of the two images, you must consciously work at going back and forth between them. You can feel your brain shifting as it organizes the visual information into first one image and then the other. The important thing to remember as you shift your perception back and forth from the young woman to the old is that the visual image *always stays the same*. It is only your perception, as controlled by your brain, that changes.

While perception can cause us to miss seeing what is actually present in the visual field, it can also do the reverse: cause us to "see" what is *not* present. In the illustration of wavy forms (**27**) you may see a perfect white circle, but there is no circle. There is only the illusion of a white circle created by breaks in the wavy forms. (If you doubt this, cover up any two adjacent forms and look at the space between them.) This is just another trick our brains play on us as part of the phenomenon of perception. The brain supplies information to create a kind of order it requires, even though that information may not be recorded by the eyes.

Some understanding of perception is extremely helpful to the appreciation of art. When you look at a painting, for example, at least three factors always are operating: the actual, physical substance of the painting; the artist's intention in making the painting; and your own perception of the painting. Each person who looks at that same painting will bring a different perception, so you can see how complex is the communication we call art. To get an idea of how this works, let us study one well-known painting.

When you look at the image shown opposite (**28**), you will see a layer of paint on canvas, the individual strokes of a brush. This is what you would see if you stood very close to the painting and focused on one area—globs of inert colored pigment attached to a canvas backing.

Now pull back farther and consider the whole painting (**29**). You see a brilliantly colored landscape with a tree, a village, a church, and a turbulent sky. This is Vincent van Gogh's masterpiece, called *The Starry Night*. If we limit ourselves to absolute scientific observation, no night sky ever looked like this. Stars do not race about in frenzied whirlpools. What was Van Gogh's perception of the scene that caused him to paint it this way? We know that he was a tormented, intense, and mystical man. Some of the torment, and a kind of ecstasy, are built into the painting.

left: 26. E. G. Boring's Object-Ambiguous Mother-in-Law.

right: 27. The Circle That Isn't There.

28. Vincent van Gogh.
The Starry Night (detail).

And what is the viewer's perception? That depends, to a large extent, on the individual's perceptual habits and biases and on past experience. The cosmologist might think *The Starry Night* alludes magnificently to the formation of the universe. A Londoner who experienced the German blitz in World War II might see a bombing raid. Someone who has been in a fever or taken drugs might see a hallucinatory vision. A person with a certain visual disorder might think that is the way a sky always looks. And the individual who views nature in a meticulous, scientific way might think that Van Gogh was crazy.

The message Van Gogh (or any other artist) sends cannot be precisely the message you receive. Van Gogh brought to his work a whole set of experiences and emotions; no one else can duplicate them exactly. However, if you open yourself to looking at the art, to receiving whatever message it may have for you,

29. Vincent van Gogh.
The Starry Night. 1889.
Oil on canvas, 29 × 36¼".
Museum of Modern Art, New York
(acquired through the
Lillie P. Bliss Bequest).

Vincent van Gogh
1853–1890

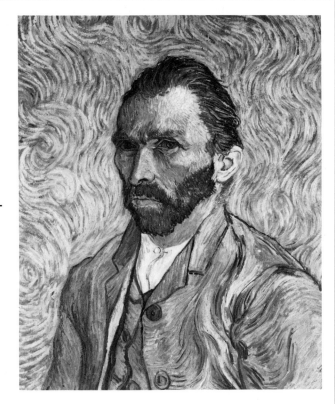

The appeal of Van Gogh for today's art lovers is easy to understand. A painfully disturbed, tormented man who, in spite of his great anguish, managed to create extraordinary art. An intensely private, introspective man who wrote eloquently about art and about life. An erratic, impulsive man who had the self-discipline to construct an enormous body of work in a career that lasted only a decade.

Vincent van Gogh was born in the town of Groot-Zundert, in Holland, the son of a Dutch Protestant minister. His early life was spent in a variety of roles, including those of theological student and lay preacher among the miners of the region. Not until the age of twenty-seven did he begin to take a serious interest in art, and then he had but ten years to live. In 1886 he went to stay in Paris with his brother Theo, an art dealer who was always his closest emotional connection. In Paris Vincent became aware of the new art movements and incorporated aspects of them into his own style, especially by introducing light, brilliant colors into his palette.

Two years later Van Gogh left Paris for the southern provincial city of Arles. There he was joined briefly by the painter Paul Gauguin, with whom Van Gogh hoped to work very closely, creating perfect art in a pure atmosphere of self-expression. However, the two artists quarreled, and, apparently in the aftermath of one intense argument, Van Gogh cut off a portion of his ear and had it delivered to a prostitute. Soon after, Van Gogh realized that his instability had gotten out of hand, and he committed himself to an asylum, where—true to form—he continued to work prolifi-cally at his painting. Most of the work we admire so much was done in the last two and a half years. Vincent (as he always signed himself) received much sympathetic encouragement during those years, both from his brother and from an unusually perceptive doctor and art connoisseur, Dr. Gachet, whom he painted several times. Nevertheless, his despair deepened, and in July of 1890 he shot himself to death.

Vincent's letters to his brother Theo represent a unique document in the history of art. They reveal a sensitive, intelligent artist pouring out his thoughts to one especially capable of understanding. In 1883, while still in Holland, he wrote to Theo: "In my opinion, I am often *rich as Croesus,* not in money, but (though it doesn't happen every day) rich, because I have found in my work something to which I can devote myself heart and soul, and which gives inspiration and significance to life. Of course my moods vary, but there is an average of serenity. I have a sure *faith* in art, a sure confidence that it is a powerful stream, which bears a man to harbour, though he himself must do his bit too; and at all events I think it such a great blessing, when a man has found his work, that I cannot count myself among the unfortunate. I mean, I may be in certain relatively great difficulties, and there may be gloomy days in my life, but I shouldn't want to be counted among the unfortunate nor would it be correct."[8]

Vincent van Gogh. *Self-Portrait.* 1890. Oil on canvas, $25\frac{1}{2} \times 21\frac{1}{2}''$. Musée d'Orsay, Paris.

then a communication exists. Communication, as we all know, is a two-way process. Two people cannot hold a conversation if one is doing all the talking and the other is sitting there dumbly. Van Gogh poured a lot of himself into *The Starry Night*. If you want to understand and enjoy—to appreciate—his art, then you also must bring something to the experience. This is where *study* comes in.

STUDYING ART

Art requires intellectual as well as sensory involvement. Your appreciation of art can be greatly improved by knowing how a work of art was made, why it was made, what went before and came after.

The understanding of process—the *how*—often contributes quite a lot to our appreciation of art. Parts III and IV of this book are largely concerned with this issue. If you understand why painting in watercolor may be different from painting in oil, why clay responds differently to the artist's hands than does wood or glass, why a stone building has different structural needs than one made of poured concrete—you will have a richer appreciation of the artist's expression.

An artist may create a specific work for any of a thousand reasons, and awareness of the *why* can also give the viewer greater understanding. We show here a late work by the American artist Charles Willson Peale (**30**). Peale was born in the colony of Maryland in 1741 and saw active service in the Revolutionary War. He is best known, perhaps, for his many portraits of George Washington, but they represent only a small portion of his achievement. Few other individuals typify so well the energy and ambition of a new nation.

Charles Willson Peale was passionately devoted to the pursuit of art and its development in the new country. (He named several of his seventeen children,

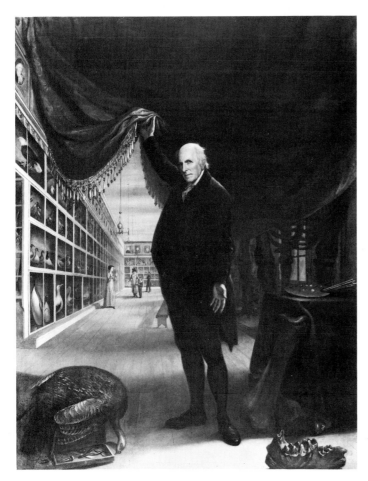

30. Charles Willson Peale.
The Artist in His Museum. 1822.
Oil on canvas, 8'7¾" × 6'7⅞".
Pennsylvania Academy
of the Fine Arts, Philadelphia
(Joseph and Sarah Harrison Collection).

above left: 31. Henri de Toulouse-Lautrec.
L'Estampe originale, cover. 1893.
Color lithograph, 17¾ × 23¾".
Metropolitan Museum of Art, New York
(Rogers Fund, 1922).

above: 32. Chobunsai Eishi.
Komurasaki of Kadotama-ya,
from the series *Greenhouse Beauties as the Six Poets*.
c. 1795. Woodcut, 15¼ × 10¼".
Art Institute of Chicago
(Clarence Buckingham Collection).

left: 33. David Hockney. *Celia*. 1973.
Lithograph, 42½ × 28½".
© David Hockney/ Gemini G.E.L., 1973.

including Titian, Raphaelle, and Rembrandt, after artists; we saw Rembrandt Peale's fine portrait of Thomas Jefferson earlier in this chapter.) Beyond this, he was a talented inventor, a scientist, and an organizer of the first museum in the United States. *The Artist in His Museum*, painted when Peale was eighty-one, was done for a specific purpose. It is a kind of summing up of his lifetime achievements. He lifts the curtain on his museum and, with quiet pride, invites the viewer to share his pleasure. In the foreground are symbols of his various careers—his artist's palette, the tools of the taxidermist, the bones of a mastodon, which he excavated. Beyond the curtain, in the museum itself, are stuffed ani-

mals and many portraits by the artist and his sons. Peale might be saying, "Here are the fruits of my life, and they are good."

The historical place of a work of art—*what went before and came after*—can be most interesting. Artists borrow and learn from each other all the time. The myth of the lonely artist—starving in a garret, isolated from human contact, leaving behind a mass of brilliant work that no one had suspected—is mostly that, a myth. There have been a few such cases, but not many. On the whole, artists study each other's work carefully, adapt ideas to serve their own needs, and then bequeath those ideas to future generations of artists. The more you know about this living current of artistic energy, the more interesting will be any specific work of art.

The three pieces illustrated here (**31,32,33**) have two things in common: each is a picture of an elegant woman, and each is a *print*—a work designed for multiple reproduction (Chapter 8). But far more than that connects them to the artistic chain letter of seeing, adapting, and passing along.

The first print (**31**) is by the French artist Henri de Toulouse-Lautrec. Lautrec was an unexcelled master of the color lithographic poster for advertising. The illustration shown here is essentially a print about a print. It shows the entertainer Jane Avril, a close friend of the artist's, examining a freshly printed proof of a poster advertising her performance at the Moulin Rouge. In this lithograph Lautrec reveals his debt to Japanese art. In 1853 Commodore Matthew Perry, an American naval officer, had sailed with his fleet into Tokyo Bay and thereby "opened" Japan to the West, ending two centuries of that country's isolation from the rest of the world.

Soon afterward Japanese prints (**32**) began to flow into Europe, and artists studied them avidly. Lautrec took from them the ideas that were most useful for his own vision, especially the large flat areas of color and the elegant, flowing silhouette lines. If you compare *L'Estampe originale* with the Japanese print made a century earlier, you will see that both have a sharply drawn, curving outline around the rather flat figure.

And a century *after* Lautrec these influences—explored by him and by other artists of his time—have made their way into contemporary art. David Hockney's *Celia* (**33**), done in 1973, shows the same rather flat figure, the same elegant, curving silhouette line. Hockney has adapted the style for his own needs, but he has also tapped into the vibrant artistic current that inspired those earlier works.

As an observer, you will find that familiarity with this artistic current contributes quite a lot to your appreciation of art. Combined with the "how" and the "why" it will move you closer to being an intelligent, informed observer. That is what this book is all about. It will give you a sample of the how, the why, and the when. With this knowledge you should have a much more active enjoyment of the art around you, the art you live with. And, in turn, you may find that you want to live much more actively with art.

There are great observers as well as great artists, each with his or her own special tendencies and interests. Whatever artists may say, their art is not done just for themselves. It is done for serious observers who, through education and experience, have made themselves sympathetic receivers of the messages of art. In the final analysis, it is for these observers that artists create.

OBSERVATION AND CRITICISM

You may be thinking to yourself, it is all well and good to say, "Be an intelligent observer," but how does one get started? If we all live with art every day, is there not some way to enjoy the art right now before devoting months or years to studying art? Yes, of course there is. Even taking a little time and paying a little more attention than usual can enhance one's appreciation of art.

When you walk into a museum, or into someone's home where art is displayed, or down a street where there is sculpture or a new building, try to approach the art as a unique visual experience. Give some time to thinking about it and trying to analyze it. To get you started, we list below six questions you might

Henri de Toulouse-Lautrec
1864–1901

Henri Marie Raymond de Toulouse-Lautrec Monfa was born at Albi, in the south of France, son of an aristocratic French family. From early childhood he showed talent for drawing and painting—a talent his family encouraged. The events that probably shaped the rest of his life and his career as an artist began at the age of thirteen, when he broke his left thigh in a fall. A year later he broke the other thigh. Although he recovered from the injuries, his legs never grew again. As an adult he stood just over 5 feet tall, with a fully developed body but shrunken legs, and he walked with difficulty and pain. In photographs, like the one here, he often stressed his odd appearance.

By the age of seventeen Lautrec had begun serious art studies in Paris. He had also gotten his first taste of Montmartre—the rather seedy part of the city where writers, painters, and students congregated; where the brothels were located; and where soon would open the famed cabaret, the Moulin Rouge. At that time he wrote to his grandmother: "I am against my will leading a truly Bohemian life and am finding it difficult to accustom myself to this milieu." Later, that bohemian milieu would be the only one in which he seemed to belong.

The artist gradually began to achieve modest success with his paintings. He also began to accumulate a circle of friends—other artists, writers, intellectuals, performers—who were attracted by his great wit and unflagging high spirits. In 1889 the Moulin Rouge opened and quickly became the focus of this social life, as well as of Lautrec's art. Singers and dancers, prostitutes and poets, the highborn and the lowborn who came to the Moulin Rouge—Lautrec drew them all, with a style and originality that captured the essence of Paris nightlife.

After two years of popularity the Moulin Rouge fell upon hard times, and its owner decided to regroup. He hired new talent, planned a grand reopening, and asked the all-but-resident artist to create a poster announcing the event. The poster Lautrec designed was unlike any Paris had ever seen—colorful, immediate, full of life, focusing on the image, not the printed words. Once again the Moulin Rouge was a sensation, and so were the artist and his poster.

In the years following his triumph as a graphic artist, Lautrec often had no regular home. He lived for periods of time at one or another of the brothels, among the prostitutes. Some of the women were his lovers, many were his friends, and all were potential subjects, whom he painted with sympathy and warmth. His dissipated life notwithstanding, he continued to work prolifically. Little by little, however, he began to drink more and work less, until the situation became so grave his family placed him in a sanitarium. A brief recovery was followed by yet more drinking, and at last the illness took over. In September of 1901, two months short of his thirty-seventh birthday, Lautrec died at his family's estate.

Lautrec's art is above all an art of people and life. He explained this himself after a brief visit to the countryside, meant to improve his health: "Only the human figure exists; landscape is, and should be, no more than an accessory, the painter exclusively of landscape is nothing but a boor. The sole function of landscape is to heighten the intelligibility of the character of the figure."[9]

Maurice Guilbert. *Lautrec par lui-même.* 1890. Photographic montage. Musée Toulouse-Lautrec, Albi, France.

ask yourself when you encounter any new work of art. At the end of Chapter 5 you will find an expanded list of questions, a more detailed method of approaching art criticism.

1. Do I know where this work fits into the history of art? Does it remind me of any others I have seen, and in what way? Can I make any connection between this piece and others?
2. What do I know about the artist? Is there anything about his or her background that would influence my reaction to this work?
3. When and where was this work made? What else was going on in the world at the same time? What are the characteristics of the culture from which it emerges?
4. Does this work depict any particular subject—a story, a person, a place, or an event? If so, how is that subject treated?
5. What feelings, memories, or associations does this work evoke in me? Does it make me feel happy, angry, sad, frightened, disgusted, uplifted, inspired? Can I imagine the artist felt the same way? Do I feel any sense of kinship with the artist?
6. What is this work of art made of? Are the materials important to the type of expression and the overall effect of the work?

You probably will not be able to answer all these questions about every work of art you see, but at least the process will start you thinking. And after a bit of practice this six-step procedure—which sounds long in the telling—will become almost automatic. You will not have to think about it, because the questions will arise, and be answered, whenever you give serious attention to a new work of art.

Living with art—living with it actively and positively—does involve some effort, but the effort is worth it. Art stretches our intellectual horizons. It taps our emotions. It deepens our humanity and makes us less alone in the world. It makes us more alive.

ART PEOPLE
Gertrude Stein

Practically no one ever has lived with art so whole-heartedly as Gertrude Stein. Students of literature remember her as a daringly experimental writer, most closely associated with the line: "Rose is a rose is a rose is a rose." But the influence of Gertrude Stein extends far beyond her literary efforts, for she was one of the most ardent collectors of art—and of artists—who ever lived.

Born in Allegheny, Pennsylvania, in 1874, Stein spent her childhood in Europe and in San Francisco. Both parents died when she was a teenager, and thereafter her intimate family would consist of her brother Leo, her oldest brother Michael, and Michael's wife, Sarah—all soon to be art collectors of great importance. Young Gertrude attended Radcliffe and then undertook medical studies at Johns Hopkins, but she never quite finished her medical degree.

In 1903 Gertrude took up residence with Leo at his new apartment in Paris. Their address—27, rue de Fleurus—was destined to become famous in the history of arts and letters. From their combined home and studio, Gertrude and Leo embarked on a fabulous career of buying innovative art. Their special pets were Pablo Picasso, Henri Matisse, and the Spanish artist Juan Gris, but they also invested in works by Cézanne, Renoir, and others. Perhaps more important, their home became a gathering place for the artists and art lovers of the time. Everybody who was anybody came to 27, rue de Fleurus. The Saturday night "at-homes" brought out painters, sculptors, composers, writers, poets, dealers, critics, and all those who wished to meet the foregoing. Picasso and Matisse often came to dine. In later years Gertrude Stein welcomed the American writers Ernest Hemingway and F. Scott Fitzgerald.

Among those who came to the rue de Fleurus was an American named Alice B. Toklas, and, as it turned out, she had come to stay. By 1910 Alice Toklas had moved into the apartment, serving Gertrude Stein as secretary, household manager, and all-purpose useful helpmeet. The two women became inseparable and remained lifelong companions. Some four years later Leo Stein moved out of rue de Fleurus, taking half the art collection with him. The close relationship between brother and sister was over.

World War I brought new adventures to Gertrude Stein. France had gone to war, and so did Miss Stein and Miss Toklas. In a ragtag Ford van nicknamed "Auntie," they traveled all over the countryside delivering supplies in behalf of the American Fund for French Wounded. Stein drove the car. Toklas navigated and handled all necessary paperwork. After the war, most of the women's efforts were directed toward getting Gertrude Stein's writings published—no easy feat, considering their individual and often maddeningly repetitive style. Actually, Stein's only commercial literary success was *The Autobiography of Alice B. Toklas,* which was in fact Gertrude Stein's own autobiography.

When Gertrude Stein died of cancer in 1946, she left her art collection to Alice Toklas, who lived on, with the paintings and her memories, until 1967. The two women are buried together in Paris. After Miss Toklas' death, the Stein family regained control of the collection and sold it for many millions of dollars.

Gertrude Stein (**right**) with Alice B. Toklas in the studio at 27, rue de Fleurus, Paris, 1922, photographed by Man Ray.

2
What Is Art?

*U*ntil about a hundred years ago almost no one would have thought to ask the question "What is art?" People who considered art at all assumed they knew what it was. In the 20th century, however, the problem of definition, of deciding what is and what is not art, has become far more complex, and this is true for several reasons.

For one thing, people today are exposed to art from many different times and places—an available body of art far more varied than at any other period in history. If you walk into a large museum, you will see on display works of art from literally all over the world, and covering a time span of some 15,000 years. Magazines, newspapers, and television also bring us into contact with different types of art. Each work of art we see is the product of its own culture, with its own prevailing standards of taste. Each represents what the person who made the work—and those for whom it was made—considered to be art.

The citizen of ancient Athens might have said that art is a sculpture, perhaps depicting a goddess, modeled to look very much like a living woman, yet taller and more beautiful than life (**34**). The tribal member from the Baluba area in Africa might have said that art is a wood figurine, stylized and exaggerated in its features, that symbolizes the human figure (**35**). The aristocrat of 18th-century France might have said that art is a portrait of a queen (or king or duke) that is a good likeness of its subject but at the same time glorifies the subject and has a properly elegant setting (**36**). Each of these works met the standards of acceptable art for its audience, and yet we cannot apply the same standard to all three. We cannot even be sure that all the objects now housed in our art museums—the Baluba figurine, for example—were considered by their makers to be art in the sense that we mean it.

Before our age of easy worldwide communication, the art produced by any specific culture tended to be relatively homogeneous—much the same in style and expression. Of course, there always has been cross-fertilization of styles

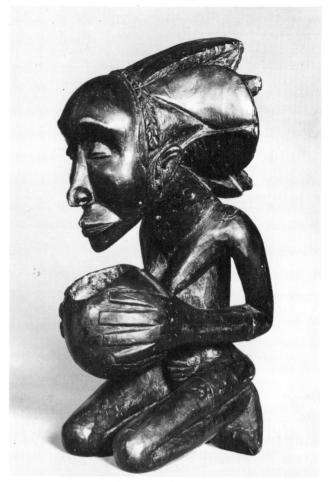

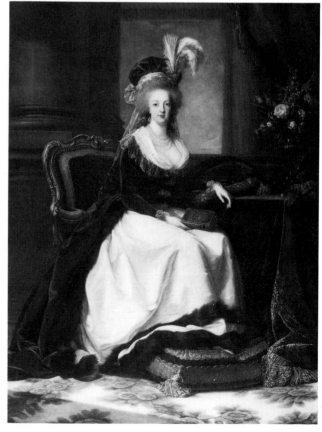

above: 34. *Aphrodite of the Cnidians.*
Roman copy after an original
of c. 330 B.C. by Praxiteles.
Marble, height 6'8".
Vatican Museums, Rome.

above right: 35. *Kneeling Woman Presenting a Bowl,*
from Luba, Zaire. Wood, height 17⅛".
Royal Museum of Central Africa, Tervuren, Belgium.

right: 36. Elisabeth Vigée-Lebrun.
Marie Antoinette. 1778
Oil on canvas, 36¾ × 30¼".
Private collection, New York.

among cultures, and styles have changed over the years, but generally we can point to a pattern. We can say, "These are the general characteristics of 4th-century B.C. Greek art" (or Italian Renaissance art or Song dynasty Chinese art), and then proceed to list them. Now, not only are we confronted with art from many different cultures, but the art of our own time defies such classification. If you were to tour the art galleries in any major city today, and look at all the different works on display, you would be hard pressed to formulate a definition of art suitable for all of them. So diverse are the styles of 20th-century art that we cannot assign them a uniform set of characteristics.

To further complicate the problem, we now have works of art created in media undreamed of a mere thirty or forty years ago. Electronic images of all kinds are made and accepted as art. Often there is no concrete "object," nothing you could hang on the wall or place on a pedestal. Some types of contemporary art are preserved only in the memory banks of computers, and some disappear forever within minutes or hours after they are created. Little wonder, then, that in our century, for the first time, we need to stand back and ask, "What exactly *is* art? How can we determine what is and what isn't?"

This book will not give the definitive answer to either question, about any particular work or about art in general. What it will do, however, is present some guidelines that will help individual viewers to make up their own minds. It will show what some people have considered to be art in different times and places, and what some people consider to be art now. With this information, the viewer should be able to make a better judgment about "What is art *for me?*"

Art and the Eye of the Beholder

There are any number of diagnostic tests we could apply to the question "What is art?" None of them is infallible, but all raise interesting issues about the nature of art and its place in society. This section considers three of the possible areas we might explore in evaluating a particular work: What do observers think about it? Who made it? Why was it made?

ART AND THE AUDIENCE

Rarely has the question "What is art?" caused such a public uproar as in a controversy that erupted in New York City in the early 1980s. At the center of the drama was a sculpture by Richard Serra, entitled *Tilted Arc* (**37**), a 12-foot-high, 120-foot-long steel wall installed in a plaza fronting a government building in lower Manhattan.

Commissioned by the Art-in-Architecture division of the General Services Administration, *Tilted Arc* was part of a program that allocates 0.5 percent of the cost of federal buildings to the purchase and installation of public art. Soon after the sculpture's installation, however, the public for whom it was intended spoke out, and their message was a resounding, *"That's* not art!" More than 7,000 workers in surrounding buildings signed petitions demanding the sculpture's removal. Opponents of the work had numerous complaints. *Tilted Arc*, they maintained, was ugly, rusty, and a target for graffiti. It blocked the view. It disrupted pedestrian traffic, since one had to walk all the way around it rather than straight across the plaza. It ruined the plaza for concerts and outdoor ceremonies. At a public hearing, one man summed up the opposition view: "I am here today to recommend its relocation to a better site—a metal salvage yard."[1]

Artists, dealers, and critics rushed to the sculpture's defense. The sculptor himself argued vehemently against any attempt to move *Tilted Arc*, maintaining that it had been commissioned specifically for that site and any new location would destroy its artistic integrity. Even former senator Jacob K. Javits, for

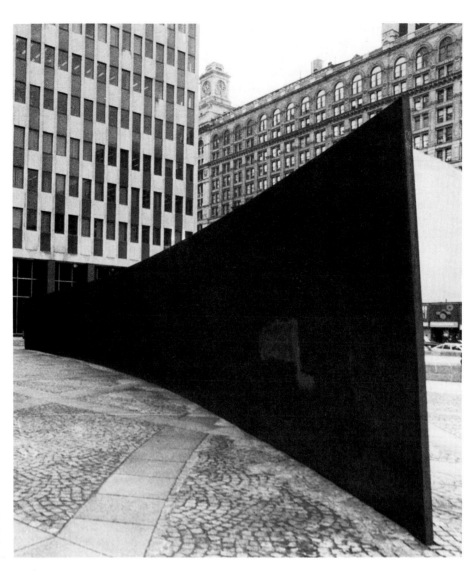

37. Richard Serra. *Tilted Arc*. 1981. Corten steel, 12′ × 120′ × 2½″. Installed at Federal Plaza, New York.

whom the building in question had been named, wrote eloquently in support of *Tilted Arc*. He said:

> Art requires freedom for the artist to make his statement about the life and time in which the artist lives. It is an expression of the deepest values of our society. The purpose of the program as I understood it when I voted as a member of the United States Senate to authorize it, was essentially to express the commitment of our country to artistic expression as a vital element of our culture.[2]

The battle raged for many months, and, while there were dissenting voices from all sides, it shaped up principally as a struggle between the art establishment (pro) and the general public (con). Finally, in an unusual editorial, *The New York Times*—a newspaper that heavily supports the arts—took a stand: "One cannot choose to see or ignore 'Tilted Arc,' as if it were in a museum or a less conspicuous public place. To the complaining workers in Federal Plaza, it is, quite simply, unavoidable. . . . The public has to live with 'Tilted Arc'; therefore the public has a right to say no, not here."[3] This time the public won. A decision was made to remove *Tilted Arc*.

So the question "What is art?" has, in at least one case, been answered by a kind of public referendum, a majority decision. This does not mean that *Tilted Arc* is not art, nor that it is inferior art. Majority decisions are not infallible. As we shall see throughout this book, some of the finest masterpieces in the history of art were initially scorned by the public.

It is tempting to speculate whether *Tilted Arc* would have been banished so readily if the name "Michelangelo" or "Picasso" had been attached to the sculpture. (A huge Picasso sculpture installed outside Chicago's Civic Center in 1967 caused a similar outcry, and it is still there.) Richard Serra, though known in art circles, is not familiar to the public at large. Whether for good or ill, the verdict on "Is this art?" has much to do with another question: Who made it?

ART AND THE ARTIST

In the summer of 1954 artist Willem de Kooning (**58**) took the three toilet seats from an outhouse on a summer property he was renting and painted the seats in a "marbleized" effect (**38**). Apparently, the painting was meant as a joke—whipped off in a few minutes before a croquet party with friends. The artist then forgot all about it, and so did everyone else. Some thirty years later the summer house was to be sold and the contents dispersed at auction. The auctioneer sensed a good thing and arranged to have the toilet-seat painting authenticated by Elaine de Kooning, Willem de Kooning's wife. The auctioneer therefore had in his possession a certified Willem de Kooning painting, and de Kooning paintings sell for millions of dollars. The toilet seats were exhibited and offered for sale. But wait a minute. Is a row of toilet seats, painted just for fun, a work of art because a master artist painted them? Some people think so. Others are outraged at the idea.

To consider the opposite extreme, is a work *not* great art because a master artist *didn't* paint it? For generations a painting called *The Man with the Golden Helmet* (**39**) was thought to be a work by Rembrandt, and moreover was praised

38. Three toilet seats from an outhouse, said to have been painted by Willem de Kooning in 1954.

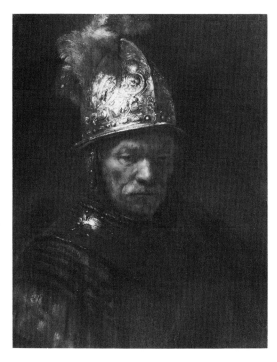

39. Unknown Dutch artist, formerly thought to be Rembrandt. *The Man with the Golden Helmet.* 17th century. Oil on canvas, 26½ × 20". State Museums, Berlin-Dahlem.

as one of the finest examples of his art. Then, in 1985, a panel of experts sent a shock wave through the art world. They "deattributed" *The Man with the Golden Helmet*—that is, they announced the painting was not by Rembrandt at all, but by an unknown contemporary or student of his. Such deattributions are not uncommon, especially with Rembrandt, whose verified artistic output seems to shrink every year. There is no question of forgery or attempt to deceive. With older paintings it is simply difficult to know for sure who painted them and when. The experts' opinions are based on such subtleties as brushwork, use of colors, handling of anatomical forms, and so on. Nevertheless, the effect of a deattribution is dramatic: A non-Rembrandt suddenly has about one-tenth the value of a real Rembrandt. Through all this controversy, we must remember, *the painting remains the same.* No matter who painted *The Man with the Golden Helmet*, it is a splendid, masterful portrait. Yet crowds of tourists, who once would have elbowed each other to get a glimpse of it, will now pass it by, looking for the "real" Rembrandts.

The student and lover of art should consider seriously how much impact the authorship of a work has to do with one's appreciation of that work. Another element we might take into account is the artist's intent. Willem de Kooning, by all reports, had no intention of making art with his toilet seats. He was just having a good time on a summer afternoon. But the artist of *The Man with the Golden Helmet* clearly meant to paint a wonderful portrait, took great pains to do so, and succeeded. Is this factor—the artist's intent and effort—a criterion for deciding what is art?

ART AND INTENTION

In many parts of the United States today you will encounter the phenomenon known as "motel art." This will be a large inventory of original oil paintings, turned out by assembly-line methods, and sold on weekends at bargain prices in suburban motels—hence the name. You may also hear this work called "sofa art," because the most popular item is the 2-by-3-foot painting considered "correct" for hanging over a sofa. As a potential buyer you are encouraged to bring your wallpaper samples, your upholstery swatches, your paint chips when shopping. This will ensure that the painting you select "goes with" your décor. If you like the painting of the flowers but its colors clash with your sofa, chances are you can find the same flowers in a different range of hues. Your sofa is unusually small or large? No problem. That same bowl of flowers comes in various sizes, like shirts or shoes.

The people who paint these pictures do so on commission from an entrepreneur, who often tells them what to paint and which colors to use. When they gear up, they turn out thirty or forty paintings in a week. Of one such sale *The New York Times* reported: "Most of the paintings on display . . . were landscapes and seascapes with little detail. While each was an original, many were markedly similar, some virtually identical." The *Times* quoted one dealer as saying his artists "prefer doing landscapes, probably because if you make a mistake on a landscape, who can tell?" Moreover, "after a while [the artists] can do them in their sleep—with their eyes shut."[4]

Are these people making art? Certainly it is billed as art by the sellers, and many buyers would agree. A buyer might say, "I like it because it looks nice on my wall and makes me happy. *For me,* this is art." We should not disparage this point of view. What is art for one person may not be art for somebody else, and that is the very problem we are addressing in this chapter.

Other critics might insist that the "motel artists" are not making art but are making *money*—and by a far safer system than printing up counterfeit bills in the basement. People on this side of the argument are disturbed by the concept of paintings that their makers can turn out "in their sleep."

The issues raised by motel art are those of motivation and satisfaction. What motivates the artist to make art? If money is the *primary* motive, can the result be art? If money is a *secondary* motive and the artist's expression comes first, is the product "more" art? Also, who is supposed to be satisfied by the

art—the commissioner, the buyer, the artist, or all three? Again, there are no absolute answers to these questions. They raise issues for consideration and debate, and the answers each of us decides upon will help to clarify our own opinions about what is art.

We might compare the factory approach of motel art to a statement by the sculptor Reuben Nakian: "In art you have to shoot your grandmother. You can't compromise. I'll compromise in life. I'll clown, I'll get drunk. But not in art, which is a life-and-death matter. If it isn't 100 percent right, zing, I'll smash it."[5]

When Nakian said, "You have to shoot your grandmother," he meant that the artist is searching for an ultimate truth, an ultimate perfection, an ultimate confrontation with the self and the art. Nothing short of this will do. By this definition, a work that is tossed off quickly to please someone else's specifications—the entrepreneur or the potential buyer—cannot possibly be considered art. Others will judge the merits of the work, but the first and most demanding judge is the artist.

This does not mean that art commissioned by someone else is necessarily inferior to art originated by the artist. As we saw in Chapter 1, artworks have always been commissioned, and throughout history there have been patrons with strong ideas about what they wanted. The ceiling of the Sistine Chapel in the Vatican—undoubtedly one of the best-known works of art in the Western world—was painted by Michelangelo on commission from Pope Julius II (**40**). What's more, Michelangelo undertook the project with great reluctance. Despite these facts, the ceiling of the Sistine Chapel is not, to say the very least, in any way comparable to "sofa art." Michelangelo spent four years of arduous labor on the ceiling paintings, and many art historians consider it miraculous that he finished them in that time. Throughout his career the artist set for himself almost inhumanly high standards. (One of his sculpture commission contracts specified that he would carve the most beautiful statue ever made.) The original idea for the Sistine ceiling might have come from Julius, but the conception and execution were all Michelangelo's—at the height of his artistic powers. Figuratively speaking, Michelangelo "shot his grandmother," and in so doing produced one of the artistic masterpieces of all time. The artist satisfied his patron only after he had satisfied himself.

But what of the viewer? What does it take to satisfy the viewer and to convince him or her that a certain piece is art and is good art? Most people bring to art a set of aesthetic *values*, a collection of likes and dislikes that predispose their judgments about what art should be. Usually, these values are instilled during childhood. One person, fond of graphic detail, likes the painting that shows every blade of grass; another admires all paintings that have a lot of blue in them, because blue is a favorite color; and so on.

To study art on a more formal basis, however, you should try to suspend these value judgments for a little while. If you set aside preconceived ideas about art and open your awareness to other possibilities, you may find that your own

40. Michelangelo.
Creation of Adam, detail
of Sistine Chapel ceiling.
1511. Fresco. Vatican, Rome.

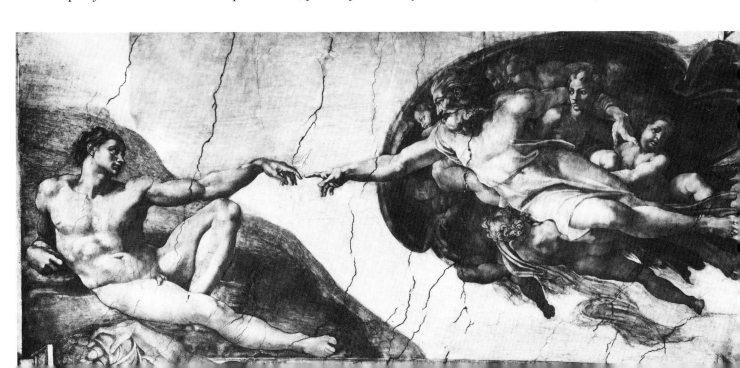

area of "likes" has broadened considerably. At the very least you will have a sounder basis for your value system. As a first step toward a heightened appreciation of art, let us look at two of the most common preconceptions about art and see if they hold up.

Art and Beauty

Many people take for granted that all art should be beautiful. They think of art as something to ornament one's home, like "sofa art." This line of thinking may cause trouble if you visit a museum exhibit, especially an exhibit of 20th-century art. You are almost certain to find a few things that you consider plain ugly. Why are they there?

We may as well face the question squarely, since it is basic to our whole attitude toward art. Why are there so many "ugly" works of art? There are several possible answers. We might reply that "beauty is in the eye of the beholder." In other words, beauty is subjective, and your personal taste leads you to reject things that might be beautiful to others. Both "beautiful" and "ugly" imply aesthetic value judgments.

Another possibility is that the ugly works of art are failures, which were hung because the museum director didn't look at them carefully or because the artist had a famous name. You might even imagine that you are the victim of a great plot designed to make a fool of you by showing you ugly things as if they were art. All these possibilities depend on the assumption that the artist's proper aim is the creation of beauty.

But there is another possibility. Perhaps the works are successes by artists who were sincerely aiming at something *other than* conventional, physical beauty. Would an artist intentionally make something ugly? And what, actually, do we mean by the words "ugly" and "beautiful"?

Over the centuries numerous writers have grappled with the concept of beauty and tried to understand it. One of the most entertaining was the 18th-century British statesman Edmund Burke, who wrote an essay called *The Sublime and the Beautiful*. In the essay Burke defined beauty as a positive and striking quality that produces pleasure by being small, smooth, gradually or gently varied, delicate, softly and variably colored. It is submissive and may arouse love. Beauty is not related to proportion, said Burke, nor to functional fitness, nor even to perfection. All these things are found apart from beauty.

The sublime, by contrast, is vast even to infinity, difficult, magnificent, dark, and rugged. According to Burke, it will "fill the mind with that sort of delightful horror, which is the most genuine effect and truest test of the sublime." A thing may be ugly and yet sublime if it is "united with such qualities as excite a strong terror." Burke made it clear that greatness lies on the side of the sublime, not of the beautiful.

This is quite a useful idea. Let's keep it in mind while we look at Ivan Albright's painting *Into the World Came a Soul Called Ida* (**41**). Albright's work is not smooth, delicate, or soft, and it is not likely to arouse love. For most people, though, it would evoke delightful horror. What is the artist aiming at? A common reaction is to say that the artist is showing us a person who is physically and mentally—even spiritually—exhausted. According to this interpretation, Albright teaches us about spiritual decay by exaggerating the physical decay. Every bulge, every wrinkle, every wart stands for a nasty blow that life has dealt. Everything about the painting speaks of hopes destroyed. The articles on the table are delicate, dainty. Their owner is not. She looks into the hand mirror, but her gesture is one of pushing it away. The "delightful horror" Burke was talking about might be evoked in those who view *Ida* in this light.

Ida has elicited very different responses from people whose definitions of "beauty" differ from Burke's. One student, when she first saw the painting, exclaimed, "How beautiful!" When her classmates looked at her in astonishment, the student explained that *Ida* reminded her of her grandmother, who had taken

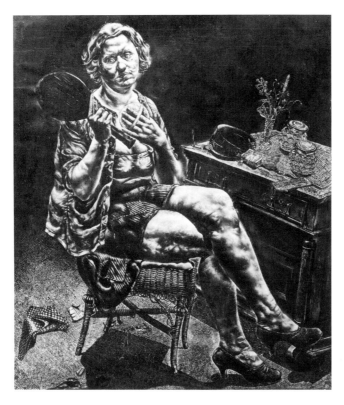

41. Ivan Albright. *Into the World Came a Soul Called Ida.* 1929–30. Oil on canvas, 4'7" × 3'9". Art Institute of Chicago (gift of the artist).

her in as a young child and raised her with much love. Clearly, Albright's painting had aroused in the viewer a sense of the "beautiful" that has little to do with physical prettiness. Another student saw *Ida* as "a marvelous study in texture," which he could look at forever.

By Burke's definition, however, Albright's *Ida* is not beautiful, although it might be called sublime. But whether it repels or attracts, *Ida* causes the observer to think and to feel. A conventionally "beautiful" painting might not have such an impact.

We do not mean to imply that art should *not* be beautiful in the more conventional sense. Many artists aim at creating this kind of beauty. If that is their goal, then we measure their success according to how well they achieve it. The important point is that art can be many different things, and "beautiful" is only one of them.

It is odd that so many people expect all painting and sculpture to be "beautiful." They don't demand this quality in the other arts. Many of the great works of drama and literature are anything but pretty. Consider the tragedies of Shakespeare or the Greek epics or, for that matter, many current novels. They are powerful, shocking, disturbing, frightening—but not beautiful in the sense that a love sonnet is beautiful. The same could be said of much modern music. It is not beautiful, but a great many people respond to it.

The observer of art should be open to the widest possible range of experience. Art that momentarily pleases the eye offers only one level of experience. Art that touches the intellect and the emotions brings far greater satisfaction.

Art and the "Real" World

Just as many people expect all art to be beautiful, many people expect all art to mimic the real world, to duplicate as closely as possible the appearance of nature. This is another preconception we might examine. If duplicating the natural world is the *only* thing art is supposed to do, why should artists bother? We

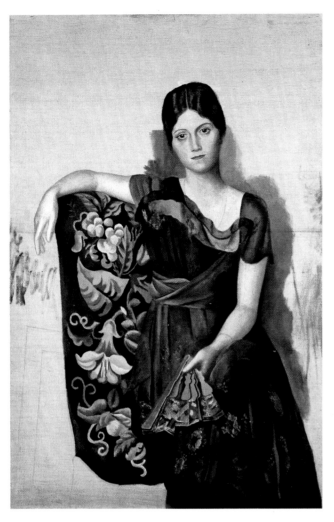

left: **42.** Pablo Picasso.
Olga Picasso in an Armchair. 1917.
Oil on canvas, 4'3¼" × 2'10⅝".
Musée Picasso, Paris.

above: **43.** Pablo Picasso.
Dora Maar Sitting. 1939.
Oil on canvas, 28⅝ × 23½".
Courtesy Perls Galleries, New York.

right: 44. *Symbol of St. Mark,*
from *The Echternach Gospels.*
Anglo-Irish, c. 700. Manuscript illumination.
Bibliothèque Nationale, Paris.

already have the natural world, so why make another? No one expects this kind of fidelity from the other arts. If, for instance, all works of literature were restricted to a faithful duplication of the real world, there could not be any novels or poems or fairy tales. There probably never was any real Cinderella or Anna Karenina or Tom Sawyer, and if there actually was a King Arthur we're not sure what he did in his life. The great works of literature are not real, they are made-up stories. It has been said that in fictional literature you "have to tell a lie to tell the truth." In other words, a made-up story can touch basic truths more vividly than can a strict recitation of facts. In a sense, this is what artists are doing: looking for a basic truth that is more "real" than the everyday world we perceive with our eyes.

Have you ever heard someone say, "That guy's a terrible artist. He can't even draw!" There is a strong feeling among much of the public that a "good" artist should be able to draw well—to make pictures of horses or dogs or people that look like the real thing. To be sure, some modern artists cannot draw lifelike images. But far more of them can—and choose not to. Picasso is a prime example of this situation. By anyone's standard, he was one of the greatest draftsmen who ever lived (**42**). Nevertheless, through most of his long career he produced works that did not look anything like the "real" world (**43**).

Picasso himself addressed this problem. He said: "They speak of naturalism in opposition to modern painting. I would like to know if anyone has ever seen a natural work of art. Nature and art, being two different things, cannot be the same thing. Through art we express our conception of what nature is not."[6]

In looking at any work of art, we must always keep in mind that it *is* a work of art. A painting of a horse is not a horse, but daubs of pigment on a backing. A sculpture of a horse is not a horse, but a chunk of metal or wood or stone. The way these works should look is dictated by the artist's aesthetic sense, not by biological laws. Artists are looking for the "lie that tells the truth," for something "realer than real."

Only in Western culture has it been supposed that art should always duplicate the natural world and, at that, only during certain periods of Western culture. We owe this idea to the ancient Greeks and Romans. Plato put forth the notion in *The Republic*, written in Athens in the 4th century B.C. He believed that the aim of painters is to create imitations of objects they see before them, as a mirror reflects the appearance of its surroundings. Even the ancient Greeks, however, were capable of attempting something "realer than real." The Greek statue at the beginning of this chapter (**34**) looks like a human being, but probably not like any human being you know. Plato to the contrary, the Greek sculptor was more interested in the *ideal* than the real. The statue is a little taller than a person, a little more perfectly proportioned, a little more beautiful than nature usually manages to be.

We tend to think that this goal of imitating the natural world carried through from the Greeks to almost our own time, when 20th-century artists broke abruptly with tradition. However, this isn't really true. From the beginning of the Christian era in Europe until the 14th century, naturalism in art was not so highly valued. The manuscript drawing (**44**) makes a good example. This work, dated about 700, is called *The Symbol of St. Mark*, and it is a lion, but it is not the sort of lion you would see in a zoo. It is flat, stylized, and decorative. In its mock ferocity it conveys the *idea* of a lion, rather than the exact appearance of a lion. Much of medieval art is like this—decorative and abstracted, symbolic rather than naturalistic. Should we assume that medieval artists "forgot" how to draw, were not as good at it as their ancient counterparts? Definitely not. The artists of the Middle Ages simply did not care all that much about imitating the natural world. Their concerns were above all spiritual, so their eyes focused on the heavens, not the earth.

The Renaissance revived the idea of naturalism as a goal for art. This period began in Italy around 1400 and gradually spread to the rest of Europe. The word *renaissance* means "rebirth," and the rebirth in question was that of ancient cultures—specifically, the cultures of Classical Greece and Rome. Artistic leaders of the Renaissance took a good look at Classical art and said, in effect, "This is the best that art has ever been."

Pablo Picasso
1881–1973

The life of Picasso defies summary in a one-page biography. Few artists have lived so long; none have produced such an immense volume of work in so diverse a range of styles and media; and only a rare few can match him in richness and variety of personal history.

Pablo Ruiz y Picasso was born in the Spanish city of Málaga. He attended art schools in Barcelona and Madrid but became impatient with their rigid, academic approach and soon abandoned formal study. After two trips to Paris—where he saw the work of Van Gogh, Gauguin, and Lautrec—he settled permanently in that city in 1904 and never again lived outside France.

Although Picasso worked in many different styles throughout his life, much of his art is classifiable into the well-known "periods": the "Blue" period, when his paintings concentrated on images of poverty and emotional depression; the "Rose" period, whose paintings included depictions of harlequins and acrobats; the Cubist period, when he worked with the painter Georges Braque; and the "Neoclassical" period, in which the figures took on qualities resembling ancient Greek and Roman sculptures.

Success came early to Picasso. Except for brief periods when he was short of funds (usually because of some romantic entanglement), he lived well and comfortably, traveled widely, and enjoyed a large circle of friends. His work was always in demand, whether in painting, sculpture, prints (of which he made thousands), theatrical design, murals, or ceramics (he took up ceramic art in 1947 and decorated some two thousand pieces in a single year).

It would be impossible to discuss Picasso's life without reference to the women who shared it, because they are a constant presence in his art. Picasso married only twice, but he maintained long, occasionally overlapping, liaisons with several other women. His attachments included Fernande Olivier; Eva Gouel; Olga Koklova, his first wife and the mother of his son Paulo; Marie-Thérèse Walter, mother of his daughter Maïa; Dora Maar; Françoise Gilot, who bore him Claude and Paloma, then later wrote a scandalous memoir of her years with the artist; and finally Jacqueline Roque, whom he married in 1961, in his eightieth year.

Despite his international celebrity, Picasso gave almost no interviews. One of the few took place in 1935 and included this insight into the nature of art: "Everyone wants to understand art. Why not try to understand the song of a bird? Why does one love the night, flowers, everything around one, without trying to understand them? But in the case of a painting people have to understand. If only they would realize above all that an artist works of necessity, that he himself is only a trifling bit of the world, and that no more importance should be attached to him than to plenty of other things which please us in the world, though we can't explain them. People who try to explain pictures are usually barking up the wrong tree."[7]

Pablo Picasso. *Self-Portrait.* 1906.
Oil on canvas, 36¼ × 28¾"
Philadelphia Museum of Art (A. E. Gallatin Collection).

During the Renaissance the imitation of nature in art became not a goal but a passion. Treatises were written. Artists made all kinds of mathematical studies to better simulate "reality." In some cases this resulted in great masterpieces, such as Michelangelo's (**40**). In others, it created works that are meticulously real—and also bland, lifeless, and boring (**148**). The trouble is, those of us who have inherited the Western tradition of art—people in North America and Europe—have gotten "stuck" at the Renaissance. Many of us look back to 15th-century Italy, to Michelangelo and Leonardo and their ilk, and say in turn, "*That is the best that art has ever been—and let's keep it that way!*" Such a point of view ignores most of the world's art and much of the living flow of history, culture, and style.

Outside the European tradition there was no similar progression away from naturalism and back again. The great artists of the Orient, of Africa, of pre-Columbian America generally had less interest in reproducing the real world. Like so many artists today, they were seeking something "realer than real." In the 15th century the Japanese artist Sesshu painted a study of *Daruma*, the first Zen Buddhist patriarch (**45**). We may hope this is not what Daruma really looked like. The stark brushwork and the horribly staring eyes are meant to show Daruma's ardent devotion to the Buddha. (Legend tells us that Daruma, while meditating on the Buddha one day, accidentally fell asleep. To punish himself, he cut off his eyelids, so that his eyes could never again close on the Buddha.)

We might compare Sesshu's painting to a self-portrait by Picasso, done in 1901 (**46**). There is an extraordinary resemblance—not in the features, but in the effect. We know that Picasso did not actually look just like this. He did have unusually piercing black eyes, and here he has emphasized that feature. He has

below: 45. Sesshu. *Daruma.* Japan, Ashikago Period, 15th century. Hanging scroll, ink on paper. Yoshinari Collection, Tokyo.

right: 46. Pablo Picasso. *Self-Portrait.* 1901. Oil on canvas, $31\frac{1}{2} \times 23\frac{5}{8}$". Musée Picasso, Paris.

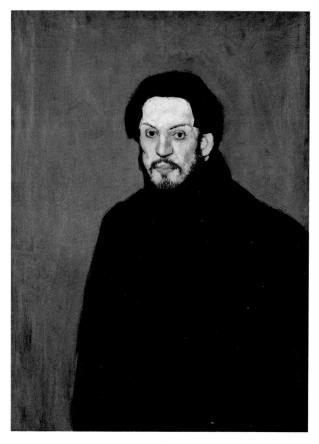

Henri Rousseau
1844–1910

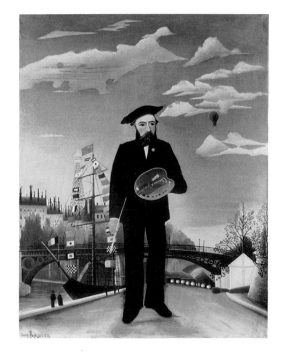

On the surface Rousseau was a ridiculous figure. One writer has observed that in the movies he would have been played by Charlie Chaplin. Like the eccentric who thinks he is Napoleon, Rousseau was convinced he was the master painter of his time. He was forever making up stories about his life, and eventually he came to believe them himself. He mingled with the pioneering artists of the day—Picasso, Braque, Kandinsky—who made him rather a pet, an object of half-real/half-mock admiration. Now, of course, the paintings of Picasso and the others are displayed in the world's great museums. So are the paintings of Henri Rousseau.

Born in a town in northwestern France, Rousseau completed secondary school and then enlisted in the army. Later he circulated the story that he had traveled with the infantry to Mexico, where he observed the tropical foliage seen in his mature paintings, but in fact he never left France. After military service, he become a toll collector for the city of Paris, and this too he exaggerated. Because he preferred the much higher rank of *douanier,* or customs inspector, he promoted himself and is often known as "le Douanier Rousseau."

Rousseau began as a Sunday painter, daubing away in his spare time. Then in 1884, at the age of forty, he took a small pension and retired to devote his life to painting. He never had any formal training in art. Instead, he set about teaching himself—copying paintings in the Louvre, studying nature at the botanical gardens in Paris, observing the work of other artists. When drawing figures he would carefully measure the features of his subjects with a tape measure, even though the results never seemed to reflect such precision. Rousseau liked to say that the great and famous art teachers had warned him never to lose the naive quality of his work. And he never did.

In specific details Rousseau's life was a harsh one. He married twice, and both of his wives died early, as did eight of his nine children. He rarely had any money, and sometimes he had to beg for food. Curiously, he seems never to have been unhappy. So convinced was he of his great talent, so caught up in his wonderful visions, so enthralled with the life he had invented for himself—that he floated serenely through the world, much as he appears to float in the self-portrait shown here. Rousseau's death, on the other hand, was a miserable one. A cut on his leg became infected and then gangrenous. "Le Douanier" died virtually alone, and was buried in a pauper's grave.

Who was Rousseau? He was a fabulous romantic, a master of the naive, a stolidly middle-class clerk, a disciplined and hard-working painter, a dreamer, a man of simple tastes and magnificent visions. His friend Picasso, even while making jokes at Rousseau's expense, admired and respected the distinctive talent. The highlight of Rousseau's life was a banquet, held in his honor, at Picasso's studio in 1908. All the bohemian artistic world of Paris turned out. Rousseau, enthroned on a chair set atop a packing case, played a composition of his own on the violin. Many toasts were drunk, and the party became quite lively. Near the end, as the story goes, Rousseau staggered up to Picasso and paid what was for Rousseau a splendid tribute: "My dear Picasso," he said, "we are the two greatest painters of our time—you in the Egyptian style and I in the modern style."

Henri Rousseau. *Myself, Portrait-Landscape.* 1890.
Oil on canvas, 4'8¼" × 3'7¼". National Gallery, Prague.

also made his face gaunt and almost corpselike. Perhaps we are seeing the intensity of passion in a young man absorbed in his art, just as Daruma was absorbed in his adoration of the Buddha. Both paintings have given us a reality beyond mere illusion.

If we demand realism, therefore, we deny ourselves the pleasure of enjoying a huge portion of the world's art. We would even dismiss a type of art that nearly everyone finds appealing—so-called naive art. Naive art, as the term implies, is made by people who are unsophisticated, lacking in formal art training, simple and fresh in their approach to art. They are not unlike the folk artists discussed in Chapter 1 (p. 8), except that they concentrate on paintings (sometimes sculptures). Best known of the naive artists was a man named Henri Rousseau, whose translation into paint of the "real" world was eccentric at best.

Rousseau worked in France during the late 19th and early 20th centuries. He was acquainted with all the up-and-coming artists of the Parisian scene, and sometimes he exhibited with them. In Rousseau's case, the naiveté of his expression came not so much from ignorance of formal art traditions as from indifference to those traditions. His last work, *The Dream* (**47**), combines typical elements: a monumental nude perched on a sofa that has no seat; improbable wild animals and birds that never coexist in nature; lush foliage no botanist ever identified; and a dark-skinned "native" (of where?) playing a musical instrument. Rousseau loved to copy plants and animals from books, to fill in from his imagination, to mix and match in a picture as the inspiration took him. He labored over the meticulous rendering of every leaf and stem, yet this rendering is not lifelike at all, for the landscape does not exist; it is a fantasy land. Rousseau's world—which was apparently very real for him—is the paint on canvas that makes a rich, complex design for the viewer's pleasure.

Before we leave this subject of art and the real world, it will be useful to discuss a few terms that will come up throughout the book. All have to do with

47. Henri Rousseau. *The Dream.* 1910. Oil on canvas, 6'8½" × 9'9½". Museum of Modern Art, New York (gift of Nelson A. Rockefeller).

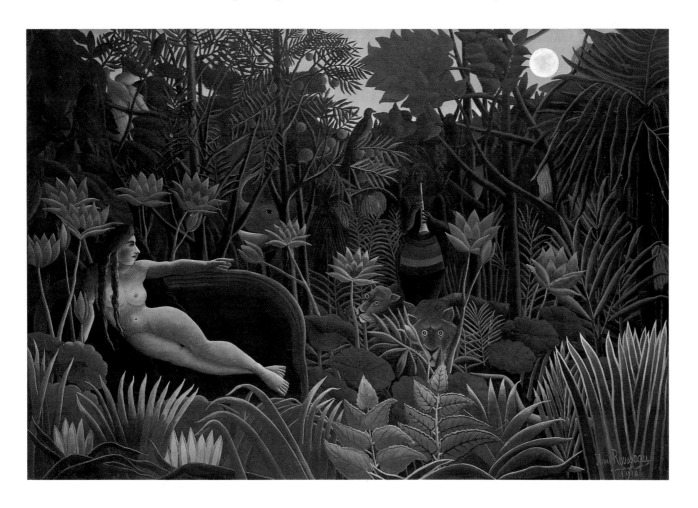

48. William Harnett. *Music and Good Luck.* 1888. Oil on canvas, 40 × 30″. Metropolitan Museum of Art, New York (purchased by Catharine Lorillard Wolfe Fund, 1963).

the relationship between the artistic image and the appearance of objects in the natural world.

Representational Art Representational or *naturalistic* images in art are those that look very much like images found in the natural world. The portrait of Marie Antoinette (**36**) fits in this category. You may also encounter the term *illusionistic*, which means images that are so natural they trick us into thinking they are real.

An extreme of illusionism is referred to as *trompe-l'oeil*, the French term for "fool the eye." The 19th-century American artist William Harnett specialized in still-life paintings that fool the eye so thoroughly as to cause the double- and triple-take. Viewers sometimes must restrain themselves from touching the canvas, so convincing is the illusion of three-dimensional objects in space. This *trompe-l'oeil* effect does not show up so well in reproduction, but we can get some idea of it in *Music and Good Luck* (**48**). Part of Harnett's visual deceit lies in his

49. Richard Haas and Brooke Alexander. *Trompe-l'oeil* mural, Mulberry Street, New York. 1975–76.

skillful painting of the objects in the composition. Far more important, however, is the meticulous rendering of textures and cast shadows. No matter how often we tell ourselves that this is absolutely flat paint on canvas, we still see the violin and other objects floating in front of the background.

Trompe-l'oeil illusionism has been out of fashion during most of this century, but recently there has been a revival of interest. In New York, artist Richard Haas has transformed several blank, depressing walls into fantasy cityscapes, like the one shown here (**49**). Both the lawyers' office and the bakery are inventions—stage flats with nothing behind them. Especially diverting is the bakery entrance, which appears to be recessed, with a "shadow" cast on the door by the shop window.

Abstract Art We call a work of art abstract when the art has reference to the natural world but does not try to duplicate it exactly. In the illustration here (**50**) the figure on the right is naturalistic. The figure at left, a sculpture from the ancient culture of the Cyclades Islands, off the coast of Greece, is highly abstract. We have no doubt that the Cycladic image is meant to portray the nude female figure, yet the form has been abstracted to an extreme. The face is a rough triangle, with another jutting triangle for the nose. The crossed arms are flat and geometric. Knees, pubic area, and the curve of the abdomen are suggested by simple incised lines. In a sense, the sculptor of this figure has given us the minimum visual information we need to identify the form. The sculpture thus becomes not any particular female figure, but the *essence* of the female figure.

Stylized is a term closely related to *abstract;* you may have difficulty separating the two words until you become accustomed to hearing them applied to

50. Comparison of abstract and naturalistic figures.

left: *Statuette of a Woman.* Cycladic, c. 3,000 B.C. Marble, height 24¾". Metropolitan Museum of Art, New York (gift of Christos G. Bastis, 1968).

right: Jean Antoine Houdon. *La Frileuse (Winter).* 1787. Bronze, height 4'9". Metropolitan Museum of Art, New York (bequest of Kate Trubee Davison, 1962).

51. Ellsworth Kelly. *Red White.* 1962. Oil on canvas, 6′8⅛″ × 7′6″. San Francisco Museum of Art, T. B. Walker Foundation Fund Purchase.

specific works of art. We are more likely to call a work of art stylized when it shows certain features of a natural form—features closely associated with that form—exaggerated in a special way. For instance, in our earlier example of the lion, the *Symbol of St. Mark* (**44**), the lion's mane, claws, and tail have been exaggerated. These are features we connect with a lion, and so we would tend to call this image stylized.

Nonrepresentational Art Nonrepresentational art has no reference to the natural world of images. It does not show people or animals or mountains, but simply shapes and sometimes colors (**51**). This art bypasses known forms and touches our senses and emotions directly. It does not "represent" anything but itself. If, for instance, you were to see a painting that was entirely red, you might suppose it to be about fire or sunsets or a volcano. It might, however, be "about" *red*, and nothing else.

Despite the apparent dissimilarities in these kinds of art, they all share a common trait. They are expressions of the artists who made them.

Art as Expression

Until now we have been talking about things that art can be but need not be. Now at last we come to something that art is always—the expression of the artist. By *expression* we mean the artist's unique view of art and of the world, an outward manifestation of the artist's emotions, thoughts, feelings, fears, dreams, and observations. We have got to the root of what Nakian meant when he talked about shooting his grandmother.

Expression means that the artist is always present in the work of art. No matter how straightforward a work may seem, it is influenced tremendously by the artist's own perspective and by his or her culture. This may be a difficult idea to grasp at first. We can look at a beautiful painted landscape, for example, and think, "But that's just the way it *looks*. The artist isn't expressing anything." Is this really true?

To test the idea, we might compare two landscapes painted just four years apart—one by the American Thomas Cole, the other by the Englishman J. M. W.

Turner (**52,53**). At first glance we are tempted to say that the Turner is expressive and the Cole is not. Turner's landscape is a fantasy of light and vapor and cloud and mist. We can scarcely identify any details. Cole's *Oxbow*, on the other hand, is a recognizable and very pretty scene on the Connecticut River. You could go there, find the right place, and it would look very much like the painting. The casual observer might say that Turner was inventing, whereas Cole was just recording nature.

The task of "just" recording nature, however, begins to seem rather formidable when we realize how many decisions Cole had to make in painting the scene. Why choose that particular spot? Why take the exact vantage point that he did? Why paint the scene by day instead of making a moonlit panorama? Why include a rainbow—wouldn't a violent storm have been more dramatic? The answer to all these questions is: that's what the artist wanted to express. That was his artistic approach to the painting. Cole is expressing himself in a naturalistic scene, just as Turner is in his vapors and mist.

52. Thomas Cole. *The Oxbow.* 1836. Oil on canvas, 4′3½″ × 6′4″. Metropolitan Museum of Art, New York (gift of Mrs. Russell Sage, 1908).

53. J. M. W. Turner. *Rockets and Blue Lights.* 1840. Oil on canvas, 3′⅛″ × 4′⅛″. Sterling and Francine Clark Art Institute, Williamstown, Mass.

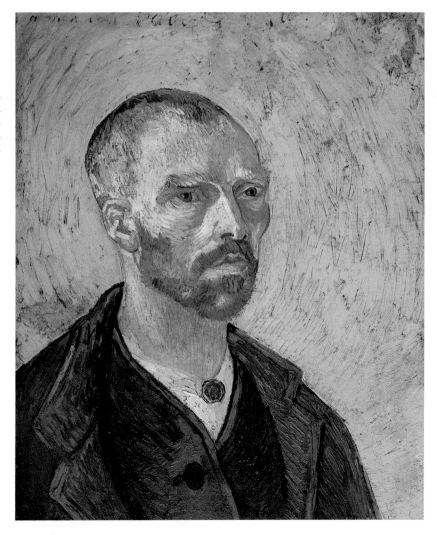

above: **54.** Paul Gauguin. *Vincent van Gogh.*
1888. Oil on canvas, $28\frac{3}{4} \times 35\frac{7}{8}''$.
Rijksmuseum Vincent van Gogh,
Amsterdam.

right: **55.** Vincent van Gogh. *Self-Portrait.*
1888. Oil on canvas, $24\frac{3}{8} \times 20\frac{1}{2}''$.
Fogg Art Museum, Harvard University,
Cambridge, Mass.
(bequest of Maurice Wertheim,
class of 1906).

An artist's expression will be equally evident in a portrait, even though the portrait may "look like" the person depicted. The two paintings illustrated next (**54,55**) were done in the same year, and both are portraits of Vincent van Gogh. The first is by Van Gogh's friend Paul Gauguin, and the second is a self-portrait. Without the titles and the background information, almost no one would identify these works as portraits of the same man at the same time. Each expresses what the artist felt about the subject—in one case, about the self.

Gauguin shows us a rather ordinary, heavy-set, middle-class man at work, delicately painting sunflowers. The subject is shifted far to the right in the composition and balanced against the sunflowers, which assume equal importance. It is as though Van Gogh and his sunflowers are two sides of the same coin. How different is Van Gogh's self-portrait! The artist strips away all background details and presents himself as a gaunt, brooding, almost monklike figure—totally introspective, totally isolated.

We may be tempted to ask ourselves, which of these two portraits is the more "real"? And the answer must be: both of them. Gauguin's portrait is the *real* Van Gogh as perceived by Gauguin, sifted through his friendship, memories, emotions, and indeed all of Gauguin's life experiences. Van Gogh's self-portrait is equally the real Van Gogh, as perceived by himself, sifted through the mental torment we know he endured, colored by the self-image he wanted to express to the world.

Two periods in the recent history of art have so intensely shown us the artist's expression that they have been labeled with the term. *Expressionism,* sometimes called *German Expressionism* because most of the leading artists worked in Germany, was a movement of the late 19th and early 20th centuries. Above all, this was an art that looked inward, to the soul and psyche. Expressionist artists sought to explore their own emotions, their own passions and terrors. Among the most moving of these artists was Käthe Kollwitz, who worked chiefly in prints. Kollwitz drew images based on her own anguish to express her feelings about a world in which there could be war and brutal death. Throughout her difficult life she maintained a fascination for the self-portrait. The lithograph shown here (**56**) portrays an old woman beyond pain and despair, and reduced to an exhausted kind of acceptance. The artist is expressing her utter weariness in a stark, poignant image.

Another movement closely linked with the artist's expression came in the mid-20th century and was known as *Abstract Expressionism* (Chapter 17). Artists identified with this style also looked inward and sought a direct expression of their emotions. This expression, however, took the form of abstract—sometimes nonrepresentational—images: colors, shapes, lines.

56. Käthe Kollwitz.
Self-Portrait. 1938.
Lithograph, $18\frac{3}{4} \times 11\frac{1}{4}''$.
National Gallery of Art,
Washington, D.C.
(Rosenwald Collection).

Jackson Pollock
1912–1956

Jackson Pollock was born on a sheep ranch in Cody, Wyoming, the youngest son in a family of five boys. During his youth the family moved around a good deal and led a fairly unstable existence. By the age of fifteen Jackson had begun to show signs of the alcoholism that would plague him all his life.

In 1930 Pollock went to New York to study at the Art Students League. His principal teacher was Thomas Hart Benton, a realistic painter of regional Americana, best known for his murals. Later, Pollock would say he was glad to have had the experience with Benton, because he then had to struggle all the harder to make art so very different from that of his mentor.

Money was a critical problem throughout the early years in New York. By 1935 Pollock was employed on the Federal Art Project of the Works Progress Administration—a Depression-era program meant to provide employment for artists. He was required to turn out, every four to eight weeks, one painting suitable for installation in public buildings, for which he was paid a stipend of about $100 a month. Frequent alcoholic binges often interfered with this work, and in 1937 Pollock began psychotherapy in an attempt to overcome his addiction.

Pollock's work was first exhibited in 1942, as part of a group show that also included the work of painter Lee Krasner. Krasner and Pollock soon formed a close relationship, and they were married in 1945. Gradually, Pollock's work began to change, to be freer and more spontaneous, to contain fewer and fewer figural elements. During the late 1940s he began exhibiting works in his mature style.

Some critics praised Pollock as the greatest of all American artists, but the general public was very slow to accept his revolutionary art. *Time* magazine epito-mized the bewilderment of the popular press, dubbing him "Jack the Dripper." Nevertheless, there were some collectors willing to invest, so that finances became less pressing.

The years 1948 to 1952—Pollock's late thirties—were the artist's prime, when he was at the height of his creative powers. After that, he seemed less sure where to go with his art, and even the sympathetic critics were not so responsive to the work. Pollock began to paint less and drink more. On the night of August 11, 1956, Pollock—along with two young women friends—was driving his convertible near his home when he lost control of the car and rammed into a clump of trees at high speed. Pollock and one of the women were killed instantly. The artist was only forty-four years old.

Pollock drunk could be violent and brutish; Pollock sober was shy, introverted, and uncommunicative. Few ever succeeded in getting him to talk about his art, but there is one quote, reprinted many times, that gives voice to his truly remarkable vision: "On the floor I am more at ease. I feel nearer, more a part of the painting, since this way I can walk around it, work from the four sides and literally be *in* the painting.... When I am *in* my painting, I am not aware of what I'm doing. It is only after a sort of 'get acquainted' period that I see what I have been about. I have no fears about making changes, destroying the image, etc., because the painting has a life of its own. I try to let it come through. It is only when I lose contact with the painting that the result is a mess. Otherwise there is pure harmony, an easy give and take, and the painting comes out well."[8]

Jackson Pollock in his studio at East Hampton, N.Y., 1950, photographed by Hans Namuth.

One of the best-known Abstract Expressionists was Jackson Pollock. In the late 1940s and early 1950s Pollock began showing works like *Convergence* (**57**). His style of painting was unusual, even revolutionary. Pollock set his huge canvases on the floor, stood above them (sometimes walked on them), and flung the paint from brushes, sticks, drippers, and even from the paint can itself. The result was an intricate web of lines and colors, with no beginning and no end. A viewer, once drawn into the painting, is led around and through it, with the eye moving continuously through a network of forms. What does the painting express? Movement, color, action, life, vitality—the spirit of the artist. As a matter of fact, many critics referred to this style as *action painting*. The artist's action in making the painting is communicated directly to the viewer. If you stand for a while in front of one of Pollock's paintings, you almost want to conduct it, as if it were an orchestra. The expression is available to anyone who is willing to receive it.

An interesting point about Pollock's art is that its *form* and its *content* are hard to separate. Indeed, the two are almost identical. Form and content are important ideas for the study of art. An understanding of how they work together will bring us closer to answering the question "What is art?" These terms are also indispensable for communicating about art to other people.

57. Jackson Pollock. *Convergence.* 1952. Oil on canvas, 7'11½" × 12'11". Albright-Knox Art Gallery, Buffalo, N.Y. (gift of Seymour H. Knox, 1956).

Form and Content

If a good idea were all it took to be a famous artist, we all would be famous. The world is full of people who are carrying around in their heads great ideas for novels, symphonies, and paintings. What is lacking is form. Unfortunately for the dreamers, form is essential to any work of art.

In simplest terms, *form* is the way a work of art looks; and *content* is what a work of art says. Form includes everything from the material the artist uses (oil paint, stone, paper, whatever), to the style in which the artist works, to the shapes and lines and colors in the art. It also includes how a work of art is put together—its *composition*.

Content refers to the message communicated by a work of art—what the artist expresses. Sometimes content begins with a story or an event or an image of something we recognize, which we could call the *subject matter*. For instance, in a painting called, say, *The Battle of Bull Run*, the subject matter would be a battle scene. The content would be a battle scene *and* what the artist wanted to communicate about that battle scene. (You can guess that the content would likely be very different if a Union sympathizer and a Confederate artist were painting the same scene.) Similarly, in a portrait, as in the two portraits of Van Gogh, the content begins with the subject and includes whatever the artist wishes to communicate about the subject.

In other types of art, however, the content may not be so clear. It could be anger or fear or loneliness or joy or, as in the Pollock, action and vitality. For an interesting study in form and content, we might look at Willem de Kooning's *Woman and Bicycle* (**58**), one of a series of "woman" paintings the artist did during the early 1950s. In form *Woman and Bicycle* is an oil painting in a highly abstract style, consisting mainly of harsh, savage brush strokes.

As to the painting's content, we have a clue in the title "woman," but that is only a starting point. De Kooning's women throughout this series are predatory monsters—all eyes and teeth and huge, engulfing breasts. The artist himself said that he always began with an image of a young, beautiful woman, only to see it transformed on canvas, as he worked, into a hideous nightmare creature. We have a sense of de Kooning struggling against the women in his paintings, struggling to carve them up and subdue them, while at the same time the painted women become more and more menacing, in danger of destroying the artist. The

58. Willem de Kooning. *Woman and Bicycle.* 1952–53. Oil on canvas, 6'4½" × 4'1". Whitney Museum of American Art, New York.

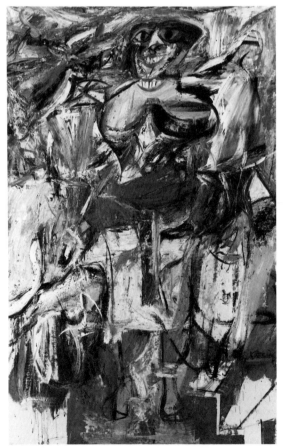

content of *Woman and Bicycle*, then, is not simply a woman, but de Kooning's conscious and unconscious feelings about women.

Throughout the preceding discussion the word *style* has been used a number of times. Style is a term familiar to us from everyday conversation, but because it is so crucial to an understanding of art, we might consider its meaning as specifically related to art.

Style

There are styles of music, styles of dress, styles of interior design, even styles of speaking and walking. When an automobile manufacturer changes the way its cars look from year to year, we speak of the "new style." If a person we know always wears jeans and cowboy boots, or always wears long flowing dresses and flowered prints, we identify that person with his or her particular style of dress. Furthermore, we may say of someone, "She really has style!" Or we might describe the décor of a particular home as "stylish." In the latter two cases, we mean the person or place shows a *desirable* style, one we admire, because everybody and everything has *some* style or other. But what exactly *is* style?

Above all, *style* is a characteristic or group of characteristics that we can identify as constant, recurring, or coherent. For instance, suppose you have a friend who has very long hair and always wears it in braids; then your friend gets a short haircut. You would call this a sudden change of style. Or perhaps you know a family whose home is entirely decorated with antiques, except for one very modern chair and table in the living room. You would recognize a mix of styles—not necessarily bad, but obvious.

In the visual arts, just as in any other area of life, style indicates a series of choices an artist has made. *Artistic style* is the sum of constant, recurring, or coherent traits identified with a certain individual or group. In painting, for example, a particular style could be composed of many elements—the materials used, the type of brush strokes, the colors, the way forms are handled, the choice of subject matter, the degree of resemblance to the natural world (representational *vs.* abstract style), and so on.

Style may be associated with a whole artistic culture (the Song dynasty style in China); with a particular time and place (the early Renaissance style in Rome); with a group of artists whose work shows similar characteristics (the Abstract Expressionist style); with one artist (Van Gogh's style); or with one artist at a certain time (Picasso's Blue Period style). In all these instances there are common elements—constant, recurring, coherent—that we can learn to recognize. Once you become familiar with Van Gogh's mature style (**29**), with its licking, flamelike brush strokes and vivid color, you will probably be able to identify other paintings by Van Gogh, even if you have never seen them before. Some artists develop a style and stick to it; others work in several styles, simultaneously or sequentially.

One way to think of style is to consider it an artist's personal "handwriting." You know that if you give ten people identical pieces of paper and identical pens and tell them to write the same sentence, you'll get ten very different results, because no two people have the same handwriting. Penmanship styles are interesting. Each is absolutely unique, yet there are characteristics we can identify, even if we don't know the person who did the writing. If you study handwriting at all, a given sample should be able to tell you if the writer is male or female, old or young, American or European, and so forth. Much the same is true of artistic styles. Every one is individual, but we may find similarities among artists of a particular time, place, or group.

To get a sense of style variations in art, let us consider three paintings (**59,60,61**) with similar subject matter. Each depicts a woman in profile, from the waist up, but the paintings are very different. Even someone who knows practically nothing about art would observe differences in style, although he or she might not be able to articulate those differences. The first, by Alesso Baldovinetti,

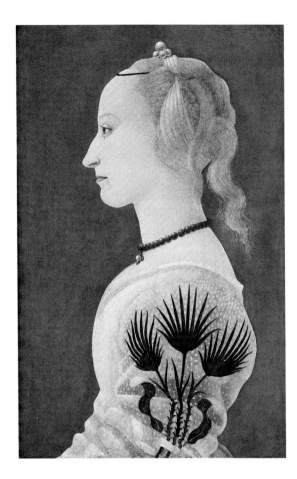

left: **59.** Alesso Baldovinetti. *Portrait of a Lady in Yellow.*
c. 1463. Wood panel, 24¾ × 16″. National Gallery, London
(reproduced by courtesy of the Trustees).

below left: **60.** *Lady with a Bird,* from Hyderabad, India.
c. 1730. Gouache on paper, 13 × 8½″.
Victoria & Albert Museum, London.

below: **61.** Joshua Reynolds. *Mrs. Mary Robinson (Perdita).*
1784. Oil on canvas, 30½ × 25″.
Wallace Collection, London (reproduced by permission
of the Trustees).

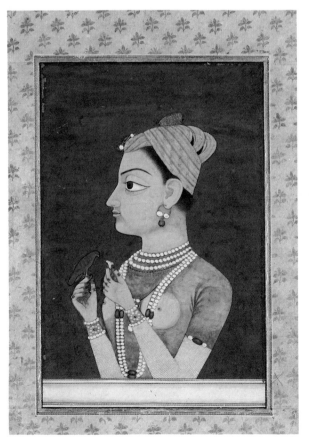

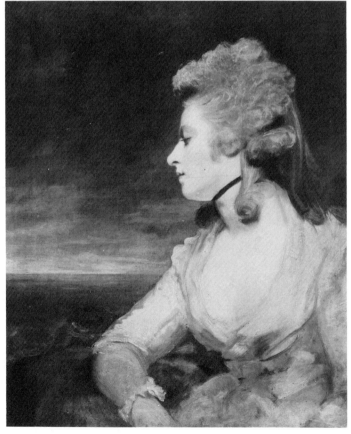

was painted in Italy in the 15th century (**59**). It shows the woman in sharp outline, against a plain blue background, almost as flat as a silhouette. The drawing is lifelike but probably idealized, made to look more beautiful than the subject actually was. All is elegance, from the pure features to the long neck to the prominent leaf pattern on the sleeve.

The second painting (**60**) was made in India in the 18th century. Again the outline is sharp against a plain background, but the subject's pose is even more rigid, almost ritually frozen. The woman holds a bird in one hand and, presumably, the bird's treat in the other, but these are really ornaments for the carefully posed hands. She does not look at the bird but instead stares off into an unseen distance. Following the artistic style of that culture, the artist has bared the woman's breasts and exaggerated her enormous, almond-shaped eyes.

Our third example (**61**), painted at almost the same time as the Indian picture, is by the great English portraitist Sir Joshua Reynolds. Here we see no flat background, but rather the illusion of deep space—a vague and romantic seascape toward which the woman seems to be gazing. Unlike the first two artists, Reynolds invites us into the sitter's mind. She is pensive, perhaps a little sad, perhaps daydreaming or remembering. Her pose is more relaxed than either of the previous two, more dramatic, even a bit theatrical. Colors are softer, the forms slightly blurred.

Three lovely portraits, each by a skilled artist, but markedly different from one another—that is the nature of style. In every case the artist's style will be influenced by choices related to time, place, and the artist's expressive needs.

We said at the beginning of this chapter that many periods in the history of art have been marked by a cohesive style, common to much or all of the art produced then. Such cohesion may occur whenever artists are strongly influenced by their societies or when they work closely together. An extreme example of style similarity occurred in the early part of this century. From 1908 to about 1912 the artists Pablo Picasso and Georges Braque worked virtually side by side in developing the style that would come to be called *Cubism* (Chapter 17). So harmonious were their efforts that, in some cases, only experts can definitely tell their paintings apart (**62,63**). Later, the styles of Picasso and Braque diverged, but for a short time they painted almost as one.

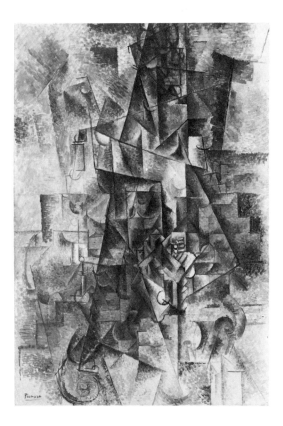

far left: 62.
Pablo Picasso.
The Accordionist.
1911. Oil on canvas,
4'3¼" × 2'11¼".
Solomon R.
Guggenheim Museum,
New York.

left: 63.
Georges Braque.
Violin and Pitcher.
1910. Oil on canvas,
46⅛ × 28¾".
Kunstmuseum, Basel.

Albrecht Dürer
1471–1528

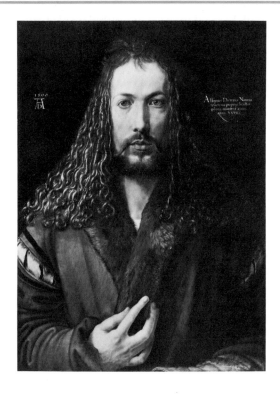

Albrecht Dürer is the first of the northern European artists who seems to us "modern" in his outlook. Unlike most of his colleagues, he had a strong sense of being an *artist*, not a craftsman, and he sought—and received—acceptance in the higher ranks of society. Moreover, Dürer appears to have understood his role in the history of art—sensed that his work would exert great influence on his contemporaries and on artists of the future. This awareness led him to date his works and sign them with the distinctive "AD" (visible in the left background of his self-portrait)—a fairly unusual practice at the time.

Born in the southern German city of Nuremberg, Dürer was the son of a goldsmith, to whom he was apprenticed as a boy. At the age of fifteen young Albrecht was sent to study in the workshop of Michael Wolgemut, then considered a leading painter in Nuremberg. He stayed with Wolgemut for four years, after which he began a four-year period of wandering through northern Europe. In 1494 Dürer's father called him back to Nuremberg for an arranged marriage. (The marriage seems not to have been a happy one and produced no children.) Soon afterward Dürer established himself as a master and opened his own studio.

Dürer made a great many paintings and drawings, but it is his output in prints (engravings, woodcuts, and etchings) that is truly extraordinary. Many people would argue that he was the greatest printmaker who ever lived. His genius derived partly from an ability to unite the best tendencies in northern and southern European art of that period, for Dürer was a well-traveled man. In 1494 he visited Italy, and he re-

turned in 1505, staying two years in Venice, where he operated a studio. This second trip was a huge success, both artistically and socially. The artist received many commissions and enjoyed the high regard of the Venetian painters as well as of important patrons in the city. Upon his return to Germany Dürer took his place among the leading writers and intellectuals of Nuremberg, who seem to have valued him for his knowledge and wit, as well as for his art. In 1515 he was appointed court painter to the Holy Roman Emperor Maximilian I.

The last years of Dürer's life were devoted largely to work on his books and treatises, through which he hoped to teach a scientific approach to painting and drawing. As a Renaissance artist, he was fascinated by perfection and by an ideal of beauty. He wrote: "What beauty is, I know not, though it adheres to many things. When we wish to bring it into our work we find it very hard. We must gather it together from far and wide, and especially in the case of the human figure throughout all its limbs from before and behind. One may often search through two or three hundred men without finding amongst them more than one or two points of beauty which can be made use of. You, therefore, if you desire to compose a fine figure, must take the head from some, the chest, arm, leg, hand, and foot from others; and, likewise, search through all members of every kind. For from many beautiful things something good may be gathered, even as honey is gathered from many flowers."[9]

Albrecht Dürer. *Self-Portrait.* 1500.
Wood panel, $25\frac{5}{8} \times 18\frac{7}{8}''$. Alte Pinakothek, Munich.

In a sense, this whole book—or any book about art—is really about style. Part II will discuss how an artist's choices of elements affect style, Parts III and IV will consider styles in the various media, and Part V will survey styles throughout history, in different parts of the world.

Before going on to these broader issues, however, we should introduce one more term that is important for the study of art. The term is related to style, because if we are to fully understand an artist's style we must know what is being depicted in a work of art and why—the work's iconography.

Iconography

Loosely, iconography is the "story" within a work of art. Many people find the term confusing, because both subject matter and content could be described in much the same way as iconography. An example may help to clear up the confusion among the three terms. Suppose you see a painting of a boy and a dog. The *subject matter* of that painting is simply "a boy and a dog." Its *content* might be "the love between a boy and his dog." But if you, the observer, see that the dog is a collie, realize that the dog is Lassie, and know the Lassie stories—know that Lassie is an intelligent and heroic dog who often saves people from danger—then you have caught the painting's *iconography.*

Artists around the world always have assumed a certain iconographical knowledge on the part of their audiences. A viewer's comprehension of the iconography includes familiarity with the people, places, and events that are depicted, as well as any symbolism intended by the artist. Much of the history of art has some literary or historical or religious reference. Quite a lot of Western art is based on the Bible. Most of the time an artist's immediate circle of patrons and viewers will grasp the iconography at once. Problems arise, however, when we confront art from times and places other than our own.

Christians around the world are familiar with the story surrounding the birth of Christ. When a person with this background looks at Fra Filippo Lippi's *Nativity* (**64**), certain things are immediately apparent. There is the child Jesus,

64. Fra Filippo Lippi. *Nativity (Adoration of the Christ Child).* c. 1459. Tempera on wood, 4′2″ × 3′10″. Staatliche Museen, West Berlin.

left: 65. Albrecht Dürer. *The Fall of Man.* 1504. Engraving, $9\frac{7}{8} \times 7\frac{5}{8}''$. Metropolitan Museum of Art, New York (Fletcher Fund, 1919).

above: 66. *Sita in the Garden of Lanka with Ravana and His Demons.* Guler School, India, c. 1720. Gold and color on paper, $22\frac{3}{4} \times 33\frac{1}{4}''$. Cleveland Museum of Art (gift of George P. Bickford).

watched over by his mother Mary (who wears a halo symbolic of her perfect sinlessness). To the left is a praying saint and, just below, Jesus' cousin John the Baptist, identified by his staff. And at the top are God the Father and the Holy Ghost in the form of a dove, completing the Trinity. Someone with no knowledge of the Christian tradition, however, would probably see a lovely mother-and-child scene and wonder who those other people are and why they are wearing such funny hats. We can try to imagine what an Inca in 15th-century Peru or a Samurai in 15th-century Japan (both contemporary with this painting) would see in Filippo Lippi's scene.

Even in the Western culture we have inherited, the iconography can sometimes be unfamiliar. Albrecht Dürer, who worked in Germany during the late 15th and early 16th centuries, was a Christian. Much of his iconography is biblical, but it is overlaid with mystical northern European symbolism. In *The Fall of Man* (**65**) we see Adam and Eve about to be banished from the Garden of Eden after their sin of eating the forbidden fruit. Dürer has included symbols of the four humors, or temperaments, which were thought to rule the human body: the elk symbolizes gall; the ox, phlegm; the cat, choler; and the rabbit, blood. Each of these humors, in turn, was associated with a particular sin—avarice, gluttony, cruelty, and lechery—sins to which the fallen Adam and Eve were now susceptible. Dürer's iconography is incredibly rich, and we can only begin to explore it here. For the artist's learned contemporaries it was perfectly understandable; for us it is new territory.

Now let us consider a work even farther outside the experience of most of us—a painting that portrays an episode from the *Ramáyana*, the classic epic poem of India (**66**). Probably composed in the 3rd century B.C., the *Ramáyana* is an integral part of daily life in India even today. Every character, every incident in the tale is as well known to the Indian public as the details of the Nativity are to practicing Christians.

Briefly, the *Ramáyana* tells the adventures of Rama—a prince who was the seventh incarnation of the god Vishnu—and his beautiful, faithful wife, Sita. Through a trick, the demon-king Ravana manages to abduct Sita and carry her off to his splendid palace at Lanka, which we see in the left half of this illustra-

tion. Ravana is so demonic, and so powerful, that he can assume any form he chooses—the worst one being a monster with ten heads and twenty arms. After kidnapping Sita, he gives her one year to renounce Rama and become his consort, and he exiles her to the forest in the keeping of demon-handmaidens. In this episode Ravana is paying Sita a visit to see if she has yet relented, but Sita remains steadfastly true to Rama.

Without this background information we find the painting lovely and exotic, but how much more interesting it becomes when we understand its iconography. Nowadays all of us are exposed to art from cultures other than our own, and it is well worth the effort to learn more about them.

We should also remember that our own culture could be equally mystifying to those outside it. What would Filippo Lippi or Dürer or the painter of the *Ramáyana* make of Audrey Flack's *Marilyn* (**67**)? The details of the tragic film star's life are well known to most Americans, and so we readily accept the symbols of glamour, of artifice, of lushness, and especially of time running out (the candle, watch, calendar, and egg timer). But to someone who has never heard of Marilyn Monroe, the painting would seem a meaningless jumble. A knowledge of any work's iconography, therefore, can greatly enhance our appreciation, as can acquaintance with the culture that produced the art.

And so, to return to the title of this chapter: What is art? It is the "lie that tells the truth." Sometimes it is beautiful, but it may be ugly. It can look like things in the natural world, but frequently it does not. It is always the expression of the artist. It is always a product of the culture that produces it. It is the artist showing us something, telling us something, making us experience something. It is communication—if we but look, listen, think, and feel.

67. Audrey Flack. *Marilyn.* 1977. Oil and acrylic on canvas, 8′ square. University of Arizona Museum of Art, Tucson (purchase with funds provided by the Edward J. Gallagher Memorial Fund).

ART PEOPLE
Theo van Gogh

We think of Theo van Gogh as the sensible one. Mentor and benefactor of his brother, the tormented artist Vincent van Gogh, Theo was nearly everything his brother was not—successful in business, financially solvent, steady and dependable, easy in friendship, a serious family man. Sometimes it is hard to remember that Vincent was the *older* brother, Theo younger by four years. The relationship between them was extraordinary. Without Theo, Vincent van Gogh probably could not have survived as an artist, or survived at all. Without Vincent, Theo probably would have lacked the grand purpose of his life.

Theo was born at the family home in Holland in 1857. When he was a teenager his uncle arranged for him to be apprenticed to a firm of international art dealers, Goupil & Co., as Vincent had been before him. Here the brothers' characters diverged. Vincent soon drifted out of the business. Theo became well established and fairly prosperous, eventually settling in as an art dealer in Paris. From a young age Theo assumed principal responsibility for Vincent's financial support, and he continued in this role through Vincent's life. Both accepted the arrangement as natural.

The Van Gogh brothers maintained a remarkable intimacy of spirit—surprisingly so, in view of the fact that, except for brief visits, they spent relatively little time in each other's company. They were together in their boyhood, then for two years in Paris, when Vincent stayed with Theo before moving to the south of France. This latter period exhausted Theo; Vincent was never an easy person to live with. Theo described Vincent's presence in the Paris apartment as "unendurable" and was relieved when the artist journeyed to Arles.

The thread of Theo and Vincent's connection depended on an immense volume of correspondence.

Vincent was compulsive in writing to Theo—his subjects ranging from intensely personal thoughts and emotions through minute descriptions of work in progress. Theo was always there for Vincent. When Vincent finished a series of paintings, he shipped them off to Theo, who did his best to promote and sell the work (with little success). When Vincent was irresponsible, Theo lectured. When Vincent was in financial crisis, Theo sent money. When Vincent was in emotional crisis, Theo arrived to pick up the pieces. Although under no illusion about his brother's difficult temperament, Theo seems to have known from the beginning that Vincent was a brilliant painter, and to have considered it his mission to sustain the painter's career.

Theo's marriage to Johanna Bonger in April of 1889 caused a brief strain in the Van Gogh bond. What had been a straight line became a triangle. Vincent suffered over having any of Theo's emotional energy diverted from himself to the new wife. Before long, however, he came to be fond of his sister-in-law and rejoiced in the birth of his nephew.

Vincent shot himself in July of 1890, and Theo was summoned to the deathbed. Three days later Theo wrote to his mother: "One cannot write how grieved one is nor find any solace. . . . Oh, Mother! He was so my own, own brother."[10] Vincent's death left Theo, only thirty-three years old, broken in health and spirits. Within six months he too was dead. The brothers are buried side by side. Afterward, the work of establishing the art of Vincent van Gogh was carried on by Theo's wife and his only child, a son, named Vincent.

Photograph of Theo van Gogh,
c. 1888–90.
Amsterdams Historisch Museum.

3
Themes and Purposes of Art

There are several ways to approach the study of art. A popular one is to trace its history chronologically, from the earliest cave paintings of the Stone Age to the art of our own time. This method offers great advantages, because it places works of art in the context of the cultures from which they emerged and allows one to follow the development of art over the centuries. Part V of this book will present a brief chronological survey of art.

The chronological approach has one drawback, however, in that we may lose sight of the characteristics that works made by different cultures have in common. For instance, a sculpture produced today and one produced ten thousand years ago may seem very different, and a chronological approach emphasizes the differences by focusing on the cultural aspects that influenced each. But suppose the two sculptures are images honoring political leaders; then we would say they have the same *theme*, so we can make interesting comparisons between them. While it is useful to understand how and why works of art differ, it is also helpful to see how much they are alike, even when thousands of miles and years separate them.

In Chapter 2 we discussed content—the subject matter of a work of art and what the artist means to convey about that subject matter. Content can be considered as theme whenever similar material is treated by many artists at various times and places. A theme is therefore like a thread running through the entire history of art, and there are many such threads. No doubt every person setting out to name the important themes in art would produce a different list. We have chosen to consider these: magic and survival, religion, pride and politics, art as the mirror of everyday life, art and nature, imagination and fantasy.

The *purpose* of a work of art is what the artist hoped to achieve (or in some cases what the art patron hoped to achieve by commissioning it). Sometimes the two factors—theme and purpose—overlap, so it is difficult to tell them apart, but in other instances we can identify a separate purpose. For example, the theme of

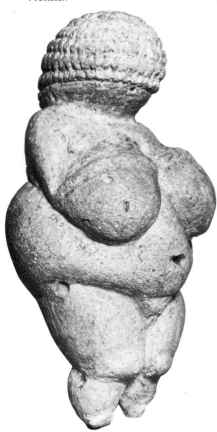

68. *Venus of Willendorf.*
c. 23,000 B.C.
Limestone, height 4⅜".
National History Museum,
Vienna.

a landscape painting would probably be nature, and the purpose simply to depict some aspect of nature. But if the artist's goal in painting a landscape is to show the glory of God's creation, then the theme is still nature but we might consider the purpose to be religion. Let us therefore examine the six themes mentioned, with several examples of each, and see how they lend themselves to various purposes. We begin with what was probably the first preoccupation of artists and indeed of all people.

Magic and Survival

Our illustration shows a little statuette that is nearly everybody's favorite way to begin studying art history (**68**). She is made of stone, was formed about twenty-three thousand years before the birth of Christ, and was found near a town in Austria. Her name: the *Venus of Willendorf*. At first her title of "Venus" may seem strange, given our usual image of the Goddess of Love. The name, of course, was applied by modern scholars, possibly supposing that people many thousands of years ago considered this sort of figure a sexual ideal. It seems clear that the little *Venus* was a fertility image, perhaps meant to be carried around as an *amulet*, or good-luck charm (the *Venus* is less than 5 inches tall). Only the features associated with childbearing have been stressed—the belly, breasts, and pubic area. Venus' face is obscured, her arms, crossed above the breasts, are barely defined, and her legs taper off to nothing. If we take this figure literally, she could not see or speak or walk or carry; what she could do was bear and nurture children.

How difficult it is for us living now to imagine what childbirth meant all those millennia ago. On the one hand it must have been a pressing necessity. Children were needed to help in the task of survival, and there may also have been an instinct to continue life through future generations. On the other hand, however, the process by which children are conceived and born was a mystery to these early peoples. The ovum and the sperm were unknown. Bringing forth a child must have seemed very much like the magician's trick of pulling a rabbit out of a hat. No wonder elements of magic became associated with childbirth. Many scholars assume that fertility figures like the *Venus of Willendorf*, which are extremely common in early art, were meant to play a cause-and-effect role. The sculptor would form an image of a woman with exaggerated reproductive features and this figure would *result* in a child (or children) being born. To primitive peoples this sequence must have made as much sense as any other.

Much primitive art seems to have been created for this purpose—to make sense out of the universe and to exert some control over the forces of nature. Today we have weather forecasters and meteorologists and seismologists and orbiting satellites and computers—but we still are not absolutely sure whether it will rain tomorrow. Early peoples had none of these, but they made the best out of what they had. Some of their arrangements startle us with their ingenuity.

On a plain in the south of England stand the enormous megaliths known as Stonehenge (**69**), much as they have stood for more than three thousand years. Stonehenge was built over a period of centuries, perhaps beginning as early as 2000 B.C. It consists of four concentric rings of stones, the outermost ring being 100 feet in diameter. The basis of the structure is *post-and-lintel* construction (Chapter 13), in which two uprights are surmounted by a horizontal crosspiece, the *lintel*. One of the most fascinating aspects of Stonehenge is the puzzle of *how* it was built. The stones, some weighing 50 tons or more, were quarried many miles away and dragged to the site by whatever primitive means may have been available. Next came the staggering feat of raising the lintels into position, without benefit of the cranes and other modern devices we take for granted. There is no mortar holding up these immense rocks. The method used by Stone Age peoples to erect them has stood up ever since.

Even more interesting is the problem of *why* Stonehenge was created. What purpose can have been so compelling as to stimulate this tremendous human effort? For centuries art historians debated the question. Then in 1964 a

above: **69.** Stonehenge. c. 2000–1500 B.C.
Height of stones 13'6". Salisbury Plain, England.

right: **70.** Double face mask, Baule tribe, Ivory Coast.
Wood with coloring, height 13¼".
Metropolitan Museum of Art, New York
(Michael C. Rockefeller Memorial Collection).

theory was advanced by astronomer Gerald S. Hawkins that appears to have solved the riddle of Stonehenge. By feeding complex measurements into a computer, Hawkins found that, at the moment of sunrise on the summer solstice (usually June 21), the sun shines through a key opening directly to an altar at the center. Similar computations showed that the position of the stones was organized to predict the winter solstice, the spring and autumnal equinoxes, and even eclipses of the sun and moon. In other words, Stonehenge apparently functioned as a giant calendar, codifying the mysterious changes of seasons and stars. Is Stonehenge a tool of magic, or the beginning of science, or a link between the two? Whichever the case, it provided the means by which its makers could plan for survival.

Whenever we talk about survival among these early peoples, we must remember that the concept probably represented far more than an individual fending off death. Survival of the *group*—of the tribe or clan—always was precarious, and this consideration may well have taken priority over all others. Magic therefore would be directed toward the endurance of the tribe. We see this tendency in "primitive" cultures of the past and present.

In many cultures throughout Africa, the Pacific, and elsewhere there has been a long tradition of making masks (**70**). These masks are usually ceremonial, magical, and related to such basic aspects of survival as birth, healing, puberty, marriage, fertility, success in the hunt, and death. (Death, seen as the transition to the afterlife, can be considered an aspect of survival.) A *shaman*, or healer-priest, may wear a mask as part of the healing ritual, thus combining the two elements of magic and survival.

Art whose theme is magic and survival has as its purpose the establishment of some sense of control. For nearly everyone, it seems, the most terrifying situation is that of being helpless, out of control, at the mercy of forces much bigger than we are. Worst of all, many psychologists contend, is the fear of *random* disasters. It is safer to believe that lightning strikes a particular spot because a spirit is angry than to know that lightning's path is arbitrary. At least a spirit can be placated, but randomness leaves us defenseless. Therefore, even if the control we take is imaginary—wearing a mask and beating a drum to quiet the lightning-god—we still are comforted.

71. Alice Aycock. *Collected Ghost Stories from the Workhouse,* from the series *How to Catch and Manufacture Ghosts.* 1980. Installed on the campus of the University of South Florida, Tampa.

Today's world is far more complex and calls for different kinds of control over powerful forces—the "magic" of the physicist, the neurosurgeon, the cosmologist, the mathematician. Even with all these specialists, there still are a great many areas of mystery in our world. Although we have learned much about the principles of birth and crop-raising and healing, we do not really know much about the nature of our universe. For most of us quasars and black holes do not seem any less magical than the idea that forming an image of a pregnant woman could produce a child. Perhaps that is why some contemporary artists have endowed their work with magical qualities not unlike those of the African shaman's art.

Among the artists who have carried this theme of magic into present-day and cosmic realms is the sculptor Alice Aycock. *Collected Ghost Stories from the Workhouse* (**71**) may remind you of an oil refinery or a factory set in the landscape. It does not seem out of keeping with the water tower at the right in this photograph, which is not part of the sculpture. *Collected Ghost Stories* is an attempt to make machinery do spiritual work. The ghosts from the title are contained in the eight round canisters in the right foreground. It is they who supply spiritual energy to power the two globes at top, which are models of the universe. According to the catalogue notes for this sculpture, Aycock requires the viewer to "ponder the magic of science." The sculpture "contains the power to conjure spirits and challenge the viewer's intellectual comprehension of material and psychic phenomena."[1] It would seem, therefore, that magic and survival are still potent issues in our world, and that artists are still striving to take control over what they cannot see.

Art in the Service of Religion

Since earliest times art has served religion in two important ways. First, it has attempted to make specific and visible something that is, by its very nature, spiritual. Religious art provides images of Christ, Buddha, the whole galaxy of Greek and Roman gods, the saints and angels, and other figures. It portrays all the legends, stories, and events that make up the fabric of a faith. Artists depict—and help others to visualize—the Crucifixion of Christ or the cremation of the Buddha. Each of these depictions, of course, is the artist's own interpretation of what a particular being or situation looked like. But by giving the faithful an image to focus on, the artist makes religion more concrete, less abstract.

The second major task of artists has been to erect the sacred temples where believers join to profess their faith and to follow the observances it requires. A very large portion of the magnificent architecture we have was built in the service of religion. Naturally the architectural style of any religious structure reflects

the culture in which it was built, but it is also dependent on the particular needs of a given religion. Three examples will help to show this.

On a high hill, the Acropolis, overlooking the city of Athens stands the shell of what many consider the most splendid building ever conceived: the Parthenon (72). The Parthenon was erected in the 5th century B.C. as a temple to the goddess Athena, patroness of the city, and at one time its core held a colossal statue of the goddess. However, the religion associated with the Parthenon was not confined to worship of a deity. In ancient Greece, veneration of the gods was closely allied to the political and social ideals of a city-state that celebrated its own greatness. The statesman Pericles, under whose sponsorship the Parthenon was built, spoke of such matters in his famous Funeral Speech during the Peloponnesian War:

> Our love of what is beautiful does not lead to extravagance; our love of the things of the mind does not make us soft. We regard wealth as something to be properly used, rather than as something to boast about. . . . What I would prefer is that you should fix your eyes every day on the greatness of Athens as she really is, and should fall in love with her. When you realize her greatness, then reflect that what made her great was men with a spirit of adventure, men who knew their duty, men who were ashamed to fall below a certain standard.[2]

Rising proudly on its hill, visible from almost every corner of the city and for miles around, the Parthenon made it possible for all literally to "fix their eyes every day on the greatness of Athens." It functioned therefore as a symbol of the citizens' aspirations. Its structure as a religious shrine seems unusual for us in that it turns outward, toward the city, rather than in upon itself. Worshipers were not meant to gather inside the building; actually, only priests could enter the inner chamber, or *cella*, where the statue of Athena stood. Religious ceremonies on festal occasions focused on processions, which began down in the city, wound their way up the steep path on the west side of the Acropolis, and circled the Parthenon and other sacred buildings at the top.

Most of the Parthenon's architectural embellishment was intended for the appreciation of the worshipers outside. All four walls of the exterior were decorated with sculptures high up under the roof, and originally portions of the marble facade were painted a vivid blue and red (591). In Chapter 13 we shall consider details of the Parthenon's structure; here we concentrate on the theme of religion and on the Parthenon's purpose, which is both religious *and* political exaltation.

At about the same time the Parthenon was being constructed in Athens, but half a continent away, one of the world's great religions was developing and

72. Ictinus and Callicrates. The Parthenon. 448–432 B.C. Acropolis, Athens.

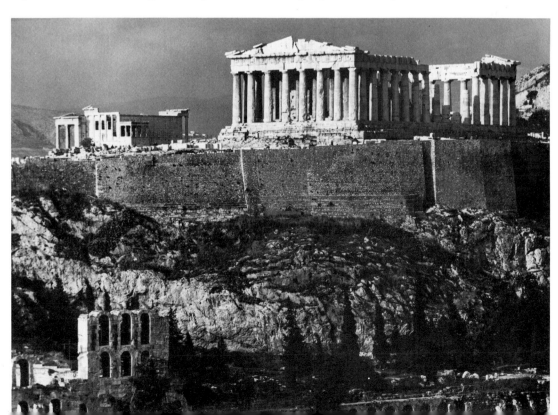

beginning to form its own architecture. Buddhism derives its principles from the teachings of Gautama Siddhartha, later known as the Buddha, who was born in India about 563 B.C. Although of noble birth, the Buddha renounced his princely status and life of ease. When he was about twenty-nine he began a long period of wandering and meditation, seeking enlightenment. He began with the supposition that humans are predisposed to live out lives of suffering, to die, then to be reborn and repeat the pattern. Ultimately, he worked out a doctrine of moral behavior that he believed could break the painful cycle of life and death, and he attracted many followers.

Buddhism is predominantly a personal religion, and its observances depend less on communal worship than on individual contemplation. It places great emphasis on symbolism, much of it referring to episodes in the life of the Buddha. Both these aspects—the personal and the symbolic—are evident in one of Buddhism's finest early shrines, the Great Stupa at Sanchi, in India (**73**). Like the Parthenon, the Great Stupa turns more outward than inward, but its moundlike form is more sculptural, intended as a representation of the cosmos. At the very top is a three-part "umbrella," symbolizing the three major aspects of Buddhism—the Buddha, the Buddha's Law, and the Monastic Order.

Buddhist shrines—the word *stupa* means "shrine"—often housed relics of the Buddha, and worship rituals called for circumambulation ("walking around") of the stupa. Thus, on the outside of the Great Stupa we see a railed pathway, where pilgrims could take the ritual clockwise walk following the Path of Life around the World Mountain. Elsewhere the stupa is embellished richly with carvings and sculpture evoking scenes from the Buddha's life. Every part of the stupa is geared to the pursuit of personal enlightenment and transcendence.

If the Buddhist temple is dedicated to private worship, then its extreme opposite can be found in the total encompassment of a community religious experience: the medieval Christian cathedral. And the supreme example of that ideal is the Cathedral of Notre Dame de Chartres, in France (**74**). Chartres Cathedral was built, rebuilt, and modified over a period of several hundred years, but the basic structure, which is in the Gothic style (Chapter 13), was established in the 13th century. A cathedral—as opposed to a church—is the bishop's domain and therefore always in a town or city. This one fact is crucial to understanding the nature of Chartres and the role it played in the people's lives.

Our illustration shows that the cathedral towers magnificently over the surrounding city, much as the Parthenon does over Athens, but here the resem-

73. The Great Stupa. Sunga and early Andhra periods, 3rd century B.C.– A.D. 1st century. Sanchi, India.

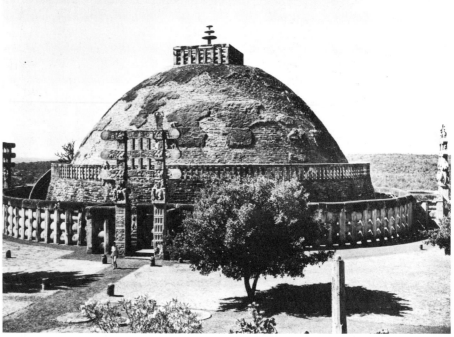

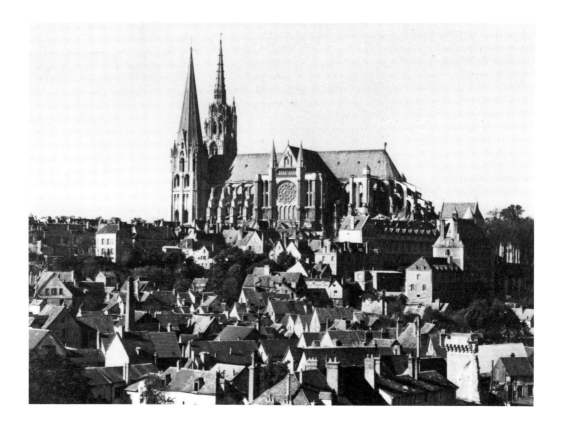

blance ends. Whereas the Parthenon is above and apart from the city, accessible only by a steep path, Chartres Cathedral is very much a living presence *within* the city. In the Middle Ages houses and shops clustered right up to its walls, and one side of the cathedral formed an edge of the busy marketplace. The cathedral functioned as a hub of all activities, both sacred and secular, within the town.

Medieval France had one dominant religion, and that was the Christianity of Rome. One could assume that almost every resident of the town of Chartres professed exactly the same faith, and so the church was an integral part of every-day life. Its bells tolled the hours for waking, starting work, praying, and retiring for the evening rest. Its feast days were the official holidays. Chartres Cathedral and its counterparts served the populace not only as a setting for religious wor-ship but as meeting hall, museum, concert stage, and social gathering place. Within its walls business deals were arranged, goods were sold, friends met, young couples courted. Where else but inside the cathedral could the townsfolk hear splendid music? Where else could they see magnificent art?

Three religious structures: the Parthenon, the Great Stupa, and Chartres Cathedral. Each was built in the service of religion but for each we can find another slightly different purpose. For the Parthenon the purpose is also *political;* for the Great Stupa there is the purely *private* observance of religion; and for Chartres the *social* role is almost as important as the religious.

These three structures demonstrate that religious art must always be un-derstood in the context of the culture for which it was created. Moreover, that context changes as the culture develops. No religion is static. Every faith changes and grows, adapts to particular times and cultures, is influenced by individuals who practice it. The same is true of art that expresses aspects of that religion. We can see this by studying two interpretations of the Crucifixion, made by artists with very different views of the world.

The Crucifixion of Christ has been a frequent subject in Western religious art for many hundreds of years. In its essentials the story is simple. Jesus Christ, who was by birth a Jew, attracted a large following by preaching a new kind of faith and was believed by many to be the long-awaited Messiah. This disturbed the authorities, who were threatened by the prospect of having a powerful "king"

74. Chartres Cathedral, view from the southeast. c. 1194–1260.

El Greco
1541?–1614

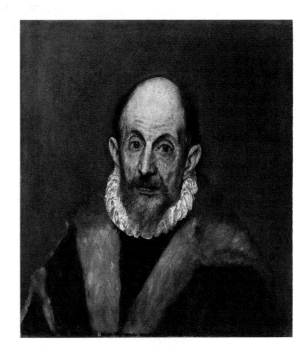

Not until the 20th century did El Greco become valued as one of the great artists of all time. Soon after his death he was all but forgotten, and nearly three centuries would elapse before serious attention was paid to his work. No doubt this is a major reason why so very little is known about his life.

The year 1541 is given tentatively as the date when Domenicos Theotocopoulos was born on the Greek island of Crete. It is believed that he began as a painter of small icons (religious images) of the sort then typical on that island. Sometime in the 1560s Theotocopoulos traveled to Venice, where he was taken as a pupil by the Renaissance master Titian, and in 1570 he moved on to Rome. There is a story that, while in Rome, Theotocopoulos—who had yet to prove himself as an artist—grandly offered to replace the *Last Judgment* fresco by Michelangelo and do a better job of it. If true, the story indicates both the artist's staunch faith in himself and a certain tactlessness in dealing with those who considered Michelangelo barely less than a god. (Many years later El Greco was quoted as saying: "Michelangelo was a good man, but he could not paint.")

Early in 1577, for reasons that are unclear, the artist left for Spain and settled in the city of Toledo, where he was to remain for the rest of his life. There he acquired the name by which he is always known: El Greco, the Greek. Possibly he had been attracted by news of the Spanish King Philip II's ambitious plans to restore his palace, which would mean many artistic commissions. However, El Greco's only commission from the king did not please its patron and was never hung in the intended spot. Thereafter, most of El Greco's commissions came from the clergy.

Not long after his arrival in Spain El Greco met a Spanish woman, Jerónima de las Cuevas, who became his lifelong companion, although they apparently never married. Almost nothing is known of Jerónima except for a lovely portrait, *Lady with a Fur*, that is assumed to be her image. In 1578 she bore El Greco's son, his only child, Jorge Manuel, who later became an artist and worked in his father's studio.

If ever an artist and a place were identified closely with one another, such was the case with El Greco and Toledo. Stronghold of Roman Catholicism, of the Spanish Inquisition and the Jesuit order, Toledo was a fervently religious city, which fit in excellently with El Greco's ardent spirituality. The artist's friends were the clergy and the intellectuals of the town, who formed an appreciative audience for his innovative treatment of religious themes. In the end, the painter who was not really a Spaniard at all is often called the greatest of all Spanish painters.

A contemporary who interviewed El Greco not long before the latter's death spoke of his extensive writings on art and philosophy. These, unfortunately, have been lost. But one comment reliably attributed to him is significant in view of his long centuries of obscurity before the world again discovered El Greco, and it is a comfort to struggling artists in our own time: "If once in a while popular taste is right, it is usually by accident and is not worth taking into account."

El Greco. *Portrait of a Man (Self-Portrait?).* c. 1610.
Oil on canvas, 20¾ × 18⅜".
Metropolitan Museum of Art, New York
(purchase, Joseph Pulitzer Bequest, 1924).

75. Matthias Grünewald.
The Crucifixion, center panel
of the *Isenheim Altarpiece*
(exterior). Completed 1515.
Panel, 8'10" × 10'1".
Musée d'Unterlinden, Colmar.

of the Jews at large, and Christ was condemned to death. After a series of tortures and humiliations, he was nailed, by the feet and hands, to a cross and left to die—a customary method of execution in those times. His dying took three hours and was witnessed by his mother, Mary, his beloved disciple St. John, and Mary Magdalene. Here is the way two artists responded to this scene of anguish.

Matthias Grünewald, a German artist of the early 16th century, painted the Crucifixion as the center of his great masterpiece, the *Isenheim Altarpiece* (**75**). Originally, the altarpiece reposed in the chapel of a hospital devoted to the treatment of illnesses afflicting the skin, including syphilis. This helps to explain the horrible appearance of Christ's body on the cross—pockmarked, bleeding from numberless wounds, tortured beyond endurance. Without question the patients in the hospital could identify with Christ's sufferings and increase their faith by being as one with him. The artist's purpose was undoubtedly in part to foster this identification.

In Grünewald's version of the Crucifixion, the twists and lacerations of the body speak of unendurable pain, but the real anguish is conveyed by the feet and hands. Christ's fingers splay out, clutching at the air but helpless to relieve the pain. His feet bend inward in a futile attempt to alleviate the pressure of his hanging body. To the left of the Cross the Virgin Mary falls in a faint, supported by St. John, and Mary Magdalene weeps in an agony that mirrors Christ's own. To the right John the Baptist offers the only sign of hope. He points calmly at the dying Savior in a gesture that foreshadows Christ's Resurrection and eventual triumph. Grünewald's interpretation of this event is in keeping with a harsh northern tradition of art in which extremes of physical agony were commonplace. Much of northern European art from this period dwells on the more grisly aspects of faith—the martyrdom of saints and the punishment of sinners.

Now let us consider a version of the same scene painted just about a hundred years later by an artist who was born in Crete, but who spent most of his

76. El Greco.
Christ on the Cross with Landscape. c. 1610.
Oil on canvas, 6′2″ × 3′8″.
Cleveland Museum of Art (gift of Hanna Fund).

professional life in Spain—the man known as El Greco (**76**). Can this possibly be the same execution scene? *This* Christ does not hang helplessly from the Cross but seems rather to float upward, lifting the Cross with him. His body twists, yes, but not so much in anguish as in a graceful transcendence over earthly concerns. No onlookers interrupt this otherworldly image of perfect goodness triumphing over pain and death.

In painting this Crucifixion, El Greco was responding to three impulses that set him apart from Grünewald. First of all, El Greco was a southern European artist, steeped in the classic traditions of Greece and Rome, aware of the Renaissance masterpieces of Michelangelo and Raphael, untouched by the harsh precedents of northern art. Second, El Greco was much an artist of the Counter-Reformation—the Roman Catholic struggle against the increasing strength of the new Protestant religions in northern Europe. El Greco reflects the Counter-Reformation mood with his supremely mystical vision of Christ on the Cross, poised in a landscape that is clearly not of this world. Catholic Spain turned its eyes upward, to the heavens rather than the earth, and forward, to eternal life rather than the earthly one. El Greco's pristine, elongated figure of Christ exactly satisfied this ideal. Finally, El Greco was himself a mystic, a visionary, a passion-

ately religious man. His Crucifixion emerges from an intense and very personal faith, supported by his strong artistic background.

So we see that religious art is deeply affected by many forces: when it was made, where, why, by whom, and for what purpose. The same is true of art that deals in more earthly matters.

Pride and Politics

It has been said that everything in life comes down to politics. All the worthy emotions—love, honor, patriotism, charity—have at their root a concern with politics, which means simply possessing the power to achieve one's desired goal. This is not the place to debate whether that theory holds true or not, but it is certainly clear that a great portion of the world's art has had political implications. The queen or pope or president who commissions an artist to make a particular work may have a true love of art, but that patron surely knows that a great masterpiece will enhance the patron's prestige and therefore increase his or her power.

Political art, and those who make it, can be divided between the "ins" and the "outs." The "ins" want to be even more in—to consolidate their power and enhance their prestige. The "outs," by and large, are unhappy with the existing political situation (whatever it may be) and hope to dislodge the "ins" and replace them. Art has traditionally served both ends; we will look at a bit of each.

The structures that many consider to be the ultimate in kingly pride, the height of political power, were built four and a half millennia ago and have never been surpassed. At Giza in Egypt rise the three great pyramids, tombs of the Pharaohs Mycerinus, Chefren, and Cheops (77). Only an immensely prideful king would divert thousands of workers to the massive chore of erecting a burial mound on this scale. Cheops' pyramid, the largest of the three, is about 450 feet tall (roughly the height of a fifty-story building), covers more than 13 acres, and consists of some 2.3 million blocks of stone. Each of these blocks had to be quarried with hand tools, dragged to the site, and assembled without mortar.

Perhaps even more interesting than the difficulty of the task is the grandiosity of the kings who willed it. The pharaohs planned these pyramids as safe and permanent resting places for themselves and their families in the afterlife. By their logic, the more powerful an individual had been in life, the more dramatic a mark that individual's tomb should make upon the landscape. The great pyramids, therefore, represent an extreme of kingly pride, of a pharaoh saying, in effect, "*My* name will never be forgotten; *my* monument will endure through all the generations to come." And so far, despite the wars and political upheavals and natural disasters that the earth has witnessed, they were right.

Given what we know about the spread of the mighty Roman Empire in the few centuries surrounding the birth of Christ, it is not surprising that some of the

77. The Great Pyramids: Pyramid of Mycerinus (c. 2500 B.C.); Pyramid of Chefren (c. 2530 B.C.); Pyramid of Cheops (c. 2570 B.C.). Giza, Egypt.

most prideful and political art was created at that time. The Roman emperors, who eventually conquered most of the civilized world they knew of, understood the political value of celebrating themselves and their achievements. An example of this approach to art is the statue of Augustus, which is known as the *Augustus of Prima Porta* (**78**).

Augustus came to power in Rome in 31 B.C. by virtue of his military successes, and he reigned unchallenged for forty-five years—the first of the great Roman emperors. Under Augustus the empire enjoyed peace, prosperity, administrative order, and a flowering of the arts. In those times the line separating admiration for the ruler and worship of a deity was a fine one; emperors and heroes took on the attributes of gods. (The little figure accompanying Augustus is a cupid, symbol of Venus, the goddess from whom the emperor was supposedly descended.) That Augustus deliberately sought to enhance this godlike image is clear, and recent scholarship provides fascinating clues about how this statue and others played a role in his "public relations" campaign.

Considerable evidence supports the theory that Augustus was in fact much less attractive than he appears here. In life he had unruly hair, a small chin, small eyes, big ears, a bony face, and thin lips. Scholars now believe that in about 27 B.C.—seven years before the presumed date of the Prima Porta figure—the emperor commissioned an idealized portrait head, which was to be used as a model for all later sculptures, regardless of the emperor's advancing age. The Prima Porta head was based on this model; it is not only beautiful and godlike but also resembles the idealized Greek style. What were Augustus' motives for promoting

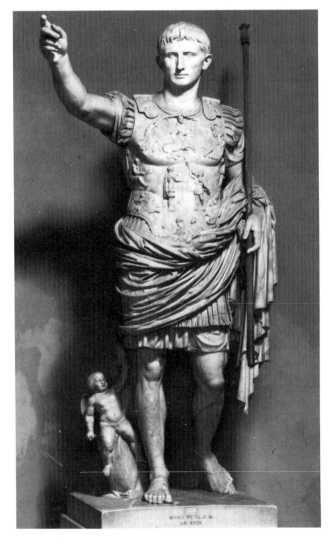

78. *Augustus of Prima Porta.* c. 20 B.C. Marble, height 6'8". Vatican Museums, Rome.

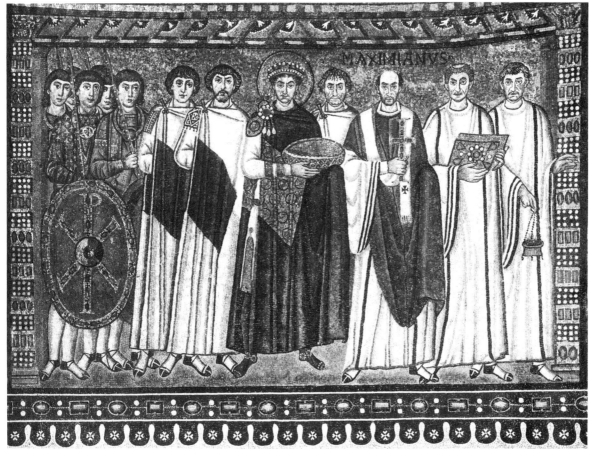

79. *Emperor Justinian and Courtiers.*
c. 547. Mosaic.
San Vitale, Ravenna.

this idealized self-portrait? According to those who have studied the question, "the portrait was supposed to show that he had ideal human qualities and, at the same time, that he stood for a culture that combined the best traditions." Also, the Prima Porta style head "was part of a representational program which gave Romans hope for the future under Augustus, as a divinely inspired leader. He claimed to be acting as the agent of the gods on earth."[3] In other words, the emperor's purpose in commissioning this art was a political one—an attempt to consolidate his power and ensure its continuity.

Despite Augustus' efforts, the empire was too big to govern, and eventually it split in two, with the western half centered at Rome, the eastern half at Byzantium (modern Istanbul, in Turkey). Five centuries after Augustus, his successor in the Eastern Empire, the Byzantine emperor Justinian, was no less inclined to glorify himself by means of art. Justinian was a Christian emperor, and so he has made the subtle transition from identification with the old Greek and Roman gods to kinship with Christ. The illustration here (**79**) is a *mosaic*—a wall decoration (in this case) assembled from tiny pieces of colored glazed tile—in the Church of San Vitale, in Ravenna. Justinian stands at center in the composition, surrounded by twelve companions (symbolic of Christ's twelve Apostles). He alone has a halo of light around his head, implying that he is divine, not human. The arrangement of figures is meant to suggest a procession, yet there is little sense of movement as Justinian poses formally, accepting with solemn dignity the homage of his subjects.

For the ultimate in a political portrait, however, we must look several hundred years later, to a king who so wholeheartedly embraced his role as divine ruler that he dared to say "L'état, c'est moi" ("I am the state")—Louis XIV of

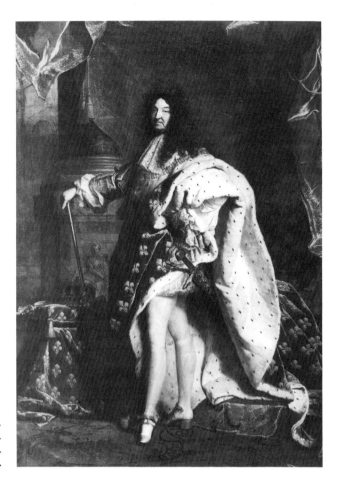

80. Hyacinthe Rigaud.
Louis XIV. 1701.
Oil on canvas, 9′1½″ × 6′2⅝″.
Louvre, Paris.

France. Hyacinthe Rigaud's portrait (**80**) captures all the pageantry of a reign that was built on drama as carefully as any full-scale operatic performance might be.

Louis himself commented on the value of visible symbols: "Those who imagine that these are merely matters of ceremony are gravely mistaken. . . . The peoples over whom we reign, being unable to apprehend the basic reality of things, usually derive their opinions from what they can see with their eyes."[4] Louis ruled as the "Sun King" for an amazing seventy-two years, and during that time France experienced a period of political, social, and artistic achievement without parallel. At his death the nation was only seventy-five years away from revolution—a revolution that would bring down the monarchy—but while Louis sat on the throne he kept all eyes focused on himself as the personification of France in her glory.

To the modern viewer Louis' costume seems absurd, his pose more than a little affected, but his subjects must have found the picture inspiring. No detail that might have contributed to the king's grandeur has been spared, from the lavish ermine-lined robes, to the lush scarlet canopy of the backdrop, to the classical Greek column at left. Louis obviously realized that political power rests on an illusion. Art that fostered the illusion could help to maintain the power.

So far in this section we have focused on the person who was the *subject* of political art, rather than the artist who made it—that is, the patron who was in control of whatever purpose was to be achieved, not the artist. Let us turn our attention now to the artist who chooses a specific political ideal and uses his or her talent to realize it. There can be no more interesting example than Jacques Louis David.

David was a painter of enormous skill who worked at a time of intense political turmoil. He epitomizes for the history of art the phrase "survival of the fittest." David's career began under the patronage of Louis XVI, descendant of

the Sun King and last of the Bourbon monarchs before the revolution. When revolution came to France in 1789 the artist slipped, with apparent ease, into the revolutionary mode and became one of its leading propagandists. Then again, when the revolution faltered and Napoleon came to power as Emperor of France, there at the forefront of artistic service to the Empire was Jacques Louis David.

What many consider to be David's finest picture was made during the revolutionary period. Its subject is Jean-Paul Marat, one of the leaders of the Reign of Terror, who was responsible for the death by guillotine of hundreds of people. Because of a painful skin ailment Marat spent his days in the bathtub, which was fitted out with a writing desk so he could work, and there he received callers. A woman named Charlotte Corday, incensed by Marat's excesses with the guillotine, gained entry to his apartments and stabbed him to death. As a memorial to his friend, David painted *The Death of Marat* (**81**).

In lesser hands Marat's demise could have been laughable—a naked man murdered in his tub by an overexcited woman in visiting dress. But David has invested the scene with all the pathos and dignity of Christ being lowered into his tomb; Marat is shown, in effect, as a kind of secular Christ martyred for the revolution. All the forms are concentrated in the lower half of the composition, and light bathes the fallen leader in an unearthly glow, both of these devices contributing to the sense of tragedy. It is probably safe to conclude that David's purpose in this work was to transform a man whom many considered Satan himself into a sainted hero.

David was demonstrably (though flexibly) on the side of the "ins." His artistic goals were compatible with the goals of those holding political power. Our next

81. Jacques Louis David. *The Death of Marat.* 1793. Oil on canvas, 5'5" × 4'2½". Musées Royaux des Beaux-Arts de Belgique, Brussels.

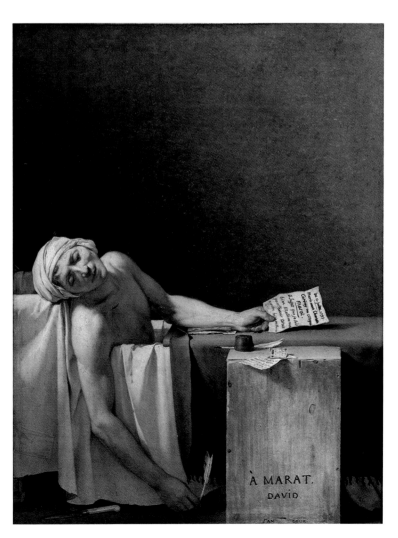

Jacob Lawrence
b. 1917

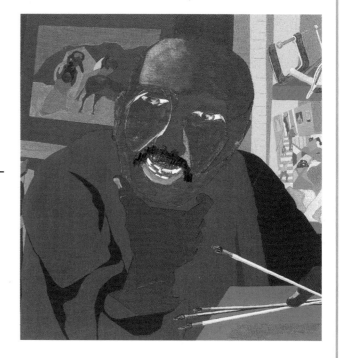

The name "Harlem" is associated in many people's minds with hardship and poverty. Poverty Harlem has always known, but during the 1920s it experienced a tremendous cultural upsurge that has come to be called the Harlem Renaissance. So many of the greatest names in black culture—musicians, writers, artists, poets, scientists—lived or worked in Harlem at the time, or simply took their inspiration from its intellectual energy. To Harlem, about 1930, came a young teenager named Jacob Lawrence, relocating from Philadelphia with his mother, brother, and sister. The flowering of the Harlem Renaissance had passed, but there remained enough momentum to help turn the child of a poor family into one of the most distinguished American artists of his generation.

Young Lawrence's home life was not happy, but he had several islands of refuge: the public library, the Harlem Art Workshop, and the Metropolitan Museum of Art. He studied at the Harlem Art Workshop from 1932 to 1934 and received much encouragement from two noted black artists, Charles Alston and Augusta Savage. By the age of twenty Lawrence had begun to exhibit his work. A year later he, like so many others, was being supported by the federal WPA Art Project, a government-sponsored program to help artists through the economic void of the Great Depression.

Even this early in his career, Lawrence had established the themes that would dominate his work. The subject matter comes from his own experience, from black experience: the hardships of poor people in the ghettos, the violence that greeted blacks moving from the South to the urban North, the upheaval of the civil rights movement during the 1960s. Nearly always his art has a narrative content or "story," and often the titles are lengthy. Although Lawrence does paint indi-

vidual pictures, the bulk of his production has been in series, such as *The Migration of the Negro*, some of them having as many as sixty images.

The year 1941 was significant for Lawrence's life and career. He married the painter Gwendolyn Knight, and he acquired his first dealer, when Edith Halpert of the Downtown Gallery in New York featured him in a major exhibition. The show was successful, and it resulted in the purchase of Lawrence's *Migration* series by two important museums.

From that point Lawrence's career prospered. His paintings always have been in demand, and he is sought after as an illustrator of magazine covers, posters, and books. His influence continues through his teaching—first at Black Mountain College in North Carolina, later at Pratt Institute, the Art Students League, and the University of Washington. In 1978 he was elected to the National Council on the Arts.

Many people would call Lawrence's paintings instruments of social protest, but his images, however stark, have more the character of reporting than of protest. It is as though he is telling us, "This is what happened, this is the way it is." What happened, of course, happened to black Americans, and Lawrence the world-famous painter does not seem to lose sight of Lawrence the poor youth in Harlem. As he has said, "My belief is that it is most important for an artist to develop an approach and philosophy about life—if he has developed this philosophy he does not put paint on canvas, he puts himself on canvas."[5]

Jacob Lawrence. *Self-Portrait*, detail. 1977.
Gouache on paper, 23 × 31".
National Academy of Design, New York.

example, however, was created by an artist whose sympathies lay with those not in power, an artist who took up his brush with a sense of fury at the "ins" who caused devastation. From his fury came one of the great masterpieces of 20th-century art. The artist was Picasso, and the painting is called *Guernica* (**82**).

It is necessary to know the story behind *Guernica* to understand its power. In 1937 Europe was moving toward war, and a trial run, so to speak, occurred in Spain, where the forces of General Francisco Franco waged civil war against the established government. Franco willingly accepted aid from Hitler, and in exchange he allowed the Nazis to test their developing air power. On April 28, 1937, the Germans bombed the town of Guernica, the old Basque capital in northern Spain. There was no real military reason for the raid; it was simply an experiment to see whether aerial bombing could wipe out a whole city. Being totally defenseless, Guernica was devastated and its civilian population massacred.

At the time Picasso, himself a Spaniard, was working in Paris and had been commissioned by his government to paint a mural for the Spanish Pavilion of the Paris World's Fair of 1939. For some time he had procrastinated about fulfilling the commission; then, within days after news of the bombing reached Paris, he started *Guernica* and completed it in little over a month. Despite the speedy execution, however, this was no unreasoning outburst of anger. Picasso controlled his rage, perhaps knowing that it could have better effect in a carefully planned canvas, and he made many preliminary drawings and sketches. The finished mural had a shocking effect on those who saw it; it remains today a chillingly dramatic protest against the brutality of war.

At first encounter with *Guernica* the viewer is overwhelmed by its size; it is more than 25 feet long and nearly 12 feet high. It dominates any space in which it is hung and seems to reach out and engulf the observer. Picasso used no colors; the whole painting is done in white and black and shades of gray, possibly to create a "newsprint" quality in reporting the event. Although the artist's symbolism is very personal (and he declined to explain it in detail), we cannot misunderstand the images of extreme pain and anguish throughout the canvas. At far left a shrieking mother holds her dead child and at far right another woman, in a burning house, screams in agony. The gaping mouths and clenched hands all speak of disbelief at such mindless cruelty.

Another victim is the dying horse to the left of center, speared from above and just as stunned by the carnage as any of the human sufferers. Various writers have interpreted the bull at upper left in different ways. Picasso drew much of his imagery from the bullfight, an ingrained part of his Spanish heritage. Perhaps the bull symbolizes the brutal victory of the Nazis; perhaps it, like the horse, is also a victim of carnage. There is even more confusion about the symbols of the lamp and the light bulb at top center. These may be indications that light is

82. Pablo Picasso. *Guernica.* 1937. Oil on canvas, $11'5\frac{1}{2}'' \times 25'5\frac{3}{4}''$. Prado, Madrid.

being cast on the horrors of war, or they may be signals of hope. Picasso did not tell us, so we are free to make our own associations.

With *Guernica* Picasso functioned as an artist of the "outs"—a voice crying against those who had power to do something of which he disapproved vehemently. Much political art of the 20th century has this purpose. Perhaps some artists throughout history have spoken against injustice, but until our era (and in our relatively free society) the "ins" were able to suppress their critics. In the United States one group, black Americans, has a long history of being "out"—out of power, out of work, out of schools, out of the material pleasures of society. No wonder, then, that oppression of blacks should have found expression in art.

Jacob Lawrence, who is himself black, took up this theme in the early 1940s with an ambitious sixty-panel series called *The Migration of the Negro.* We illustrate here the best-known panel from that series, *One of the Largest Race Riots Occurred in East St. Louis* (**83**). As a work of social protest, Lawrence's painting can be compared, in concept if not in style, to Picasso's *Guernica.* Rather than depicting realistically the bloody violence of a race riot, Lawrence has transformed the action into a stylized ballet of flat, abstract shapes. Interpreted this way, the conflict takes on universal implications, revealing not just a vicious clash of individuals, but the underlying hatreds of "us" against "them" that mark a pattern throughout human history. Lawrence's composition is a masterful geometric arrangement, all forms leading to the clenched fist holding a knife—the one form silhouetted above the horizon line.

As the arenas of political and social violence shift, political art changes to reflect them. The paintings of Leon Golub focus on the death and torture squads of present-day Central and South America. In *White Squad (El Salvador) IV* (**84**) we see a body sprawled in a coffin, the killer apparently just replacing the gun in his pocket. We do not see the face of the dead man; he is without identity, the impersonal victim of mindless brutality and sadism. In parts of Latin America today political power is absolute. The "ins" may be in briefly, but while they have power they create havoc. Leaders answer to no one. Citizens disappear with no trace, and their relatives and friends have no recourse. Golub himself has never actually witnessed these scenes. He acknowledges taking his imagery, in

83. Jacob Lawrence. *One of the Largest Race Riots Occurred in East St. Louis,* Panel 52 from *The Migration of the Negro.* 1940–41. Tempera on composition board, 12 × 18". Museum of Modern Art, New York (gift of Mrs. David M. Levy).

84. Leon Golub. *White Squad (El Salvador) IV.* 1983. Acrylic on canvas, 10' × 12'10". Saatchi Collection.

bits and pieces, from the front pages of newspapers, from sports photographs (think of a boxing match), even from pornographic magazines. The painting is raw, scraped down—literally—on the canvas until the paint resembles a faded poster on a wall. Golub asks us to confront ourselves in the figures of the assassins, to question how much we identify with their brutality, whether our civilization is only a thin veneer that might be scraped away.

Although Golub's scenes are invented in their specifics, those familiar with the political situation in Latin America have said they ring true. For many people in certain parts of Latin America, terrorism and torture are facts of everyday life. Golub's political art, therefore, records a perversion of the next major artistic theme we shall consider—an everyday life that is far gentler.

Art as the Mirror of Everyday Life

When children start to draw and paint, they deal in the images they know best: mother and father, sisters and brothers, the teacher, the house, the dog. Many artists never lose their preoccupation with everyday things, and so we have a rich heritage of art depicting those concerns that are closest to the artist's personal world.

Art that depicts the little moments of everyday life and its surroundings is known as *genre*. Often, its purpose is a simple one—to record, to please the eye, to make us smile. A series of charming genre paintings occurs in an early French manuscript, one page of which we shall examine here. During the Middle Ages wealthy patrons customarily would commission artists to *illuminate*, or hand-illustrate, books, particularly prayer books. In the early 15th century a close relationship existed between the Duc de Berry, brother of the French king, and three artist brothers, the Limbourgs. The Limbourgs painted for the duke what has become one of the most famous illuminated books in the history of art, *Les Très Riches Heures* ("the very rich book of hours"). It contains a calendar, with each month's painting showing a typical seasonal activity of either the peasantry or the aristocracy.

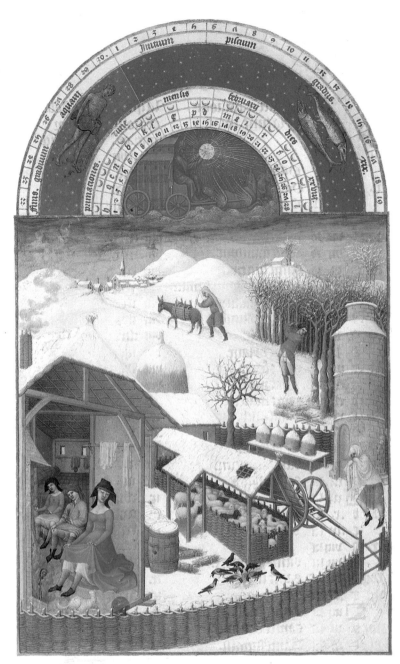

The *February* page, shown here (**85**), focuses on a small peasant hut with its occupants clustered around the fire, their garments pulled back to get maximum benefit from the warmth. (Underwear as we know it had not yet been invented, and so this forthright image has occasionally been censored.) With a touch of poetic license, the artists have removed the front of the hut so that we may look inside. Outside the hut we see what may be the earliest snow-covered landscape

ever painted. Sheep cluster in their enclosure, a peasant comes rushing across the barnyard pulling his cloak about his face to keep in the warm breath. From there the movement progresses diagonally up the slope to a man chopping firewood, another urging a donkey uphill, and finally the church at the top. Such was the everyday life of the lower classes in medieval France, and the Limbourgs have left us a capsule picture of it.

Some twenty years later another northern European artist, Jan van Eyck, painted a picture that is quite literally the "mirror" of life, this time of bourgeois life. *Giovanni Arnolfini and His Wife* (**86**) is believed by many experts to have a specific purpose; it apparently served as a marriage document, made to record and legitimize the nuptials between the merchant Arnolfini and his bride, Giovanna Cenami. At center in the painting is a mirror reflecting the artist, who has come to bear witness to the ceremony, adding his signature "Jan van Eyck was here, 1434." To reinforce the solemn nature of the occasion, the artist has included many symbols, such as the little dog at the couple's feet—an emblem of fidelity. Arnolfini has removed his shoes to indicate that he is standing on sacred ground—the ground on which are pledged the holy vows of matrimony. Many symbols relate to the potential fruitfulness of marriage, from the actual fruits on the windowsill to the marriage bed in the background. In fact, some observers have concluded that the new wife is already pregnant, but her gesture and rounded form are probably due mostly to the fashions of the day.

As the mirror of everyday life has recorded important occasions, so it has been used to capture life's little moments, the fleeting experiences that last for an instant and then are gone. This type of subject was a particular favorite with the Impressionist painters of the late 19th century, whose goal was to record that which is transitory—an impression (Chapter 17). In Pierre-Auguste Renoir's *Le Moulin de la Galette* (**87**) young couples meet at the outdoor café, they dance, they fall in love. The viewer has a quick impression of the most delightful of all ways to spend a summer day. As observers, we seem to have glanced briefly at the scene and absorbed its essence, rather than its details. We can almost hear the bright music (a waltz tune unquestionably), feel the warm breezes, sense an atmosphere of innocent flirtation and fun.

87. Pierre-Auguste Renoir. *Le Moulin de la Galette.* 1876. Oil on canvas, 4'3½" × 5'9". Musée d'Orsay, Paris.

88. Paula Modersohn-Becker.
Mother and Child. 1906.
Oil on canvas, 2'10½" × 4'1".
Sammlung Böttcherstrasse,
Bremen.

Another of life's little moments, this time a very private one, is recorded by Paula Modersohn-Becker in her *Mother and Child* (**88**). What might have been simply a woman nursing her baby has been given a universal quality by Modersohn-Becker, so that the image seems to be *all* mothers nursing all babies since time began. The mother's body, heavy and solid as the earth itself, curves protectively around the child, who in turn curves into the mother's belly. Both figures are anonymous; the baby's face is obscured, and the woman's barely articulated. This, however, is a far cry from the faceless fertility of the *Venus of Willendorf* (**68**). Modersohn-Becker's image speaks not of mindless childbearing but of the unbreakable attachment, the love, between mother and child—the most basic aspect of everyday life that allows it to continue.

Everyday life in the late 20th century may take on a different kind of timeless quality, as evidenced by the sculptures of George Segal (**89**). In 1982 Segal set up three of his life-size figures in New York City's Port Authority bus terminal, ostensibly waiting in line to buy a ticket. The figures are naturalistic, having been cast from living models (Chapter 11 and **366**), but they are made of un-

89. George Segal. *Next Departure.*
1979. Bronze, metal, plaster,
wood, paper, and vinyl;
7 × 6 × 8'. Installation 1982
at Port Authority of N.Y.
and N.J. Bus Terminal, New York.
Courtesy Sidney Janis Gallery,
New York.

painted white plaster. And they wait. Patiently, eternally, they wait in line, much as the modern-day individual has to wait for the bureaucratic realities of life to sort themselves out. Commuters moving through the bus terminal were much taken by Segal's waiting people. Some good-humored passersby fell casually in line behind them, as though prepared to stand immobile as long as they did, amused by this image of themselves. Segal, himself a commuter, managed to capture what is for the urbanite, unfortunately, a faithful mirror of everyday life.

Art and Nature

If art is the mirror of everyday life, it is also the mirror of everyday surroundings. Drive out into the country on a splendid autumn day, and along the road you are likely to see cars parked, easels set up, amateur painters trying to distill, on canvas or watercolor paper, the glories of the natural landscape. Throughout history professional artists, too, have responded to this impulse and have turned their eyes to nature as an engrossing subject for art. What they have seen depends on many things, including the cultures in which they worked and their own artistic visions.

A hanging scroll attributed to Li Cheng shows how a Chinese painter of the 10th century might interpret nature according to the magnificent landscape style that flourished in that period (**90**). Li Cheng's painting, characteristic of the Northern Song dynasty "monumental" style, emphasizes naturalism in details of the landscape. It was considered important for the viewer to be able to "walk through" the painting visually and to imagine him- or herself actually walking

90. Li Cheng (?). *A Solitary Temple amid Clearing Peaks.* 919–967. Hanging scroll, ink and slight color on silk; 44 × 22". Nelson-Atkins Museum of Art, Kansas City (Nelson Fund).

Paul Cézanne
1839–1906

Paul Cézanne remains one of the most enigmatic figures in modern art history, even though the details of his life are well known. A word often used to describe his personality is "difficult." Clearly, he was a man of intelligence and great sensitivity, yet he could be rude to strangers and boorish with his friends. Although he was acquainted with most of the leading artists then working in Paris, he spent the greater part of his life in isolation in the southern French town of Aix-en-Provence, where he was born.

Cézanne's banker father tried to steer his son into his own profession or the law, but the young man showed so little talent and inclination for either that eventually the father gave up and permitted him to undertake art studies. Cézanne's first attempts at exhibiting his work met with disastrous results; the critics' reactions ranged from ridicule to outrage. Nevertheless, he persevered, struggling on alone to achieve the form in art that was his vision. Cézanne's paintings are difficult to date, because he worked on many canvases at once and often labored over the same painting for several years. So demanding was he with live models that few sitters were willing to pose for him. One who did pose, the art dealer Ambroise Vollard, reported that he was forced to endure 115 sittings, some lasting three hours or more.

In 1869, while visiting Paris, Cézanne met a young woman, Marie-Hortense Fiquet, and they became lovers. Some three years later their son Paul was born. Cézanne went to extraordinary lengths to conceal this liaison from his domineering father, for fear his allowance would be cut.

For most of Cézanne's life only the very discerning—and they were few—recognized the genius of his art.

After his initial disappointments, the artist stopped exhibiting in Paris for twenty years. Then in 1895 Ambroise Vollard decided to mount a show—Cézanne's first one-man exhibition—and asked the artist to send all available work. Cézanne bundled up 150 canvases and shipped them off to Paris from Aix. The show took Paris completely by surprise and was an immediate sensation. From that time until his death the artist gradually acquired the recognition he deserved; ironically, he had become so embittered by long neglect that the acclaim seems to have given him little pleasure.

While alternatively mocked and ignored by critics and the general public, Cézanne never lost faith in himself and his art. In 1874 he wrote this to his mother: "I am beginning to find myself stronger than any of those around me. . . . I must go on working, but not in order to attain a finished perfection, which is so much sought after by imbeciles. And this quality which is commonly so much admired is nothing but the accomplishment of a craftsman, and makes any work produced in that way inartistic and vulgar. I must not try to finish anything except for the pleasure of making it truer and wiser. And you may be sure that there will come a time when I shall come into my own, and that I have admirers who are much more fervent, more steadfast than those who are attracted only by an empty outward appearance."[6]

Paul Cézanne. *Self-Portrait with a Beret.* c. 1906. Oil on canvas, 25¼ × 21″. Museum of Fine Arts, Boston (Charles H. Bayley Picture and Painting Fund and partial gift of Elizabeth Paine Metcalf).

through the terrain. One is led into the landscape at the bottom, then the eye moves upward gradually, much as the traveler would cross the bridge, walk up from the buildings at the base of the hill, climb to the temple, and then progress farther to the towering peak in the background. Especially typical of Li Cheng's style is the gnarled quality of the trees, each of which is seen as an individual entity. As viewers we stand apart from the landscape and see it in the distance, yet it is accessible if we choose to enter.

How different is our experience of John Constable's landscapes, such as *The White Horse* (**91**). Constable was perhaps the greatest of the English 19th-century landscape artists, and, like Li Cheng, he was concerned with absolute naturalism, a sense of what—for that artist—the landscape *really* looked like. In Constable's paintings, however, the viewer does not stand outside but seems almost to be surrounded by the natural scene, inside it without taking a step. To stand before one of these huge canvases is to be transported to another world, a peaceful corner of the rural English countryside. Constable was meticulous about recording details of foliage and other features, but his main fascination lay in transitory effects of light and changing patterns in the sky. The sunlight dapples through the leaves, reflects off the water, and picks out the white horse that gives the painting its name. Clouds scuttling across the sky seem actually to be in motion; we know that a second earlier or later the effect would be different. Whereas a Chinese landscape seems frozen in peace for eternity, Constable's visions capture a moment that will never come again.

91. John Constable. *The White Horse.* 1819. Oil on canvas, 4'3⅝" × 6'2⅛". Frick Collection, New York (copyright).

Yet another approach to the theme of nature can be found in Paul Cézanne's many versions of Mont Sainte-Victoire (**92**), a mountain near his home in Provence. We may be amazed to see that less than a hundred years and only the breadth of the English Channel separate Cézanne's landscape from Constable's. Through the later years of Cézanne's life Mont Sainte-Victoire obsessed him, but his interest was less in recording nature than in searching for a solidity and unity of form in nature, an inherent order that he saw with his painter's eye. To Cézanne, geometry served as the basis for all forms, including those in the landscape. He sought to discover the forms of geometric solids—the cone, the sphere, the cylinder—in nature and to record them in his paintings.

Absolute naturalism, a lifelike recording, is not the goal of Cézanne's expression. His purpose was to explore the landscape as a vehicle for the study of forms in space, much as he would study a group of objects on a table for a still life painting. Here he has reduced the vista of Mont Sainte-Victoire to a pattern of color patches, with individual brush strokes defining planes and surfaces. Details are generally obscured. One does not walk through this landscape or repose within it; one stands back and considers it as a perfect realization of form.

92. Paul Cézanne. *Mont Sainte-Victoire.*
1902–04. Oil on canvas, $27\frac{1}{2} \times 35\frac{1}{4}''$.
Philadelphia Museum of Art
(George W. Elkins Collection).

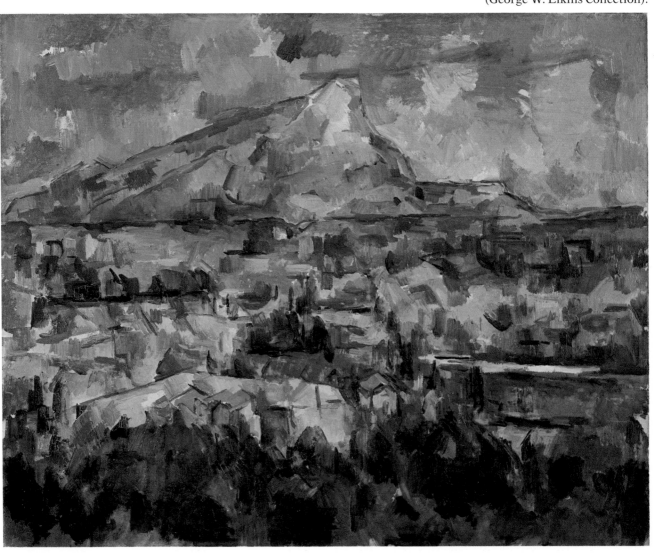

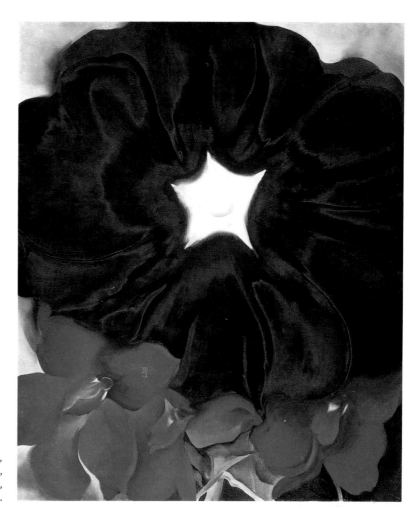

93. Georgia O'Keeffe. *Black Hollyhock,
Blue Larkspur.* 1929. Oil on canvas,
36 × 30". Metropolitan Museum of Art,
New York (George A. Hearn Fund, 1934).

Finally, we turn to an artist who, rather than viewing nature from a distance, zooms in on it as tightly as possible. The paintings of Georgia O'Keeffe, such as *Black Hollyhock, Blue Larkspur* (**93**), are extreme close-ups, almost to the point of abstraction. O'Keeffe examines every nuance of the form minutely, as though a whole universe were unfolding within the flower. Much has been made of the apparent sexual symbolism in these paintings, and, although the artist denied it, there is an elemental quality in the flower's lush opening.

So far we have considered artists who look primarily to the outside for their inspiration. Our final thematic category focuses on artists who turn inward, to their own brains and psyches, for the genesis of their art.

Imagination and Fantasy

The purposes of imaginative art are as complex and as individual as imagination itself. An artist may look inward and paint what he or she sees in an attempt to understand this inner life, to purge it of its terrors, or simply because the products of the imagination seem more interesting than the realities of every day. We may be tempted to think of imaginative art as a purely 20th-century phenomenon, a product of the Freudian era or even of the "me generation." Looking closely at one's dreams and fantasies—and then recording them as art—does indeed seem to be a peculiarly modern preoccupation. Nevertheless, we can trace imaginative art back at least to the 16th century, where it flourished in the hands of the extraordinary Netherlandish artist Hieronymus Bosch.

Georgia O'Keeffe
1887–1986

"At last! A woman on paper!" According to legend, this was the reaction of the famed photographer and art dealer Alfred Stieglitz, in 1916, when he first saw the work of Georgia O'Keeffe. Whether accurate or not, the quote sums up Stieglitz' view of O'Keeffe as the first great artist to bring to her work the true essence and experience of womanhood. Ultimately, much of the critical art world came to share Stieglitz' opinion.

O'Keeffe was born on a farm in Wisconsin. She received a thorough, if conventional, art training at the School of the Art Institute of Chicago and the Art Students League in New York. During the early years she supported herself by teaching art in schools and colleges. By 1912 she was teaching in Amarillo, Texas—the beginning of a lifelong infatuation with the terrain of the Southwest.

In the winter of 1915–16 O'Keeffe sent a number of drawings to a friend in New York, asking her not to show the drawings to anyone. The friend violated this trust—and no doubt helped to set the path for O'Keeffe's entire life and career. She took the drawings to Stieglitz.

By 1916 Stieglitz had gained considerable fame, not only as a photographer but, through his "291" Gallery, as an exhibitor of the most innovative European and American painters. He was stunned by O'Keeffe's work. Later that year he included her in a group show at "291," and in 1917 gave her a solo exhibition. This was the beginning of an extraordinary artistic and personal collaboration that would last until Stieglitz' death in 1946.

O'Keeffe moved to New York. Stieglitz left his wife and lived with her. O'Keeffe painted; Stieglitz exhibited her work and made hundreds of photographs of her. The couple married in 1924, but their union was always an unconventional one. For more than a quarter-century their paths crossed and separated. Stieglitz was most at home in New York City and at his family's summer place at Lake George. O'Keeffe was drawn increasingly to the stark landscapes of Texas and New Mexico. O'Keeffe treasured her husband's presence but could paint at her best only in the Southwest. Stieglitz longed for her company but also needed and wanted her paintings for his gallery.

O'Keeffe gained critical acclaim with her first exhibition, and it never entirely left her. Although major showings of her work were rare after Stieglitz died, no one forgot Georgia O'Keeffe. She was part of no "school" or style. Her work took an exceptionally personal path, as did her life. She dressed almost exclusively in black. She came and went as she pleased and accepted into her world only those people whom she found talented and interesting. More than most, O'Keeffe marched to her own drummer.

After 1949 O'Keeffe lived permanently in New Mexico, the area with which she is most closely associated. In 1972, when she was eighty-four years old, a potter in his twenties, Juan Hamilton, came into her life, and they became close companions. Rumors that they married are probably unfounded, but Hamilton remained with the increasingly feeble, almost-blind artist until her death.

Early on, in her thirties, O'Keeffe had expressed her impatience with other people's standards for life and art: "I decided I was a very stupid fool not to at least paint as I wanted to and say what I wanted to when I painted as that seemed to be the only thing I could do that didn't concern anybody but myself—that was nobody's business but my own."[7]

Alfred Stieglitz. *Georgia O'Keeffe.* 1932. Photograph. Metropolitan Museum of Art, New York (Alfred Stieglitz Collection, lent by Georgia O'Keeffe).

When we first encounter *The Garden of Earthly Delights* (**94**), we might think we have wandered into a fun house of a particularly macabre kind. Bosch's large *triptych* (a three-section panel, of which we show only the middle portion) is like a peep into Hell—but this is an X-rated earthly Hell. Hundreds of nude human figures cavort in a fantasy landscape peopled also by giant plants, animals no biologist ever classified, and strange creatures that are part human, part vegetation. Humans ride upon, emerge from, are devoured by, or become part of the plant and animal forms. It is as though Bosch has let his imagination and perhaps his dream imagery go wherever it might. Bosch drew upon many sources for his creations, including folklore, literature, astrology, and religious writings, but only his own inventiveness could have constructed an amazing fantasy land like this one.

Artists who deal in the realm of the imagination are often quite interesting as personalities. This was true of Bosch, and it was true also of an English artist/ poet who worked during the late 18th and early 19th centuries. William Blake was, by the standards of his time and most others, a thoroughgoing eccentric. He was foremost a poet and will be remembered by generations of college literature students for the lines "Tyger, tyger, burning bright/In the forests of the night." Much of Blake's production as an artist involved the illustration of books, not only of his own volumes of poetry but also of the Bible, Shakespeare, and Dante. In these he expressed a kind of personal theology, which he claimed had been

94. Hieronymus Bosch.
The Garden of Earthly Delights, center section.
c. 1505–10.
Panel, 7'2⅝" × 6'4¾".
Prado, Madrid.

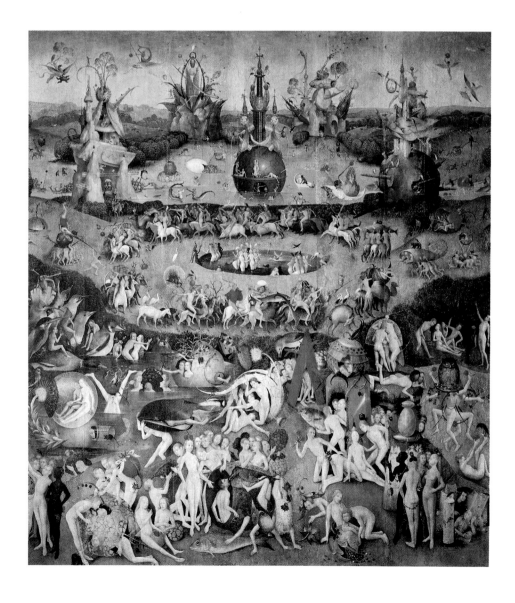

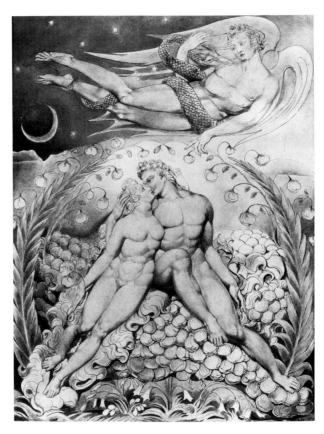

95. William Blake.
*Satan Watching the Caresses
of Adam and Eve,*
illustration for *Paradise Lost.*
1808. Pen and watercolor
on paper, 19⅞ × 15".
Museum of Fine Arts, Boston
(gift by subscription, 1890).

revealed to him in visions of God, Christ, various angels, and certain notable personages from history.

Typical is his *Satan Watching the Caresses of Adam and Eve* (**95**), an illustration for John Milton's epic poem, *Paradise Lost.* The scene depicted does not appear in the Scripture, nor in Milton's poetic version of the fall from grace of Adam and Eve. According to standard Christian doctrine, Adam and Eve were innocent and free of carnal desire before eating the forbidden fruit. William Blake, however, had other ideas, and he followed his own theological and sexual interpretation in this work. Years later, in discussing the illustration, he insisted: "I saw Milton in imagination, and he told me to beware of being misled by his *Paradise Lost.* In particular he wished me to shew the falsehood of his doctrine that the pleasure of sex arose from the Fall. The Fall could not produce any pleasure."[8]

96. Salvador Dali.
The Temptation of St. Anthony.
1947. Oil on canvas, 35¼ × 47".
Musées Royaux des Beaux-Arts
de Belgique, Brussels.

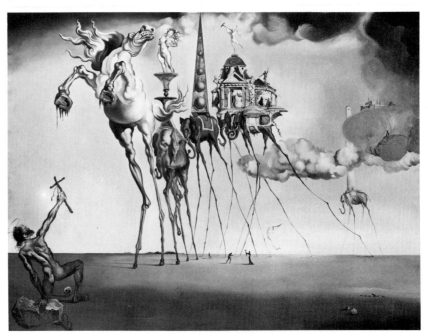

Blake's picture, therefore, shows the first couple, still not having touched the apple, still in the Garden of Eden, engaged in a decidedly erotic pursuit. They are enveloped in a lush circle of fantasy foilage, and their bodies are muscular and full-fleshed in the manner of Dürer or Michelangelo, both of whose works were known to the artist. Floating above the pair is the figure of Satan—part angel (it must be remembered that Satan was the fallen angel Lucifer) and part serpent. Soon afterward, Satan, in the guise of a serpent, will tempt Eve to eat the apple, resulting in banishment from the Garden of Eden. Blake's Satan looks down upon the lovers with something rather like jealousy, which gives new meaning to the story of the temptation. The artist's imagery comes not from the Bible, not from Milton, but from his own imagination.

Imaginative treatment of a religious subject also appears in the work of the 20th-century Spanish artist Salvador Dali. In *The Temptation of St. Anthony* (**96**) Dali addresses a subject that had been popular throughout the Middle Ages and early Renaissance. The story concerns efforts by the holy man, St. Anthony, to fend off temptations of the flesh that tormented him in his thoughts and dreams. Earlier representations showed the saint being assailed by all manner of hellish demons and often being lured by a lustful woman or women. Dali has perhaps come closer to the truth by reinterpreting the temptation as a dream/nightmare landscape.

Dali's art, often identified as *Surrealism* (Chapter 17), is predominantly an art of the unconscious. The artist explored his own dreams, studied case histories of psychotic individuals, and even toyed with waking hallucinations, which he claimed he could summon on command. In *The Temptation* St. Anthony appears as a gaunt figure, besieged yet strong, holding off a nightmare parade of fantastic creatures stalking across an endless plain on giant insect-legs. Dali's demons are not actual monsters from Hell, but the demons of the mind.

Another 20th-century artist who explored the mysteries of the mind was the Russian-born painter Marc Chagall. In his most famous work, *I and the Village* (**97**), Chagall interweaves many diverse memory images from his childhood to evoke a warm and happy picture of village life. At right we see a green-faced

97. Marc Chagall. *I and the Village.* 1911.
Oil on canvas, 6'3½" × 4'11½".
Museum of Modern Art, New York
(Mrs. Simon Guggenheim Fund).

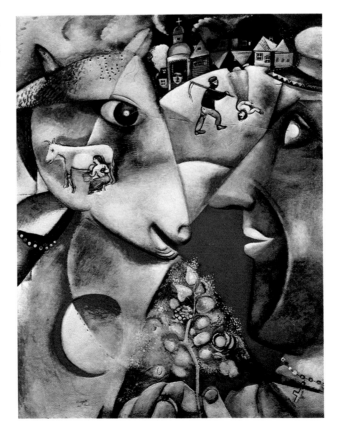

young man, at left a transparent cow through which is visible a milkmaid tending another cow. A farmer carrying a scythe strides toward an upside-down peasant woman against a background of colorful Russian provincial architecture. All conventions of realistic color, size, and placement have been abandoned in favor of an inner reality—the reality of the mind. Chagall chooses and arranges his elements according to their importance for him, his private associations, and the structural needs of the painting as he conceives it.

These, then, are some of the recurring themes in art and a few of the purposes various types of art have served. In the chapters that follow we shall consider works of art from other points of view; but it will be useful to keep in mind that each of them, while it is analyzed for its medium or its place in history, also is part of a basic theme—one of those discussed here or possibly another that you can identify.

part two
THE VOCABULARY OF ART

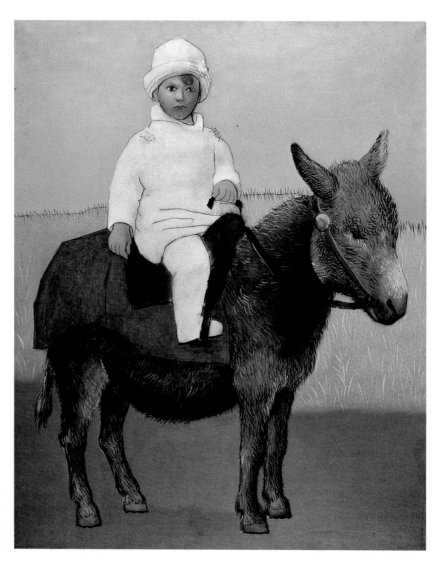

98. Pablo Picasso.
Paulo on a Donkey. 1923.
Oil on canvas, $39\frac{3}{8} \times 31\frac{7}{8}''$.
Collection Bernard Picasso,
Paris.

4
The Visual Elements

*I*f somebody asked you what you see in our first illustration (**98**), you might say something like "a picture of a little boy on a donkey." You know it isn't a real little boy or a real donkey, but a representation in paint on canvas. This is a painting by Pablo Picasso of his own small son Paulo.

Now look closer and observe how the painting is constructed. You will see that Picasso has used *lines* to draw around the boy's head and figure, to show the hairs on the donkey's body, to suggest blades of grass in the background. He has created the *shapes* of a boy and a donkey and differentiated them from the open *space* of the sky and earth. The animal's body has a rough *texture*, similar to the texture of the grass but contrasted with the smoother texture of the boy's outfit. The painting is full of *light*, which illuminates this daytime scene. Picasso has used a range of *colors*—white for the boy's costume, gray-black for the donkey, rust for the donkey's blanket, blue for the sky—and a range of *values* from light in the clothing to dark in the donkey.

These seven things Picasso used to construct his picture—line, shape, texture, light, value, color, and space—are the ingredients an artist has available in making any work of art. They are called the *visual elements*. (As we shall see, some works of art also depend on time and motion, so these two are sometimes added to the list.) No matter what kind of art, no matter where or when it was made, the character of these elements, and how they are organized, determine what the work of art will be like.

In this chapter we shall look closely at the visual elements—what they are, how they are used, and how they affect a work of art. Chapter 5 deals with organization of these elements according to the principles of design.

Line

By conventional definition, a line is the path left by a moving point. You put down your pencil on a sheet of paper and *move* its point across the paper to make a line. We can also think of line as an extended mark. Line is so basic to art that it is difficult to conceive of any work of art *not* having lines.

When you sit down to write a letter or an examination paper or a note to yourself, you are making lines, whether you think of it that way or not. The letters of the alphabet are lines, and they are also symbols of sounds. Artists, too, use lines as symbols. In Picasso's painting of Paulo, the oval line around Paulo's

face is a symbol. People don't actually have lines around their faces; people's faces are composed of flesh and bone. At the point where flesh meets space, our eyes see an imaginary line, so Picasso has drawn that line in his painting to symbolize "face." This task of symbolically outlining form is only one of the many functions line performs in a work of art.

FUNCTIONS OF LINE

Outline and Form In Ellsworth Kelly's drawing *Apples* (**99**) a thin, elegant line describes the shape of the fruit. This is called an *outline drawing*. There is no shading, no interior detail, and no background. By this amazingly economical line Kelly convinces us that we see a group of rounded apples resting on an invisible surface. As in Picasso's painting, the line creates a boundary. It marks the point where the apples stop and the surrounding area begins. This function of line as outline is extremely important to art.

Whereas Kelly uses line to create the illusion of three-dimensional form, Alexander Calder, in *The Hostess* (**100**), uses line to create a form that is actually three-dimensional. This witty little sculpture consists of a few pieces of wire welded and twisted together—the wire drawing lines in space. Somehow, Calder makes these few thin lines suggest a very proper society matron ready to entertain guests. Details drawn in line are the key to this sculpture—the curls of the hair, the long nose, the lorgnette poised in one hand, the high heels. We imagine this figure walking along in jerky little steps. Line alone, when used by a master like Calder, has the power to convey a whole character.

Movement and Emphasis Line often implies movement, and this is another of its functions. Every line goes somewhere, and the viewer's eye naturally follows it. Frank Stella's *Itata* (**101**) uses line to reinforce the unusual shape of the canvas and to enhance the sense of movement. The lines draw our eyes across, down,

below: **99.** Ellsworth Kelly. *Apples*. 1949.
Pencil, $17\frac{1}{8} \times 22\frac{1}{8}''$. Museum of Modern Art, New York
(gift of John S. Newberry).

right: **100.** Alexander Calder. *The Hostess*. 1928.
Wire, height $11\frac{1}{2}''$. Museum of Modern Art, New York
(gift of Edward M. M. Warburg).

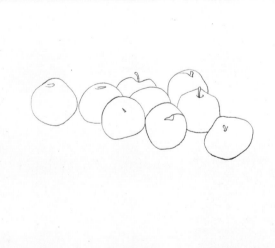

101. Frank Stella. *Itata.* 1964.
Metallic powder and polymer emulsion
on canvas, 6'5" × 10'2".
Courtesy Leo Castelli Gallery, New York.

and across; and because we expect lines to be continuous, we tend to follow the lines even beyond the composition to an imaginary space outside.

Line also plays a role in creating emphasis in a work of art. In Paul Cézanne's painting *The Great Bathers* (**102**), diagonal lines of trees bend inward to form a triangle in the center of the canvas. The figures lean in such a way as to echo the diagonal line. By means of this triangle Cézanne focuses attention on the main figures at the bottom center of the composition. His diagonal lines create a frame-within-a-frame, so we concentrate on forms within the triangle.

Pattern and Texture Yet another function of line in art is the creation of pattern and texture. We saw the latter in Picasso's painting (**98**), where closely spaced short lines suggest the texture of animal hair and grass. Saul Steinberg has used

102. Paul Cézanne.
The Great Bathers. 1898–1905.
Oil on canvas, 6'11" × 8'2".
Philadelphia Museum of Art
(purchase;
the W. P. Wilstach Collection).

103. Saul Steinberg. *Hen*. 1945.
Pen, brush, and India ink;
$14\frac{1}{2} \times 23\frac{1}{8}''$.
Museum of Modern Art,
New York (purchase).

line to great effect in creating the ornate texture of chicken feathers in his ink drawing *Hen* (**103**). Repeated, interwoven squiggly lines, drawn in a decorative pattern, suggest a fabulous plumage that any bird would be proud of. The face and feet of the hen seem almost an afterthought to this rich display of texture. Later in the chapter (p. 124) we will consider pattern and texture in more detail.

Shading and Modeling One very important function of line, especially in drawing and printmaking, is the creation of shaded effects. Shading is natural to some media, like pencil; the artist can simply use the side of the pencil instead of the point. But with a more "linear" medium, such as pen and ink, this is not possible. Instead the artist will create shaded effects by means of closely spaced short lines (**104**). There are three basic techniques. *Hatching* is an area of closely spaced parallel lines. *Cross-hatching* is similar except that the parallel lines intersect like a narrow checkerboard. *Stippling* means that the lines are reduced to dots and spaced closer together or farther apart as desired.

Often, the goal of shading is to *model*, or to create the illusion of roundness, of three-dimensionality on a flat surface. We can see this in Michelangelo's *Head of a Satyr* (**105**). Michelangelo has drawn some areas of hatching, especially in the hair at the right side of the drawing, but most of the modeling is accomplished by

104. Line techniques to create modeling: hatching, cross-hatching, and stippling.

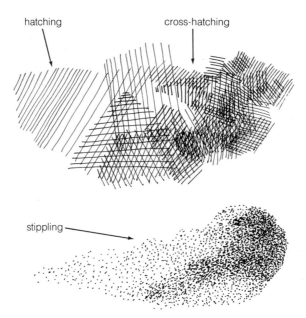

hatching

cross-hatching

stippling

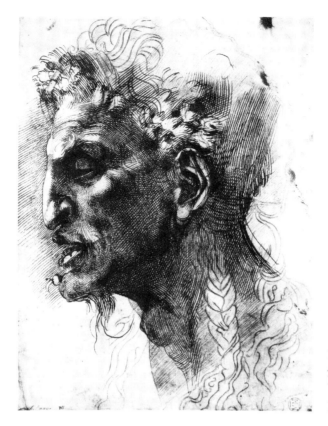

105. Michelangelo.
Head of a Satyr.
Pen and ink over chalk,
$10\frac{5}{8} \times 7\frac{7}{8}''$.
Louvre, Paris.

cross-hatching. Areas we are meant to perceive as hollows, or depressions in the face, have the densest cross-hatching: the socket of the eye, the back of the nostril, the jawline below the ear, and so forth. Conversely, where we are meant to see a raised area, such as the cheekbone, there is no cross-hatching at all. (If you put your finger over the highlight of the cheekbone, you will see that the face seems much flatter.) By the skillful use of line Michelangelo has persuaded us that the head is three-dimensional.

TYPES OF LINES

The preceding sections have dealt primarily with actual lines—visible marks made in pencil or paint or some other medium. In studying art, however, we often have to take into account other types of lines (**106**). Actual lines are the most familiar, so we begin with them.

106. Actual line **(a)**,
implied lines **(b, c)**,
and line created by edge **(d)**.

Raphael
1483–1520

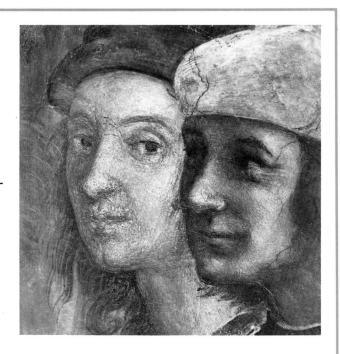

According to the 16th-century biographer Giorgio Vasari, we find in Raphael "an artist as talented as he was gracious," possessed of unbounded "grace, industry, looks, modesty, and excellence of character." Whereas both Michelangelo and Leonardo da Vinci emerge as rather moody, solitary figures, their younger colleague seems to have been the sort of person who charms everybody and to whom success comes as naturally as breathing.

Born in the town of Urbino, Raffaello Sanzio received his first art training from his father, then later became an assistant to the early Renaissance master Pietro Perugino. At twenty-one Raphael struck out on his own, but he continued to study avidly the work of other artists—including Leonardo and Michelangelo, both of whom influenced him greatly. (Vasari claims that Raphael was secretly let into the locked Sistine Chapel when Michelangelo had temporarily stopped work on the ceiling frescoes so that he could get an advance look at the figures.)

Raphael established his reputation early and throughout his career never lacked for patrons. A major preoccupation was the madonna and child group, of which he made numerous versions. In 1508 Pope Julius II called Raphael to Rome, where the artist began the decoration in fresco of four rooms in the Vatican. Among these frescoes was the famous *School of Athens* (**230**).

By his early thirties Raphael had become a busy person indeed, testing his artistic skills in many areas. Increasingly, the work of carrying out his commissions was delegated to assistants. He had been named chief architect of Saint Peter's Basilica in the Vatican and was also director of excavations for ancient Greek and Roman art in and around the city of Rome. On commission from Pope Leo, Julius' successor, Raphael designed ten huge tapestries for the Sistine Chapel and perhaps executed the cartoons (drawings to guide the weavers) himself, although this point is in dispute.

Raphael's private life seems to have been as full and satisfying as his artistic career. At home in any social situation, sought after as a friend, he played as energetically as he worked. He never married—possibly because he hoped to be made a cardinal of the Church—but he lived for many years with the same woman. The biographer Vasari refers to "secret love affairs" and comments that the artist "pursued his pleasures with no sense of moderation." If we are to believe Vasari, Raphael's death at the tragically premature age of thirty-seven came as the aftermath of such lack of moderation, which brought on a "violent fever" made fatal by unwise medical attention.

Among Raphael's great talents was the ability to please his patrons while at the same time fulfilling his own ideals of art. In about 1514 he wrote this to a noble client: "I should consider myself a great master if [a drawing of Galatea] had half the merits you mention in your letter. However, I perceive in your words the love that you bear me; . . . I am making use of a certain idea which comes into my mind. Whether it is possessed of any artistic excellence I do not know. But I do strive to attain it."[1]

Raphael. *School of Athens,*
detail with presumed self-portrait (**left**). 1510–11.
Fresco. Stanza della Segnatura, Vatican, Rome.

107. Robert Motherwell.
Procession, with Oil. 1981.
Oil and acrylic on canvas, 5'6" × 7'6".
Collection Takami Takahashi.

Actual Lines Actual lines are obvious in Robert Motherwell's *Procession, with Oil* (**107**); in fact, they are the dominant element in the composition. Bold, thick, black lines are arranged in such a way that they resemble Oriental calligraphy—the art of "beautiful writing." The sheer size of the painting (it is more than 5 by 7 feet) gives the lines tremendous force. This work is totally nonobjective, or free of any visual reference to the natural world. Its interest lies in the interplay between black lines and space, the dynamic shapes created between the lines, and—above all—the energy implicit in the powerful lines. We imagine Motherwell drawing the lines with a sweeping arc of the whole arm.

Implied Lines When a person stops on a street corner and gazes upward, other passersby will also stop and look up, following the "line" of sight. When someone points a finger, we automatically follow the direction of the point. Artists often exploit this natural response by using implied lines in their work. In Raphael's painting *The Madonna of the Meadows* (**108**), implied lines of sight between the Virgin and the two children help to pull the composition together and direct the eyes of the viewer to the most important figure in the painting—the child Jesus (**109**). The Madonna casts her eyes downward toward John the Baptist, who, in

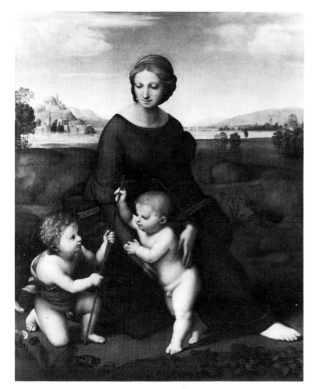

left: 108. Raphael. *The Madonna of the Meadows.*
1505. Oil on panel, 44½ × 34¼".
Kunsthistorisches Museum, Vienna.

below: 109. Line analysis of Raphael's
Madonna of the Meadows.

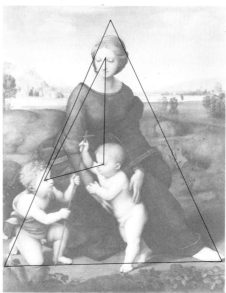

110. Claes Oldenburg.
Stake Hitch. 1984.
Painted epoxied aluminum,
urethane foam, polyester resin,
and fiberglass; height 39'.
Dallas Museum of Art
(commissioned to honor
John Dabney Murchison, Sr.,
for his arts and civic leadership
and presented by his family).

turn, gazes upward at the baby Jesus, establishing a triangular flow. As observers, we unconsciously follow these lines of sight around and through the painting, just as we would glance upward if we saw someone in the street staring up. Implied lines here give both coherence and a subtle sense of movement to the painting.

Lines Formed by Edges If you press the palms of your two hands flat together in a praying gesture, you will see that a "line" seems to form where they meet. There is no line, in reality, but the point where the edge of one form meets the edge of another form creates the impression of a line. This can happen in two-dimensional art as well, wherever one shape or color area meets another shape or color area. The line created by edge is evident in our next illustration—a sculpture by Claes Oldenburg in the Dallas Museum of Art (**110**). *Stake Hitch*, with its giant "rope" stretched from floor to ceiling, is actually a three-dimensional form, but in contrast to the light-colored background we perceive a wavy, scalloped line on either side of the rope. The edges of buildings, of sculptures, of any shapes isolated against a plain background fool the eye into seeing lines where none exist.

Let's return again to Picasso's painting of Paulo (**98**). The line of the child's chin and cheeks would have been an edge line in real life, the sense of a line formed by the juncture of face and background. Picasso turned an imaginary line into an actual line for the painting.

CHARACTERISTICS OF LINES

When someone mentions the word "house," everyone who hears it forms a different mental image. Listeners might picture anything from a small cabin in the woods to Buckingham Palace, depending on their frame of reference. So it is with line. Line is such a broad term that it can encompass everything from Motherwell's huge black strokes to the delicate pencil marks of Kelly's *Apples* (**99**). The characteristics of any given line have much to do with how that line performs in a work of art. Two important characteristics are direction and linear quality.

Direction Most of us have instinctive reactions to the direction of line, which are related to our experience of gravity. Flat, horizontal lines seem placid, like the horizon line or a body in repose. Vertical lines, like those of an upright body or a skyscraper jutting up from the ground, may have an assertive quality; they defy

gravity in their upward thrust. But the most dynamic lines are the diagonals, which almost always imply action. Think of a runner hurtling down the track or a skier down the slope. The body leans forward, so that only the forward motion keeps it from toppling over. Diagonal lines in art have the same effect. We sense motion because the lines are unstable; we half expect them to topple over. (One exception is the diagonal line that makes up part of a triangle or pyramid, as in Cézanne's painting [102]; such lines are very stable because the triangle form is closed and solid.) To see how linear direction works, let us compare two paintings that both show a boat in the water.

In Thomas Eakins' *The Biglen Brothers Racing* (111) nearly all the lines are horizontals. The two boats, the shoreline, the ripples on the river, the treetops, even the clouds scuttling across the sky are horizontal. Only the diagonal lines of the oars and rowers' arms and bodies suggest that this is a race. Why should a race be so placid? Eakins has captured the essence of sculling, races involving flat, long-oared boats powered by one or two rowers. Usually done on calm bodies of water, sculling has an odd, streamlined quality in the way the boats knife through the still water. The only apparent motion is in the bodies of the rowers, whose brisk, automaton movements in tandem make them seem, from a distance, like little mechanical toys. Eakins, therefore, has given his painting an overall serenity, broken only by the diagonals of the men.

A diagram will help to show the great differences in linear direction, and thus in emotional effect, between Eakins' work and our next illustration (112).

111. Thomas Eakins.
The Biglen Brothers Racing. 1873.
Oil on canvas, 24$\frac{1}{8}$ × 36$\frac{1}{8}$".
National Gallery of Art,
Washington, D.C.
(gift of **Mr. & Mrs.** Cornelius
Vanderbilt Whitney, 1953).

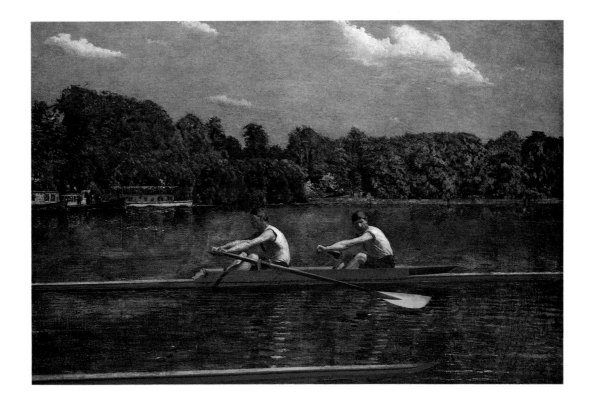

a b

112. Line analyses of Eakins'
The Biglen Brothers Racing **(a)**
and Gericault's *The Raft of the Medusa* **(b).**

Serenity was the last thing Théodore Géricault wanted for his painting *The Raft of the Medusa* (**113**). Géricault's work is based on an actual event—the wreck of the French government ship *Medusa* off North Africa in 1816. Only a few of those on board survived, some by clinging to a raft. The artist has chosen to depict the dramatic moment when those on the raft sighted a rescue ship. Virtually all the lines in the composition—the men straining forward, the arc of the sail, the bodies of the dead and dying in the foreground—are diagonal. Their thrust reinforces the sense of a desperate situation as the raft plunges toward safety. And all these exciting diagonals build toward the climax of the one vertical—the man signaling to the rescue ship. The artist's use of line direction may be overt or subtle, but we can rarely fail to respond to it.

Linear Quality As with direction, the artist's use of linear quality does much to influence the overall impact of the work, including the viewer's emotional response. Lines can be any length, thick or thin or tapered, straight or curved or angular. For example, we might compare the linear quality in three works reproduced here.

A drawing by Vincent van Gogh, *Cypresses with Two Women* (**114**), consists almost entirely of short, wavy, flamelike lines—a style characteristic of Van Gogh's later drawings. The cypress trees seem to be in undulating motion, their leaves perhaps shivering in the wind, and this movement is differentiated from the more stable foreground foliage defined in curling lines.

Henri Matisse's lithograph has a very different subject—the curve of a woman's back (**115**). The artist has employed a long, elegant, gently curving line to convey the sensual, ripe quality of the form. So delicate is the line that in places it disappears altogether, leaving a space—and an implied line to connect the two sections.

How different is the linear quality of the lines in Eugène Delacroix's drawing (**116**). The lines in *Study for the Death of Sardanapalus* swoop and swirl with tremendous energy. Just by looking at these turbulent lines we know that Delacroix made them swiftly, not with studied deliberation. The emotional tumult all but leaps out of the boundaries of the paper, carrying the viewer along with it.

113. Théodore Géricault.
The Raft of the Medusa. 1818–19.
Oil on canvas, 16'1¾" × 23'9".
Louvre, Paris.

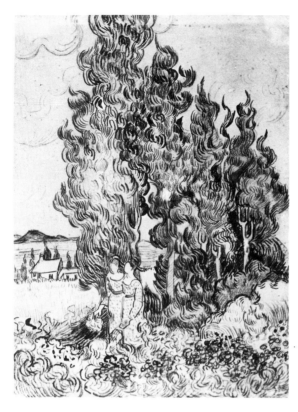

This brief discussion of linear quality ends our discussion of line. We turn next to a second vital element in art—shape, and its three-dimensional counterpart, mass. However, it must be remembered here and throughout the chapter that all the elements are interdependent and affect each other continually. The quality of line, for example, will influence the quality of a shape it produces.

Shape and Mass

A *shape* is a two-dimensional area with identifiable boundaries. A *mass* is a three-dimensional solid with identifiable boundaries. These definitions are correct as far as they go, and they will make sense to anyone who has studied geometry. Circles and squares are shapes; spheres and cubes are masses. So far, so good. Confusion arises, however, when we try to move beyond these bare-bones

statements, and for two reasons. First, there is little consistency in the way the terms are used in everyday conversation; people are just as likely to call a three-dimensional object a "shape." Second, there are at least two other terms—*form* and *volume*—that have similar meanings and overlap the first two. Consulting a dictionary will not help to dispel the confusion, because you will find these words defining each other. For example:

mass A three-dimensional *shape* or *volume* . . .

shape The flat character of a *form* . . .

form The *shape* of a thing or person; three-dimensional quality or *volume* . . .

volume A *mass* or quantity . . .

Is it any wonder few people can agree on how to apply the terms? In this section we will try to provide workable definitions that will serve for analysis of the art elements. Soon you will learn to understand the words as they appear in context, in this book and in other situations.

A *shape* is a two-dimensional area. Shapes are created by lines, by color areas, by contrasting textures, or by some combination of these. If the artist draws a circle and colors it red inside the line, the result is a round red shape. Even if there is no line, just a roundish daub of red paint, we still perceive a circular red shape set off from the surrounding space by its red edges.

A *mass* is a three-dimensional solid. It has actual depth in space. An orange is a piece of fruit, and it is also a spherical orange mass. Sometimes the word "mass" implies bulk, density, and weight. We might speak of the mass of a heavy paperweight or the mass of a natural rock formation.

Volume may be synonymous with mass, except that volume can also refer to a void, an empty but enclosed space, whereas mass usually refers to a solid.

117. Piet Mondrian. *Composition with Red, Yellow, and Blue.* 1928. Oil on canvas, $4'\frac{3}{4}'' \times 2'7\frac{1}{2}''$. Collection Stefan Edlis, Chicago.

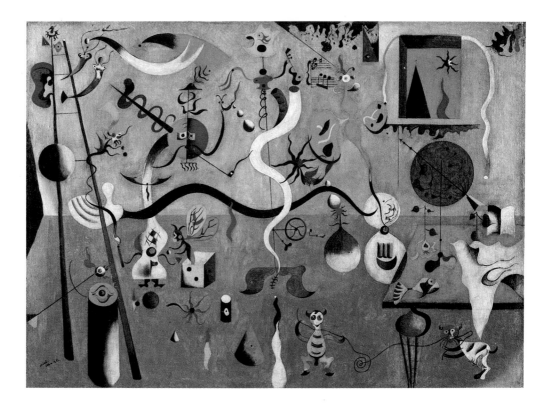

118. Joan Miró.
Carnival of Harlequin. 1924–25.
Oil on canvas, 26 × 36⅜".
Albright-Knox Art Gallery,
Buffalo, N.Y.
(Room of Contemporary Art
Fund, 1976).

For example, we might refer to the mass of the Rock of Gibraltar (we might also refer to its volume), but inside a large building, such as the Guggenheim Museum (**141**), we would talk about the volume enclosed and created by the structure.

Form is the trickiest term of all, because it has so many meanings. It can mean shape or mass. As mentioned in Chapter 2, it can refer generally to the way a work of art looks or the way it is put together. It can also mean composition or structure or even style.

For this discussion of the art elements we have chosen to focus on the terms "shape" and "mass." These two have the most easily restricted definitions and lend themselves more readily to analysis.

Shape on a two-dimensional surface may give the *illusion* of mass. In Picasso's painting (**98**) we see the flat shape of a boy on a donkey, drawn so as to create the illusion of roundness. A real boy on a real donkey—or a sculpture of them—would be an actual mass.

It is customary to distinguish two broad categories in both shapes and masses: organic and geometric. Geometric shapes, based on the mechanically drawn line, include the square, the rectangle, the circle, and the triangle. Organic shapes are based on the forms in nature, which are usually rounded, irregular, and curving. Many works of art combine these two categories, but often one or the other will predominate.

One artist who devoted a career to exploring the potential of geometric shape was the Dutch painter Piet Mondrian (**117**). Mondrian's *Composition with Red, Yellow, and Blue* is typical of his mature work and represents the artist's search for what he called a "pure reality." Mondrian felt that certain things are universal, common to all people—the rectangle, the vertical and horizontal, the primary colors red, yellow, and blue, plus black and white. By these means he hoped to cut through cultural and emotional differences among people and make a visual statement that would be meaningful to all. Mondrian's canvases, apparently so simple, rest on the hair's-breadth balance of line, shape, and color. Shift one line, alter the dimensions of one rectangle, change one area of color, and the entire composition falls apart—that is the kind of dynamic equilibrium Mondrian achieved with geometric shapes.

Organic shapes prevail in Joan Miró's *Carnival of Harlequin* (**118**). This fantasy landscape is as warm with odd little creatures—animals and fish and insects and perhaps a snake or two—as well as nameless organic forms that participate in Miró's madcap carnival. Much of Miró's imagery suggests a very cheerful

119. M. C. Escher.
*Study of Regular Division
of the Plane with Horsemen.*
1946. India ink and watercolor.
Escher Foundation,
Gemeentemuseum, The Hague.

sexuality, as though the whole space of the world were occupied with light-hearted erotic play and reproduction. To achieve this effect the artist employed mostly organic shapes, except for the mysterious square, circle, and triangle at upper right.

Before we complete our discussion of two-dimensional shape, we should touch upon one more aspect of it, and that is the concept of positive/negative shape, sometimes called *figure-ground relationship.* A painting or other work of two-dimensional art usually has one or more shapes meant to be perceived as positive. In a representational work, they are the shapes of the subject; in a nonrepresentational work, they are the shapes that seem active or dominant. For instance, in Picasso's painting of Paulo, the little boy and the donkey are positive shapes, or figure. Everything else is negative shape, or background. If you compare this to a work by M. C. Escher (**119**), you will find it hard to decide which are the positive shapes and which are the negative ones. Focus your eyes on the dark figures, and the light ones become ground; focus on the light ones, and the opposite is true. Escher meant this drawing to be a clever visual puzzle, but it makes an important point about art in general. Looking back at Motherwell's painting (**107**), maybe the white in this painting really is "figure" and the black lines are negative, or "ground." We don't usually think in these terms until an artist gives us figure and ground that can exchange roles, as Escher has done. What Escher's drawing emphasizes is that both positive and negative shapes are dynamic elements in art.

Three-dimensional mass also can be considered either geometric or organic. George Sugarman's *Yellow Spiral* (**120**) consists of a series of shallow, hollowed-out cubes (a geometric mass) arranged in a broken spiral. Although the plain shape of the cube can seem static, even boring, this work is full of movement. No single cube stands flat on its side; all are caught in a precarious teetering pose and dependent on their neighbors for stability. The sculpture seems particularly effective in contrast to the traditional equestrian statue in the background—an organic mass.

Perhaps no elements are more important to the visual impact of a work of art than shape and mass. When describing a work it is usually the shapes we talk about first. The next three elements, however, are also crucial, for they dramatically influence our response to art.

Light, Value, and Color

Light, value, and color are intimately connected elements. Color is a function of light and therefore directly dependent on its presence. Value, being a measure of relative lightness or darkness, plays a role in all our perceptions of light and color.

Apart from the purely sensory pleasure we derive from it, color helps to define shape and mass. For example, we notice that the *green* hills are set off against the *blue* sky. In a nonobjective painting color may be the only means by which we identify shapes and spaces. Color is also used by artists to convey emotion. Value defines shape when, for instance, we see a light shape against a dark background, and it too carries emotional impact. We speak of "dark, brooding" paintings or "light, airy" ones.

In this section we take up the subjects of light, value, and color insofar as they affect our response to art. All involve complex sciences, but only a little of the science is necessary to understand how these elements operate.

120. George Sugarman.
Yellow Spiral. 1970.
Metal, height c. 10′6″.
Installed in Rodney Square,
Wilmington, Del.

LIGHT

Actual Light In architecture and in sculptures meant to be exhibited outdoors we are particularly aware of the influence of natural light. The architect of an old cast-iron building in New York, photographed by Evelyn Hofer (**121**), probably

121. Evelyn Hofer.
*Cast-Iron Building, Broadway
and Broome Streets, New York.*
1965. Photograph.
Courtesy the photographer.

realized how important would be the play of light and shadow on its ornate façade. The photographer has seen this too and has captured a moment when patterns of light are especially dramatic. One could say that this photograph is "about" light, as light interacts with three-dimensional mass.

Dazzling natural light admitted by a glass roof is virtually the most important element in the great hall of Vancouver's courthouse (**122**). Reacting against the usual image of a courthouse as stuffy and claustrophobic, architect Arthur Erickson has "turned the traditional courthouse inside-out." Shadow patterns over the course of a day make a fascinating, ever-changing mosaic on the floors and throughout the interior. Erickson has welcomed light as an important part of his design, but any artist whose work will be exposed to natural light must take it into account.

The Illusion of Light Artists working in two-dimensional art—painting or drawing or prints, for instance—often wish to create the impression of light illuminating their subjects. This apparent light may be daylight evenly illuminating a scene or dappling the leaves in a landscape or the light cast by a lamp, candle, or fire. In some cases the supposed light source is included in the image, as when a painter depicts figures clustered around a lamp. At other times the light source is assumed to be outside the frame of the picture, but we see its effects clearly. A subject bathed in light from a definite angle, with the resultant shadows, may seem more lifelike and three-dimensional. (When light is general and comes from no specific source, figures tend to be flattened.)

We can see how light enhances the sense of depth in Thomas Eakins' painting *The Concert Singer* (**123**). This work shows the singer Weda Cook in a solo performance. The strong light coming from below and to her left is apparently from a footlight on the concert stage. Eakins obviously was intrigued with the effects of light on form. The lower part of the gown is the most brilliantly illuminated, while more than half the face remains in shadow. Light picks out folds in the dress, hollows in the singer's throat, the musculature of the arms—all of these details contributing to the roundness of the figure.

122. Arthur Erickson. Great Hall, Courthouse, Vancouver, B.C. Completed 1979.

VALUE

The term *value,* as we have said, means relative lightness or darkness, whether in color or in black and white. Values are perhaps easier to see in black and white than in color; we are accustomed to their effects in black-and-white television, photography, and reproductions, such as the ones in this book. When *The Concert Singer* is reproduced in black and white (**124**), the pale pink on the near side of the dress is seen as a very light gray, the singer's illuminated arm and cheek slightly darker grays, and so on, to the very dark grays that represent the shadows behind the singer and on her right side. Color values are translated into values of gray. In black-and-white, then, lacking the color cues we have in most situations, we rely to a large extent on contrasts of grays to help us distinguish one form from another.

For purposes of analysis, value is usually considered in terms of a value scale (**125**), ranging from white (the lightest) to black (the darkest), with several gradations in between. (The same value scale can be applied to colors, as we shall see.) Works of art in which light values predominate are called high-key, those in which dark values predominate low-key.

Value contrasts—contrasts of light and dark—may be used in a painting or drawing to create the effects of light and shadow in the natural world. This

left: 123. Thomas Eakins.
The Concert Singer. 1892.
Oil on canvas, 6′3⅛″ × 4′6¼″.
Philadelphia Museum of Art
(given by Mrs. Thomas Eakins
and Miss Mary A. Williams).

right: 124. *The Concert Singer*
reproduced in black and white,
to show gray values.

125. Value scale in gray.

| white | high light | light | low light | medium | high dark | dark | low dark | black |

126. Lorenzo di Credi.
Drapery for a Standing Man,
Represented Frontally.
Late 15th–early 16th century.
Brush and gray wash
on brown paper,
15¼ × 10⅝".
Louvre, Paris.

technique is called *chiaroscuro*, which literally means "light/dark." In Lorenzo di Credi's *Drapery for a Standing Man* (**126**) there is no explicit light source, such as a lamp or candle, yet the figure has clearly been modeled as though light were coming from somewhere beyond the man's right shoulder (our left as we look at the drawing). The lightest values are reserved for folds of drapery at the left side of the drawing and on the out-thrust knee. Much darker values appear in folds of drapery that are supposed to be in shadow. These contrasts and gradations of value give a sense of depth and three-dimensionality to the drapery study. In fact, one of the reasons why the head and torso seem so flat by comparison is that chiaroscuro is not used for this portion of the drawing. The figure seems linear; the drapery looks almost sculptural.

Lorenzo's drawing is primarily black-and-white. The effects of value, light, and contrast become even more complex when we add the ingredient of color.

COLOR

It is probably safe to say that none of the visual elements give us so much pleasure as color. You will understand this if you have ever been restricted to watching an old black-and-white television and then suddenly have access to a color set. For the same reason certain entrepreneurs have acquired the rights to classic films like *Casablanca*, and "colorized" them—applied color by painstaking computer methods to what was originally a black-and-white movie. The debate about whether this practice is acceptable, ethically and aesthetically, will continue for many years, but obviously the "colorizers" are hoping to tap a segment of the market that demands full color.

Various studies have demonstrated that color affects a wide range of psychological and physiological responses. Restaurants often are decorated in red, which is believed to increase appetite and therefore food consumption. A com-

mon treatment for premature babies born with potentially fatal jaundice is to bathe them in blue light, which, for reasons not fully understood, eliminates the need to transfuse their blood. Blue surroundings also will significantly lower a person's blood pressure, pulse, and respiration rate. In one experiment subjects were asked to identify, by taste, ordinary mashed potatoes colored bright green. Because of the disorienting color cues, they could not say what they were eating. And in one California detention center violent children are routinely placed in an 8-by-4-foot cell painted bubble-gum pink. The children relax, become calmer, and often fall asleep within ten minutes. This color has been dubbed "passive pink." The mechanism involved in all these color responses is still unclear, but there can be no doubt that color "works" on the human brain and body in powerful ways.

In this book you will find about 180 works of art reproduced in full color. This color does not exactly duplicate the colors you would see if you stood in front of the actual works, because mechanical reproduction on paper is never wholly accurate. But you will no doubt look at these color reproductions first—before the black-and-white pictures—and will look at them more often. Color always draws the eye.

At the beginning of this section we said that color is a function of light. Without light there can be no color. The principles of color theory explain why this is so.

Color Theory Much of our present-day color theory can be traced back to experiments made by Sir Isaac Newton, who is better known for his work with the laws of gravity. In 1666 Newton passed a ray of sunlight through a prism, a transparent glass form with nonparallel sides. He observed that the ray of sunlight broke up or *refracted* into different colors, which were arranged in the order of the colors of the rainbow (**127**). By setting up a second prism Newton found he could recombine the rainbow colors into white light, like the original sunlight. These experiments proved that colors are components of light.

In fact, all colors are dependent on light, and no object possesses color intrinsically. You may own a red shirt and a blue pen and a purple chair, but these items have no color in and of themselves. What we perceive as color is reflected light rays. When light strikes the red shirt, for example, the shirt absorbs all the color rays *except* the red ones, which are reflected, so your eye perceives red. The purple chair reflects the purple rays and absorbs all the others, and so on. Both the physiological activity of the human eye and the science of electromagnetic wavelengths take part in this process.

If we take the colors separated out by Newton's prism—red, orange, yellow, green, blue, and violet—add the transitional color red-violet (which does

127. Sketch of colors separated by a prism.

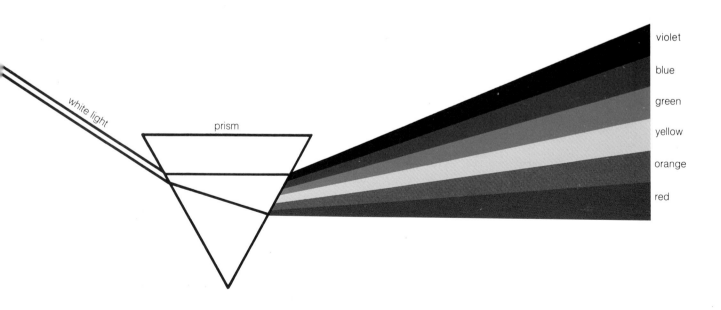

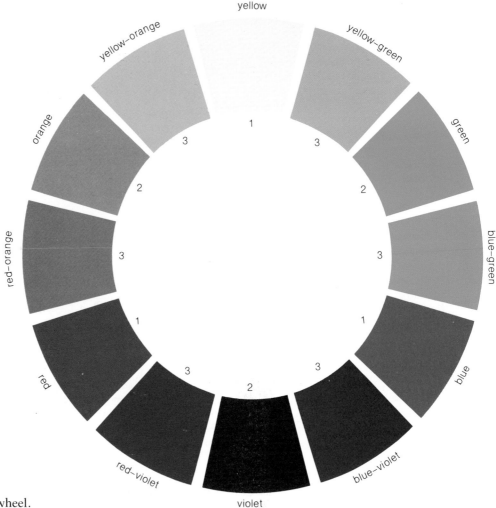

128. Color wheel.

not exist in the rainbow), and arrange these colors in a circle, we have a *color wheel* (**128**). Different theorists have constructed different color wheels, but the one shown here is fairly standard.

Primary colors—red, yellow, and blue—are labeled with the numeral *1* on the color wheel. They are called primary because (theoretically at least) they cannot be made by any mixture of other colors.

Secondary colors—orange, green, and violet—are labeled with the numeral *2*. Each is made by combining two primary colors. For most of us this information is not new. Even in kindergarten children working with poster paints learn to make green by mixing yellow and blue.

Tertiary colors, labeled number *3*, are the product of a primary color and an adjacent secondary color; mixing yellow with green yields yellow-green.

Complementary colors are those directly opposite one another on the color wheel. They are assumed to be as different from one another as possible. The relationship between complementary colors, as we shall see, is extremely important in such areas as the optical and emotional effects of color.

Color Properties Any color has three properties: hue, value, and intensity.

Hue is the name of the color—green or red or violet-blue. In any serious discussion of color it is important to avoid the poetic color names promoted by the fashion industry, such as "fuchsia" or "topaz." The hues listed on the color wheel and the designations on the color chart (**129**) are meant to be standard, so that people can agree on their meanings. "Peacock blue" could mean many things to many people, but "blue, high dark, ¾ intensity" is precise; you could pick the correct color out of a box of standard color chips.

Value, again, refers to relative lightness or darkness. Most colors are recognizable in a full range of values; for instance, we identify as "red" everything

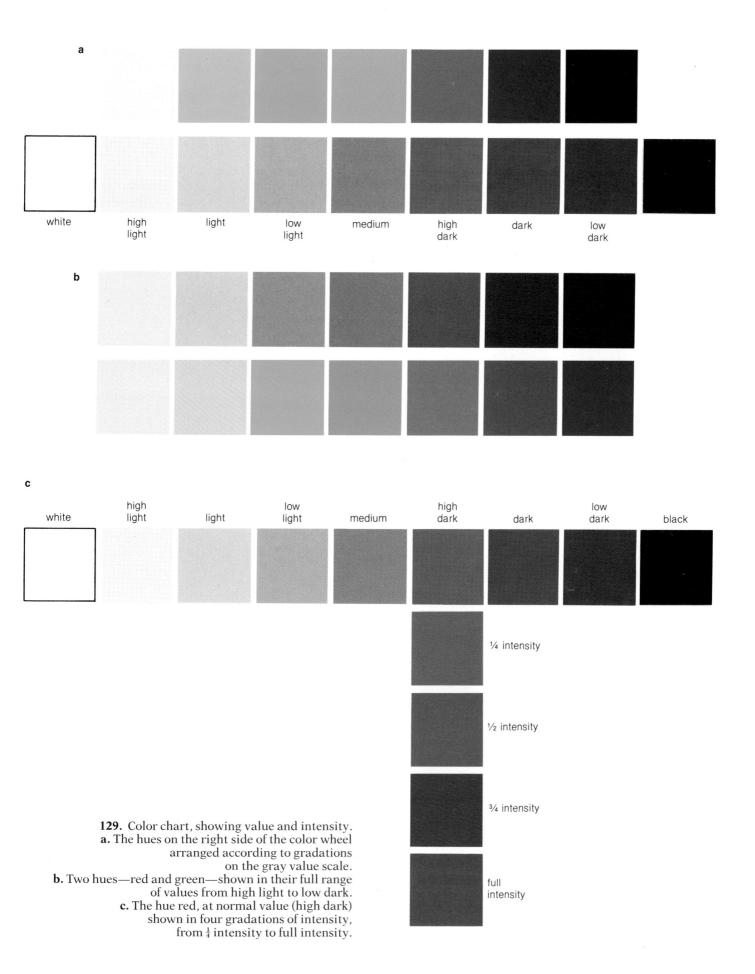

a

white · high light · light · low light · medium · high dark · dark · low dark

b

c

white · high light · light · low light · medium · high dark · dark · low dark · black

¼ intensity

½ intensity

¾ intensity

full intensity

129. Color chart, showing value and intensity.
a. The hues on the right side of the color wheel arranged according to gradations on the gray value scale.
b. Two hues—red and green—shown in their full range of values from high light to low dark.
c. The hue red, at normal value (high dark) shown in four gradations of intensity, from ¼ intensity to full intensity.

from palest pink to darkest maroon. In addition, all hues have what is known as a *normal value*—the value at which we expect to find that hue. We think of yellow as a "light" color and violet as a "dark" color, for example, even though each has a full range of values. The top section of the color chart (**129a**) shows the hues on the right side of the color wheel organized according to their normal values in relation to the gray value scale. We could do the same with the left half of the wheel, pairing yellow-orange with light, and so on. The middle section of the color chart (**129b**) shows a full range of values, from high light to low dark, for two hues: red and green.

A color lighter than the hue's normal value is known as a *tint;* for example, pink is a tint of red. A color darker than the hue's normal value is called a *shade;* maroon is a shade of red. (This terminology is specific to color theory and differs from everyday usage of the word "shade" to mean any variation of a color, as in, "My coat is a lovely shade of blue.")

Intensity—also called *chroma* or *saturation*—refers to the relative purity of a color. The difference between intensity and value can be a bit difficult to understand until you see how it works on the color chart (**129c**). Colors may be pure and saturated, as they appear on the color wheel, or they may be grayed and softened to some degree. The purest colors are said to have high intensity; grayer colors, lower intensity. In the color chart (**129c**) we show four intensity gradations of the hue red at normal value. We could construct the same intensity scale for any other hue. To lower the intensity of a color when mixing paints or dyes, the artist may add a combination of black and white (gray) or may add a little of the color's complement.

Light and Pigment Colors behave differently depending on whether the artist is working with light or with pigment. In light, as we said, white light is the sum of all colors. In other words, if you combine all colors, you will get white. This is not true for pigment—artists' colors or dyes. If you mix all these colors together, you will get a *neutral*—either black or an almost colorless brownish-gray.

Artists who work in light—including video artists, photographers, and filmmakers—need to master a complex technology of light/color dynamics. For instance, the image shown here (**130**) was made in a machine known as a color *quantizer*, which combines television imagery with sophisticated color technology. The operator begins by focusing a black-and-white camera on a subject, such as a person, and thus breaking up that subject into values of gray. Next, by manipulating dials on the quantizer, the operator can substitute colors for each of the values in the subject. The operator might decide, say, that all the high-dark values in the image (see value scale, **125**), should be replaced with orange. Often the colors in this type of imagery are *arbitrary*—unrelated to colors in the natural world. In effect, the artist is working with an "electronic palette,"

130. Joe L. Clark, Jr. *Waiting Angel.* 1982.
Video image created with quantizer
and photographed from the screen.
Courtesy the artist.

131. Titian. *Portrait of a Man.* Mid-16th century. Oil on canvas, 32 × 26″. National Gallery, London (reproduced by courtesy of the Trustees).

which allows him or her to choose from an infinite range of colors and combinations with just the twist of a dial. The colors can be tried, adjusted, rejected, retrieved, and recombined indefinitely. This is where video art gets its expressive and individual power; the machine does not control the artist, but rather the artist controls the machine. As we see in this illustration, the quantizer can also merge two or more images and vary their sizes—perhaps to attach a bird's wings to a full-grown human male.

Artists using real light usually select their colors mechanically, at a distance, by pushing buttons or choosing filters or adjusting dials. Their work requires a sophisticated knowledge of color science. By contrast, artists who work in pigments—watercolors or oil paints or similar media—usually blend their colors by trial and error, using their own hands. In both cases, familiarity with the color wheel and the color properties can help, as can understanding of the color harmonies.

Color Harmonies A color harmony, sometimes called a *color scheme,* is the selective use of two or more colors in a single composition. We tend to think of this especially in relation to interior design; you may say, for instance, "The color scheme in my kitchen is blue and green with touches of brown." But color harmonies also apply to the pictorial arts, although they may be more difficult to spot because of differences in value and intensity.

Usually, an artist's choice of colors is intuitive, so that it is only after a work of art has been completed that observers can identify the color harmony involved. These harmonies do, however, help us to understand why certain combinations of colors produce certain visual effects. There are several categories of color harmonies.

Monochromatic harmonies are composed of variations on the same hue, often with differences of value and intensity. A painting all in reds, pinks, and maroons would be considered to have a monochromatic harmony. The great Renaissance painter Titian, who was considered a brilliant colorist, often liked to restrict his *palette,* or choice of colors. His *Portrait of a Man* (**131**) is painted almost entirely in variations of blue, for an effect of simple, aristocratic elegance.

Suzanne Valadon
1867–1938

In 1867, in a small town in central France, was born an illegitimate child named Marie-Clémentine Valade. When Marie was three years old her mother brought her to Paris, where they lived in extreme poverty, subsisting on vegetables discarded as garbage at the market. Little Marie worked as a laundress and, later, joined a circus as animal rider and trapeze artist. At the age of eighteen she, in turn, gave birth to an illegitimate child, who would become the painter Maurice Utrillo. During her childhood she taught herself to draw—first with cinders given to her by a coal-hauler, then with whatever drawing materials she could find. After an accident at the circus, she became an artist's model, posing for Degas, Renoir, and the young painter Henri de Toulouse-Lautrec. The latter formed a friendship, perhaps a romance, with Marie, and is said to have given her a new name—Suzanne Valadon.

Although she never had a formal lesson, Valadon received much encouragement from her artist-patrons, whose work she was able to study at close range. She began to paint, and then to make prints. By the time she was twenty-eight she had had her work exhibited by an important dealer and had sold many drawings and etchings. Some compared her painting to that of Paul Gauguin, whom she much admired, yet always she retained an originality and reliance on her own instincts, especially in her use of the bold, definitive outline.

In 1894 Valadon took up with a rich banker, Paul Mousis, and spent the next fourteen years living as his wife—they never married legally—in a large house in the Paris suburbs. Despite the slightly scandalous nature of their unwed relationship and the presence of Valadon's illegitimate (and alcoholic) son, this proved to be the *least* bohemian period in her colorful life.

Valadon continued to work and to exhibit, and she taught Maurice to paint, apparently in the hope that it would help him to overcome his alcoholism. But in 1908 Valadon herself slipped back into what most people considered a bohemian life style. She fell in love with a young painter, André Utter, a friend of Maurice's twenty-one years her junior, and went to live with him. On one occasion the three—Valadon, Utter, and Utrillo—held a joint exhibition in Paris, but the public was more interested in the trio's sins than in their art.

Toward the end of her life, Valadon achieved some measure of fame and considerable financial security. Until her last year she continued to paint and to show, in both solo and joint exhibitions. Indeed, death came, in the form of a stroke, while she was at her easel working on a new painting. The mourners at her funeral included virtually the whole Paris art community, among them Picasso.

Certainly the details of Valadon's life are interesting, and they mark her as a genuine individual. In her life, as in her art, she followed her own path, copying no one, offering no explanation. She seldom spoke, and never wrote, about her art, but one comment that was recorded seems to sum up her faith in her own vision: "I don't understand the experts, neither their explanations, nor their comparisons. When they speak of technique, balance and values they simply make me dizzy. Only two things exist for me and all others who paint: good pictures and bad pictures, that's all."[2]

Suzanne Valadon. *Self-Portrait.* 1927.
Oil on wood, $24\frac{1}{2} \times 19\frac{3}{4}''$.
Courtesy Paul Petrides, Paris.

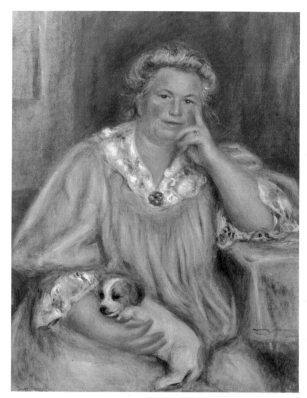

Complementary harmonies involve colors directly opposite one another on the color wheel. Suzanne Valadon's *La Poupée Abandonnée* (**132**) illustrates such a harmony, with its contrast of red and dull green. Complementaries "react" with each other more vividly than do other colors. Here Valadon has exploited the shrill reaction of background tones to offset the nude figure of a young girl just emerging into womanhood, her abandoned doll (this is what the title means) lying on the floor.

Analogous harmonies combine colors adjacent to one another on the color wheel, such as red, red-orange, and orange. In *Portrait of Madame Renoir with Bob* (**133**) Renoir holds to this scheme to create a warm and charming image of his wife with their small dog. Except for touches of white, nearly all the colors in this work can be found in the upper left third of our color wheel (**128**), from yellow through the oranges to red. Even the puppy sports a golden orange.

Triad harmonies use three colors equidistant on the color wheel. The most obvious combination is red, yellow, and blue, as in Mondrian's painting (**117**). In addition, there are several more complicated color harmonies that are significant mainly to color theorists. For our purposes here it is enough to know that such harmonies exist and that they may sometimes help us to understand why particular colors work together.

Optical Effects of Color Certain uses and combinations of colors can "play tricks" on our eyes, or, more accurately, on the way we perceive colors registered by our eyes. For one thing, there is the phenomenon known as *simultaneous contrast*. If you place two complementary colors next to each other, both of them will seem more brilliant: red seems redder, green greener, and so forth. Food merchandisers understand this well. Strawberries are nearly always packaged in green, the complement of red, and the meat counter in a grocery store often will have some touch of green. Both the fruit and the meat therefore seem redder and more appetizing. Similarly, the home decorator might create an instant "still life" by piling fresh oranges into a blue bowl on the table; the two colors spark against each other and dazzle the eye.

left: **132.** Suzanne Valadon. *La Poupée Abandonnée.* 1921. Oil on canvas, 4′3″ × 2′8″. National Museum of Women in the Arts, Washington, D.C. (Holladay Collection).

right: **133.** Pierre Auguste Renoir. *Portrait of Madame Renoir with Bob.* c. 1910. Oil on canvas, $31\frac{7}{8} \times 25\frac{5}{8}$″. Wadsworth Atheneum, Hartford, Conn. (Ella Gallup Sumner and Mary Catlin Sumner Collection).

134. Demonstration of the effects of afterimage in colors. Stare at the dot in the center of the flag for at least 30 seconds. Then quickly turn your eyes to a white paper or a white wall. The flag should appear in its usual colors, which are complimentary to those shown here.

Another phenomenon associated with complementary colors is *afterimage.* If you stare fixedly at the color areas in the illustration (**134**) for half a minute or so, and then turn your eyes quickly to a white page or white wall, you will see a faint afterimage of the color patches in their complementary colors.

Some colors seem to "advance," others to "recede." Interior designers know that if you place a bright red chair in a room it will seem larger and farther forward than the same chair upholstered in beige or pale blue. Thus, color can dramatically influence our perceptions of space and size. In general, colors that create the illusion of large size and advancing are those with warmer hues (red, orange, yellow), high intensity, and dark value; small size and receding are suggested by colors with cooler hues (blue, green), low intensity, and light value.

Colors can be mixed in light or pigment, but they can also be mixed by the eyes. When small patches of different colors are placed close together, the eye may blend them to produce a new color. This is known as *optical color mixture,* and it is an important feature in the painting of Georges Seurat. Seurat's style of painting, known as *pointillism,* depends on the painstaking arrangement of many, many tiny dots of color very close together. From a distance of a few

left: 135. Georges Seurat. *Study for Le Chahut,* detail of **136.**

right: 136. Georges Seurat. *Study for Le Chahut.* 1889. Oil on canvas, $21\frac{7}{8} \times 18\frac{3}{8}''$. Albright-Knox Art Gallery, Buffalo, N.Y. (General Purchase Funds, 1943).

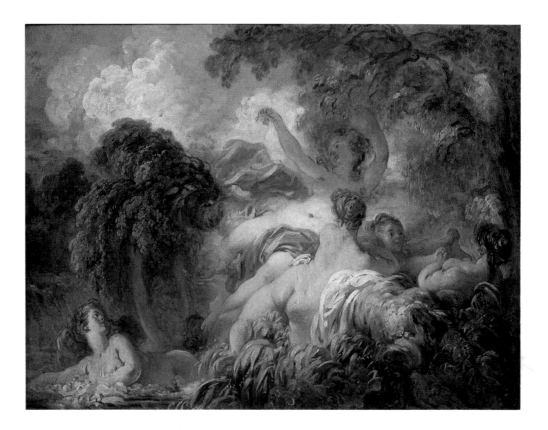

inches a Seurat painting looks like a meaningless jumble of color dots (**135**). But as the viewer moves back, the dots merge to form soft, subtly gradated colors (**136**). Although Seurat's work is the epitome of optical color mixture, many artists use the effect in less extreme forms.

Emotional Qualities of Color Endless books have been written in an attempt to explain the emotional effects of color. Why does a bull chase something red? Why does a person wearing a red shirt or dress immediately attract our attention? Why are red, white, and silver status colors for an automobile, whereas orange is not? Whatever the reasons, one group of experts—packaging designers—have been aggressive in exploiting these qualities. If you scan the shelves of the supermarket, you will discover that few packages are entirely free of red, because red seems to attract attention better than any other color. (One exception is foods promoted as being "natural," whose packages usually feature beige and brown.)

In our language we have given specific emotional symbolism to the different color names. Green is associated with envy; blue, with sadness; red, with anger; yellow, with cowardice; and so on. Beyond this, we think of colors as having different "temperatures," as suggested earlier. Red and orange are thought of as being "warm" colors, perhaps because of their association with fire, sunsets, and the like. Conversely, blue and green are considered "cool."

An artist choosing colors for a particular work will expect those colors to have some emotional impact on the viewer, an impact that supports the intent in that work of art. We can see this by comparing two paintings with very different emotional qualities. Both paintings show figures floating in a swirling space, but here the resemblance stops.

Jean-Honoré Fragonard's *Bathers* (**137**) is a masterpiece of the mid-18th-century style known as Rococo (Chapter 16). Fragonard's work celebrates an ideal of frivolous, light-hearted love, frolicking play, and gentle sensuality. No serious concerns intrude in this artist's world. His people might have moved straight into adulthood from the nursery and simply incorporated the pleasures of the flesh into their play. Nearly all the colors in the painting are soft pastels,

137. Jean-Honoré Fragonard.
Bathers. c. 1765.
Oil on canvas, $25\frac{1}{4} \times 31\frac{1}{2}''$.
Louvre, Paris.

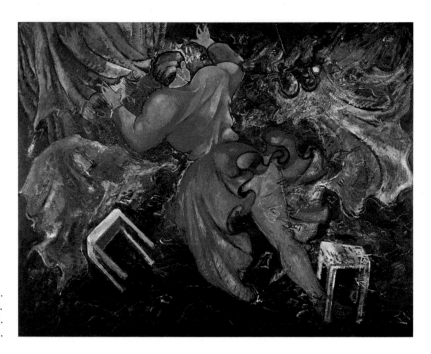

138. Sandro Chia.
Incident at the Café Tintoretto.
1981. Oil on canvas, 8'5" × 11'2".
Courtesy the artist.

with special emphasis on abundant pink bodies. The mood is supposed to be light and charming, and Fragonard's colors foster this.

How different is *Incident at the Café Tintoretto* (**138**) by the contemporary Italian artist Sandro Chia. Often identified as one of the *Neo-Expressionists* (Chapter 17), Chia paints simple everyday events and yet gives them cosmic importance. The "incident" depicted here might be an ordinary fight in a café, but it has all the drama of a scene from Dante's *Inferno*. Part of the reason for its impact is the dense, seething composition, but another part is the color. Chia's color absolutely *shrieks* at us, compelling attention with its vividness and "clash." Our emotional response to this work cannot help but be poles apart from our response to the Fragonard.

These two examples should be enough to demonstrate how potent a force color can be in a work of art, just as it is in life. Our next element is also a major factor in the experience of everyday life, and artists have learned to explore its power in art.

Texture

Texture refers to surface quality—a perception of smooth or rough, flat or bumpy, fine or coarse. Our world would be bland and uninteresting without contrasts of texture. Most of us, when we encounter a dog or cat, are moved to pet the animal, partly because the animal likes it, but also because we enjoy the feel of the fur's texture against our hands. In planning our clothes we instinctively take texture into account. We might put on a thick, nubby sweater over a smooth cotton shirt and enjoy the contrast. We look for this textural interest in all facets of our environment. Few people can resist running their hands over a smooth chunk of marble or a glossy length of silk. This is the outstanding feature of texture: it makes us want to touch it.

ACTUAL TEXTURE

All the textures referred to above are *actual* or *tactile;* we experience them through the sense of touch. The rougher the texture, the greater is the difference in surface elevation. If we cannot touch these surfaces, as it is forbidden to touch

most sculptures in museums, we understand their actual textures by remembering similar objects we *have* touched.

Actual texture in art is usually associated with sculpture, architecture, and the crafts. But many paintings also have actual texture. When an artist lays on the paint in thick layers (a technique known as *impasto*), with some areas thicker than others, the painting may have actual surface texture (**235**). Sometimes, too, an artist may attach three-dimensional objects to a canvas, giving it actual surface texture. More often, of course, the textures we see in a painting are visual.

VISUAL TEXTURE

Raoul Dufy's *Visit of the English Squadron to Havre* (**139**) illustrates the concept of visual texture. If you could touch the paper, you would find it to be primarily flat. Nevertheless, the eye perceives a texture because of the closely spaced, small forms and brush strokes, especially the waves in the sea. This work reminds us of forms in the natural world that do in fact have texture, so we apply remembered perceptions of tactile texture to the visual expression.

We saw another type of visual texture in Steinberg's *Hen* (**103**). In this drawing Steinberg used ink lines to evoke a tactile texture from the natural world—the feathers of a hen. Throughout history artists have attempted to simulate, on the flat surface of a canvas, natural textures—textures of fur and hair and fabric, for example, or textures of fruits and vegetables in a still life.

A visual texture, therefore, may be aimed at creating an illusion, or it may exist simply for its own sake, to provide visual interest. Either way, the texture helps to enliven a work of art.

PATTERN

As was mentioned in the section dealing with line, pattern is any decorative, repetitive motif. What is the difference between texture and pattern? Pattern nearly always creates visual texture, but texture may not be seen as pattern all the time. For instance, in Picasso's *Paulo on a Donkey* (**98**) there are definite textures of grass and fur and so on, but we probably would not call them pattern. On the other hand, when a visual texture is decorative, highly repetitive, and

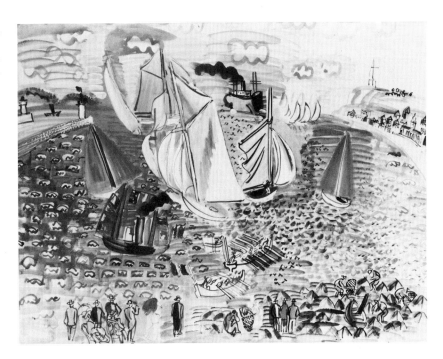

139. Raoul Dufy.
Visit of the English Squadron to Havre.
c. 1928. Gouache, $18\frac{3}{4} \times 25\frac{1}{2}''$.
Searle Collection.

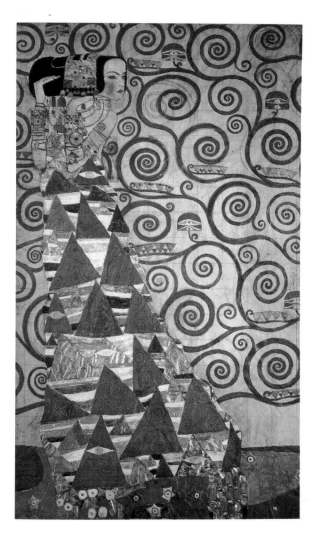

140. Gustav Klimt. *Expectation.* c. 1905–09. Mixed media with silver and gold leaf on paper, 6'4" × 3'9⅜". Österreichisches Museum für Angewandte Kunst, Vienna.

evenly spaced over an area, we are more likely to call it pattern. A good example is the drawing by Gustav Klimt (**140**). Klimt's subject in this work, a common one for him, is a woman in a long, flowing dress. The dress has been fragmented into a series of irregular triangles. Only this pattern separates the figure from its background, which consists of spiraling plantlike tendrils—another pattern. The figure, then, becomes a point of departure for the overall decorative patterns.

Klimt's drawing is full of movement and energy, thanks to the background spirals, which seem to spin like whirlpools. It is meant to be decorative, not naturalistic. You may observe that there is no impression of roundness in this figure, no distinction of foreground and background, no sense of looking through the "window" of the picture area into a real world. Klimt meant his picture to be "flat," but other artists have had very different goals. This brings us to consideration of the most complex visual element—space.

Space

The word "space," especially in our technological world, sometimes conveys the idea of nothingness. We think of outer space as a huge void, hostile to human life except when protected by complex support systems. A person who is "spaced out" is blank, unfocused, not really "there." But the space in and around a work of art is not a void, and it is very much there. It is a dynamic visual element that

interacts with the lines and shapes and colors and textures of a work of art to give them definition. Consider space in this way: How could there be a line if there were not the spaces on either side of it to mark its edges? How could there be a shape without the space around it to set it off?

In this section we will look at the different types of space an artist deals with and how these spaces affect the other elements.

THREE-DIMENSIONAL SPACE

Sculpture, architecture, and all forms with mass exist in three-dimensional space—that is, the actual space in which our bodies also stand. These works of art take their character from the individual ways in which they carve out sections of space within and around them.

Architecture, in particular, can be thought of as a means of carving space. Without the walls and the roof of a building, the space would be limitless; with them, the space has boundaries and therefore has volume. For instance, in a very simple house, say a shoebox-shaped house, the walls and roof create a "cube" of space that could be measured in terms of its volume. If the house is subdivided into rooms, then several smaller cubes of space have been created. The interior of the Solomon R. Guggenheim Museum in New York, designed by Frank Lloyd Wright (**141**), provides a more complex example. Inside the building Wright constructed a huge, bubblelike volume enlivened by curved forms cutting in and out, and culminating in the skylight dome overhead. Because of this unusual treatment, Wright makes us think of space as active rather than passive, something rather than nothing. From outside we might view the Guggenheim Museum as a *mass;* inside we experience it as *shaped space.* The mass and the space are equal partners, since neither could exist without the other.

Space is also a vital element of sculpture, and this is true even of prehistoric structures such as the ancient burial chamber at Pentre-Ifan, in Wales (**142**). This form is exciting because of the spaces between the stones and especially the open space under the balanced capstone. If you try to visualize how the form would look if all the spaces were closed up by solid rock, you will begin to understand the active role of space in three-dimensional art.

TWO-DIMENSIONAL SPACE

Two-dimensional space refers to the space in a painting, drawing, print, or other type of flat art. As the name implies, this kind of space has only height and width, no depth. There are two major considerations in dealing with this space. The first

left: 141. Frank Lloyd Wright. Solomon R. Guggenheim Museum, New York, interior view.

right: 142. Large burial chamber, Pentre-Ifan, Pembrokeshire, Wales. c. 3800–2000 B.C.

is the way in which shapes, lines, and other elements are arranged vertically or horizontally within the space. The second is the possibility of visual depth, or the *illusion* of three-dimensional space on a two-dimensional surface.

Spatial Organization Working on a picture surface that is flat and has no depth, the artist has to decide where to place forms in that flat space—high or low, left or right, centered or off to one side. Each time the artist makes a mark of any kind, the space is divided into segments that were not there before.

In Jean Arp's collage *Arrangement According to the Laws of Chance* (**143**) the square forms have been organized more or less evenly throughout the space. The spaces between squares are similar, as are the top and bottom spaces. Now let us compare the spatial organization in Edgar Degas' *Dancers Practicing at the Barre* (**144**). The two major forms are crowded into the upper-right quadrant of the painting, leaving the rest of the canvas as open space. Why would Degas design such an unusual division of space? Partly because he was influenced by Japanese art, in which asymmetrical balance is common (**178**). Also partly because he was fascinated by the unexpected angle of vision, such as a viewer might catch by peeping in a window or over a balcony. Even with the eccentric placement of the dancers at upper right, the space below and to the left does not seem "dead." Quite the opposite—the daring composition and sharp diagonal bring the whole space to life.

Illusion of Depth In some works of art the artist will try to create on a flat surface the illusion of deep, three-dimensional space, as one might see in a natural landscape. This space appears to go backward in depth "behind" the front surface of the painting, which is referred to as the *picture plane.* When artists establish illusionary depth, they create the impression that some forms in the composition are farther away than others, and that some forms are in front of or behind others in space.

At different times in history and in different cultures there have been several methods used to create the illusion of depth on a two-dimensional surface.

143. Jean Arp. *Arrangement According to the Laws of Chance.* 1916–17. Torn and pasted papers, 19⅛ × 13⅝". Museum of Modern Art, New York (purchase).

144. Edgar Degas.
Dancers Practicing at the Barre.
1877. Oil, freely mixed
with turpentine, on canvas;
29¾ × 32".
Metropolitan Museum of Art,
New York
(H. O. Havemeyer Collection,
bequest of Mrs. H. O. Havemeyer,
1929).

One of the simplest of these is *overlapping*. If one form overlaps another, that form appears to be in front of the other one. We see this effect in the mosaic of *The Good Shepherd Separating the Sheep from the Goats* (**145**). The composition is essentially flat with virtually no suggestion of background depth. Still, because the animals are placed in front of the angels and Christ's hand overlaps the angel at our left, we perceive the animals and the Christ figure to be farther forward in space. This picture could be read as having two very shallow planes—one at the picture plane, where Christ and the animals stand, one slightly farther back.

145. *The Good Shepherd Separating the Sheep from the Goats.* c. 520. Mosaic. Sant' Apollinare Nuovo, Ravenna.

146. School of Bihzad.
Dervishes Dancing,
leaf from the *Diwan.* c. 1490.
Color on paper.
Metropolitan Museum of Art,
New York (Rogers Fund, 1917).

Another device to show spatial depth is *position,* which is especially common in Persian and Indian art. In a Persian painting illustrating the verses of the great 14th-century poet Hafiz, *Dervishes Dancing* (**146**), all the figures are roughly the same size, and the landscape background is more decorative than lifelike. But the figures placed *higher* in the composition are assumed to be farther back in space than those toward the bottom. The audience for whom this painting was made understood the convention perfectly, though it seems unusual to Western eyes. In addition to the placement of the forms, the artist has used some overlapping to foster the sense of spatial depth.

During the 15th century in Italy artists perfected the science of *linear perspective*—the most "realistic" method of portraying in two dimensions the visual depth of the natural world. Although linear perspective can be extremely complex and mathematical, it is based on the application of two simple, observable phenomena. In linear perspective:

1. Forms that are far away from the viewer seem smaller than those that are close up.
2. Parallel lines receding into the distance seem to converge, until they meet at a point on the horizon line where they disappear. This point is known as the *vanishing point.*

You can visualize this second idea if you remember gazing down a straight highway. As the highway recedes farther from you, the two edges seem to come closer together, until they disappear at the horizon line (**147**). Linear perspective is a translation into drawing principles of these two ideas.

Renaissance artists took up linear perspective with as much delight as a child takes up a new toy. For the first time in the history of civilization (as far as they knew) they could depict absolutely naturalistic scenes, and this was an important goal at the time. Several paintings were done as academic exercises to

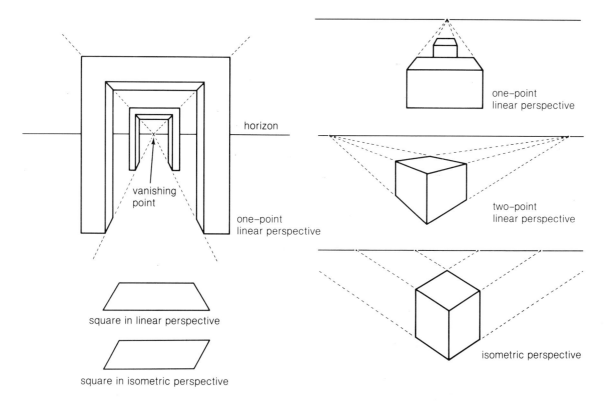

horizon

vanishing point

one-point linear perspective

one-point linear perspective

two-point linear perspective

isometric perspective

square in linear perspective

square in isometric perspective

View of an Ideal City (**148**) with perspective lines

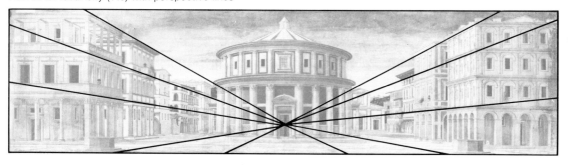

Canyon (**149**) with perspective lines

Kumano Mandala (**150**) with perspective lines

147. Sketches of linear and isometric perspective, including perspective sketches of *View of an Ideal City* (**148**), *Canyon* (**149**), and the *Kumano Mandala* (**150**).

148. Piero della Francesca and Luciano Laurana. *View of an Ideal City.* c. 1460. Tempera on panel, 1'11⅝" × 6'6¾". Galleria Nazionale della Marche, Palazzo Ducale, Urbino.

test the new science of perspective, including *View of an Ideal City* (**148**). In this work the ground lines, the facades of the buildings, the roof lines, and the protruding architectural elements recede in a perfectly contrived scheme toward a vanishing point somewhere behind the circular building. Also, the buildings get smaller and smaller as they go back into space.

Linear perspective may seem "correct" to our eyes because of our experience with photographs; many photographs, especially of architecture, look much like a drawing in careful linear perspective (**149**). Nevertheless, it is not the ultimate key to perfect art, as some Renaissance artists thought. This perspective works only if the viewer stands motionless and fixes his or her eyes (or, even better, one eye with the other closed) on a particular spot. For this reason the results of academically perfect linear perspective may seem static and lifeless—much like the *Ideal City*, which reminds us less of a living metropolis than of a ghost town. Expanding the perspective to include two or more vanishing points (**147**), a more complex form of perspective, helps to give a more vital image, but the results may still be rather rigid. Linear perspective is only one of many tools artists can use when they wish to portray three-dimensional space.

In Eastern art linear perspective has played much less of a role. Instead, artists often have relied on a system of *isometric perspective,* in which distant forms *are* made smaller, but parallel lines do not converge. The Shinto shrines

149. Berenice Abbott. *Canyon, Broadway and Exchange Place.* 1936. Photograph. Courtesy Berenice Abbott/ Commerce Graphics Ltd., Inc.

150. *Kumano Mandala,* Japan. Kamakura Period, A.D. c. 1300. Color on silk, 4′4¾″ × 2′⅜″. Cleveland Museum of Art (purchase, John L. Severance Fund).

depicted in the *Kumano Mandala* (**150**) might be considered the Japanese equivalent of a Renaissance "ideal city" (**147**). As usual in isometric perspective, lines that would be perpendicular to the picture plane are drawn as sharp diagonals. Whereas linear perspective turns the square into a trapezoid, isometric perspective turns the square into a parallelogram (**147**). Architects and industrial draftsmen often use this type of perspective for their drawings, because it allows them to indicate accurate measurements.

In conjunction with linear or isometric perspective, the artist may employ the device of *atmospheric perspective.* This means that forms meant to be perceived as far in the distance are blurred, indistinct, and misty—much as the eye perceives distant forms in nature. You can see this effect in many landscape paintings reproduced throughout this book.

To sum up, then, artists can draw upon several devices to create the illusion of three-dimensional depth on a two-dimensional surface. Here are some of the major ones:

Seen as Foreground	**Seen as Background**
large size	small size
set low in the picture	set high in the picture
parallel lines far apart	parallel lines converging
overlapping other forms	overlapped by other forms
sharply defined forms	blurred forms
intense colors	grayed colors
rough textures	smooth textures

151. Andrea Mantegna. *Dead Christ.* After 1466. Tempera on canvas, $26\frac{3}{4} \times 31\frac{7}{8}''$. Brera Gallery, Milan.

When linear perspective is applied to human or animal forms or to objects receding into depth, the result is called *foreshortening*. Literally, the body, or part of it, is "shortened" from its normal vertical height to better convey the appearance of figures that are perpendicular to the picture plane. A classic example of foreshortening is Andrea Mantegna's *Dead Christ* (**151**). If you could lift this fig-

152. Romare Bearden. *Miss Bertha & Mr. Seth.* 1978. Collage, $25\frac{1}{2} \times 18\frac{1}{2}''$. Private collection, New Jersey.

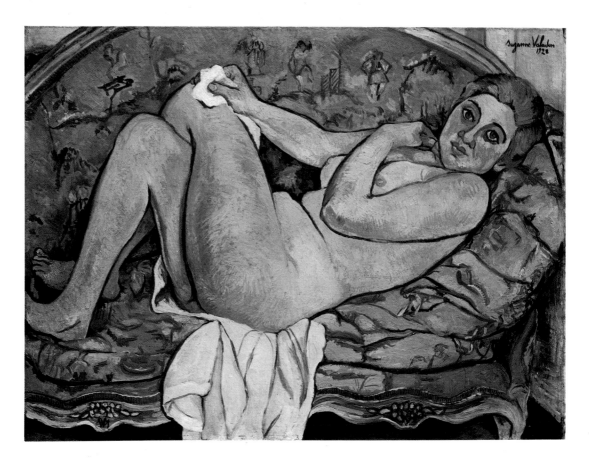

ure out of the painting and stand it upright, its proportions would seem very strange indeed. The legs are far too short for the body, and the entire figure would be absurdly short compared to its breadth. Mantegna's composition, however, seems entirely believable given the unusual angle of vision. And his choice of this angle makes the body of the dead Christ all the more poignant and vulnerable.

The aim of all perspective systems, including the device of foreshortening, is to create the impression of realism. Yet once the artist has the *ability* to convey the idea of depth on a flat surface, the question remains, how much sense of depth does he or she want in any given work? Most Renaissance artists would have answered this question by saying "the more the better," the more depth in a painting, the better the artist has succeeded. Later artists, however, have had many different goals, and illusion of depth is only one of them.

The space in Romare Bearden's *Miss Bertha & Mr. Seth* (**152**) is almost entirely flat. The figures stand flush at the picture plane, and the backdrop pushes up very close behind them. Moreover, the figures themselves have no full-bodied roundness; they are more like paper dolls or the large cardboard cutouts one might see in a shop window. Only in the extreme right-hand side of the composition has Bearden given us a suggestion of depth. We see a hint of a deep landscape, but this serves to make the space of the entire work even more complicated. Bearden knows how to draw deep space, but in this case he chooses not to. He stands his figures flat at the front of the canvas, thereby giving them an importance and a dignity they might not have had were they worked into a conventional landscape.

The French artist Suzanne Valadon also knew how to draw deep space, but for her *Reclining Nude* (**153**) she has chosen to keep the space of the painting quite shallow. The figure is posed rather awkwardly on a too-small sofa, with legs crossed and one arm clutched across the breast in a self-protective gesture. This model presents herself for our inspection, but at the same time she pulls away and keeps to herself. Valadon has outlined the figure in a strong black line and concentrated especially on the powerful volumes of thigh and belly and upper

153. Suzanne Valadon. *Reclining Nude.* Oil on canvas, $23\frac{5}{8} \times 31\frac{11}{16}''$. Metropolitan Museum of Art, New York (Robert Lehman Collection, 1975).

arm. But the most fascinating aspect of this painting is its claustrophobic space. We as viewers seem to be very close to the model, who is hemmed in on three sides by the sofa. The tight space creates a tension, a psychological confrontation, between the viewer and the model. She is naked but private; the viewer is perhaps embarrassed and sympathetic, surely intrigued.

So we see that pictorial depth, or the lack thereof, is a powerful tool that an artist can use for whatever effect is desired. Once the skill is acquired, the possibilities are endless. Yet no matter how skilled the artist, it is not possible to make a painted scene look exactly like a real scene for one simple reason: our world does not stand still. At every moment there is the sense of passing time, the sense of movement. Some works of art, however, do deal in the realms of time and motion. We turn finally to a consideration of these two factors.

Time and Motion

The ancient Egyptians undoubtedly would have been puzzled to find time and motion included in a discussion of art. In Egyptian culture, and in many others, art was supposed to be time*less*, motion*less* for all eternity. Our own world, however, is considerably more dynamic. Most of us, especially in the industrialized nations, are obsessed with time, and motion is a fact of everyday life. Both time and motion have come to be recognized as important elements in art.

ELAPSED TIME

154. Le Corbusier. Notre-Dame-du-Haut, Ronchamp, exterior. 1950–55.

155. Le Corbusier. Notre-Dame-du-Haut, Ronchamp, interior. 1950–55.

In the three-dimensional arts, especially sculpture and architecture, time is always a factor in the observer's reaction. When you walk through a building or walk around a sculpture, your viewpoint changes with every split second that elapses. Usually, you *cannot* experience every aspect of the structure from one vantage point or at one moment. You must expend time to accumulate all the different points of view and assemble them into an understanding of the whole. The architects of the great cathedrals knew this, and so did the architect of one of the great modern churches.

Set high in the Vosges Mountains of eastern France, near Switzerland, is the Chapel of Notre-Dame-du-Haut (Our Lady on High), designed by the con-

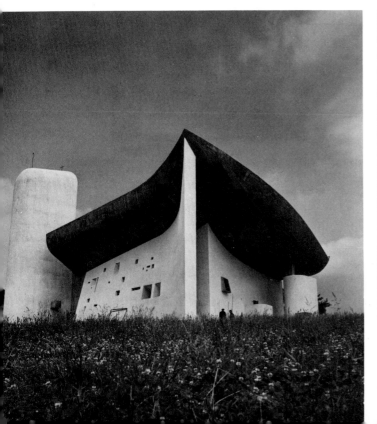

156. George Rickey.
Two Rectangles Vertical Gyratory.
1969. Stainless steel, height 45'.
Collection City of Rotterdam,
courtesy the artist.

temporary architect known as Le Corbusier. The little church sits atop a pinnacle, overlooking the town of Ronchamp (154). There is only one access road, so the visitor's viewpoint while approaching the church is controlled at every turn. Having reached the summit, the visitor finds no obvious entrance to the church on the facing side, and so must walk all around to enter. The exterior of Notre-Dame-du-Haut is endlessly unpredictable. Each new viewpoint, each moment of elapsed time, brings a different perspective.

The inside of the chapel (155) is equally unusual. Irregular openings cut into the thick walls admit light according to a constantly changing pattern—a pattern affected by time during the day. No one vantage point will reveal everything about the chapel. The visitor must walk around, move from spot to spot, draw closer and then pull away to get a full sense of the building's architecture. Notre-Dame-du-Haut is as much a masterpiece of time as it is of mass and space and light.

ACTUAL MOTION

When time is a factor in art, it is often assumed that the viewer is in motion. In some cases, however, the work of art is also in motion. One sculptor whose special preoccupation has been forms in motion is George Rickey. In any Rickey sculpture the shape of the object is less important than the movements that may be produced by that shape. *Two Rectangles Vertical Gyratory* (156) floats above the streets of Rotterdam, its two rectangular slabs set in constant, nonrepetitive motion by the wind. The balance of these slabs makes them receptive to any passing breeze, but no one can predict exactly what configuration they will take at any moment. Their polished surfaces reflect light from above, the street scene from below, in an ever-changing pattern.

ILLUSION OF MOTION

Just as artists have long attempted to create the illusion of deep space on a flat surface, so have they often tried to create the illusion of motion where there is none, and, as with spatial depth, the artist has a choice. Some works of art are planned to be rather static and motionless and a sense of movement would actually be harmful to the artist's intent. Picasso's *Paulo* (**98**) and Valadon's *Reclining Nude* (**153**) both fit this category. In other cases a sense of movement contributes much to the success of the work. Géricault's *The Raft of the Medusa* (**113**) seems dynamic because the artist has created an illusion of the raft plunging through the water, an illusion of motion. We could find many other examples of this situation. Indeed, in Gustav Klimt's drawing (**140**) the illusion of motion—caused by the repetitive pattern of spirals that seem to spin—becomes one of the most important elements in the composition.

The same is true for the three works illustrated here. Bridget Riley's *Current* (**157**), an example of the style known as *Op Art*, has as its theme the illusion of motion caused by optical effects, a direct response by the retina of the eye to lines and colors arranged in certain ways. The lines in this painting are just that—precisely drawn lines on flat canvas—but as we stare at them they begin to swim before our eyes, and the painting actually seems to be in motion. Some viewers have experienced vertigo or even nausea after spending time in front of an Op canvas, so powerful is the effect on one's central nervous system.

Giacomo Balla's *Dynamism of a Dog on a Leash* (**158**) shows another device by which motion can be suggested. Balla was a member of the *Futurist* group that flourished in Italy during the second decade of this century. An important (though short-lived) movement, Futurism, as the name implies, rejected the art forms of the past, which it considered static, in favor of images that conveyed movement and energy. In *Dog on a Leash* Balla has blurred the forms of dog, leash, and dog-walker, repeating the feet, tail, and leash many times to set them in motion across the canvas. When we look at this charming painting, we might almost swear we see the dog's tail wagging, its little feet scampering along.

Seventy years later Andy Warhol employed a similar technique to suggest motion in his screenprint *Superman* (**159**). The ghost image to the right of Superman's full-color form creates the impression of him streaking through the sky so fast that he registers as a blur. Here Warhol is capitalizing on our familiarity with motion photography to present an image of believable motion.

Line, shape and mass, light, value, color, texture, space, time and motion—these are the raw materials, the elements, of a work of art. Some people are troubled

157. Bridget Riley. *Current.* 1964. Synthetic polymer paint on composition board, 4'10⅜" square. Museum of Modern Art, New York (Philip Johnson Fund).

above: **158.** Giacomo Balla.
Dynamism of a Dog on a Leash.
1912. Oil on canvas, $35\frac{3}{8} \times 43\frac{1}{4}''$.
Albright-Knox Art Gallery, Buffalo, N.Y.
(bequest of A. Conger Goodyear
and gift of George F. Goodyear, 1964).

right: **159.** Andy Warhol. *Superman*,
from the series *Myths*.
1981. Silkscreen, 38″ square.
Courtesy Ronald Feldman Fine Arts, New York.

by this approach to works of art, taking them apart and putting them back together again like jigsaw puzzles. And how can we justify discussion of the art elements in the face of utterly down-to-earth and commonsensical remarks like Suzanne Valadon's declaration that such analyses made her "dizzy"?

Whether she cared to talk about it or not, Valadon understood the art elements. She had absorbed them into her eye and her hand and her soul as an artist. For the rest of us, a discussion of the elements gives systematic and intellectual order to our aesthetic appreciation of art. With a knowledge of the elements, we begin to understand *why* we love one work of art, why we do not much like another. And then we—along with Valadon—can make intelligent judgments about "good pictures and bad pictures, that's all."

ART PEOPLE
Giorgio Vasari

A biographer is by nature a gossip. We value the art of biography because it enables us to better understand the work of noted individuals through knowing their histories. At a more basic level, however, nearly all of us love to learn the details of other people's lives—in other words, gossip. And one of the most delightful gossips in history was Giorgio Vasari.

Vasari was a painter and architect of considerable skill. Born in Arezzo, in the Italian province of Tuscany, in 1511, he pursued the career of artist throughout his life. Many of his paintings still exist, and his major work as an architect, the Uffizi Palace in Florence, is now an important museum. But for two facts, Vasari might today be known as a prominent artist of the Renaissance. The facts are these: Vasari was inevitably overshadowed by the giants at work in Italy at the same time, notably Leonardo da Vinci, Michelangelo, and Raphael. And Vasari's artistic production was overshadowed by his own brilliant literary endeavor—a comprehensive biography of the outstanding Renaissance artists.

The first edition of his masterwork, *Lives of the Most Excellent Architects, Painters, and Sculptors*, was published in 1550, after seven years of hard work. (A revised and expanded edition of the book was published in 1568.) Although other biographies had been written, nothing on this scale had ever been completed. Reading the *Lives* today, we may find the style a trifle precious, but at the time Vasari's approach was considered natural and conversational. For his research, Vasari traveled constantly (on horseback, over bad roads), spoke with anyone he could, viewed works of art whenever possible. Some of his subjects, including Raphael, were long dead when he began the *Lives*, so he depended on secondhand sources. Others, like Michelangelo, were close and respected friends. It is on Michelangelo that Vasari pours out the extremes of his flowery admiration.

Everyone seems to have liked Vasari. He had a vast network of friends, a huge correspondence, a long list of patrons. His genial temperament gave him access to information about all the leading artists. In the *Lives*, Vasari's style is so charming, so enthusiastic, so *cheerful*, that reading him now, more than four hundred years later—we like him too.

Against his extremely busy public life, Vasari's personal life was uneventful. Under pressure from one of his patrons, a cardinal of the Church, he "resolved to do something, which hitherto I had not wished to do, that is to take a wife." In 1550 he married Niccolosa Bacci, always called Cosina, for whom he seems to have had a rather absent-minded affection but little passion. The couple had no children.

As historian and biographer, Vasari must be taken with a grain of salt. His grasp of dates is particularly casual. We should remember, however, that Vasari was breaking new ground. In his day there were no reference books to check facts, no encyclopedias, no public libraries. Under the circumstances, the *Lives* must be viewed as a staggering achievement, giving us a picture of Renaissance artists that is true in its quality if shaky in some specifics. For without Vasari, we would have had little picture at all.

Giorgio Vasari. *Self-Portrait.* c. 1571. Uffizi, Florence.

5
Principles
of Design
in Art

When an artist sets about making any work, he or she is faced with infinite choices. How big or small? What kinds of lines and where should the lines go? What kinds of shapes? How much space between the shapes. How many colors and how much of each one? What amounts of light and dark values? Somehow, the elements discussed in Chapter 4—line, shape, light, value, color, texture, space, and possibly time and motion—must be organized in such a way as to satisfy the artist's expressive intent. In two-dimensional art this organization is often called *composition*, but the more inclusive term, applicable to all kinds of art, is *design*. The task of making all the decisions involved in designing a work of art would be paralyzing were it not for certain guidelines that, once understood, become almost instinctive. These guidelines are usually known as the *principles of design*.

All of us have some built-in sense of what looks right or wrong, what "works" or doesn't. Some—including most artists—have a stronger sense of what "works" than others. If two families each decorate a living room, and one room is attractive, welcoming, and pulled together while the other seems drab and uninviting, we might say that the first family has better "taste." Taste is a common term that, in this context, describes how some people make visual selections. What we really mean by "good taste," oftentimes, is that some people have a better grasp of the principles of design and how to use them.

The principles of design are a natural part of perception. Most of us are not conscious of them in everyday life, but artists usually are very aware of them, because they have trained themselves to be aware. These principles codify, or explain systematically, our sense of "rightness" and help to show why certain designs work better than others. For the artist they offer guidelines for making the most effective choices; for the observer an understanding of the principles of design gives greater insight into works of art.

It must be stressed that the principles of design are not rules or laws. If they were, nearly every great artist would have been guilty of breaking them at one time or another. They are, as we said, guidelines that apply in most situations. There are circumstances, however, in which an artist may choose deliberately to violate or ignore these guidelines to achieve a particular effect.

The principles of design most often identified are unity and variety, balance, emphasis and focal point, proportion and scale, and rhythm. This chapter illustrates some forty works of art that show these principles very clearly. But *any* work of art, regardless of its form or the culture in which it was made, could be discussed in terms of the principles of design, for they are integral to all art.

above: 160. Ben Jones. *Black Face and Arm Unit.* 1971. Painted plaster, lifesize. New Jersey State Museum, Trenton (purchase).

right: 161. Stuart Davis. *Ready to Wear.* 1955. Oil on canvas, 4′8¼″ × 3′6″. Art Institute of Chicago (Sigmund W. Kunstadler Gift and Goodman Fund).

Unity and Variety

Unity is a sense of oneness, of things belonging together and making up a coherent whole. Variety is difference, which provides interest. We discuss them together because the two generally coexist in a work of art. A solid wall painted white has unity for sure, but it is not likely to hold your interest for long. Take that same blank wall and ask fifty people each to make a mark on it and you will get plenty of variety, but there probably will be no unity whatever. In fact, there will be so *much* variety that no one can form a meaningful visual impression. Unity and variety exist on a spectrum, with total blandness at one end, total disorder at the other. For most works of art the artist strives to find just the right point on that spectrum—the point at which there is sufficient visual unity enlivened by sufficient variety.

Ben Jones' *Black Face and Arm Unit* (**160**) illustrates the way unity and variety work together. This wall-mounted sculpture consists of several units of a painted masklike face above a decorated arm. We get the impression of a whole personality from each of the units; each face-and-arm pair stands for an entire human being. There is unity in the basic forms—face above arm—and in the spacing of the forms. Yet the artist has provided great variety in facial expressions, decorative motifs, even the direction in which the arms are bent.

How does an artist achieve unity? One way is by holding one or two elements constant and varying the others. Jones, in his sculpture, kept the elements of shape and space constant and varied the lines, colors, and visual textures. Similarly, in Stuart Davis' *Ready to Wear* (**161**) shape is the unifying element. Nearly all the shapes in Davis' painting are roughly geometric, and most are variations on the rectangle or oval. Yet we see great variety in size, placement, angle, and overlapping of the shapes. The composition is unified and at the same time excitingly diverse.

Henri Matisse used color to unify *The Red Studio* (**162**). Walls and floor are saturated with a vivid scarlet, and some of the furniture is drawn as though transparent to let the red show through. By this method Matisse pulls together the variety of what might be any artist's home studio—paintings displayed and

162. Henri Matisse.
The Red Studio. 1911.
Oil on canvas,
5'11¼" × 7'2¼".
Museum of Modern Art, New York
(Mrs. Simon Guggenheim Fund).

stacked against the wall, a clock and bureau, drawing and eating utensils. Although the spatial organization may at first glance seem random, we get a strong sense of unity due largely to the color.

Unity is especially important in architecture, because one is working on such a grand scale. Think how unsettling it would be to see a large building in which the parts didn't seem to belong together. Not only the major forms but also the decorative design should contribute to the overall effect intended by the architect. In Moscow, which we often consider to be a stronghold of stern, bureaucratic drabness, stands one of the most delightfully ornate churches in the world, the Cathedral of St. Basil (**163**). Many domes—some of them called "onion" domes because of their bulbous shape—crown this magnificent structure. The amazing richness of detail makes us think more of a fairy-tale castle than a Christian church. Points and arches, triangles and half-circles and zigzags, round and square and octagonal shapes—everything the creative imagination can dream up has been lavished on this design. A major factor in pulling it all together is a unifying texture. Although the shapes are riotously varied, their surface texture, which catches the light and casts shadows, creates a harmonious pattern.

The classic exercise in achieving unity-with-variety is the still-life painting. To make a still life, the artist brings together a number of diverse objects having different colors, shapes, sizes, and textures, and arranges them into a pleasing composition. The usual goal is to make these forms belong together, to harmonize with and yet play against one another. Chardin's glorious *Kitchen Still Life* (**164**) consists of homely objects one might expect to find in an 18th-century kitchen—earthenware jugs, a casserole, a deep cooking pot, a bit of raw meat, some fish, two eggs. Shape is a unifying element here, as most of the forms are round or curves, including the table edge. But beyond this, Chardin has made the curves echo and overlap one another, resulting in a gentle, rhythmic motion. For the viewer there is little "stillness" in this still life. Our eyes move up and around and down, following the rounded shapes. Each object is treated as though it were

163. Cathedral of St. Basil, Moscow. 1555–60.

right: **164.**
Jean Baptiste Siméon Chardin.
Kitchen Still Life. c. 1730–35.
Oil on canvas, $12\frac{1}{2} \times 15\frac{1}{4}''$.
Ashmolean Museum, Oxford.

165. Miriam Schapiro.
Children of Paradise. 1984.
Color lithograph with collage,
$31\frac{1}{2} \times 47\frac{1}{4}''$.
Courtesy Graphicstudio II,
University of South Florida,
USF Art Galleries,
Tampa, Florida.

perfect, the most beautiful form in the world, yet all are drawn together in a unified composition.

The five works we have just considered show a primarily *visual* unity—unity of shape or space or color or texture or pattern. We should also take into account the potential for *conceptual* unity, or unity of ideas, which may enhance or even replace visual unity. For instance, if Miriam Schapiro's *Children of Paradise* (**165**) reminds you of a patchwork quilt, that is no accident. The quiltlike quality is a major factor in unifying the composition; we perceive all the forms as being of cloth, and we identify the decorative fabric-type designs we would see in a quilt. Even though the little boy's suit and the little girl's dress are not alike in shape or color, we look at them and think "child's outfit." Schapiro is much interested in the handcrafts of 19th-century American women, and she has used this idea to unify her composition. Visual unity is provided by the repeated heart and house motifs, but variety abounds in the colors, patterns, positions, and overlapping of forms.

166. Joseph Cornell.
The Hotel Eden. 1945.
Assemblage with music box,
$15\frac{1}{8} \times 15\frac{1}{8} \times 4\frac{3}{4}''$.
National Gallery of Canada,
Ottawa.

Conceptual unity predominates in the works of Joseph Cornell, such as *The Hotel Eden* (**166**). Cornell devoted most of his career to making boxlike structures that enclosed many dissimilar but related objects. Contained within the boxes, these objects build their own private worlds. Cornell collected things, odds and ends, wherever he went. His studio held crates of stuff filed according to a personal system. There were even crates labeled "flotsam" and "jetsam." When making his box sculptures, Cornell would select and arrange these objects to create a conceptual unity that was meaningful to him, based on his dreams, nostalgia, and fantasies. This is not sufficient to provide a *visual* unity, and so the boxed enclosure and the smaller boxes within it take care of the latter.

167. Andy Warhol.
200 Campbell Soup Cans. 1962.
Casein on canvas, $6' \times 8'4\frac{1}{8}''$.
Courtesy Leo Castelli Gallery,
New York.

All the works illustrated so far strike a balance between unity and variety, and this is most often the artist's goal. Sometimes, however, an artist will aim at extreme unity or extreme variety. Andy Warhol's *200 Campbell Soup Cans* (**167**) is an example of the first. No one would question that this composition has unity. What little variety Warhol gives us comes in the different soup names, and this is

a subtle variety to say the least. Warhol, like many Pop artists of the 1960s, is commenting on the packaged uniformity of our society. He might be saying that we have sacrificed variety for efficiency, in manufacture and in life, so that this is our world—row upon row of sameness.

When a composition is as unified as the *200 Campbell Soup Cans*, there is likely to be a side effect in the automatic achievement of compositional balance. In most works of art, however, balance is more subtle and somewhat more difficult to create.

Balance

How can a ballet dancer stand, poised on the toes of one foot, with arm and chest thrust out in one direction, extended leg thrust out in the other direction? The answer, of course, is balance. The dancer has instinctively calculated bodily weight so it is dispersed and balanced perfectly around the supporting leg.

If our bodies were not balanced in standing and walking and running, we would topple over. We have an innate desire for balance and stability. Maybe that is why we seek balance in a work of art, why we feel threatened by instability when balance is absent. *Actual weight*, physical weight in pounds, is important in some types of art, such as sculpture and architecture. All art, however, must deal with the concept of *visual weight*. Visual weight refers to the apparent "heaviness" or "lightness" of forms arranged in a composition. When two sides of a flat composition have the same visual weight, the composition is in balance. Let us see how this works by considering the three types of balance—symmetrical, asymmetrical, and radial.

SYMMETRICAL BALANCE

Symmetry in art means that forms in the two halves of a composition—on either side of an imaginary vertical dividing line—correspond to one another in size, shape, and placement. Sometimes the symmetry is so perfect that the two sides of a composition are mirror images of one another; more often the correspondence is very close but not exact—a situation some writers have called *relieved symmetry*. In either case we consider the composition symmetrically balanced. Since the two sides are identical or nearly so, they have the same visual weight, and therefore they are balanced. The Matisse collage (**168**) is symmetrically balanced; if you were to fold this image down the middle and match the two sides, they would fit almost exactly. Except for color variations, the forms on one side of the center axis correspond to those on the other side.

168. Henri Matisse. *Large Composition with Masks.* 1953. Collage, paper on canvas; 11'7¼" × 32'8½". National Gallery of Art, Washington, D.C. (Ailsa Mellon Bruce Fund, 1973).

Henri Matisse
1869–1954

How ironic it is that Matisse, of all people, should have provoked a critic to call him a "wild beast," for, while his art may indeed have seemed a bit wild at first, the artist himself could scarcely have been less so. Cautious, reserved, cheerful, a hard worker, a dedicated family man, frugal, painstaking—these are the qualities that describe Matisse. His longtime friend and rival Picasso captured more of the headlines, but the steadfast Matisse created art no less innovative and enduring.

Matisse's father intended him to be a lawyer, but a bout of appendicitis at the age of twenty-one changed his life—and changed the course of all modern art. Henri's mother bought him a box of paints as a diversion, and, for once, Matisse reacted strongly. Much later he said of this experience, "It was as if I had been called. Henceforth I did not lead my life. It led me."[1]

Matisse enrolled at the Ecole des Beaux-Arts in Paris and studied with the painter Gustave Moreau, a brilliant teacher who is said to have told his young pupil, "You were born to simplify painting." After a period of experimentation in various styles, Matisse burst onto the Parisian art scene at the Salon d'Automne (autumn salon) in 1905, when he exhibited, along with several younger colleagues, works of such pure, intense, and arbitrary color that a critic labeled the artists *fauves*—wild beasts. In these early years Matisse did not fare much better with the general public. However, he had the good fortune to attract the attention of certain wealthy Americans who have achieved fame as inspired collectors, including the Stein family (Gertrude and her brothers) and the eccentric Cone sisters of Baltimore.

Considering the period in which he lived, encompassing two world wars, Matisse kept himself remark-ably outside the fray. His art did not touch upon politics or social issues. Throughout his life, his favorite subjects remained the human body (usually a beautiful female body) and the pleasant domestic interior. The joys of home life, of family, of cherished objects dominate his expression. In 1898 Matisse married Amélie Parayre, with whom he maintained a contented relationship for many years. Mme. Matisse was lovely, a willing model, charming and lively, and devoted to her husband's career. Their three children all chose art-related lives, Pierre becoming a prominent art dealer in New York.

We think of Matisse as a painter, but he worked in many fields—sculpture, book illustration, architectural design (of a small, jewel-like chapel near his home), and finally in *découpage*. By the early 1930s Matisse had begun to use cut-up paper as a means of planning his canvases, and a decade later the cut paper had become an end in itself. When he was very old and could no longer stand at his easel, Matisse sat in his wheelchair or in his bed, cutting and arranging segments of pre-painted paper into compositions, some of mural size.

Perhaps it was at the end that he came nearest to his goal: "What I dream of is an art of balance, of purity and serenity, devoid of troubling or depressing subject matter, an art which might be for every mental worker, be he businessman or writer, like an appeasing influence, like a mental soother, something like a good armchair in which to rest from physical fatigue."[2]

Henri Matisse,
photographed by Robert Capa.

Symmetrical balance served the artist Frida Kahlo with exceptional force in *The Two Fridas* (**169**), for she used it to express the warring duality of her own nature. Kahlo was born in Mexico in 1907, the child of a Hungarian/Jewish father and an Indian/Spanish mother. These two influences—the European and the Mexican—coexisted uneasily in her psyche and her art as long as she lived. We might almost say that Frida Kahlo was Siamese twins who didn't get along. *The Two Fridas* shows this graphically. At left is the "European Frida," dressed in an elegant white gown; at right, the "Mexican Frida" wears a costume suited to that country's natives. Both have their hearts exposed in gory anatomical detail, with veins connecting them. The Mexican Frida holds a tiny portrait of the artist Diego Rivera, to whom Kahlo was married. The European Frida snips the vein connected to the portrait, allowing blood to fall on her skirt. This picture's symmetrical format gives a chilling interpretation to the double identity of its maker.

The symmetrical balance in Paul Gauguin's *Day of the God* (**170**) is a little more subtle, but it is nonetheless clear when we study the painting. Here the

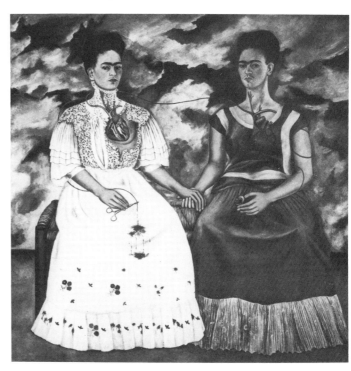

right: 169. Frida Kahlo. *The Two Fridas.* 1939. Oil on canvas, 5′8½″ square. Museo de Arte Moderno, Mexico City.

below: 170. Paul Gauguin. *Day of the God (Mahana no Atua).* 1894. Oil on canvas, 27⅜ × 35⅝″. Art Institute of Chicago (Helen Birch Bartlett Memorial Collection).

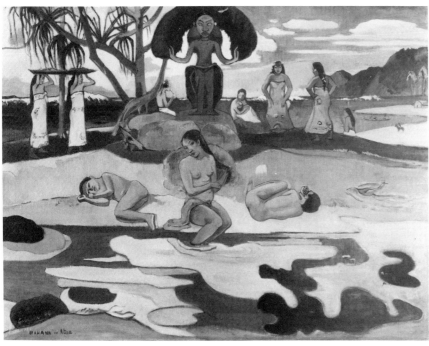

"god" is centered at the top of the composition, with the main figure directly below flanked by two curled-up reclining bodies. In the background paired figures stand at either side of the god. These major forms establish the symmetry and therefore the essential balance.

When you stand with your feet flat on the floor and your arms at your sides, you are in symmetrical balance. But if you thrust an arm out in one direction and a leg out in the other, your balance is asymmetrical (*not* symmetrical). Of the two, asymmetrical balance is often considered to be the more dynamic.

ASYMMETRICAL BALANCE

An asymmetrical composition has two sides that do not match. If it seems to be balanced, that is because the visual weights in the two halves are very similar. What looks "heavy" and what looks "light"? Unfortunately, there are no mathematical formulas to follow. The drawing (**171**) illustrates some very general precepts about asymmetrical or *informal balance:*

1. A large form is visually heavier than a smaller form.
2. A dark-value form is visually heavier than a light form of the same size.
3. A textured form is visually heavier than a smooth form of the same size.
4. A form placed close to the central axis may be visually heavier than a similar form placed near the outer edge of the composition.
5. Two or more small forms can balance a larger one.
6. A smaller dark form can balance a larger light one.

These are only a few of the possibilities. Keeping them in mind, you may still wonder, but how does an artist actually go about balancing a composition? The answer is unsatisfactory but true: The composition is balanced when it looks balanced. An understanding of visual weights can help the artist achieve balance or see what is wrong when the balance doesn't work, but it is no exact science.

A fairly straightforward example of small forms balancing a large one (#5 in the drawing) can be found in Paul Klee's *Costumed Puppets* (**172**). The single

171. Sketch showing some of the different factors in visual balance.

left: **172.** Paul Klee. *Costumed Puppets.* 1922.
Ink on paper, mounted on board; $9\frac{1}{2} \times 6\frac{3}{4}''$.
Solomon R. Guggenheim Museum, New York.

above: **173.** Photographic postcard. Early 1900s.
Gotham Book Mart Collection.

large form to right of the center axis is offset by two smaller forms at the left. Because Klee was a brilliant draftsman and designer, the balance does not seem static. The lower small figure curves in toward center, and Klee's endlessly inventive pen line animates the entire composition.

A photographic postcard from the early 1900s (**173**) has much more complicated balance, involving placement, size, value, and several other variables. The man sitting just to the right of the center axis provides most of the visual weight in the right side of the composition. Not only is he the largest form and placed close to the center axis, but he is a human being. People attract our attention, thereby gaining a lot of visual weight. To balance this weight on the right, the photographer has made the crescent moon (a large form and light value) curve upward on the left side and also placed the flag on the left. The hat perched on the tip of the crescent is crucial; it finishes the perfect balance. Our eyes are drawn to it immediately because, after all, it's rather silly to have a hat on the point of a moon. If you put your finger over the hat, you'll find that the balance is upset and the composition tilts to the right.

An equestrian sculpture from Africa also reveals an elegant asymmetrical balance (**174**). The upraised horse's head and longer front legs balance the form of the rider, who is mounted very far to the rear. Obviously, the Mali sculptor who made this figurine knew that horses do not have much longer front legs, that people do not have arms twice the length of their legs, and that riders do not sit

174. *Equestrian Figure,* Prim-African, Dogon tribe, Mali. Wood, height $27\frac{1}{8}''$. Metropolitan Museum of Art, New York (Michael C. Rockefeller Memorial Collection, bequest of Nelson A. Rockefeller, 1979).

175. Albrecht Dürer.
Reclining Female Nude
(Proportion Study). 1501.
Pen and brush on green paper,
$6\frac{3}{4} \times 8\frac{5}{8}$". Albertina, Vienna.

just over the horse's tail. These features have been adjusted and stylized to create a sculptural balance.

At first glance we might think that Dürer's *Reclining Female Nude* (175) is out of balance. Nearly the whole figure, and most of its bulk, lies in the right half of the composition. But the subtitle, *Proportion Study*, gives us a clue to Dürer's intent. He was undoubtedly studying not only the proportions of the human body but also the placement of a figure within the picture space. The figure gazes to the left, and we, as observers, follow her gaze. Thus we find a center of interest in the left side of the drawing when nothing is there! In our minds we fill in the blank of whatever the woman is looking at. This is not imbalance but a daring balance created by conceptual rather than visual cues.

left: 176. Mt. Pleasant,
Philadelphia. c. 1761.

right: 177. Michael Moyers.
Vacation house, near Dunsmuir,
Calif. 1970s.

Balance in architecture has special importance because of the size of the object. Any flaws in balance will be greatly enlarged and evident to all passersby. Moreover, unlike a painting or sculpture or print, architecture often changes over the years, especially the architecture of houses. A wing may be added, a garage tacked on, a porch removed. With any such changes the balance of the whole structure must somehow be maintained.

Like any other work of art, a building can be balanced symmetrically or asymmetrically. The two houses illustrated here show these different approaches. An 18th-century Philadelphia mansion in the style known as "Georgian" (**176**) is absolutely symmetrical. The entrance opens precisely in the middle of the façade, and windows, chimneys, and all other architectural details are paired on the two sides. Symmetrical balance is thought to give a building stateliness and quiet grandeur. For this reason it has been, and sometimes still is, used for official government buildings. Even a small house seems dignified when its balance is symmetrical.

By contrast, a vacation house in California (**177**) was designed with dramatic, exciting asymmetry. Part of the reason for this was functional. The house is set on a very steep slope; any symmetrical design probably would have seemed *un*balanced against the slant of the hill, so the architect has considered the landscape as a factor in the design. In this photograph the mass of the facade juts out to the left, and this thrust is counterbalanced by that of the stairway/deck to the right. Asymmetrically balanced structures may seem less formal and more dynamic than symmetrically balanced ones.

We said at the beginning of this discussion that an artist may choose deliberately to violate the principles of design. Occasionally, asymmetrical balance may be carried to such an extreme that the composition appears unbalanced. We find this often in the work of Chinese and Japanese painters. Nonomura Sotatsu's *Zen Priest Choka* (**178**) shows the priest perched in a tree that barely makes it into the composition. In oriental art as much importance may be placed on what

178. Nonomura Sotatsu. *Zen Priest Choka.* Late 16th–early 17th century. Hanging scroll, ink on paper; $37\frac{3}{4} \times 15\frac{1}{4}''$. Cleveland Museum of Art (purchase, Norman O. Stone and Ella A. Stone Memorial Fund).

179. Ilia Chashnik. *Floating Suprematist Forms.* 1922. Watercolor, 29 × 20⅞". Courtesy Leonard Hutton Galleries, New York.

is *not* there as on what is there. The empty space to the right and below may be visually empty, but it is animated by the daring unbalanced design. In looking at this work we feel a tension, a lack of resolution or closure. Imbalance might be compared to someone's starting a story "Once upon a time . . . ," but never getting to ". . . and they lived happily ever after." We are left feeling keyed up, still waiting for something else to happen.

Another painting (**179**), this one by a Western artist, is balanced (asymmetrically and perfectly) from left to right, but it seems unbalanced vertically. Nearly all the forms appear in the top half of the composition. This is the reverse of what we expect. We are used to gravity, to heavy things being down. In most works of art of all kinds you will find the greatest weight—visual or actual—toward the bottom, so that the composition is firmly rooted in the ground. Ilia Chashnik's watercolor catches us, quite literally, off balance. We get a sense of the rectangular shapes falling continuously. The forms never actually fall, of course, but against all reason we feel that they are doing so. By using imbalance artists are able to make us see movement where none exists.

RADIAL BALANCE

There is a third possibility for balance, which is more common in architecture and the crafts than in the pictorial arts. Radial balance means that elements in the composition radiate outward from a central point. A frequent expression of this is the architectural dome (**180**). The dome of the Baptistry in Ravenna, Italy, has the scene of Christ's baptism in the center with the twelve Apostles arranged in a radial pattern around the outside. Radial balance works especially well with a circular format, and it nearly always focuses attention on the central point.

180. *Baptism of Christ and Procession of Twelve Apostles*, dome mosaic. c. 520. Arian Baptistry, Ravenna.

Emphasis and Focal Point

Emphasis means that the viewer's attention will be centered more on certain parts of a composition than on others. A focal point is a specific spot to which one's attention is directed. Our everyday perception is structured around focal points. Walking down a crowded street, we naturally pick out from the throng the person who is dressed bizarrely; the one person who is exceptionally tall; the person who is waving to attract attention. Not all works of art have a focal point—Warhol's *Soup Cans* does not—but the vast majority do have areas of greater emphasis and one or more focal points. Without them, the composition might seem bland and repetitive.

There are numerous methods by which an artist can create a focal point or center of emphasis in a work of art. Grant Wood used several of them in his painting *Parson Weems' Fable* (**181**). The fable in question is the story of a young George Washington chopping down the cherry tree, then admitting to the evil

181. Grant Wood. *Parson Weems' Fable*. 1939. Oil on canvas, 3'2⅜" × 4'2⅛". Amon Carter Museum, Fort Worth.

deed because he "could not tell a lie." Although the boy George is one of the smaller elements in the picture, we have no doubt that he is the center of interest. For one thing, Wood has employed strong directional lines. George's father gestures directly at the boy, and Parson Weems' pointing finger also carries our attention to him. Moreover, the curve of the drapery at right and the opposing curve of the half-chopped tree frame little George between them. In case we still miss the point, the artist has placed George almost precisely in the middle of the composition and given him a white shirt—the lightest value in the painting. (Although this has little to do with emphasis, we might notice for fun that Wood has painted George's head like that of a full-grown man, the Father of his Country, and put that venerable head atop the body of a boy caught red-handed.)

Another device for creating emphasis is the manipulation of light. We see this in Artemisia Gentileschi's painting of *Judith and Maidservant with the Head of Holofernes* (**182**). In this work light is used much as it would be in the theater, to spotlight attention. Gentileschi took her subject from the biblical story of Judith. According to the Scripture, Judith, a pious and beautiful Israelite widow, volunteered to rescue her people from the invading armies of the Assyrian general Holofernes. Judith charmed the general, accepted his invitation to a banquet, waited patiently until he drank himself into a stupor, then calmly beheaded him, wrapped up his head in a sack, and escaped. In the painting the light, apparently coming from a single candle, focuses attention on Judith's upraised hand and on the other arm holding the sword. The gory deed is done, and Judith signals for silence and caution, so she can flee with Holofernes' head.

Both directional lines and light create the focal point in Francisco de Goya's *Executions of the Third of May, 1808* (**183**). The event Goya depicted was the invasion of Spain by Napoleon's armies and their savage execution of Spanish resisters. Our interest is centered on one heroic but doomed Spaniard, his arms raised in a pose of crucifixion. This tragic figure is bathed in light, while

[handwritten margin notes: implied lines / framing with shapes / position / value]

182. Artemisia Gentileschi.
Judith and Maidservant with the Head of Holofernes. Early 1620s.
Oil on canvas, 6'1½" × 4'7¾".
Detroit Institute of Arts
(gift of Mr. Leslie H. Green).

above: **183.** Francisco de Goya.
Executions of the Third of May, 1808.
1814–15. Oil on canvas, 8'9" × 13'4".
Prado, Madrid.

right: **184.** Anna Mary Robertson
("Grandma") Moses.
Hoosick Falls, N.Y., in Winter. 1944.
Oil, 19¾ × 23¾". Phillips Collection,
Washington, D.C.

most of the rest of the painting remains in shadow. Moreover, the faceless figures of the soldiers point their rifles at him, and even the stance of their bodies focuses our attention on the victim. Goya's sympathies clearly lay with the killed, not the killers. He therefore chose to emphasize the poignant sacrifice of one man, to deemphasize the mechanical slaughter by the others.

Emphasis by placement is evident in Grandma Moses' painting, *Hoosick Falls, N.Y., in Winter* (**184**). In this tranquil town landscape Grandma Moses has chosen to emphasize the locomotive of the train steaming across the picture. To accomplish this, she has placed the locomotive just on the bridge crossing the

Francisco de Goya
1746–1828

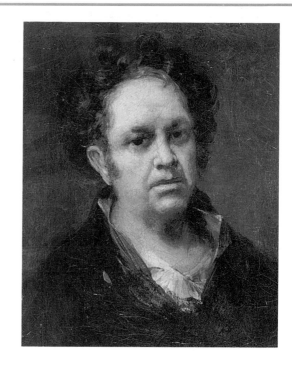

Writers on Goya have long been fascinated by the close friendship between him and the Duchess of Alba, the powerful aristocrat whom many considered the most beautiful woman of her time in Spain. It is a measure of this artist's complexity and uniqueness that the haughty duchess should form a special bond with one who emerged from quite humble origins, whose temperament was often morose and reclusive, and whose imagery could be shockingly gruesome.

Francisco José de Goya y Lucientes was born in a village in the bleak northeast section of Spain. While a young man Goya may have supported himself partially as a bullfighter, but this is one of many unverifiable stories about his intriguing life. By the age of twenty he was in Madrid.

Goya's earliest commissions were for church murals and tapestry cartoons. In 1783 he was launched in one of the two artistic arenas for which he is best known—portraitist to the nobility. Within a few years he was active at the royal court, and in 1799 he was appointed court painter to Charles IV, King of Spain. Some of Goya's portraits, including two of the Duchess of Alba, are exquisitely lovely; others have a darker side to them. According to some critics, Goya's pictures of the royal family, while appearing to flatter, were actually subtle revelations of the subjects' greed, stupidity, and corruption.

Goya's other major field of expression was prints, of which he was an unexcelled master. Two major series, each having about eighty images, constitute the bulk of his work: *Los Caprichos*, in which the many follies of human nature are satirized; and *The Disasters of War*, an often brutally explicit catalogue of the cruelties prevalent in wartime.

Goya achieved both fame and financial success relatively early. While his career prospered, however, his personal life was repeatedly marked by tragedy. His marriage to Josefa Bayeu seems to have been more of a convenience than a passion. She bore him many children—perhaps as many as twenty—but only one survived to maturity. In 1792 the artist was struck by a severe illness that left him almost totally deaf. Another near-fatal illness in 1819 increased his isolation and pessimism; Goya bought a home outside Madrid, known as La Quinta del Sordo ("The House of the Deaf Man"), to which he retired and painted a series of works known as the "Black Paintings," for their dark tonality and aura of despair. After all, the artist's relationship with the Duchess of Alba, whatever it might have been (some maintain that they were lovers), seems to have been one of few bright periods in his life.

Goya's education was sketchy, and as an adult he read and wrote with some difficulty. An announcement for *Los Caprichos* probably was written with the help of a friend, but it captures Goya's attitude toward his art: "Painting, like poetry, selects in the universe whatever she deems most appropriate to her ends. She assembles in a single fantastic personage circumstances and features which nature distributes among many individuals. From this combination, ingeniously composed, results that happy imitation by virtue of which the artist earns the title of inventor and not of servile copyist."[3]

Francisco de Goya. *Self-Portrait*. 1815.
Oil on canvas, 18⅛ × 15¾"
Prado, Madrid.

river, with the pale tone of the water acting as a contrasting background. The horseshoe curve of the river also helps to direct our attention to the train.

A variation on emphasis by placement is emphasis by isolation. Kliban's Fourth of July parade of cats (**185**) has row upon row of cats in scout kerchiefs marching before a line of spectators, indicated only by their feet. One cat (the Catmaster?) is isolated from the others against a white background, and this leader immediately becomes the focal point of the cartoon.

Emphasis by contrast works much the same way. Contrast can mean any obvious distinction—dark against light, big against small, textured against smooth, color against gray. Marc Chagall's painting *Woman, Flowers, and Bird* (**186**) is done almost entirely in a neutral bluish gray, with touches of white and pale green leaves at the center. There are only two spots of vivid color, the two bright pink flowers, and they attract our attention immediately. This painting is interesting, however, in that the colorful flowers are *not* the main focal point, although they are certainly areas of emphasis. In effect, they are "assistant" focal points. They claim our interest and direct it toward the area they frame—the woman's face, the real focal point of the picture.

Finally, we should mention emphasis by content. Regardless of other focal devices employed by an artist, certain visual images, when included in a composition, will draw the viewer's attention. Blood and gore attract attention; anything shocking or surprising will act as a focal point. In a figural work the face is nearly always the major focal point, because we are used to looking at people's faces rather than their elbows or hips. And in general, as mentioned earlier, the human figure will tend to draw the viewer's eye.

above: 185. B. Kliban. "July" page from the 1982 Cat Calendar. Copyright © B. Kliban.

right: 186. Marc Chagall. *Woman, Flowers, and Bird.* 1952–53. Gouache, $25\frac{3}{4} \times 19\frac{7}{8}''$. Stedelijk Museum, Amsterdam.

Proportion and Scale

Proportion and scale both have to do with size. Sometimes the two words are used interchangeably, but there is a difference. *Scale* means size in relation to some constant or "normal" size. For example, a model airplane is small scale in relation to a real airplane, or to the usual size for an airplane. *Proportion*, on the other hand, refers to size relationships between parts of a whole, or between two or more people or objects perceived as a unit. When we see a skyscraper next to a two- or three-story apartment house, we always notice, because the two seem out of proportion to one another. René Magritte played with this idea in *La Folie des grandeurs* (**187**). The three sections of the nude torso are in different proportions, so they do not fit together at all. Magritte, of course, used this jarring disproportion on purpose to create a startling image.

There are many reasons an artist may choose to violate normal proportions in a work of art. In Morris Hirshfield's *Boy with Dog* (**188**), for instance, the disproportion was undoubtedly made to serve decorative purposes. Hirshfield, known as a folk or "naive" painter, relished decorative pattern. Here the boy's dog, even if it is a toy poodle (though it looks a bit like a miniature horse), is much too small in relation to the boy. And the boy's arms, hands, and feet are far too small for his body. Yet there is a pleasing sense of flow in the figures of the boy and dog—a flow that echoes the rhythm of the wave-like background. The boy's tiny right arm curves downward in an arc, is met by the opposing arc of the leash, and then again by the arc of the dog's body. From head to shoulder to tail we can draw a lovely, undulating S-curve—all of which is mirrored in the background. Similar curving lines move from the boy's hair down through the shirt and coat tails to the legs, and terminate gracefully in the boy's minute feet. If the proportions had been accurate, this decorative effect would have been lost.

below: 187. René Magritte. *La Folie des grandeurs.* 1948. Oil on canvas, 39⅛ × 32⅛". Hirshhorn Museum and Sculpture Garden, Smithsonian Institution, Washington, D.C. (gift of Joseph H. Hirshhorn Foundation, 1972.)

right: 188. Morris Hirshfield. *Boy with Dog.* 1945. Oil on canvas, 32 × 23". Courtesy Sidney Janis Gallery, New York.

Disparate proportions can also indicate status—of a religious or political figure, for instance. According to this system, sometimes known as *hierarchical proportioning*, the more important a figure is, the larger will be its size relative to others in the composition. In the watercolor of the *Tathagata Buddha* (**189**), the figure of the Buddha is much larger than the surrounding personages because the Buddha is the most important element in the composition. This work is meant to be symbolic and reverential, not naturalistic, so the disproportion seems fitting.

Our first three illustrations in this section have shown proportions that are "wrong"—that is, proportions that seem inappropriate, based on our experience of the natural world. In a sense, it is easier to understand the usual applications of proportion by studying the *un*usual, the exceptions. But most artists, most of the time, seek to find the "right" proportions for their work, and the great majority of illustrations in this book have proportions that seem harmonious, seem to mesh with our impressions of the natural world.

Since the time of the ancient Greeks people have been seeking the "ideal" proportions in art. Much classical Greek figure sculpture was based on a *canon*, or set of rules, of ideal proportions in which the figure's head was to be one-eighth of the total height, the width of the chest one-quarter of the total height, and so on (**190**). (These proportions would remain the same regardless of the figure's scale.) Similarly, in Greek architecture, vase-making, and presumably painting, proportions derived from what is known as the *golden section*, or *golden mean*. Algebraically, the golden mean (**191**) says that a:b = b:(a + b). If *a* is the width of a temple and *b* is its length, then the ratio of width to length should be the same as the ratio of length of width-plus-length. For those not mathematically inclined, we can translate this formula into an example. Suppose you want to build a house, and you want it to be 40 feet wide. How long should the house be to fit the "ideal" proportions of the golden section? The answer is about 65 feet. Your house would end up being a rectangle rather like the one shown in the drawing (**191**).

left: 189. *A Tathagata Buddha*, from Tibet. 13th–14th century. Opaque watercolors on cloth, $36\frac{1}{4} \times 26\frac{7}{8}''$. Los Angeles County Museum of Art (Nasli and Alice Heeramaneck Collection, Museum Associates Purchase).

right: 190. *Poseidon* or *Zeus*. c. 460–450 B.C. Bronze, height 6'10". National Museum, Athens.

below: 191. Sketches of proportions in the Golden Section.

For mathematicians the golden section, sometimes known as *phi*, has far-reaching implications. The illustration (**191**) shows that every time you cut off a square from one end of a golden rectangle, you are left with another golden rectangle, and so on indefinitely. For the artist, as the Greeks knew 2,500 years ago, the golden section "feels right," and to the viewer it "looks right." Many objects in our daily life approximate the golden section in their proportions. The standard 3 × 5 index card is an almost perfect golden rectangle, and the standard playing card comes close. If you were to measure the illustrations in this book, you would find that a large number of them approach the golden mean in their dimensions. Piet Mondrian, that most precise and mathematical of artists, worked within a perfect golden rectangle for his *Composition with Red, Yellow, and Blue* (**117**). Even the so-called "motel art" we discussed in Chapter 2 (p. 36) holds close to the golden mean in its typical 2 × 3 format. Whatever the reason, this proportion is one we find inherently pleasing and satisfying.

above: **192.** Nicholas Africano.
Whiskey per tutti! 1980–81.
Oil, acrylic, and Magna
on enamel on Masonite; 4 × 7'.
Courtesy Holly Solomon Gallery,
New York.

left: **193.** Pieter Bruegel the Elder.
Wedding Dance. c. 1566.
Oil on panel, 3'11" × 5'2".
Detroit Institute of Arts
(City of Detroit Purchase).

Proportion and scale must be considered together because they nearly always operate simultaneously. A painting that is, say, 10 feet by 15 feet is certainly large-scale; it is larger than most of the paintings we have seen. We must also take into account, however, where the painting is to be hung. If it is hung in a small house, it will be out of proportion to its surroundings. But if it is hung in a huge auditorium, the proportions may be just right.

Scale and proportion can work side by side *within* a work of art. The figures in Nicholas Africano's *Whiskey per tutti!* (**192**) and the figures in Pieter Bruegel's *Wedding Dance* (**193**) are all small scale. If you were standing in front of the actual paintings, the figures would be just a few inches tall. The proportions in the two paintings, however, are quite different. Africano's little people are set in a huge, almost empty canvas, so they seem tiny and lost. They are out of proportion to the field they inhabit. Bruegel's painting has many figures, arranged to fill the composition, so its proportions seem perfectly normal. The reason for this discrepancy lies in the different intents of the two artists. Bruegel was drawing a naturalistic festive scene. Africano is aiming at a grand theatrical image, a vision of tiny people lost on an enormous opera stage.

Rhythm

People who are totally deaf can learn to dance. No one is quite sure how they keep time when they cannot hear the sounds, but they do. Apparently, they have some perception of rhythm that is independent of aural cues. All of us are accustomed to rhythm in music, in dance, in poetry (where it is called meter), and in many other aspects of life. Intuitively, we seek this rhythm in the visual arts.

Visual rhythm depends upon the repetition of accented elements, usually shapes. In Edward Hopper's *Early Sunday Morning* (**194**) we find several different rhythms moving horizontally across the canvas (**195**). At top there is the rhythm of the eaves under the roof, and below that the strong rhythmic pulse of

194. Edward Hopper. *Early Sunday Morning.* 1930. Oil on canvas, 2′11″ × 5′. Whitney Museum of American Art, New York.

195. Sketch of the visual rhythms in Hopper's *Early Sunday Morning.*

left: **196.** Piet Mondrian. *Composition in Blue B*.
1917. Oil on canvas, 24 × 19″.
Rijksmuseum Kroller-Müller,
Otterlo, The Netherlands.

below: **197.** Vincent van Gogh. *The Starry Night*.
1889. Oil on canvas, 29 × 36¼″.
Museum of Modern Art, New York
(acquired through the Lillie P. Bliss Bequest).

198. Pat Steir. *Yellow Chrysanthemum.* 1981.
Oil on canvas, 5′ × 6′8″. Private collection, New York.

the second-story windows alternating with plain wall. At bottom the rhythm of the repeated storefronts counters the two patterns above. Although this is a very repetitive rhythm, we do not find it boring, because there is enough variation of color and light to create interest. The two focal points of fire hydrant and barber pole punctuate the rhythm.

The rhythm in Piet Mondrian's *Composition in Blue B* (**196**) is sharp and staccato. Rectangles of color, many of them overlapping, intersperse with smaller black rectangles that act as weaker beats in the pulse. There is so much energetic movement in this composition that it could almost be set to music.

Rhythm is crucial to Van Gogh's *Starry Night* (**197**)—a swirling, swooping rhythm made up of both the pattern of lighted forms and their frenzied circular motion. An important function of rhythm in art is that it keeps the viewer's eye moving through the composition. Nowhere is this more evident than in *The Starry Night.* Our eyes follow the tumbling shapes up, around, down, and back again in a constant motion. Even the vertical tree form at left participates in this, as it carries the eye upward to start the roller-coaster ride all over again.

As in music, there are different kinds of rhythm in the visual arts. One is simple repetition of regular beats, visible in Hopper's painting. Another is alternating rhythm—stronger beats alternating with weaker ones, as in Mondrian's painting. Van Gogh's *Starry Night* has a circular rhythm. Yet a fourth type of rhythm is *progression.* Progression means that the visual beats gradually increase (or decrease) according to a definite pattern. We see this in Pat Steir's *Yellow Chrysanthemum* (**198**). Steir's triptych (three-part work) is obviously meant to be "read" from left to right. Moving our eyes across the canvas, we almost cannot help but think "flower . . . FLOWER . . . FLOWER!" The composition climaxes at right with a giant close-up chrysanthemum, much as a symphony might climax with full sound and all the instruments playing.

Elements and Principles:
A Summary

In this chapter and the preceding one we have focused one by one on the elements of art and principles of design, isolating each for individual scrutiny. Every member of the ensemble, so to speak, was brought before the curtain and allowed to take a separate bow. Now, to finish this section, we should put the actors back together, reunite the company into a performing unit. By analyzing one work of art in some detail, we can begin to see how the elements and principles interact. It should become clear that we cannot easily talk about one ele-

199. Pablo Picasso. *Girl Before a Mirror.* 1932. Oil on canvas, 5′3¾″ × 4′3¼″. Museum of Modern Art, New York (gift of Mrs. Simon Guggenheim).

ment or principle without involving several of the others. The painting we will analyze is Pablo Picasso's *Girl Before a Mirror* (**199**).

In *Girl Before a Mirror* a young woman—probably inspired by Picasso's lover at the time, Marie-Thérèse Walter—contemplates her nude image in a mirror (at right) just at the time when she is reaching maturity and realizing her sexual and childbearing capabilities. The reproductive organs are therefore prominent in the image. This is a very brief summary of the painting's content. Now let us consider its visual design.

Unity is achieved in several ways, including the dominance of curved lines (**200a**). The straight lines, horizontals and diagonals (**200b**), serve as a kind of background "filler" to the large swooping curves, and they also provide linear variety. Unity of shape is particularly important to this work; the circle motif— be it face, breast, womb, or buttock—recurs in a rhythmic pattern (**200c**). The concept of unity with variety becomes clearer when we put together the straight lines and curved shapes (**200d**).

Colors are brilliantly varied, but they fall generally in the same range of values and intensities, thus contributing unity. A skeleton of dark, almost black values in both shape and line provides the structure on which the whole picture is "hung" (**200e**), much as the human body is hung on its bony skeleton.

The balance of *Girl Before a Mirror* is predominantly symmetrical (**200e**). Picasso has even provided a vertical line in the center of the composition to divide the two halves. Subtle differences between the girl's body and her mirror reflection enliven and relieve the symmetry. There is almost a pendulum effect as our eyes shift back and forth rhythmically between one side and the other—a pendulum effect enhanced by the curve of the arm.

There are several areas of emphasis in *Girl Before a Mirror*, most of which can be found in the shapes painted with the lightest values (**200f**). Also, the two faces—the light face of the girl and the darker and more menacing one of the reflection—are emphasized by their colors, their placement, and simply by the fact that they *are* faces. Secondary areas of emphasis are the reproductive organs below, shown in a kind of X-ray vision, which gain emphasis by their brightness and by the repetition of the round form. Even with these areas of emphasis, however, it should be borne in mind that the background of this painting is almost as important as the figures. There is no "dead" space, no area of rest for the eyes; every inch of the canvas is important to the artist's expression.

In scale the *Girl Before a Mirror* is rather large, but not unusually so. The proportions are more interesting. Picasso has filled almost the entire space of the composition with the two figures; they jam the picture space from top to bottom and left to right. Also interesting are the proportions of shapes to one another.

200. Linear analyses of Picasso's *Girl Before a Mirror*.

Small circles and ovals play off against larger and larger circles, to the oval of the mirror image.

Finally, we have alluded before to the rhythms in this work—the rhythm of echoing curved lines, of repeated circular forms, of the pendulum swing from side to side (**200g**). Besides the pendulum swing, there is a figure-eight rhythm that swoops us through the two figures. By introducing these rhythms Picasso has made what might have been a static image—a girl facing a mirror in a flat space—assume qualities of almost dancelike grace.

Picasso had no program when he painted *Girl Before a Mirror*. He did not stand before his easel with a checklist and make sure that all the visual elements had been accounted for in the proper amounts of unity, variety, balance, scale, proportion, and rhythm. He *knew* what he was doing, but he would not have spelled it out in these terms. Being able to articulate the elements and principles does, however, help the viewer to better understand works of art, and to penetrate, a little, the genius of those who make them.

Observation and Criticism

Having considered the art elements and principles of design, we are now ready to formulate a slightly more detailed plan for seeing and criticizing art—for becoming an intelligent observer—than was outlined in Chapter 1. As before, the main point is to take a little time and pay more attention than usual to any new work of art you encounter. While you look, ask yourself the following questions and do your best to answer them. Some of the questions given below duplicate those listed in Chapter 1; others are based on increased art-critical skills you have gained from reading Chapters 2 through 5.

Naturally, you will not ask yourself every one of these questions about every single work of art, from pencil drawing to skyscraper. Rather, the questions are to be filed away in the back of your mind, to be called up as needed for a given situation.

1. Where does this work fit into the history of art? Does it remind me of any others I have seen, and in what way? Can I make any connection between this piece and others?
2. What do I know about the artist? Is there anything about his or her background that would influence my reaction to this work?
3. Does this work fall into any particular theme in the history of art? If so, how does it echo or contradict other works done in the same theme?
4. When and where was this work made? What else was going on in the world at the same time? What are the characteristics of the culture from which it emerges, and how does the work reflect those characteristics?
5. What is the form of this work? What is it made of, and how it is organized?
6. What is the content of this work? What do I know about its iconography? Is there a recognizable subject and, if so, how is that subject treated? Are there symbols, and can I decode them?
7. What are the most prominent art elements in this work? Lines? Shapes? Values? Colors? How do these elements influence my reaction to the work? How does the artist use space? What is the quality of the texture? Are time and motion factors in my appreciation of this work?
8. Does this work seem unified, and is there enough variety to sustain interest? How has the artist balanced the composition? What is the focal point or points, and how did the artist create them? What roles do proportion and scale play, and how are they handled? Do I sense a particular kind of rhythm?
9. Are the materials of this work important to its type of expression and its overall effect? Does the work seem well crafted? If so (or if not), does it matter?

10. What feelings, memories, or associations does this work evoke in me? Does it make me feel happy, angry, sad, frightened, disgusted, uplifted, inspired, depressed? Can I imagine the artist felt the same way? Do I feel any sense of kinship with the artist?

And finally:

11. Do I like it? Could I live with this art?

By answering these questions—or as many of them as seem applicable—about a new work of art you encounter, you give what every serious artist deserves: an intelligent, thoughtful, informed appraisal of the work. If, after such consideration, you don't like the work of art, that is nobody's business but your own. If you do like it, you have given something to yourself as well as to the artist—another small spot of satisfaction for your life. Indeed, you have enriched your own life.

ART PEOPLE
Claribel and Etta Cone

To the family of Helen and Herman Cone in the latter part of the 19th century were born thirteen children, ten boys and three girls. The boys were expected to go into business; the girls were expected to be sweet and demure and to make good marriages. One of the girls performed as anticipated. The other two—Claribel and Etta—were hardly demure, never married, and became, in time, the most endearingly eccentric collectors of art one could imagine. They are the extraordinary Cone sisters of Baltimore.

Claribel launched the sisters on the path of unpredictability in 1882, when she announced her desire to become a doctor—an almost unheard-of role for a woman at the time. She undertook studies at the Women's Medical College in Baltimore and earned her license. Dr. Claribel treated one private patient, declared that was sufficient, and never saw another.

Meanwhile, Etta proved equally unpredictable. A small event in 1896 set the stage for the Cones' lifelong adventure. The oldest Cone brother had given Etta $500 to enhance the family parlor, assuming she would buy rugs or furniture. Instead, Etta bought four shockingly modern paintings. It was a modest beginning, but the Cone sisters were on their way.

Soon after the turn of the century began the pattern of many long trips to Europe. Separately or together, Claribel and Etta traveled constantly. Often their base was Paris, where they had close contact with another noted pair of collectors, Gertrude and Leo Stein. It was the Steins who introduced them to two young, struggling, unknown artists: Pablo Picasso and Henri Matisse. With Gertrude Stein, Etta paid her first visit to Picasso's studio, which she found hopelessly cluttered. Drawings and watercolors littered the floor. Etta scooped up handfuls, chose two, and bought them for $20. Eventually the sisters would buy many Picassos, at ever-increasing prices, but their favorite was Matisse, who became a close friend. Bit by bit they amassed a world-class collection of his art.

As their tastes and financial resources expanded, the Cones bought works by Cézanne, Van Gogh, Degas, Gauguin, Chagall—virtually a catalogue of modern art. Always compulsive shoppers, they also invested heavily in antiques, textiles, and fine laces. These they shipped back to their apartments in Baltimore, which soon resembled a packed museum.

Dr. Claribel and Miss Etta were as remarkable for their personalities as for their collecting. Claribel, older by six years, always dominated the pair. A huge woman with a spellbinding manner of speaking, Claribel held forth in company while Etta kept to the background and attended to all the housekeeping details of their complicated lives. Their friends thought of Etta as the "wife." Both sisters dressed flamboyantly, usually in long black gowns topped with wildly colorful shawls and exotic jewelry. Both also had a passion for food—high in quality, vast in quantity. This had the inevitable result, and, according to their great-niece, they had to be pushed in and out of taxicabs backwards with a special stick that had a carved hand on the end.

When Dr. Claribel died in 1929, she left her collection to Miss Etta, who kept it intact. At Etta's death twenty years later the joint collection went to the Baltimore Museum of Art. In 1949 it was valued at three million dollars. Now, of course, it is priceless.

left: Pablo Picasso. *Dr. Claribel Cone.* 1922. Pencil on paper, $25\frac{3}{16} \times 19\frac{1}{2}''$. Baltimore Museum of Art (Cone Collection).

right: Henri Matisse. *Miss Etta Cone.* 1931–34. Charcoal on wove paper, $27\frac{3}{4} \times 16''$. Baltimore Museum of Art (Cone Collection, formed by Dr. Claribel and Miss Etta Cone of Baltimore, Maryland).

part three
TWO-DIMENSIONAL MEDIA

6
Drawing

*E*verybody draws. There can scarcely be a person above the age of two who has never made a drawing. Many people take photographs, some paint, a few make sculpture, and a very few may even design a building. But everybody draws. You see a patch of wet sand at the beach, a dusty tabletop, or a blank note pad while you are sitting in class or at a business meeting—and your natural impulse is to draw something, even if it is only a stick figure.

Children begin to draw long before they begin to write, sometimes before they can talk intelligibly, and their drawings give us fascinating insight into the child's perspective on the world (**201**). In drawing far more than in speech, children reveal their fantasies and their fears. Whatever the content, nearly all children draw, which shows how truly universal is this method of expression.

Two qualities often associated with drawing are familiarity and intimacy. Drawing is familiar in that it uses the materials we are all accustomed to—the pencil, the pen, the stick of chalk. There are no mysterious or exotic ingredients. You can pick up a pencil and draw somebody's likeness on paper and so can a great draftsman like Ingres (**204**). Your drawing almost certainly will not look as good as his, but it is the same kind of expression.

Drawing seems intimate because it is frequently—although not always—the artist's private note-taking. Many drawings are not intended for exhibition and therefore are not shown publicly during the artist's lifetime. They may be preliminary sketches for some other work of art or just the artist's refined doodling. We think of such drawings as direct expression—from brain to hand—without the intervening censor of desired public approval. In looking at a sketch by Michelangelo (**202**), for example, we can speculate about what he was actually thinking as he drew those lines.

The drawing illustrated here is a notebook page showing studies for the ceiling paintings of the Sistine Chapel (**40**). When we look at the finished paintings, they seem so perfect that we cannot imagine the forms being any other way.

201. Bay Baxter, age 6½.
This Is Bay When She Is Grown Up.
1979. Colored pencils.

202. Michelangelo.
Arm Studies for the Lord,
and Studies for Angels
in the Creation of Adam,
preparatory drawings
for Sistine Chapel ceiling. 1511.
Red chalk over black chalk,
8⅜ × 11″. Teylersmuseum,
Haarlem.

It is almost as though the composition sprang fully realized from Michelangelo's brush. But, of course, it did not. The artist tried and rejected forms repeatedly, as this drawing demonstrates. Here he is testing various poses for the arm of God in the act of creating Adam, one of the best-known painted forms in Western art. Through the drawing Michelangelo becomes more human to us, as we watch him experimenting, correcting, playing with new shapes. Drawings give a clue to the often agonizing path of genius.

Other factors may contribute to drawing's sense of intimacy. Most drawings are relatively small (compared to paintings), and many are executed quickly. Drawings are often made in great quantities; some artists do hundreds

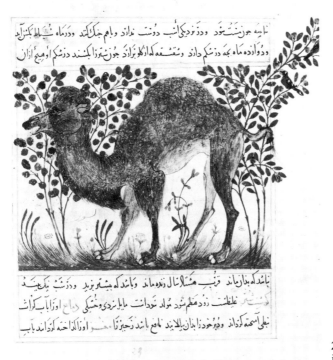

203. *Camel,* miniature
in a manuscript, from Persia.
1297–99. Pierpont Morgan
Library, New York.

of drawings for every "finished" work. There are exceptions to this generalization—drawings that are large and/or are executed with painstaking attention to detail, including several examples in this chapter (**204,206,209,210**). But part of the charm of drawing as a medium must surely be the fact that, even when a work *is* intended for exhibition, it still retains an air of intimacy.

We usually associate drawings with paper, but paper as we know it did not appear in Europe and the Western world until the 12th century. Before that, we must assume, people drew images on any available surface, and most of these drawings have been lost. The oldest artworks we know of are the cave drawings found in southern France and in Spain (**2**). (These images are often referred to as paintings, but many have a strong linear quality that would more accurately categorize them as drawings.) The artists who made the cave images worked directly on the stone walls of the caves; archaeologists speculate they drew the outlines either with mats of hair or with charred sticks, then filled in by blowing colors through a hollow pipe. Some 5,000 to 10,000 years after the cave drawings were done, nomadic peoples developed the technique of pottery making. A number of later cultures had strong pottery traditions, including the ancient Greeks (**459**) and the peoples of pre-Columbian Central and South America. The images drawn on ceramic vessels tell us much about the drawing styles of these artists.

According to legend, the Chinese invented paper in A.D. 105. Despite this, they continued to draw on silk, their special material. Other cultures worked on papyrus (a paperlike material made from pressed plant stems) or on parchment (treated animal skins). It was the Moslems who spread the knowledge of papermaking from the Orient to the West. The drawing of a camel (**203**), from a manuscript dated about 1299, shows a typical flat, decorative design, with stylized foliage filling and overlapping the background. The square, or enclosing picture frame, was a new idea to these artists and had not yet become an absolute boundary, so the design has been allowed to burst exuberantly outside its limits.

Nowadays, the artist who wants to make a drawing has a dizzying array of surfaces and materials to choose from. Some materials are ancient, while others depend on space-age technology. In this chapter we shall look first at the range of materials used for drawing and the effects each can produce. Then we will consider the unique linear characteristics of drawing. Finally, we will explore the various purposes for which a drawing can be made.

Materials for Drawing

Some artists draw almost exclusively in one favorite material, whereas others experiment widely and are eager to try each new medium that comes along. It would be difficult to say how much a choice of material influences the resulting work. Of course, the potential for expression comes from within the artist, not from any substance, but it is nevertheless true that different materials tend to produce particular effects. By "playing" with many tools and papers the artist may be inspired to create new types of imagery.

All drawing media (and, for that matter, all painting media) are based on *pigment*—coloring material in a neutral or some version of a hue that has been ground and mixed with a substance that enables it to adhere to the drawing surface. Drawing materials generally are divided into two categories—dry media and liquid media. The dry media tend to be abrasive. They "scratch" across a paper or other surface, depositing particles wherever they come in contact with the surface. Liquid media, in contrast, have particles of pigment suspended in fluid, so they flow onto the surface much more freely.

DRY MEDIA

Pencil The graphite pencil, sometimes called a "lead" pencil, probably has made more drawings than any other medium. Pencils are cheap, readily available, and easy to work with. Mistakes can be erased. If the drawing turns out badly, it can be thrown away at no great expense.

In spite of the pencil's humble status, however, some of the most sensitive, elegant drawings we know have been done with graphite pencil. The acknowledged master of this technique was Jean Auguste Dominique Ingres. In the work shown here (**204**) Ingres used the sharp point of a pencil to draw an exquisite portrait of a woman and her daughter. The figures are idealized—cool, pale, reserved, and aristocratic—and the delicate pencil line is perfectly suited for rendering this ideal.

Pencil can also be a warm medium, especially the colored pencils that some artists favor. David Hockney's portrait of *Marinka Nude* (**205**) exemplifies this quality; it is wonderfully vibrant. The artist has reserved his strongest colors for the model's hair and eyes, making her head the focal point. Marinka is naked and thus, we might think, exposed; but she holds her body primly, and her expression is very private. In Hockney's interpretation, the body, the chair, and the background all serve to focus attention on that compelling face.

Metalpoint Metalpoint, the ancestor of the graphite pencil, is an old technique that was especially popular during the Renaissance. Few artists use it now, because it is not very forgiving of mistakes or indecision. Once put down, the lines cannot easily be changed or erased. The drawing material is a thin wire of metal, often of pure silver (in which case the medium is called *silverpoint*), mounted in some kind of holding device, such as a wooden shaft or a modern mechanical pencil. The drawing surface must be specially coated with white poster paint or a similar ground—historically, the coating was bone dust and glue—and the lines produced by the metalpoint are thin and of uniform width.

Metalpoint drawings are characterized by a fine elegance, a finished perfection. Because of the thin, uniform lines it is somewhat difficult to model rounded forms, so artists often highlighted their drawings in white paint to enhance the illusion of depth, as in Perugino's magnificent *Man in Armor* (**206**). This drawing undoubtedly was meant to be a finished work, not a preliminary sketch. It is as carefully planned as any painting, in its subtle effect of gray line against lovely blue ground.

Charcoal Charcoal's effects are almost the exact opposite of those offered by metalpoint. Where metalpoint produces a thin, delicate line, charcoal's line is dark, sometimes very soft, occasionally harsh. Charcoal is actually burned sticks of wood—the best-quality charcoal coming from special vine wood heated in a

above: 204.
Jean Auguste Dominique Ingres.
Madame Reiset and Her Daughter. 1844.
Graphite pencil, 12 × 10½″.
Museum Boymans-Van Beuningen,
Rotterdam.

above right: 205.
David Hockney. *Marinka Nude.* 1977.
Colored pencil on paper, 17 × 14″.
© David Hockney, 1977.

right: 206. Perugino. *A Man in Armor.*
Late 15th–early 16th century.
Metalpoint, heightened with white,
on blue ground; 9¾ × 7¼″.
Windsor Castle, Royal Library.
© Her Majesty Queen Elizabeth II.

177

207. Honoré Daumier. *Fright.*
19th century.
Charcoal over pencil, $8\frac{1}{4} \times 9\frac{3}{8}''$.
Art Institute of Chicago
(gift of Robert Allerton).

kiln until only carbon remains. Charcoal lines can be thin or thick, pale to velvety black. If charcoal is used on a paper with a "tooth," or heavy grain, the results are textured. Honoré Daumier used charcoal to create the drawing called *Fright* (**207**). The undulating charcoal line and repeated form make the figure seem actually to be trembling in fear. No delicate medium could so easily have produced this chilling image.

Chalk and Crayon A wide range of chalks and crayons are available to the artist, and nearly all of them offer color effects. We consider them together here, because there is not always agreement among manufacturers or artists (or even textbook writers) about what to call a given product. Generally speaking, the main difference between chalks and crayons is the *binder*—the substance that holds particles of pigment together. Chalks have nonfat binders, whereas crayons have a fatty or greasy binder, so there is considerable variation in the way these materials react to contact with paper. If you imagine blackboard chalk and ordinary children's crayons, this difference should be clear.

Chalks and crayons vary in several characteristics. Artists need to experiment with specific products from specific manufacturers to find the effects they want. We can, however, make certain generalizations, bearing in mind they are

208. Georges Seurat.
Seated Boy with Straw Hat,
study for *Une Baignade.* 1882.
Conté crayon, $9\frac{1}{2} \times 12\frac{1}{4}''$.
Yale University Art Gallery,
New Haven, Conn.
(Everett V. Meeks Fund).

209. Dante Gabriel Rossetti. *Jane Burden.* 1858. Crayon, 17 × 13". National Gallery of Ireland, Dublin.

not hard-and-fast rules. Chalks, being drier and more crumbly, blend well and can be overlaid (two or more colors on top of one another) to produce shaded effects. They usually require a paper with some tooth, are relatively fragile unless covered by a fixative, and offer a limited range of colors. The greasier crayons adhere well to paper and are more permanent, but they are difficult to blend with one another for subtle tones and gradations. (However, the newer oil-based crayons can be finger-blended almost as easily as oil paints blend.) Crayons usually offer a wider choice of colors than do chalks, and they come in varying degrees of hardness to permit sharp lines or tonal areas.

Crayon can mean anything from the wax crayons used by children through the lithographic crayon meant for drawing on stone in printmaking (Chapter 8). But the commonest drawing material is *conté crayon*—a fine-textured stick medium available in shades of red, brown, and black.

The artist who comes to mind most readily in discussing conté crayon drawings is Georges Seurat. In Chapter 4 we looked at Seurat's painting technique, called *pointillism,* in which tiny dots of color are massed together to build form (**135,136**). Seurat also did many drawings. By working in conté on rough-textured paper he could approximate the effect of color dots in paint. *Seated Boy with Straw Hat* (**208**) is a preliminary study for Seurat's large painting *Une Baignade.* Unlike Michelangelo's rough sketches for the arm of God, however, this drawing, along with many of Seurat's studies, is a fully realized work of art. The figure is shown in soft silhouette, blending into the even softer background. It was Seurat's practice to work out his figures very completely as separate units in drawing, and then to transfer them to the painted canvas.

A harder crayon and smoother paper resulted in the much more detailed modeling in Dante Gabriel Rossetti's portrait of *Jane Burden* (**209**). Rossetti was one of a group of mid-19th-century artists known collectively as the "pre-Raphaelites." One characteristic of their art is concentration on a specific ideal of female beauty—thick, flowing hair, enormous eyes, and a pursed rosebud mouth. Jane Burden was the perfect embodiment of this type. In the drawing Rossetti has taken advantage of the precision afforded by the hard crayon, which can produce either a sharp line or a shadowy gray one. He has left the figure and gown pale and only slightly defined, to focus on the model's haunting pre-Raphaelite face.

210. Mary Cassatt. *Woman with Baby.*
Pastel on gray paper, $28\frac{3}{8} \times 20\frac{7}{8}''$.
Sterling and Francine Clark Art Institute,
Williamstown, Mass.
(gift of the Executors
of Governor Lehman's Estate
and the Edith and Herbert Lehman Foundation).

One other medium that should be mentioned along with the chalks and crayons is *pastel*. Because it is very soft and offers a full range of colors, pastel is often considered a borderline medium, somewhere between painting and drawing. Being fine-textured, it lends itself especially well to the kind of blending of hues that creates gradated tones. Pastel was a favorite medium of the American artist Mary Cassatt, no doubt because this soft drawing material provided an intimacy suitable for the mother-and-child scenes Cassatt liked to depict. In *Woman with Baby* (**210**) an intense, vibrant orange warms the whole page, contradicting our everyday use of the term "pastel" to mean a pale, light-value color.

LIQUID MEDIA

Pen and Ink Ink flowing onto paper gives a smooth, uninterrupted line. As with other relatively permanent media, such as silverpoint, there is little possibility for correction once the lines have been inscribed. A major variable in the ink drawing, however, is the relative thickness or thinness of lines, which depends on the pen point used. The lines can be all one width, ranging from fine to heavy, or they can vary. A single line may change, perhaps starting as a fine thread, broadening into thickness, and then tapering down again to a slender mark. Such thick-and-thin lines are often referred to as *calligraphic* or *gestural*.

As crayon makes us think of Seurat, pen and ink makes us think of Rembrandt—one of the greatest draftsmen who ever lived. Rembrandt made thousands of drawings during his long career, and he drew almost everything imaginable. But it is his landscapes that perhaps more than any other theme reveal Rembrandt's personal "handwriting." In *A Thatched Cottage by a Tree* (**211**) the

curling penwork in the trees and foreground foliage, drawn with a reed pen, is typical of his rapid, sketchy style. The stiff reed point yields a rather bold line with much visual character. We know that trees have leaves, not swirling shapes, and yet ever since Rembrandt this curving line seems to us the very essence of "tree." The drawing may seem sketchy and quick, but the artist has given us a strong sense of forms in space.

Another artist who achieved a distinctive style in pen and ink—quite a different style—was Van Gogh. In *A Peasant of the Camargue* (**212**) the pen marks are massed together to produce visual texture. Van Gogh combined a reed pen with the more flexible quill to obtain quite varied lines—fine and thready in the face, heavy in the shirt and around the hat, short and choppy in the background. All the splendid modeling in the face is accomplished by patterning of thick and thin lines. The background texture of dots and tiny strokes makes the figure stand out plainly. Van Gogh did this drawing as a study for a painting, using the different types of pen marks and textures to represent contrasting colors he would employ in the later work.

above: **211.** Rembrandt.
A Thatched Cottage by a Tree. c. 1652.
Reed pen and bistre, $6\frac{7}{8} \times 10\frac{1}{2}''$.
Devonshire Collection, Chatsworth
(reproduced by permission
of the Chatsworth Settlement Trustees).

right: **212.** Vincent van Gogh.
A Peasant of the Camargue. 1888.
Quill and reed pen and ink
over soft graphite, $19\frac{1}{2} \times 15''$.
Fogg Art Museum, Harvard University,
Cambridge, Mass.
(Grenville L. Winthrop Bequest).

Käthe Kollwitz
1867–1945

In a time when the word "'artist" usually meant a painter or a sculptor, Kollwitz did the bulk of her work in prints and drawings. In a time when vivid, sometimes startling color was preoccupying the art world, Kollwitz concentrated on black and white. And, in a time when nearly all artists were men, Kollwitz was—triumphantly—a woman, a woman whose life and art focused on the special concerns of women. This combination of oddities might have doomed a lesser artist to obscurity, but not one of Kollwitz' great gifts and powerful personality.

Käthe Schmidt was born in Königsberg (then in Prussia, now part of the U.S.S.R.), the second child in an intellectually active middle-class family. Her parents were remarkably enlightened in encouraging all their children to take an active part in political and social causes, and to develop their talents—in Käthe's case a talent for drawing. Käthe received the best art training then available for a woman, in Berlin and Munich. In 1891, after a seven-year engagement, she married Karl Kollwitz, a physician who seems to have been equally supportive of his wife's career. The couple established themselves in Berlin, where they kept a doctor's office and artist's studio for fifty years.

During her student days Kollwitz had gradually focused on line and had come to realize that draftsmanship was her genius. Her conventional artistic training must have intensified the shock when she "suddenly saw that I was not a painter at all."[1] She concentrated thereafter on drawings and prints—etchings and woodcuts early on, lithographs when her eyesight grew weaker.

Five major themes dominate Kollwitz' art: herself, in a great many self-portraits and images for which she served as model; the ties between mothers and their children; the hardships of the working classes, usually interpreted through women's plight; the unspeakable cruelties of war; and death as a force unto itself. As a socialist Kollwitz identified passionately with the sufferings of working people; as a mother she identified with the struggle of women to keep their children safe.

Kollwitz bore two sons—Hans in 1892 and Peter in 1896. The first of many tragedies that marked her later life came in 1914, with the death of Peter in World War I. She lived long enough to see her beloved grandson, also named Peter, killed in World War II. During the almost thirty years separating those losses, she continued to work prolifically, but her obsession with death never left her.

Few artists have so touchingly described their attempts to achieve a certain goal, and their continual frustration at falling short. In Kollwitz' case, the artistic goals were generally realized, but the emotional and political goals—never: "While I drew, and wept along with the terrified children I was drawing, I really felt the burden I am bearing. I felt that I have no right to withdraw from the responsibility of being an advocate. It is my duty to voice the sufferings of men, the never-ending sufferings heaped mountain-high. This is my task, but it is not an easy one to fulfill. Work is supposed to relieve you. . . . Did I feel relieved when I made the prints on war and knew that the war would go on raging? Certainly not."[2]

Käthe Kollwitz. *Small Self-Portrait, Facing Left.* 1922.
Lithograph, 13⅝ × 9⅞".
National Gallery of Art, Washington, D.C.
(Rosenwald Collection).

213. Alexander Calder.
The Circus. 1932. Pen and ink, 20¼ × 29¾".
Courtesy Perls Galleries, New York.

Still another use of the pen line can be seen in Alexander Calder's circus drawings of the 1930s (**213**). These drawings are related to Calder's thin wire sculptures from that period (**100**), and they are just as economical in form, just as uniform in line as the three-dimensional wires. The artist gives us only the barest outlines of the figures, the minimum needed to show shape and position. This type of drawing is a kind of visual shorthand, energetic and playful. Calder suggests the huge space of the Big Top by his placement of curving parallel lines. The figures are transparent, as they would be when done in wire, but we have no doubt about their arrangement in space. Only a skilled draftsman can give us so much sense of place with so little.

Brush and Ink The brush has long been the favorite drawing tool of Oriental artists. Because in the East the brush is commonly used for writing, its handling seems as natural there as using a pencil does to Westerners. When the brush is manipulated in the Oriental way, it is the ideal tool (better than a pen) for producing the calligraphic line—thin at the beginning, broadening along its length, and then tapering again to very thin. We see this effect in a marvelous drawing by Wu Zongyuan, *The Procession of the Five Heavenly Rulers* (**214**). No other medium but fluid ink could have yielded these graceful, swirling lines, which give the drawing so much energy.

When ink is diluted with water and applied with a brush, the result is called a *wash* drawing. Käthe Kollwitz used touches of wash and thick, aggressive lines of pure black for the powerful image of a *Fettered Man* (**215**). Kollwitz made a great many drawings, and nearly all of them are charcoal, a much softer medium. For this figure of extreme anguish she chose the far bolder black ink.

left: **214.** Wu Zongyuan
(attributed by Zhao Mengfu).
*The Procession of the Five
Heavenly Rulers,* detail.
First half of 11th century.
Ink on silk.
Collection C. C. Wang
and family, New York.

right: **215.** Käthe Kollwitz.
Fettered Man. 1927.
Pen and wash, 17½ × 14½".
Private collection, New York.

Kollwitz' drawing shows plainly the interaction between drawing medium and imagery. In this case we might suspect that the artist had an image in mind and selected the medium that would best fit that image. Other times the reverse may occur: an artist experiments with a particular medium and thus is inspired with an image idea.

NEW DRAWING MEDIA

Artists today have a broad spectrum of drawing media to work with, and they do not limit themselves to the traditional materials we have just described. In this electronic age drawings are made by computer, by video technology, by all kinds of sophisticated equipment. For instance, if we came upon a reproduction of Barbara Nessim's *Two Shadows Outside Two Women* (**216**), without looking at the caption we might speculate about what materials the artist used. Perhaps chalk or crayon for the lines, and maybe a colored wash for the pink and blue and purple tones, but how did she get the very fine stippled (dotted) effects in the figures? Actually, this drawing was made on an IBM PC computer terminal, then printed for permanence. Many of us associate computer graphics with flow charts and other business applications, but this delicate and lovely image shows how artists can tap the advanced image-making abilities of the computer.

Whether an image is made by pencil or by computer, the quality of line remains a vital aspect of drawing. We turn, therefore, to a brief discussion of the different kinds of lines and their effects.

Line Quality in Drawing

Chapter 4 discussed line quality in some detail (pp. 106–107); here we might focus, with just a few examples, on the drawing as a work of art, and how line quality affects it. Our first two examples (**217**,**218**) show the same subject, a nude or partially nude woman arranging her hair, in almost identical poses. Yet how different are the effects of the two drawings. The first, a pastel by Degas, is softly modeled, almost painterly in its subtle shadings that mold the fully rounded form. Modeled lines are usually drawn in very soft dry media, often with the side

216. Barbara Nessim.
Two Shadows Outside Two Women.
1985. Computer drawing,
Cibachrome print, 16 × 20″.
© Barbara Nessim, 1985.

left: 217. Edgar Degas. *Nude Combing Her Hair.*
c. 1885. Pastel, 24⅛ × 18⅛".
Metropolitan Museum of Art, New York
(gift of Mr. and Mrs. Nate B. Spingold, 1956).

below: 218. Katsushika Hokusai. *Woman Fixing Her Hair.*
Early 19th century. Ink on paper, 16¼ × 11⅝".
Metropolitan Museum of Art, New York
(Charles Stewart Smith Collection, gift of
Mrs. Charles Stewart Smith, Charles Stewart Smith, Jr.,
and Howard Caswell Smith, in memory of
Charles Stewart Smith, 1914).

of a pencil or a piece of chalk. We might not even call these blurred outlines
"lines," so gently do they define the contours of the human body. The second
drawing, by the great Japanese artist Katsushika Hokusai, is sketched in a few
quick calligraphic lines. In spite of this, the second figure seems as full-bodied
and round as the first. One deft stroke down the center of the back, combined
with the curve of breast and belly, and Hokusai has made us believe in the three-
dimensional form.

 The soft modeled line and the calligraphic line are but two possibilities for
drawing. Another is the contour line. A contour line describes only the outlines of
a subject, with no shading and often very few inside details. The line is usually

continuous and of unvarying width. We see a good example in Matisse's still life (**219**). Especially fine is the handling of the pears and peaches in the foreground. With the simplest of outlines Matisse presents these fruits unmistakably.

So we have seen three of the possibilities in line quality: the soft, modeled line; the thick-and-thin calligraphic line; and the uniform contour line. Although it is not in quite the same category as the other types of lines, we cannot leave out the decorative line. Picasso, whose play instinct never left him in his ninety-odd years, delighted in making lines for the sheer joy of pattern and decoration. In *Head of a Man* (**220**) it is difficult to separate the lines defining facial features from those drawn for their own sake. For instance, which curly lines are hair or beard and which are just curly lines? Many of Picasso's drawings seem like complicated doodles, like the work of someone who says, "Let's start this line and see where it might go."

Simple doodling is one of the many purposes of drawing. Practically everyone does it. When you doodle, your goal may be nothing more than to pass the time or to fill up white space on a page. Like the rest of us, great artists often doodle, but, as we have seen, they also make drawings with specific artistic goals in mind. In the following section we will consider some of these purposes.

Purposes of Drawing

PRELIMINARY STUDY

left: 219. Henri Matisse.
Nature Morte, Fruits et Potiche.
1941. Pen and ink,
20¾ × 16¾″.
Musée National d'Art Moderne,
Centre Georges Pompidou, Paris.

right: 220. Pablo Picasso.
Head of a Man in Profile.
1967. Ink on paper,
25⅝ × 19¾″.
Private collection.

Many of the drawings reproduced in this chapter—including those by Michelangelo, Seurat, and Van Gogh—were done as preliminary studies for paintings. Before committing time and material to a finished painting, the artist will often sketch and experiment until the form seems exactly right. Artists working in all fields do the same thing. Sculptors, architects, interior designers, printmakers, landscape architects, and industrial designers—all make preliminary drawings.

Whenever we encounter an artist who is noted in some particular field, such as sculpture or architecture, and then discover that the artist has an unusual flair for drawing, we may feel we have earned a bonus—a gift on top of a

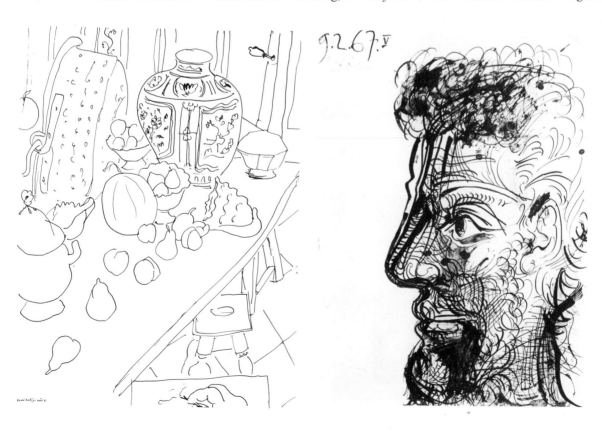

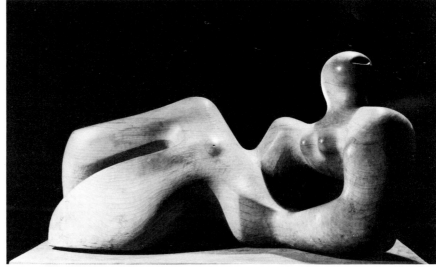

above: **221.**
Henry Moore. *Reclining Nude.*
1931. Brush and wash in sepia,
$9\frac{15}{16} \times 18\frac{1}{4}''$.
Victoria & Albert Museum, London.

right: **222.** Henry Moore.
Reclining Figure. 1935.
Elmwood, $19 \times 35 \times 15''$.
Albright-Knox Art Gallery,
Buffalo, N.Y.
(Room of Contemporary Art Fund).

gift. The public works are out in the world for all to see; we study the drawings quietly, more privately, as though we were having a personal conversation with the artist.

Henry Moore was best known as a sculptor, but he drew constantly throughout his life, sometimes with drawing as an end in itself, other times as a study for works in stone or wood or metal. The drawing shown here (**221**) is a general exploration of the volumes and masses of the nude female figure—the subject of many of Moore's sculptures. It does not, however, look very much like Moore's finished works (**222**). The drawing is naturalistic, while the sculpture is much more abstract. We can learn a good deal about the process of abstraction by comparing the two. As mentioned in Chapter 2, abstraction is always based on forms from the natural world. Clearly Moore understood the forms of the human body thoroughly. Once he had mastered them—by studying the volumes and weights and interplay of parts—he could show them to us in a new way, as in the sculpture.

Architects use drawing throughout the process of designing a building. At the beginning they may make very rough sketches, which they gradually refine as the idea takes shape. They may also make detailed sketches of certain parts of the building. Finally they make a finished drawing for presentation to the client, to sell the idea. Most architects get by with basic drafting skills, but a few have delighted in drawing for its own sake. One such architect was Frank Lloyd Wright. Wright liked to work in colored pencils, and he nearly always sketched in much of the landscape surrounding the proposed building, in keeping with his

Henry Moore
1898–1986

On the occasion of Henry Moore's eightieth birthday, art critic John Russell wrote that "it is a great thing to be before the public uninterruptedly for the best part of half a century and still stand up, erect and uncontaminated, as a completely honorable human being."[3] Few people would argue with Russell's assessment. If fate smiles on certain individuals, Moore was surely one of them, but one cannot begrudge this "completely honorable" man having enjoyed rich talents as a draftsman and sculptor, international fame, a warm and loving family, respect from his friends, and a long, productive life.

Born in a small mining town in the north of England, Moore was the seventh child of a miner and his wife. Quite early he settled upon the career of sculptor as his goal. ("When I was 11, I was in Sunday school and I heard a story about Michelangelo. I can't remember the story, but what I retained was that Michelangelo was esteemed the greatest sculptor who ever lived. That unremarkable bit of information moved me, then and there, to decide to become a sculptor myself."[4]) After a brief stint in the army during World War I, Moore entered art school in the city of Leeds and first encountered modern art in a private collection there. Later he moved on to London's Royal College of Art.

Henry Moore was no overnight sensation; the type of sculpture he made was too new, too innovative for the public at large to accept. During the 1920s and 1930s Moore patiently laid the groundwork for what would become a world-class career. He worked steadily, exhibited often, taught first at the Royal College and later the Chelsea School of Art. In 1929 he married Irina Radetzky, a painting student, to whom he remained happily wed all his life. (Their daughter Mary was born in 1946.)

The year 1940 marked something of a turning point for Moore. England was at war, and he became an official war artist. His drawings of Londoners huddled in shelters to escape the Nazi bombing raids have become famous, both because of their unique circumstances and because the artist's sensitive rendering turned the act of hiding underground into a heroic gesture. The English people never forgot that it was Moore who showed them so poignantly in their "finest hour." After the war he was recognized as one of England's foremost artists, and his stature thereafter increased steadily.

Whether in stone or wood or metal, Moore's sculptures focused on three great themes: the family group (or mother and child), the reclining female figure, the form within a form. These sculptures are in the collections—and often adorn the outsides—of the world's great museums. And always this prolific artist continued to draw, for study and for drawing's own sake.

Reflecting on a lifetime devoted to art, Moore retained the joy and excitement that motivated a little boy who learned about Michelangelo: "Art is not practical, and shouldn't be practical. Art is not to earn a living. It's to make the difference between us and animals, like cows. I mean a cow doesn't stop and look at a field and say, isn't it a beautiful green. Painting and sculpture . . . are there to make life more interesting, more wonderful than it would be without them."[5]

Photograph of Henry Moore, 1980.

belief that a structure should be integral with its environment. His project drawing for a hunting lodge at Lake Tahoe (**223**) is almost as lyrical as a Chinese landscape painting. Wright has sketched this tree-house-among-trees as though the house had simply grown there, just like any other natural element. For this master builder, at least, drawing was not only a means to an end but an end in itself.

What was true of Wright is true for many artists. A drawing that is preliminary to something else is not necessarily trivial or hasty. For any artist who enjoys the act of drawing, each drawing is potentially a perfect work of art.

ILLUSTRATION

Another purpose for drawing is illustration, and this field is enormous. Illustrations are made for books, for magazines, for newspapers, for advertising, for fashion displays. Before the advent of the camera, drawn illustrations were the only kind available. Illustrators today still make drawings to record events where the camera is not permitted, such as at many courtroom trials.

One of the most famous illustrators of all time was the 19th-century English artist Aubrey Beardsley. Beardsley was a fascinating character who achieved international recognition by the age of twenty, was enormously productive, and died of tuberculosis at twenty-six. His style is distinctive, bringing together elements of the erotic and the grotesque with ornate, free-flowing decoration. The style has influenced many later illustrators but has never quite been imitated. Beardsley's illustrations for books and magazines (**224**) have strong contrasting areas of black and white. The drawing is broad and exaggerated—in this example almost a caricature. Like any great illustrator, Beardsley went beyond the story he was illustrating to create a whole new world from his own imagination. Once you get to know Beardsley's style, you cannot fail to recognize it. For an illustrator, the style, the personal view of the world, is all important.

There are two major areas in which drawn illustration has never given way to the camera but is still used extensively—fashion illustration and the illustration of children's books. Both fields have enjoyed unwavering popularity, and their styles have kept pace with other types of art.

Illustration for children's books has been greatly influenced by the innovative work of Maurice Sendak. Sendak's drawings are not the gentle, benign images that several previous generations had thought appropriate for children. Sendak draws monsters, monsters who dwell somewhere between the naughty

left: 223. Frank Lloyd Wright. Project drawing for Hunting Lodge, Tahoe Summer Colony, Lake Tahoe, Calif. 1923. Pencil and colored pencils on tracing paper, $21\frac{7}{8} \times 15\frac{1}{8}''$. Frank Lloyd Wright Memorial Foundation, copyright © The Frank Lloyd Wright Foundation, 1957.

right: 224. Aubrey Beardsley. Cover design for *The Forty Thieves*. 1897. Pen and black ink, brush and black chalk; $9\frac{7}{16} \times 7\frac{13}{16}''$. Fogg Art Museum, Harvard University, Cambridge, Mass. (Grenville L. Winthrop Bequest).

225. Maurice Sendak.
Drawing from *Where the
Wild Things Are*. 1963.
Courtesy Harper & Row
Publishers, Inc., New York.

and the truly wicked. In his book *Where the Wild Things Are* (**225**) the artist gives concrete form to the dreadful creatures that inhabit children's fantasies. Some critics have attacked the drawings as being too frightening for children. Others suggest that the drawings have psychological value, in that Sendak's stories allow children to confront their monsters and conquer them. From the audience, however, there has never been any argument. Children love the drawings, scary though they be.

There is one more type of drawing associated with illustration—the cartoon. Cartooning is a terrifically demanding art. Most cartoons have specific narrative content, which may be amusing, dramatic, satirical, political, or a combination of these. The artist has to convey this content in one drawing, or, in the case of a comic strip, in a few economical drawings. If the cartoon has a caption, it too must be economical. Perhaps more than any other art, the cartoon must live up to the old saying, "One picture is worth a thousand words." By the clever marriage of a few words and an image, the cartoonist may clarify a very complex idea (**226**).

EXPRESSION

All drawings are made for the expression of the artist, regardless of any other purpose they might serve, and self-expression was a key motivation for most of the drawings we have seen in this chapter. Artists record on paper what they see,

226. "Does it strike anyone else
as weird that none of the great
painters have ever been men?"
Drawing by Lorenz;
© 1980, The New Yorker
Magazine, Inc.

"Does it strike anyone else as weird that none of the great painters have ever been men?"

in the unique way they see it. Drawing is just one way in which the imagination takes concrete form.

Contemporary artists have expanded the potential for expression in drawing, as in every other artistic medium. For example, the work by Julian Schnabel (**227**), which many people would call a painting, actually contains a great many areas that resemble drawing, particularly the nude figure at left. Schnabel's materials—oil and modeling paste on velvet—are not those of drawing; indeed they are not even the materials of conventional painting. But Schnabel's imagery, with its sketchy, linear quality, clearly derives from the world of the sketchbook. Above all, his work shows that the line between drawing and painting, at least for certain artists, has all but disappeared.

With the work of Jonathan Borofsky we have come full circle from the cave drawings of earliest history. Borofsky often draws directly on the walls of a room, and his images are those remembered and recorded from dreams (**228**). Some historians speculate that the cave artists as well were recording dreams, and their surfaces too were the walls around them. In bypassing conventional surfaces, such as paper, Borofsky shows us that drawing today need accept no limits, no restrictive sizes or shapes. Drawing is so much a natural impulse that it can be around us and among us in the most natural way.

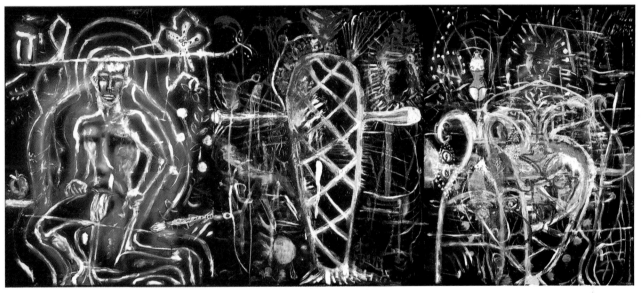

above: 227. Julian Schnabel. *Nicknames of Maitre d's.*
1984. Oil and modeling paste on velvet, 9 × 21'.
Courtesy Pace Gallery, New York.

right: 228. Jonathan Borofsky. Installation on
four walls, floor, and ceiling, Venice Biennale, 1980.
Mixed media, wall height 20'.
Courtesy Paula Cooper Gallery, New York.

ART PEOPLE
Leo Castelli

"I wanted to be the perfect Renaissance man." This is the way art dealer Leo Castelli recalls the ambitions of his youth—to be multitalented, well-versed in arts and letters, comfortable in many languages and places, proficient in many realms, from music to art to athletics. Few people attain such lofty youthful goals, but Castelli did. He is the perfect Renaissance man.

Artists today rarely sell their works directly to collectors. Instead, the transactions are carried out through a dealer, the owner of an art gallery, who agrees to handle a particular artist's work for commission. Among dealers in New York and the world, Leo Castelli stands with the elite, the best of the best.

Castelli was born in Trieste, in northern Italy, in 1907. His banker father encouraged a wide-ranging education, including art-historical studies and languages, then sent Leo to the University of Milan, where the youth acquired a law degree. Leo then embarked upon a career in banking, which took him to many parts of Europe. One of his posts was Bucharest, in Rumania, where he met and married Ileana Sonnabend. The couple continued to move about, and eventually they arrived in New York.

Leo Castelli was nearly fifty years old before he launched the career for which he will always be known. He and Sonnabend occupied an apartment on East 77th Street in Manhattan, and from their living quarters, in 1957, they began to exhibit and to sell contemporary art. Both had an eye, a knack, almost a sixth sense about how the artistic winds were blowing. Pop art was about to soar to the top of prevailing fashion, and the Leo Castelli Gallery was in at the beginning. Later, Castelli would take the lead in the ensuing trends of Minimal Art, Conceptual Art, and Neo-Expressionist Art. Although he does not take credit for discovering or establishing any artist, there can be no doubt that Castelli was vital to the careers of numerous important artists—Robert Rauschenberg, Jasper Johns, Frank Stella, Andy Warhol, Roy Lichtenstein, Ellsworth Kelly, Claes Oldenburg, and many others.

Castelli and Sonnabend divorced (both remarried), but they have remained close professional colleagues. Sonnabend operates her own gallery, and Castelli maintains two major gallery spaces in New York. Castelli the dealer wields enormous power, yet he is known for his integrity and generosity. His relationships with his artists have been marked by an exceptionally high degree of warmth and friendliness. From the beginning he established the unusual practice of paying each young artist a monthly stipend, a kind of allowance, so the artist could devote full time to art and not have to worry about putting food on the table. Castelli the man is known for his charm, his intriguing personality, his multilingual poise and good manners—the Renaissance man. Small and slight and wiry, he has been called "Mighty Mouse."

Mighty is indeed the word for this elegant old-world gentleman whose impact on the new world of 20th-century art has been incalculable. Castelli himself summed it up best: "It makes me very happy that any important contemporary collection would have to include 15 or 20 of my artists."[6]

Andy Warhol. *Portrait of Leo*, detail. 1973.
Acrylic and silkscreen on canvas, 40⅜" square.
Courtesy Leo Castelli Gallery, New York.

7
Painting

*P*ainting is the queen of the arts. Ask ten people to form a quick mental image of "art," and nine of them are likely to visualize a painting on a wall. There are several reasons for the prominence of painting. For one thing, paintings usually are full of color, and—as was noted in Chapter 4—color is a potent visual stimulus. For another, paintings often are framed, some quite elaborately, so that one has the impression of a very precious object set off from the rest of the world for our visual excitement. Even without a frame, a painting may seem a thing apart—a focus of energy and life, a universe unto itself. Whatever the painting shows, it establishes its own visual scope, sets its own rules.

If we consider some of the earliest cave images, especially the more elaborate and colorful ones, to be paintings, then the art has been practiced for at least twelve thousand years. During that long history the styles of painting have changed considerably, as have the media in which paintings are done–the physical substances the painter uses. In the latter case it might be more accurate to say broadened, rather than changed, for few media have been completely abandoned while many new options have been added to the painter's repertoire.

To begin this discussion of painting, we should define certain terms crucial to the understanding of how, physically, such a work of art is put together. As with drawing media (Chapter 6), the color element in paint is the *pigment*, which consists of natural or synthetic color particles. Pigments usually come in the form of a powder, which by itself cannot be spread or made to adhere to the painting surface.

The *medium* or *binder* is the substance in which the pigment is suspended. ("Suspension" here means that the particles are mixed with a liquid or semi-liquid material without dissolving or changing chemically.) Linseed oil—as in oil paint—is possibly the best-known medium, but there are many others. A successful medium allows the painter to spread the colors on a surface as desired and, when it dries, adheres securely to the surface. The name of the medium of a

particular work is often used to describe the work: an oil painting, a watercolor painting, and so on.

The *solvent* or *vehicle* enables the artist to thin the paint so as to control its flow and also to clean the brushes. A solvent is selected according to whether the paint is *aqueous* (water-solvent) or *nonaqueous* (dissolved by other than water). Most of us are familiar with the distinction used for house paints—water-base or oil-base. For water-base paints you can wash the brushes with tap water, but for oil-base paints you need to use turpentine. Much the same distinction applies to artists' paints.

Finally, there is the painting *support*, which is the canvas, paper, wood panel, wall, or other surface on which the artist works. The painter may first apply a preliminary coating known as a *ground* or *primer* to make the support more receptive to the paint and/or to create certain effects.

In this chapter we shall first discuss the painting media—the mechanics and expressive possibilities of each. Then we will look at how different artists have adapted the various media to meet their own expressive needs.

Painting Media

As suggested earlier, practically every painting medium ever invented is still in use somewhere, by somebody. Artists interested in history or chemistry love to experiment with obscure techniques that went out of fashion centuries ago. Most of the painting media that have fallen out of favor have been abandoned because they were cumbersome or because they were replaced by similar media that had certain advantages—lower cost, clearer colors, easier preparation, better adherence to the support, quicker drying time, slower drying time—whatever artists might wish.

It is impossible to tell which painting medium is the oldest, but we know that ancient peoples mixed their pigments with such things as fat and honey. Apparently, the first widespread and well-perfected technique came into use in the Classical period, the few hundred years surrounding the birth of Christ. This was encaustic painting.

ENCAUSTIC

For encaustic, the pigment particles are suspended in hot beeswax, which must be kept at the proper temperature for spreading on a support (often a wood panel). Encaustic is an extremely demanding medium, and few contemporary artists want to cope with its difficulties. However, the wax gives a clear, luminous quality that almost no other medium can rival. The early Christians in Egypt, the Copts, were especially proficient at encaustic painting, and their works retain a splendid brilliance even two thousand years later (**229**).

FRESCO

To make a fresco the artist paints in water-suspended pigment on a surface of freshly spread plaster. As the plaster dries, the colors are absorbed into it, so that the two substances—paint and plaster—fuse. The painting will survive in good condition as long as the plaster remains intact.

Fresco is above all a wall-painting technique, and it has been used for large-scale murals since ancient times. Probably no other painting medium requires such careful planning, such meticulous attention to the chemical properties of the medium, and such hard physical labor. The plaster can be painted only when it has the proper degree of dampness; therefore, the artist must plan each day's work and spread plaster only in the area that can be painted in one session. (Michelangelo could cover about 1 square yard of wall or ceiling in a day.)

229. *Young Woman with a Gold Pectoral.* Egypto-Roman (Coptic), A.D. c. 100. Encaustic. Louvre, Paris.

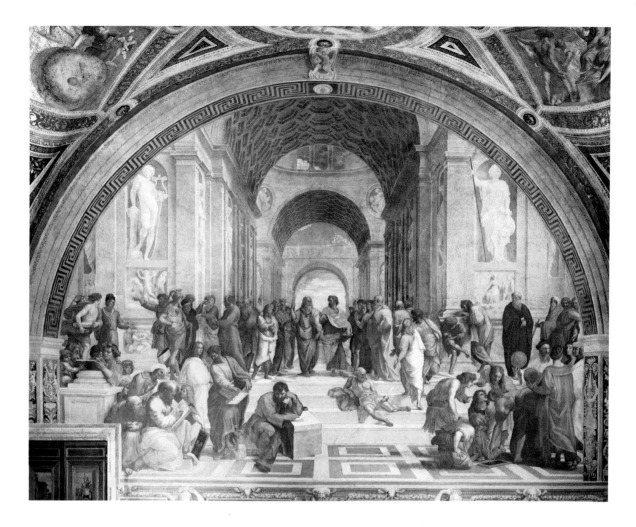

There is nothing tentative about fresco. Whereas in some media the artist can experiment, try out forms, and then paint over them to make corrections, every touch of the brush in fresco is a commitment. The only way an artist can correct mistakes or change the forms is to let the plaster dry, chip it away, and start all over again. Usually, the artist begins with a preliminary drawing called a *cartoon.* This may be a scaled-down or full-size version of the finished painting. If the cartoon is full size, the artist may cut it up into pieces, each the size of a day's work. Next the artist outlines major forms by placing the cartoon on the surface and poking through its lines with a sharp tool to leave a row of pinholes in the plaster.

There have been three great eras of fresco painting in the history of art: the Classical period in the Aegean and Rome, the Renaissance in 15th- and 16th-century Italy, and the early 20th century in Mexico. Only a few of the Classical frescoes have survived (**466**); as buildings become ruins, so do their frescoed walls. But among the works we consider the greatest of all in Western art are the magnificent frescoes of the Italian Renaissance.

While Michelangelo was at work on the frescoes of the Sistine Chapel ceiling (**40,488**), Pope Julius II brought in Raphael to decorate the walls of several rooms in the Vatican Palace. Raphael's fresco for the end wall of the Stanza della Segnatura, a room that may have been the Pope's library, is considered by many to be the summation of Renaissance art. It is called *The School of Athens* (**230**) and depicts the Greek philosophers Plato and Aristotle, centered in the composition and framed by the arch, along with their followers and students. The "school" in question means the two schools of philosophy represented by the two Classical thinkers—Plato's the more abstract and metaphysical, Aristotle's the more earthly and physical.

Everything about Raphael's composition celebrates the Renaissance ideals of perfection, beauty, natural representation, and noble principles. The towering

230. Raphael.
The School of Athens. 1510–11.
Fresco, 26 × 18′.
Stanza della Segnatura,
Vatican, Rome.

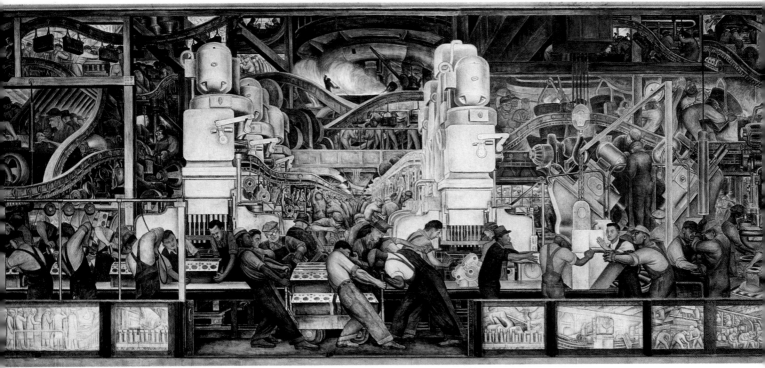

231. Diego Rivera. *Detroit Industry*, detail. 1932–33. Fresco, 17'8½" × 45'
(north wall, central panel). Detroit Institute of Arts (Founders Society Purchase,
Edsel B. Ford Fund and gift of Edsel B. Ford).

architectural setting provides an arena for quiet intellectual debate, and it is
drawn in masterful linear perspective (Chapter 4, p. 131; the vanishing point is
between the heads of the two philosophers). The figures, perhaps influenced by
Michelangelo's figures on the Sistine ceiling, are idealized—more perfect than
life, full-bodied and dynamic. *The School of Athens* perfectly reflects Raphael's
vision of one Golden Age—the Renaissance—and establishes its kinship with the
Golden Age of Greece two thousand years earlier.

The era that spawned the great fresco artists of Mexico, while scarcely
"golden," was a fertile and turbulent one. The Mexican Revolution began in 1911
and continued for twenty years. It launched a period of great economic and
social upheaval, overlapping with the social upheaval of Depression in the
United States. A number of Mexican artists, trained in Mexico but influenced by
European art of the time, sought to revive fresco painting, and in this they were
supported by the Mexican government.

Diego Rivera's enormous frescoed murals in many public buildings in
Mexico and the United States typify this style. *Detroit Industry* (**231**), an ambi-
tious four-wall panorama at the Detroit Institute of Arts, illustrates the grand
scale and monumental quality that often characterize mural painting. Con-
ceived as a tribute to the city and the worker, Rivera's mural has a complex
iconography. The detail shown here portrays the manufacture of the 1932 Ford
V-8 automobile. Every step of the job, every event in the worker's day is repre-
sented, from the punching of the time clock through steel processing, molding,
welding, drilling—even the lunch break. The mural treatment bestows a gran-
deur on the everyday operations of the assembly line. In fact, the frescoed mural
probably served Rivera's expressive needs better than any other medium could
have done.

EGG TEMPERA

Anyone who has washed breakfast dishes knows about the adhesive strength and
quick drying of egg yolk. A painting medium based on egg yolk, called tempera,
was preferred by artists throughout the medieval period, until the introduction

of oil paint. Egg tempera's yellow color, surprisingly, does not distort a pigment color, and, also surprisingly, tempera works tend to yellow less with age than do those in oil. Paintings done in tempera hundreds of years ago retain their brilliant glow and clear colors. The one disadvantage is that tempera is not as flexible as oil or the synthetics, not nearly as convenient in the application. Oils or acrylics can be laid on in large strokes, small strokes, thick or thin. But in tempera forms must be built up slowly, with small, individual brush strokes. For those few contemporary artists who care to take the trouble, the rewards are gratifying.

Among 20th-century artists one painter in particular has made tempera his own medium—Andrew Wyeth. Wyeth's painting *Braids* (**232**) shows the luminous technique at its best. *Braids* is part of a large cache of paintings and drawings that Wyeth had kept secret from most of the art world for fifteen years until a surprise showing in 1986. Nearly all the works depict a woman known as Helga. *Braids* shows Helga's face and upper torso painted in the most painstaking tempera technique. Individual brush strokes highlight single strands of hair, eyelashes, and threads in the sweater, and the face has an almost claylike texture from innumerable tiny strokes of paint. Helga seems natural and lifelike, yet we do not expect her to come to life, to move or turn her head. She is frozen in time by the meticulous rendering of the tempera paint.

OIL

A popular legend says that oil painting was invented early in the 15th century by the great Netherlandish artist Jan van Eyck, who experimented with it for this portrait (**233**). However, Van Eyck probably learned the technique from another artist and merely perfected it himself. From that time and for about five hundred years the word "painting" was virtually synonymous with "oil painting." Only in the 1950s, with the introduction of acrylics, was the supremacy of oil challenged, and even then many artists clung to their oil paints.

The outstanding characteristic of oil paint is that it dries very slowly. This creates both advantages and disadvantages for the artist. On the plus side, it

below: 232. Andrew Wyeth. *Braids.* 1979.
Tempera on canvas, $16\frac{1}{2} \times 20\frac{1}{2}''$.
Copyright © 1986 Leonard E. B. Andrews.

right: 233. Jan van Eyck. *Man in a Red Turban (Self-Portrait?).*
1433. Oil on panel, $10\frac{1}{4} \times 7\frac{1}{2}''$. National Gallery, London
(reproduced by courtesy of the Trustees).

left: **234.** Oskar Kokoschka. *Self-Portrait*. 1917.
Oil on canvas, $31\frac{1}{8} \times 24\frac{3}{4}''$.
Von der Heydt Museum, Wuppertal, West Germany.

above: **235.** Detail of Kokoschka's *Self-Portrait*, 234.

means that colors can be blended very subtly, layers of paint can be applied on top of other layers with little danger of separating or cracking, and the artist can rework sections of the painting almost indefinitely. This same asset becomes a liability when the artist is pressed for time—perhaps when an exhibition has been scheduled. Oil paint dries so *very* slowly that it may be weeks or months before the paint has truly "set."

Another great advantage of oil is that it can be worked in an almost infinite range of consistencies, from very thick to very thin. The German Expressionist painter Oskar Kokoschka often used thick oil paints straight from the tube, occa-

236. Jan Vermeer.
Woman Holding a Balance. c. 1664.
Oil on canvas, $16\frac{3}{4} \times 15''$.
National Gallery of Art,
Washington, D.C.
(Widener Collection, 1942).

sionally squeezing them directly on the canvas without a brush (**234**). He could then mold and shape the thick paint with a palette knife (a spatula-shaped tool) to create actual three-dimensional depth on the canvas (**235**). Any thick application of paint is referred to as *impasto,* and Kokoschka's is an extreme version of this. The ability to use paint in this way was important for Kokoschka's expression, because the sinewy coils of paint in the *Self-Portrait* trace the artist's passionate exploration of his inner self. A smoother medium could not so define his anguished personality.

Oil paint can with equal ease be diluted and applied in very thin layers called *glazes.* By painting glaze upon glaze the artist can achieve a sense of depth, a subtle coloration, and a luminous quality that are very different from the effect of impasto application. This was the technique of many European artists during the 16th and 17th centuries. We find a masterful example in Jan Vermeer's *Woman Holding a Balance* (**236**). The warm, rich glow of this work comes from the application of many glazes and is intensified by Vermeer's method of placing tiny light dots of opaque paint as highlights. Like many artists of his time, Vermeer was much concerned with naturalism, and the thin application of oil paint in layers lends itself to lifelike portrayal.

Another generation of artists, many years later, also concerned themselves with naturalism, but the techniques and the visual results were quite different. This group, who worked in France during the late 19th century, were known as the Impressionists. We can see the basic characteristics of their style and method of working with oil paint in Pierre-Auguste Renoir's *Piazza San Marco* (**237**).

The Impressionists attempted to paint what the eye actually sees, rather than what the brain interprets from visual cues. For example, if you look at a house in the distance and you know intellectually that the house is painted a uniform color of yellow, you might "see" all one shade of yellow, because your brain tells you that is correct. In purely visual terms, however, your eyes register many variations of yellow, depending on how light strikes the house and the shadows it creates. This is what the Impressionists were after—the true visual impression, not the version filtered through the knowing brain.

The Impressionists strove to capture what the eye actually sees by applying oil paint using many individual brush strokes of varying colors, placed side by side with no blending. Viewed up close, an Impressionist painting seems a meaningless jumble of color daubs (**238**). When you move farther away, however, your eyes "mix" the colors to produce a recognizable subject with shimmering effects of light. This is yet another example of the kinds of effects that oil can produce.

left: 237. Pierre-Auguste Renoir. *Piazza San Marco.* 1881. Oil on linen, 25⅝ × 32″. Minneapolis Institute of Arts (John R. van Derlip Fund).

right: 238. Detail of Renoir's *Piazza San Marco,* **237.**

Rembrandt
1606–1669

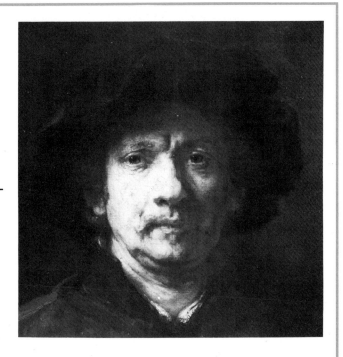

Of the few artists classified as "greatest of the great," Rembrandt is the most accessible to us. Through more than one hundred self-portraits, we follow his path from the brashness of youth to the high good spirits and prosperity of middle life to the melancholy loneliness of old age. Rembrandt's penetrating self-portraits represent a search for the self, but to the viewer they are a revelation of the self.

Born in the Dutch city of Leiden, Rembrandt Harmensz van Rijn was the son of a miller. At fourteen he began art lessons in Leiden and later studied with a master in Amsterdam. By the age of twenty-two he had pupils of his own. About 1631 he settled permanently in Amsterdam, having by then attracted considerable fame as a portrait painter. Thus began for Rembrandt a decade of professional success and personal happiness—a high point that would never come again in his life.

In 1634 Rembrandt married Saskia van Uijlenburgh, an heiress of good family, thus improving his own social status. The pair must have been rather a dashing couple-about-Amsterdam. The artist's portraits were in demand, his style was fashionable, and he had money enough to indulge himself in material possessions, especially to collect art. One blight on this happy period was the arrival of four children, none of whom survived. But in 1641 Rembrandt's beloved son Titus was born.

Rembrandt's range as an artist was enormous. He was master not only of painting but of drawing and of the demanding technique of etching for prints. (It is said that Rembrandt went out sketching with an etcher's needle, as other artists might carry a pencil.) Besides the many portraits, the artist displayed un-

paralleled genius in other themes, including landscapes and religious scenes.

In 1642 Rembrandt's fortunes again changed, this time, irrevocably, for the worse. Saskia died not long after giving birth to Titus. The artist's financial affairs were in great disarray, no doubt partly because of his self-indulgence in buying art and precious objects. Although he continued to work and to earn money, Rembrandt showed little talent for money management. Ultimately he was forced into bankruptcy and had to sell not only his art collection but even Saskia's burial plot. About 1649 Hendrickje Stoffels came to live with Rembrandt, and she is thought of as his second wife, although they did not marry legally. She joined forces with Titus to form an art dealership in an attempt to protect the artist from his creditors. Capping the long series of tragedies that marked Rembrandt's later life, Hendrickje died in 1663 and Titus in 1668, a year before his father.

Rembrandt's legacy is almost totally a visual one. He does not seem to have written much. Ironically, one of the few recorded comments comes in a letter to a patron, begging for payment—payment for paintings that are now considered priceless and hang in one of the world's great museums. "I pray you my kind lord that my warrant might now be prepared at once so that I may now at last receive my well-earned 1244 guilders and I shall always seek to recompense your lordship for this with reverential service and proof of friendship."[1]

Rembrandt. *Self-Portrait*, detail. 1652. Oil on canvas, 44½ × 31⅞″ (entire work). Kunsthistorisches Museum, Vienna.

239. Rembrandt. *Sortie of Captain Banning Cocq's Company of the Civic Guard (The Night Watch)*. 1642. Oil on canvas, 12'2" × 14'7". Rijksmuseum, Amsterdam.

Before we leave the topic of oil paints, we might mention one more interesting fact about the medium. Oil paintings very often are coated with a top layer of varnish to protect the painted forms underneath. Although many types of paintings and drawings are framed behind glass, oils seldom are. The varnish therefore serves roughly the same purpose as glass would in preserving the artwork. Sometimes the varnish does more to distort than it does to protect. This was the case with one of Rembrandt's most famous paintings.

Sortie of Captain Banning Cocq's Company of the Civic Guard (**239**) shows a kind of private elite militia guard going out on an exercise. In the center is Captain Cocq, giving orders to his lieutenant, and grouped around are members of the company, who seem especially pleased to be dressed up and playing war games. For many years Rembrandt's painting was known as *The Night Watch*, and it still is informally called by this name. The reason has nothing to do with the artist's intent. A heavy layer of varnish applied on top of the oil paint, combined with smoke from a nearby fireplace, had gradually darkened the painting's surface until it seemed to portray a nighttime scene. No one alive remembered it any differently.

During World War II Rembrandt's masterpiece was put away for safekeeping. Before it was returned to exhibition after the war, the varnish was removed and the surface thoroughly cleaned. What emerged was a painting very different from the one art lovers had become accustomed to. *The Night Watch* is shot through with light and is, in fact, a daytime scene. Details that had long been obscured were once again visible, as Rembrandt painted them. The painting was to have still more adventures, as we shall see in the Epilogue (**585**).

240. Maurice Prendergast. *Sunlight on the Piazzetta, Venice.* c. 1888–89. Watercolor over graphite, $12\frac{1}{2} \times 20\frac{5}{8}''$. Museum of Fine Arts, Boston (gift of Mr. and Mrs. William T. Aldrich).

WATERCOLOR

Watercolor is thought of as an intimate art, usually small in scale and executed with great freedom and spontaneity. Watercolor straddles the border between painting and drawing.

The pigments for watercolor are suspended in gum arabic (a gummy plant substance), thinned with water, and painted with a flowing motion onto paper of good quality. Generally, the watercolor is translucent, so that much of the white paper shows through. Watercolors are meant to be done quickly, according to the inspiration of the moment. Mistakes cannot easily be corrected, and too much overworking spoils the spontaneity of the medium.

Maurice Prendergast's painting *Sunlight on the Piazzetta, Venice* (**240**) illustrates the watercolor technique at its most vibrant. Prendergast, an American artist who worked at the turn of the 20th century, was much influenced by the French Impressionists. His style is filled with light and color—the quick blink-of-an-eye impression of life in motion. Watercolor captures the immediacy of the moment, the gaiety and fleeting charm of a sunlit outdoor scene.

Watercolor has been an important part of traditional Chinese painting, where it is often combined with ink or ink washes (sweeps of diluted ink). The Chinese skill with the brush lends itself especially well to a rapid, assured execution. Qiu Ying's hanging scroll, *A Lady in a Pavilion Overlooking a Lake* (**241**), exemplifies the watercolor refined to miniature proportions. The artist's brushwork, so precise in detailing the architecture of the pavilion, changes subtly to create a sense of lushness in the foreground trees and then changes again to suggest the mountains in the distance. Watercolor is often thought to be exclusively a broad technique, with flowing washes and large color areas, but Qiu Ying uses it with the most delicate precision.

GOUACHE

When opaque (nontranslucent) white is added to watercolors, the result is known as gouache. The white may be either mixed with the paints or coated on the support before the watercolors are applied. Because gouache is exceptionally

quick-drying, it is well suited for sketches and preliminary drawings, but this also means that brush strokes do not blend well. The artist must adapt to this characteristic by placing colors and forms side by side, rather than overlapping them or blending them into one another. Wassily Kandinsky has exploited this quality splendidly in *Russian Beauty in a Landscape* (**242**). Individual daubs of flat, opaque paint are laid down like the tiles in a mosaic to create a shimmering, exotic image. The effect is not naturalistic, not like the real world at all, but rather more like an illustrated book of fairy tales, so that the woman is transformed into a beautiful princess, the landscape into a magical kingdom.

DISTEMPER

Distemper, commonly known as poster paint, is a medium based on water-soluble glue into which pigments are mixed. Like gouache, it dries very quickly, so the blending of brush strokes or the glazing of colors is almost impossible. We often think of distemper as the best painting medium for children because it is inexpensive, covers mistakes solidly, and cleans up easily. But it is also a respectable medium for adult artists who are willing to adjust to its difficulties. The French artist Edouard Vuillard, who began his career painting stage flats for the theater, developed an affinity for this fast-drying medium and later adapted it to

left: **241.** Qiu Ying.
*A Lady in a Pavilion
Overlooking a Lake.*
China, Ming Dynasty, c. 1552–60.
Hanging scroll, ink and color
on paper; height 35⅛".
Museum of Fine Arts, Boston
(Chinese and Japanese
Special Fund).

right: **242.** Wassily Kandinsky.
Russian Beauty in a Landscape.
1904. Gouache, 16¼ × 10⅝".
Städtische Galerie
in Lenbachhaus, Munich.

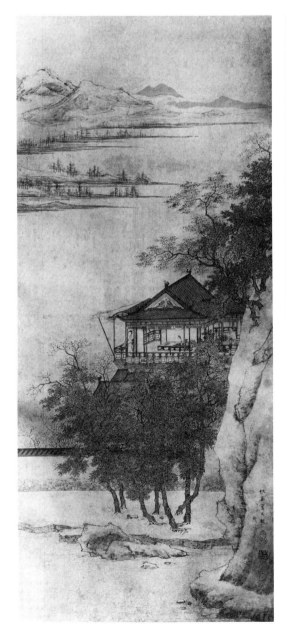

left: **243.** Edouard Vuillard. *The First Steps.* 1902. Distemper, 19½ × 13¾″. Private collection, courtesy Acquavella Galleries, Inc., New York.

right: **244.** David Alfaro Siqueiros. *María Asúnsolo as a Child.* 1935. Duco on plywood, 39⅜ × 29½″. Collection María Asúnsolo, Mexico City.

his easel paintings, such as *The First Steps* (**243**). As in Kandinsky's gouache painting, this work has many individual, unblended brush strokes, but here they are smaller, with subtle gradations of value areas. Under Vuillard's expert handling the sturdy medium of distemper seems to flicker and pulsate with life.

SYNTHETIC MEDIA

The enormous developments made in chemistry during the early 20th century had an impact in artists' studios. All painting media available up to that time had certain limitations. Oil, the most widely used, had the disadvantage of excessively slow drying time. The new synthetic media offered the promise of more control—control of fluidity, color fidelity, drying time, and durability. It should be noted, however, that there is still no *one* perfect medium for all types of expression and for all artists. The introduction of synthetic media, especially the acrylics, has simply expanded the range of possibilities.

By the 1930s the chemical industry had learned to make strong, weatherproof paint based on plastic resins, as well as new fade-proof colors for use in industry. The first painter known to have adapted these paints to art was the Mexican artist David Alfaro Siqueiros. In Los Angeles in 1932 Siqueiros organized his students into an industrial crew to paint outdoor murals with plastic resin paints, using slide projectors to transfer designs to the walls and spray guns to apply the paint. The murals, like those of Rivera, were meant to convey a social message. But the most revolutionary part of Siqueiros' work was the way the murals were made. The acrylic paints many artists use today are a development of these early synthetic resins, with similar characteristics of quick drying and resistance to weather and fading.

Siqueiros also pioneered in the use of synthetic paints for smaller works, such as the portrait illustrated here (**244**). The quick-drying Duco paint allowed

him to build up rich surface textures, strong value contrasts, and an almost sculptural quality—all of which would be possible but far more laborious in oil.

Synthetic paints were still a novelty in the 1930s, but within twenty years they had become a fact of everyday life and work for artists. The most popular synthetic paints are the water-base acrylics, which were introduced in the 1950s. Acrylics offer quick drying time (though not as unmanageably quick as that of the earlier synthetic resins), pure and intense colors, and great flexibility in methods of application. While many artists still paint with conventional brushes, others have adapted the acrylic medium to pouring, throwing, or dripping. Thinned down, acrylics can be shot through an airbrush—a tool that sprays a controlled mist of paint—as in the work of Audrey Flack (67). It has been suggested that the "hard-edge" painting of the 1960s (246) could not have developed without acrylic paints, because they permit the artist to block off areas with masking tape to achieve an absolutely straight line. The masking tape could not be put down on top of slower-drying oils or most other media. Acrylics also can be applied to many kinds of supports (not just primed canvas), and they combine well with certain other techniques, such as silkscreen (Chapter 8).

New media and methods can enlarge an artist's scope and can make possible new types of expression, but they do not dictate form. It is up to the artist to apply the specific qualities of any given medium to his or her thematic and formal needs. Throughout history artists have used the same medium to achieve very different artistic goals.

Medium and Expression

The next two paintings (245, 246) were done with acrylics, yet they have little else in common. The first, a "stained" work by Helen Frankenthaler (245), shows how

left: 245. Helen Frankenthaler. *Enigma.* 1975.
Acrylic on canvas, 10′ × 5′10″.
Courtesy André Emmerich Gallery, New York.

below: 246. Kenneth Noland. *Bridge.* 1964.
Acrylic on canvas, 7′5″ × 8′2″.
Courtesy André Emmerich Gallery, New York.

acrylic can behave when it is thinned to the consistency of a dye and applied to raw canvas, which partially absorbs the color. In this work there is little actual surface texture and practically no illusion of pictorial depth. The forms are organic, creating a color landscape of their own within the rectangle of the painting, but they make no specific reference to the natural landscape. Free-flowing washes of color spread and overlap on the canvas in what appears to be an immediate, spontaneous burst of imagery. Like Jackson Pollock (**57,535**), Frankenthaler often places her canvases flat on the floor, the better to control the flow of paint.

Almost the exact opposite of Frankenthaler's style is the razor-sharp geometry of the "hard-edge" painters, such as Kenneth Noland (**246**). Noland and other painters of the 1960s and 1970s sought to refine painting to its most basic elements—pure color and pure shape. The colors are flat and unvaried, the forms

left: 247. John Marin.
From the Bridge, New York City. 1933.
Watercolor, $21\frac{7}{8} \times 26\frac{3}{4}''$.
Wadsworth Atheneum, Hartford.

below: 248. Winslow Homer.
For To Be a Farmer's Boy. 1887.
Watercolor, $14 \times 20''$.
Art Institute of Chicago (gift from
Mrs. George T. Langhorne in Memory
of Edward Carson Waller).

are geometric, and lines are drawn literally with a straightedge. Just as Frankenthaler exploited the acrylic medium for its flowing qualities, Noland found in acrylic the perfect material for precision.

The same divergence of styles that we find in acrylics can be found in other media. Both John Marin and Winslow Homer were noted for their watercolors; in fact, Marin worked primarily in this medium. If you compare their paintings, however, you will see that the two artists used the watercolor technique in very different ways. Marin's cityscapes, such as *From the Bridge, New York City* (**247**), capture the essence and the spirit of the metropolis, rather than its actual appearance. Full of vigor and energy and exciting diagonals, they make us feel the city's pulse, its movement. The brushwork is loose and free, with form only barely sketched in. Marin's style exploits the fluidity of watercolor to the fullest extent.

Homer's watercolor style, while retaining the freedom and spontaneity of the medium, is far more contained. In *For To Be a Farmer's Boy* (**248**) the forms are defined by small color patches—in contrast to Marin's long sweeps of liquid paint. Homer was certainly capable of dramatic diagonals, but here there is a predominance of serene horizontal lines, broken only by the vertical of the boy's figure. Homer's more controlled handling of watercolor in this work shows us the pleasures of a peaceful summer afternoon on the farm.

And what of oil? Still considered by many to be the only "true" painting medium, oil has for nearly five centuries met the requirements of artists from every possible school. Three portraits will illustrate oil's amazing range.

John Singleton Copley's *Portrait of Mrs. Thomas Boylston* (**249**) might be considered the "hard-edge" painting of its day. Forms are perfectly and clearly defined; there is a definite break between hand and skirt, face and cap, figure and background. Copley has given meticulous attention to such details as the folds in the gloves and the lines of the face. His treatment of the shimmering satin in the dress is a virtuoso performance in handling the oil medium. Copley's brush strokes are tiny and almost indistinguishable except at very close range.

By contrast, Frans Hals' portrait of *Willem Croes* (**250**) is much more in the style called "painterly." Edges are blurred and indistinct, brush strokes are clearly visible and overlap, and there is more of a sense of surface texture. We can

left: 249. John Singleton Copley. *Portrait of Mrs. Thomas Boylston.* 1766. Oil on canvas, $4'1\frac{1}{2}'' \times 3'4\frac{1}{4}''$. Harvard University Portrait Collection, Cambridge, Mass. (bequest of Ward Nicholas Boylston to Harvard University, 1828).

right: 250. Frans Hals. *Willem Croes.* c. 1660. Oil on canvas, $18\frac{1}{2} \times 13\frac{3}{8}''$. Alte Pinakothek, Munich.

Alice Neel
1900–1984

When an acquaintance once remarked that Alice Neel painted "like a man," the artist retorted, "No, I don't paint like a man; but I don't paint like they expect a woman to paint." As a matter of fact, this extraordinary woman spent a long lifetime doing the unexpected, with cheerful disregard for the prevailing mores and fashions.

Alice Neel was born in Merion Square, Pennsylvania, the daughter of a proper middle-class family that she described as "anti-bohemian." She studied at what was then the Philadelphia School of Design for Women—"a school where rich girls went before they got married"—and received a thorough, if conventional, grounding in art.

Her personal life, too, was conventional up to that point, but soon it changed drastically. Neel referred to the men who played important roles in her life by stereotype, rather than by name. Upon leaving art school she married "the Cuban." The couple moved to Havana, where Neel continued to paint and had her first exhibition in 1926. The Cuban marriage eventually broke up, after which Neel returned to New York and worked on the W.P.A. project—the government-sponsored Depression program to help support artists. Along the way she took up with "the sailor," with whom she lived until he cut up and burned all her work. ("You know how men are, they get jealous, they're possessive.") With "the Harvard man" she maintained a friendship for decades, but she claimed he was most useful in the thirties, because, when everyone was very poor, he took her to expensive places to eat. There was also "the Puerto Rican singer."

From the beginning Neel was a portraitist, although she preferred to call herself a "people painter," feeling that portraitists are looked down on. This assessment actually proved correct through most of her career. Just at the point when Neel should have been in her artistic prime—the 1940s and 1950s—abstraction had completely taken over the art world. The painter of figures was out of fashion and remained so for at least twenty years. Not until 1974, at the age of seventy-four, did Neel have her first important show—at the Whitney Museum in New York. The show included some fifteen pictures that had not previously been "off the shelf." Alice Neel waited a long time to hear an important critic name her as the best portrait painter of the 20th century, and then she herself did not contradict that statement. The pictures, however, have transcended portrait status in the sense of recording someone's looks. They are major paintings that have people as their subjects.

Quite obviously, Alice Neel was an original, an exceptionally self-directed artist and human being. Neither her personal life nor her career was modeled after any example, nor did she follow anything but her own inclinations: "When they asked me if I had influences I said I never copy anybody. I never did, because I feel that the most important thing about art and in art—and I tell students this—is to find your own road."[2]

Alice Neel. *Nude Self-Portrait*. 1980. Oil on canvas, 4′6″ × 3′4″. National Portrait Gallery, Washington, D.C.

see this especially in the treatment of the hands in the two paintings. Copley's is precise, but Hals manages to capture the impression of full-fleshed solidity with far broader strokes. Each artist had a vision, and each found a realization of that vision in oil paint.

To prove that oil can hold its own in the late 20th century, we need only look at Alice Neel's picture of the *Westreich Family* (**251**). As is typical of a Neel portrait, this image gives a portrait of the whole body, not just the face, and the group portrait is particularly interesting for its psychological insights into the family dynamic. Neel invites us to study these people and speculate about their relationships. How do these family members feel about each other? Are they close or distant? Are some members bound together while others stand outside the family group? Who are the dominant members? The artist provides us with a number of clues. Notice how the various members of the family hold their hands, their arms, their shoulders, their legs and feet. Observe the ways their bodies lean and the direction of their gaze. See how each of the subjects is dressed.

If we did not know this painting's medium, we might be tempted to think it was acrylic, especially seeing it in reproduction. The rather flat color areas and sharp defining lines around the figures (especially the legs), the arbitrary blues and greens on flesh—all these seem too "modern" somehow for oil paint. But that is just the point, that oil has the flexibility to be a great many things. In this thoroughly contemporary painting, oil seems every bit as modern as any substance invented by chemistry.

This brief survey should have demonstrated that the various painting media and the artists who use them yield endless possibilities. It would be difficult to say which comes first—the artist's imagery or the material. Did the first cave artist have the impulse to paint something and search about for a material with which to do it? Or did the cave artist find some pigmented material and then speculate about what would happen if the substance were applied to a wall? The answer is not important, but the two aspects—idea and medium—feed upon each other. No visual image could be realized without the medium in which to make it concrete. And no medium would be of any consequence without the artist's idea— and the artist's compelling urge to paint.

251. Alice Neel.
Westreich Family. 1978.
Oil on canvas, 3′11″ × 5′8″.
Collection Mrs. T. Westreich,
Washington, D.C.

ART PEOPLE
Han van Meegeren

Han van Meegeren based his career—if we may properly call it a career—on revenge. Born in Holland in 1889, Van Meegeren was a painter who, by his early forties, had achieved some modest success. Unfortunately, the success was all too modest for Van Meegeren. Furious at the lukewarm reception to what he considered a great talent, he set out to prove that the critics and art experts were fools. Van Meegeren began to forge brand new "old masterpieces."

After trying his hand at the styles of various Dutch masters, he decided upon Vermeer as the most likely candidate for forgery. This was a happy choice for several reasons, but mainly because Vermeers were scarce. Jan Vermeer, who worked in Delft during the 17th century, was not prolific and left fewer than forty paintings definitely by his hand. Anyone who could produce a "lost" Vermeer could name the price. So Van Meegeren did just that.

No slipshod, third-rate forger was he. Not content merely to copy the master's style, this intelligent crook painted the pictures that Vermeer *might* have painted if he'd got around to it. Knowing that Vermeer, in his youth, had painted religious subjects, Van Meegeren painted a new "Vermeer" with a religious theme.

The forger's preparations were meticulous. He labored for four years, experimenting with various paints and techniques, aiming at a result that would fool even the most careful eye into thinking the painting was three hundred years old. He bought an old picture—a genuine work by a minor artist—and carefully rubbed off the paint to use the canvas. He even devised a special oven to bake the finished work and harden the paint. Then he took another six months to paint his "Vermeer." When done, he concocted a story that a family of his acquaintance had owned the painting for centuries and wished now to sell it—with Van Meegeren as agent.

And it worked. The art world was at first stunned, then rapturous. The "Vermeer" was subjected to many tests of its authenticity, and it passed them all. The Boymans Museum in Rotterdam bought the painting for $285,000. Initially, Van Meegeren planned to confess his hoax soon after the sale and thus thumb his nose at the experts. But he hesitated. Always extravagant, always unable to hold onto money, the artist had made a tidy sum from his forgery. Soon he settled down to produce yet more "Vermeers," and eventually he turned out six of them. By 1945 he was an immensely wealthy man.

The art critics never unmasked Van Meegeren; it was politics that brought about his downfall. During World War II one of the fake Vermeers was acquired by Hermann Goering, Hitler's close deputy. The Dutch people, outraged that a national treasure, a Vermeer, had fallen into the hands of the Nazis, denounced Van Meegeren—the supposed agent—as a traitor. The artist was arrested and subjected to intense questioning. Finally, he burst out: "Fools! You are fools like the rest of them! I sold no Vermeer to the Germans! I sold no treasure! I painted the picture myself!"[3]

In a supreme twist of irony, nobody believed him. To prove the truth, Van Meegeren had to paint yet another "Vermeer" under the watching eyes of his accusers. He was tried for forgery in 1947 and sentenced to a year in prison, but before the sentence could be carried out, he died of a heart attack.

In a way, perhaps, the forger's goal was realized. His motivation was to outsmart the world, and he nearly succeeded. Han van Meegeren may not be esteemed as a master painter, but he remains the master forger of them all.

Han van Meegeren at his trial.

8
Prints

*I*f you have ever received a handmade greeting card for Christmas, for a birthday, or as an invitation to a party, then you will appreciate the difference between an art print and a mass-produced reproduction. Commercial greeting cards are cranked out by the thousands, even millions, by the major card manufacturers. But many people like to make their own cards with their own original designs. Usually they will *print* the cards by some type of stamping process. The design is carved out on a printing block made of wood, linoleum, or even the cut side of a potato, leaving some areas raised as in a rubber stamp. Then the printing block is coated with ink and pressed carefully onto paper to make the card.

An image made this way is special. For one thing, the design is unique—a personal expression of the individual who conceived it. Also, each card will be slightly different from all the others because of variations in pressure, placement on the paper, and steadiness of the hand. There is a human touch, which we find missing from commercial products. For each separate image, *one* person made it, judged its quality, and was satisfied. All these factors apply equally to art prints.

Prints differ from most other works of art in two important respects. First, they are made by an indirect process. The artist does not draw or paint directly on the work of art, but instead creates the surface that *makes* the work of art. (In some cases the artist may add special touches to each print, but this is not the most common practice.) Second, the printing process results in many nearly identical images, which is the reason it is called an art of *multiples*. Each image—called an impression—is considered an original work of art. This latter point is crucial to an understanding of art prints, so we need to discuss it more fully.

Before the 1950s there were no strict guidelines for what could genuinely be labeled an "original" print. In the past twenty to thirty years, however, certain criteria have been established, and the value of recent prints has much to do with

their adherence to these criteria. The guidelines were set up in an attempt to avoid abuses that had crept into the print market, such as inferior, shoddy, or inauthentic works being passed off as fine art.

Printmaking procedures now are rigidly controlled. The artist works on a plate or stone or some other surface to make the image. Then the image is printed on paper, by hand or by a hand-operated machine, either by the artist or by someone under the artist's immediate supervision. Each print is examined to make sure it meets the artist's standards, and any faulty impressions are destroyed. Usually the artist and printer decide in advance how many impressions will be made—ten, fifty, a hundred or more—and this number is referred to as the *edition*. The size of the edition may be determined by the material used for printing. Hard metal can print many perfect impressions, but a softer material, such as linoleum, will begin to wear down, resulting in a blurred image. Once the planned number of prints has been made, the plate or block is *canceled* (by scratching cross marks on it) or destroyed, so that no more prints can be struck. Finally, the artist signs each print individually and numbers each one. For example, if you buy a print marked 10/100, you will know you have the tenth print made in an edition of one hundred. Prints made earlier in the edition are sometimes considered more valuable.

The type of print we are talking about must be distinguished from posters and other reproductions made by mechanical or photographic processes, such as the illustrations in this book. You can buy a color reproduction of a Rembrandt or Picasso painting, or a poster featuring a rock star or film personality, but these are not prints in the sense that we are discussing in this chapter, not original works of art. The artist who made the image has no supervision over the printing process and may not even know about it. The quality of the reproduction is nowhere near as meticulously controlled as that of an art print. Such reproductions are useful for study purposes and they often give pleasure, but they have little artistic or monetary value.

Today's art print, above all, is designed to *be* a print. It is not a copy of a work done in some other medium, although it may be adapted from an image in another medium. Some artists, for instance, will take a theme they have used in painting and explore its possibilities in prints, but in this case the artist adjusts the image to fit the physical qualities and expressive potential of the particular print medium chosen.

Like drawings, prints are a great boon to the art lover and the collector. At a time when original paintings by well-known artists are beyond the means of any but the very rich, prints by equally well-known artists—sometimes the same ones—often can be purchased for just a few hundred dollars. (The most fashionable artists command several thousand dollars for each print, but this price range is limited to a small group.) Young collectors starting out, and even large corporations with huge resources, have eagerly taken to buying prints. They may be a sound financial investment, but far more important is the fact that they give aesthetic pleasure and the joy of owning original art.

There are four basic methods for making an art print (**252**)—relief, intaglio, lithography, and screenprinting. In this chapter we shall look at each in turn and then consider a few advanced and combined techniques.

252. The four basic print methods: relief, intaglio, lithography, and screenprinting.

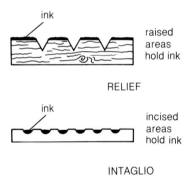

ink

raised areas hold ink

RELIEF

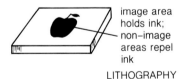

ink

incised areas hold ink

INTAGLIO

image area holds ink; non–image areas repel ink

LITHOGRAPHY

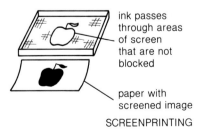

ink passes through areas of screen that are not blocked

paper with screened image

SCREENPRINTING

Relief

The term relief describes any printing method in which the image to be printed is *raised* from a background (**252**). Think of a rubber stamp. When you look at the stamp itself, you may see the words "First Class" or "Special Delivery" standing out from the background in reverse. You press the stamp to an ink pad, then to paper, and the words print right side out—a mirror image of the stamp. All relief processes work according to this general principle. The most common of the relief methods is the woodcut.

253. Anonymous master, Bohemia.
Rest on the Flight into Egypt.
c. 1410. Hand-colored woodcut.
Albertina, Vienna.

WOODCUT

To make a woodcut the artist first draws the desired image on a block of wood. Then all the areas that are not meant to print—the background areas—are cut and gouged out of the wood so that the image stands out in relief. When the block is inked, only the raised areas take the ink. Finally, the block is pressed onto paper, or else paper is placed on the block and rubbed to transfer the ink and make the print.

Woodcut is the oldest of the printmaking methods, having been developed in the Western world as soon as paper became available, about 1400. In fact, even before papermaking techniques were introduced in Europe, wood blocks were used to stamp designs on textiles. It was a simple transition from cloth to paper, and so the new art form advanced rapidly.

Early woodcut prints were used for both religious and secular purposes. Until the 15th century only the very rich could afford to own religious pictures, which had to be drawn by hand. Prints put such images into the reach of anyone who wanted them. An early example is *Rest on the Flight into Egypt* (**253**), made about 1410 by an unknown artist in Bohemia.

This charming woodcut depicts a scene in the life of the infant Christ, when the Virgin Mary and Joseph, with their child, have fled Jerusalem to escape the terrors of King Herod. Here they have stopped by the wayside to rest from their journey. Mary nurses the child Jesus, while Joseph stoops over the fire to prepare a hasty meal. Despite the halos and Mary's crown, these figures seem very down-to-earth, like ordinary people one might meet on a trip. The artist's style is graceful, especially in the drapery of the Virgin's gown, in Joseph's beard, and in the flames of the cooking fire. An angel perched over the rather small figure of Joseph balances the composition.

Besides teaching the common people about religious tradition, woodcut served another basic need—for amusement. Early playing cards were made by

254. "Steward" and "barber," playing cards of a courtly pack with illustrations of trades, from south Germany or Austria. 1453–57. Hand-colored woodcuts, each $5\frac{3}{8} \times 3\frac{7}{8}''$. Kunsthistorisches Museum, Vienna.

wood blocks, and our illustration (**254**) shows part of the earliest surviving woodcut "deck" of cards. An anonymous master from south Germany or Austria made these cards about the middle of the 15th century. They depict the various trades—barber, baker, metalsmith—which must have made their users feel right at home while playing games of chance. The little figures, going about their work, are cheerful and charming. And, while the drawing style is fairly simple, the bodies and clothing of the tradesmen seem animated, and their faces suggest individual personality.

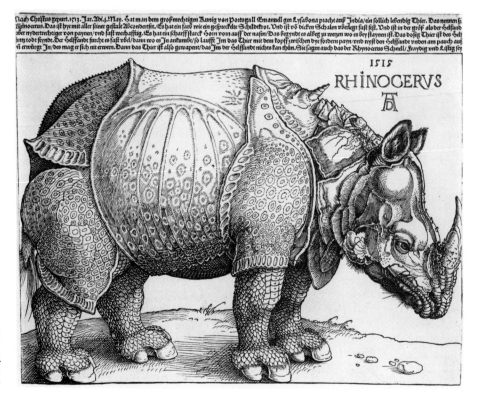

255. Albrecht Dürer. *Rhinoceros.* 1515. Woodcut, $8\frac{3}{8} \times 11\frac{5}{8}''$. Metropolitan Museum of Art, New York (gift of Junius S. Morgan, 1919).

The woodcut print reached a high point in Germany and northern Europe during the 15th and 16th centuries, with the work of such masters as Albrecht Dürer. Dürer's *Rhinoceros* (**255**) represents an attempt by a highly imaginative artist to depict a beast he had never seen, but knew only from description. The artist must surely have amused himself very much in creating such wonderful decorative detail, and his results amuse us equally today. (Dürer also worked in other print media, and we shall look at one of his engravings later in this chapter.)

By the 17th century prints began appearing in the Orient, where Japanese artists, in particular, experimented with the new medium. In the mid-18th century Japanese printmakers perfected the technique of full-color woodcut printing, using several blocks. This method required careful planning in the design and cutting of the wood blocks.

For color printing the artist usually must cut one block for each color that is to appear in the print. On the "red" block, for instance, only the areas that are to print in red are raised; on the "blue" block only the blue areas are raised; and so forth. Then the blocks are printed one color at a time on each sheet of paper in the edition. The impressions made by the various color blocks must be lined up very carefully, one on top of the other, so there are no unintended gaps or overlapping in the finished print. This process is known as *registration*.

The two names most often associated with masterful Japanese woodcut prints are Hiroshige and Hokusai. Ando Hiroshige was renowned for his landscapes, such as *Rain Shower on Ohashi Bridge* (**256**). As in many of Hiroshige's prints, the work is composed primarily of diagonals—the bridge slanting from

256. Ando Hiroshige.
Rain Shower on Ohashi Bridge.
19th century.
Color woodcut, $13\frac{7}{8} \times 9\frac{1}{8}''$.
Cleveland Museum of Art
(gift from J. H. Wade).

Katsushika Hokusai
1760–1849

One of the most delightfully eccentric figures in the history of art is the Japanese painter and woodcut designer who has come to be known as Hokusai. During his eighty-nine years Hokusai lived in at least ninety different houses and used some fifty names. The name that stuck for posterity—Hokusai—means "Star of the Northern Constellation."

Hokusai was born in the city of Edo (now Tokyo), the son of a metal engraver. At the age of eighteen he was sent as an apprentice to the print designer Katsukawa Shunsho. So impressed was the master with his pupil's work that he allowed the young man to adopt part of his own name, and for several years Hokusai called himself "Shunro." Later the two quarreled, and Hokusai changed his name.

Even in his early years Hokusai always worked very quickly, producing huge quantities of drawings. As he finished a drawing, he would toss it on the floor, until there were papers scattered all over the studio, making cleaning impossible. When the house got too filthy and disorderly, he would simply move to another, followed by his long-suffering wife.

Hokusai's first book of sketches was published in 1800 and showed various scenes in and around Edo. That same year the artist produced a novel, which he sent off to a publisher accompanied by the self-portrait here. (Hokusai's head is shaved in the manner of Japanese artists and writers of that time.) Both books achieved popular success, but, characteristically, Hokusai never bothered to open the packets of money sent by his publisher. If a creditor stopped by, he would hand over a packet or two without counting it. Throughout his life he remained indifferent to money and despite his accomplishments was usually at the brink of starvation.

As Hokusai's fame spread he was often invited to give public drawing demonstrations. Legends of his virtuosity abound. On one occasion, the story goes, he stood before the assembled crowd outside a temple and drew an immense image of the Buddha, using a brush as big as a broom. Another time he drew birds in flight on a single grain of rice. Hokusai's sense of humor, never far below the surface, came bubbling out when he was asked to perform for the Shogun (the military governor). As onlookers gathered at the palace, Hokusai spread a large piece of paper on the floor, painted blue watercolor waves across it, then took a live rooster, dipped its feet in red paint, and allowed it to run across the painting. Bowing respectfully, he announced to the Shogun that this was a picture of red maple leaves floating down the river.[1]

Though well aware of his own skill, Hokusai often amused himself by pretending modesty. In the preface to one of his books he wrote: "From the age of six I had a mania for drawing. At seventy-three I had learned a little . . . in consequence when I am eighty I shall have made still more progress, and when I am a hundred and ten, everything I do . . . will be alive." But the artist did not make it quite that far. As he lay on his deathbed, he cried out: "If Heaven would grant me ten more years!" And then: "If Heaven would grant me *five* more years, I would become a real painter."[2] His grave is marked by a slab on which is carved the last of his many names: Gwakio Rojin—Old Man Mad About Drawing.

Katsushika Hokusai. *Self-Portrait,*
from *The Tactics of General Oven.* 1800.
Woodcut. Art Institute of Chicago.

257. Katsushika Hokusai.
View of Fuji from Seven-Ri Beach.
1823–29. Color woodcut, $10\frac{1}{8} \times 15''$.
Metropolitan Museum of Art, New York
(Rogers Fund, 1914).

lower left to middle right, the rain slashing down at a different angle, the river-bank cutting across at yet another diagonal. The figures crossing the bridge are small and are depicted not as individuals but as people responding to, and buffeted by, the weather. In a Hiroshige landscape nature is grand and people are small. The long parallel lines of the rain give this print a wonderful rich visual texture.

Katsushika Hokusai also made many landscapes during his prolific career. Best known are his numerous views of Mt. Fuji—the cone-shaped volcano that is the highest mountain in Japan and also is considered a sacred spot to the Japanese. Hokusai drew Fuji in all seasons, in all weathers, and from many vantage points. *View of Fuji from Seven-Ri Beach* (**257**) presents a vista that seems not entirely of this world. The white cone of the mountain hovers tranquilly in a realm of puffy green foliage and spreading clouds of vivid blue.

As was mentioned in Chapter 1, Japanese woodcut prints were imported to Europe in great quantities during the latter part of the 19th century. Many artists were influenced by aspects of their style, including the emphasis on diagonals, the subtle use of asymmetrical balance (note that Fuji is thrust far to right in the composition and balanced by the calligraphy at upper left), and the areas of flat, unshaded color in many prints. These style characteristics have been absorbed into the mainstream of contemporary art, so they no longer seem "Japanese" but are part of a universal visual expression.

The German Expressionist artists of the early 20th century found in wood-cut a medium uniquely compatible with their style. A splendid example is Emil

258. Emil Nolde. *The Prophet.*
1912. Woodcut, $12\frac{5}{8} \times 8\frac{5}{8}''$.
National Gallery of Art,
Washington, D.C.
(Rosenwald Collection).

Nolde's *The Prophet* (**258**). Expressionist imagery is stark, somewhat primitive, and occasionally shocking. Woodcut readily lends itself to this style by allowing harsh contrasts of black and white as well as broad—even crude—drawing and cutting. Expressionism is just what its name implies—expressive, and also brooding, emotional, uncompromising. Of all the print methods, woodcut offers the greatest possibilities for realization of that expression.

259. Susan Rothenberg. *Pinks.*
1980. Hand-wiped woodcut,
$20 \times 37\frac{3}{4}''$.
Courtesy Multiples, Inc.,
New York.

A number of contemporary printmakers work in woodcut, and they have adapted this old medium to fit the more complex technologies and the special expressive goals of our era. At the beginning of this chapter we said that some artists work directly on the prints, so that each one is different. Susan Rothen-

berg's *Pinks* (**259**) is an extreme version of this approach. Each print in the edition of twenty has a hand print on the left and a crude face on the right superimposed over a hand outline, with the fingers becoming hair and perhaps ears. Rather than using an inking roller, the artist has hand-rubbed each print individually over the ink, so the intensity of the color varies. Rothenberg has confined herself to three colors—black, pink, and white—but the use of these colors varies from impression to impression. She has also allowed the grain of the wood block to take part in the image, using rough wood with ridges and knots. From Rothenberg's example we can see that the oldest printmaking technique still has much potential to be explored.

LINOCUT

A linoleum cut, or linocut, is very similar to a woodcut. The major difference is that the material is much softer than wood, which makes it both easier to carve and less durable in printing multiple impressions, resulting in smaller editions. Linoleum has no grain, so it is possible to make cuts in any direction with equal ease. Some artists dismiss linoleum as being suitable only for schoolchildren (or for greeting cards), but Picasso never let such preconceived ideas interfere with his creativity. His color linocut depicting a *Seated Woman (after Cranach)* (**260**) is, as the title implies, an interpretation of a painting by the 16th-century German artist Lucas Cranach, but a more abstract treatment than Cranach could ever

260. Pablo Picasso.
Seated Woman (after Cranach).
1958. Color linocut,
$25\frac{5}{8} \times 21\frac{1}{8}''$.
Museum of Modern Art,
New York (gift of
Mr. and Mrs. Daniel Saidenberg).

have imagined. The splendid colors result from printing with several linoleum blocks, just as is done with color wood blocks. The richly detailed textures in the hair, arm bands, and jewelry may have been made easier to achieve by the relatively soft linoleum.

WOOD ENGRAVING

Wood engraving differs in several respects from woodcut. For one thing, it is done on the end grain of the wood. If you imagine a board, say a 2-by-4, the long, smooth plank sides would be used for woodcut, but the grainy cut end would be used for wood engraving. The end grain can be cut in any direction without chipping or splintering, unlike the plank sides.

A distinctive characteristic of wood engraving is that it is a "white-line" technique. The tool used for cutting makes fine, narrow grooves in the wood, and these grooves, which do not take the ink, result in white lines when the inked wood block is pressed to paper. Woodcut, by contrast, usually has larger, broader, more irregular uninked white areas because of the coarser tools that gouge out background areas.

During the 19th century wood engraving was used widely for printing books and journals. The cut end of the wood could easily be prepared to be "type high"—the same height ($\frac{7}{8}$ inch) as the wooden alphabet letters that printers worked with at the time. Therefore, both images and text could conveniently be printed together. Photography was a young art, and methods for reproducing photographs had not been perfected. Most illustrations still were made in the form of prints. In the United States this art of illustration was dominated by Winslow Homer, who worked for several periodicals during the latter half of the 1800s. Homer depicted events of the Civil War, important political figures, and scenes of everyday life.

One of Homer's best-known prints was *The Robin's Note* (**261**). We can see the white-line effect clearly in the woman's dress, the column, and the background foliage. This is a simple enough scene—a young woman lying in a hammock—but Homer has composed it brilliantly. The strict vertical of the pillar, the diagonal of the porch floor, the arc of the hammock, the spill of the dress over the side, and the rich texture of the background—all these add up to a striking, almost classical composition. The robin of the title is isolated in the sky, centered in the V of the hammock. Wood engraving's capacity for fine detail was especially suited to Homer's style.

Intaglio

The second major category of printmaking techniques is intaglio (from an Italian word meaning "to cut"), which includes several related methods. Intaglio is exactly the reverse of relief, in that the areas meant to print are *below* the surface of the printing plate (**252**). The artist uses a sharp tool or acid to make depressions—lines or grooves—in a metal plate (**262**). When the plate is inked, the ink sinks into the depressions. Then the surface of the plate is wiped clean. When dampened paper is brought into contact with the plate under pressure, the paper is pushed into the inked depressions to pick up the image.

There are five basic types of intaglio printing: engraving, drypoint, mezzotint, etching, and aquatint.

ENGRAVING

The oldest of the intaglio techniques, engraving developed from the medieval practice of incising (cutting) linear designs in armor and other metal surfaces.

above: **261.** Winslow Homer. *The Robin's Note.* 1870.
Wood engraving, $8\frac{7}{8} \times 9''$. New York Public Library,
Prints Division (Astor, Lenox and Tilden Foundation).

below: **262.** Plate-making methods for intaglio printing:
engraving, drypoint, mezzotint, etching, aquatint.

below: **263.** Albrecht Dürer.
St. Jerome in His Study. 1514.
Engraving, $9\frac{3}{4} \times 7\frac{1}{2}''$. British Museum, London.

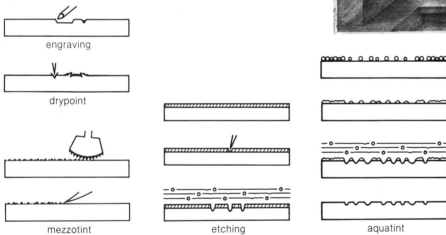

engraving

drypoint

mezzotint

etching

aquatint

The armorer's art had achieved a high level of expertise, and it was just a short step to realizing that the engraved lines could be filled with ink and the design transferred to paper.

The basic tool of engraving is the *burin*, a sharp, V-shaped instrument used to cut lines into the metal plate (**262**). Shallow cuts produce a light, thin line, while deeper gouges in the metal result in a thicker and darker line. Engraving is closely related to drawing in pen or sharp pencil in both technique and the visual effect of the work. Looking at a reproduction it is hard to tell an engraving from a fine pen or pencil drawing. As in these drawing media, modeling and shading usually are achieved by hatching, cross-hatching, or stippling (**104**).

One of the first great masters of engraving, perhaps the greatest ever, was Albrecht Dürer. In *St. Jerome in His Study* (**263**) we seem to stand on the threshold

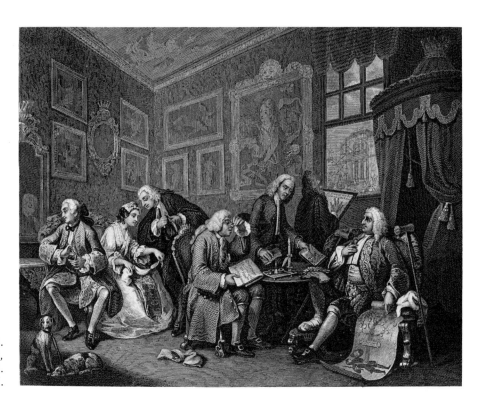

264. William Hogarth.
The Marriage Contract,
from *Marriage à la Mode*. 1745.
Engraving, $13\frac{15}{16} \times 17\frac{1}{2}''$.

of a quiet room, where Jerome is at work—perhaps on his major project, the translation of the Bible into Latin. Light streams in through the window of the study, which is drawn in careful perspective. According to legend, St. Jerome once removed a thorn from a lion's paw, and so he is often depicted with a lion at his feet. Here the dozing, friendly lion and a dog add to the overall impression of serenity and quiet work. The scene is rich with detail, for Dürer has exploited the possibilities of the engraving technique with remarkable skill.

In Dürer's time one great benefit of engraving was the dissemination of artistic ideas and innovations. Because prints were circulated throughout Europe, noted artists were able to study each other's work and learn from one another with far greater ease than ever before. Previously, an artist's master-

265. Reuben Nakian. *Myths and Legends*. c. 1980.
Drypoint, $19\frac{3}{4} \times 25\frac{5}{8}''$.
Courtesy DiLaurenti Gallery, New York.

works were known only to those who lived in the city where a given work was kept or who traveled to that city. Journeys to Italy from the northern countries were common; those from south to north less so. Engraved copies enabled artists to examine the work of their distant colleagues without leaving home, and soon influences among artists occurred more rapidly. Art styles of the various regions gradually became less distinctly different.

Around the 18th century engraved copies of well-known paintings became sought-after items for middle-class people. The change came about largely through the efforts of the English artist William Hogarth. Hogarth is best known for three large series of paintings—*The Rake's Progress, The Harlot's Progress,* and *Marriage à la Mode.* Each series was a "picture story" with a moral, and each portrayed the progress of an individual (or in the last case, a couple) from innocent beginnings through increasing sin to complete ruin. Being short of funds, Hogarth hit on the idea of making engraved copies of the paintings, copyrighting the engravings, and selling them cheaply in great quantities. This plan worked splendidly. (It also formed the basis for English copyright law in regard to art.)

The first scene in *Marriage à la Mode* (**264**) sets the stage for eventual disaster. A poverty-stricken nobleman is marrying off his son to the daughter of a rich but middle-class merchant. The two fathers settle the details of the marriage contract as they would any business deal. Meanwhile, the engaged couple, at left, ignore each other. Hogarth is not subtle in pointing out that this is not a love match. In fact, the future bride is already responding to the attentions of Counsellor Silvertongue, the lawyer, who will soon become her lover. Later scenes in the series portray infidelities by both partners, great excess of all kinds, a duel, and ultimately the death of the husband.

Hogarth's satire may seem a bit heavy-handed to us today, but his eye for the telling detail—such as the groom's father having a bandaged foot as a result of gout, a disease supposedly caused by excesses of food and drink—must have greatly amused his public. Engraving was the ideal technique for Hogarth, for its precision enabled him to capture a wealth of detail. Not surprisingly, Hogarth's satirical prints were extremely popular with members of the working class.

DRYPOINT

Drypoint is similar to engraving, except that the cutting instrument used is a drypoint needle. The artist draws on the plate, usually a copper plate, almost as freely as one can draw on paper with a pencil. As the needle scratches across the plate, it raises a *burr,* or thin ridge of metal (**262**). This burr holds the ink, making a line that is softer and less sharply detailed than an engraved line. If engraving is like fine pen drawing, sharp and distinct, then drypoint is more like drawing in soft pencil or crayon, with slightly blurred edges. This soft, sketchy quality is obvious in the figures of Reuben Nakian's drypoint *Myths and Legends* (**265**).

MEZZOTINT

Mezzotint is a reverse process, in which the artist works from dark to light. To prepare a mezzotint plate, the artist first roughens the entire plate with a sharp tool called a *rocker.* If the plate were inked and printed after this stage, it would print a sheet of paper entirely black, because each roughened spot would catch and hold the ink. Lighter tones can be created only by smoothing or rubbing out these rough spots so as not to trap the ink. To do this, the artist goes over portions of the plate with a burnisher (a smoothing tool) and/or a scraper to wear down the roughened burrs (**262**). Where the burrs are partially removed, the plate will print intermediate values. Highlights—very light values—print in areas where the burrs are smoothed away.

The major advantage of mezzotint is that it is capable of subtle gradations from dark to light. Whereas engraving and drypoint are predominantly line techniques, mezzotint is based on values. We see this effect in Peter Pelham's

portrait *Cotton Mather* (**266**), one of the earliest prints made in the American colonies. So finely modeled is this portrait of the great Puritan leader that, in reproduction, we might almost mistake it for an oil painting. The face, in particular, is wonderfully naturalistic because of the skillful use of values. This naturalism would be hard to achieve in an engraving or in one of the relief processes.

ETCHING

Etching is done with acids, which "eat" lines and depressions into a metal plate much as sharp tools cut those depressions in the other methods. To make an etching the artist first coats the entire printing plate with an acid-resistant substance called a *ground*, made from beeswax, asphalt, and other materials. Next, the artist draws on the coated plate with an etching needle. The needle removes the ground, exposing the bare metal in areas meant to print (**262**). Then the entire plate is dipped in acid. Only the portions of the plate exposed by the needle are eaten into by the acid, leaving the rest of the plate intact. Finally, the ground is removed, and the plate is inked and printed. Etched lines are not as sharp and precise as those made by the engraver's burin, because the biting action of the acid is slightly irregular.

Rembrandt, who was a prolific printmaker, made hundreds of etchings. Unfortunately, many of his plates were not canceled or destroyed. Long after his death, and long after the plates had worn down badly, people greedy to produce yet more "Rembrandts" struck impressions from the plates. These later impressions lack detail and give us little idea of what the artist intended. To get a true sense of Rembrandt's genius as an etcher, we must look at prints that are known to be early impressions, such as the magnificent portrait of *Arnold Tholinx* (**267**). In this work the artist brought to bear his most refined skills, accomplishing the fully rounded modeling entirely with hatching and cross-hatching (**104**). The face

left: 266. Peter Pelham. *Cotton Mather.* 1727. Mezzotint, 11 × 15". Courtesy Kennedy Galleries, Inc., New York.

right: 267. Rembrandt. *Arnold Tholinx.* c. 1656. Etching, drypoint, and engraving; $17\frac{13}{16} \times 5\frac{7}{8}$". Louvre, Paris (Cabinet Rothschild).

is serious, the man almost severe, possibly impatient with having his portrait done. Rembrandt's triumph is in conveying not just the physical image but the personality as well. Perhaps no one else could give us so sensitive an insight into character in this demanding medium.

Another master of the etching technique was the Spanish artist Francisco de Goya. Goya made several ambitious series of prints, and he worked in all the various print media, sometimes, as here, in more than one technique for a single print. The soft, occasionally irregular line of etching gives it a rather "dark," brooding quality, suited to Goya's political and social satire. *Hasta la Muerte* (*Until Death*, **268**) is from one of his major series, called *Los Caprichos*, meaning caprices, whims, eccentricities, freakishness. We see a grotesque old woman primping absurdly for her seventy-fifth birthday party, reflected even more horribly by her mirror. The look of satisfaction on her face suggests that *she* does not see the ugliness that we and the mocking onlookers see. Goya is poking none-too-gentle fun at her vanity, her girlish costume, her attempt at painting a very faded lily. The message of this print, as of many of *Los Caprichos*, might be: "We do not see ourselves as others see us."

If etching can produce the dark, gruesome qualities that Goya was looking for, it is also capable of more delicate effects, as in the work of contemporary printmaker Donald Saff. *Our Lady of Sarcasm* (**269**) presents an airy female figure apparently floating in a garden of pale flowers. There are many ambiguities in this etching. Is the woman reclining, or is she drifting gently from right to left? Why are the beautifully drawn flowers at left canceled out by the harsh black scribbling at right? Why is the woman's expression so melancholy, why is her form barely suggested, and what is the round ball halfway down her figure? Above all, what is the meaning in the title *Our Lady of Sarcasm*? These mysteries draw us back again and again to study the print. We may understand imperfectly and yet be hypnotized by the elusive image.

left: 268. Francisco de Goya. *Hasta la Muerte*, from *Los Caprichos*. 1797–98. Etching and aquatint, first edition; 8½ × 6". Meadows Museum, Southern Methodist University, Dallas, Algur H. Meadows Collection.

right: 269. Donald Saff. *Our Lady of Sarcasm*. 1978. Etching with hand coloring, 24 × 19". Courtesy Getler/Pall Gallery, New York.

left: **270.** Mary Cassatt.
In the Omnibus. 1891.
Color aquatint with drypoint
and soft-ground,
14 15/16 × 10 1/2".
Cleveland Museum of Art
(bequest of Charles T. Brooks).

right: **271.** Honoré Daumier.
Après Vous! (After You!).
c. 1867–68. Lithograph, 10 × 9 1/4".
Museum of Fine Arts, Boston
(bequest of William P. Babcock).

AQUATINT

A variation on the etching process, aquatint is a way of achieving flat areas of tone—gray values or intermediate values of color. To understand why this is desirable, we need only look back at the portrait of *Arnold Tholinx* (**267**). In that etching Rembrandt created the *illusion* of tone and shading by means of lines, hatched and cross-hatched. But aquatint allows the intaglio printmaker to produce real, not simulated tone.

To prepare the plate, the artist first dusts it with particles of resin. Several methods are available to control where and how thickly the resin is distributed on the plate. Then the plate is heated, so the resin sticks to it. When the plate is dipped in acid, the acid bites everywhere there is no resin, all around the particles (**262**). For instance, if the particles are thinly dusted and far apart, the acid will be able to bite into larger areas of the plate, but if the particles are close together the acid will have limited space to penetrate. Different tones, from light to dark, can be produced depending on the density of the particles, the length of time the plate is held in the acid, or the strength of the acid bath.

Because aquatint does not print lines but only areas of tone it is nearly always combined with one or more of the other intaglio techniques—drypoint, etching, or engraving. The 19th-century American artist Mary Cassatt, who was much influenced by the flat areas of color in Japanese woodcuts, adopted aquatint for a great many of her prints. *In the Omnibus* (**270**) has broad areas of soft tone in the women's dresses, the baby's bunting, and part of the background, but the faces and other details have been precisely rendered in drypoint and etching.

By combining techniques the intaglio artist can get almost any result he or she wishes. Because the artist can achieve effects ranging from the most precisely drawn lines to the most subtle areas of tone, the possibilities for imagery are much greater than in the relief methods. We turn now, however, to a branch of printmaking that is even more flexible in its effects.

Lithography

All the major printmaking categories except one have origins going far back into history, having developed from other art forms, such as decoration of armor, printing on fabrics, and so on. That one exception is lithography. Lithography

was invented in a particular place at a particular time by a particular individual—a man named Alois Senefelder.

Senefelder was a young German actor and playwright living in Munich during the 1790s. Frustrated by the expense of publishing his plays, he began experimenting with variations on the etching process as a cheap method of reproducing them. He was too poor to invest much money in copper plates, so he tried working on the smooth Bavarian limestones that lined the streets of Munich, which he excavated from the street and brought to his studio. One day, when he was experimenting with ingredients for drawing on the stone, his laundress appeared unexpectedly, and Senefelder hastily wrote out his laundry list on the stone, using his new combination of materials—wax, soap, and lampblack. Later, he decided to try immersing the stone in acid. To his delight he found that his laundry list appeared in slight relief on the stone. This event paved the way for his development of the lithographic process. While the relief aspect eventually ceased to play a role, the groundwork for lithography had been laid.

Lithography is a *planographic* process, which means that the printing surface is flat—not raised as in relief, or depressed as in intaglio (**252**). It depends, instead, upon the principle that oil and water do not mix. To make a lithographic print the artist first draws the image on the stone with a greasy material—usually a grease-based lithographic crayon composed of such materials as wax, soap, and shellac. (Senefelder's Bavarian limestone is still in use as a surface, but aluminum plates are also common.) Then the whole stone is treated with a light acid bath to fix the image and is soaked in water. Water is absorbed by the stone only in the areas *not* coated with grease. When the stone is inked, the greasy ink sticks to the greasy image areas and is repelled by the water-soaked background areas. Although the printing surface, stone or plate, is flat, only the image areas print on paper. (This book was printed by a mechanical version of lithography, known as *offset lithography*.)

Within a few years after Senefelder's discovery, many artists familiar with the relief and intaglio methods had taken up lithography. One of the first was the French artist Honoré Daumier. Daumier was a painter, but he achieved greater renown as a political cartoonist, and he possessed all the traits necessary for the latter occupation—wit, humor, an unerring eye for pretense, and a pen (or lithographic crayon) that could strike like a stiletto. In the early 1830s Daumier's harsh political criticism brought him fame but also got him into trouble with the authorities. Later he softened his approach, devoting himself to social and political satire that was widely dispersed in prints. A study of his seemingly endless output of lithographs can afford the viewer hours of entertainment. For Daumier knew where to poke and how to poke. His genius lay in discovering any vanity, pomposity, deception, fraud, or hypocrisy—and setting them up for ridicule with a simple drawing and a few economical words. The lithograph called *After You!* (**271**) shows two groups of armed men facing off outside a door labeled "Bureau de Désarmement" (disarmament office). Their leaders smile, bow, and display the most charming manners, each saying: "After *you*, my dear sir." "No, no! After *you*." Daumier was referring to France and her neighbors to the east—Germany, Prussia, and Austria. But how easy it is, more than a century later, to imagine these figures as Russians and Americans, each politely urging the other to go first through the disarmament door.

The potential of lithography was recognized almost immediately. By this method artists could create a wide range of effects, both linear and tonal, with relative ease and consequently low cost. The general public thus could be supplied with inexpensive, high-quality prints suitable for framing. Many companies on both sides of the Atlantic went into the business of making lithographs, but in the United States one firm so dominated the market that its name became almost automatically associated with the word "lithograph." That firm's name was Currier & Ives.

Nathaniel Currier established his lithographic company in New York City in 1834, and in 1857 James Merritt Ives joined him as a partner. During the nearly seventy years the firm was in business it produced an estimated seven thousand lithographs on a wide variety of subjects. There was something for every taste—Civil War battles, landscapes, religious themes, famous disasters

(especially fires, which allowed for lurid red effects in the sky), great trains and ships, scenes from the American West, sports (from prize fighting to fishing), and many other categories.

Currier & Ives devised an ingenious system for manufacturing the prints. They employed a great many artists to do the original drawings, after which the image was transferred to stone by professional lithographers. Although color printing, which required several stones, was feasible, Currier & Ives rarely used this expensive method. Instead, after the prints had been run off in black and white, each one was individually hand-colored in assembly-line fashion by platoons of young women sitting at long tables—one color per person. The colorists were supposed to follow color keys supplied by the artist, but quite often—perhaps to break the tedium of the job—they would select colors according to the whim of the moment. A catalogue from 1860 lists prices ranging from 8¢ to $3.75 for each print. In today's auction market a good Currier & Ives lithograph might sell for many thousands of dollars.

One of the most talented and certainly the busiest of Currier & Ives' artists was Flora Bond (Fanny) Palmer. During her career with the firm Palmer made an astonishing number of prints, on all the various subjects. Her detailed drawing style, plus an instinct for what the public would like, put her work greatly in demand. *American Express Train* (**272**) shows a favorite subject, drawn with her usual attention to detail and set in a picture-perfect landscape.

Most of the Currier & Ives artists were anonymous. It was the firm name that mattered, not the names of individual artists. Even Fanny Palmer signed few of her lithographs; later experts have identified her prints by analyzing the drawing style. By the end of the century, however, a number of well-known artists, especially in Europe, had taken up the new process. The Frenchman Henri de Toulouse-Lautrec has become closely identified with the lithograph because of one of those rare perfect convergences: He had the right artistic style for the right medium at the right time.

As we saw in Chapter 1, Lautrec practically invented the color lithographic poster, with the designs he made to advertise the Moulin Rouge nightclub and its performers. *La Goulue at the Moulin Rouge* (**273**) is a superior example. One of the featured dancers at the Moulin Rouge, La Goulue (the glutton) is shown doing the can-can before an audience rendered in silhouette. Lautrec understood well that a poster must, above all, catch the eye. Its message is simple: Come to the Moulin Rouge, where you will have a good time. The influence of Japanese prints is obvious in the flattened forms, the broad color areas, and the sharply uptilted perspective, which is visible especially in the floorboards. Despite the apparent foreground (the man in silhouette), middle ground, and background, we get little

272. Flora Bond Palmer, for Currier & Ives. *American Express Train.* 1864. Lithograph. Museum of the City of New York (Harry T. Peters Collection).

AMERICAN EXPRESS TRAIN.

sense of spatial depth. The composition is meant to be flat and decorative. Lithography provided Lautrec with the means to achieve, with relative ease, both the definite outline and the flat areas of tone. In all, the effect is frivolous, bohemian, and just a trifle sinister—like the Moulin Rouge itself.

Lithography also was well adapted to the stark, intense, brooding imagery of the Norwegian artist Edvard Munch (**274**). Munch's lithograph *Sin* is done almost entirely in red, symbolic of the title, and we find it shocking to see such an intense color used so freely. Because the green eyes are the only contrast, they rivet our attention. (Red and green, being complementary colors, jar against one another to increase the tension in this print.) The woman's eyes seem at once to be looking inward and gazing at some dreadful horror. This image associates female sexuality with evil and shame—a theme that obsessed Munch throughout his life. Of course, the sense of evil and shame is inherent in the artist, not necessarily in his subjects. Women's hair, especially in quantity as here, was seen by Munch as both an allurement and a potential danger for men. This effect of voluptuous hair—gorgeous yet menacing—was enhanced by the free-drawing capabilities of the lithographic crayon on stone.

A number of contemporary artists who are best known as painters have taken up lithography as a means of broadening their range of expression. Among them is Jim Dine. In recent years Dine has used lithography and other printmaking media to explore the expressive possibilities of a series of motifs, or repeated images. During the late 1970s and early 1980s his motif often was a disembodied

left: **273.**
Henri de Toulouse-Lautrec.
La Goulue at the Moulin Rouge.
1891. Color lithograph,
5′5″ × 3′10″.
Philadelphia Museum of Art
(gift of Mr. and Mrs.
R. Sturgis Ingersoll).

right: **274.** Edvard Munch.
Sin. 1901.
Color lithograph, $27\frac{3}{8} \times 15\frac{1}{2}''$.
Rijksmuseum, Amsterdam.

Edvard Munch
1863–1944

The picture reproduced above, *Self-Portrait Between Clock and Bed*, was completed by Edvard Munch two years before his death. Munch chose to portray himself in light of the short time left to him (symbolized by the clock), beside the bed on which he would die. It is not surprising that a man in his eightieth year was anticipating death, but for Munch it was nothing new. Death obsessed him throughout his life and was an ongoing presence in his art.

Born in a small town in Norway, Munch was raised in Christiania, as Oslo was then called. When he was five his mother died, and nine years later his beloved older sister died of tuberculosis. These events haunted the artist and no doubt contributed much to his extreme anguish and anxiety. At seventeen he began art studies in Christiania, becoming involved as well in the rather morbid, sexually permissive bohemian life of the city. In 1885 Munch paid the first of many visits to Paris. There he saw, and was influenced by, the work of the Impressionists and Post-Impressionists, especially that of Paul Gauguin. Although Munch borrowed aspects of painting techniques, his themes remained personal ones—death and dying, generalized anxiety, the despair of loneliness and abandonment, the passions between men and women, the sexual force of Woman as a source of terror.

Munch's first one-man show, in Berlin in 1892, was a disaster. His powerful subject matter and (to onlookers) harsh painting style caused an uproar, and the show was closed within a week. Nevertheless, the artist decided to take a studio in Berlin, where he remained for several years. The sixteen years following the Berlin exhibition, spent mainly in Germany and Paris, were Munch's most fertile period. It was then that he developed his interest in prints—woodcuts, lithographs, etchings—of which he eventually made more than seven hundred. Prints allowed him to explore, in many variations, the subjects that absorbed him. Often a subject he had tried in painting became starker, more disturbing, more intensely colored in subsequent print versions.

By 1908 Munch had become internationally famous, but his personal life was far from tranquil. Alcoholic, worn out with hard work, overstimulated by the bohemian clique in Berlin, tormented by at least one miserable love affair—Munch suffered a nervous breakdown and checked himself into a sanitarium in Copenhagen. There he underwent electric shock therapy to counteract effects on his brain of "persistent battering from an obsessive idea."[3]

If there is such a thing as a "Norwegian temperament"—brooding, melancholy, dark as the long nights of northern winter—Munch had it. Certainly it is difficult to visualize imagery like his coming from a French or Italian artist. After the breakdown, however, Munch's torments eased, and the output from his later years lacks the power of the Berlin/Paris period. It is as though the therapy that healed him took away all the passion, and the passion was necessary to his art. Perhaps he understood this. As he himself said, "I shouldn't like to be without suffering. How much of my art I owe to suffering!"[4]

Edvard Munch. *Self-Portrait between Clock and Bed.* c. 1942. Oil on canvas, 5'7⅜" × 3'11⅝". Oslo Kommunes Kunstsamlinger.

bathrobe, representative of himself (**275**). Celebrated in an oversized print (there are woodcut versions as well as lithographs), the bathrobe seems a commanding presence, a personality and force unto itself.

Lithography has been a favorite technique of contemporary artists, because it offers so much freedom in drawing and design. The technical limits of the medium are few. Our final branch of printmaking, however, gives even greater freedom in one particular respect—the use of color.

Screenprinting

To understand the basic principle of screenprinting, you need only picture the lettering stencils used by schoolchildren. The stencil is a piece of heavy cardboard from which the forms of the alphabet letters have been cut out. To trace the letters onto paper, you simply place the stencil over the paper and fill in the holes with pencil or ink.

Today's art screenprinting works much the same way. The screen is a fine mesh of silk or synthetic fiber mounted in a frame, rather like a window screen. (Silk is the traditional material, so the process is often called *silkscreen* or *serigraphy*—"silk writing.") Working from drawings, the printmaker blocks *(stops out)* areas in the screen that are *not* meant to print by plugging up the holes, usually with some kind of glue, so that no ink can pass through. Then the screen is placed over paper, and the ink is forced through the mesh with a tool called a *squeegee*. Only the areas not stopped out allow the ink to pass through and print on paper (**252**).

To make a color screenprint, the artist prepares one screen for each color. On the "blue" screen, for example, all areas not meant to print in blue are stopped out, and so on for each of the other colors. The preparation of multiple color screens is relatively easy and inexpensive. For this reason it is not unusual to see serigraphs printed in ten, twenty, or more colors. This color flexibility would be very difficult to achieve in any of the other methods. (Imagine preparing twenty-five Bavarian limestones, each weighing many pounds, for a single color lithograph!)

Andy Warhol's portrait of *George Gershwin* (**276**) exploits another capability of screenprinting—its potential for flat areas of color. A broad area of un-

left: 275. Jim Dine.
The Yellow Robe. 1980.
Lithograph, 4'2" × 2'11".
Courtesy Pace Gallery, New York.

right: 276. Andy Warhol.
George Gershwin,
from *Ten Portraits of Jews
of the Twentieth Century.* 1980.
Silkscreen, 40 × 32". Courtesy
Ronald Feldman Fine Arts Inc.,
New York.

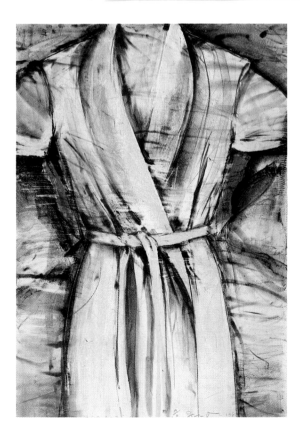

shaded color can be achieved simply by not stopping out the screen in that area. In Warhol's print the composer's face, in profile, is divided into four quadrants, each in a different electric color, with the linear detail kept to a minimum. Take away the startling color, and this print would be just a rather straightforward sketch of Gershwin. By treating an ordinary likeness in such an unexpected way Warhol jolts the viewer into a new awareness of how colors and forms influence one another.

One of the most appealing qualities of screenprinting for the contemporary artist is its flexibility in combining with other techniques. Such combining has become a favorite practice for Robert Rauschenberg. Rauschenberg's *Arcanum IV* (**277**) is part silkscreen, along with silk collage (layers of silk are applied to the backing of each print) and watercolor. The surface of the print is richly textured with many different images, screened on both paper and silk, overlapping and sometimes seen through a film of translucent silk. The imagery itself is complex—bits of machinery, bombs, spaceships, a rodeo rider, parts of Old Master paintings—all suggesting a riddle or puzzle to be solved, as the title *Arcanum* (mystery) implies.

Rauschenberg's *Arcanum,* like the Rothenberg woodcut we saw earlier (**259**), illustrates the tendency of some contemporary artists to use printmaking media as a "starting-off" point or a base, but not necessarily as an end. In other words, a given printmaking technique can be considered one of the many tools an artist has at his or her disposal to achieve an expressive goal, just as a paintbrush and colors could be used to do an easel painting, to make a mural, to decorate a sculpture, or indeed to individualize the prints in an edition.

Special Techniques

There is one major exception to the rule, stated at the beginning of this chapter, that prints are an art of multiples. That exception is the *monotype,* or *monoprint.* Monotypes are made by an indirect process, like any other print, but, as the prefix "mono" implies, only one print results. To make a monotype, the artist draws on a metal plate or some other smooth surface, often with diluted oil paints. Then the plate is run through a press to transfer the image to paper. Or the artist may simply place a sheet of paper on the plate and hand-rub it to transfer the image. Either way, the original is destroyed or so altered that there can be no duplicate impressions. If a series of prints is planned, the artist must do more work on the plate.

Monotype offers several technical advantages. The range of colors is unlimited, as is the potential for lines or tones. No problems arise with cutting against a grain or into resistant metal. One can work as freely as in a direct process like painting or drawing. You may wonder, then, why *not* simply draw or paint? Why bother with the indirect touch of the print? There can be as many reasons as there are monotype artists, but we might list a few. Monotype offers the "accidental" quality of the press as intermediary; even when the original is finished, one cannot be quite sure how the print will look when it comes through the press. Colors absorb into the paper differently, giving a "printed" effect many artists seek. There is the potential for working over the printed image to create a "layered" appearance. Probably the best reason is the simplest: artists love to experiment with techniques that expand their expressive range.

The French artist Edgar Degas (**144,217**) was particularly fond of the monotype and made hundreds of such prints. In the last decade or so the technique has enjoyed a new surge of popularity, encouraging many contemporary artists to explore the monotype. Janet Stayton's *Red Balustrade* (**278**) shows the painterly effects that are possible in this medium. Part of a series inspired by classical gardens in Europe, *Red Balustrade* features a row of statues at top, reflected fluidly in a blue pool at the bottom, with the two sections separated by the balustrade of the title. Stayton's colors are intense and vibrating, picked up all of a piece (not from separate plates) in the monotype method.

As printmaking techniques have expanded, so have methods of making paper. It may be difficult to think of paper as being "made." For most of us, paper comes in tablets or sheets or rolls, and we don't give much thought to how it got that way. But paper is composed of vegetable fibers, pounded into a pulp and then pressed into sheets. There is no reason why it cannot be pressed into other forms—forms that are quite different from the pages of this text or a memo pad.

One artist who has explored the realm of cast paper is Mary Frank, whose untitled print (**279**) has been further embellished with imagery that may remind

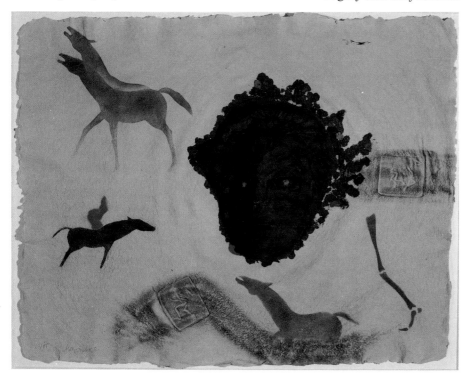

Robert Rauschenberg
b. 1925

Born in Port Arthur, Texas, Milton Rauschenberg—who later became known as Bob and then Robert—had no exposure to art as such until he was seventeen. His original intention to become a pharmacist faded when he was expelled from the University of Texas within six months, for failure (he claims) to dissect a frog. After three years in the Navy during World War II, Rauschenberg spent a year at the Kansas City Art Institute, then traveled to Paris for further study. At the Académie Julian in Paris he met the artist Susan Weil, whom he later married.

Upon his return to the United States in 1948, Rauschenberg enrolled in the now-famous art program headed by the painter Josef Albers at Black Mountain College in North Carolina. Many of his long-term attachments and interests developed during this period, including his close working relationship with the avant-garde choreographer Merce Cunningham. In 1950 Rauschenberg moved to New York, where he supported himself partly by doing window displays for the fashionable Fifth Avenue stores Bonwit Teller and Tiffany's.

Rauschenberg's work began to attract critical attention soon after his first one-man exhibition at the Betty Parsons Gallery in New York. The artist reports that, between the time Parsons selected the works to be exhibited and the opening of the show, he had completely reworked everything, and that "Betty was surprised." More surprises were soon to come from this unpredictable artist.

The range of Rauschenberg's work makes him difficult to categorize. In addition to paintings, prints, and combination pieces, he has done extensive set and costume design for dances by Cunningham and others, as well as graphic design for magazines and books. "Happenings" and performance art played a role in his work from the very beginning. In 1952, at Black Mountain College, he participated in *Theater Piece #1*, by the composer John Cage, which included improvised dance, recitations, piano music, the playing of old records, and projected slides of Rauschenberg's paintings. Even the works usually classified as paintings are anything but conventional. One has an actual stuffed bird attached to the front of the canvas. Another consists of a bed, with a quilt on it, hung upright on the wall and splashed with paint. Works that might be called sculptures are primarily assemblage; for example, *Sor Aqua* (1973) is composed of a bathtub (with water) above which a large, irregular chunk of metal seems to be flying, attached by rope to a glass bottle in the tub.

We get from Rauschenberg a sense of boundaries being dissolved—boundaries between media, between art and nonart, between art and life. He has said: "I don't think any artist sets out to make art. You love art, you live art, you are art, you do art, but you are just doing something, you are doing what no one can stop you from doing, and so it doesn't have to be art, and that is your life. But you also can't make life, and so there is something in between there, because you flirt with the idea that it is art."[5]

Robert Rauschenberg, photographed by Hans Namuth.

280. Red Grooms. *Gertrude.* 1975.
Six-color lithograph, cut out,
mounted, and boxed
in Plexiglas;
$19\frac{1}{4} \times 22 \times 10\frac{1}{2}''$.
Copublished by
Brooke Alexander, Inc.,
and Marlborough Graphics, Inc.,
New York.

you of the early cave drawings (**2**). Like most other prints, these cast-paper works can be duplicated for an edition, because the mold (usually of rubber) is reusable. The image consists not only of lines and colors, but is an actual three-dimensional impression.

Once prints start expanding into the third dimension, there is no stopping them. Contemporary printmakers are masters of the "why not try . . . ?" Take an artist whose imagination and sense of humor are manic, who understands the lithographic process, who appreciates pop-up books and paper dolls—and you get *Gertrude* (**280**). Red Grooms made *Gertrude*—the writer and art collector Gertrude Stein (p. 30)—from two lithographic prints, cut, folded, and mounted in three dimensions within an acrylic box. She (we cannot think of the work as "it") is a multiple, but she might just as well have fit into the sculpture chapter of this text. There she sits, pudgy in her flowered blouse in her pudgy flowered chair—an example of where prints can go if artists don't take themselves too seriously.

If you had any doubt at the beginning of this chapter that printmaking is a lively art, chances are you have changed your mind by now. In some ways it is an art ideally suited to our life style. The painter, the sculptor, the architect—all these make *one* work of art at a time, that will reside in one place. People who want to see the original must journey to do so. But the print made in an edition of three hundred will reside in three hundred different places and be enjoyed by thousands of people. Truly, the print allows nearly anyone to corner a small piece of the world of art.

9

The Camera Arts: Photography, Film, and Video

A room with a view. This phrase may make you think of real estate or of a classic novel, but we may borrow it here, because it describes the essence of a camera. *Camera* is the Latin word for "room," and it is not farfetched to think of any camera as being a little room with a view—real or imaginary—of the outside world.

The desire to record and preserve images is probably as old as civilization. In the 4th century B.C. the Greek philosopher Aristotle understood the most basic principle of the camera, for he noted the ability of light, under controlled circumstances, to duplicate an image. Aristotle lacked the technology to exploit this phenomenon, and so did many generations after him. In fact, not until the 16th century did anyone construct a practical device to harness the image-transferring property of light. That device came to be known as the *camera obscura*.

You can make a *camera obscura* yourself. Find a light-tight room, even a closet or a very large cardboard box. Arrange for a small hole, no bigger than the diameter of a pencil, in one wall of the room to admit light. Inside, hold a sheet of white paper a few inches from the hole. You will see an image of the scene outside the room projected on the paper—upside-down and rather blurry, but recognizable. That is the principle of the *camera obscura*, which simply means "dark room."

Artists of the Renaissance welcomed the *camera obscura* with enthusiasm, because it aided them in achieving a major goal—to reproduce the natural world as accurately as possible, with correct proportions and perspective. By the 16th century the mechanism had come into use as a drawing tool; once an image had been captured in the *camera obscura*, the artist could trace over it, thus ensuring an accurate rendering of the scene. A portable shack serving as a *camera obscura*

was sketched in cutaway (one wall and the roof removed for illustration purposes) in the 17th century (**281**).

Today we have come a long way from the *camera obscura*, but its principles remain intact. The modern camera is still dependent on controlled light, and it is still a room with a view. That view, however, may be anything the artist chooses to make it, from a straightforward recording of the natural scene to the most elaborate special effects the mind can conceive. Let us now consider the camera arts—photography, film, and video—and their unique view of the world.

Photography

Photography is the art form that best demonstrates a basic truth: Artistry resides not in the hands but in the head. People who cannot draw well sometimes think that painters have some unusual skill in their hands, just as a singer may have an exceptional voice. But while some art forms do demand manual skill, the difference between a merely competent mechanical performance and a great work of art lies not in the artist's hands but in the brain—in the artistic inspiration that tells the hands what to do.

It is this confusion between mechanical skill and inspiration that has caused some people to question photography as an art form. After all, painters and sculptors *create* forms; photographers only *find and record* forms. Nevertheless, just as the painter's brain tells the hands what marks to make on canvas, so the photographer's brain interprets what is seen by the eyes and tells the camera what to do. Whereas the average person walks through the world seeing trees and buildings and people, the creative photographer walks through the world seeing compositions—possible photographs. We might almost say that the photographer has an invisible frame somewhere behind the eyes—a frame that is constantly composing pictures.

281. *Camera obscura*, in cutaway view. 1646. Engraving.
International Museum of Photography at George Eastman House, Rochester, N.Y.

In composing a picture the photographer makes many decisions. We might analyze one well-known photograph to see how this works (**282**). The American photographer Russell Lee took the picture in Missouri during the Great Depression. Writing for the Museum of Modern Art, John Szarkowski said this about it:

> The simplicity of photography lies in the fact that it is very easy to make a picture. The staggering complexity of it lies in the fact that a thousand other pictures of the same subject would have been equally easy. Should the picture be made from farther away, or closer? Perhaps only the top of the dresser with the oil lamps and the boy's reflection in the mirror would be better; one step to the left might show the curve of the boy's cheek, but his head now touches the oil lamp, and the tape on the broken mirror falls on the reflection of his face. The feet are necessary. Would a vertical be better? Are the hats and the romantic landscapes on the wall, and the slop pail, part of the picture? How large is the boy and how small the room? What is the proper relationship between them? An infinite number of possibilities present themselves simultaneously, to be instinctively resolved, well or badly, in a moment, while the situation itself continues to change.

> No one can now know what other pictures might have been made here, but the one that Russell Lee made is perfect.[1]

Szarkowski's analysis of the Russell Lee photograph makes us question the popular idea that photography simply "tells the truth," or that the "camera can't lie." Lee's photograph of a sharecropper's little boy is obviously the "truth" of what took place at that particular time in a shack in Missouri. But suppose, for example, Lee had zeroed in on the child, screening out nearly everything else; we might have had a charming photo of a little boy combing his hair. Or suppose the child had not appeared in the picture; the image would have shown disorder and poverty, but not the poignancy of poverty reflected in a child. Each situation, therefore, contains many truths, and the truth of a particular picture is whatever the creative photographer selects for us to see, selects as one particular view of the world.

THE STILL CAMERA AND ITS BEGINNINGS

Despite the amazing sophistication of modern photographic equipment, the basic mechanism of the camera is simple, and it is no different in theory from

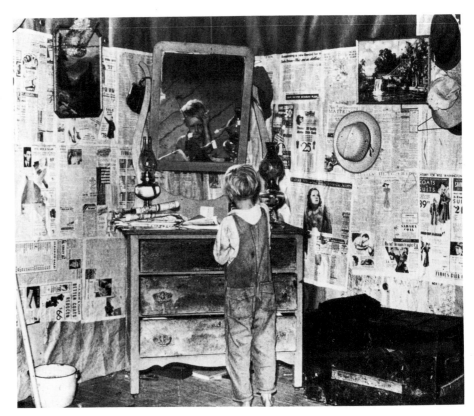

282. Russell Lee.
Son of a Sharecropper Combing Hair in Bedroom of Shack, Missouri.
1938. Gelatin-silver print
from original negative
in the Library of Congress,
$7\frac{3}{8} \times 9\frac{1}{2}$". Museum of
Modern Art, New York.

that of the *camera obscura*. A camera is a light-tight box (**283**) with an opening at one end to admit light, a lens to focus and refract the light, and a light-sensitive surface (today it is usually film) to receive the light-image and hold it. The last of these—the holding of the image—was the major drawback of the *camera obscura*. It could capture an image—and later versions of the *camera obscura* had a lens to focus the image and make it sharp—but there was no way to preserve the image, much less walk away with it in your hand. It was to this end that a number of people in the 19th century directed their attention.

One of them was Joseph Nicéphore Niépce, a French inventor. Working with a specially coated pewter plate in the *camera obscura*, Niépce managed, in 1826, to record a fuzzy version of the view from his window after an exposure of eight hours. Although we may consider Niépce's "heliograph" (or sun-writing), as he called it, to be the first permanent photograph, the method was not really practical.

Niépce was corresponding with another Frenchman, Louis Jacques Mandé Daguerre, who was also experimenting with methods to fix the photographic image. The two men were cagey with one another, each knowing that whoever was first to develop a simple, inexpensive process would strike a commercial gold mine. Daguerre won the contest. In 1837 he recorded an image of his studio that was clear and sharp, by methods that others could duplicate easily. Daguerre's light-sensitive surface was a copper plate, and he christened his invention the *daguerreotype*. Other pioneers worked with light-sensitive paper (the *calotype*), glass (the *ambrotype*), and dark metal (the *tintype*).

Daguerre's invention caused great excitement throughout Europe and North America. Entrepreneurs and the general public alike were quick to see the potential of photography, especially for portraits. It is hard to realize now, but until photography came along only the rich could afford to have their likenesses made, by sitting for a portrait painter. Within three years after Daguerre made his first plate, a "daguerreotype gallery for portraits" had opened in New York, and such galleries soon proliferated. To our eyes the portraits seem stiff and posed, which they were. Subjects had to remain motionless, without blinking, for between half a minute and a full minute. (If this doesn't seem long to you, try doing it). What's more, the idea of sitting for an "official" portrait was very new to most of these subjects. The sitters look awkward, and the results are often amusing—and charming (**284**).

The desire to record what people look like remains an important function of photography, for professionals and amateurs alike. Nearly everyone has a drawerful of photographs and slides, recording significant events from birth (some have been photographed *during* birth) through childhood, adolescence, romance, marriage, parenthood, and old age. Despite the popularity of amateur photography, the professional still plays a role in recording what people look like. Portraits comprise one of the major categories in photography.

SUBJECT MATTER IN PHOTOGRAPHY

Portraits The professional portrait, at its best, goes beyond merely recording the subject's physical attributes. Like any other photograph, it tells one "truth"—a selected version of all the possible things one could record about the subject. And, like any other portrait—an oil painting, for example—it may serve as a revelation of the subject's character. Certain photographers have demonstrated a particular genius for portrait photography.

In the mid-19th century one man, by virtue of creative talent, enterprise, and sheer hard work, dominated the field of photography in the United States. That man was Mathew Brady. Brady opened a daguerreotype studio in New York in 1844, at the age of twenty-one. Later there was a studio in Washington and more studios in New York. From these bases he set out to photograph all the illustrious people of the time, and he very nearly succeeded. He employed many assistant photographers, called "operators," including Timothy O'Sullivan, whose work we shall see later in the chapter (**289**). In many cases it is impossible to tell which pictures Brady himself took, because his name appears on all products of his studios.

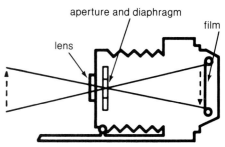

283. The basic parts of a camera.

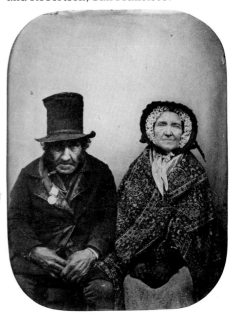

284. Anonymous photographer, Great Britain. *An Elderly Veteran of Waterloo Posed with His Wife.* c. 1885. Hand-colored ambrotype, $4\frac{3}{4} \times 3\frac{1}{2}''$. Rubel Collection, courtesy Thackrey and Robertson, San Francisco.

The photograph shown here, however, almost certainly came from Brady's own camera. In 1860, when Abraham Lincoln was running for election to the presidency, he arrived in New York to make a speech at Cooper Union, an important college. During his visit he presented himself at Brady's studio, where this sensitive portrait was made (**285**). Brady shows us a young Lincoln, clean-shaven, not yet torn by the heartache of war, fresh out of the back country of Illinois. His suit is obviously new, bought for the occasion, with the shirt cuff hanging down awkwardly from the jacket sleeve. Lincoln's facial expression is stern and dignified, but we also sense a bit of apprehension—perhaps caused by the leap into national politics, perhaps caused by the novel experience of having his portrait done.

Lincoln's Cooper Union speech was a success. Brady's photograph was in great demand, and thousands of copies were sold. After the election, Lincoln reportedly said, "Brady and the Cooper Union speech made me President."

Another famous portraitist of the 19th century—and an equally fascinating personality—was Frances Benjamin Johnston, who, without benefit of multiple assistants, was almost as prolific as Brady. Like Brady, she photographed an extraordinary range of subjects. Johnston was a niece of Mrs. Grover Cleveland, so she had access to the White House and, by extension, to many illustrious people, and she photographed them all. One of her most memorable works, however, is her portrait of herself (**286**). As we can see, Johnston was a strong personality who flouted convention. This seems to have helped rather than hindered her career. She has chosen to portray herself with a beer stein in one hand and a cigarette in the other—both virtually unheard of for a woman in 1895. Most shocking of all, though her costume is in line with the demure fashions of the day, her pose is decidedly "unladylike." She leaves us with the impression of a woman who lives and works exactly as she wishes, does it well, and answers to no one.

As we have said, the true photographic portrait is not just an accurate likeness but an interpretation of character. This is particularly clear in Berenice Abbott's portrait of James Joyce, made in Paris in 1928 (**287**). Joyce poses in an

left: 285. Mathew Brady.
Cooper Union Lincoln Portrait.
1860. Photograph.
Library of Congress,
Washington, D.C.

right: 286.
Frances Benjamin Johnston.
Self-Portrait. 1895. Photograph.
Library of Congress,
Washington, D.C.

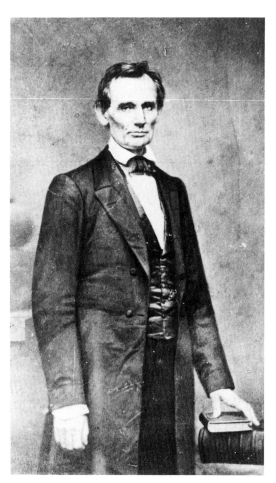

elegant costume, with a fine beaver hat and cane, but everything about him speaks of exhaustion and near-despair. His body seems shrunken within the suit, his hands too weary to hold themselves up. Abbott has lighted the scene so that her camera picks up every detail, even to the unspeakably sad expression in the writer's eyes.

Another writer, the poet Carl Sandburg, inspired photographer Edward Steichen to create a multiple image (**288**). It is as though Sandburg was so alive, so animated, so full of wisdom and charm that one likeness alone would not do justice to his character. Moreover, the repetition of Sandburg's head creates a visual rhythm that suggests the cadence of his poetry. Steichen's trademark was the dramatic use of light, especially of light-and-dark contrasts, and nowhere did he put it to better effect than in this portrait. Only the head is lighted, sometimes only the face. It is easy to imagine how much *less* striking this photograph would have been if the whole figure had been included.

Landscape From the first, landscape has been a popular subject for photographers, whether it was the natural beauty of the countryside or the constructed landscape of the city. Some early photographers, like Timothy O'Sullivan, went to great extremes to capture nature's forms. Hauling what was then very cumbersome photographic equipment through mountains and desert presented a real challenge, but the results were well worth the effort.

In 1867 O'Sullivan signed on as official photographer to an expedition commissioned by the federal government to explore the territories of Nevada and Colorado. One of his most dramatic photos from this trip (**289**) shows the

left: **287.** Berenice Abbott. *James Joyce.* 1928. Gelatin-silver print, 13⅜ × 10⅜". Museum of Modern Art, New York (Stephen R. Currier Memorial Fund).

right: **288.** Edward Steichen. *Carl Sandburg.* 1936. Montage, gelatin-silver print; 13 11/16 × 16⅞". Museum of Modern Art, New York (gift of the photographer).

289. Timothy O'Sullivan. *Sand Springs, Nevada.* 1867. Photograph. Library of Congress, Washington, D.C.

290. Ansel Adams.
Moon and Half Dome. 1966.
Photograph.

mule-drawn ambulance O'Sullivan had hired to carry water for his traveling darkroom. Tiny and stark against the vast shifting dunes, the vehicle looks like a dignified toy. We imagine that the footprints and grooves left by the wheels were the first marks ever made in this spot by anything but the wind.

The acknowledged master of 20th-century landscape photography was Ansel Adams. Our illustration (**290**) shows one of his most famous pictures, *Moon and Half Dome.* Although the scene that Adams chose to photograph is undeniably dramatic, that alone does not account for the artistry of this picture. Adams had "set up" the shot by choosing a precise vantage point; by *framing* the photo precisely (that is, including just the portion of landscape he wanted and no more); and by waiting until the moon, light, and shadows seemed just right. The composition is perfectly balanced, with the dark foreground rock at left and the dark shadow at right framing the lighted expanse of the rock known as Half Dome. The brilliant moon at top not only completes the balance of the picture but is its major focal point. Light is used to define the natural forms, to create contrast, to pick out textures and details; indeed, light structures the entire photograph. Adams demonstrates that the successful landscape photo, far from being a happy accident of nature, is a demanding art.

Genre In the visual arts, as we have seen, the theme of genre focuses on everyday life. Usually people are included, but the intention is not to make a portrait of individuals. Instead, a genre photograph captures one of life's "little moments," as in André Kertész' *Couple in the Park* (**291**). The young couple, strolling through a park in Budapest, have paused for a moment to kiss. Who they are is not important; what matters is the sweetness of life and of young love. We see both tenderness and sensuality in this picture, heightened by the dark background and the light falling on the woman's face. Is she pulling away slightly? Perhaps, but her hands are clasped firmly behind her lover's back.

Our next photographer's pictures, while not strictly genre, expand that theme. The work of Diane Arbus concentrated on people who are unusual, apart from the norm—some would say "freaks." Arbus photographed a sword swallower, aging nudists, and people with physical abnormalities of all kinds. Her goal was to look directly, unflinchingly, at that which others turn away from. Often, her pictures reveal jarring incongruities. *The King and Queen of a Senior Citizens Dance* (**292**) shows a couple decked out in absurdly elaborate robes and

crowns, which seem all the more absurd against their banal street clothing. Presumably this is meant to be a festive occasion, but the "king" and "queen" have such mournful expressions that we doubt any pleasure in their monarchy. Their postures are weary, and the woman in particular looks as though she has just plopped herself down in exhaustion. Arbus might be showing us that any attempt to impose gaiety or celebration on this couple will be futile.

Abstraction As has been noted before, abstraction is a process by which natural forms are simplified and reduced to their most characteristic aspects. We might think the camera, which tells only the "truth," cannot do this, but indeed it can. Abstraction in photography can result from viewpoint, angle, distance (including close-up), special lenses, darkroom techniques, or any combination of these.

 Many of Edward Weston's photographs are extreme close-ups of familiar objects, such as the *Artichoke, Halved*, shown here (**293**). Without the title, you might not be able to identify the picture's subject matter. By moving in close and picking up the exquisite detail of the vegetable, Weston gives it a majestic quality. All sense of scale is destroyed; this could just as easily be a huge underground cavern or a mysterious growth in a tropical rain forest—or a modern abstract painting. In creating this abstraction Weston challenges our preconceived notion of what an artichoke looks like. He may also encourage us to look beyond the overly familiar appearance of other common objects and consider their possibilities for abstraction of line, form, and texture.

left: **291.** André Kertész.
Couple in the Park. 1915.
Photograph. © Estate
of André Kertész.

right: **292.** Diane Arbus.
*The King and Queen
of a Senior Citizens Dance,
New York City.* 1970.
Gelatin-silver print,
15 × 11⅜″.
Copyright © The Estate
of Diane Arbus, 1970.
Museum of Modern Art, New York
(Mrs. Armand P. Bartos Fund).

293. Edward Weston.
Artichoke, Halved. 1930.
Photograph. © 1981
Arizona Board of Regents,
Center for Creative Photography.

294. Bill Brandt.
*Nude on a Pebbled Beach,
East Sussex Coast.* 1953.
Photograph.

A special lens known as a wide-angle lens produced the dreamlike abstraction of Bill Brandt's *Nude on a Pebbled Beach* (**294**). Under some circumstances the wide-angle lens distorts what it records, stretching out shapes horizontally. Here the photographer has manipulated it in such a way that the nude figure takes on a monumental quality, not unlike Henry Moore's sculptural abstractions of the human form (**222**). Only the most essential features give us clues to the identity of this subject—the flow of hair, the swell of the hips, and the line between the buttocks. The last is most important. If the left quarter of the picture is covered up, the form could be almost anything.

From a straightforward portrait to a naked monolith on a beach, the subject matter of photography includes everything in this world and—since the advent of space travel and sophisticated telescopes—more than a few things that are out of our world. The choice of imagery is limited only by the limits of the photographer's imagination. In some cases, however, the choice of subject matter may be influenced by the photographer's circumstances. Like drawings, photographs often are made for specific applications. The following section explores some of the purposes of photography.

PURPOSES OF PHOTOGRAPHY

Many photographs are made for specific commercial applications, such as publication in books, magazines, and newspapers, and their purpose is primarily illustrative or documentary. Other pictures have no external incentive beyond the photographer's expressive impulse. The dividing line between these two categories is not a rigid one. The photographer on assignment from a magazine may make an image that survives for its artistic qualities long after that issue of the magazine has been forgotten. And, of course, art photographs often are reprinted in books and magazines. Nevertheless, our appreciation of photographs can be enhanced by considering the primary purpose for which each was taken, because this strongly affects the photographer's expression.

The "Art" Photograph By art photograph, we mean a picture that is specifically intended for exhibition as art. Such photos are appreciated for their formal qualities and for their expressiveness, rather than for any illustrative value. Almost

since the beginnings of the medium photographers have explored the purely expressive potential of the camera. But what we think of as today's art photography owes a great deal to the influence of one man in particular, both because of his own work and because of his efforts to promote photography as an art form. That man was Alfred Stieglitz, and his most famous picture is *The Steerage* (**295**).

The story of how *The Steerage* was made illustrates our point about photographers moving through the world with an invisible frame behind their eyes. In 1907 Stieglitz was aboard ship on his way to Europe, traveling first class. One day as he was walking the deck, he happened to look down into the steerage section—that portion of the ship where the poorest passengers, paying the lowest fares, were herded together like cattle. Before him he saw a perfectly composed photograph—the smokestack leaning to the left at one end, the iron stairway leaning to the right at the other, the chained drawbridge cutting across, even to such details as the round straw hat on the man looking down and the grouping of women and children below. Stieglitz knew he had only one unexposed plate left (the equivalent of one exposure at the end of a roll of film). He raced to his cabin to get his camera. When he returned, the scene was exactly the same; no one had moved. That one plate became *The Steerage*.

By the 1950s photography had definitely come into its own as an art medium, and among those recognized as master photographers was Harry Callahan. Over the years Callahan has made many pictures of his wife, Eleanor, but they are in no sense portraits. Some are quite abstract, and many, like *Eleanor, Port Huron* (**296**), show her distant and alone in a large, tranquil landscape. Callahan's photographs are very personal, a direct expression of his emotions. Their trademark is the use of strong contrasts between light and dark values, as here. If you squint your eyes, the brilliant white form of the woman's body almost seems to be floating in the lush dark background foliage. This image conveys utter serenity. Perhaps it speaks of Callahan's love for his wife, better than any portrait could do, in a grander way—as part of his love for life and nature.

One model also dominates photographs by Cindy Sherman, but in this case the model is the photographer herself, disguised in each picture so that her work presents an extremely varied cast of characters. Since her early college days Sherman has been preoccupied with makeup, wigs, costumes, props—all the elaborate trappings of theatrical presentation. Soon she began not only dressing

left: 295. Alfred Stieglitz. *The Steerage.* 1907. Photograph. Art Institute of Chicago (Alfred Stieglitz Collection).

right: 296. Harry Callahan. *Eleanor, Port Huron.* 1954. Photograph, $6\frac{5}{8} \times 6\frac{1}{2}''$. Copyright Harry Callahan. Courtesy Pace/MacGill Gallery, New York.

Alfred Stieglitz
1864–1946

If one had to choose the individual most responsible for establishing photography as an art form, the strongest candidate probably would be Alfred Stieglitz. Born in Hoboken, New Jersey, Stieglitz was the eldest child of German parents. His youth was spent in travel between Europe and the United States, and he studied at both the City College of New York and the University of Berlin. In 1883, at the age of nineteen, Stieglitz bought his first camera in Berlin; thereafter his life's work seems never to have been in doubt.

Stieglitz settled more or less permanently in New York in 1890, although he continued to travel widely. The first of his major efforts to promote photography as an art form came in 1896, when he was instrumental in founding the Camera Club of New York. The following year he became editor of its quarterly publication, *Camera Notes*. But the group most closely associated with his name was the "Photo-Secession," founded in 1902. A loosely structured national organization of photographers, the Photo-Secession was devoted to promoting exhibitions of photographers, later of contemporary painters and sculptors as well. Stieglitz served as editor of its quarterly, *Camera Work*, which maintained extremely high standards for photographs published and reproduction quality.

As a photographer, Stieglitz dedicated his talents to demonstrating that the medium was accessible to anyone, even those with unsophisticated equipment and little training. He often worked with the simplest cameras, had his photographs printed commercially, and delighted in shooting under difficult conditions—in rain, fog, and darkness. His pictures were exhibited widely and were collected by major museums.

In 1905 Stieglitz, along with photographer Edward Steichen, opened the Little Galleries of the Photo-Secession at 291 Fifth Avenue in New York, usually called "291." There the American public viewed the work of "art" photographers and also had its first opportunity to see the paintings of Picasso, Matisse, Cézanne, and other avant-garde European artists, as well as the most innovative of the Americans. Through his gallery Stieglitz had considerable influence on the spread of modern art.

Among the artists showing at 291 was the painter Georgia O'Keeffe. In 1918 Stieglitz left his first wife and moved in with O'Keeffe, whom he married after his divorce became final. His photographic portraits of O'Keeffe, including many close-up studies of her hands, are among his most sensitive and striking images. Although Stieglitz and O'Keeffe were frequently apart, often at different parts of the globe (their chronology for the next twenty years or so reads like a travelogue), they remained married until his death at the age of eighty-two.

Stieglitz wrote extensively about his work, but perhaps the most characteristic statement can be found in his catalogue notes for an exhibit of his photographs in 1921: "My teachers have been life—work—continuous experiment. Incidentally a great deal of hard thinking. Any one can build on this experience with means available to all. . . . I was born in Hoboken. I am an American. Photography is my passion. The search for Truth my obsession."[2]

Alfred Stieglitz. *Self-Portrait.* Photograph.
Philadelphia Museum of Art (Dorothy S. Norman Collection).

297. Cindy Sherman. *Untitled.*
1983. Color photograph,
$7'2\frac{3}{4}'' \times 4'9\frac{3}{4}''$.
Copyright Cindy Sherman.
Courtesy Metro Pictures,
New York.

herself up, but photographing the results. A Sherman photograph has a rich but unspecific narrative content, a "story" behind the picture, which may remind us of films, television programs, and even commercials of the 1950s and 1960s (**297**). Sherman's work is strongly influenced by the mass media, as well as by performance art (Chapter 17). The characters are often stereotypes: dumb-blonde starlet, all-American girl model, woman as victim. For the photo illustrated here, she says, "I put some red makeup around my face to make it look like I was so angry I was going to burst. . . . It was a kind of a Frances Farmerish influence."[3] No explicit reference to a particular film or video image is intended. Rather, these complex, tension-filled photographs evoke feelings and memories in viewers familiar with the media imagery of the period.

Photojournalism and Editorial Photography Until the 19th century the only pictures that ever appeared in newspapers and magazines were made from drawings or from prints, usually engravings (**261**). Then photography came along, opening the potential for actual documentation of events. Mathew Brady, whose portrait of Lincoln we saw earlier (**285**), was among the first to exploit the potential of photographs for journalism. When North and South went to war in 1860, Brady and his team also went to war, carrying their equipment in peculiar horse-drawn wagons that the soldiers dubbed "Whatsits." Because his photos still required a fairly long exposure time at sittings, Brady could not photograph actual battles (which obviously would not stand still for the camera), but he recorded scenes of camp life, important generals and their aides, and especially the poignant aftermath of battle. The American Civil War, therefore, was the first major war photographed for posterity.

Because no method had yet been perfected to reproduce the photographs accurately and clearly, early photographs like Brady's were first translated into drawings and then into woodcuts for reproduction. Then, about 1900, the first process for photomechanical reproduction—high-speed printing of photographs along with type—came into being.

Today nearly every event that might remotely be considered newsworthy is covered by photojournalists, from the carnage of war to the escape of a pet snake in a residential neighborhood. News photographers must depend to a certain extent on luck. Their best pictures result when they are in the right place at the right time, when some extraordinary event occurs. Nevertheless, it is the photographer's skill that turns a record of an event into a great picture.

On May 6, 1937, the enormous German airship *Hindenburg* was scheduled to land at Lakehurst, New Jersey. Even though it was the dirigible's seventh transatlantic crossing, the arrival was still considered remarkable enough that a crowd gathered, and twenty-two photographers from the New York and Philadelphia papers had been sent to cover the landing. The photographers were set up to compose shots for feature stories. Just as the giant silver balloon was about to be secured to the mooring tower, it exploded and burst into flames. Of the ninety-two people on board, thirty-six were killed. Every one of the photographers, despite the tremendous heat and danger, managed to snap a few pictures before dashing to cover. Sam Shere's photo, with the tower silhouetted in front of the inferno, is one of the more memorable (**298**).

The burning of the *Hindenburg* was the first disaster to be thoroughly documented in photographs. During the decade of the thirties, however, another kind of disaster—not a sudden one, but a long and painful one—was covered in depth by the most creative photographers of the time. The Great Depression, which began in 1929 and lasted until the onset of World War II, caused hardships for photographers as well as for the population as a whole. To ease the first problem and document the second, the Farm Security Administration (FSA) of the U.S. Department of Agriculture subsidized photographers and sent them out to record conditions across the nation. One of these was Russell Lee, whose picture of a sharecropper's son we saw at the beginning of this chapter (**282**). Another was Dorothea Lange.

Lange devoted her attention to the migrants who had been uprooted from their farms by combined effects of the Depression and drought. *Heading West, Tulare Lake, California* (**299**) shows a mother and her two children, dirty and disheveled, in a battered truck. Despair is written on all three faces, as the eyes stare off at some distant point that may offer no relief from misery. Lange's masterful composition gives an importance, a universal quality, to the tragedy of one family. The picture's basic structure is a triangle, with the boy's head at the apex, one side running down through his leg, the other diagonal through the mother's head and the younger child, and the base resting on the bottom of the photo. (Compare Raphael's *Madonna*, **108**.) FSA photos like this one were offered free to newspapers and magazines across the United States. After the government project ended, Lange published her Depression photographs in a book, *An American Exodus: A Record of Human Erosion*.

Dorothea Lange's travels for the FSA took her to nearly every part of the country. In one summer alone she logged 17,000 miles in her car. Photojournalism is hard work. It may also be dangerous, as when the *Hindenburg* exploded. But the most difficult and dangerous job is that of war photographer.

W. Eugene Smith, who was on assignment for *Life* magazine for many years, worked as a combat photographer during World War II. A man with deep compassion for human suffering, Smith committed his photographic talent to

left: 298. Sam Shere. *Explosion of the Hindenburg, Lakehurst, New Jersey.* 1937. Photograph.

right: 299. Dorothea Lange. *Heading West, Tulare Lake, California.* 1939. Photograph. Library of Congress, Washington, D.C.

portraying that suffering in the hope of preventing its recurrence. The picture shown here (**300**) was taken in Saipan in 1944, during the closing months of the Pacific campaign. A soldier in battle dress holds a naked infant from the local population. The picture raises many questions: What is the baby doing there? Where is its mother? Is it dead or alive? Did the soldier just stumble upon the child in the underbrush? The contrast between the burly soldier and the tiny, helpless child tells us *this* is the reality of war.

The photojournalist, as we said, needs a certain amount of luck. He or she must wait for the picture to happen. There is another branch of journalistic photography, however, that *makes* pictures happen. This is editorial photography. Editorial photographers may deal in fashion, in food, in architecture, or many other areas. Their goal is to make the subject attractive and appealing, or possibly to interpret an idea photographically. Their pictures are "set up" very deliberately to achieve this purpose.

Fashion photography, like fashion illustration, usually aims at creating an illusion—the illusion of an impossible, idealized beauty that the viewer will feel compelled to emulate. No one has mastered this art of illusion better than Irving Penn. Penn's *Woman in Black Dress* (**301**) is almost an abstraction. The model, impossibly tall and thin, does not seem to resemble any living creature. We cannot imagine her walking or moving. If you cover up the head, you might be hard-pressed to identify the rest as a human body. Penn has posed the figure exactly in the center of the composition, and he has balanced one outstretched arm against the froufrou at the back of the dress. What matters here is not depiction of reality but a glimpse of unearthly elegance.

Despite its unreal quality, Penn's photograph is essentially "straight," as are most of those we have seen so far in this chapter. None employ complicated darkroom techniques or other special effects. The camera clicks, and the photograph is made. For other photographers, however, the click of the shutter is only the beginning of a process that will create an image very different from the one viewed outside the little room of the camera.

left: 300: W. Eugene Smith. *Saipan.* 1944. Photograph. © 1944 W. Eugene Smith/Black Star.

right: 301. Irving Penn. *Woman in Black Dress.* 1950. Gelatin-silver print, 16¼ × 11″. Museum of Modern Art, New York (gift of the photographer).

left: **302.** Anonymous photographer, India.
Portrait of a Landowner. c. 1900.
Photograph, painted. Smithsonian Institution,
Washington, D.C., and American Institute of Indian Studies.

below: **303.** David Hockney. *Celia, Los Angeles.* 1982.
Polaroid assemblage, $14\frac{1}{2} \times 26\frac{1}{2}''$.
Copyright David Hockney, 1982.

SPECIAL EFFECTS AND TECHNIQUES

The idea of using the photographic image only as a starting point is not a new one. We have already explored the problem of photography as truth-teller and asked, *which* truth? To this we must add another question: *whose* truth? The visual "truth" of a photograph may be influenced by a photographer's inner vision, by prevailing art styles, even by the culture in which photographs are made. We encounter the last of these in seeing how photography developed in a culture apart from Western traditions.

Photography reached India in the 1840s and was eagerly adopted by the populace. The Indian approach to the medium was very different from that in the West, however. Europeans, steeped in Renaissance concepts of depth and perspective, greeted photography as an ever more "real" depiction of the natural world. The Indians, by contrast, had a tradition of miniature painting in which the illusion of deep space was irrelevant. Paintings were flat, all in one plane, and highly decorative. So when they took up photography, the Indians proceeded to paint over the camera image until it looked "correct" to *them*.

Our illustration shows a splendid example (**302**). This portrait of a land-owner, taken about 1900, has been meticulously painted all over. While the subject's face and hands retain a suggestion of roundness from the photograph, the rest of his body is flat, thanks to the painting. The chair seems to float in space, while the meeting of patterned rug and wall is just a vertical division of the picture plane, not an indication that the rug is perpendicular to the picture plane. (Possibly the rug was a plain floor in the photograph; it has been painted with no perspective at all, as though it were parallel to the picture plane.) The background wall—which in the photo must have showed another room opening to the left and a vista out the window at right—now seems more like a painted backdrop for the theater.

There is a lesson to be learned from this approach to photography. Our understanding of how things "are" and how things "should be" has much to do with cultural conditioning. The Indians' cultural heritage predisposed them to the belief that a flat, decorative image is the ideal expression of art; Western cultural heritage predisposes us to believe that the illusion of depth on a flat surface is superior. Actually, neither is right or better. Through understanding and exposure, we can learn to appreciate aesthetic values different from our own. This applies to all aspects of art and culture, not just to photography.

A century later and half a world away, the English artist David Hockney has also taken a fresh approach to perspective, with a different technique. Hockney's *Celia, Los Angeles* (**303**) is an assemblage of thirty-two Polaroid shots, each focusing on one part of the subject. Taken all together, the thirty-two images give a recognizable picture of the woman Celia. However, because each shot has a different perspective and scale, the effect is jarring and disorienting. Celia has been fragmented; the fragments add up to a whole, but it is a disturbing whole.

Jerry Uelsmann is another photographer who likes to combine images for special effect—not side by side but one on top of another. *Apocalypse II* (**304**) was printed from three negatives—two for the ghostlike white tree and a third for the silhouetted children on the beach. Cleverly, the photographer has made it seem that the figures are staring at the tree as though it were some mysterious cosmic force. You may be reminded of contemporary horror movies in which children possess demonic powers.

The Surrealist artist Man Ray experimented with several unusual photographic techniques in the 1920s and 1930s. One of them was *solarization,* a process by which an exposed negative is briefly reexposed to light during development. This causes chemical changes in the photographic emulsion—the light-sensitive coating on film. Contemporary photographer David Vine used solarization in *The Old Man of the World* (**305**). This image combines the visual effects we would expect to see in a photographic negative *and* a positive print. Most of the left side of the photo, except the hat, is "negative." The rest is "positive." Together, these effects give the old man's portrait an eerie quality but also an imposing dignity.

In-camera color separation is a technique that has been developed extensively by Charles Swedlund. Although fairly complicated, it basically involves "separating" the colors in an image by means of filters, photographing each individually, and then recombining them to make the print, much as one would

left: **304.** Jerry N. Uelsmann.
Apocalypse II. 1967. Photograph.
Copyright Jerry N. Uelsmann.

right: **305.** David Vine.
The Old Man of the World. 1984.
Solarized print.
Courtesy the photographer.

print several colors together for a woodcut or silkscreen (page 215). The brilliant tones and soft focus in *Red Chair* (**306**) result from this method.

Finally, some artists have explored the potential of machine-mounted photographic equipment meant for copying documents, such as Xerox. You know that if you put your hand on the copying surface of a Xerox machine and push the button, you will get a "print" of your hand. But when you control the exposure time and set up the shot more deliberately, the machine becomes a creative tool, like a hand-held camera. Joan Lyons used a Xerox machine to make her *Self-Portrait* (**307**), which she then transferred to a lithographic plate for printing.

When considering special effects like the ones we have just seen, it is important to remember that the impulse for a photograph comes from the photographer, not from technology. Any camera, from the simplest to the most sophisticated, is just so much hardware until it is brought to life with the eye, the mind, and the heart of a creative photographer.

We might very well ask, then, what will photography do next? It is now possible to photograph the vastness of the universe through telescopes and the most minute forms of life through electron microscopes. Just as quickly as scientists have developed new techniques for their studies, creative artists have adapted those techniques for aesthetic purposes. In a mere century and a half photography has come farther and faster than any of the media that have been with us for thousands of years. Where does the camera go from here?

One of the places the camera can go is into a realm we have not yet touched upon in this chapter. This realm is not really a new one. It was first explored about a hundred years ago, but progress since that time has been extraordinary. The camera can seek to capture motion.

PHOTOGRAPHY AND MOTION

Throughout history artists have tried to create the illusion of motion in a still image. Painters have drawn galloping horses, running people, action of all kinds—never being sure that their depictions of the movement were "correct" and life-

like. To draw a running horse with absolute realism, for instance, the artist would have to freeze the horse in one moment of the run, but because the motion is too quick for the eye to follow, the artist had no assurance a running horse ever does take a particular pose. In 1878 a man named Eadweard Muybridge addressed this problem, and the story behind his solution is a classic in the history of photography.

Leland Stanford, a former governor of California, had bet a friend twenty-five thousand dollars that a horse at full gallop sometimes has all four feet off the ground. Since observation by the naked eye could not settle the bet one way or the other, Stanford hired Muybridge, known as a photographer of landscapes, to photograph one of the governor's racehorses. Muybridge devised an ingenious method to take the pictures. He set up twelve cameras, each connected to a black thread stretched across the racecourse. As Stanford's mare ran down the track, she snapped the threads that triggered the cameras' shutters—and proved conclusively that a running horse does gather all four feet off the ground at certain times. Stanford won the bet, and Muybridge went on to more ambitious studies of motion.

In 1887 Muybridge published *Animal Locomotion,* his most important project. Somehow, he persuaded a great many of his friends to take off their clothes and move about doing specific physical activities—in this case, inexplicably, kicking a pith helmet—while he photographed them (**308**). There were 781 plates in the series—many of nude people, some of clothed people, some of animals—all in motion. For the first time ever the world could see what positions living creatures really assume when they move.

Undoubtedly, Muybridge's experiments whetted the public's appetite. The little room with a view had glimpsed a different world, a world that does not stand still but spins and moves and dances, and the public wanted more of this. The public did not have long to wait.

Film

On the night of December 28, 1895, a small audience gathered in the basement of a Paris café, which was to become the first commercial movie theater in history. The audience viewed several very short films, including one of a baby being fed its dinner, another of a gardener being doused by a hose. One film in particular caused a strong reaction. *L'Arrivée d'un train en gare (The Arrival of a Train at the Station)* set the audience to screaming, ducking for cover, and jumping from their seats, because it featured a train hurtling directly toward the viewers. Never before, except in real life, had people seen anything of the kind, and they responded automatically. We may laugh at their naiveté—until we remember that contemporary horror films often have the same effect on today's far more sophisticated viewers. From the beginning, motion pictures could make an image projected on a screen seem very real indeed.

308. Eadweard Muybridge. *Woman Kicking,* Plate 367 from *Animal Locomotion.* 1887. Collotype, $7\frac{1}{2} \times 20\frac{1}{4}''$. Museum of Modern Art, New York (gift of the Philadelphia Commercial Museum).

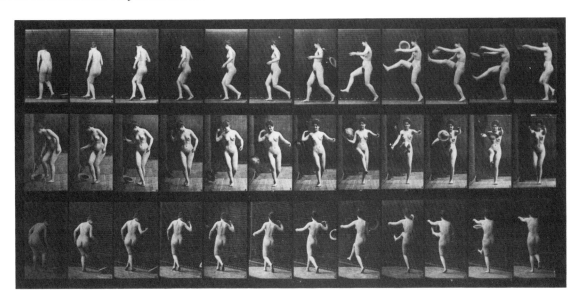

THE ORIGINS OF MOTION PICTURES

Film depends on a phenomenon called *persistence of vision*. The human brain retains a visual image for a fraction of a second longer than the eye actually records it. If this were not true, your visual perception of the world would be continually interrupted by blinks of your eyes. Instead, your brain "carries over" the visual image during the split second while the eyes are closed. Similarly, the brain carries over when still images are flashed before the eyes with only the briefest space between them. Motion-picture film is, of course, not real motion but a series of still images projected at a speed of 24 frames per second, which makes the action seem fluid and continuous.

Interest in moving pictures really predates the development of the still camera. As early as 1832 a toy was patented in Europe in which a series of drawn images, each slightly different from the next, was made to spin in a revolving wheel so that the image appeared to move. Eadweard Muybridge later applied this principle to his multiple photographic images, spinning them in a wheel he called the *Zoopraxiscope*.

Commercial applications of the motion picture, however, awaited three major developments. In 1888 the American George Eastman introduced celluloid film, which he intended for the Kodak still camera but which made it possible to string images together, rather than using the individual photographic plates required by early cameras. Another big step was taken by Thomas Edison, the famous American inventor better known for his development of the electric light bulb and the phonograph (precursor of the stereo). It was in Edison's laboratory, in 1894, that technicians created what was apparently the first genuine motion picture. Lasting only a few seconds, the film was made on celluloid. Its "star" was one of Edison's mechanics, a man who had the ability to sneeze amusingly on command. Its title: *Fred Ott's Sneeze*.

Edison's filmmaking project had been directed by his brilliant assistant, W. K. L. Dickson, and Dickson had solved many of the problems involved in turning films into a commercial enterprise. One major drawback remained. There was no satisfactory method for projecting the films to an audience. Here the challenge was taken up by two Frenchmen, brothers appropriately named Lumière (*lumière* means "light"), who in 1895 succeeded in building a workable film projector. The films shown in that Paris café were made by the brothers Lumière. From that point the motion-picture industry was off and running.

Film technology advanced rapidly. Almost overnight, it seemed, film companies sprang up on both sides of the Atlantic. Once the novelty of viewing motion pictures had passed, simple everyday events—such as a man sneezing or a baby eating—no longer satisfied. Filmmakers cast about for more dramatic and entertaining episodes to capture in the camera. Trained stage actors found themselves in great demand, and stories became more complex. The earliest movies were in fact rather "stagy." Actors entered and exited as they would in a theater, and all the action occurred in a shallow plane. Soon, however, filmmakers discovered the far greater flexibility of the movie arena. People could move, cameras could move, space need not be restricted, time could be expanded or compressed at will.

The fabulous era of silent films began with the Lumières' movie snippets in that Paris basement in 1895, and it lasted for just over thirty years. During that time a wholly new creature—the movie star—came into being, and the names from that generation live in legend: Rudolph Valentino, Mary Pickford, Douglas Fairbanks, Lillian Gish, and perhaps the greatest of them all, Charles Chaplin. Silent-film stars filled a gap in the American consciousness. In a time when studio salaries were huge and income tax a trifling matter, they lived and behaved like royalty. Some would have long careers in the cinema. Others fell victim to the next major breakthrough in film technology. Sound film was introduced in 1927, and not all stars of the silent era could not make the transition, for their voices did not match their physical attributes. Those who did pass muster vocally were launched into another great period of film history. By the late 1920s the camera—the little room with a view—had come of age. It not only had eyes, but ears as well. Soon it would see and hear things undreamed of theretofore.

Filmmaking of the twenties and thirties seems amazing in at least three respects: the tiny budgets; the rapid production times—perhaps just two or three weeks of shooting for a full-length film; and the relatively small number of people involved. Today a major film may cost tens of millions and be in production for a year or more. Moreover, as we watch the credits roll by on the movie screen nowadays, it seems that a large number of people are needed to make a film, and certainly this is true. But from the beginning of motion-picture history the greatest films, the classic films, have often been the product of one creative imagination. Usually, though not always, the creative force behind an important film is its director. Let us turn now to a brief survey of classic films and the creative artists who made them.

FILMS AND FILMMAKERS

The word "epic," in films, suggests a picture that is long, crowded, and grand. Usually, an epic film has a story taken from some significant point in history, or perhaps from the Bible. It will employ many actors—the proverbial "cast of thousands"—in climactic scenes with considerable action, such as battles, riots, or natural disasters. Often, the epic film has a moral to preach to its audience. Through the history of film there have been many epics, but the pioneer of the form was a man named David Wark Griffith.

D. W. Griffith began his movie career in 1908 as a director of very short (ten-minute) silent films cranked out at the rate of two a week. This apprenticeship taught him much about the mechanics of filmmaking, so that by the time Griffith had attained greater creative independence, he was ready for it. In 1914 the producer-director shot his first feature-length picture, and even its title proclaims an epic: *The Birth of a Nation* (**309**). Griffith took his story from a contemporary novel. *The Birth of a Nation* is set in the American South before, during, and after the Civil War. In a now-familiar device, it interweaves the histories of two families—one northern, one southern—whose paths cross and whose members fall in love with one another. The plot allowed for many battle scenes and a particularly effective staging of President Lincoln's assassination. We must remember that this was a *silent* film. All action, all plot, all emotions had to be conveyed by visual images only, without dialogue or sound effects. (There was usually live musical accompaniment in the early movie theaters.)

Most viewers today would find it difficult to sit through *The Birth of a Nation*, for when it is not exaggerated in style it is offensive in its racial prejudice and simplistic morality. Even in its day some audiences reacted strenuously to these aspects of the movie. Reviewing the film on March 4, 1915, *The New York Times* complained about "melodramatic and inflammatory material." The *Times*, however, went on to evaluate "the film as a film" and deemed it "an impressive new illustration of the scope of the motion picture camera."[4] So it was, for Griffith had revolutionized the mechanics of filmmaking.

Each unbroken sequence of movie frames, with the camera rolling, is called a *shot*. Before Griffith, the standard in films had been the *full shot*, showing

309. Scene from *The Birth of a Nation,* directed by D. W. Griffith. Released 1915.

actors from head to toe as a theater audience would view them. Griffith preferred to experiment with a full range of shots for dramatic effect: the *medium shot* (from the waist up), the *close-up* (head and shoulders), the *extreme close-up* (part of a face), and the *long shot* (seen from the distance). Dissatisfied with the camera as immobile observer of a scene, Griffith developed the *pan shot* (camera moving from side to side) and the *traveling shot* (camera moving from back to front on a track). He also perfected the technique of *cross-cutting,* in which two or more scenes are alternated to advance the action of the film. For example, he might film scenes of a heroine in distress and her hero rushing to save her, then cut back and forth rapidly between the two in order to build suspense. This last shows Griffith's mastery of film *editing,* or assembling the film creatively after all scenes have been photographed. In *The Birth of a Nation* Griffith also made effective use of the *iris shot* (**309**), in which the edges of the film are blacked out to create a circle of interest, as though one character in the film is looking at the events on the screen. *The Birth of a Nation* even has *flashbacks,* or cuts to episodes that are supposed to have taken place before the main action of the film. To sum up, Griffith had virtually written a menu of possibilities for future filmmakers.

The mechanics of filmmaking being in place, other creative movie people could focus on story line. Griffith's plots, obviously, had been dramatic. They could move audiences to tears or anger or patriotism. But film audiences also wanted to laugh, and filmmakers of the silent era gave them plenty of opportunity. The next great genius of the film was a man who tapped the endlessly entertaining possibilities of the human condition—of laughing at oneself and the ridiculous situations one encounters in daily life. His name was Charles Chaplin.

Chaplin began his career as an actor. Sometime in the years 1913–14 he began to develop the character of "Charlie," the Little Tramp, whom he played in most of his films. Physically, Charlie was what today we might call a "wimp"— undersized, clumsy, comical in appearance, wearing shoes and trousers far too big for him, sporting an absurd derby hat and a cane. Charlie was inevitably the one who got the pie in the face, the splash of slush from a passing streetcar, the foot caught in a goldfish bowl. He was the perennial outsider, always looking in wistfully at people who were rich, graceful, beautiful, and successful. But Charlie had courage, and he had a heart of gold. He would rush to save a maiden in trouble, only to lose her affections to the handsome leading man. Charlie was Everyman adrift in a world where anything could go wrong, anybody could trip him up.

Through many silent films Chaplin refined the character of Charlie and also honed his skills as a filmmaker. Soon he was not only acting but writing, directing, and producing the films, often creating the musical accompaniment as well. By the 1930s Chaplin was at the top of his form. Sound had been introduced, and although the Little Tramp did not speak (which would have been contrary to his mime-type character), Chaplin allowed for sound effects, and had Charlie sing a kind of nonsense song. *Modern Times* (**310**) is considered by many to be Chaplin's greatest film. In this movie Chaplin pits himself against the modern assembly line and, predictably, loses the contest. Chaplin's inventive genius goes into high gear, so to speak, as Charlie struggles against the machine and the machine fights back. *Modern Times* continues the battle of the odd little hero

left: 310. Charles Chaplin as "Charlie," the Little Tramp, in a scene from *Modern Times,* directed by Charles Chaplin. 1936.

right: 311. Scene from *Gone with the Wind,* produced by David O. Selznick. 1939. © Selznick International Pictures, Inc., ren. 1967 Metro-Goldwyn-Mayer, Inc.

312. Orson Welles as Charles Foster Kane and Ruth Warrick as his first wife in a scene from *Citizen Kane*, produced and directed by Orson Welles. 1941.

against adversity, but now his opponents are mechanical, not human. As with all his films, Chaplin concealed a message in *Modern Times*—that our fast-paced world is hard on innocent nonconformists—but as always that message is presented with side-splitting humor.

From the beginnings of movie history the prospect of filming in color had been on filmmakers' minds. Black and white has its virtues. So many of the all-time classic films were shot in black and white, and certain filmmakers, for certain films, prefer to work in that medium even today. But color adds an extra dimension, an extra lushness. There are some films we cannot imagine *except* in color, and probably the earliest of these is *Gone with the Wind*.

Color photography for films was feasible in the early 1930s. By the end of that decade it had been perfected sufficiently to be available to master producer David O. Selznick when he set out to reproduce in film Margaret Mitchell's spectacularly best-selling novel of the Civil War. *Gone with the Wind* was not unlike *The Birth of a Nation* in its story line or its epic proportions, but for the filmmaker there was a difference. Mitchell's book had so thoroughly captivated the imaginations of millions of readers that a potential audience *knew* exactly what a film based on the novel should look like. The filmmaker who let them down would do so at great peril! Selznick as producer took full charge of the movie, overwhelming writers (there were several) and directors (also several), even the stars. And Selznick delivered. The movie of *Gone with the Wind* was, and remains, a tremendous success with audiences.

The color effects in *Gone with the Wind* are always vivid (**311**). For the most intense scenes Selznick poured on a saturated red—the burning of Atlanta; the moment when the heroine, Scarlett O'Hara, resolves to survive the devastation of the war; the climax of the film, when Scarlett vows to reclaim her lover, Rhett Butler. Red worked for Selznick and the film on different levels. It is associated with the clayey soil of Georgia, where the story takes place. It is inherently dramatic. It often symbolizes passion, in this case the passion of the Scarlett-Rhett affair and the passions of the war. To our eyes now, accustomed to color films, the "scorched" effects of *Gone with the Wind* may seem a little exaggerated, but for that time and that movie they were exactly right.

Selznick's control of *Gone with the Wind* was considerable, but it may seem modest compared to the creative involvement by the next filmmaker we shall study. In 1941 R.K.O. released a film created almost single-handed by a twenty-six-year-old "boy genius" who played the starring role, produced and directed the film, co-authored the screenplay, supervised the editing and set design, and, it is said, even sewed some of the costumes himself. The film was not a success with contemporary audiences or critics. It did not win any major Academy Award. Today, however, when movie people compile lists of the "ten best" filmmakers and films, we are sure to find the names of Orson Welles and his masterpiece, *Citizen Kane* (**312**).

Welles based his story, loosely, on the life of the newspaper publisher William Randolph Hearst, here renamed Charles Foster Kane (played by Welles). What could have been a simple biography of a powerful man was turned by Welles into a startling cinematic achievement. *Citizen Kane* was innovative on a number of levels. Its structure, at first glance an ordinary flashback, begins with Kane's death, then traces his life from childhood and youth up through old age and back to his death again. But the actual telling of the story is far more complex than that. Kane's life on film is divided into five sections—the first played out in blaring newsreel films, the other four narrated in turn from the points of view of four people involved with Kane. Welles begins with a superficial outside view of the brash, successful young Kane, then gradually probes deeper and deeper into Kane's psychic center, as that center slowly disintegrates into lonely, bitter old age.

Cinematically, the movie opens the filmmaker's grab bag of tricks—all meant to highlight Kane's personality. There are *low-angle shots* (to show a towering Kane), dramatic long shots, extreme contrasts of light and dark, and many traveling shots intended to convey physical and emotional separation. For instance, as Kane's relationship with his first wife becomes cooler, the camera shows the couple farther and farther apart at the ends of an ever-lengthening dinner table. The introduction of garish newsreel-type footage, used for scenes of Kane's public life, contrasts with the brooding quality of the main story line. Welles calculated every shot to convey the mood, the emotional symbols, the portrait of a character he intended. *Citizen Kane* could not be a stage play. It is too dependent on film techniques for its impact. More than any filmmaker before him, Welles had shown what the camera, used imaginatively, could do.

With a few exceptions, American filmmakers dominated the movie industry in the early days, but starting in the 1920s they were challenged seriously from abroad, as creative artists in France, Germany, Russia, and other countries began to build their own styles for the motion picture. Increasingly the word "movie" ceased to be synonymous with "Hollywood." By the 1950s and 1960s, when Hollywood was investing heavily in musicals and light comedies, critical attention began to focus on European filmmakers with more serious aims. Two of these—one Swedish, one Italian—attracted special attention in the United States; they were Ingmar Bergman and Federico Fellini.

Ingmar Bergman's first internationally successful film, and some would say his greatest, was *The Seventh Seal*, made in 1957. *The Seventh Seal* is an allegory, a story filled with religious and macabre symbolism, a kind of morality play, set in the 14th century apparently in Sweden. As it begins, a knight returning from the Crusades is met on the beach by the figure of Death (313), who announces that the knight's time has come. Stalling for time, the knight challenges Death to a game of chess, and they agree that Death will not claim him until the game is over. The knight hopes to use this borrowed time to find some meaning in life, to accomplish some deed that he cannot name. As the game goes on intermittently, the knight and his squire, with other characters they meet, journey toward the knight's castle. Along the way they encounter a young couple,

left: 313. The figure of Death in an early scene from *The Seventh Seal*, directed by Ingmar Bergman. 1957.

right: 314. Opening sequence of *La Dolce Vita*, directed by Federico Fellini. 1959.

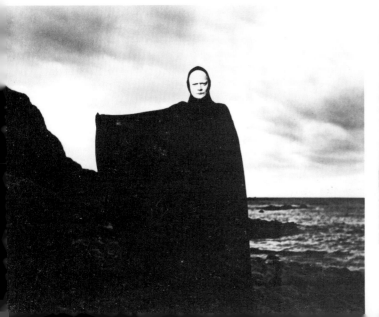

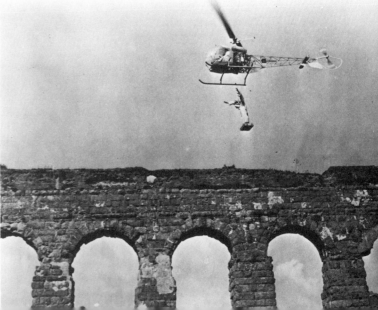

Jof (Joseph) and Mia (Mary) and their baby son—undoubtedly symbolic of the Christ child and his parents. In the end Death wins the chess game and calls the knight and his party to darkness, but the knight tricks Death into sparing the innocent couple and their baby.

Bergman, who both wrote and directed *The Seventh Seal*, was able to put an unusually personal stamp on this and all his films, because over the years he developed a close-knit repertory company of actors and supporting crew, accustomed to him and to one another. His actors, camera crews, and other associates became almost extensions of himself. They worked together on film after film, and some of them formed close personal relationships with the director.

Of the filmmakers we have considered so far, Bergman is the best example (though many would argue that Welles also qualifies) of what is called an *auteur*. The French word *auteur* translates literally as "author," but in relation to films it implies a great deal more. A cinematic *auteur* has maximum control over a film's production and imparts an individual style to a film or series of films. He or she often writes the screenplay—or closely supervises its writing—and may draw upon personal imagery, dreams, obsessions, fears, memories, beliefs, or loves as subject matter. This was certainly true of Bergman, and it is equally true of his counterpart in Italy, Federico Fellini.

Where Bergman is somber and melancholy, Fellini is flamboyant. His films may at first seem light-hearted, but there is a darker quality beneath the surface. A good example of this complexity is found in one of Fellini's best-known films, *La Dolce Vita* (**314**). The title, translated as "the sweet life," surely is ironic, for Fellini's camera zeroes in on people for whom life has become a series of superficial, momentary pleasures, carried to the extreme of depravity. Contrasts are made throughout the film between the old, stable values and society's new focus on instant sensual gratification. Fellini establishes this in his opening sequence, when a huge Christ figure is carried dangling from a helicopter over the city of Rome (**314**). A number of young women in bikinis, sunbathing on a rooftop, rise to wave at it. The symbolism is apt. Rome is, after all, a city of many churches, the seat of the Roman Catholic Church. But the Romans caught by Fellini's camera are more interested in indulgences of the flesh. They are rich, privileged, idle, and dissolute. Major events in the film include a suicide and an orgy. Fellini's message seems to be that this "sweet life" is not sweet at all, but poisonous; its participants not alive, but acting out a living death.

Despite the prominence of European filmmakers, not all serious films of this period were made outside Hollywood, and not all Hollywood films were musicals or frothy comedies. Long after Welles' *Citizen Kane*, Hollywood still could support a serious filmmaker, indeed an *auteur*, and it found its own in the person of a transplanted English director named Alfred Hitchcock. We might describe Hitchcock as the "purest" of filmmakers in the sense that his fascination lay almost entirely with the techniques of the camera, the view from the little room. Hitchcock had limited interest in story line, even less in dialogue, and he did not much care to direct his performers in interpreting their lines. Actually, by the time the cameras were ready to roll and the actors were in position, most of his creative work was over—a remarkable stance for a director. For Hitchcock, by then, would have plotted every shot to the last detail, established the camera angles and cuts, visualized the completed film. No editor could tamper with his work afterward, because he did not—as is the usual practice—shoot several versions of each scene. He shot only what he wanted in the film, what he had determined beforehand.

We see Hitchcock's masterful control of visual imagery in a classic scene from his thriller *North by Northwest*, released in 1959 (**315**). The hero, played by Cary Grant, has been duped into riding a bus to an isolated spot in the middle of a cornfield. There he stands, waiting for a supposed meeting with a man he does not know (and who, it turns out, does not exist). As Grant waits in the hot sun, there is no sound but the scrunch of his feet on the ground. Hitchcock gives no "meaningful" background music. Then a small airplane appears in the distance, flies closer, and heads directly for Grant. We realize the plane is trying to mow him down, either with its landing gear or with gunshots fired from the plane. Again, there is no sound but the airplane's engine and Grant's breathing as he

Alfred Hitchcock
1899–1980

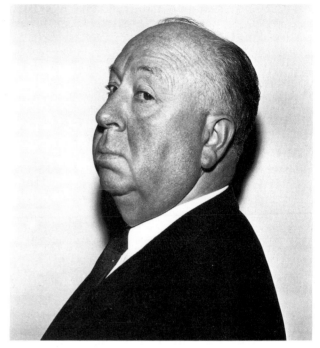

In the first scene of the film *North by Northwest* a man misses a bus and the doors slam in his face. He appears on screen for only a few moments and is never again seen in the movie. But in a very real sense the man missing the bus is the star of the picture. Making the "cameo" appearance that was his trademark in nearly every film, that man is the director—Alfred Hitchcock.

Born in a poor section of London, Hitchcock—who as an adult was always called "Hitch"—was the son of a greengrocer and his wife. His formal schooling ended at age fourteen, after which he worked at assorted jobs to help support his family. When he was twenty he got a job with an American film company based in London. The film industry then was very new, and the roles of participants tended to overlap. Hired as a designer of title cards, Hitchcock soon found himself filling in as scriptwriter, set designer, supervisor of costumes, production manager, and director. No better apprenticeship could have been planned for the man who would later be acclaimed as the technical virtuoso of filmmaking.

As the film industry expanded, so did Hitchcock's fortunes. Eventually he would direct nine silent films and fourteen sound features in London. With *The Lodger*, a silent film of 1927, Hitchcock already had begun to attract critical notice. Meanwhile, he had married Alma Reville, who would remain his lifelong creative partner. Their daughter Pat was born in 1928.

By the late 1930s the British film business was faltering. Hollywood had become the colossus of the film world. For a time Hitchcock and Hollywood played out a sort of mating dance. Then they were wed. In March of 1939 the Hitchcocks sailed for the United States, which would become their permanent home.

During the balance of that year Hitchcock worked on the first, and one of the most famous, of his American films, *Rebecca*.

Not until 1954, however, did Hitchcock truly hit his stride. Most of the pictures that established his filmmaking genius were made in the decade starting with that year: *Rear Window*, *To Catch a Thief*, *Vertigo*, *North by Northwest*, *Psycho*, and *The Birds*. Hitchcock's themes were usually macabre, featuring suspense, murder, psychosexual madness, or (in *The Birds*) placid nature turned to mayhem. During this decade, too, Hitchcock's major preoccupations got their fullest indulgence. He was a demon practical joker, often turning rather cruel pranks against his actors on the set. His devotion to gourmet foods and fine wines sent his weight soaring over 300 pounds. And he indulged another passion (always intense, always platonic) in his choice of female stars for his films—the cool, distant, aristocratic blonde exemplified by Grace Kelly, the first of Hitchcock's favorites.

After 1964 Hitchcock's concentration seemed to fail. Though he made several more films, almost none attained the quality of those from his prime. Still, until his death, neither the world nor the man himself lost the sense of Hitchcock as the consummate director. As early as 1925 Hitchcock had predicted his role as a creative force in filmmaking. Addressing a meeting of his colleagues, he said, "*We* make a film succeed. The name of the director should be associated in the public's mind with a quality product. Actors come and actors go, but the name of the director should stay clearly in the mind of the audience."[5]

Photograph of Alfred Hitchcock.

runs this way and that, trying to elude the plane (**315**). The scene is eerily terrifying, not least because viewers are unprepared for the spectacle of a man in a business suit, stranded in flat country, trying to escape death from a dive-bombing airplane. We never see the pilot or any other occupant of the plane. Considered logically, this scene is absurd; businessmen do not get attacked by murderous airplanes. Considered cinematically, it is a triumph—a life-and-death struggle of man against anonymous machine. Hitchcock spoke of how he planned this scene to be the *opposite* of what normally we would expect to be a menacing situation. Most filmmakers, setting up danger, would show darkness, looming buildings, mysterious figures peering from windows. Not Hitchcock. He gave us: "Just nothing. Just bright sunshine and a blank, open countryside with barely a house or tree in which any lurking menaces could hide."[6] That is the genius of Hitchcock's technique. Menace drops out of the sky into ordinary life.

In today's world of dazzlingly high-budget films, with their consequent monetary risk, it is unusual for a filmmaker to have the kind of absolute creative freedom that Hitchcock did—or Welles or Bergman or the others we have discussed. Films are giant corporate productions, with artistic decisions influenced by committees and financial administrators. One filmmaker who has escaped this bureaucratic control, who has managed to maintain the position of *auteur* right up to the present, is Woody Allen. Allen, who first achieved both critical and commercial success with *Annie Hall* in 1977, makes films that are nearly always loosely autobiographical and usually set in the artistic-literary world of New York City. An Allen film tests the viewer's command of trivia in such areas as film history, popular music, literature, New York gossip, and Jewish culture. Nevertheless, one can enjoy a Woody Allen film without fully understanding its iconography; probably no one could catch *all* his references, simply because they are special to him.

Radio Days, released in 1987, is a sentimental memoir of Woody Allen's youth, of the days before television when the radio provided the key to a world of glamour and excitement. The film has very little story line. Most of the events that take place are world events, such as the bombing of Pearl Harbor by the Japanese in 1941, conveyed through radio broadcasts and the characters' reactions. Many of the characters are set up as types rather than individuals, with names like "Bea's Third Date," "Deranged Man," "Sophisticated Songstress," and "Naked Lady." But *Radio Days* is far more than a simple recollection. Allen constructed every shot as though it were a painting (**316**), and his effects are endlessly lovely and rich. Reviewing the film, *The New York Times* wrote that *Radio Days* "is so densely packed with vivid detail of place, time, music, event, and character that it's virtually impossible to take them all in in one sitting."[7] For Allen, obviously, the "radio days" were a magical time, so he has translated his internal magic into a glittery visual feast for the viewer.

Like most of the films we have considered so far, *Radio Days* is essentially "straight." Its view is of a world that *could* be real, even if it isn't exactly real. Before closing our brief discussion of the film, we should look at another kind of world that is often captured by the camera—a world in which dogs talk, giant apes climb on buildings, creatures from other planets land in the suburbs of

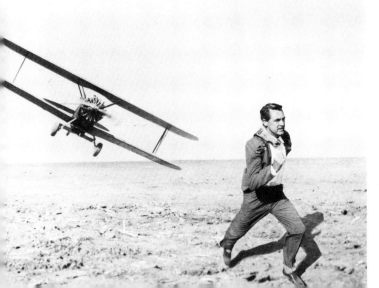

California, and galaxies go to war with one another. This is the world of special effects and animation.

SPECIAL EFFECTS AND ANIMATION

King Kong was not the first film to employ special effects, but it was certainly one of the more memorable. Made in 1932, *King Kong* is an adventure story concerning a giant gorilla, some 50 feet tall, which is captured in Africa and somehow transported to New York for display as a curiosity. Also, the film is an odd kind of love story, because when Kong inevitably escapes from his captors he falls in love with a normal-sized woman and carries her around with him. Mostly, though, *King Kong* was an opportunity to try some of the most imaginative and startling visual effects yet attempted on film.

The model of Kong used for filming was about 18 inches tall. Through trick photography the figure was transformed into a monster capable of climbing the Empire State Building and grabbing at the airplanes that try to shoot him down (**317**). Effects like these were achieved because filmmakers had become more comfortable with the potential of the camera. No longer need anyone's imagination be limited by physical constraints. A filmmaker could daydream, "What if a giant ape climbed the Empire State Building?" and then proceed to make it happen on film. In life or on the stage, such a feat would present staggering difficulties. In film, anything is possible.

Animation is another tool that expands the filmmaker's range of possibilities. The word *animation* means "bringing to life," and that is precisely what the filmic animator does with drawings of people, animals, and inanimate objects. Animated films are, in principle, little more than sophisticated versions of Muybridge's sequential photographs (**308**) made to spin in a wheel. They involve a series of drawings or cartoons, each slightly different from the next, arranged on film and projected at a speed that makes the drawn figures seem to move. The classic method of animation was perfected by Walt Disney Studios in the late 1920s. You can appreciate how time-consuming this was if you realize how much your body moves just in walking two steps, and consider how many drawings it would take to capture that movement. If the motion is not to seem jerky and unnatural, every shift of position by the merest fraction of an inch requires a new drawing. The smoothest animation, therefore, demanded about 24 different drawings per *second* or some 130,000 drawings for a feature-length film. In its heyday, the 1930s and 1940s, Disney Studios employed armies of illustrators to fill this need.

Through animation, the improbable becomes commonplace. Dogs talk and have unlikely adventures and fall in love, as in Disney's 1955 classic *Lady and the Tramp* (**318**). Puppets come to life, as in *Pinocchio*. Actually, any object that can be drawn can be made to move, dance, grow, shrink, or do whatever the filmmaker's creativity can devise.

Today the mechanics of animation have been simplified by computers. Modern animation is accomplished directly at the computer terminal, using

left: 317. Scene from *King Kong.* 1932.

right: 318. Scene from the animated film *Lady and the Tramp.* 1955. Copyright © 1955 Walt Disney Company.

319. Scene from *TRON*. 1982. Copyright © 1982 Walt Disney Company.

light rather than paint. The artist draws an original picture on the display screen and then programs the computer to "draw" the changing images that simulate action. Images and colors can be varied at will, live action can be combined with animation—the possibilities are literally endless. It seems appropriate that the landmark 1982 movie *TRON* (**319**) was produced by the pioneers of animation, Walt Disney Productions, because this was the first major motion picture to combine live action with computer animation.

TRON may also serve as a bridge to our final section in the discussion of camera arts, for it represents an application of technology that had been common in television for some time. The video arts—of which television is most prominent—probably touch more people more significantly than any other visual medium. How extraordinary this seems when we remember they have existed for barely fifty years.

Video

All art is about communication, but the video arts in particular are about *mass* communication. No other medium even approaches television in its potential for presenting to millions of people the same visual experience at the same moment. A national or international event—such as the rededication of the Statue of Liberty or the Olympic Games (**320**)—is telecast simultaneously into homes around the globe, complete with the graphics and other visual trappings devised by the networks to capture our attention. Viewers can, if they wish, compare their re-

320. TV graphics, Statue of Liberty.

sponses to an identical visual stimulus. This holds true not only for dramatic one-of-a-kind events, but also for the recurring fare of television. In offices, in supermarkets, in schools across the United States, conversations start with, "Did you see [name a popular show] last night?" For anyone alive now this is normal, but for all the billions of people who populated the earth before the 1950s it would be almost incomprehensible. Thanks to television, living with art has acquired another dimension: It is a mass visual experience.

Video is an electronic medium. Cameras record images, break them down into tiny dots, then transmit the dots electronically to receivers where the images are reassembled. The first official television broadcast in the United States took place in 1939, in connection with the opening of the New York World's Fair. Few people noticed, however, because there were practically no television receivers to accept the transmission. Americans were still under the spell of the "radio days" chronicled in Woody Allen's film (316).

It is difficult to date the beginning of television precisely, considering the number of elements needed to complete the package. The technology had to be perfected, television stations and networks had to be established, and the public had to be persuaded to buy television sets for their homes. By the season of 1949–50 these ingredients were pretty well in place. Technological advances had improved the quality of the images, the networks were broadcasting a full schedule of evening programs, and television sets had begun to appear in living rooms—enough of them to make broadcasting profitable.

From its beginnings television covered the full range of areas we take for granted today. NBC telecast a regularly scheduled sports program as early as 1944, and boxing soon became a favorite television diversion. (There were, of course, no instant replays at the time.) Television news—now a fact of life enhanced by on-the-spot interviews and sophisticated graphics—also was in place by 1944, using a straightforward speaking style carried over from radio. Only very gradually did news telecasts expand to the ballyhoo we expect for a presidential inaguration, an election, or a major sports event.

The word "sitcom" (situation comedy) did not appear until much later, but starting in 1951 CBS had on the air the first blockbuster sitcom, "I Love Lucy" (321). Across the United States ordinary life came to a halt at 9:00 P.M. on Mondays, when Lucy Ricardo (Lucille Ball) and her friends played out their amusing adventures. When Lucy supposedly gave birth to "Little Ricky" on the program in January 1953—the same day the actress gave birth to a son in real life—untold millions tuned in to watch, and the event completely eclipsed the inauguration of President Dwight D. Eisenhower the next day. "I Love Lucy" served as a model for sitcoms up to the present; it appears in reruns all over the world.

left: 321. Ricky (Desi Arnaz), Ethel (Vivian Vance), and Lucy (Lucille Ball) in a scene from "I Love Lucy." 1953.

right: 322. Siobhan McKenna, Robert Morley, and Claire Bloom in a scene from George Bernard Shaw's comedy, *Misalliance*, a feature of "Playhouse 90."

323. Music video,
Madonna in performance.

The mid-1950s represented a "golden age" of television drama. Programs like "Playhouse 90" and "Studio One" employed high-quality actors in high-quality plays (**322**). Such telecasts anticipated today's miniseries, but there was one big difference: The action was usually *live*. If an actor fumbled a line or missed a cue, if a scenic backdrop fell over, if a prop gun failed to shoot—millions of viewers saw it happen. Some of our best-known American actors got their training under these harrowing conditions. Today virtually everything on television (except sports events and segments of news programs) is film or videotape. We may be lulled by the smoothness of the presentation, but it would be exciting to see once again the tension of live drama on the video screen.

News and sports, comedy and drama—together with game shows, adventure shows, variety shows—all these have been staples since the advent of television. One type of programming, however, is a relatively new entry into the world of television, having become common only in the 1980s, and that is music video (**323**). Music video is difficult to categorize and to illustrate with one example, because it includes so many different types of expression. The lowest common denominator inheres in its name: There is music (often throbbing rock music) and there is video imagery. Some music videos dramatize the words of a song or even create brief visual dramas that are only vaguely related to the music. Some offer a message or statement. Some are relatively straightforward recordings of the performers at work. What we might call the "purest" of music videos have no story or plot line but instead present color and movement and visual stimulation to complement the music. This last category reaches directly for the senses—for sight and hearing.

Music video has great appeal and attracts a wide audience. The lure of constantly changing, constantly exciting and colorful visual imagery is very much a part of today's world. It should come as no surprise, therefore, that music video for the home television screen has a close cousin in the museums and art galleries, where we find the work of serious video artists.

We have already seen one example of video art in this book—the quantizer image in Chapter 4 (**130**). Here the artist actually creates an image on the television screen by manipulating dials, selecting colors, combining figures and other elements. Many artists believe this type of expression to be the most valid for our electronic age. Foremost among today's video artists is Korean-born, New York-based Nam June Paik. Paik envisioned a new art of video technology as early as 1960. He does not *reproduce* images electronically, as network television might show an image of a painting by Picasso or Renoir. Rather, the image is *produced*

324. Nam June Paik. Scene from *Global Groove*. 1973. Video art. Courtesy the artist.

and controlled by means of the electronic equipment itself (**324**). What is especially exciting about this approach is its immediacy, its "aliveness." According to Paik, "Most paintings reflect light. So when it's white paint, for example, you see the white light. Whereas television pictures are glowing light. Light is coming out, sprouting out. So it is much more intense physically. . . ."[8] Paik's video installations are expensive and take up space; they are not the sort of art that most collectors could expect to have in their homes. Still, they draw large crowds at museum exhibitions. We have grown accustomed to television. The fascination of flickering, transitory images is inherent in our world. Click—the art is there; click—it's gone; click—it's back again.

A room with a view—the camera. What do we see through the peephole of the room? Images from the past, images of the present, images of a possible future. Our fondest memories and our most horrifying nightmares. Colors and shapes known or imaginary. The artistry of those who direct the camera's view need accept no limitations whatever, for the view outside grows bigger all the time.

10

Graphic Design

*A*ll art has to do with communication, but this is uniquely true of graphic design. Graphic design has as its goal the communication of some *specific* message to a group of people, and the success of a design is measured by how well that message is conveyed. The message may be, "This is a good product to buy," or "You will want to read this book/magazine/article," or "This is an important, respected company," or "This way to the elevators (or rest rooms or newsstand)" or any of countless others. If it can be demonstrated that the public received the intended message—because the product sold well or the company's stock went up or the traveler found the right services—then the design has worked.

Not all graphic design has to do with selling, but much of it does, and so for a long time it was known as "commercial art." The term "graphic design" is more inclusive and describes more accurately what artists in this field really do. They create a visual image by some combination of words and/or pictures to communicate a message quickly and effectively. Graphic artists design books and packages and advertisements. They devise the trademarks and symbols (logos) that construct a special corporate identity for firms doing business around the world. They invent symbols that have the same meaning to people who speak different languages. They provide the colorful images that introduce television programs and movies.

Printed words play an important role in many graphic designs, but designers rely heavily on recognizable visual images as well. Certain images have long-standing and almost universal familiarity. For instance, the skull-and-crossbones has been associated for centuries with pirates and pirate ships (**325**), so that by extension it has come to mean danger and is often used on bottles containing poison.

The art of the graphic designer rarely involves subtle, complicated symbolism, as is often true of painting. The image presented must have an immediate

"If you don't mind my saying so, Captain, I love your graphics."

left: 325. "If you don't mind my saying so, Captain, I love your graphics." Drawing by Lorenz; © 1982 The New Yorker Magazine, Inc.

right: 326. *Map of Europe*, made in England. c. 1200. National Library of Ireland, Dublin.

327. Hobo signs, United States.

shared impact on a large number of people in order for the communication process to work. Seldom are these designs meant to be savored, studied, or enjoyed at leisure—although they can be. The effect on the observer is supposed to be immediate and lasting.

Because of our constant exposure to television commercials and sophisticated magazine advertisements, graphic design seems very much a phenomenon of the 20th century, but in fact it has existed almost since the beginning of civilized life. Street signs and shop signs were used in ancient Rome and, presumably, continued through subsequent centuries. Most graphic images were undoubtedly made in wood and other perishable materials, so we have little concrete evidence, but it is clear that graphic design gradually took hold until it became a central part of urban life.

Three factors are ultimately responsible for the growing influence of graphic design: the invention of the printing press in the 15th century; the Industrial Revolution in the 18th century; and the revolution in travel and communication in the 20th century.

Anyone can paint one sign, or two or three. The printing press, however, made it possible to reproduce a graphic image many hundreds or thousands of times. This gave designers the *ability* to communicate with a broad public. The

need for such communication was largely a result of the Industrial Revolution, which began in Europe in the latter part of the 18th century. Before that time, most products were grown or made locally to serve a local population. The person who wanted, say, a new pair of shoes could walk down the road to the village cobbler, or perhaps wait for the monthly fair at which cobblers from the neighboring towns might appear, but the choices were fairly limited. With the advent of machines huge quantities of goods were produced in centralized factories for wide distribution, and competition between producers became intense. It was necessary, therefore, to inform the buying public about the availability of certain goods and their relative merits. Graphic design in the form of advertising filled that need.

The history of graphic design for travelers is interesting, too. Some of it is speculative; we wonder, for instance, whether Robin Hood followed signs leading to Nottingham, or whether the pilgrims Chaucer wrote about found signs pointing the way to Canterbury. We do know that maps existed very early on, as our example shows (**326**). This map, drawn in England about A.D. 1200, purports to show the outlines of Western Europe. It makes no sense whatsoever until we realize that the mapmaker has turned Europe on its side—in fact, practically upside down, according to our usual north-south orientation—so that Rome is at the very top. The peculiar dog-bone shape at bottom is Ireland (Hibernia), and the boomerang-shaped outline above is Britain. To the left, neatly outlined in little boxes, are Hungary, Bohemia, and Bavaria; to the right, Spain. France occupies the center of the map. Rivers are indicated by the dark skyrocket shapes that swoop into land masses. For instance, the River Thames arcs into the top right of Britain, and we see London drawn as a tiny castle beside the river. It is assumed this map was intended for travelers journeying from Ireland and Britain to Rome, by way of Paris, Lyon, Pavia, and Piacenza. So naive is the geography, it seems a miracle they ever got there.

One of the more intriguing of travelers' communication systems was the one traditionally practiced by hobos in the United States. "Hobo signs" were simple, graphic images, usually scratched in chalk on a fence or post or sidewalk (**327**). The casual passerby probably would not have noticed them, but for those intrepid souls who rode the freight trains, slept under bridges, and caught a meal wherever they could, these signs had meaning. Some were *pictographic*, or visually suggestive of what they meant ("good place to catch a train"), while others were purely arbitrary and conveyed meaning from hobo to hobo because they had been learned. The message conveyed by "hobo signs" was a message of comradeship: "This is the experience I had here, and I want you to profit by it."

In the last few decades international travel has increased dramatically. People journey to foreign countries, without knowing the local language, and expect to get around comfortably and safely. Such travel has opened up a whole new realm for the graphic designer. Nowhere, perhaps, is the need to communicate without words more evident than at the Olympic Games, which draw athletes from scores of countries into one location. Somehow all the athletes must be housed, must find the places where they are supposed to be at various times, and must obtain the services they need. Preparing signs written in all the languages represented would be tedious and cumbersome. So whenever the games are held, graphic images are designed to mark basic areas and functions. The images are designed anew each time, but always they are simple, straightforward, and free of cultural biases (**328**). Even without captions you should have little difficulty identifying the sports they portray.

So in international travel as well as international commerce the need for graphic design has burgeoned. Fortunately, the *ability* to communicate graphically has also increased, thanks to new mechanical and electronic processes. Together, need and ability have yielded an unprecedented outpouring of graphic design. With this background, let us look first at the tools used by the graphic designer and then at some of the many categories of graphic design.

328. Graphics from the 1984 Summer Olympic Games, Los Angeles.
Courtesy Los Angeles Olympic Organizing Committee.

Regardless of the kind of graphic design or the method of reproduction, the graphic designer works with three tools: *type* (printed letters), *photography,* and drawn or painted *illustration.* Every design has at least one of these resources and usually has two or more in combination. We must also take into account the variable of color, because color is often responsible for much of a design's impact. And motion—whether in television or in computer graphics—can dramatically influence the way these three elements operate.

Type design has come a long way since the invention of movable type about 1450. Contemporary graphic designers have a bewildering array of typefaces and styles to choose from, in an infinite range of sizes. This book, for instance, is printed in a typeface known as *Aster,* which is popular for books because it is easy to read, legible in fairly small sizes, and not tiring to the eyes.

With so many typefaces and sizes to choose from, the designer can select one that best fits the character of the design and the tone of the message to be communicated. Moreover, type design itself has changed radically. In earlier times the letters of type were painstakingly carved out of wood or cast in metal. Today, type is "set"—or created and placed in position—by computer and photographic methods, so it is relatively easy to design an original typeface for a specific purpose. The designer can make a "word picture" that symbolizes the idea of the graphic design. One of the most inventive ways to do this is by "manipulating" the type into a shape that demonstrates some particular concept— say, the difference between a nonstop flight and a flight with stopovers (**329**).

A major decision for any graphic designer is whether to use photography or drawn illustration. In either case the options are limitless, so the choice becomes one of finding the image that will best present the idea for a particular audience. How, for example, might a designer convey the menace of urban sprawl, of the city relentlessly spreading out to encroach upon suburbs and country? A photograph showing factories among the farmlands might give some idea of the problem, but perhaps more effective, in this case, is James Grashow's drawing of a huge "citymonster," ready to devour the little houses and barns of the countryside (**330**). The "citymonster" has a body, tail, and teeth made of skyscrapers, and its eyes are clocks, suggesting that time is running out for rural America.

Another instance in which a drawn illustration proved compelling came in a *Boston Globe Magazine* article about veterinary medicine (**331**). Here the art director *could* have used a standard photograph of a veterinarian treating someone's pet dog. Instead, illustrator Seymour Chwast was called in to do this charming drawing of a large animal (a cow?) in a wheelchair, blanket up to its chin, icebag on its head, looking very much under the weather. This illustration would attract almost anyone's attention to the article.

Sometimes a photograph is the better choice for a particular design situation, but then the question becomes, "What sort of photograph?" To promote an upcoming art exhibition, for instance, the designer might choose to work with a

329. Advertisement for Air Canada.
Art director: Bill Tsapalas; illustrator: Ed Lindlof; creative directors: Camille McMennamin and Carl Christie; agency: McCaffrey and McCall, Inc.

photo of some painting in the exhibition, or a photograph of a featured artist. Our illustration shows a different approach (332). For an exhibition sponsored by the Kentucky Arts Commission, the designers used a photograph of eggs, beautifully arranged and lighted, with three of the eggs apparently broken to produce "yolks" in brilliant primary colors. The idea of "fresh paint" suggests new paintings come to town, and a viewer might well be eager to see the exhibition that inspired such a splash of hues.

These three tools, then—type, photography, and illustration—lend themselves to literally infinite combinations. The following brief survey of graphic design categories should give some idea of the scope and variety in this field. We begin with the most pervasive design category of modern times.

Advertising

Imagine you have bet someone that you could get through an entire day without being exposed to a single advertisement. How would you go about winning the bet? You couldn't watch television or listen to the radio, of course, nor could you read any magazines or newspapers. You'd have to be careful about the food you ate; so many packages and cans have advertising on them, for themselves or for some other product. You couldn't go to work or to class: too many billboards on the street, advertising posters on the bus, people handing out flyers on street corners. Should you settle down with a good book? Many books carry advertising for other books, either on the back cover or bound inside. A day at the beach? No, there's a skywriting airplane flying overhead and somebody's radio turned up loud. Perhaps a walk in the woods. But will it rain? You decide to call the weather service on the telephone. You've lost the bet! The weather report now includes commercial messages.

More than any other time in history we are bombarded from every side by advertising. So many products are made, so many consumers are there to buy them, so many millions of dollars are at stake in bringing the two together. Often-

330. James Grashow.
Illustration for an op-ed article in *The New York Times.*
1977. Woodcut.
Art director: Steven Heller.

left: 331. Seymour Chwast.
"Cow in Wheelchair,"
illustration for a story
in *Boston Globe Magazine.*
1983. Pen and ink on newsprint
with Cello Tak.
Art director: Ronn Campisi.

right: 332.
Poster for an exhibition
of the Kentucky Arts Commission.
Art directors and designers:
Julius Friedman and Nathan Felde;
photographer: Warren Lynch;
design firm: Images.

times the success of a product has more to do with the advertising campaign than with the product's intrinsic worth. This is especially true when products are alike. How different, really, are household cleaners? All have more or less the same ingredients, and all will get the sink clean. The manufacturer's job, therefore, is to fix the product name in the consumer's mind and have that consumer *perceive* a difference. For this the manufacturer relies on advertising.

The question then arises, what makes a successful advertisement? Why do some ads work better than others? Countless books have been written on this

right: 333. "Looking Good Mona," generic image promotion for WHAS-TV, Louisville, Ky. Designer: Teresa Heintzman.

below: 334. "Moving billboard" truck advertising for Levi's. Courtesy Levi Strauss & Co.

subject, and the answer sometimes involves complex psychological responses. Certain key factors can be identified, however, as contributing to an advertisement's effectiveness.

First of all, the ad must be noticed. Getting the viewer's attention is the advertising designer's first task, especially given the huge number of commercial messages constantly assailing us. One very popular technique for getting attention is consumer identification, as in ads for expensive items. While flipping through a magazine or newspaper, you see a picture of an elegant person or group and think to yourself, "I want to be just like that." After a barrage of such ads, you associate the product name with that desirable image.

A related approach is to take the expected, the familiar, and do something unexpected with it. Practically everyone knows the *Mona Lisa*, but few have ever imagined her in any of the guises shown in an advertisement for television station WHAS (333). This device is bound to attract attention, then generate a few chuckles, then possibly cause the observer to think, "How witty and creative those people must be"—which is no doubt the impression WHAS wanted.

Yet another method of attracting attention is by sheer size. Levi Strauss & Company tapped an unexpected resource when it decided to turn its three hundred trailer trucks into "moving billboards," with huge 6-by-8-foot decal advertisements on the sides (334). In the language of the market researchers who participated in this ad campaign, each truck-billboard would garner seventy "consumer impressions" for every mile the truck was driven. Consumer impressions, naturally, translate into consumer purchases—or so it is hoped.

Most advertisements, regardless of what they are selling, are planned to appeal to the self-interest of the people at whom they are directed. The viewer is supposed to think, "This would be good for *me*." Advertising designers have known this for at least a hundred years. An ad for Arbuckles' coffee, dating from the 1880s (335) suggests that home-roasting of coffee beans in those days was both a common practice and a "burning issue." The little dialogue in the ad is straightforward. It presents the problem in such a way that consumers can perceive a need, and then it offers a solution in comforting terms: "You will have no trouble." Since everybody wants "no trouble," the ad probably succeeded.

Coffee advertisements have changed rather a lot in the last century, as we can see by comparing the Arbuckles' ad with one from the 1980s (336). Here is "Juan Valdez," the fictional representative of Colombian coffee growers, stretched out on an analyst's couch with his burro on another couch beside him. Both are presumably suffering from the effects of fame—so many autographs to sign, so much attention—caused by the popularity of Colombian coffee. We cannot doubt the attention-getting qualities of this ad; few people could miss the image of a burro on a couch, its legs waving in the air. And how does this advertisement appeal to the consumer's self-interest? Well, after all, don't most people want to associate with the rich and famous? If Colombian coffee has produced all this fame, shouldn't one go out and buy some?

Print Media: Books, Magazines, and Posters

Book designers, of all graphic artists, often have the most difficulty making people understand what they do. In this book, for example, the designer selected the typefaces; chose the appropriate sizes of type for text, headings, captions, and so forth; and decided how much space to allow for margins and between various elements. She also devised a way to set off the artists' biographies and the "Art People" from the main text.

Cover design is easier to fathom. Usually, a book's cover will have an image—photograph or illustration—and the book's title and author's name printed in a suitable typeface. Cover design has two related purposes: to make the book attractive and appealing, and to encourage a potential reader to pick it up. The old adage says, "You can't judge a book by its cover," but to some extent

335. Chromolithograph poster, advertisement for Arbuckles' Coffee. 1880s. New-York Historical Society (Bella C. Landauer Collection).

336. Advertisement for the National Federation of Coffee Growers of Colombia. 1983. Art director: Mark Hughes; copywriter: D. J. Webster; photographer: Larry Robbins; agency: DDB Needham Worldwide.

you can. Certainly the reader browsing in a library or bookstore will often be drawn by a cover, then will explore the book further.

Most cover designs attempt to interpret the book's content. The illustrator known simply as Bascove carries this idea a little further; she attempts to interpret and express a book's mood (337). For her originals Bascove usually works in woodcut—a singular approach considering that illustrators generally choose watercolor or pen or some other drawing or painting medium. She has been strongly influenced by the the German Expressionists (compare 258), who also were attracted by the stark qualities of woodcut. Bascove's cover for *Aunt Jeanne*, a novel by Georges Simenon, reflects the brooding, deeply psychological quality of the author's work. Even the letters of the title and the author's name are cut into the wood block, making the cover design an integrated whole.

The design of magazine covers, while drawing on the same elements as book cover design (type, photography, illustration), differs in certain respects. For one thing, magazine covers are more influential in a reader's decision to purchase. You may be motivated to buy a particular book for any of several reasons—it's on the best-seller list, you heard about it from a friend, you are familiar with the author's work, and so on. But buying a magazine is more often a spur-of-the-moment decision. You are dashing for the train, waiting to check out at the supermarket, faced with a boring evening when your friends are away and there's nothing on television. You scan the magazine racks looking for diversion. Chances are, you will buy the magazine whose cover attracts you.

Another difference between magazine and book cover design has to do with longevity. Books often are kept, in homes and libraries, for many years. Magazines tend to be read quickly and then thrown away. (There are exceptions; in 1982 a Connecticut couple narrowly escaped disaster when several years' worth of stored *National Geographic* issues crashed through the floor of their attic to the bedroom below, landing on the bed to which they would soon have retired.) Because of their short life span, magazines can have covers that are contemporary, following up-to-the-minute fashions and current events.

When a drawn illustration is to be used for a cover, the choice of an illustrator is up to the designer of the cover or the magazine's art director—the person in charge of the visual aspects of the whole magazine. Occasionally a particular illustrator is used over and over, has a distinctive style, and therefore becomes closely associated with that magazine. There could be no better example of such a partnership than the one that existed between Norman Rockwell and the *Saturday Evening Post*.

In 1916 a very young Norman Rockwell, just twenty-two years old, presented himself at the Philadelphia offices of the *Saturday Evening Post*, a popular weekly magazine. He carried two paintings meant as potential *Post* covers and a sketch for a third. The *Post*'s art director was impressed and immediately bought the young artist's illustrations, requesting more. Rockwell's first *Post* cover appeared in May of that year, and his covers continued to appear regularly until 1963, when the artist branched out to other magazines. His last *Post* cover was a portrait of President John F. Kennedy, used as a memorial on the December 14 issue—three weeks after the president's assassination. During those forty-seven years Rockwell averaged about six covers each year—an amazing feat when one considers that each of the illustrations was a fully developed painting, often including many characters. Every Rockwell cover was greeted with delight by *Post* readers and guaranteed an increase in sales.

Rockwell's task was not an easy one; working in the magazine's format imposed many restrictions (338). Obviously, the image had to fit within a certain vertical framework—the shape of the magazine cover. Space had to be allowed at the top for the magazine's title and the date. Sometimes "teaser" blurbs for articles were superimposed over the artwork; Rockwell once mildly complained that the blurbs always seemed to fall just over the spot where he had drawn his most interesting detail. Nevertheless, Rockwell's association with the *Saturday Evening Post* proved to be a long and happy one for all concerned. As with many enduring works of art, Norman Rockwell's illustrations offered the right style in the right medium at the right time.

Most contemporary magazines attempt, through their covers, to establish a certain "tone" or style that is to be associated in readers' minds with the magazine. Computer and electronics magazines have photographs of high-tech equipment, fashion magazines picture models wearing the latest styles, expensive cooking magazines feature elegant, beautifully composed photographs of chic food, and so forth. Some magazines shift back and forth between illustration and photography, but most stick to one or the other. A prime example of the latter preference is the *The New Yorker*.

The style of *New Yorker* covers has not changed for decades (**339**). Every cover is an illustration, never a photograph. Although many different illustrators are used, the style is unmistakable. Anyone familiar with the magazine would recognize a *New Yorker* cover, even without the title, regardless of whether it is last week's issue or a number from thirty years ago. Exactly why this is so would be difficult to analyze, because, considered individually, the products of various artists seem very different from one another. One could say there is a unifying tone of whimsicality that readers have come to identify. A *New Yorker* cover does not reflect any article inside the magazine, and there are no teaser blurbs on the cover. Readers generally do not buy an issue for any particular article or story, but simply because it is *The New Yorker*. The cover style is part of this identity.

From the magazine cover to the poster is not a large step; in fact, some exceptional magazine covers—often *New Yorker* covers—have been transformed into posters and found their way onto home and office walls around the country. Posters are by no means new, but only since the 1960s have they been such an ever-present factor in our lives. Nowadays, it is the rare individual who has never hung up a poster from a museum exhibition, a travel poster, a poster featuring a film or music star, even an advertising poster, if it is particularly attractive.

above left: 337. Bascove. Book jacket for Georges Simenon's *Aunt Jeanne*, published by Harcourt Brace Jovanovich. 1982. Woodcut with overlays. Art director: Rubin Pfeffer.

above right: 338. Norman Rockwell. *The Tom Boy*, cover for *Saturday Evening Post*, May 23, 1953. Reprinted from *The Saturday Evening Post* © 1953 The Curtis Publishing Company.

339. Cover for *The New Yorker* magazine, April 20, 1987. Cover-drawing by W. Steig; © 1987 The New Yorker Magazine, Inc.

Norman Rockwell
1894–1978

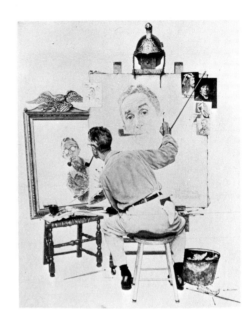

Norman Rockwell, chronicler of small-town America, was born in New York City and raised in a section known as the Bronx. By the age of fourteen, already determined on a career as an artist, he assumed responsibility for his own education—selecting the art schools he would attend (which eventually included the Art Students League) and finding odd jobs to support himself. One such job was as an extra, often a spear carrier, at the Metropolitan Opera, where he became rather a pet of the legendary tenor Enrico Caruso.

At eighteen Rockwell began to get his first professional commissions, most of them for illustrations in boys' magazines and children's books. Then in 1916 came the first *Saturday Evening Post* cover. After his early triumph at the *Post*, Rockwell never again lacked for assignments. His career blossomed, and he remained busy trying to keep up with the demand for his work until the onset of his last illness at the age of eighty-four.

Rockwell's great success was based on the simplest of formulas: He drew ordinary people in ordinary situations doing the sorts of things all the *Post*'s readers were accustomed to doing. He drew them with a gentle humor that poked fun at the situations while never poking fun at the people. The magazine's readers could laugh at themselves, at the odd and funny plights they got themselves into, because they sensed the artist was one of *them*, subject to the same foibles as anybody else.

After leaving New York, Rockwell first lived in a suburb of the city, then for many years in Vermont. Ultimately he settled in Stockbridge, Massachusetts, the town with which he is most closely associated. His models for *Post* covers and other illustrations were the townspeople—the mayor, the barber, the village clerk, the children of the neighborhood. In the early years Rockwell painted them from life, but later he developed a system of photographing the scenes and models, then painting from the photographs. Not all Rockwell's subjects were Stockbridge villagers, however. Routinely he was called upon to paint the famous and the mighty—presidents and presidential candidates, from Eisenhower onward; heads of state; sports heroes and astronauts; and many entertainment figures, including Bob Hope, Frank Sinatra, John Wayne, and even Lassie.

Rockwell married three times—the latter two marriages were apparently very happy ones—and had three sons. Apart from the sudden death of his second wife, little trouble marred a peaceful, productive life. Although the major art critics always were harsh in their assessment of Rockwell's work, he enjoyed enormous popularity with the general public. In 1969 Rockwell had his first one-man show of paintings in New York; the local critics savaged the show, but nearly every painting sold at the preview, before the exhibit opened officially.

Actually, the problem of criticism arose only when people tried to evaluate the artist as a *painter*; few ever questioned his gifts as an illustrator. Rockwell himself commented once on this distinction: "Some people have been kind enough to call me a fine artist. I've always called myself an illustrator. I'm not sure what the difference is. All I know is that whatever type of work I do, I try to give it my very best. Art has been my life."[1]

Norman Rockwell. *Triple Self-Portrait*, cover for *Saturday Evening Post*, February 13, 1960. Reprinted from *The Saturday Evening Post* © 1960 The Curtis Publishing Company.

Posters are supposed to catch the eye, to create an instant impression, and perhaps to make us smile. All three qualities are present in Seymour Chwast's poster advertising *Happy Birthday, Bach* (**340**), a book published on the three-hundredth anniversary of the composer's birth. A familiar image of Bach, known from an old painting, has been cheerfully transformed by Chwast's pen, which turns the powdered wig into a tiered birthday cake and adds a celebratory cigar. On the whole, Bach has a rather stuffy reputation, but not when he is interpreted by the creative poster artist.

Our next example also features a well-known image, but in this case the image is thrown into a wholly unexpected context. Although many people are familiar with Picasso's self-portrait (p. 42), few are prepared to see Picasso catching the subway at Grand Central Station in New York (**341**). This poster's visual impact is brilliant in its simplicity, and the message it conveys is understated but clear. The School of Visual Arts teaches courses in art. Probably the bulk of its students commute by subway, and that is where the poster has been displayed. Thus, if the artist can take the subway, the subway can take you to art.

So far, our examples in this chapter have been made with conventional materials—paint, ink, pencil, pen. We turn now to the newest branch of graphic design, which depends on the medium of our age: the computer.

left: **340.** Seymour Chwast. *Happy Birthday, Bach,* poster advertising a book by Seymour Chwast and Peter Schickele. 1985. Acrylic and colored pencils on chipboard. Doubleday/Pushpin Editions.

right: **341.** Subway poster for the School of Visual Arts, New York. 1983. Illustrator: Robert Weaver.

342. Logo for ABC Television. 1987.

Graphics and the Computer

The computer has done more to influence graphic design than anything since the invention of the printing press. Each of the three tools available to the designer—type, photography, and illustration—can be manipulated in special ways when the computer's help is enlisted.

Computer-designed typography is now commonplace. Unique typefaces can be created, stored, rearranged, and redesigned with a speed and flexibility unheard of just a few years ago. The computer influences the character of mechanically produced alphabets as surely as the quill and ink influenced the design of letters centuries ago. For instance, letters designed by computer can be set against graphically exciting backgrounds (**342**), or even designed to move in a colorful landscape. The word "move" is significant. While most computer-designed type resembles older style typography, the computer offers the poten-

tial of an extra dimension. If desired, computer lettering can be made to float or bounce or streak across the screen of a television set or display terminal. Quite often, computer graphics are graphics in motion.

Through computer technology images, too, can be made to streak through an apparently three-dimensional landscape. Designer/director Mario Kamberg used a glittering high-tech image, seeming to have the transparency of glass, to create a television commercial for Rockwell International (**343**). Unfortunately, a still image, as we must show here, cannot really convey the electric visual impact of moving graphics. They flash across our visual field like lightning—dazzling and colorful and exciting—and then are gone almost before we can take them in.

The computer has changed the way graphic artists in *all* media work. Even if the end result is to be a printed design—an advertisement or magazine cover, for example—some graphic designers have replaced their sketch pads with computer terminals. Designing, testing of ideas and forms and color, is done on the screen with as much flexibility as the pencil or pen could offer, but much faster. The design can then be transmitted almost instantly anywhere it needs to go—to the client, the art director, or the home office.

Illustration is particularly well adapted to computer assistance. Computers provide speed in making the drawings, speed in making corrections, speed in trying out various colors, shapes, and proportions. Before computer graphics became available, the designer whose drawing seemed almost right but not perfect—say, the proportions were a little off—would have to start all over again and make a new sketch. Now the proportions can be altered in seconds and a new image displayed on the computer screen, with the push of a button.

A major contribution of the computer to graphic design is in the field of animation—the creation of illusory movement through a series of drawn illustrations. As mentioned in Chapter 9, animation means "bringing to life." The images brought to life by computer techniques can be any of the graphic tools we have mentioned—type, photographs, illustrations. Letters can move, still photographs can move, drawn images can move, and any two or three of these can be combined so as to interact with one another.

Animated films—ambitious versions of the cartoon—have been with us for decades, but new computer technology has vastly increased their sophistication. A feature-length film called *Quest* (**344**), made in 1985, employed a method known as "ray tracing," which is capable of producing quite realistic effects of transparency, reflection, texture, and shadows. A scene from the film showing the Main Temple Arcade appears to have ripples and reflections in the water, shadows on the columns, and a transparent arched roof overhead. At present, ray tracing is a relatively slow technique, as computer graphics go, but by the time you read this it probably won't be any longer.

One hesitates to say too much about computer graphics, because the field is evolving so rapidly. In the short time that elapses between the writing of this book and its publication, tremendous expansion of computer graphics will undoubtedly take place. Without question we are in the middle of another revolution in graphic design. It will be fascinating to watch its development.

left: 343. Still from a commercial for Rockwell International, made on a Cray Super-Computer. Designer: Mario Kamberg.

right: 344. Main Temple Arcade, from the film *Quest: A Long Ray's Journey into Light*. A poll-computer, Chelmsford, Mass. Producer/Director: Michael Sciulli.

part four

THREE-DIMENSIONAL MEDIA

below: **347.** Auguste Rodin.
Eustache de St. Pierre,
nude study for *The Burghers
of Calais.* 1884–85.
Terra cotta, height 12¼″.
Musée Rodin, Paris.

right: **348.** Manuel Neri. *Red Legs.*
1979. Plaster, dry pigment,
steel armature, and Styrofoam core;
33½ × 33 × 25″.
Private collection, San Francisco.

Our illustration (**347**) shows a clay study for Eustache de St. Pierre, one of the figures in Rodin's *Burghers of Calais* (**362**), a life-size bronze piece. We can learn much about the sculptor's creative process by comparing the little terra cotta sketch—only about a foot tall—to the large finished work. Most obvious is the fact that the clay model is nude, while the figures in the *Burghers* are clothed. Undoubtedly Rodin wanted to explore the way this man would hold his body, to capture every line of muscle and bone, to study the movement of legs, arms, and shoulders, the curve of the back—before draping the figure in garments. In our photograph of the completed *Burghers* (**362**) Eustache de St. Pierre appears just to right of center, facing us. Rodin has changed the pose from that of his terra cotta study. In the modeled clay figure the arms are held out from the body, almost as though in supplication. But the bronze Eustache—more inward-looking, more self-contained—holds his arms closer to his sides. Only after many such sketches, in clay and plaster, did Rodin settle upon the final composition for his work. We are fortunate in having the clay study, not only because it helps us to understand the creative process, but also for its own sake. Despite this figure's small size, the clay modeling is wonderfully lifelike and expressive.

Rodin also made studies in plaster, and this too has traditionally been a common material for preliminary models. But in contemporary sculpture plaster has come into its own as a medium for finished work. Modern sculptors seem to like the flat, white impersonality of plaster, as well as its ready acceptance of bright color. Manuel Neri's *Red Legs* (**348**), modeled in plaster over a steel frame or *armature,* seems almost cheerful in its vivid colors and jaunty pose. But this gaiety is in direct contradiction to the flat blue face. A face without features is depersonalized and frightening. We cannot tell where the figure is looking or what it is thinking, and it cannot speak to us. There is only that blank, staring oval of blue.

In some ways modeling is the most direct of sculpture methods. The workable material responds to every touch, light or heavy, of the sculptor's fingers, so that the maker and the made become almost one.

CASTING

In contrast to modeling, casting seems like a very *indirect* method of creating a sculpture. Sometimes the sculptor never touches the final piece at all. Metal, and

part four
THREE-
DIMENSIONAL
MEDIA

11
Sculpture

*T*he study of sculpture confronts us with the third dimension, with the concept of *depth*. This seems like an easy and obvious point, but there is more to it than you might imagine. In everyday life we are faced constantly with situations in which our brains have to make adjustments for depth. Just walking down the street requires the brain to make a thousand calculations. How far away is that building? If you misjudge the distance, you may bump into it. How high is the curb? Unless you estimate correctly, you may trip and fall. The mass media require us to make a similar set of adjustments. We see images of people on the movie screen or television set. Even though these are, in reality, flat images, we perceive the people as being full-bodied and three-dimensional.

To appreciate fully how complex is our perception of depth we might consider what happens when that perception is absent. M. von Senden's book *Space and Sight* describes experiments with people who were blind from birth and then gained their sight through surgical techniques. The results of these experiments are fascinating. Von Senden concluded that, after regaining their sight, most patients were unable to see depth or distance. Accustomed always to making judgments about depth by touch, they could not convert their knowledge to an understanding of visual cues. One patient confused depth with roundness; for her, three-dimensionality always meant the globe form of a ball or an orange, for instance. Another patient, when shown photographs and paintings, wanted to know, "Why do they put those dark marks all over them?" She was told the dark marks were shadows, and that without them everything would look flat. The patient replied, "Well, that's how things do look. Everything looks flat with dark patches." Once patients learned to recognize faces and other familiar things in photographs, they were startled to discover that the *photographs* were flat and did not have the same bumps and textures they were used to sensing by touch.

Distance presented similar problems. Until their operations the patients' entire concept of distance had been limited by what they could reach with their hands. One man said that everything he could not touch with his hand was "to the side." The researchers gradually understood that, as far as this man was concerned, objects across the room, in the next room, or on the other side of town were all the same distance away. Many of the newly sighted people had difficulty grasping the idea that their sight could travel farther than their hands. Some thought at first that seeing involved bringing an object into *contact* with the eyes.

One of the newly sighted people worked out a method to practice his visual apprehension of distance. He would take off one of his boots, throw it some distance away, then estimate how far it was from him and how many steps it would take to reach it. If he failed to reach it, he'd take another step or two and try again until he could touch the boot. In effect, this adult man was trying painstakingly to learn depth perceptions that sighted people have assumed since babyhood—and to *un*learn the different perceptions he had mastered while he was blind.

Those of us sighted from birth have learned to make enormously complicated judgments about depth, size, and distance. But as we approach sculpture, we ought to place ourselves in the position of the formerly blind man with his boot. We should train our eyes to see in new ways and to be aware of seeing. We should train our minds to understand the dynamics of three-dimensional form. Heightened awareness of the third dimension is crucial to our appreciation of sculpture. Sculptures are like our selves, full-bodied and substantial. Usually they look different when viewed from different angles. The experience of looking at a flat painting on a wall is quite unlike the experience of walking up to a freestanding sculpture, circling it, observing it from various viewpoints, and then integrating many visual perceptions into an understanding of the sculpture as a whole.

This chapter will explore a wide range of three-dimensional forms, from many times and places. Sculpture has one of the longest histories of any art medium, and yet it is especially vital and exciting today. A major reason for this vitality in contemporary sculpture is its use of materials and techniques that were unheard of just a century ago. We will look first at the sculptor's methods, how materials are handled, and how sculptures are designed.

Methods of Sculpture

There are four basic methods for making a sculpture: modeling, casting, carving, and assembling. Modeling and assembling are considered *additive* processes. The sculptor begins with a simple framework or core or nothing at all and *adds* material until the sculpture is finished. Carving is a *subtractive* process in which one starts with a mass of material larger than the planned sculpture and *subtracts*, or takes away, material until only the desired form remains. Some people consider casting to be an additive process, but in a sense this method occupies a category all its own. Casting involves a mold of some kind, into which liquid or semiliquid material is poured and allowed to harden. Often casting is used to make several identical sculptures.

Let us consider each of these methods in more detail.

MODELING

Modeling is familiar to most of us from childhood. As children we experimented with Silly Putty or clay to construct lopsided figures of people and animals. For sculpture, the most common modeling material is clay, an earth substance found in most parts of the world. Wet clay is wonderfully pliable; few can resist the temptation to squeeze and shape it. As long as clay remains wet, the sculptor can do almost anything with it—add on more and more clay to build up the

form, gouge away sections, pinch it outward, scratch into it with a sharp tool, smooth it with the hands. But when a clay form has dried and been *fired*—heated to a high temperature in a kiln (Chapter 12, p. 306)—it becomes hard. Fired clay, sometimes called by the Italian name *terra cotta*, is surprisingly durable. Much of the ancient art that has survived was formed from this material.

A female figure made in Cyprus more than three thousand years ago (**345**) is typical of the fertility images found in most early cultures. The artist who created this little statue had learned to exploit many of the possibilities of clay. After the overall form had been shaped by the fingers, delicate lines defining the form were incised with a sharp tool. The arms and "earrings" were shaped of separate pieces of clay and then added to the main piece.

Throughout their history the Chinese have been masters of ceramic sculpture—sculpture made from clay—but not until recently has the enormous scope of their production been fully appreciated. In 1974 well diggers near the central Chinese city of Xi-an accidentally uncovered part of the tomb complex of the first Emperor of China, Shi Huang Di. Buried since 210 B.C., guarding the tomb in military formation, were a whole army of life-size clay soldiers, horses, and attendants—at least seven thousand of them (**346**). The warriors' faces and bodies are modeled with amazing naturalism, and each variety of provincial headdress is rendered in specific detail. The horses stand waiting to be harnessed and ridden off into battle. More recent digs have unearthed a similar array of scribes, or clerks, suggesting that the entire court, represented in clay, may have gone into the emperor's tomb. We can only speculate how many sculptors labored to build this immense ceramic population, especially in view of the high quality maintained in the figures.

Clay served the Chinese tomb builders well, because of its permanence and potential for naturalism. But later artists have prized clay for other qualities. Sculptors often use clay modeling in the same way that painters traditionally have used drawing, to test ideas before committing themselves to a finished sculpture. As long as the clay is kept damp, it can be worked and reworked almost indefinitely. Even the terminology is the same; we sometimes call a clay test piece a "sketch."

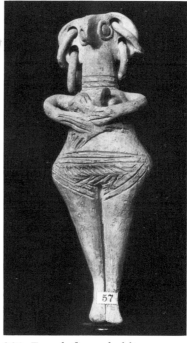

345. Female figure holding a fluttering bird (fertility image?), from Cyprus. c. 1500–1200 B.C. Terra cotta, height 8⅜". Metropolitan Museum of Art, New York (Cesnola Collection; purchased by subscription, 1874–1876).

346. *Cavalryman and Saddle Horse from Earthenware Army of First Emperor of Qin.* c. 210 B.C. Terra cotta, height of man 5'10½". Cultural Relics Bureau, Beijing, and Metropolitan Museum of Art, New York.

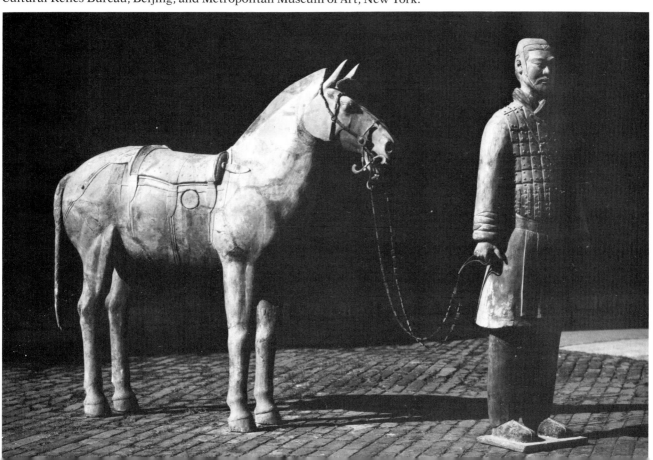

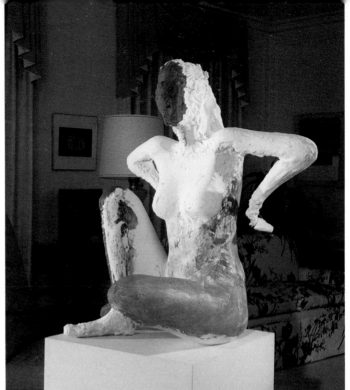

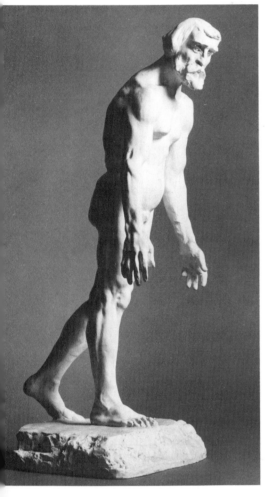

below: **347.** Auguste Rodin. *Eustache de St. Pierre*, nude study for *The Burghers of Calais*. 1884–85. Terra cotta, height 12¼". Musée Rodin, Paris.

right: **348.** Manuel Neri. *Red Legs*. 1979. Plaster, dry pigment, steel armature, and Styrofoam core; 33½ × 33 × 25". Private collection, San Francisco.

Our illustration (**347**) shows a clay study for Eustache de St. Pierre, one of the figures in Rodin's *Burghers of Calais* (**362**), a life-size bronze piece. We can learn much about the sculptor's creative process by comparing the little terra cotta sketch—only about a foot tall—to the large finished work. Most obvious is the fact that the clay model is nude, while the figures in the *Burghers* are clothed. Undoubtedly Rodin wanted to explore the way this man would hold his body, to capture every line of muscle and bone, to study the movement of legs, arms, and shoulders, the curve of the back—before draping the figure in garments. In our photograph of the completed *Burghers* (**362**) Eustache de St. Pierre appears just to right of center, facing us. Rodin has changed the pose from that of his terra cotta study. In the modeled clay figure the arms are held out from the body, almost as though in supplication. But the bronze Eustache—more inward-looking, more self-contained—holds his arms closer to his sides. Only after many such sketches, in clay and plaster, did Rodin settle upon the final composition for his work. We are fortunate in having the clay study, not only because it helps us to understand the creative process, but also for its own sake. Despite this figure's small size, the clay modeling is wonderfully lifelike and expressive.

Rodin also made studies in plaster, and this too has traditionally been a common material for preliminary models. But in contemporary sculpture plaster has come into its own as a medium for finished work. Modern sculptors seem to like the flat, white impersonality of plaster, as well as its ready acceptance of bright color. Manuel Neri's *Red Legs* (**348**), modeled in plaster over a steel frame or *armature*, seems almost cheerful in its vivid colors and jaunty pose. But this gaiety is in direct contradiction to the flat blue face. A face without features is depersonalized and frightening. We cannot tell where the figure is looking or what it is thinking, and it cannot speak to us. There is only that blank, staring oval of blue.

In some ways modeling is the most direct of sculpture methods. The workable material responds to every touch, light or heavy, of the sculptor's fingers, so that the maker and the made become almost one.

CASTING

In contrast to modeling, casting seems like a very *indirect* method of creating a sculpture. Sometimes the sculptor never touches the final piece at all. Metal, and

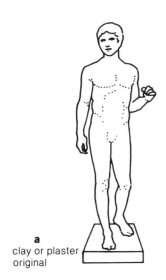

a
clay or plaster
original

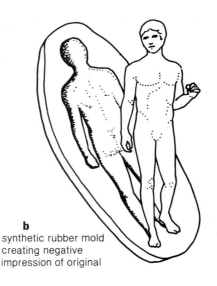

b
synthetic rubber mold
creating negative
impression of original

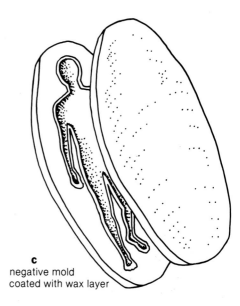

c
negative mold
coated with wax layer

specifically bronze, is the material we think of most readily in relation to casting. Bronze can be superheated until it flows, will pour freely into the tiniest crevices and forms, and then hardens to extreme durability. Even for a thin little projection, like a finger, there is no fear of it breaking off. Other materials also can be cast, including many plastics and clay.

The simplest type of casting is *solid* casting—that is, solid as opposed to hollow. You make a solid cast every time you make an ice cube. You pour liquid material (water) into a mold (the ice-cube tray), cause it to harden (by freezing), and then remove the cast (the ice cube). Novelty ice-cube trays can make cast-ice "sculptures" in the shape of hearts or flowers or any number of other shapes. Some plastics are cast by a very similar method. Liquid plastic is poured into a mold and allowed to set, after which the mold is removed.

There are three problems with solid casting. First, it uses quite a lot of material, and this can be expensive, especially with metal. Second, solid-cast objects tend to be very heavy unless they are made of lightweight plastic. Third, many materials, including metal and clay, develop cracks if cast solid. For all these reasons various methods have been developed to make *hollow* casts—that is, casts with an inner core of air.

Metal usually is cast by the *lost-wax* method, sometimes known by the French name, *cire-perdue*. This is an extremely complex process. The following description and the illustration (**349**) outline its basic principles.

1. The sculptor works either in clay or in plaster to create a full-size model of the intended sculpture (**349a**). For the sculptor this may end the creative part; very likely specialized technicians will take over afterward to complete the casting.
2. A coating of synthetic rubber is applied to the clay or plaster model. (Earlier generations used other materials.) This rubber coating makes an outside mold of the sculpture's contours that is accurate in every detail (**349b**). The synthetic rubber mold is removed from the outside of the model.
3. The synthetic rubber mold is now a *negative* or exterior mold of the sculpture (**349c**). Wax is coated inside the parts of the synthetic rubber mold to a depth of about ⅛ inch. The wax layer is the exact shape and thickness that is wanted for the final metal sculpture.
4. The space inside the wax layer—what will eventually be the sculpture's hollow core—is filled with a mixture of wet plaster called *investment*, which is then allowed to dry (**349d**). This plaster core is held in place by a series of metal pins. Then the synthetic rubber mold is removed from the outside of the wax layer. A network of wax rods is constructed all over the outside of the wax model. (Later, when the wax is melted away and the metal poured in, these rodlike channels will serve as conduits for the flow of material.)

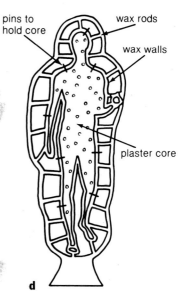

pins to
hold core
wax rods
wax walls
plaster core

d
cutaway view of wax figure
showing walls and plaster core

349. Sketch of the major steps in lost-wax casting.

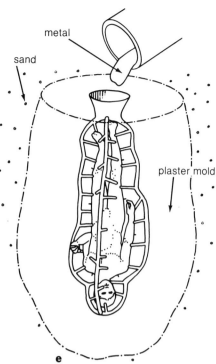

metal

sand

plaster mold

e
pouring molten metal into the mold
to replace the "lost" wax

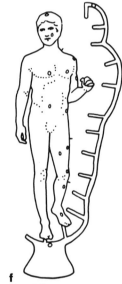

f
completed figure as metal rods
are being removed

350. Andrea del Verrocchio.
Equestrian Monument of Colleoni.
c. 1483–88. Bronze,
height c. 13′.
Campo SS. Giovanni e Paolo,
Venice.

5. The wax model, complete with rods and plaster core, is coated with another layer of investment plaster, and the assembly is placed in a kiln (**349e**). The kiln melts away the wax—hence the term *"lost" wax*—leaving an empty space between the inner core and outer layer of plaster that is exactly the shape and thickness of the desired sculpture. (The metal pins maintain the gap between these two sections of plaster, now that the wax is no longer there to hold them apart.) Molten metal is poured into the space that once held the wax, filling every crevice and filling all the rodlike channels. Metal, therefore, has replaced the wax, which is why casting is often known as a *replacement* method. Depending on the size of the sculpture, it may take several days for the metal to cool and set.

6. The new metal sculpture is taken from the kiln, and both inner core and outer layer of plaster are removed. Then the rods, now also metal, are cut from the sculpture (**349f**), rough spots are filed away, and the sculpture is cleaned and polished.

A common application for lost-wax casting has been the large equestrian (rider on horseback) statues we see in parks and plazas. The ancient Romans were masters of the equestrian portrait, and it remained popular for depicting military heroes well into this century. Almost no material except bronze would be strong enough, for the horse and its rider, life-size or larger, must be balanced on slender legs in an animated pose. An outstanding example is the statue of *Colleoni* (**350**) by the 15th-century Italian sculptor Andrea del Verrocchio. The sculptor has shaped the tense muscles and alert poses of both figures with such skill that the horse, although cast in rigid bronze, seems about to leap off its pedestal and gallop away.

Besides providing the necessary strength to make thin forms and projections, cast metal offers the sculptor two other great advantages. First, because the mold is generally reusable, one can make several identical casts of the work. Each is considered an original sculpture, just as each impression of a graphic print is considered an original work of art (Chapter 8). Second, casting makes

permanent the most fleeting gesture of the sculptor's hands. The sculptor can work freely in some soft material like clay or wax, and then translate that free expression into a more durable material. Edgar Degas' *Dancer* (**351**) was one of about seventy wax figures, among many broken fragments, found in the artist's studio after his death. Later cast in bronze, the little *Dancer* embodies a spontaneous creative drive in the aging artist as he experimented with forms and balances. By the time he made this sculpture Degas was almost blind. The pliable wax took the imprints of his fingers as he "saw" through his hands when modeling forms. The solid bronze of the cast preserves this expression for later viewers.

Still another asset of cast bronze is its resistance to weather. If properly cleaned and cared for, a bronze sculpture installed outdoors will not only withstand the elements but will in time acquire a desirable *patina*, or surface coloring. Bronze was the preferred material of the sculptor Henry Moore (**352**), whose massive, organic works are displayed in outdoor spaces around the world. Moore's sculptures seem equally at home in a fountain beside a modern building or in a parkland of trees and grass.

CARVING

Carving is more aggressive than modeling, more direct than casting. In this process the sculptor begins with a block of material and cuts, chips, and gouges away until the form of the sculpture emerges. Wood and stone are the principal materials for carving, and both tend to resist the sculptor's tools. When approaching the block to be carved, the sculptor must carefully study the grain of the material—its fibrous or crystalline structure—so as to work *with* that material. An attempt to violate the grain could result in a failed sculpture.

Wood carving reached an especially high level of expertise in Europe during the Middle Ages and Early Renaissance. A work from 15th-century Germany shows the wood-carver's skill at its most refined. Adriaen van Wesel portrays the *Death of the Virgin*, the death of Jesus Christ's aged mother, in an intricate oak carving just 30 inches high. Grouped around the dying Madonna are Christ's twelve Apostles, each showing by individualized facial expression, pose, and gesture his grief at parting from the beloved Mary. Although the space of the carving is shallow, only a few inches deep, the figures do not seem crowded or crammed

left: 351. Edgar Degas. *Dancer: developpé en avant.* Cast bronze, height 16". Metropolitan Museum of Art, New York (bequest of Mrs. H. O. Havemeyer, 1929).

right: 352. Henry Moore. *Draped Reclining Mother and Baby.* 1983–84. Bronze, length 8'7". Courtesy The Henry Moore Foundation, Much Hadham, Hertfordshire, England

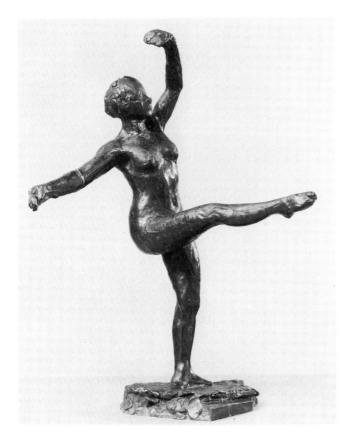

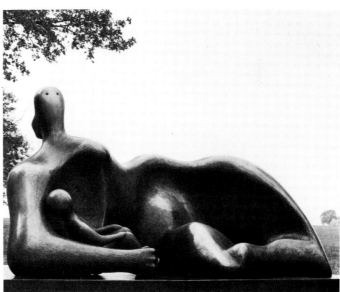

together, so artfully has the sculptor arranged them (**353**). The grain of the oak is apparent throughout the piece, enhancing the texture created by exceptionally fine carving in the hair, faces, and drapery. Given the tendency of wood to chip and split, we can only marvel at this sculptor's ability to achieve sensitive detail in such a small scale.

Stone carving presents an even greater challenge to the sculptor, because the material—stone suitable for carving—is scarcer, more expensive, and more resistant to the chisel. The risks are tremendous: One wrong move and the sculpture is ruined. The sculptor cannot put back a piece mistakenly cut away. Most people consider Michelangelo to have been the greatest genius of stone carving in the history of art; we will see his marble figure of *David* in Chapter 16 (**487**). According to writings from his day, Michelangelo believed that the sculptor's task is simply to free the subject from its imprisoning block of stone. So perfectly did he visualize the figure inside a block of marble that he announced one had only to cut away those parts of the stone that weren't the figure. Few other sculptors would be quite so confident.

One who approached Michelangelo in skill—and took second place to no one in self-confidence—was the 17th-century Italian artist Gianlorenzo Bernini. The portrait bust of his mistress, Costanza Bonarelli (**354**), would present sufficient answer to anyone who feels that marble cannot be warm and alive. As carved by Bernini, Costanza is not merely alive but sensual and magnetic. The slightly parted lips, the intense eyes, the disarranged bodice of the dress all suggest a woman whose emotions are barely contained within the cool white of the stone. Looking at the sculpture, we know it to be stone, but we see hair, flesh, and rumpled linen. In his writings Bernini spoke of the difficulties a sculptor faces when trying to convey personality all in one color (p. 400). In his portrait of Costanza Bonarelli he shows how he overcame those difficulties. He made Costanza live; we half expect her to breathe.

Sculptors who work in stone are harder to find today than they were in Bernini's time, but they do exist. Even artists who specialize in decidedly 20th-century materials, like steel and plastic, may go back to stone every once in a while, possibly as a way of keeping in touch with their colleagues from earlier times. No other material is so solid and yet so alive, so cold and yet so inviting to the touch, so resistant and yet so satisfying.

left: 353. Adriaen van Wesel.
Death of the Virgin.
15th century. Oak, 30 × 21¼".
Rijksmuseum, Amsterdam.

right: 354. Gianlorenzo Bernini.
Costanza Bonarelli. c. 1635.
Marble.
Bargello, Florence.

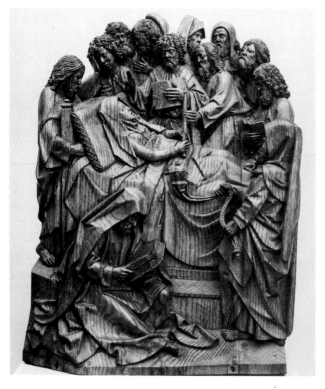

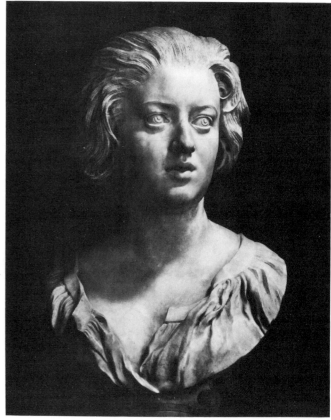

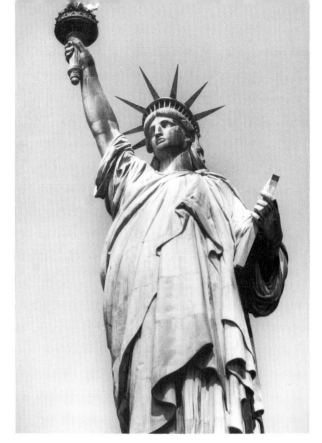

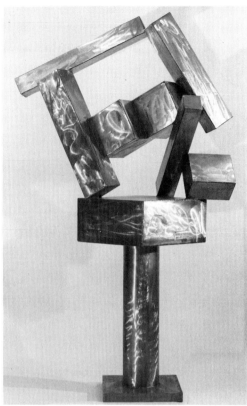

ASSEMBLING

Assembling is a process by which individual pieces or segments or objects are brought together to form a sculpture. Some writers make a distinction between *assembling*, in which parts of the sculpture, often "found" objects, are simply placed on or near each other, and *constructing*, in which the parts are actually joined together through welding, nailing, or a similar procedure. We have chosen to use the term *assemblage* for both types of work, because often the line separating one from the other is a fine one.

Assemblage was the method employed to make the sculpture that, for people in the United States, is better known than any other. We are so used to thinking of it as a "statue," a symbol, that we forget it is a sculpture. It is the Statue of Liberty (**355**). Formally named *Liberty Enlightening the World*, the statue was conceived by the French sculptor Frédéric Auguste Bartholdi and was presented to the United States by the people of France on the one hundredth anniversary of American independence. Bartholdi's grand scheme required unusual means. From top to toe the figure is 151 feet high, or about the size of a seventeen-story building. Liberty's index finger is 8 feet long.

No conventional sculpture method could have produced this immense piece. Its sheer size made ordinary casting impractical. Working with the engineer Gustave Eiffel, who built the Eiffel Tower (**417**), Bartholdi devised a system by which the statue was divided into manageable segments, and an outside mold was made for each segment. Individual sheets of copper were hammered into the molds; then the entire sculpture was riveted together under the sculptor's supervision. On the outside the joints are practically invisible, but inside the statue one can see how *Liberty* was put together. Upon her arrival from France, *Liberty* was widely heralded as "the most expensive statue in the world." Her recent and thorough restoration helps to confirm that title.

The 20th-century American sculptor David Smith came to assemblage in an unusual way. While trying to establish himself as an artist, Smith worked as a welder. Later, when he began to concentrate on sculpture, he readily adapted his welding skills to a different purpose. His mature works broke new ground in both materials and forms (**356**). Sculptures like *Cubi XVII* are of steel, which eventually became Smith's favorite material. Steel had long been used for the frame-

left: **355.**
Frédéric-Auguste Bartholdi.
*Liberty Enlightening the World
(Statue of Liberty).* 1874–75.
Copper and iron,
height of figure 151'.
Liberty Island, New York City.

right: **356.**
David Smith. *Cubi XVII*.
1963. Stainless steel, height 9'.
Dallas Museum of Art (Eugene
and Margaret McDermott Fund).

David Smith
1906–1965

David Smith holds a special interest for students of art history because, more than most artists of past or present, he was extremely articulate about his work and wrote widely about the business of making art. The man himself was something of a paradox. Physically strong and burly, he personified what we would now call a "macho" life style, having worked as a logger, an oilman, and a welder; as a sculptor his expression depended on the physical skills of the blacksmith. But from the noisy atmosphere of the machine shop Smith produced sculptures of shimmering pure form, and this same macho hero was also a lover of classical music, a lifelong poet, a gourmet cook, and a sensitive father to two daughters.

Smith was born in Decatur, Indiana, where he remained for the first twenty years of his life. By 1926 he was in New York, studying painting at the Art Students League. He took a variety of jobs to support himself, including one that proved crucial for his later work—that of metal welder in an automobile factory. In 1927 he married the artist Dorothy Dehner; two years later the couple bought the now-famous farm in Bolton Landing overlooking Lake George, New York, where Smith worked until his death and where he displayed quantities of his large sculptures outdoors.

About 1933 Smith turned from painting and collage to sculpture. Influenced by the iron sculptures of Picasso, he focused on metal and began using his welding skills to assemble the forms. Finding a suitable place to work became a problem. As he told it: "One Sunday afternoon we were walking on a navy pier [in Brooklyn]. Down below on the ferry terminal was a long rambly junky looking shack called Terminal Iron Works. Wife said, 'David that's where you ought to be for your work.' Next morning I walked in and was met by a big Irishman named Blackburn. 'I'm an artist. I have a welding outfit. I'd like to work here.' 'Hell! yes—move in.' I learned a lot from those guys."[1]

From that point Smith worked almost exclusively in metal, soon focusing on steel. He had his first exhibition in New York in 1937, after which his reputation as a sculptor grew steadily. Whether in New York or Bolton Landing, he worked prolifically, and he also played with gusto, enjoying a wide range of friendships with many of the most successful artists of the period. After the breakup of his first marriage, Smith married Jean Freas in 1953, and his daughters, Rebecca and Candida, were born in the following two years. The artist's life ended prematurely when, driving near the farm, he failed to negotiate a turn in the road, crashed his truck, and was killed.

The sculpture of David Smith is represented in nearly every major collection of modern art, but the works housed indoors in museums may strike the viewer as out of place, almost uncomfortable. Smith always preferred his pieces to be displayed outdoors. He wrote: "I like outdoor sculpture and the most practical thing for outdoor sculpture is stainless steel, and I make them and I polish them in such a way that on a dull day, they take on the dull blue, or the color of the sky in the late afternoon sun, the glow, golden like the rays, the colors of nature.... They are colored by the sky and the surroundings, the green or blue of water. Some are down by the water and some are by the mountains. They reflect the colors. They are designed for outdoors."[2]

Photograph of David Smith by Irving Penn.

work of cars, of refrigerators, of locomotives, but Smith explored its aesthetic potential. He polished the surfaces so they would shine in the sunlight when exhibited outdoors. The form of these works is also daring—cube piled upon cube in a seemingly precarious structure. Steel, with its great strength, makes possible the dynamic balance of *Cubi XVII,* and assemblage makes possible the soaring composition.

The recent sculptures of Nancy Graves also are assembled, but that fact tells only part of their story. Graves begins with "found" objects, some of them organic—bean pods, palm fronds, corn husks, flowers—and some manufactured cast-offs. These objects are cast in bronze, then assembled into the form the sculptor wants, and finally painted with bright-hued enamels. The result may be something like *Wheeler* (**357**), a whimsical, delicately balanced, merry construction that bears little relation to its original components. Graves' constructions make us want to smile, to participate in their colorful and cheerful presence.

A very different use of found objects for assemblage has long characterized the work of Louise Nevelson. Nevelson's sculptures, like *Mrs. N's Palace* (**358**), consist of odds and ends, mostly pieces of wood, that she has accumulated in her studio over many years. Some of the objects are handmade, others machine products, and they have no connection with one another until the sculptor *makes* a connection by assembling them, setting up relationships of form that never existed before. Arranged in boxlike structures, painted a uniform color (often black), the found objects create a rich, intricate, serene world of their own.

Sculpture and the Third Dimension

Most of the sculptures we have looked at so far are *in the round,* or freestanding and completely finished on all sides, like the human body. Nevelson's box sculpture, however, is usually described as a *relief,* which means it is supposed to be placed against a wall and viewed from the front only. Relief sculptures have three-dimensional depth, but they do not occupy space as independently as do sculptures in the round. Often they are used to decorate architecture or functional objects.

left: 357. Nancy Graves. *Wheeler.* 1985. Bronze and steel with polyurethane paint and baked enamel, 6'5" × 5'3½" × 2'4". Courtesy M. Knoedler & Co., New York.

right: 358. Louise Nevelson. *Mrs. N's. Palace.* 1964–77. Black-painted wood with black mirror floor, 11'8" × 19'11" × 15'. Metropolitan Museum of Art, New York (gift of the artist, 1985).

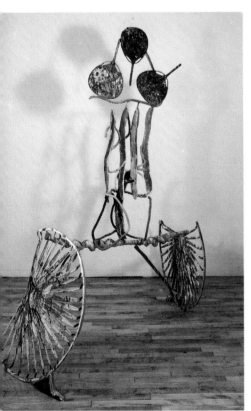

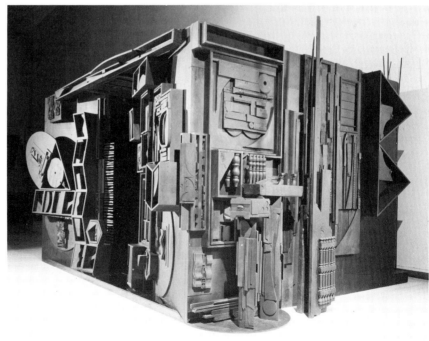

Louise Nevelson
1899–1988

As a sculptor and as a person, Louise Nevelson always projected the image of royalty. Many of her large works have names suggesting royal subjects—kings, queens, palaces—and the artist made it her personal trademark to dress with an exotic flamboyance suitable for an eastern princess. This preoccupation seems related to her expressed conviction that one can make one's life be anything one chooses. She said that royalty is "dressing beautifully and having comfort and great houses and great art. Who wouldn't want it? Who wants to live in a hut?"[3]

Born Louise Berliawsky in Kiev, Russia, Nevelson emigrated with her family to Rockland, Maine, in 1905. She claimed she was drawn to art as a child because the schoolhouse in Maine was alway cold, and the art room was the only warm place. When she was just twenty-one she married Charles Nevelson. Decades later she would say the marriage was the only thing in her life she would have done differently, because she was not equipped for it. Nevelson's son Mike was born in 1922, but only a few years later the marriage collapsed, and the artist remained single thereafter.

Nevelson attended the Art Students League in New York for three years, then traveled to Europe where she studied briefly with the painter Hans Hoffmann. Her first one-woman show came in 1941 at an important New York gallery. Despite favorable critical notice, many years passed before the public showed any interest in her work and it became financially sustaining. The artist felt this was because the components of her sculptures have little material value. From her earliest years in New York (where she lived until her death) she formed the habit of picking up cast-off wooden objects in the street—bits of furniture, old tools, sections of architectural elements, and the like. Her most characteristic sculptures are complex assemblages of these "found" objects in shallow, boxlike grids, many of which are wall- or room-size. The assemblages are each spray-painted a uniform color—occasionally white or gold, but most often black, which Nevelson called an "aristocratic" color.

In the late 1960s and 1970s Nevelson experimented with new materials—aluminum and steel—and made several large outdoor sculptures that echo the feeling of her box assemblages. She also accepted an unusual commission for the complete interior design of a Christian church (Nevelson was Jewish) in New York, including architectural details, sculptural decoration, even the priest's vestments.

Louise Nevelson was always an extremely prolific worker. All through the years of struggle she continued to produce. She maintained that she had a preconceived blueprint for her life and that, by and large, she had fulfilled it. "I remember my mother telling me, 'You know, art is a very difficult life, and why do you want to choose that? You won't live as well as you could otherwise.' And I said, 'It's not how I live, it is how I finish my life.' And I did it."[4]

Photograph of Louise Nevelson.

If you have a nickel in your pocket, take it out and look at it. On the face you'll see a profile of Thomas Jefferson and on the back an image of his home, Monticello. Both images are in *low relief*, sometimes called by the French name *bas-relief*. The subjects project very slightly from their background. Many kinds of flat surfaces serve as fields for low-relief sculpture—coins, tombstones, walls, decorative plates, book covers. The illustration here (**359**) shows the back of a throne found in the tomb of the Egyptian king, Tutankhamun. A low relief applied to pure sheet gold depicts the young King "Tut" and his queen in graceful poses. The flowing clothes of the two monarchs are of silver, and their head-dresses and jeweled collars are inset with colored glass and gemstones.

When a sculpture projects more boldly from the background, we call it *high relief* (or *haut-relief*). To fit this category, the sculptured elements should project by at least half their depth, and parts of the figures may be in the round, unattached to the background. The wood carving by Adriaen van Wesel (**353**), with its rounded heads and torsos of the Apostles, qualifies as moderately high relief. *Mrs. N's Palace* is even higher relief; if the museum guard will let you, you can walk inside it.

Both low and high relief are evident in *The Story of Jacob and Esau* (**360**), one panel of Lorenzo Ghiberti's famous bronze doors for the Baptistry of Florence Cathedral (**480**). The arched openings, the figures at upper right, and some of the background figures are in low relief. But nearly all the foreground figures are in very high relief—still attached to the background, but fully round and almost freestanding. Ghiberti used these gradations in relief to create a sense of deep space, which is heightened by the receding perspective of the arches. The impression of depth is enhanced even more by the figures that overlap the frame at left and right, in such a way that they actually seem to advance into our space.

We may be tempted to think of figural relief sculpture as "primitive"—something artists of earlier centuries did before they developed the skill necessary to make fully round sculptures. This isn't true at all. The Egyptians and certainly the sculptors of the Renaissance, like Ghiberti, were quite capable of undertaking freestanding works. Moreover, in our own time sculptures still are made to decorate the walls of buildings, and a few contemporary artists have experimented with relief sculpture for its own sake.

left: **359.**
Tutankhamun and His Queen,
relief on the back
of the Golden Throne
found in the tomb
of King Tutankhamun. c. 1325 B.C.
Sheet gold, silver,
colored glass, and carnelian.
Cairo Museum.

right: **360.** Lorenzo Ghiberti.
The Story of Jacob and Esau,
detail from
The Gates of Paradise. c. 1435.
Gilt bronze, 31¼" square.
Baptistry, Florence.

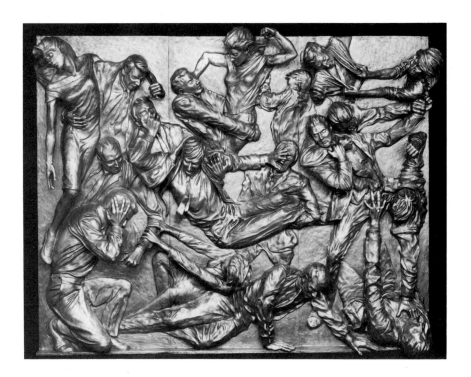

361. Robert Longo. *Corporate Wars: Wall of Influence,* 1982. Cast aluminum, 7 × 9 × 3'. Collection Emily and Jerry Spiegel, courtesy Metro Pictures, New York.

Robert Longo's *Corporate Wars* (**361**), made in 1982, is a modern version of high-relief sculpture. A huge work in cast aluminum, *Corporate Wars* depicts a hellish tangle of people in business suits—clawing, pushing, choking, and punching one another, presumably in an effort to get ahead in the corporation. Parts of the figures jut out in high relief, and some even overlap the frame of the panel. Longo's composition offers a fascinating contrast to Ghiberti's *Story of Jacob and Esau.* The Ghiberti was designed to project order and serenity. The Longo work, with its chaotically overlapping forms, erupts in violence and ugly emotions.

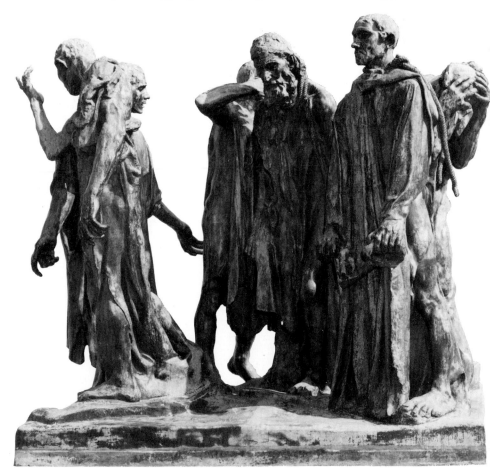

362. Auguste Rodin. *The Burghers of Calais.* 1886. Bronze, 6'10½" × 7'11" × 6'6". Hirshhorn Museum and Sculpture Garden, Smithsonian Institution, Washington, D.C. (gift of Joseph H. Hirshhorn, 1966).

Although we have already looked at several examples of sculpture in the round, it will be useful here to consider one work primarily from the standpoint of its complex interaction with space. Sculpture in the round exists wholly in our world. We can walk around it and see it from every angle. This is a terrific challenge to the sculptor's compositional ability, since every viewpoint must be under control. Even when there is a definite front and back, as there usually is in figurative sculpture, all viewpoints should be interesting. And the fact that the work looks different from every angle makes the observer's experience much richer.

An excellent example of sculpture in the round is Rodin's *Burghers of Calais* (**362**), whose preliminary study we examined earlier in this chapter (**347**). Rodin made this sculpture for public display in the city of Calais, and it depicts an episode in the town's medieval history. Six men have offered to give their lives to ransom their city from the English, who hold it captive. Each of them faces certain death, but they confront their sacrifice in different ways. One is angry, one sorrowful, one merely resigned, and so on—but each is unique, facing a personal tragedy amid shared crisis. We can read the mens' emotions from their various postures, facial expressions, and gestures. The six hostages march in an irregular circle, some determinedly erect, others drooping in despair. And the viewer must also walk in a circle, because there is no angle from which all faces are visible. Rodin's message is complex, and so he has expressed it in the complex form of sculpture in the round.

The Human Figure in Sculpture

We humans tend to be egocentric. We are interested in ourselves, in anything that touches upon our immediate concerns. Artists throughout history have expressed this egocentrism with the self-portrait. So it should come as no surprise that the human figure has always been a basic subject of sculpture. What could be more interesting than oneself—or a figure shaped like oneself? We respond psychologically to the sculpture of a human form much as we would to a real human being. What is that person like? Why does he or she look that way? What is that person thinking?

When children see a figurative sculpture, they often arrange their bodies into the same pose as that of the sculpture. As adults we may be tempted to do the same thing, but we have learned to be more inhibited in public. We may be surprised to discover that we have the same impulse to let our bodies mimic the shape of *abstract* sculptures, but this is not really so strange. There is considerable similarity in the way naturalistic and abstract (or nonobjective) sculptures are designed. By studying the figure in sculpture, we can learn much about the way nonfigurative sculptures are designed—how the sculptor handles weights, balances, stresses, and the composition in general. Some nonobjective sculptors go back occasionally to study the human figure, in order to test their understanding of forms in space.

The sculptural treatment of figures throughout history usually has been greatly influenced by the culture in which a particular piece was made. For example, in ancient Egypt figural sculptures, especially those depicting members of the nobility, tended to be somewhat rigid and immobile. Just as the Egyptians built their pyramids for all eternity, so they meant their kings and queens to be posed in eternal serenity. In the sculpture of *Mycerinus and His Queen* (**363**) both figures stand proudly erect, facing straight ahead. Although each has the left foot planted slightly forward, there is no real suggestion of walking. The shoulders and hips are level, the arms frozen at solemn attention.

In contrast to the formal poses favored by the Egyptians, we find the *contrapposto* perfected by the Greeks in the 5th and 4th centuries B.C. Contrapposto means "counterpoise" or "counterbalance," and it is intended to be natural, curving, and relaxed, to imply motion. We have the impression the sculptor has caught the figure in the middle of a movement, and that one second earlier or

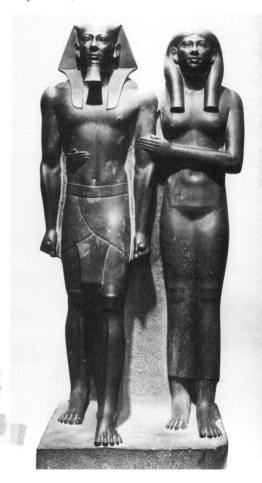

363. *Mycerinus and His Queen,* from Giza, Egypt. 2599–2571 B.C. Slate, height 4′6½″. Museum of Fine Arts, Boston (Harvard University–M.F.A. Expedition).

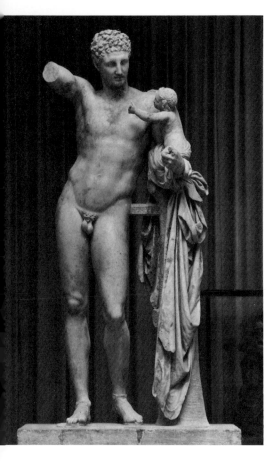

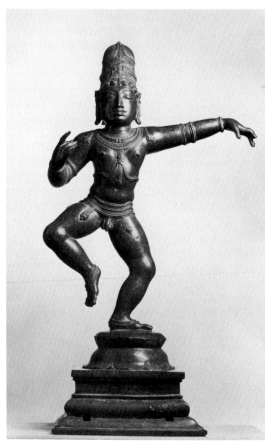

later the pose would have been different. You can see this effect in *Hermes with
the Infant Dionysus* (**364**), which is probably an original by the famous Greek
sculptor Praxiteles. Hermes' weight is on his right foot, so that his right hip is
raised and his left leg bent and relaxed. To counterbalance this, Hermes' left
shoulder is raised, and the whole figure stands in a gentle S-curve. This elegant

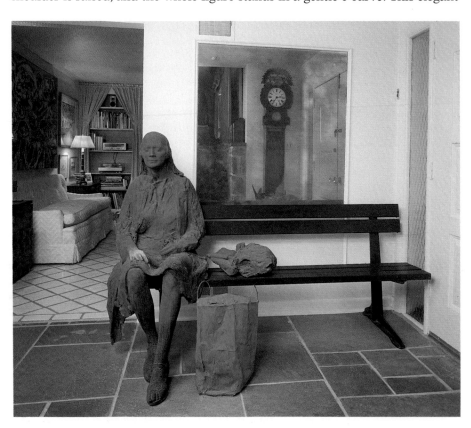

366. George Segal.
Blue Girl on Park Bench. 1980.
Painted plaster and aluminum,
lifesize. Collection Jeanette,
Nina, and Constance Golder.

curve was Praxiteles' trademark and has been copied ever since. We see exaggerated versions of it today in the poses of such "living statues" as fashion models and professional body builders, who use contrapposto to show off to best advantage accomplishments in fabric or muscle tissue.

Eastern art also presents examples of formal and informal poses. The Buddha, who exists in eternity like the monarchs of Egypt, is routinely depicted in a serene, motionless pose (**565**). But less exalted beings may be modeled in animated motion. Our illustration (**365**) shows Krishna, one of the most charming personages in Indian mythology. The Krishna legend is full of tales about his boyish pranks and escapades. Here he is "the butter thief," stealing butter from his cowherd foster parents. The child Krishna dances impishly as he runs away with the butter. All his weight is balanced on one leg, with the other bent and his arms held out in counterbalance. We expect him to dance right off the pedestal in delight at his trick.

Contemporary sculptors are less committed to specific categories of poses, yet they are no less interested in the human figure as a subject. One modern sculptor who has concentrated on the figure almost exclusively is George Segal. Segal works in plaster, and his figures are cast from living models. The "sculpting" is done by selecting, dressing, and posing his subject. After that, technology largely takes over. The artist pastes plaster-saturated cloth squares over the model to form a perfectly defined shell of the body. After the plaster has hardened, the shell is removed in sections. Later, Segal reassembles the sections and uses this shell as a mold in which to make a plaster cast. Earlier works were left in the pure chalky white of the plaster, but of late Segal has begun to paint some of his people in vivid colors, as evidenced by *Blue Girl on Park Bench* (**366**).

Segal likes to place his figures in a setting of objects from the real world, such as the actual park bench supporting the *Blue Girl* (or the real-life bus terminal, **89**). His expressionless people suggest isolation, boredom, and mental stagnation in a packaged society. The *Blue Girl* might be waiting for a bus, but one has the feeling that if the bus doesn't come, she will go on waiting impassively for all time. These figures are antiheroic. Just as heroic figures show us that we might aspire to be, Segal's show us what we might fear to become.

When you look at the next illustration (**367**), Duane Hanson's *Self-Portrait with Model*, you may think you are seeing a photograph of two people sitting at a table. But in fact this is a photograph of a sculpture, and the two figures are made

367. Duane Hanson. *Self-Portrait with Model.* 1979. Painted polyester and mixed media, lifesize. Courtesy O. K. Harris Works of Art, New York.

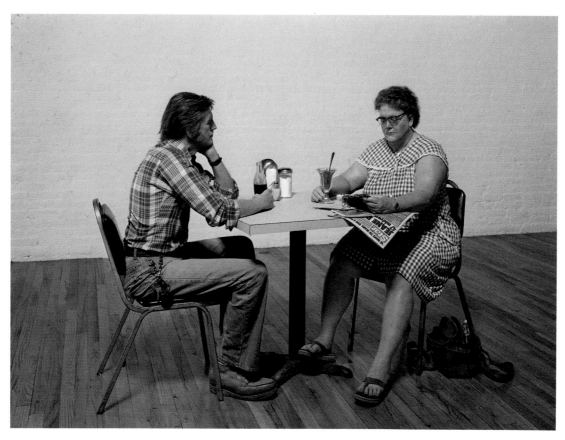

of polyester and fiberglass. Like Segal's plaster people, Hanson's figures are cast from life, but they are painted to be as naturalistic as possible and have been dressed in real clothes and hair and positioned at a real table. If you see an exhibition of Hanson's work, you may have to keep reminding yourself that the real people are the ones who move, the sculptures are the ones who don't.

Hanson makes us look at people, really look at them, the way they are in everyday situations—in the supermarket, at the lunch counter, on the beach. His figures may be "types," but they are the types that make up the bulk of our society. Normally we wouldn't pay much attention to such people. By making something artificial, Hanson confronts us with what is real. He deals in middle-aged, middle-class, middle-Americans who cope with life as it comes along from day to day. Perhaps this is one reason why much contemporary figurative sculpture is so approachable. It is not set up on a pedestal, far away, to be admired. It is us.

Sculpture and the Environment

The term "environmental sculpture" may cause some confusion, because it is used in at least three different ways. First, it can refer to sculptures that are large enough for viewers to enter and move about in, sculptures that create their own environments. Second, it can mean large sculptures designed for display in the outdoor environment, such as a sculpture commissioned for a city square. And third, it can be sculptures that are actually a part of the natural environment, such as the presidents' heads carved out of the natural rock of Mt. Rushmore. We will look at one or two examples of each type.

Red Grooms has made a kind of specialty of the huge-scale, zany, colorful sculptured environment depicting a place or event. His constructions—always witty and entertaining, always crammed with people, buildings, and things—resemble a cross between an amusement-park funhouse and a comic strip come to three dimensions. In 1975 Grooms lampooned New York City, with comic depictions of a subway car, the Brooklyn Bridge, and other landmarks. In 1982 the city of Philadelphia requested the same madcap treatment, in honor of its three hundredth birthday. The result was *Philadelphia Cornucopia* (**368**), a 2,500-

368. Red Grooms. *Philadelphia Cornucopia*, detail. 1982. Mixed media. Installed at Institute of Contemporary Art, University of Pennsylvania, Philadelphia.

369. Judy Pfaff. *Kabuki (Formula Atlantic)*. 1980. Mixed media.
Installation February 12 to May 3, 1981, at the Hirshhorn Museum
and Sculpture Garden, Washington, D.C. Courtesy Holly Solomon Gallery, New York.

square-foot environment installed at the Institute of Contemporary Art. Inspired
by the history, romance, and glorious tradition of the city, Red Grooms, as the
saying goes, really went to town. His centerpiece is an 11-foot-tall figure of
George Washington, proudly standing at the helm of a "ship of state" whose
figurehead is an image of Martha Washington. Many other ghosts from Philadel-
phia's past rise up in colorful caricature, including Benjamin Franklin, Thomas
Jefferson, Betsy Ross, and of course the artist Charles Willson Peale (**30**) in his
museum.

Grooms' constructions are built of any material at hand—wire, cloth,
wood, plastic, metal. And they are painted, but not with the naturalistic skin
tones favored by Hanson. Grooms paints his figures the way a clown puts on
makeup—the broader, the more exaggerated, the better. *Philadelphia Cornuco-
pia* demonstrates Grooms' desire for active audience participation in large-scale
works of art. Viewers are allowed to walk among the structures and interact with
the outlandish creatures who dwell there. To enter this environment is to sus-
pend judgments about reality and let the magic take over.

Also full of vivid colors, Judy Pfaff's environmental sculptures are not figu-
rative but instead are abstract and poetic. Walking into a work like *Kabuki* (**369**)
is not unlike carrying around with you the vague memory of a dream whose
details you can't quite recall. Everything in Pfaff's environment comes into play—
the walls, ceiling, floor, and objects placed or suspended in the composition.
Viewers who venture in are surrounded by a self-contained world of colors and
shapes. Because the work is entirely nonrepresentational, it is even truer than
usual that each viewer experiences the environment differently. Pfaff controls
the visual stimuli, but she cannot control the associations we bring to her work.

370. Claes Oldenburg,
Coosje van Bruggen,
and Frank O. Gehry.
The Knife Ship
from "Il Corso del Coltello."
1985. Steel, 26 × 40′.
Installed at the
Solomon R. Guggenheim Museum,
New York.

Claes Oldenburg's *Knife Ship* (**370**) is a giant representation in steel of an ordinary pocket knife, with double blade and corkscrew, motorized so that the blades move up and down and the corkscrew turns. The huge size of the sculpture—it is 40 feet long—requires exhibition outdoors or in a large enclosed space, such as the interior of the Guggenheim Museum shown here. By taking an ordinary object, blowing it up to massive scale, and setting it in a public place, Oldenburg makes the form heroic. In effect the artist is saying, "Look at this form, look at it in the new way I have shown it to you." Now, many people have a pocket knife, perhaps a Swiss army officer's knife, and normally this object would not command our attention. But a pocket knife a hundred times the usual size, painted bright red, and equipped with "oars" to make a "ship"—*that* catches our attention. If one of the functions of sculpture is to make us look at form with fresh perspective, Oldenburg has certainly found a way to do that.

Environmental sculpture on a grand scale occurs when an artist sets out to sculpt the earth itself. Robert Smithson's *Spiral Jetty* (**371**) is such a construction, and it has become one of the classics of modern sculpture. The *Spiral Jetty* is a

371. Robert Smithson.
Spiral Jetty. 1970. Rock,
salt crystals, earth, algae;
coil length 1500′.
Great Salt Lake, Utah
(now submerged).

372. Christo. *Running Fence.* 1972–76. Nylon fabric and steel poles, 18′ × 24½ miles. Installed in Sonoma and Marin Counties, California, for two weeks, fall 1976.

1,500-foot-long ramp of earth and rock, bulldozed into position in a secluded part of the Great Salt Lake in Utah. When the *Jetty* was constructed in 1970, the United States was actively involved in space exploration, and for the first time we could see photographs of what our planet looks like from "the outside." We became aware that Earth is always in a state of change, with forms continually building up and breaking down. Smithson's work exemplifies this process on a grand scale; although intended as a permanent structure, the *Spiral Jetty* is no longer visible, because the lake has risen to cover it. The long curl of the spiral also reminds us of old legends about the Great Salt Lake being connected by an underground canal to the Pacific Ocean. According to these legends, the flow of water back and forth created huge whirlpools in the lake, similar to the form of the spiral. Above all, the spiral is a timeless symbol. Spirals have been a recurring motif in the arts since earliest ages. Smithson took the bold step of carving a giant spiral into the very land we inhabit.

A similarly ambitious work, Christo's *Running Fence* (**372**), never was intended to be anything but temporary. Constructed of 18-foot-high nylon panels set on steel posts, the *Running Fence* meandered over the hills and fields of northern California for 24½ miles, starting at the Pacific Ocean and moving inland. It was built by a team of workers, stood for two weeks, and then, as planned, was removed. All that remain are photographs, films, and preliminary drawings.

Christo's work is similar to *Conceptual Art*, which we shall explore in more detail in Chapter 17 (pp. 453–454). More important than the physical structure itself is the concept underlying it—in this case the experience of conceiving, planning, building, recording, and removing a monumental work. This artist's sculptures make a mark upon the landscape; they confront nature on a giant scale. The impulse is similar to, though grander than, that of drawing one's initials in wet concrete or painting them on a rock. And yet, after all, one cannot leave a 24½-mile fence across California. Christo deliberately chose to create a structure that had to come down, that had removal built into its concept, in order to focus attention on the process.

Motion, Light, and Time

The world we live in is preoccupied with action—change and movement and energy—so it is only natural that some of our sculpture would reflect this. *Kinetic sculpture* is a broad term generally used to describe works that incorporate mo-

373. Alexander Calder. *Untitled.* 1976. Painted aluminum and tempered steel, 29′10½″ × 76′. National Gallery of Art, Washington, D.C. (gift of the Collectors Committee).

tion as part of their artistic expression. The mobiles of Alexander Calder (**373**), for instance, are light and fluid, balanced so that the slightest current of air will set them moving. In a sense they are *about* motion, which is to say their subject is constant change and a never-ending formation of new relationships in space. Implicit in these mobiles is the element of time. We said of Rodin's *Burghers* (**362**) that you have to move around the sculpture to appreciate it fully. You can also move around a Calder mobile, but *it* is moving too, so the experience of elapsed time, of changing forms and spaces, is even more complex.

Weightless as they seem to be, Calder's mobiles still have substance. If you could touch one, you would feel thin, rigid pieces of metal. Other sculptors have created works based on an element with no substance at all—light. The light

374. James Turrell. *Afrum.* 1967. Xenon light. Installation 1976 at the Stedelijk Museum, Amsterdam. Collection Dr. Giuseppe Panza di Blumo, Varese, Italy.

sculptures of James Turrell are designed to "make light inhabit space so it feels materially present," according to the artist. In *Afrum* (**374**), for instance, we see what appears to be a solid cube hovering in the air. Closer inspection, however, leads us to discover that the cube consists entirely of light. Turrell's work is based on illusion, and that illusion is very persuasive—so much so, in fact, that a 1980 exhibition of his work at the Whitney Museum of American Art resulted in two lawsuits. In both cases visitors to the exhibition leaned against what seemed to be a wall but was only a light-illusion, lost their balance, and fell to the floor.

To the person whose idea of sculpture is the stone carvings of Michelangelo and Bernini, the cast bronzes of Verrocchio or Moore, this conception of light as sculpture may be strange, even shocking. But somehow it seems appropriate that our electronic world should produce sculptures just this transitory and just this susceptible to a modern phenomenon—the power failure.

As a matter of fact, nearly all of us have had experience making sculptures out of materials almost as insubstantial as light—snow and sand. You build a snowman or snowwoman or snowdog; the sun comes out, and it melts. You build a sand castle at the beach; the tide comes in, and it washes away. Even the most elaborate sand sculpture (**375**) is made with the understanding that nature will soon remove every trace of it. Are these really sculptures? Perhaps, by some definitions. They have form, they exist in three dimensions, they are a human creation for the purpose of aesthetic expression. The only thing unusual is that they exist for just a little while and then fade, never to be duplicated exactly.

One thing is clear: we cannot evaluate sculptures according to how long they last. Classical civilizations made sculptures to survive for all eternity, but they will not. Wood sculptures may burn, stone sculptures are eaten away by acid rain and industrial pollution. In times of war metal sculptures have sometimes been melted down to be turned into bullets. What remains, what cannot be taken away, is the sculptor's expression and the experience of the viewer—even if it lasts only for a moment.

375. Fantasy castle at Crystal State Park Beach, California.

12
Crafts

The works of art considered in this chapter have certain things in common with one another, but they also share traits with other media, such as sculpture. Most of them have roots in the traditional trades of the Middle Ages—potter, blacksmith, woodworker, and so forth. It is from this background that the word "craft" derives, referring to expert work done by hand. We still describe as "well-crafted" anything finely made, including a chair, an automobile, a house, even sometimes a painting or sculpture. The specific connotation of craft, however, is an object made by hand, not by machine, and this is true of all the works shown in this chapter.

A common assumption people make about the crafts is that objects are made for some functional use, such as eating, drinking, wearing, or sitting. For this reason they have often been called the "functional arts" or the "applied arts"—that is, applied to everyday necessities. And, to be sure, many of the objects we will look at have that very reason for being. A beautiful handmade dinner plate or wine goblet is a craft object, meant to be used for eating or drinking. However, it has never been true that all works considered crafts are purely utilitarian, and it is much less true today than in the past.

Our first three illustrations (376, 377, 378) show objects made of clay, made by hand. We would probably call the first one (376) a pot or a cup. It was made specifically for holding tea and was deliberately made simple and rough, according to the requirements of the Japanese tea ceremony. The second piece (377) might be called a sculpture; it is not different in concept from many of the works in Chapter 11, several of which are also made of clay. But how do we classify the third example (378)? This is a "stirrup vessel" made by the Mochica Indians of ancient Peru, dating from about A.D. 200–500. Although it was made to hold liquids and actually has a pouring spout (the name "stirrup" comes from the

above: 376. Choniu. Tea bowl, from Japan. c. 1760. Raku ware, height 3½″. Metropolitan Museum of Art, New York (Mansfield Collection, gift of Howard Mansfield, 1936).

far right: 377. Viola Frey. *Lady in Red Dress.* 1983. Ceramic, height 7′7½″. Collection Nancy and Bernard Kattler, Los Angeles.

right: 378. Stirrup vessel in the shape of a kneeling warrior. Mochica culture, Peru. A.D. 200–500. Earthenware, height 9⅛″. Metropolitan Museum of Art, New York (gift of Nathan Cummings, 1963).

arc-shaped spout), the piece is so masterfully sculpted that its form takes precedence over any practical use. Most people would be more inclined to put it on display as an art object than to store it in a kitchen cupboard. Would we then call it a "sculptural pot"?

The point is that we can draw no definite line between the functional object and the art object, between the piece meant to be used and the one meant only to be admired. Furthermore, the object intended for use will still be admired for its beauty of form and the unique expression of its maker. Many craft artists move freely back and forth from the functional to the sculptural. For example, it is not uncommon for the ceramist who worked all day yesterday making a set of coffee mugs to spend today building a large ceramic sculpture. This versatility is true of the glass blower, the weaver, the metalsmith, and the woodworker as well.

What may distinguish the crafts from the other arts is their emphasis on particular materials. The traditional materials of the crafts are clay, glass, fiber, metal, and wood. While a sculptor might be equally proficient in several different materials, most craft artists concentrate on one material only and have learned to realize its potential for many different kinds of expression. Each of these materials has its own capabilities and limitations, and each lends itself to certain kinds of structural and decorative design. In this chapter, then, we shall consider each of these materials in turn.

Clay

The craft of *ceramics* involves making objects from clay, a naturally occurring earth substance. When dry, clay has a powdery consistency; mixed with water it becomes *plastic*—that is, moldable and cohesive. In this form it can be modeled, pinched, rolled, or shaped between the hands. Once a clay form has been built and permitted to dry, it will hold its shape, but it is very fragile. To ensure permanence the form must be *fired* in a kiln, at temperatures ranging between about 1,200 and 2,700 degrees Fahrenheit, or higher. Firing changes the chemical composition of the clay so that it can never again be made plastic. A fired ceramic object, especially one fired at a high temperature, is quite durable. It can be shattered by a hard blow, but the pieces will not disintegrate. A sizable portion of the ancient art that has survived is ceramic, because—unlike wood or fiber—fired clay is highly resistant to the elements. Most large museums have very old ceramic treasures that have been patiently reassembled from the fragments discovered at archaeological sites.

Nearly every culture we know of has practiced the craft of ceramics, and civilizations in the Middle East understood the basic techniques by as early as 5000 B.C. The first ceramic ware was undoubtedly made by *pinching*—simple molding and squeezing of a lump of clay between the fingers. This method is adequate for making a small figurine or a miniature bowl, but it would be inefficient to impossible for larger items.

A major requirement for most ceramic objects is that they be hollow, that they have thin walls around a hollow core. There are two reasons for this. First,

379. *Haniwa: Horse,* from Japan. A.D. 3rd–6th century. Terra cotta, height 23½". Cleveland Museum of Art (Norweb Collection).

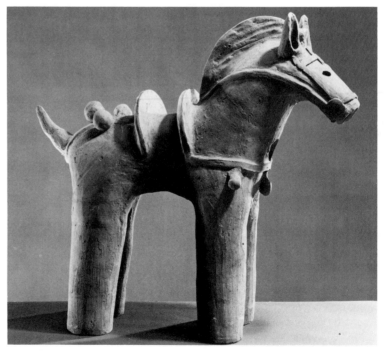

380. María Martínez.
Black-on-black jar.

many ceramic wares are meant to contain things—food or liquids, for instance. Second, a solid clay piece is difficult to fire and may very well explode in the kiln. To meet this need for hollowness, ceramists over the ages have developed specialized forming techniques.

One such technique is called *slab construction.* The ceramist rolls out the clay into a sheet, very much as a baker would roll out a pie crust, and then allows the sheet to dry slightly. The sheet, or slab, can then be handled in many ways. It can be cut into pieces for assembly into a box form, curled into a cylinder, draped over a mold to make a bowl, or shaped into free-form sculptural configurations. Slab building is usually the method of choice for forming rectilinear objects.

Slab construction was used to create the little horse shown here (**379**). This charming figure is an example of *haniwa*—clay figures placed around Japanese burial mounds between the 3rd and the 6th centuries. *Haniwa* were made to represent many subjects—horses, warriors, birds, and elegant costumed ladies. Usually there was little attempt at naturalism; the subjects were rendered in simple, tubular forms—the word *haniwa* means "circle of clay." This figure intentionally looks more like a toy horse than a real one. The slab construction lends itself readily to the creation of these basic sculptural forms.

Coiling is another technique for making a thin, hollow form. The ceramist rolls out ropelike strands of clay, then coils them upon one another and joins them together. A vessel made from coils attached one atop the other will have a ridged surface, but the coils can be smoothed completely, to produce a uniform, flat wall. The Indian tribes of the southwestern United States (who never developed the potter's wheel common in most other parts of the world) made extraordinarily large, finely shaped pots by coiling. In this century their craft has been revived by a few supremely talented individuals, including the famous Indian potter María Martínez (**380**).

By far the fastest method of creating a hollow, rounded form is by means of the *potter's wheel* (**381**). Egyptian potters were using the wheel by about 4000 B.C. Despite some modern improvements and the addition of electricity, the basic principle of wheel construction remains the same as it was in ancient times. The wheel is a flat disk mounted on a vertical shaft, which can be made to turn

381. Throwing
on the potter's wheel.

María Martínez
1881(?)–1980

It is a long way in miles and in time between the tiny pueblo of San Ildefonso in New Mexico and the White House in Washington, D.C. But the extraordinary ceramic artist María Martínez made that journey, and many others, in a long lifetime devoted to the craft of pottery-making. María—as she signed herself and is known professionally—began her career as a folk potter and ended it as a first-ranked potter of international reputation.

A Pueblo Indian, María most likely was born in 1881, but there are no records. As a child she learned to make pottery, using the coil method, by watching her aunt and other women of the community. Part of her youth was spent at St. Catherine's Indian School in Santa Fe, where she became friends with Julián Martínez. The couple married in 1904.

Although the husband worked at other jobs, the two Martínezes early formed a partnership for making pottery—she doing the building, he the decorating. Between 1907 and 1910 he was employed as a laborer on an archaeological site near the pueblo, under the direction of Dr. Edgar L. Hewett. The amazing career of María Martínez was launched in a simple way: Dr. Hewett gave her a broken piece of pottery from the site and asked her to reconstruct a whole pot in that style using the traditional Indian blackware techniques.

About 1919 the Martínezes developed the special black-on-black pottery that was to make them and the pueblo of San Ildefonso famous. The shiny black ware—created from red clay by a process of smothering the dung-fueled bonfire used for firing—was decorated with matte-black designs. This black-on-black ware was commercially quite successful. María Mar-

tínez and her husband became wealthy by the standards of the pueblo and, as was customary, shared that wealth with the entire community.

María bore four sons who survived. Eventually they and their wives and children and grandchildren became partners in her enterprise. One shadow on her domestic life was her husband's serious alcoholism, which began early in their marriage and contributed to his death in 1943. After he was gone, María's daughter-in-law Santana took over much of the decorating of pots, later to be followed by María's son Poponi Da.

As María's fame spread, she traveled widely, giving demonstrations at many world's fairs. Among the awards she received were an honorary doctorate from the University of Colorado and the American Ceramic Society's highest honor for a lifetime of devotion to clay. Her visit to Washington during the 1930s was a highlight. President Franklin D. Roosevelt was not at home, but Mrs. Eleanor Roosevelt was, and she reportedly told María, "You are one of the important ones. We have a piece of your pottery here in the White House, and we treasure it and show it to visitors from overseas."

Undoubtedly, María's greatest achievement was in reviving and popularizing the traditions of fine pottery-making among the Pueblo Indians. Not long before her death, according to her great-granddaughter, she said: "When I am gone, essentially other people have my pots. But to you I leave my greatest achievement, which is the ability to do it."[1]

Photograph of María Martínez.

rapidly either by electricity or by foot power. The ceramist centers a mound of clay on the wheel and, as the wheel turns, uses the hands to shape, "open," and lift the clay form—a procedure known as *throwing*. Throwing on the wheel always produces a rounded or cylindrical form, although the thrown pieces can later be reshaped, cut apart, or otherwise altered. Two or more thrown forms can also be joined together.

The most suitable technique, therefore, is one choice the ceramist needs to make in planning a particular work; another choice is the type of clay to be used. Clays differ in their composition, and this in turn affects the character of pieces made from them. Usually a clay is categorized by its firing temperature—the optimum temperature needed to change the clay's chemical composition permanently and make it hard. *Earthenware* clays, generally red or brown, fire at the lowest temperatures. Fired earthenware objects are often called *terra cotta* ("baked earth"). They tend to be coarse and porous and will not hold liquids unless coated with a glaze (see below). *Stoneware* clays, which fire at medium temperatures, are generally brown or grayish. Much commercial dinnerware is made of stoneware, and these clays have been popular among artist-potters.

The aristocrats of clays are the pure white *porcelains*, which fire at the highest temperatures. Porcelain is the material of the finest dinnerware and in the past was used for the most elegant of commercial vases and figurines. Until recently, individual artist-potters seldom worked in porcelain because the high firing temperatures are difficult to achieve with noncommercial equipment and because porcelain clays are less plastic and thus more difficult to handle than earthenware or stoneware. In the last few years, however, additives have been developed for porcelain clays that decrease the problems, so there has been renewed interest in porcelain among craft artists. (A term often used—and misused—by commercial ceramics manufacturers is *china*, which refers to a ware not unlike porcelain but firing at a lower temperature. China clays have little plasticity, and they are rarely used by the craft artist.)

While clays themselves may have interesting colors and textures, much of the potential for decoration in ceramics comes from the glaze. A *glaze* is a glass-like material usually applied to the surface of a ceramic piece and then fired on so as to fuse the glaze with the clay body. Nearly always this is a second firing, which follows the preliminary one to harden the clay. There is virtually no limit to the different effects that can be produced by combining glazes or by the various methods of applying them. While there are clear glazes, most glazes have color, and this is a major reason for their application. A secondary purpose of the glaze is to make an object watertight and nonabsorbent—especially important for cooking and eating vessels and for the more porous low-fired clays.

One of the earliest glazes, in use by 3000 B.C., is known as *Egyptian paste*. Unlike most glazes, this material is mixed into the clay rather than applied on top of it. When the piece is fired (in a single firing) a glassy coating, often turquoise in color, forms on the surface. We see this in the Metropolitan Museum's famous hippopotamus figure, affectionately known as "William" (**382**).

382. *Hippopotamus,* from the tomb of Senbi at Meir, Egypt. XII Dynasty, 2000–1788 B.C. Egyptian faience, height 4⅜". Metropolitan Museum of Art, New York (gift of Edward S. Harkness, 1917).

383. *The Calydonian Boar,*
decorated plate
from Urbino, Italy. c. 1542.
Majolica ware, diameter 10¾".
Victoria & Albert Museum,
London.

Conventional glazes can be applied in many ways—by pouring, dipping, or spraying, for example. When properly compounded, glazes can also be painted onto a surface with all the precision and potential for color effects available to an artist using oil paints on canvas. The best examples of this technique appear in the decorated plates from Renaissance Italy and Spain, known as *majolica* ware (**383**). Elaborate painted scenes, some of them quite naturalistic, were achieved through the use of multicolored glazes. In this type of expression the form of the ceramic piece is much less important than its decoration. The plate becomes just another surface on which to paint.

384. Elena Karina. *Botticelli.*
1979. Porcelain, height 13".
Collection Mr. and Mrs.
Alvin Ferst, Jr.

385. Betty Woodman.
Cloistered Arbor Room. 1981.
Handmade earthenware tiles
with glaze, height of columns 5′.
Installation at Bennington
College, Vermont.
Courtesy Hadler/Rodriguez
Galleries, New York and Houston.

In contemporary ceramics we are more likely to find a balance of form and decoration—a blend so perfect that one could not exist without the other. This is apparent in the work of Elena Karina (**384**). Karina's forms may remind us of seashells, but if so, they are the most delicate, intricate, and complex seashells ever made. Shaped by hand from porcelain, Karina's vessels shimmer with a variable opalescent glaze that seems like a natural extension of the form.

Today's ceramic artists have many advantages over those of the past. Improvements in technology have encouraged a new willingness to experiment with form and design. Above all, size is no longer a limitation. Whereas most ceramists up to the last decade focused on the individual piece, the one perfect object, now it is common for ceramic artists to assemble components separately formed and fired into a larger structure or an environment. Viola Frey's *Lady in Red Dress* (**377**), which is more than 7 feet tall, was made this way, as was Betty Woodman's *Cloistered Arbor Room* (**385**). The columns that make up this "room" are composed of individual glazed tiles, assembled and attached to the wall. What intrigues us about the *Arbor Room* is its unexpected use of the material. We expect to see tiles on a wall, but not arranged into column-like forms; and we may expect to see flat columns on a wall, but usually they are of wood or stone. Arranged in an orderly progression, the ceramic columns have a monumental, dignified quality. Woodman's work pushes ceramic art into a new dimension, one that defines space rather than just ornamenting it.

Glass

If clay is one of the most versatile of the craft materials, glass is perhaps the most fascinating. Few people, when presented with a beautiful glass form, can resist holding it up to the light, watching how light changes its appearance from different angles.

While there are thousands of formulas for glass, its principal ingredient is usually silica, or sand. The addition of other materials can affect color, melting point, strength, and so on. When heated, glass becomes molten, and in that state it can be shaped by several different methods. Unlike clay, glass never changes chemically as it moves from a soft, workable state to a hard, rigid one. As glass cools it hardens, but it can then be reheated and rendered molten again for further working.

Glass as a material holds many risks, both during the creative process and afterward. The shaping of a glass object demands split-second timing—quick

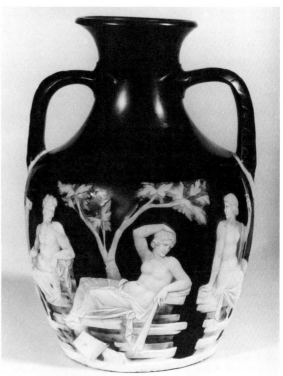

decisions and quick handwork—while the glass remains hot. What's more, a finished glass piece is the most fragile of all craft wares. One quick blow can shatter it irreparably. There is something almost heroic about an artist who would spend days, weeks, even months making an object that is so vulnerable.

Glassmaking is nearly as old a craft as ceramics, but it was not until the Roman era, shortly before the birth of Christ, that the first great period of glassmaking as an art began. The Roman era saw the invention of the blowpipe—an instrument that has changed very little in two thousand years (**386**). To blow glass, the artist dips up a portion of molten glass at the end of the pipe and then blows through the pipe to produce a bubble. The bubble can be shaped or cut by various methods while it is still hot. Besides blowing, other ways of forming glass include molding, pressing, and rolling.

The Roman historian Pliny the Elder wrote of large "statues" made from glass, but almost nothing is known about them. It is assumed that they were chiseled out of solid glass blocks and then polished. Although we can only speculate about such pieces, many examples of glassware from the Roman period have survived, including what is perhaps the most famous glass object in the world—the *Portland Vase* (**387**). The incredible virtuosity displayed in this vessel testifies to long experience in glassmaking. The vase was made in three stages. First the basic form of dark blue glass was blown, and then a layer of semi-opaque white glass was added to the outside. Next the vase was given over to a cameo cutter—a carver of low-relief figural designs—who patiently chipped away the white glass to create a relief design of many gradations. In some areas the dark blue shows faintly through the white to give a shaded effect. Later glass artists have tried to duplicate the remarkable cameo quality of the *Portland Vase* and have failed.

About a thousand years later, another great era of glassmaking took place in Italy. This time it centered on the city of Venice. By the year 1291 there were so many glass factories in Venice, with so many furnaces burning day and night, that the entire city seemed in danger of going up in flames. As a result, the Senate demanded that all the glass factories be removed to the island of Murano, where many remain to this day.

Venetian glassmakers excelled in decorative design and perfected many elaborate techniques. Among their specialties were enameling ("painting" with

colored glass), etching with acids, gilding, trailing on thin ribbons of molten glass in preplanned designs, and combinations of these. Ornate examples of Venetian glass like this elaborately decorated goblet (**388**) were highly sought throughout Europe. Because their glasswares were such valuable trading items, Venetian glassmakers were forbidden to leave Murano, and the techniques were closely guarded secrets. Nevertheless, several of the artisans escaped, and their knowledge spread across Europe and to North America.

Contemporary glass artists, like their counterparts in ceramics, strive for a balance of form and decoration. In glass—in the hands of a sensitive artist—this balance may develop as the piece is conceived. Peter Bramhall's *Water Series Interior* (**389**), a hand-blown glass piece more than a foot in diameter, exemplifies this exquisite partnership of shape and expressive design. The title suggests a flow of underwater reeds and grasses in constant, gentle motion, yet these forms are merely implied, not deliberately drawn. They emerge from the fluid nature of the glass and create their own universe inside the perfect bubble.

Dale Chihuly's designs are more exuberant, more deliberately sculptural (**390**). Their decoration seems to evolve from the form itself, rather than being applied to an existing structure. Chihuly's blown-glass works are very thin and translucent; they have a fluid quality reminiscent of shapes in the natural world—in this case, as the title suggests, the world of the sea.

In spite of the fact that glassmaking is an ancient art, its popularity as an expressive craft medium faded after the Venetian era. Not until the 1960s did craft artists rediscover glass, so that all the traditional techniques had to be relearned—and then applied to contemporary styles. Nevertheless, glass artists have made tremendous strides in catching up with the other craft media.

Metal

From the most fragile craft material we turn to the most indestructible. Metals rust and corrode under some circumstances, but they do not shatter, chip, or rot away. Indeed, sometimes the action of the elements has a beneficial effect on

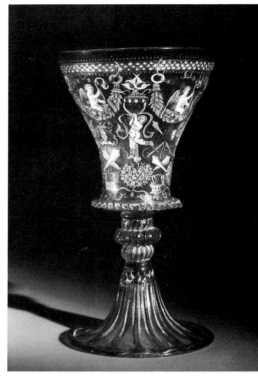

388. Goblet, from Venice.
Early 16th century.
Cristallo with enameled
and gilt decoration, height 9¼".
Corning Museum of Glass,
Corning Glass Center, Corning, N.Y.

left: 389. Peter Bramhall. *Water Series Interior.* 1983. Brown glass, diameter 16".
Collection Mr. and Mrs. Laurance Rockefeller.

right: 390. Dale Chihuly. *Macchia Seaforms.* 1983. Blown glass with threading and glass "jimmies," width c. 25". Courtesy Charles Cowles Gallery, New York.

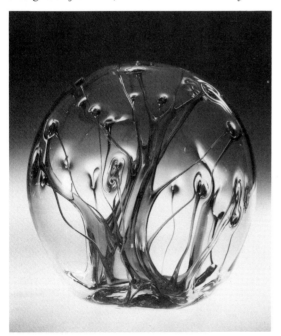

391. *Tiger,* from China. Late Zhou period, 9th century B.C. Bronze, length 29⅝″. Freer Gallery of Art, Smithsonian Institution, Washington, D.C.

metals. As was mentioned in reference to cast-bronze sculptures (p. 287), weathering may give metals a surface color, or patina, that is more attractive than their original appearance.

Ever since humans learned to work metals, they have made splendid art, as well as functional tools, from this versatile family of materials. Given all the sophisticated technology we have available today, we might think that metalwork would simply get better and better. Yet for sheer beauty of form and decoration, few artists have matched the skill of bronze craftsmen in China during the Shang and Zhou dynasties three thousand years ago.

Ornate bronze vessels were made in China as early as the 16th century B.C. The piece illustrated here (**391**) is later, dating from the Late Zhou dynasty (9th century B.C.). It is interesting to note that this work predates by hundreds of years the art of Classical Greece, which many Westerners consider to have been the beginning of all civilized art. Chapter 11 (p. 285) explained the process of lost-wax casting. The Shang and Zhou bronzes also were cast, but by a far more demanding method. Archaeologists now speculate that the Chinese metalworkers were able to build a two-piece "sandwich" mold without benefit of the wax layer to hold the two sections apart—an inexplicable and astonishing feat for that time or any other. The tiger shown here is thought to have been made as a base support for some large structure, perhaps a throne. Like most works from this period, it is covered with stylized geometric designs in relief.

One distinctive aspect of metal is that it is equally at home in the mundane and the sublime—the bridge that spans a river or the precious ring on a finger; the plow that turns up the earth or the crown on a princess' head. Whatever the application, the basic composition of the material is the same, and the methods of working it are similar.

Casting is but one of several methods for working metal. Another ancient technique is *forging*—the art of the blacksmith. Forging involves heating a chunk of metal over a fire until it is red-hot, then beating and shaping it with hammers. This is how horseshoes traditionally were made, and it is also the method of making wrought iron.

A hundred years ago there was a blacksmith in every town. This was necessary to serve the needs of a populace that could travel only when its animals were properly shod. The more inventive of these blacksmiths also answered the enormous demand for decorative metal objects—doorways, grilles, balconies, hinges, door knockers, and many others. Today such commissions are rare, partly because the public taste for ornamental metal has declined, partly because most such objects are mass-produced. However, when it was decided to restore the Senate Chamber of the state capitol building in Albany, New York, the planners found themselves a modern counterpart of yesterday's creative blacksmith.

Albert Paley, a noted metalsmith who teaches at the State University of New York at Brockport, was commissioned to execute new doors for the Senate chamber, first designed in the 1870s. Paley's gates (**392**), forged and fabricated from steel, brass, and bronze, are modern in their streamlined, linear design, yet they harmonize extremely well with the century-old structure. His design is so elegant and classic as to seem timeless.

Forging is the method of hammering heated metal, but some metals can also be hammered cold. This is the technique of many fine silversmiths. The artisan begins with a thin sheet of metal and, working from the back, strikes it repeatedly with small hammers, a technique known as *repoussé*. In some cases the metal sheet is placed on top of a mold and hammered so as to conform to the shape of the mold. Silver, in particular, is a soft enough metal to endure this kind of constant pounding, yield to it, but seldom break or develop holes. The vase illustrated (**393**) is a wonderful example of this technique. It was made by Tiffany and Company for the World's Columbian Exposition in 1893, and no effort was spared to make it as elaborate—and as uniquely American—as possible. Hammered into relief are flowers and plants from every region of the United States. Both the overall shape of the vase and the handles at the top were inspired by pottery forms from the ancient tribes that inhabited the Americas before the arrival of Columbus.

One of the oldest uses of metal as an expressive medium is for jewelry. This has been true since prehistoric times. Early cultures believed that wearing special stones or special metals could ward off disease and evil spirits—a practice continued today in the wearing of copper bracelets for therapeutic purposes.

left: 392. Albert Paley. *Portal Gates.* 1980. Mild steel, brass, and bronze; height 13′6″. Commissioned for the Senate Chambers, Capitol Building, Albany, N.Y. Courtesy Fendrick Gallery, Washington, D.C.

right: 393. Tiffany and Company. *Magnolia Vase,* made for World's Columbian Exposition, 1893. Silver, gold, and enamel; height 31″. Metropolitan Museum of Art, New York (gift of Mrs. Winthrop Atwell, 1899).

Apart from its supposed magical powers, metal has great symbolic value. People wear jewelry to symbolize wealth and status. They also wear jewelry to symbolize belonging—to a person (a wedding ring), to an institution (a school ring), to a group (a club or fraternity or religious ring).

Among contemporary metal artists jewelry has been a major preoccupation—not the jewelry of the perfect one-carat diamond in a traditional setting, but far more creative forms. Any of the various metalworking techniques can be used for jewelry, and sometimes two or more are combined in the same piece. For instance, Merry Renk's necklace *Arizona Conference* (**394**) was created by a combination of sawing, casting, soldering, carving, and hammering. The design recalls an event in the life of the artist—a goldsmiths' conference she attended shortly before she made this piece. The flock of little silver cactus wrens is a witty reference to her fellow metalsmiths.

The use of metals for precious objects reached a high point around the turn of this century in the work of Peter Carl Fabergé, a Russian of French descent. Fabergé had established a shop in St. Petersburg (now Leningrad), and about 1884 he was named official jeweler and goldsmith to the imperial family. Czar Alexander III was his first patron, followed by Czar Nicholas II. Between 1884 and 1917 Fabergé created numerous pieces in gold, enamels, and gems for his royal clients. His greatest achievement, however, was a series of objects that are unique in all the world. Only 53 are known to exist. They are the imperial Easter eggs (**395**).

It is a Russian custom to give eggs at Easter. Czar Alexander improved upon the custom by having Fabergé construct, every year, an elaborate metal-and-jeweled egg for presentation to the empress. Each egg was as ornate and lavishly decorated as Fabergé's skilled workers could manage, and each contained a "surprise." When a tiny pearl or diamond on the outside was pressed, the egg opened to reveal a separate, gemlike little object—a portrait, a miniature basket of flowers, or, in the case of the "coronation egg" shown here, a finely detailed gold coach. Alexander's son Nicholas continued the custom, commis-

sioning Fabergé to make Easter eggs for his empress, Alexandra, and for his mother as well. This practice was repeated yearly until the Russian Revolution of 1917 wiped out both the imperial family and Fabergé's workshop.

Wood

There are two reasons for the great popularity of wood as a craft material throughout the entire history of art. One is that it is relatively easy to work. The simplest tools will shape it, and there is no need for extreme heat, as with clay, glass, or metal. The second reason is that wood is so widely available. In most inhabited areas of the globe wood is abundant and relatively easy to obtain.

These two qualities would make wood the ideal material were it not for certain drawbacks. Because of its organic nature, wood is not very durable. Cold and heat distort it, water rots it, and insects can eat it away. More than one collector has tried to import a gorgeous wood carving from Africa, only to find it contained an active colony of insects that left nothing but a crumbling shell. We must assume that only a tiny fraction of the wood artifacts made over the centuries have survived. Perhaps that is why the few very old wood pieces we have seem all the more marvelous.

A particularly rich trove of carved-wood objects was found at Oseberg in southern Norway, in a buried Viking ship dating from the early 9th century. The Oseberg ship, itself made of wood and decorated with a wonderfully carved prow, is believed to have been a luxury vessel intended for cruising the coastline and rivers. Among its contents was a splendid animal head (**396**) that adorned the top of a post—the sort of post probably carried in religious processions. In style the head represents an artistic tradition, the so-called *animal style*, common in northwestern Europe from about the 5th to the 10th century. The main feature of this style is a delicate interlacing of lines, seen here on the neck of the animal. Obviously, enormous skill was required to plan and execute this intricate design in wood.

Wood carving, especially of figures, reached a high point in the United States during the 19th century. Certain types of figures flourished: cigar-store Indians and other images that adorned the fronts of shops; magnificent figure-heads, usually of women with long, flowing hair, that crowned the prows of sailing ships; and ornate carrousel animals. Generations raised on look-alike merry-go-round horses can scarcely comprehend the ingenuity of carrousel figures carved a century ago. Not only horses, but lions and giraffes and elephants and camels—all were meticulously hand-carved and imaginatively painted (**397**). The thrill of the ride was far less important than the exotic experience of sitting atop one of these fanciful sculptures in wood.

above: 396. *Animal Head,* from Oseberg Burial Ship. c. 825. Wood, height c. 18″. University Museum of National Antiquities, Oslo.

below: 397. Carrousel figure. 19th century. Wood, length 5′2″. National Museum of American History, Smithsonian Institution, Washington, D.C. (Van Alstyne Collection of American Folk Art).

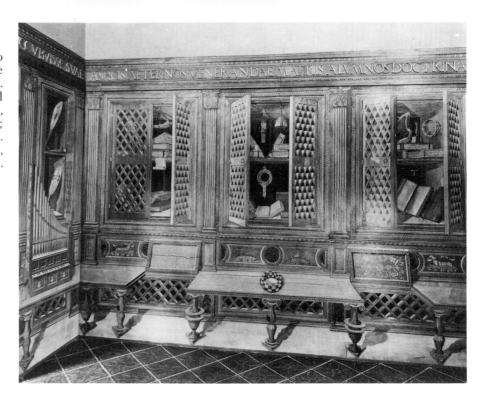

398. Francesco di Giorgio of Siena. Room from the Ducal Palace, Gubbio, Italy. Late 15th century. Trompe-l'oeil inlay of walnut, oak, beech, rosewood, and fruitwoods; height of room 8'10". Metropolitan Museum of Art, New York (Rogers Fund, 1939).

left: 399. Peter Korn. Rocking chair. 1981. Walnut with upholstered seat. Courtesy the artist.

right: 400. Klindt Houlberg. *Phantasy Plenishing.* 1980. Wood, height 7'. Courtesy the artist.

Carving is only one of several methods for working with wood. It is a subtractive process (pieces of wood are cut away), but there are also additive processes for wood, such as nailing and gluing pieces together. One of the more interesting of these is the old technique of *inlay*, in which small pieces of wood, often with different grains and colors, are glued together to make a pattern. When this method is used to decorate a wall or the face of a piece of furniture, it is often called *marquetry*. A splendid example of this art comes from the Ducal Palace at Gubbio, in Italy (**398**). Small pieces of different woods have been cleverly combined to give a *trompe-l'oeil* (fool-the-eye) effect of three-dimensional space, even though the wall is absolutely flat. The open cabinet doors, the benches below

them, even the shadows are all illusions! This type of visual deceit was much prized in earlier centuries, and it still astonishes us as we move closer to see that, yes, it really *is* a flat surface of wood.

For most of us, of course, wood is usually associated with furniture, which is generally constructed by a process of nailing and/or gluing. Contemporary wood artists have interpreted the basic furniture designs in wholly new ways to enhance the special qualities of wood. A walnut rocking chair by Peter Korn (**399**) reminds us of classic designs from the past, yet it is strikingly modern in its elegant shape and line.

When furniture craft and fine wood carving merge, we may get a zany result like the bedstead illustrated here (**400**). Klindt Houlberg's *Phantasy Plenishing* looks like a normal, well-crafted bed frame—up to about a foot from the floor. Above that the artist's imagination runs wild. One bedpost is a nude female figure, another a fantasy tree with a bird perched on top, and so on. Houlberg's work makes us realize how rich our environment could be if more everyday objects were treated with this kind of delightful expressiveness.

Fiber

The design possibilities for works of fiber are enormous. By fiber we mean a narrow strand of vegetable or animal material (cotton, linen, wool, silk) or the modern-day synthetic equivalents. Like wood, fiber is widely available and quite perishable, but the construction methods used for fiber are unique to this pliable medium.

For centuries the most common method of working with fiber has been *weaving*. Weaving involves placing two sets of parallel fibers at right angles to one another and interlacing one set through the other in an up-and-down movement, generally on a loom or frame. One set of fibers is held taut; this is called the *warp*. The other set, known as the *weft* or *woof*, is interwoven through the warp to make a fabric. Nearly all fabrics, including those used for our clothing, are made by some variation of this process.

A complex loom is a little like a computer. Much of the designing of fabric takes place when the loom is "programmed." The weaver decides in advance how the warp yarns are to be arranged on the loom and also decides on the pattern of interlacing for the weft yarns. After the planning stage, the weaving progresses more or less automatically. Amazingly intricate fabrics can be created on the loom.

Tapestry is a special type of weaving in which the weft yarns are manipulated freely to form a pattern or design on the front of the fabric. Often the weft yarns are of several colors, and the weaver can use the different colored yarn almost as flexibly as a painter uses pigment on a canvas. The weavers of ancient Peru specialized in tapestry weaves with geometric forms or stylized animal figures (**401**). The shirt illustrated here seems even more remarkable when we consider that it was woven on the simplest, most primitive of looms.

401. Shirt, Ica, south coast of Peru. 13th–15th century. Tapestry of wool and cotton, height 23½". Metropolitan Museum of Art, New York (Michael C. Rockefeller Memorial Collection, bequest of Nelson A. Rockefeller, 1979).

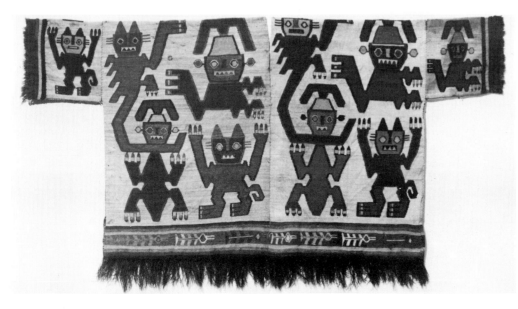

VIGIO: MAR E TRAN SI

402. *Norman Fleet Sailing to England*, detail of the *Bayeux Tapestry*. c. 1073–88. Wool embroidery on linen; height 20″, overall length 231′. Town Hall, Bayeux, reproduced with special authorization of the City of Bayeux.

One of the most famous examples of fiber art in the Western world once hung in the Cathedral of Bayeux and now is preserved in the Town Hall of that French city. This is the *Bayeux Tapestry* (**402**)—misnamed, because it is actually a work of embroidery. (In the past, large-scale fabrics, especially those hung in buildings, often were loosely called "tapestries," regardless of the construction method.) *Embroidery* is a technique in which colored yarns are sewn to an existing woven background; frequently the sewing takes the form of decorative motifs or images, as here. The *Bayeux Tapestry* is like a long picture book—20 inches high and 231 feet long—telling the story of the conquest of England by William of Normandy in 1066. The scene illustrated, one of seventy-two separate episodes reading from left to right, shows the Norman boats setting sail to wage war on Saxon England. The fabric's pictorial design is simple and flat. The two smaller boats, meant to be seen as farther away than the three large ones, do not contribute to any sense of spatial depth; they almost seem to be floating in the air. Despite the charming naïveté of these images, however, scholars have learned more about the events surrounding the Norman Conquest from the *Bayeux Tapestry* than they have from any of the literature of the time.

Centuries later and light-years away in expression, Lynda Benglis' *Patang* (**403**) shares one of the functions of the *Bayeux Tapestry*—to cover the bare walls of a public building. It is a work in *appliqué,* or pieces of fabric stitched onto a fabric backing, and hangs above a check-in counter at Atlanta's airport. Benglis' work makes an interesting contrast with the *Bayeux Tapestry*. Where the latter originally hung, high up on the walls in a dim cathedral, it is unlikely that viewers could see much of its detail, and this was apparently of little concern to its makers. *Patang*, on the other hand, was designed for maximum impact at a distance in a large, open space. Planned for this location, it presents large, bold, abstract designs in brilliant colors.

Benglis' work represents a revival of the use of fabric to decorate large expanses of wall. Ten years ago the architects of this building probably would have left the wall plain. Fifty years ago they might have commissioned a painter to do a mural. Today, increasingly, architects and interior designers seek the work of the fiber artist. Why is this so, why has fashion turned in this direction? We cannot say for sure, but it is certainly true that fiber brings a warmth, a softness, a flexibility to the often-forbidding steel and concrete of our world.

While fiberworks can be stretched taut or laid flat against the wall or even sculpted into three-dimensionality, we usually associate fabric with pliability. Clothing flows around our bodies as we move, sails puff out and fill with the wind, flags flutter. This association of fabric with movement is inherent in Ina Kozel's *Seven Sisters* (**404**). Installed in the atrium of Atlanta's Ashford-Green Building, *Seven Sisters* is an assemblage of hand-painted "kites" that swoop and pivot constantly as they are propelled by air currents. Within this six-story glass enclosure has been contained a gentle reminder of all graceful things that fly.

above: 403. Lynda Benglis. *Patang.* 1980. Satin
appliqué on canvas, 15 × 90'.
Atlanta Airport Commission,
Courtesy Paula Cooper Gallery, New York.

left: 404. Ina Kozel. *Seven Sisters.*
Hand-painted fabric. Installed in the
Ashford-Green Building, Atlanta, 1982.
Courtesy Eve Mannes Gallery, Atlanta.

The illustrations in this chapter cover five different families of materials and four
thousand years of human history. They are very different, yet they have certain
things in common. Each of them represents a perfect use of the material from
which it was made. Each has been formed with the highest possible standards of
craftsmanship. Above all, each shows the striving for aesthetic satisfaction that is
part of humanity.

ART PEOPLE
Aileen Osborn Webb

The American craft movement today is remarkably healthy. Craft fairs abound in every corner of the United States throughout the summer and increasingly in other seasons as well. Major department stores sell handmade craft items in special "boutiques." Numerous craft magazines are published regularly. Organizations of craft artists are active and well-structured. This happy situation has existed for a surprisingly short time, and it exists largely through the efforts of one woman—a woman who began life as a most unlikely candidate for patron of the crafts.

Aileen Osborn was born in 1892, in the Hudson River town of Garrison, New York, to a family of great wealth and prestige. Her early years were correct for a privileged young woman of the time—private schools, a finishing school in Paris, a formal debut into society at age seventeen, marriage at twenty to an equally privileged young man, Vanderbilt Webb. For some time after the marriage, life continued as Aileen Osborn's parents, and her parents' parents, could have predicted—four children were born, lavish entertainments were planned and executed, servants were instructed, flowers were arranged. One cannot doubt that young Mrs. Webb was busy, for the management of a 102-room mansion requires energy and skill. But far more ambitious projects lay ahead for this tireless, creative woman.

It was during the 1930s, at the height of the Great Depression, that Mrs. Webb became interested in handcrafts. Cushioned herself by almost unlimited money, she nevertheless saw that many of her neighbors in the area were suffering terrible hardships. Jobs were scarce, and many families had difficulty putting food on the table. Aileen Webb reasoned that if a method could be found to popularize objects finely made by hand, this could provide employment and income for needy people. In 1932 she founded Putnam County Products, a cooperative association intended to market the wares of craftworkers. The effort was modest, but Aileen Webb had only just gotten started.

Largely through Mrs. Webb's efforts, the American Craftsmen's Council (later the American Craft Council) was founded in 1943. From this root grew many branches: the retail outlet called America House, in New York City, which sold only craft objects made by hand; the magazine *Craft Horizons* (now *American Craft*), and its offspring publications; the Museum of Contemporary Crafts in New York; and eventually the World Craft Council, launched in 1964. Aileen Webb's participation in these activities was not merely that of a Lady Bountiful, writing checks; rather she was deeply involved in the day-to-day work. Until shortly before her death in 1979, at the age of 87, she appeared regularly at her American Craft Council office.

Never one to look on benignly from a distance, Aileen Webb became accomplished at enameling, woodcarving, and especially ceramics. The hands that birth and social class had designated for arranging flowers found their true expression plunged up to the elbows in potter's clay. Obviously, whatever the task to be done, Mrs. Webb plunged in up to the elbows, and every craft artist working today benefits from her efforts.

Aileen Osborn Webb at her potter's wheel in Garrison, New York, 1977.

13
Architecture

*A*rchitecture satisfies a basic, universal human need for a roof over one's head. More than walls, more than a chair to sit on or a soft bed upon which to lie, a roof is the classic symbol of protection and security. We've all heard the expression "I have a roof over my head," but it would be unusual to hear someone say, "I'm all right because I have walls around me." Of course, in purely practical terms a roof does keep out the worst of the elements, snow and rain, and in warm climates a roof may be sufficient to keep people dry and comfortable. The roof seems to be symbolic of the nature of architecture.

As was discussed in Chapter 4 (p. 127), the walls and roof of a building shape space and define it. We can discuss architecture equally in terms of the spaces and volumes created within a structure and in terms of the forms that create those spaces.

More than any of the other arts, architecture demands structural stability. Every one of us daily moves in and out of buildings—schools, houses, offices, stores, churches, bus stations, banks, and movie theaters—and we take for granted, usually without thinking about it, that they will not collapse on top of us. That they do not is a tribute to their engineering; if a building is physically stable, this means it adheres faithfully to the principles of the particular *structural system* or systems on which its architecture is based.

Structural Systems in Architecture

Any building is a defiance of gravity. Since earliest times architects have tackled the challenge of erecting a roof over empty space, setting walls upright, and

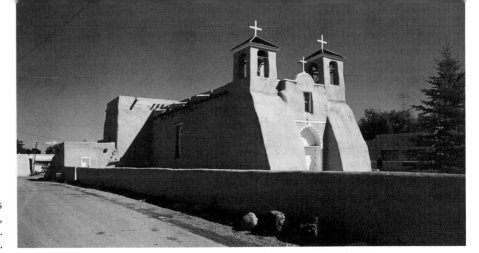

405. Mission St. Francis
of Assisi, Ranchos de Taos,
New Mexico.
c. 1776–80.

having the whole stand secure. Their solutions have depended upon the materials they had available, for, as we shall see, certain materials are better suited than others to a particular structural system. There are two basic families of structural systems: the *shell* system and the *skeleton-and-skin* system.

In the shell system one building material provides both structural support and sheathing (outside covering). Buildings made of brick or stone or adobe fall into this category (**405**). So do older (pre–19th-century) wood buildings constructed of heavy timbers, the most obvious example being the log cabin. The structural material comprises the walls and roof, marks the boundary between inside and outside, and is visible as the exterior surface. Shell construction prevailed until the 19th century, when it began to fall out of favor. Today, however, the development of strong cast materials, including many plastics, has brought renewed interest in shell structures.

The skeleton-and-skin system might be compared to the human body, which has a rigid bony skeleton to support its basic frame and a more fragile skin for sheathing. We find it in modern skyscrapers, with their steel frames (skeletons) supporting the structure and a sheathing (skin) of glass or some other light material. Also, most houses today—at least in Western cultures—are built with a skeleton of wood beams nailed together, topped with a sheathing of light wood boards, shingles, aluminum siding, or the like. Skeleton-and-skin construction is largely a product of the Industrial Revolution; not until the mid-19th century could steel for beams or metal nails be manufactured in practical quantities.

Two factors that must be considered in any structural system are *weight* and *tensile strength*. Walls must support the weight of the roof, and lower stories must support the weight of upper stories. In other words, all the weight of the building must somehow be carried safely to the ground. You can get a sense of this if you imagine your own body as a structural member. Suppose you are lying flat on your back, your body held rigid. You are going to be lifted high in the air, to become a "roof." First you are lifted by four people: One supports you under the shoulders, one under the buttocks, one holds your arms extended

406. Pyramid of the Sun,
Teotihuacán, Mexico. c. 510–660.

above your head, another holds your feet. Your weight is therefore channeled down through four vertical people to the ground, and so you can hold yourself horizontally with some ease. Next you are lifted by two people, one holding your shoulders, another your feet. A lot of your weight is concentrated in the center of your body, which is unsupported, so eventually you sag in the middle and fall to the floor. Then you are lifted by one person, who holds you at the center of your back. The weight at both ends of your body has nowhere to go, nothing to carry it to the ground, and you sag at both ends.

Tensile strength, as applied to architecture, is the ability of a material to span horizontal distances with minimum support from underneath. Returning to the analogy of the body, imagine you are not made of flesh and blood but of strong plastic or metal. Regardless of how you are held up in the air, you can stay rigid and horizontal, because you have great tensile strength.

If you keep these images in mind, you may find it easier to understand the various structural systems we shall consider below. They are introduced here in roughly the chronological order in which they were developed. As was mentioned earlier, all will be of the shell type until we reach the 19th century.

LOAD-BEARING CONSTRUCTION

Another term for load-bearing construction is "stacking and piling." This is the simplest method of making a building, and it is suitable for brick, stone, adobe, ice blocks, and certain modern materials. Essentially, the builder constructs the walls by piling layer upon layer, starting thick at the bottom, getting thinner as the structure rises, and usually tapering inward near the highest point. The whole may then be topped by a lightweight roof, perhaps of thatch or wood. This construction is stable, because its greatest weight is concentrated at the bottom and weight diminishes gradually as the walls grow higher.

Load-bearing structures tend to have few and small openings (if any) in the walls, because the method does not readily allow for support of material above a void, such as a window opening. This was the system used to construct the Ranchos de Taos church in New Mexico (**405**), a piled-up mass of adobe, or sun-dried mud. Although the Taos church is hollow, meant to contain worshippers inside, many load-bearing structures are solid all the way through, or perhaps have only small open chambers within them. Indeed, some of the ancient pyramids of the Americas are more accurately referred to as "mound temples," because all ceremonies were conducted atop the pyramids and there are no interior spaces. We find such a structure in the colossal Pyramid of the Sun at Teotihuacán, near Mexico City, part of a giant temple complex built in the 6th or 7th century A.D. (**406**).

POST-AND-LINTEL

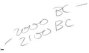

We encountered post-and-lintel construction earlier, in the discussion of Stonehenge (**69**). After stacking and piling, it is the most elementary structural method, based on two uprights (the posts) supporting a horizontal crosspiece (the lintel, or beam). This configuration can be continued indefinitely, so that there may be one very long horizontal supported at critical points along the way by vertical posts to carry its weight to the ground. The most common materials for post-and-lintel construction are stone and wood. Since neither has great tensile strength, these materials will yield and cave in when forced to span long distances, so the architect must provide supporting posts at close intervals.

Post-and-lintel construction has been, for at least four thousand years, a favorite method of architects for raising a roof and providing for open space underneath. Tracing its history back to the first culture we know well, we find post-and-lintel used widely by the ancient Egyptians. At Luxor on the east bank of the Nile in Egypt stand the ruins of the mighty temple of Amen-Mut-Khonsu

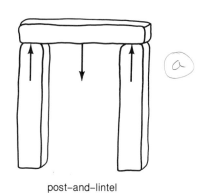

post–and–lintel

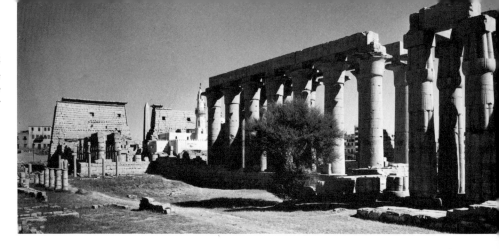

407. Colonnade and Court of Amenhotep III, Temple of Amen-Mut-Khonsu, Luxor, Egypt. c. 1390 B.C.

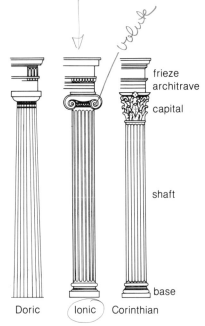

408. Comparison of column styles in the Greek Orders.

(**407**), planned by the pharaoh Amenhotep III in the 14th century B.C. The heavy lintels of the colonnade are supported solidly by tall, massive columns, almost too massive for the job they had to do. Perhaps the builder deliberately made the columns heavier than necessary in order to create an imposing effect.

In ancient Greece the design of post-and-lintel buildings, especially temples, became rather standardized in certain features. There were three major architectural styles, which appeared in sequence (with some overlapping), and they are known as the Greek Orders. The most distinctive feature of each was the design of the column (**408**). By the 7th century B.C. the *Doric* style had been introduced. A Doric column has no base, nothing separating it from the floor below; its *capital*, the topmost part between the shaft of the column and the roof or lintel, is a plain stone slab above a rounded stone. The *Ionic* style was developed in the 6th century B.C. and gradually replaced the Doric. An Ionic column has a stepped base and a carved capital in the form of two graceful spirals known as *volutes*. The *Corinthian* style, which appeared in the 4th century B.C., is yet more elaborate, having a more detailed base and a capital of delicately carved acanthus leaves.

Possibly the best-known and most impressive post-and-lintel building of all time is the Parthenon in Athens, which is in the Doric style (**409**). We have already studied the Parthenon as a religious and political structure (Chapter 3, p. 67); here we will focus on its construction. Had the Parthenon been simply an academic exercise in placing horizontal members atop vertical supports—a kind of Classical Age prefabrication—it never would have been so admired for its architectural purity. What sets it apart are the many subtle refinements in its structure.

To begin with, the Parthenon has a particularly satisfying proportion of width to length to height—many would say a "perfect" proportion. Legend claims there are no straight lines in the Parthenon, but this is probably a roman-

409. Ictinus and Callicrates. Parthenon, Athens. 447–432 B.C. Marble.

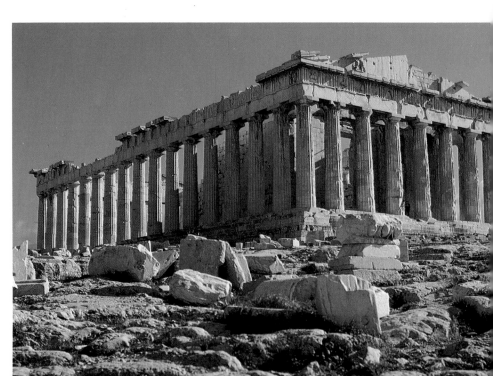

tic exaggeration. Many of the lines we expect to be straight, however, are not. What the builders did was adjust the physical lines of the temple so they would appear to be straight visually. For example, tall columns that are absolutely straight may appear to bend inward at the center, so the columns on the Parthenon have been given a slight bulge, known as *entasis,* to compensate for the visual effect. Also, a long horizontal, such as the Parthenon's porch steps, may appear to sag in the middle; to correct for this optical illusion, the level has been adjusted very slightly, rising about 2½ inches to form an arc higher at the center. A large building rising perpendicular to the ground may loom over the visitor and seem to be leaning forward; to avoid this impression, the architects of the Parthenon tilted the whole facade back very slightly. Corner columns, seen against the sky, would have seemed thinner than inside columns, which have the building as a backdrop; therefore, the outside columns were made slightly heavier than all the others. These are only a few of the structural refinements that resulted in a beautiful temple.

Because the Parthenon looks so visually perfect, these optical corrections are not noticeable to the casual viewer. Precise measurements have revealed the secrets of the Parthenon's majesty. The point is, post-and-lintel construction, which at first appears to be so rudimentary, can embody the most sublime forms ever conceived by an architect's mind.

People often assume the Parthenon is a ruin simply because it is old, but this is far from true. Not only is post-and-lintel construction highly stable, but the builders who took such trouble about visual details were equally careful about structural soundness. In fact, were it not for an unfortunate incident in the 17th century, the Parthenon would stand today much as it did twenty-four hundred years ago. In 1687 the Turks, who then controlled Athens and were at war with the Venetians, used the Parthenon as an ammunition dump. The Venetians laid siege to the city, a well-placed bullet ignited the ammunition, and the Parthenon blew up. No structural system yet devised can withstand the tragic consequences of conflict between nations.

The post-and-lintel system, then, offers potential for both structural soundness and grandeur. When applied to wood or stone, however, it leaves one problem unsolved, and that is the spanning of relatively large open spaces. The first attempt at solving this problem was the invention of the arch.

ROUND ARCH AND VAULT

Although the round arch was used by the ancient peoples of Mesopotamia several centuries before the birth of Christ (**456**), it was most fully developed by the Romans, who perfected the form in the 2nd century B.C. To get a sense of how the arch works, we might go back to the analogy of the body. Imagine that, instead of lying flat on your back, you are bent over forward into a curve, and again you will be lifted into the air. One person will support your hands, another your feet. As long as your body follows the proper arc—that is, your two supporters stand the correct distance apart—you can maintain the pose for some time. If they stand too close together, you start to topple first one way and then the other; if they move too far apart, you have insufficient support in the middle and plunge to the floor. An arch incorporates more complex forces of *tension* (pulling apart) and *compression* (pushing together), but the general idea is the same.

The arch has many virtues. In addition to being an attractive form, it enables the architect to open up fairly large spaces in a wall without risking the building's structural soundness. These spaces admit light, reduce the weight of the walls, and decrease the amount of material needed. As utilized by the Romans, the arch is a perfect semicircle, although it may seem elongated if it rests on columns. It is constructed from wedge-shaped pieces of stone that meet at an angle always perpendicular to the curve of the arch. Because of tensions and compressions inherent in the form, the arch is stable only when it is complete, when the topmost stone, the *keystone,* has been set in place. For this reason an arch under construction must be supported from below, usually by a wooden framework.

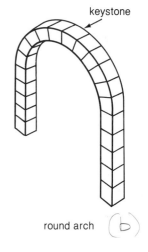

keystone

round arch (b)

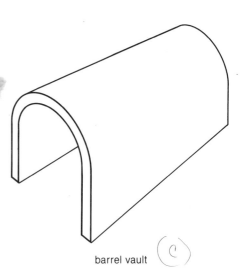

barrel vault (c)

410. Pont du Gard, Nîmes, France. A.D. early 1st century. Length 902′.

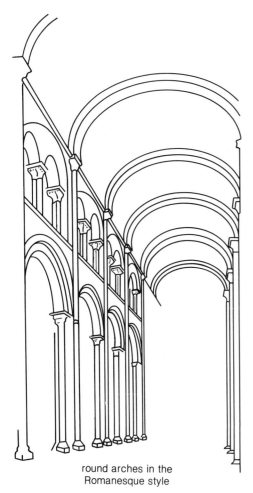

round arches in the
Romanesque style

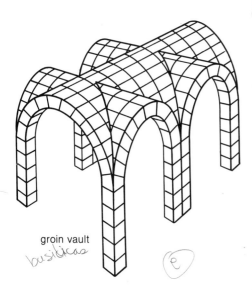

groin vault
basilicas

Among the most elegant and enduring of Roman structures based on the arch is the Pont du Gard at Nîmes, France (**410**), built in A.D. 15 when the empire was nearing its farthest expansion through Europe. At this time industry, commerce, and agriculture were at their peak. Roman engineering was applied to an ambitious system of public-works projects, not just in Italy but in the outlying areas as well. The Pont du Gard functioned as an aqueduct, a structure meant to transport water, and its lower level served as a footbridge across the river. That it stands today virtually intact after nearly two thousand years (and is crossed by cyclists on the route of the famous Tour de France bicycle race), testifies to the Romans' brilliant engineering skills. Visually, the Pont du Gard exemplifies the best qualities of arch construction. Solid and heavy, obviously durable, it is nevertheless shot through with open spaces that make it seem light and its weight-bearing capabilities effortless.

When the arch is extended in depth—when it is, in reality, many arches placed flush one behind the other—the result is called a *barrel vault* or *tunnel vault*. This vault construction makes it possible to create large interior spaces. The Romans made great use of the barrel vault, but for its finest expression we look many hundreds of years later, to the cathedrals of the Middle Ages.

The church of St. Sernin (**411**), in the southern French city of Toulouse, is an example of the style prevalent throughout Western Europe from about 1050 to 1200—a style known as *Romanesque*. Romanesque builders adopted the old Roman forms of round arch and barrel vault so as to add height to their churches. Until this period most churches had beamed wooden roofs, which not only posed a threat of fire but also limited the height to which architects could aspire. With the stone barrel vault, they could achieve the soaring, majestic space we see in the *nave* (the long central area) of St. Sernin. Round arches set on half columns punctuate the ceiling, leading one's eye forward to the altar.

On the side aisles of St. Sernin (not visible in the photograph) the builders employed a series of *groin vaults*. A groin vault results when two vaults are crossed at right angles to each other, thus directing the weights and stresses down into the four corners. By dividing up a space into square segments known as *bays*, each of which contains one groin vault, the architects could cover a long span safely and economically. The arrangement of bays also creates a satisfying rhythmic pattern down the length of the structure.

POINTED ARCH AND VAULT

While the round arch and vault of the Romanesque era solved many problems and made many things possible, they nevertheless had certain drawbacks. For one thing, a round arch, to be stable, must be a semicircle; therefore, the height of

the arch is limited by its width. Two other difficulties were weight and darkness. Barrel vaults are both literally and visually heavy, calling for huge masses of stone to maintain their structural stability. Also, the builders who constructed them dared not make light-admitting openings in or around them, for fear the arches and vaults would collapse, and so the interiors of Romanesque buildings tend to be dark. The *Gothic* period in Europe, which followed the Romanesque, solved these problems with the pointed arch.

The pointed arch, while seemingly not very different from the round one, offers many advantages. Because the sides arc up to a point, weight is channeled down to the ground at a steeper angle, and therefore the arch can be taller. The vault constructed from such an arch also can be much taller than a barrel vault. Architects of the Gothic period found they did not need heavy masses of material throughout the curve of the vault, as long as the major points of intersection were reinforced. These reinforcements, called *ribs,* are visible in the nave ceiling of Chartres Cathedral (**412**; see also **74**). The lighter vault also enabled builders to introduce stained-glass windows in the stone walls, and so the Gothic church generally is much brighter inside than its Romanesque predecessor.

Gothic builders also provided for structural reinforcement outside the churches. Given that the walls were relatively thin, and that arches tend to create a sideways or lateral thrust, there remained the danger that a large cathedral could "lean" outward and collapse. To prevent this, architects developed a system of exterior masonry columns or *piers,* joined to the body of the church by *flying buttresses,* or arched supports. In effect, the flying buttresses (visible in our exterior view of Chartres Cathedral, **74**) "hold in" the walls of the church. As the style progressed, they were increasingly carved and embellished to become decorative outside features of the buildings.

THE DOME

A dome is an architectural structure generally in the shape of a hemisphere, or half globe. One customary definition of the dome is an arch rotated 360 degrees on its axis, and this is really more accurate, because, for example, the dome

left: **411.** Nave, Cathedral of St. Sernin, Toulouse, France. c. 1080–1120.

right: **412.** Nave, Chartres Cathedral, France. c. 1194–1260.

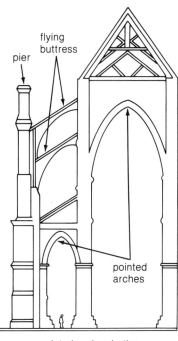

flying buttress

pier

pointed arches

pointed arches in the Gothic style

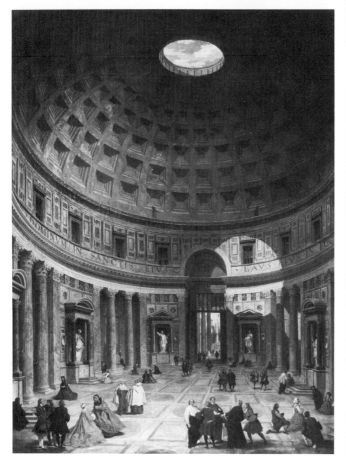

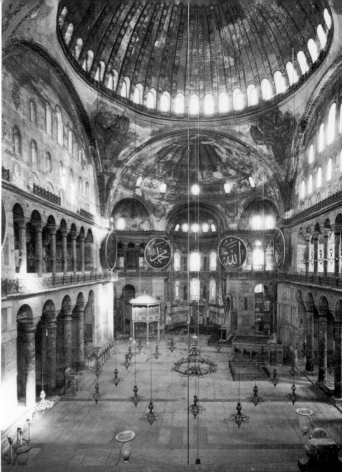

left: **413.** Giovanni Paolo Panini.
Interior of the Pantheon.
c. 1740. Oil on canvas,
$4'2\frac{1}{2}'' \times 3'3''$.
National Gallery of Art,
Washington, D.C.
(Samuel H. Kress Collection, 1939).

right: **414.** Interior,
Hagia Sophia,
Istanbul. 532–37.
Height of dome 183'.

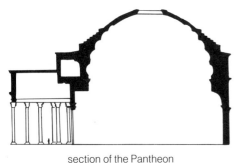

section of the Pantheon

based on a pointed arch will be pointed at the top, not perfectly hemispherical. The stresses in a dome are much like those of an arch, except that they are spread in a circle around the dome's perimeter. Unless the dome is buttressed—supported from the outside—from all sides, there is a tendency for it to "explode"—for the stones to pop outward in all directions.

Like so many other architectural structures, the dome was perfected under the incomparable engineering genius of the Romans, and one of the finest domed buildings ever erected dates from the early 2nd century. It is called the Pantheon, which means a temple dedicated to "all the gods"—or, at least, all the gods who were venerated in ancient Rome. We reproduce here an 18th-century painting of the interior (**413**) because the circular building is so vast that it is impossible to find a camera angle to convey adequately its shape and scale.

As seen from the inside, the Pantheon has a perfect hemispherical dome soaring 142 feet above the floor, resting upon a cylinder almost exactly the same in diameter—140 feet. At the very top of the dome is an opening 29 feet in diameter called an *oculus*, or eye, thought to be symbolic of the "eye of Heaven." This opening provides the sole (and plentiful) illumination for the building. In its conception, then, the Pantheon is amazingly simple—equal in height and width, symmetrical in its structure, round form set upon round form. Yet because of its scale and its classic proportions, the effect is overwhelming. The fact that the Romans, in ancient times, could enclose such a huge space without interior supports today seems extraordinary.

When an architect wishes to set a round dome atop a square building, as is very often the case, the structural problems become more complex. Some transitional device is required between the circle (at the dome's base) and the square (of the building's top), preferably one that bolsters the dome. An elegant solution can be found in Hagia Sophia (the Church of the Holy Wisdom) in Istanbul (**414**). Hagia Sophia was built as a Christian church during the 6th century, when Istanbul, then called Constantinople, was the capital of the great Byzantine Empire (p. 374). When the Turks conquered the city in the 15th century, Hagia Sophia became an Islamic mosque, and it is now preserved as a museum. In

sheer size and perfection of form it was the architectural triumph of its time and has seldom been matched since then.

The dome of Hagia Sophia rises 183 feet above the floor, with its weight carried to the ground by heavy stone piers—in this case, squared columns—at the four corners of the immense nave. Around the base of the dome is a row of closely spaced arched windows, which make the heavy dome seem to "float" upward. Each of the four sides of the building consists of a monumental round arch, and between the arches and the dome are curved triangular sections known as *pendentives*. It is the function of the pendentives to make a smooth transition between rectangle and dome.

Because domes have so much been a feature of public buildings, both religious and political, we may think of them as the capstones of "official" architecture. St. Peter's Basilica in Rome (**489**), the U.S. Capitol in Washington (**424**) and its many offshoots in the state capitals, the great cathedrals of London—all are monumental structures topped by imposing domes. One of the loveliest of all domed buildings, however, originally was constructed for a private purpose, and despite its size it has a more intimate quality. This is the famous Taj Mahal in Agra, India.

The Taj Mahal (**415**) was built in the mid-17th century by the Moslem emperor of India, Shah Jahan, as a tomb for his beloved wife, Arjummand Banu, who died at the age of thirty-nine after having borne fourteen children. Although the Taj is nearly as large as Hagia Sophia and possessed of a dome rising some 30 feet higher, it seems comparatively fragile and weightless. Nearly all its exterior lines reach upward, from the graceful pointed arches, to the pointed dome, to the four slender towers—minarets—poised at the outside corners. The Taj Mahal, constructed entirely of pure white marble, appears almost as a shimmering mirage, which has come to rest for a moment beside the peaceful reflecting pool but may float away at any time.

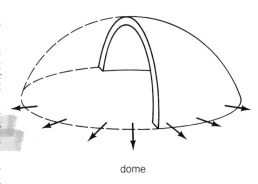

dome

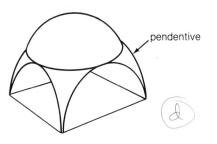

pendentive

dome with pendentives

CAST-IRON CONSTRUCTION

With the perfection of the post-and-lintel, the arch, and the dome, construction in stone and brick had gone just about as far as it could go. Not until the introduction of a new building material did the next major breakthrough in structural systems take place. Iron had been known for thousands of years and had been used for tools and objects of all kinds, but only in the 19th century did architects realize that its great strength offered promise for structural support. This principle was demonstrated brilliantly in a project that few contemporary observers took seriously.

In 1851 the city of London was planning a great exhibition, under the sponsorship of Prince Albert, husband of Queen Victoria. The challenge was to house under one roof the "Works of Industry of All Nations," and the commission for erecting a suitable structure fell to Joseph Paxton, a designer of greenhouses.

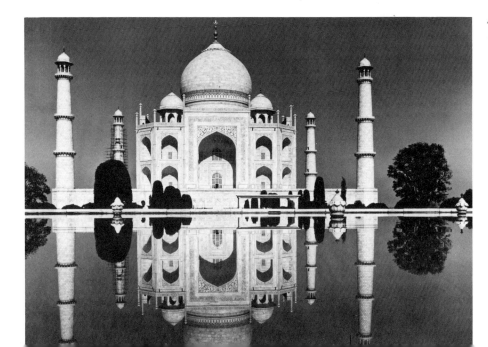

415. Taj Mahal, Agra, India. 1632–53. White marble.

331

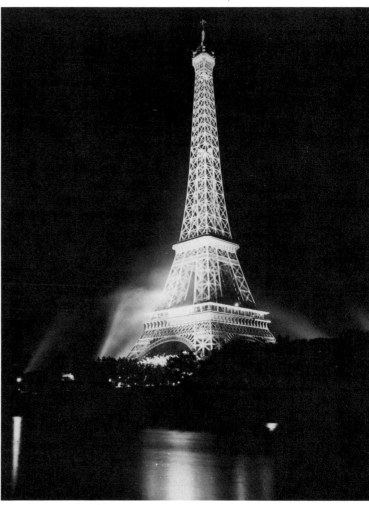

Paxton raised in Hyde Park a wondrous building framed in cast iron and sheathed in glass—probably the first modern skeleton-and-skin construction ever designed (**416**). The Crystal Palace, as Paxton's creation came to be known, covered more than 17 acres and reached a height of 108 feet. Because of an ingenious system of prefabrication, the whole was erected in just sixteen weeks.

Visitors to the exhibition considered the Crystal Palace a curiosity—a marvelous one, to be sure, but still an oddity outside the realm of architecture. They could not have foreseen that Paxton's design, solid iron framework clothed in a glass skin, would pave the way for 20th-century architecture. In fact, Paxton had taken a giant step in demonstrating that as long as a building's skeleton held firm its skin could be light and non-load-bearing. Several intermediary steps would be required before this principle could be translated into today's architecture.

Another bold experiment in iron construction came a few decades later just across the English Channel, in France, and involved a plan that many considered to be foolhardy, if not downright insane. Gustave Eiffel, a French engineer, proposed to build in the center of Paris a skeleton iron tower, nearly a thousand feet tall, to act as a centerpiece for the Paris World's Fair of 1889. Nothing of the sort had ever been suggested, much less built. In spite of loud protests, the Eiffel Tower (**417**) was constructed, at a cost of about a million dollars—an unheard-of sum for those times. It rises on four arched columns, which curve inward until they meet in a single tower thrusting up boldly above the cityscape of Paris. The tower's importance for the future of architecture rests on the fact that it *was* a skeleton that proudly showed itself without benefit of any cosmetic embellishment. No marble, no glass, no tiles, no skin of any kind—just the clean lines drawn in an industrial-age product. Two concepts emerged from this daring

construction. First, metal in and of itself can make beautiful architecture. Second, metal can provide a solid framework for a very large structure, self-sustaining and permanent. Today the Eiffel Tower is the ultimate symbol of Paris, and no tourist would pass up a visit. From folly to landmark in less than a century—such is the course of innovative architecture.

Iron for structural members was not the only breakthrough of the mid-19th century. The Industrial Revolution also introduced a construction material that was much humbler but equally significant in its implications for architecture: the nail. And for want of that simple little nail, most of the houses we live in today could not have been built.

BALLOON-FRAME CONSTRUCTION

So far in this chapter the illustrations have concentrated on grand and public buildings—churches, temples, monuments. These are the glories of architecture, the buildings we admire and travel great distances to see. We should not forget, however, that the overwhelming majority of structures in the world have been houses for people to live in, or what is called *domestic* architecture.

Until the mid-19th century houses were of shell construction. They were made of brick or stone (and, in warmer climates, of such materials as reeds and bamboo) with load-bearing construction, or else they were post-and-lintel structures in which heavy timbers were assembled by complicated notching and joinery, sometimes with wooden pegs. Nails, if any, had to be fabricated by hand and were very expensive.

About 1833, in Chicago, the technique of *balloon-frame* construction was introduced. Balloon-frame construction is a true skeleton-and-skin method. It developed from two innovations: improved methods for milling lumber and mass-produced nails. In this system, the builder first erects a framework or skeleton by nailing together sturdy but lightweight boards (the familiar 2-by-4 "stud"), then adding a roof and sheathing the walls in clapboard, shingles, stucco, or whatever the homeowner wishes. Glass for windows can be used lavishly, as long as it does not interrupt the underlying wood structure, since the exterior sheathing plays little part in holding the building together.

When houses of this type were introduced, the term "balloon framing" was meant to be sarcastic. Skeptics thought the buildings would soon fall down, or burst just like balloons. But some of the earliest balloon-frame houses stand firm today, and this method is still the most popular for new house construction in Western countries.

The balloon frame, of course, has its limitations. Wood beams 2 by 4 inches thick cannot support a skyscraper ten or fifty stories high, and that was the very sort of building architects had begun to dream of late in the 19th century. For such soaring ambitions, a new material was needed, and it was found. The material was steel.

balloon-frame construction

STEEL-FRAME CONSTRUCTION

Although multistory buildings have been with us since the Roman Empire, the development of the skyscraper, as we know it, required two late-19th-century innovations: the elevator and steel-frame construction. Steel-frame construction, like balloon framing, is a true skeleton-and-skin arrangement. Rather than piling floor upon floor, with each of the lower stories supporting those above it, the builders first erect a steel "cage" that is capable of sustaining the entire weight of the building, and then apply a skin of some other material. But if one is going to erect a building of great height, one cannot expect people to walk up ten or more flights of stairs to get to the top floors. Hence, the elevator made its appearance.

What many consider to be the first genuinely modern building was designed by Louis Sullivan and built between 1890 and 1891 in St. Louis. Known

steel-frame construction

left: **418.** Louis Sullivan. Wainwright Building, Saint Louis. 1890–91.

right: **419.** Gordon Bunshaft of Skidmore, Owings, and Merrill. Lever House, New York. 1952.

as the Wainwright Building (**418**), it employed a steel framework sheathed in masonry. Other architects had experimented with steel support but had carefully covered their structures in heavy stone so as to reflect traditional architectural forms and make the construction seem reliably sturdy. Centuries of precedent had prepared the public to expect bigness to go hand in hand with heaviness. Sullivan broke new ground by making his sheathing light, letting the skin of his building echo, even celebrate, the steel framing underneath. Regular bays of windows on the seven office floors are separated by strong vertical lines, and the four corners of the building are emphasized by vertical piers. The Wainwright Building's message is subtle but definite: the nation had stopped growing outward and started growing *up*.

Sullivan's design looks forward to the 20th century, but it nevertheless clings to certain architectural details rooted in classical history, most notably the heavy *cornice*—the projecting roof ornament—that terminates upward movement at the top of the building. In a very few decades even these backward glances into the architectural past would become rare.

Toward the middle of the 20th century skyscrapers began to take over the downtown areas of major cities, and city planners had to grapple with unprecedented problems. How high is too high? How much air space should a building consume? What provision, if any, should be made to prevent tall buildings from completely blocking out the sunlight from the streets below? In New York, and certain other cities ordinances were passed that resulted in a number of lookalike and architecturally undistinguished buildings. The laws required that, if a building filled the ground space of a city block right up to the sidewalk, it could rise for only a certain number of feet or stories before being "stepped back," or narrowed; then it could rise for only a specified number of additional feet before being stepped back again. The resultant structures came to be known as "wedding-cake" buildings. A few architects, however, found more creative ways of meeting the air space requirement; those working in the style known as *International* (in fact, European) designed some of the most admired American skyscrapers, such as Lever House.

Lever House in New York (**419**), designed by the architectural firm of Skidmore, Owings, and Merrill and built in 1952, was heralded as as breath of fresh

air in the smog of look-alike structures. Its sleek understated form was widely copied but never equaled. Lever House might be compared to two shimmering glass dominoes, one resting horizontally on freestanding supports, the other balanced upright and off-center on the first. At a time when most architects of office buildings strove to fill every square inch of air space to which they were entitled—both vertically and horizontally—the elegant Lever House drew back and raised its slender rectangle aloof from its neighbors, surrounded by free space. Even its base does not rest on the ground but rides on thin supports to allow for open plazas and passageways beneath the building. Practically no other system of construction except steel frame could have made possible this graceful form.

420. Verrazano-Narrows Bridge, New York. 1964.
Ammann and Whitney, consulting engineers;
John B. Peterkin, Aymar Embury II, and Edward D. Stone, consulting architects.

SUSPENSION

Also made feasible by steel, suspension is the structural method we associate primarily with bridges, although it has been employed for some buildings as well. The concept of suspension was developed for bridges late in the 19th century. In essence, the weight of the structure is suspended from steel cables supported on vertical pylons driven into the ground. A long bridge, such as the Verrazano-Narrows Bridge in New York (**420**), may have only two sets of pylons planted in the riverbed, but the steel cables suspended under tension from their towers are strong enough to support a span between them more than four-fifths of a mile long. Suspension structures are among the most graceful in architecture, involving as they do long sweeping curves and the slender lines of the cables. A bridge in particular, suspended over water, may seem almost weightless when viewed from a distance, and there is a sense of flexibility—both visual and physical, because the roadbed may rise and fall several feet depending on winds and passing traffic.

TRUSS CONSTRUCTION

By contrast, the truss is one of the most rigid structural systems in architecture. It is based on the triangle, and it derives its stability from the fact that the tri-

trusses

angle, unlike other geometric shapes, cannot be bent out of shape without changing the length of one of its legs. The truss, therefore, can be used to span horizontal distances much in the way post-and-lintel is employed, but with far less support from underneath.

Although truss construction has been known since the Middle Ages, its principles have been fully developed only in the 20th century. It is most often associated with wood, since the triangular arrangement gives that inexpensive material greater strength than it otherwise would have, but there are also trusses in iron and steel. In the Federal Correctional Institution at Bastrop, Texas (**421**), thick wood trusses are part of a design that constitutes a startling departure from our usual image of prison architecture. The trusses support the roof and are angled so that their long sides provide a surface on which to rest solar energy collectors. Beyond this, the repeated trusses set up a rhythmic pattern that unifies the entire complex of the buildings.

REINFORCED CONCRETE CONSTRUCTION

Concrete is an old material that was known and used by the Romans. A mixture of cement, gravel, and water, concrete can be poured, will assume the shape of any mold, and then will set to hardness. Its major problem is that it tends to be brittle and has low tensile strength. This problem is often observed in the thin concrete slabs used for sidewalks and patios, which may crack and split apart as a result of weight and weather. Late in the 19th century, however, a method was developed for reinforcing concrete forms by imbedding iron rods inside the concrete before it hardened. The iron contributes tensile strength, while the concrete provides shape and surface. In the 20th century reinforced concrete, also known as *ferroconcrete*, has been used in a wide variety of structures, often in those with

left: 421. CRS Sirrine. Federal Correctional Institution, Bastrop, Tex. Completed 1979.

right: 422. Joern Utzon. Sydney Opera House, Australia. 1959–72. Reinforced concrete, height of highest shell 200'.

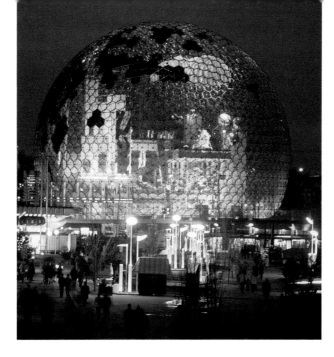

423. R. Buckminster Fuller. U.S. Pavilion, Expo 67, Montreal. Geodesic dome, diameter 250'.

free-form, organic shapes. While it may seem at first to be a skeleton-and-skin construction, ferroconcrete actually works more like a shell, because the iron rods (or sometimes a steel mesh) and concrete are bonded permanently and can form structures that are self-sustaining, even when very thin.

A special kind of ferroconcrete construction—precast reinforced sections— was used to create the soaring shell-like forms of the famous Sydney Opera House in Australia (**422**). The Opera House, which is really an all-around entertainment complex, is almost as famous for its construction difficulties as it is for its extraordinary design. So daring was its concept that the necessary technology virtually had to be invented as the project went along. Planned as a symbol of the great port city in whose harbor it stands, the Opera House gives the impression of a wonderful clipper ship at full sail. Three sets of pointed shells, oriented in different directions, turn the building into a giant sculpture in which walls and roof are one. Reinforced concrete is the sort of material that allows the builder to experiment and try new techniques, that allows the architect to dream impossible dreams.

reinforced concrete

GEODESIC DOMES

Of all the structural systems, probably the only one that can be attributed to a single individual is the geodesic dome, which was developed by the American architectural engineer R. Buckminster Fuller. Fuller's dome (**423**) is essentially a bubble, formed by a network of metal rods arranged in triangles and further organized into tetrahedrons. (A tetrahedron is a three-dimensional geometric figure having four faces.) This basic metal framework can be sheathed in any of several lightweight materials, including wood, glass, plastic, even paper.

The geodesic dome offers a combination of advantages never before available in architecture. Although very light in weight in relation to size, it is amazingly strong, because its structure rests on a mathematically sophisticated use of the triangle. It requires no interior support, and so all the space encompassed by the dome can be used with total freedom. The geodesic dome can be built in any size. In theory, at least, a structurally sound geodesic dome 2 miles across could be built, although nothing of this scope has ever been attempted. Perhaps most important for modern building techniques, Fuller's dome is based on a modular system of construction. Individual segments—modules—can be prefabricated to allow for extremely quick assembly of even a large dome. And finally, because of the flexibility in choice of sheathing materials, there are virtually endless options for climate and light control.

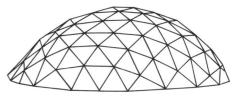

geodesic dome

R. Buckminster Fuller
1895–1983

The term "eccentric genius" might have been coined to describe the 20th-century architect/engineer/inventor/philosopher R. Buckminster Fuller, known to his friends as "Bucky." Whether history will characterize him as more of an eccentric or more of a genius remains to be seen.

Born in a suburb of Boston, Fuller was the black sheep of a distinguished New England family. He attended Harvard University for a short time, but, as he explained afterward, "I cut classes and went out quite deliberately to get into trouble, and so naturally I got kicked out." There followed a variety of odd jobs and a stint in the Navy. After he married Anne Hewlett in 1917, Fuller went into partnership with his father-in-law, an architect, in a building-block company. The year 1922 marked a crisis in his life. The business did not prosper, and the Fullers' daughter Alexandra died on her fourth birthday. Fuller sank into a terrible depression—working all day and drinking all night. At the lowest ebb he seriously considered suicide. Then in 1927, for some reason, he reached a critical turning point. One night, he later recalled, he found himself saying, "You do not have the right to eliminate yourself. You do not belong to you. You belong to the universe." From that moment he dedicated his life to discovering "the principles operative in the universe and [turning] them over to my fellow men."

The theory Fuller eventually formulated was both simple and extraordinarily grandiose: any problem in the world can be solved by design and technology. He believed wholeheartedly that "there is absolutely nothing that cannot be done." Fuller liked to talk about our planet as "Spaceship Earth" and felt that it should be designed as efficiently as any space vehicle; one of his twenty-five books is entitled *Operating Manual for Spaceship Earth.*

The first practical application of Fuller's theories was the Dymaxion House, patented in 1927. This experimental dwelling had glass walls, rooms hung from a central mast, and such energy-efficient devices as an automatic vacuum-cleaning system. Next came the Dymaxion automobile, a three-wheeled vehicle capable of speeds up to 120 m.p.h. Neither invention achieved any popular success, but in 1947 Fuller patented the design for which he is most famous—the geodesic dome. Based on a system of triangles arranged into four-planed figures, or tetrahedrons, the geodesic dome could enclose a huge amount of space without interior support and allow for total climatic control. Thousands of Fuller's domes have been built around the world. One of his most ambitious projects, however—the complete enclosure of midtown Manhattan in a dome 3 miles across—was (understandably) considered impractical.

Fuller remained active until about a month before his death, at the age of eighty-seven. He traveled widely, lecturing about his theories, and particularly enjoyed speaking to college audiences, among whom he attracted something of a cult following. Education was one of his many interests, for, as he explained: "Every child is born a genius. It is my conviction, from having watched a great many babies grow up, that all of humanity is born a genius and then becomes degeniused very rapidly by unfavorable circumstances and by the frustration of all their extraordinary built-in capabilities."[1]

Photograph of R. Buckminster Fuller.

Fuller patented the geodesic dome in 1947, but it was not until twenty years later, when his design served as the U.S. Pavilion at Montreal's World's Fair, that the public's attention was awakened to its possibilities. The dome at Expo 67, shown here, amazed the architectural world and fairgoers alike. It was 250 feet in diameter (about the size of a football field rounded off) and, being sheathed in translucent material, lighted up the sky at night like a giant spaceship set down on earth.

After Expo 67 some predicted that before long all houses and public buildings would be geodesic domes. This dream has faded considerably, but Fuller's dome has proved exceptionally well suited for government and scientific operations in arctic climates. To build a habitable structure in the freezing wastes of Antarctica, for example, one needs a lightweight material that can be shipped and assembled easily, great strength to withstand below freezing temperatures and high winds, and control of the interior environment. The geodesic dome meets all these requirements.

In this brief survey of the major structural systems we have seen that the form of architecture and its method of construction are largely determined by the materials available. Wood readily lends itself to post-and-lintel construction, balloon-frame construction, or the truss; stone works for post-and-lintel also, as well as for the arch and dome; metal allows for steel-frame construction, suspension, or reinforced concrete; and so on. But there is another factor—often a more important one—that affects the shape of architecture, and that is the purpose a building will serve. For the rest of this chapter we will look at some of the possibilities.

Purposes of Architecture

Architecture throughout the ages has been enormously diverse, but nearly every structure fits into one of just a few major categories: government buildings; other public buildings, such as libraries or museums; commercial buildings, including offices, banks, and shops; buildings for transportation—airline terminals and train stations, for example; religious buildings; and, of course, residences. In other words, nearly every structure has been designed to serve a specific purpose.

This section of the chapter will consider four types of structures—the government building, the museum, the office building, and the house—and give three examples of each. The examples are not meant to cover the entire range of possibilities for any given architectural purpose; that would be impossible in a book many times this size. Rather, they have been chosen because they provide interesting comparisons with one another, and because they reveal how architects have attempted to serve the purposes at hand in different times, in different places.

THREE GOVERNMENT BUILDINGS

The function of government is ruling, managing, controlling, protecting the people it governs. In order to do so it must establish and maintain its legitimacy. A government that was not taken seriously by those it governs would have difficulty sustaining itself. For this reason most governments throughout history have taken pains to create outward symbols of their legitimacy, and some of the most powerful of those symbols have been in the form of official architecture. Anyone who has visited the United States Capitol building in Washington will understand this (**424**). Its architecture states emphatically: *Here* is something of stability and order. *Here* is a foundation on which a nation stands. As discussed in Chapter 1 (p. 18), President Abraham Lincoln, during whose administration the Capitol was finished, was fully aware of the symbolic role played by government buildings.

424. Thomas Ustick Walter. U.S. Capitol, Washington, D.C. 1865.

425. Benjamin H. Latrobe. Corncob capital, U.S. Capitol, Washington, D.C. c. 1808.

The original Capitol building was begun in 1793, a mere four years after the new government of the United States had been established, and George Washington himself laid the cornerstone. After many embellishments, repairs (following a severe fire in the War of 1812), and additions, it assumed in 1865 the form it has now (**424**). It is easy to look back and understand why the framers of this newly independent nation would want an impressive building. Just free from Britain, just victorious in war, just come from formulating an innovative method of government—the founders celebrated their achievements in marble and stone and classical architecture. Their choice was a structure that combines the best of Greek and Roman architecture.

One of the early architects of the Capitol, Benjamin Latrobe, even designed an American "classical" column for the inside of the building (**425**). Based on the ancient Greeks' Corinthian style (**408**), the column featured corncobs and other plants native to the Americas. The Greeks had their Orders; the architects of our new nation wanted an American Order—both an architectural Order and an ordered government.

Even today, accustomed as we are to enormous sports arenas and the like, we find the Capitol awe-inspiring. To enter one climbs a steep flight of marble stairs and passes through a formal Greek-style porch, continually aware of the immense building flanking out in both directions. Above the whole is the dome, 268 feet high, circled with columns and arches, crowned by a monumental statue representing Freedom. Inside the building, under the dome, those with a taste for history may feel brushed by the ghosts of Washington, Adams, Jefferson, Madison—the nation's past standing by to oversee the nation's present. The best of government buildings, like the U.S. Capitol, represent the legitimacy and continuity of the government; at the same time they reach back to the past and forward to the future. The purpose of a government building, therefore, is not just to house the machinery of government but also to symbolize the solidity of government.

At roughly the same time that the U.S. Capitol was completed, the former mother country, across the Atlantic, also was building a structure to serve its legislative body. The Houses of Parliament in London (**426**), finished in 1860, aimed at quite a different architectural ideal. Washington's Capitol looked backward to Greece and Rome for legitimacy, but the Houses of Parliament sought another precedent on which to base England's national pride—the Gothic period of the Middle Ages. The Gothic style, as exemplified by Chartres Cathedral (**74,412**), had prevailed throughout Western Europe starting in the 13th century, but each nation, including England, claimed it as its own. For England, Gothic represented a Golden Age. In contrast to the stately, dignified U.S. Capitol, the Houses of Parliament, with its three Gothic-Revival towers of different heights

426. Charles Barry and A. W. N. Pugin. Houses of Parliament, London. 1840–60.

and shapes, seems to be all lightness and vertical thrust—more like a castle than a sober government building.

Government buildings today project many different kinds of images; they interpret in varied ways the purpose of housing the machinery of state. One of the more interesting of recent structures is the City Hall in Dallas, designed by I. M. Pei (**427**). Its sharp diagonal overhang of glass serves a functional purpose—to keep out the relentless sun of a Texas summer. Beyond this, however, the dramatic overhang may suggest either the protective roof of government or the looming presence of Government with a capital G, depending on your point of view. Government buildings nearly always evoke powerful associations.

THREE MUSEUMS

Art museums make an interesting study in architectural design, because they are works of art meant to display other works of art. How they go about fulfilling this purpose tells us much about the nature of architecture.

427. I. M. Pei. City Hall, Dallas. Completed 1977.

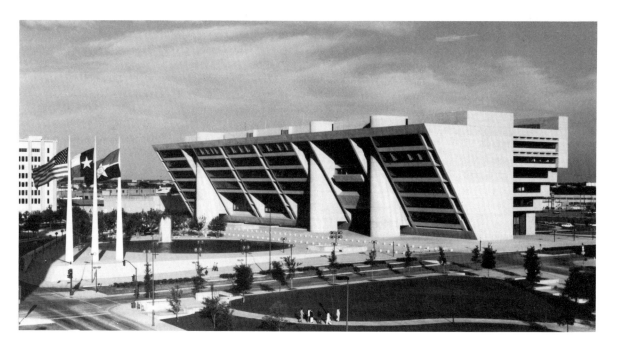

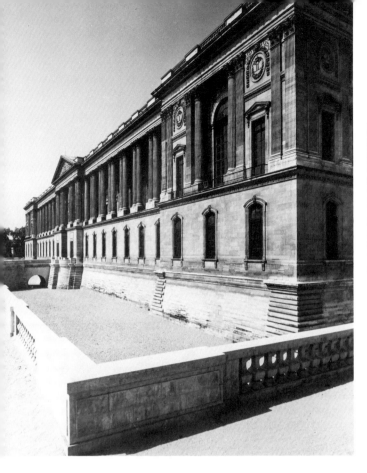

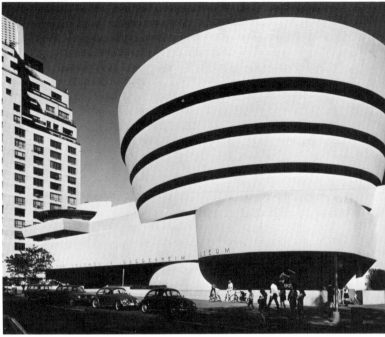

left: **428.** Claude Perrault. Louvre, east façade, Paris. 1667–70.

right: **429.** Frank Lloyd Wright. Solomon R. Guggenheim Museum, New York. 1957–59.

One of the largest museums in the world, and probably the most famous, is the Louvre in Paris (**428**). It houses the *Mona Lisa* (**486**)—the best-known painting in the Western world—and literally millions of other priceless works of art. The Louvre, however, was not originally designed to be a public museum. Built on the site of a 13th-century castle, the Louvre was erected as a royal palace in the 16th century, and it did not assume its present role as a museum until some two hundred years later, following the French Revolution. As a consequence, it does not always provide the ideal setting in which to view art. The long, classically decorated building, intended for the display of kingly power, has sapped the energy of many an art-loving tourist. Inside, the lighting and display surfaces are less than perfect, and the architecture is too grand to seem welcoming.

In company with the British Museum in London and the Metropolitan Museum of Art in New York, the Louvre exists as a kind of stately shrine to art—a huge, imposing, somewhat intimidating monument filled with treasures beyond compare. Crammed into its endless galleries are carloads of works, any one of which could be the star attraction at a decent small museum. Art lovers approach the Louvre with awe and reverence. So authoritative is its presence that any object contained within its walls takes on the automatic stamp of "greatness." This is due largely to the nature of the architecture; a building so utterly sure of itself could not accept anything but the most sublime of art.

Quite different standards may prevail when someone sets out to design a building specifically for the display of art. Such was the case with the Solomon R. Guggenheim Museum in New York (**141,429**). The commission fell to master architect Frank Lloyd Wright, who created a museum unlike any before. Wright's architecture in general is distinguished by its coherence of interior and exterior, and nowhere is this more apparent than in the Guggenheim Museum. The outside consists of a series of curves arranged into a cylinder, looking rather like a spinning top when set among the boxlike structures around it. The cylinder shape is duplicated inside the museum. There is a long, curving ramp that spirals from the top of the building to the ground level, so that visitors' usual practice is to take an elevator to the top and walk down the ramp.

When the Guggenheim Museum opened, it attracted much controversy. Some people said that Wright had pulled off a great joke on painters and sculptors, whom he did not much admire. It is true that Wright's building carefully *controls* the circumstances under which one may view art. The viewer cannot get very far away from any work of art because of the width of the ramp, and the ramp keeps one always slightly off-balance, going uphill or downhill. Also, the form of the museum itself is so intriguing that it competes with almost anything that is put inside it. But after some thirty years, most of the shouting has died down, and the Guggenheim has settled peaceably into the art community. It has a dynamic of its own, a tension of push and pull, that acts with, not against, the art it contains. And when the art it contains is as bold and assertive as Claes Oldenburg's *Knife Ship* (**370**), the competition between art and museum seems more like a friendly match of equals.

If the Louvre looks like a royal palace, and the Guggenheim looks like a spinning top, our third museum example looks like an unfinished building, or, as many have suggested, an oil refinery. Completed in 1977, the Georges Pompidou National Center for Art and Culture (**430**), sometimes called the "Beaubourg," shocked contemporary Parisians at least as much as the Eiffel Tower (**417**) shocked their great-grandparents nearly a century before, and for similar reasons. The Eiffel Tower proudly raised its iron skeleton to the skies without benefit of any decorative skin. The Pompidou Center wears its internal organs, so to speak, on the outside of the body. Structural members, heating ducts, plumbing conduits, elevators and escalators—all the necessary items we expect to be neatly hidden away within a building's core are boldly displayed on the outside and painted in bright colors. Paris had wanted a space-age structure to house its modern art, and Paris got what it wanted—and then some.

The Pompidou Center is not just a museum of art. It is an ongoing light-and-motion show (as the elevators and escalators move visibly outside), a library, a film studio, a theater and concert hall, a mecca for all the arts. Both physically and symbolically, the Pompidou Center is meant to seem "open"—that is, open to many different types of artistic expression, open to many different people who might want to participate. Whereas the Louvre stands as a monument to reverence for art, the Pompidou Center actively encourages one to *live* with art.

Three museums with three different points of view. Each reflects the time and place of its building, each creates a specific ambience for viewing art. Art lovers cannot help but respond intuitively to these individual citadels of art.

THREE OFFICE BUILDINGS

The architecture of commerce, like that of government, often has strong symbolic value. Its primary purpose is to house offices, but a secondary one may be to make a statement about the firm that owns the building. When a company decides to erect a new office building, its leaders give serious thought to the image

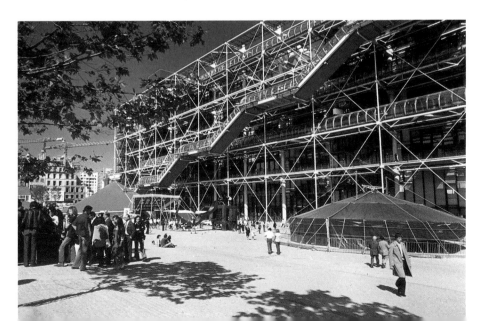

430. Renzo Piano and Richard Rogers. Georges Pompidou National Center for Art and Culture, Paris. Completed 1977.

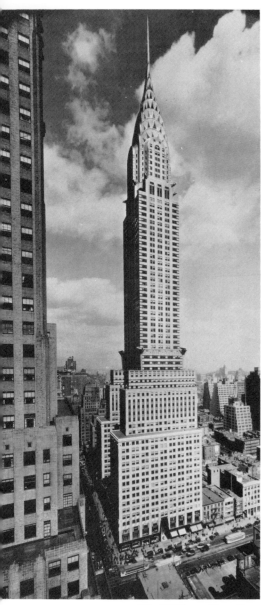

431. William Van Alen.
Chrysler Building, New York.
Completed 1930.

that will be projected by that building and lodged in the minds of the public. Unlike the government structure, however, the office building rarely seeks a model in traditional architecture, but rather attempts to convey the impression of dynamic modernism—of a company forging ahead to the future. The office building of the 20th-century has therefore tended to be a creature of fashion, taking its design from the trend of the times. Three examples spanning half a century will illustrate this.

The Chrysler Building in New York, indisputably the gem of early skyscrapers, was completed in 1930 and was the first office building to rise above 1,000 feet. Its slender, elegantly pointed spire (**431**) changed the skyline of New York dramatically and still remains distinctive, in spite of later, taller buildings around it. We might list three elements that contributed to this splendid building: the great success of the automobile industry, which enabled Walter Percy Chrysler to erect a monument to his name; the relative cheapness of fine building materials and labor; and the prevalence of the style known as Art Deco.

Art Deco, then at the height of fashion, was marked by geometric patterns and a rich display of surface decoration. (The term "deco" came from the Exposition des Arts Décoratifs, held in Paris in 1925, where the style first appeared as a significant force.) Art Deco was definitely a product of the machine age, for its favorite materials were chrome and steel and glass and aluminum—modern materials that glitter and sparkle, preferably in elaborate combinations to dazzle the eye. Its symbolism, indeed, is razzle-dazzle, and it celebrates the speed of the automobile and the airplane, people on the move. The top of the Chrysler Building is layered in an overlapping sunburst pattern pierced with triangular windows—a streamlined, geometric sculpture cutting through the sky. All throughout the building, inside and out, attention was lavished on decorative detail for even the most functional elements, such as the elevator cabs. When Art Deco passed out of fashion, much of the elaborate decoration of the Chrysler Building fell into disrepair, but it has recently been restored to its former splendor.

The patterned forms of Art Deco gave way in the 1940s to the pared-down, austere design aesthetic of the International Style. In a sense the roots of the International Style might be traced back to Louis Sullivan (**418**), who insisted that "form follows function." In other words, the form of a building or any other object should be expressive of what it is supposed to do, not overlaid with arbitrary decoration. This theme was taken up by two European architects, Le Corbusier and Ludwig Mies van der Rohe, and translated into a style that dominated American architecture through the 1970s. Mies van der Rohe added another catch phrase to the history of art when he made his often-quoted statement: "Less is more." By this he meant that architects (and other designers) must strip their forms to the barest essentials, the parts necessary to the work's function, and by so doing they would achieve a more honest, satisfying design.

As mentioned earlier, the International Style was introduced to the United States by such buildings as Lever House (**419**). Diagonally across the street from Lever House is a building many consider to be the quintessence of that style. The Seagram Building (**432**), designed by Mies van der Rohe and Philip Johnson, is almost the direct opposite of the Chrysler Building in its design aesthetic. A stark vertical slab resting on stilts, the Seagram Building rises abruptly from the base and terminates abruptly at the top, with no attempt at accent or decoration. Its form is the extended cube, and much of its visual appeal comes from the combination of bronze-colored steel and amber glass sheathing.

For more than twenty years after the Seagram Building was completed, through the 1970s, the International Style held sway as the most luxurious and sophisticated style for skyscraper architecture. Across the United States towers of steel and glass vied with other for height and simplicity of design. By about 1980 it became clear that some change was due, that the business firm of the 1980s and 1990s would be looking for an image quite different from "the old company that lived in a box." Architects too were ready for change, and from the evolving tastes of corporate client and architectural firm emerged a style that has been called "postmodern."

Postmodern architecture is practically everything the International style was not. It emphasizes curves and decorative details, not pure straight lines. It is

complex rather than simple, warm rather than cool. Its structures are understood gradually, through exploration and study from many angles, in contrast to the severe box of the International Style, which could be absorbed at a glance. Sometimes the postmodern building is even brightly colored. Several of these traits are evident in the new General Foods Corporation headquarters in Rye, New York completed in 1984 (**433**).

One need not be a student of architecture to see the most obvious characteristics that separate the General Foods headquarters from the Chrysler and Seagram buildings. The earlier buildings are skyscrapers; General Foods hugs the ground and spreads out horizontally. Chrysler and Seagram are "city" buildings, packed in among their neighbors. General Foods is set in a suburban location and meant to be accessible to the automobile. Another clear difference is the pattern of employee traffic mandated by the architecture. We imagine employees at Chrysler and Seagram being whisked up to their offices by high-speed elevators, then whisked down again at day's end. At General Foods, employees are encouraged to walk. There are bridges and passageways and even a large glass-enclosed garden atrium in the center of the building.

In its overall style the General Foods headquarters most resembles a very grand European country house dressed in modern materials, and this is the effect the architects (and the corporate client) were after. Chief architect Kevin Roche said of the building:

> I am very interested in the idea of the corporate headquarters as a house. The house analogy really has to do with the family—the idea being that any group of people who work together become a family that can be as important to the individual as the family he or she may belong to. A working group establishes relationships similar to those of a family.[2]

This notion of office building as house, as a home away from home, has rarely been recognized in architecture, but it fits well into the patterns of modern life. Most people today do, in fact, spend the greater part of their waking lives outside the traditional home. Roche's concept raises a number of interesting questions. If the office is a house, what is the place where one sleeps? Into which of them is one's self-image more closely tied—the daytime house or the nighttime house? Who decides on the image that is to be projected—the employer, the architect, or the individual? Historically, one's home, the place where a person slept and ate and experienced traditional family life, was the embodiment of self-image. We conclude this chapter, then, by looking at three houses—each personal, all different from one another.

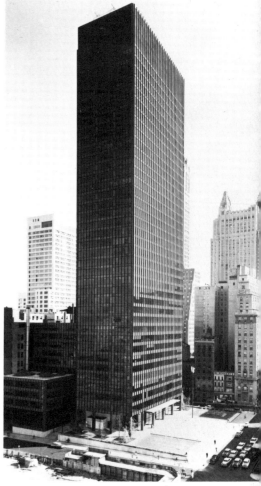

432. Ludwig Mies van der Rohe and Philip Johnson. Seagram Building, New York. 1958.

433. Kevin Roche John Dinkeloo and Associates. General Foods Corporation Headquarters, Rye, N.Y. 1983.

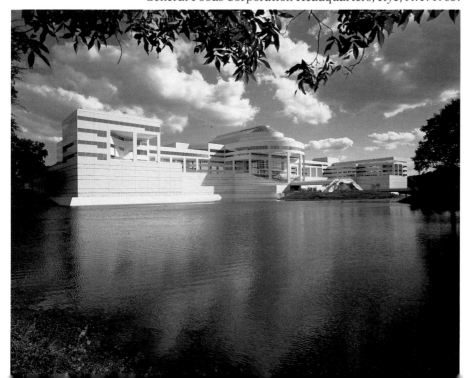

Frank Lloyd Wright
1867–1959

Many critics consider Frank Lloyd Wright to have been the greatest American architect of his time; certainly few would dispute the claim that he was the greatest designer of residential architecture. To see a Wright-designed building from the first decade of this century is to be shocked by how remarkably modern it seems.

Wright had very little formal education. He attended high school in Madison, Wisconsin, but apparently did not graduate. Later, he completed the equivalent of about one year's course work in civil engineering at the University of Wisconsin, while holding down a job as a draftsman. In 1887 he moved to Chicago and eventually found work in the architectural firm headed by Louis Sullivan, the great designer of early office buildings. Before long Wright had assumed responsibility for fulfilling most of the residential commissions that came into the company, and in 1893 he opened a firm of his own.

During the next two decades Wright refined the principles of the "Prairie houses" that are his trademark. Most are in the Midwest, and they echo that flat expanse of the Great Plains—predominantly horizontal, stretching out over considerable ground area but usually in one story. All expressed Wright's special interest in textures and materials; he liked whenever possible to build with materials native to the immediate surroundings, so that the houses blend with their environments. Interiors were designed on an open plan, with rooms flowing into one another (an unusual practice for the time), and the inside and outside of the house were also well integrated. These ingredients added up to what Wright referred to as "organic" architecture.

For most of his long life Wright's personal situation was far from tranquil. His parents seem to have had a bitterly unhappy marriage, and they divorced in 1885, when Wright was seventeen—an extraordinary event for that era. Wright himself had a troubled marital history. His first marriage ended when he eloped to Europe with Mamah Brothwick, the wife of a former client, leaving his own wife and six children behind. Five years later, back in Wisconsin, Brothwick was brutally murdered by a deranged servant while Wright was out of the house. This tragedy sent the architect off on a period of wandering through faraway parts of the world. A final marriage in the late 1920s lasted out his lifetime and appears to have given him his first real happiness.

Although he is best known for his domestic architecture, Wright also designed many large-scale commercial and public buildings, including the Solomon R. Guggenheim Museum in New York. His innovative design for the Imperial Hotel in Tokyo, planned to be stable in an area plagued by earthquakes, proved successful when the hotel survived without damage a devastating quake just a year after it was completed.

Wright was the author of several books on his theories of architecture, and always he focused on the organic nature of his work and on his own individuality. "Beautiful buildings are more than scientific. They are true organisms, spiritually conceived, works of art, using the best technology by inspiration rather than the idiosyncrasies of mere taste or any averaging by the committee mind."[3]

Photograph of Frank Lloyd Wright.

THREE HOUSES

Ever since humans came down from the trees or out of their caves, most of the architecture built has been in the form of houses. Needless to say, dwellings from different times and places have displayed enormous variety. Each of the three houses considered here reflects a special point of view about what it means to dwell within a building, what kind of roof one should have over one's head.

Some of the most interesting domestic architecture can be found in cities or regions that grew up very quickly, for one reason or another. This is true of Washington, D.C.—a "planned" city that was deliberately selected to be the nation's capital (**440**). It is true of Rotterdam, in Holland, which was heavily damaged in World War II but rebuilt afterward. And it is true of San Francisco.

In 1847 San Francisco, then known as Yerba Buena, had a population of about 800 people. A year later gold was discovered at Sutter's Mill, and the famous gold rush was on, drawing thousands of potential millionaires to the area. By 1850, when San Francisco was incorporated as a city and California was admitted to the Union as a state, the population had increased to more than 10,000. A tremendous building boom started, meeting the needs not only of gold prospectors but of more respectable citizens with pioneering spirit, and San Francisco grew up in the blink of an eye, or so it seemed.

During this period Queen Victoria sat on the throne of England, and the style known as "Victorian" or "high Gothic revival" dominated much of San Francisco's new architecture. Victorian architecture is not simple. A late-19th-century house in San Francisco (which survived the disastrous earthquake and fire of 1906) will demonstrate this (**434**). Every surface that might conceivably be decorated has been decorated. There are turrets and towers and columns and arches and gables and moldings and scrollwork. There are squares and triangles and cones and pyramids and cylinders. We might suspect that the person who designed this building threw open the whole architect's bag of possibilities and said, "Let's use one of everything." This is decidedly a city house, and a house planned to advertise the success of its owners. Mies van der Rohe may have thought that "less is more," but the prosperous citizens of Victorian San Francisco obviously felt that more is better.

A mere half-century later a kind of architecture was being built in the United States that almost seems to have emerged from a totally different culture, thousands of years and miles away. The architect was Frank Lloyd Wright, who designed the Guggenheim Museum (**141,429**). Wright's theory of domestic architecture was characterized by two related principles: first, a house should blend with its environment; second, the interior and exterior of a house should be visually and physically integrated.

The Kaufmann House in Bear Run, Pennsylvania, usually known as "Fallingwater," is considered to be Wright's masterpiece (**435**). Sited beside a water-

left: 434. Victorian Gothic house, San Francisco. Late 19th century.

right: 435. Frank Lloyd Wright. "Fallingwater" (Kaufmann House), Bear Run, Pa. 1936–37.

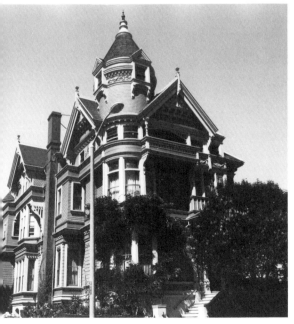

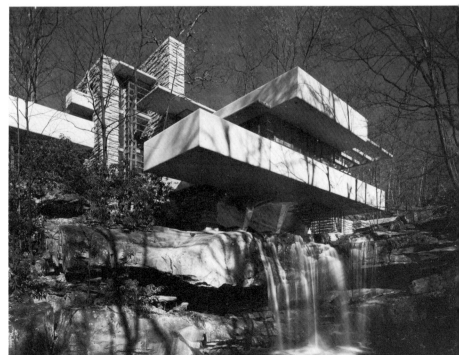

fall, it was designed to take best advantage of the surrounding landscape. Much of the house is built of stone, quarried from the immediate area, so that it seems to grow up from the site, rather than being set down upon it. One departure from this use of natural materials comes in the three terraces of reinforced concrete, two of them cantilevered over the waterfall. A *cantilever* is a horizontal form supported at only one end, jutting out into space at the other. Reinforced concrete, with its high tensile strength, makes such a construction possible, and Wright was among the first to exploit the cantilever for domestic architecture. Although not strictly "natural," the concrete cantilevers emphasize the waterfall and make it seem a natural extension of the house. Wright's architecture, then, blends with the natural surroundings and at the same time makes use of them.

Our third example would seem, at first glance, not to blend with anything whatsoever, but a longer view would show that the Norton house, designed by Frank Gehry (**436**) does blend—sort of—with its eclectic neighbors overlooking the beach in Venice, California. Venice is a community of millionaires and beachcombers, where typical vehicles are the Mercedes-Benz and the skateboard. Gehry's design seems to have borrowed a little from each extreme, but it is nonetheless a presence unto itself. This architect likes to take risks and he likes the concept of the "little jewel," the small one-family house. He happily indulges in postmodern design, and the Norton house displays a coat of many colors—blue and green and yellow tiles on the front, red and orange on the street side. Its most distinctive feature is the tiny suspended study, joined to the main house by a ladder staircase, patterned after a lifeguard station from the beach and offering superb views of the ocean. Gehry's architecture takes some getting used to; it is so fresh and innovative, but at the same time so very human. It is hard to imagine that anyone living in such a house could ever be bored.

Architecture touches us more directly than any of the other arts. As we move through our everyday lives, we are influenced continually by the structures we enter, leave, or pass by. A huge, forbidding structure makes us feel uncomfortable; a warm and welcoming one makes us feel secure. Moreover, when we seek to learn about other cultures—far away or long ago—it is often their architecture that we study most closely. The people who built the Parthenon, the Taj Mahal, the Sydney Opera House, the Pyramid of the Sun—yes, even the Victorian house in San Francisco—were telling us much about their way of life and the values they considered to be important. A society's choice of materials, structural systems, and styles of architecture makes a fundamental statement. Architecture tells us who we are. It shows us the face we want to present to the world.

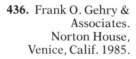

436. Frank O. Gehry & Associates. Norton House, Venice, Calif. 1985.

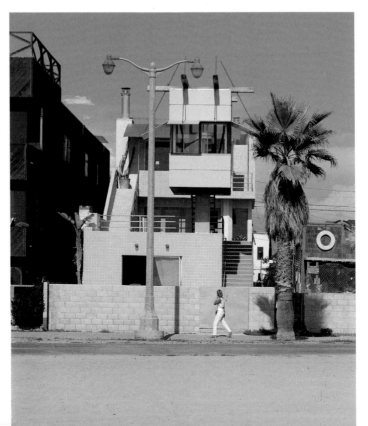

14
Environmental Design

W hen Buckminster Fuller proposed to build a 3-mile-wide geodesic dome over the whole midtown area of Manhattan Island, he probably knew that his idea would never be put into practice. Fuller was a visionary, and visionary plans usually falter before the realities of everyday life. In the abstract, however, the dome concept had its attractions. Think of it: The business district of New York City no longer would be plagued by the stifling heat of August or the cold and slush of January. Snow removal—a huge expense in the city's budget—would become a thing of the past. Individual buildings would not need to be heated or cooled; the entire atmosphere under the dome would be climatically ideal year-round. Air pollution, too, would become obsolete. No more would prevailing winds carry the smoke from factories to the west of the city into its heart, and whatever exhaust fumes were produced inside the dome could be vacuumed away efficiently. Hence, there would no doubt be a sharp decrease in respiratory ailments, along with a reduction in medical costs and therefore medical insurance premiums. Flying insects, such as flies and mosquitoes, could be all but eliminated, as could New York's perennial pigeon problem. There would be no more gloomy Mondays. Workers returning from their weekends would be greeted by a light (artificially lighted, if necessary), cheerful environment. Perhaps depressions would lift, psychological problems diminish, crime rates plummet. . . . One could go on listing the possibilities.

In proposing to "dome" Manhattan, Fuller was responding to an impulse that has tempted many artists—the urge to design an entire environment, to improve the quality of life through total design. *Environmental design* can be defined as large-scale planning to improve the aesthetic quality of the surroundings in which we live and make them more habitable. This type of design may involve architects, urban planners, landscape designers, and even psychologists and sociologists. While modern technology has greatly expanded the potential scope of the environmental designer, the concept of environmental design has actually been with us for thousands of years.

Environmental Design in History

The planned environment may seem as new as today, but we have only to look back to the ancient city of Babylon to realize how long humans have sought to order their space. Babylon was a city of Mesopotamia (the ruins are in modern Iraq, near Baghdad), and it was built over a period of many years—from the 18th to the 6th century B.C. Its history includes several famous rulers, from Hammurabi (who wrote an exemplary legal code) to Nebuchadnezzar (under whose reign was built the Ishtar Gate, **456**).

According to the old writings, Babylon was constructed as a square, bisected by the Euphrates River (**437**). Its perimeter was about 60 miles. Walls 300 feet high and 75 feet thick surrounded the city, and outside the walls was a large water-filled moat. The Greek historian Herodotus wrote that Babylon "surpasses in splendor any city of the known world." It had broad, even streets, crossing each other at right angles, and a covered bridge spanned the river. In one sector of the city were the legendary Hanging Gardens of Babylon, one of the Seven Wonders of the Ancient World; in another was the tower that probably inspired the biblical story about the Tower of Babel. All told, the planners of Babylon seem to have thought of everything important that touched upon their way of life: the security of the city, convenience of movement, and a pleasant visual aspect.

Like the Babylonians the ancient Greeks and Romans—master designers—favored the *grid* system for city planning. Streets crossed at right angles, with broader avenues allocated for the passage of many chariots. The Romans also pioneered in a surprisingly modern approach to high-density living in downtown areas—apartment houses of four and five stories. But after the Roman Empire and through the Middle Ages, environmental design as such was apparently not considered a priority. Cities grew up as they would, following the contours of the landscape and of well-traveled paths (**438**), with major access routes leading to the churches and markets. Not until the Renaissance did total design again excite the interest of artists.

437. Plan of Babylon, as rebuilt by Nebuchadnezzar. c. 604–561 B.C.

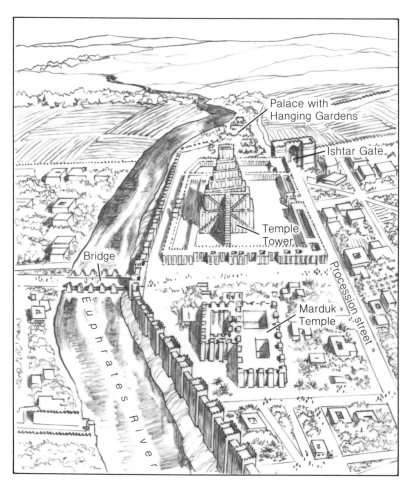

438. View of the village of Conques, France, a medieval town.

Several artists of the Renaissance, including Michelangelo and Leonardo da Vinci, turned their attention to the concept of "ideal" cities and large urban spaces. One Renaissance architect, Antonio Filarete of Florence, actually planned such a city in detail, naming it Sforzinda after his patron, the duke Francesco Sforza. Sforzinda was to have broad, straight streets, large public spaces, and housing and work areas for every level of society. Filarete's plan was never realized, but during the 15th and 16th centuries a number of European cities, most notably Rome, were substantially rebuilt in an effort to eliminate the crowded, dirty, and disorganized conditions that had developed during the Middle Ages.

In the 17th century the quest for large, well-planned urban spaces gathered momentum. One such example, designed by the Italian architect and sculptor Gianlorenzo Bernini, was the plaza in front of St. Peter's Basilica at the Vatican in Rome. St. Peter's—the heart of the Roman Catholic Church—had been under construction since 1450, on the site once occupied by a 4th-century church. This site is the presumed burial place of the Apostle Peter, the first pope. In the mid-16th century Michelangelo designed the dome and the main section of the church containing the altar (**489**). The remainder of the basilica and the façade were completed in the first quarter of the 17th century by the architect Carlo Maderno. There remained the problem of creating a suitable plaza in front of the church, and this problem was addressed immediately after the election of Pope Alexander VII in 1655. As the story goes, before the sun set on the first day of his papacy, Alexander sent for Bernini.

Bernini's challenge was to design an enclosed area capable of holding the enormous crowds that converge on St. Peter's to receive the pope's blessing on ceremonial occasions, particularly on Easter Sunday. His solution was a structure consisting mainly of a double set of roofed colonnades (rows of columns) creating a wedge-shaped space in front of the church and then bulging into an enormous oval that encompasses the plaza (**439**). Thus enclosed, the space can

439. Gianlorenzo Bernini. Plaza and colonnades, St. Peter's Basilica. 1656–63. Vatican, Rome.

hold as many as two million people. The colonnades are symbolic of the "arms of the church" reaching out to embrace the faithful. Atop them are scores of monumental marble statues of the saints carved by Bernini's assistants following his designs.

Besides providing a suitable and awe-inspiring setting for the pope's appearances, Bernini had another architectural goal in mind. He felt that Maderno's facade was too wide and too low, that its proportions were incorrect. Since he could not adjust the proportions physically, he did so visually. The colonnades, like pincers, visually "squeeze" the facade to make it seem taller and narrower. In all, Bernini's design was a brilliant conclusion to what had been a somewhat disjointed architectural scheme, for it pulled together into one cohesive unit all the diverse elements in the papal enclave. It is an environmental solution to an architectural problem.

Beginning in the late 18th century and continuing through the 19th, two extremely ambitious city-planning projects were carried out. Both involved great capital cities, and both took place in the aftermath of political revolution. Moreover, both were based on a combination of the grid plan, with streets at right angles to one another, and the *radial* plan, in which streets radiate outward on the diagonal from central points like the spokes in a wheel. The two cities in question were Washington, D.C., and Paris.

The construction of Washington was an adventure, and one at first plagued by tremendous difficulties. In its conception it reflected the ideals of the newly independent United States. Just as the founders of the young country set out to construct a totally new model of government, so too they set out to build, from the ground up, a grand and glorious capital city on an unoccupied spot—a spot, in fact, consisting principally of swampland. George Washington chose the site, and his selection had more to do with political considerations than with physical ones. The area of the city was then roughly equidistant from the northernmost and the southernmost states. In terms of climate, however, the first president's choice was not a happy one; a swamp is a swamp. Letters written by the early government leaders are filled with complaints about the city's oppressive heat in summer, the mosquitoes, the generally unhealthful atmosphere. Not until the advent of modern air conditioning did Washington become a truly comfortable place to be.

To design the city, the president called in Pierre Charles L'Enfant, a young French engineer who had volunteered his services in the American Revolution. L'Enfant's plan is surprisingly ambitious and innovative, considering that he

440. The Mall, Washington, D.C., viewed from the steps of the Lincoln Memorial, with the reflecting pool, the Washington Monument, and the Capitol dome in the distance.

441. Place de l'Etoile, Paris,
as it appeared about 1870.
Engraving.

worked in a time when most cities had rather narrow and often winding streets. At the very center of the original city limits stands the Capitol building (**424**). From the Capitol, running along a north-northwest axis, is the main throughfare, Pennsylvania Avenue, which is 160 feet wide and leads directly to the White House. The Capitol also serves as the eastern anchor of The Mall (**440**), a parklike area lined with museums and government buildings. The Mall has three main focal points, arranged precisely in an east-west row: the Capitol at the east, the Washington Monument in the center, and the Lincoln Memorial at the west, on the banks of the Potomac River. (Not all of these buildings existed in L'Enfant's plan. Lincoln had not yet been born when the plans were drawn up.) The president and the Congress can look at each other from their windows, and now the Congress can look down The Mall for inspiration from Washington and Lincoln.

L'Enfant's design provided for several elements deemed desirable for an important capital city—broad, ceremonial avenues, imposing vistas, open public areas, major buildings as focal points. All these are possible when one is building from "scratch" and has a master plan. It is far more difficult to impose such an order on an existing city, one that has grown up haphazardly over the centuries. To a large extent, however, the city of Paris accomplished this.

The transformation of Paris from a medieval town to a city of many monuments, stately public buildings, and majestic avenues took place over several centuries. Nearly always the construction was undertaken to satisfy grandiose, ego-enhancing ambitions of a monarch. The last Bourbon kings of France, in the 17th and 18th centuries, made a number of major contributions in and around Paris, including Louis XIV's conception for the gigantic Versailles Palace and gardens (**503**). During the French Revolution, beginning in 1789, the mood ran more to tearing down than to building up. The main square of Paris, the Place de la Concorde, became the headquarters of the guillotine, the device invented as a "humane" method of severing heads. In the Place during the Revolution more than 2,500 people were executed, among them the king and queen.

A mere fifteen years after the Revolution began, Napoleon came to power in France, styled himself emperor, and set out to create a regime equal in glory to the empire of ancient Rome. To this end he ordered built numerous monuments, streets, plazas, gardens, and bridges. His projects included first one and then a second huge triumphal arch, modeled on Roman designs. The Arc de Triomphe at the Place de l'Etoile is the grander of the two (**441**), placed in the center of a circle that interrupts Paris' main avenue, the Champs-Elysées. Later, during the

third quarter of the 19th century and under the rule of Napoleon III, the first emperor's nephew, more grand-scale city planning was undertaken. Large sections of the city were flattened to allow for the construction of diagonal avenues radiating outward from important monuments. At the Place de l'Etoile, as shown in the illustration, *six* major thoroughfares intersect to create a focal point for the arch—and a traffic problem of staggering proportions.

Both Washington and Paris demonstrate that when it comes to environmental design the grand and the efficient do not always coexist. Washington, too, has traffic problems. To anyone not intimately familiar with the city, the business of getting around by car can be formidable. Generously proportioned boulevards tend to stop abruptly—at one of those majestic focal points!—and though they pick up on the other side of the monument, one often has no clear idea how to *get* to the other side. Neither city, in fact, was conceived with the automobile in mind.

The automobile is but one of many developments that have changed the character of environmental design. Others include the challenge of cities housing millions of people, the blight of urban slums, air pollution, the concentration of office buildings, mass transportation and communication, limited natural resources, and the desire for open space on a crowded planet. Environmental designers of the 20th century have far more complex problems to solve than their predecessors ever dreamed of.

Environmental Design for the Modern World

To compare the environmental designs of our own age with those of previous ones, we might look at a 20th-century architect's scheme for the same city in which Louis XIV and Napoleon erected their tributes to kingly power. The architect who in 1925 planned a drastic renovation of Paris was Charles Edouard Jeanneret, known as Le Corbusier, designer of Notre-Dame-du-Haut at Ronchamps (**154,155**).

Le Corbusier, in his way, could be just as grandiose as a king or an emperor. What he proposed for Paris involved no less than leveling a large area in the center of the city—600 acres—and starting all over again. His design for a new Paris (**442**) would have concentrated the central Parisian population into sixteen tall, glass-sheathed skyscrapers with open spaces around them. The old public spaces would be abolished; for example, Le Corbusier wrote that his dream was "to see the Place de la Concorde empty once more, silent and lonely." In this vision of the ideal city, the automobile would rule. Motorized traffic would be given a priority, and pedestrian traffic would cease to exist.

Not being a king, Le Corbusier had neither the power nor the funds to put his idea into practice, and subsequent generations have expressed gratitude that this is so. The trouble with Le Corbusier's plan—and Fuller's dome plan for Manhattan—is that it ignores how people *do* live and *want* to live, and reflects instead one artist's idea of how people *should* live. And people, by and large, resist doing what they "should" do. A population such as that of Paris, accustomed to small, individual houses and used to living an energetic life in the streets and squares, would take up arms before being stacked into vertical towers of glass. The more far-sighted contemporary environmental designers strive to understand the fabric of people's lives and make their plans an enhancement, not a restructuring, of modern civilization.

Today's environmental design is as varied as the populations it attempts to serve. At its best, it asks many questions before attempting to provide answers. Where is this environment—city, suburbs, or country? What are its geographical location and climate? Who lives in the environment—children, teenagers, young adults, middle-aged adults, elderly people, or a mixed group? How do they move about—on foot, on bicycle, by car, or by mass transit? What do they do in the environment—eat, sleep, work, study, play, or some combination of these? What

442. Le Corbusier.
Drawing of the "Voisin" Plan for Paris. 1925.
Fondation Le Corbusier, Paris.

is the image to be projected by this environment? How do the people who plan it, and those who will use it, feel about themselves, and what do they want to show to the world?

To see how designers have grappled with these questions, we will look at a few environmental designs in three important categories, the first of which should be familiar to readers of this book.

DESIGN FOR LEARNING: THREE COLLEGE CAMPUSES

Thomas Jefferson referred to the college campus as an "academical village." This term is apt, because a campus typically possesses most of the characteristics we would find in a traditional village. It is self-contained. It provides nearly all the essentials for daily life—sleeping and eating facilities, work spaces, health care, provision for goods and services, places for social gathering. Its inhabitants interact closely with one another and have common interests and goals.

The stereotypical view of a college campus evokes the "halls of ivy"—that is, imposing, monumental buildings, perhaps in the Gothic style, possibly with ivy growing thickly up the walls. As a matter of fact, some campuses do look like this, at least in their older sections. But campus design is just as diversified as any other; the personality of each college is unique.

There could hardly be a more challenging or interesting task for the environmental designer than planning a college campus. After all, it is much like designing a city from the ground up, and few people in history have had the opportunity to do that. The campus will, presumably, endure for many hundreds of years. It will serve as a working environment and home away from home for a constantly changing population of students and professors. It must be comfortable and efficient, but above all it must express the special personality of the college. It must say through its design: This is who we are. Let us see how three designers tackled this challenge.

Jefferson was not trained as an architect, much less as an environmental designer—if such a term could have existed in the early 19th century. In his day, however, the educated person was expected to be informed on many subjects. Honored now as drafter of the Declaration of Independence and third president of the United States, Jefferson drew more satisfaction from being a cultivated student of the arts and sciences. His great pride was the college he established

and whose architecture and overall layout he designed—the University of Virginia (**443**).

Jefferson's plan for the University of Virginia combined the qualities we admire in the man himself: idealism and practicality. Idealism was embodied in the veneration of knowledge; practicality in the belief that one's surroundings when pursuing knowledge should be comfortable and conducive to study. The university is organized around a rectangle, with a large, grassy lawn at its center. Its focus is the Rotunda, the library, which is modeled after the Pantheon in Rome (**413**), for Jefferson's ideals were rooted in the traditions of ancient Greece and Rome. Strung out along the two sides of the lawn are ten "pavilions," each meant to house the professor of one branch of learning and his college of students. This situation was intended to provide natural and spirited communication between teacher and pupils. (In Jefferson's time education was based on the tutorial system. Each subject had one distinguished professor, around whom students grouped.)

The pavilions are not identical, but each is based on a specific classical prototype, some in the Doric style, some the Ionic (**408**). Joined to one another by roofed colonnades, the pavilions are planned for an elegant balance between ready access and studious seclusion. Behind the pavilions are formal gardens, then another range of buildings on each side, including "hotels" meant as dining rooms. Overall, Jefferson's design expresses magnificently his concept of "who we are." The "we" in this case—the students and faculty of the University of Virginia—are rational, orderly, dedicated to learning, and enlightened heirs to the great legacy of Greece and Rome.

Just over half a century later, and a continent apart from Virginia, another great university, a very different one, was established and designed. Its patron was Leland Stanford, once governor of California, who endowed the university in memory of his dead son. (We met Governor Stanford earlier in this book, in connection with a bet on his racehorse that inspired Eadweard Muybridge's serial photographs, p. 253.)

In contrast to the University of Virginia, Stanford University is not classical in its design aesthetic. Rather, it draws its inspiration from the Romanesque monastery cloister, but even more specifically from California history. During the 18th and early 19th centuries Spanish Franciscan priests had established a series of mission churches up and down the coast of California. It is this "mission-style" architecture, with its low buildings and red-tiled roofs, that Stanford University emulates (**444**). Seen from a distance, the university looks rather like a Mediterranean village, growing naturally from the landscape. Its basic motif is not the square post-and-lintel of Jefferson's design, but the graceful arch. For Stanford University, "who we are" is identified clearly with the West, with California, with the legacy of Spanish colonists.

Yet another half century or so brings us to our third campus design—in this instance a design rooted in time and technology rather than place. The U.S. Air Force was organized as an independent branch of the military in 1947, and in 1954 it established its own service academy (**445**). Rejecting the architectural examples of its kin—the army academy at West Point (Gothic) and the naval

443. Thomas Jefferson. University of Virginia, Charlottesville. 1817–26.

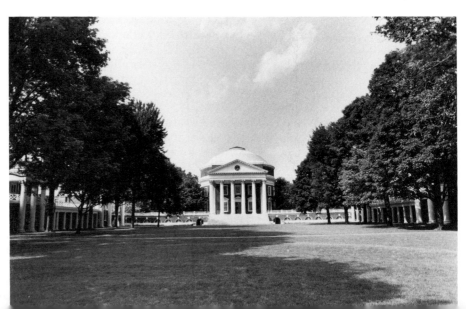

academy at Annapolis (Classical)—the U.S. Air Force Academy sought an environment that would speak to the present and the future. The architectural firm of Skidmore, Owings & Merrill designed for the Colorado Springs site a campus that is consciously modern, sleek as an airplane, boasting of speed, progress, and technological power. For the students and faculty of the Air Force Academy, obviously, "who we are" is a people meant to fly, to be the wave of the future.

Design of the "academical village" is not static. Over the years needs change, student populations grow, buildings must be added. Even Jefferson foresaw this, leaving the grassy central rectangle at the University of Virginia open on one end for possible future expansion. Nevertheless, design of the campus does afford the rare opportunity for total, harmonious environmental planning. Quite different are the challenges for a designer working within an existing city.

DESIGN FOR THE CITY

As often as not, the urban environmental designer is brought in to "fix" something that is already there but has gone wrong. Few American cities were actually planned (Washington being a major exception). Mostly, the cities just grew, with individual districts taking shape as the need presented itself. Trouble arose when that need no longer applied.

left: **444.** Charles A. Coolidge. Stanford University, Palo Alto, Calif. Begun 1886.

below: **445.** Skidmore, Owings & Merrill. United States Air Force Academy, Colorado Springs, Colo. 1956–63.

357

A problem often addressed by urban planners is the rejuvenation of decaying sections of the city, especially waterfront areas. So many of the old cities in the United States were founded initially as major ports, but with the decline of the shipping trade the waterfront sections fell into disrepair. Designers have confronted this question: What do you do with a seaport that is no longer a seaport? In New York and Baltimore, in Boston and San Francisco, the answer has been to turn a waterfront area into a community center.

Boston's harbor renewal is a good example (**446**). Decrepit buildings in a once-seedy part of town have been renovated to house restaurants, shops, and artists' studios. Charming pedestrian walkways make the area a pleasant place by day or night. A neighborhood that good Bostonians once skirted and tourists avoided has become a focus of the city's social life and a tourist attraction.

Port cities are not the only ones with decaying older sections. Many cities in the interior of the country have seen their downtown areas become shabby and deserted as a result of a post–World War II trend—the flight from the cities to the suburbs. The burgeoning of huge shopping malls in the suburbs has caused many downtown stores to close for lack of customers. Then, as stores and restaurants have moved out of the inner city, downtown areas have become unpleasant places to be, especially at night, and so increasing numbers of residents have also fled to the suburbs. Many large cities have found that a formerly bustling district in the heart of town has become desolate, run-down, and dangerous.

Dayton, Ohio, is one of a number of cities that has taken active steps to remedy this problem. In downtown Dayton stand many fine old buildings, constructed between 1902 and 1904, that once housed such facilities as a farmer's market and government offices. These buildings now form the center of Arcade Square (**447**). This project, undertaken in the late 1970s, involved a partnership between the City of Dayton and a private corporation backed by individual and business funds. The result is an exciting mix of the old and the new. While the basic architectural character of the buildings has been retained, the interiors have been substantially remodeled to allow for retail stores, restaurants, and apartments. So far, the outcome has been promising, largely because of the civic leaders' quest for excellence. As *Progressive Architecture* commented, "Not every city, of course, has officials with the sensitivity and/or the wisdom to hire talented design people and listen to them. It is much to the credit of both this city and this developer that, for the most part, they listened."[1]

446. Boston waterfront district, Quincy Market.

447. Lorenz & Williams, Inc. Rotunda, Arcade Square, Dayton, Ohio. 1902–04 (rebuilt late 1970s).

Renewal is one solution to keeping the city alive and thriving, but innovative new construction is another. In New York the Citicorp atrium (448) represents a particularly creative use of urban space, for it gives city workers a planned and streamlined version of exactly the sort of space they are used to occupying. The Citicorp tower is an office building in midtown Manhattan. On its ground and below-ground levels is a three-tiered area that merges with the outdoors and that includes many restaurants, shops, bookstalls, sitting areas, "green spots" of plantings, and walkways. Here New Yorkers can stroll through to take a shortcut, meet their friends, get a meal or a snack, browse in the shops, or simply "hang out." The realities of city life—the way people do live, not how someone believes they should live—are given a splendid setting.

Then what of the realities of suburban life? The most stunning reality is the very phenomenon the planners in Dayton, Ohio, were trying to counteract. As an exercise in environmental design, in total planning, in response to ultramodern life styles, one could hardly top the suburban mall.

DESIGN FOR THE SUBURBS: THE MALL

"I shop; therefore I am." This witty paraphrase of René Descartes' famous philosophical statement ("I think, therefore I am") sums up the essence of the mall. Once upon a time people shopped only when they needed something. Now people visit the mall as an integral part of life, as entertainment. The mall has become the equivalent of the village green, a gathering place as comprehensive as the old medieval cathedral. Even if you don't need anything, even if you aren't going to shop today—come to the mall.

448. Hugh Stubbins and Associates, and Emery Ross and Sons. Atrium, Citicorp Building, New York. Completed 1977.

359

Chapter 3 of this book, in its discussion of Chartres Cathedral (p. 69), pointed out the vital role played by the cathedral in people's daily lives. Today that role has largely been assumed by the mall. Nearly all the social activities one could want are satisfied within the enclosed environment of the mall—sports and entertainment, music and dramatic performances, socializing with friends, having a meal or a snack, and of course buying, or simply admiring, an endless array of consumer goods. The people of medieval Europe walked, so their obvious gathering place was the cathedral in the center of town. The people of suburban North America drive cars; their obvious gathering place is the mall.

The king of the malls, the world's largest—as of this writing—is located in West Edmonton, Alberta, in Canada (**449,450**). Its dimensions stagger the imagination. Housed under one roof is a complex the size of 108 football fields, including 11 department stores and more than 800 shops. If you are hungry, you can choose from among some 110 restaurants. For entertainment you might visit the zoo, the ice-skating rink, the huge "waterpark" with its elaborate swimming pool, or the canal with its submarines. No matter what the weather outside—and Edmonton has a brutal winter climate—you can pursue whatever activities you fancy under the roof of the mall. One can't help but think Buckminster Fuller would have loved it. The mall is, after all, one version of life inside the dome.

If we try to envision the environmental design of the future, we will be in precisely the position of Pierre L'Enfant, who laid out the city of Washington without knowing about the automobile. We don't know what lies ahead. We don't know what factors will influence human life fifty or a hundred years hence. Yes, certain things probably can be taken for granted. Population will increase, and there will be a greater need for housing. Industrial pollution must be eliminated or counteracted. But how will the dominance of the computer affect life and the environment? How will space travel influence future generations? Must we plan now for the colonization of the moon and of distant planets? Should the L'Enfant of our day set out to plan a capital city in the "swampland" of our galaxy? Environmental design is among the most dynamic and most perplexing of all the arts, because the environment keeps changing before our very eyes.

left: 449.
West Edmonton Mall, Alberta,
showing the lagoon
with submarines.

right: 450.
West Edmonton Mall, Alberta,
the Waterpark.

part five
ARTS
IN TIME

451. *The Great Sphinx.*
c. 2530 B.C. Stone, height 65′.
Giza, Egypt.

15
The Ancient World to the Middle Ages

A major factor in the understanding and appreciation of art is knowledge of its time frame—when a work of art was made and under what circumstances. For this reason the final part of this book has been devoted to a brief chronological survey, tracing the major movements in art from earliest times to the present. The four chapters here, together with the time lines beginning on page 481, should help in placing *all* the works of art discussed throughout the text in their historical context. At the same time, the artworks illustrated in this section can be considered primarily for their themes, their design components, and their media.

Some of the earliest surviving works of art have already been presented in this book—the cave paintings of southern Europe (**2**) and the figurines made by very early peoples (**68**). For the most part these are isolated examples, deriving from cultures that were essentially nomadic, oriented toward hunting to meet their needs for food. Not until we come to two cultures, both in the Middle East, do we find a coherent, reasonably intact artistic production about which we know a great deal. These are the ancient cultures of Egypt and Mesopotamia—the ancestors of Western art and civilization.

The Egyptians and Mesopotamians built their societies around mighty rivers, which enabled them to develop agriculture and therefore establish permanent settlements. This permanence, in turn, led to the development of architecture, the standardization of religions and rituals, and the creation of a social climate in which art could flourish. Our brief survey of Western art history, therefore, begins in the regions of these mighty rivers—the Nile in Egypt, the Tigris and Euphrates in Mesopotamia.

Egypt

The principal message of Egyptian art is continuity—a seamless span of time reaching back infinitely into history and forward into the future. The Sphinx (**451**), the symbol of this most important characteristic of Egyptian art, is the

left: **452.** *Palette of King Narmer,* from Hierakonpolis. c. 3100 B.C. Slate, height 25″. Egyptian Museum, Cairo.

right: **453.** *Queen Nefertiti.* c. 1365 B.C. Limestone, height 20″. State Museums, West Berlin.

essence of stability, order, and endurance. Built about 2530 B.C. and towering to a height of 65 feet, it faces into the rising sun, seeming to cast its immobile gaze down the centuries for all eternity. The Sphinx has the body of a reclining lion and the head of a man, thought to be the pharaoh Chefren, whose pyramid tomb is nearby. Egyptian kings ruled absolutely and enjoyed a semidivine status, taking their authority from the sun-god, Ra, from whom they were assumed to be descended. Power and continuity both are embodied in this splendid monument.

An even earlier relic from Egyptian culture, the so-called *Palette of King Narmer* (**452**), illustrates many characteristics of Egyptian art. The Greek philosopher Plato wrote that Egyptian art did not change for ten thousand years; while this may be something of an exaggeration, there were many features that remained stable over long periods of time. The palette (so named because it is thought to have been a slab for mixing cosmetics) commemorates a victory by the forces of Upper Egypt, led by Narmer, over those of Lower Egypt, resulting in a unified kingdom. Narmer is the largest figure and is positioned near the center of the palette to indicate his high status. He holds a fallen enemy by the hair and is about to deliver the death blow. In the lowest sector of the tablet are two more defeated enemies. At upper right is a falcon representing Horus, the god of Upper Egypt. In its organization of images the palette is strikingly logical and balanced. The central section has Narmer's figure just to left of the middle, with his upraised arm and the form of a servant filling the space, while the falcon and the victim complete the right-hand side of the composition.

Narmer's pose is peculiar to Egyptian art and one of its most distinctive features. In depicting an important personage, the Egyptian artist strove to show each part of the body to best advantage. Thus, Narmer's lower body is seen in profile, his torso full front, his head in profile, but his eye front again. This same pose recurs throughout most two-dimensional art in Egypt. It is believed that the priests, who had much control over the art, established this figure style and decreed that it be maintained, for the sake of continuity. Obviously, it is not a posture that suggests much motion, apart from a ritualized gesture like that of Narmer's upraised arm. But action was not important to Egyptian art, no more in the smaller objects than in the large monuments; order and stability were its primary goals.

One brief period in the history of Egyptian culture stands apart from the rest and therefore has fascinated scholars and art-lovers alike. This was the reign of the pharaoh Amenhotep IV, who came to power in 1372 B.C. For a civilization that prized continuity above all else, Amenhotep was a genuine revolutionary. He changed his name (to Akhenaten), moved his capital, attempted to establish monotheism (belief in one god) among a people who worshiped many gods, and fostered a new, more relaxed style in art. Nowhere is this last more apparent than in the famous portrait bust of his queen, Nefertiti (453). While enchanted by Nefertiti's beauty, the modern viewer is perhaps even more taken by how contemporary she seems, how she appears to bridge the gap of more than three thousand years to our own world. Despite her regal headdress and elongated neck, Nefertiti might be a model in this month's fashion magazine. When the opportunity presented itself, the Egyptian sculptor was capable of great humanity and warmth, of letting a subject's real characteristcs transcend convention.

Mesopotamia

At the same time that ancient Egypt was flourishing, another great civilization had established itself to the east, in Mesopotamia, roughly in the area of modern-day Syria and Iraq. The two cultures had contact with one another but maintained their separate identities, and their styles in art were quite different. Mesopotamia occupied a large, flat area made fertile by its two rivers, the Tigris and the Euphrates. Many archaeologists and historians believe that the biblical Garden of Eden was located here, at a point near where the rivers join before flowing into the Persian Gulf.

Unlike Egypt, which was protected on two sides by the sea and elsewhere by the desert, Mesopotamia had few natural defenses against invasion. Successive waves of people conquered the region—the most important being the Sumerians, the Assyrians, and the Babylonians. Judging by the surviving art, each culture centered around the temple as a place of worship and a focus of daily life.

The unique character of Sumerian art is exemplified by a group of marble statues from the Abu Temple at Tell Asmar, approximately contemporary with the Sphinx (454). The tallest figure is Abu, the god of vegetation, and just to the right is a mother goddess, while the rest of the statues represent priests and worshipers. No real attempt has been made to carve these figures naturalisti-

454. Group of votive statuettes, from the Square Temple of the god Abu, Tell Asmar, Iraq. c. 2900–2600 B.C. Marble, height of tallest figure 30″. Iraq Museum, Baghdad, and Oriental Institute, University of Chicago.

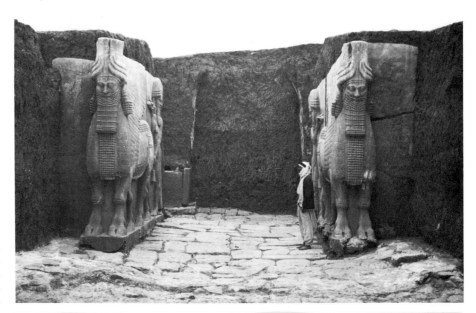

455. Outer Portal of the Citadel, Palace of Sargon II, Dur Sharrukin, Iraq. c. 721–705 B.C.

cally; the bodies are extremely stylized and some of the figures seem rather like decorated cylinders. Each has the hands clasped in the ritual Sumerian gesture of worship. The male figures show the heavily textured beards characteristic of this art, and the lips are curved upward as though to smile—a convention that means the persons depicted are alive, not dead, though not necessarily happy. The most extraordinary and riveting feature of each statue is, of course, the eyes, which are enormous, especially in the two gods. Outlined in black and inset with colored stones and shells, the eyes apparently served as the medium of communication between the worshipers and their gods. They give to these sculptures an exotic appearance very different from that of most Western art from ancient times.

Mesopotamia's history over the centuries was a turbulent one marked by almost continual warfare and conquest. A major goal of architecture, therefore, was the erection of mighty citadels to ensure the safety of temples and palaces. Such a citadel was that of the Assyrian ruler Sargon II, built at Dur Sharrukin in

456. Ishtar Gate (restored), from Babylon c. 575 B.C. Enameled sun-dried brick, height 48'9". Near Eastern Museum, State Museums, East Berlin.

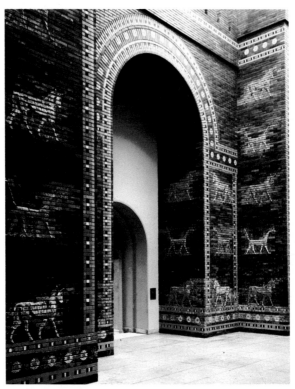

the 7th century B.C. One of its gates (**455**) shows the monumental stone slabs that protected the entrance, which have been carved into guardian demons meant to impress—and intimidate—any visitor to the citadel.

The Babylonians, who followed the Assyrians, surely must be ranked among the great architects of the ancient world (**437**), although far less of their production remains than does that of Greece and Rome. We get some idea of their skill from the Ishtar Gate (reconstructed in a German museum), which was built in the 6th century B.C. under the great king Nebuchadnezzar (**456**). Made of thousands of glazed mud bricks, the gate has two massive towers flanking a central arch—the latter proving that, although the Romans developed the arch extensively, the Babylonians had discovered its uses earlier. On ceremonial occasions Nebuchadnezzar would sit under the arch in majesty to receive his subjects. The walls of the gate are decorated with processions of glazed ceramic animals, probably meant as spirit-guardians.

Both Mesopotamia and Egypt had access to the Mediterranean Sea, the "highway" of the ancient world. If we were to sail northwest from Egypt, or west-northwest from Mesopotamia, we would reach the Aegean Sea, an arm of the Mediterranean separating Greece from what is now Turkey. Around the Aegean we find a third focus of early artistic production.

The Aegean

The artistic cultures of the Aegean parallel in time those of Egypt and Mesopotamia, for the earliest begins about 3000 B.C., when Old Kingdom Egypt and the Sumerian civilization were becoming established. There were three major Aegean cultures: the *Cycladic,* centered on a group of small islands in the Aegean; the *Minoan,* based on the island of Crete at the southern end of the Aegean; and the *Mycenaean,* on the mainland of Greece.

Cycladic art is a puzzle, because we know almost nothing about the people who made it. Nearly all consists of nude female figures like the one we saw in Chapter 2 (**50a**)—simplified, abstract, composed of geometric lines and shapes and projections. The figures vary in size from the roughly 2-foot height of our example to approximately life-size, but they are much alike in style. Presumably they were meant as fertility images, although they are a far cry from the fleshier "Venuses" found earlier in the north (**68**). To modern eyes the Cycladic figurines seem astonishingly sophisticated in their ability to reduce anatomical forms to the essence of shape.

The Minoan culture on Crete can be traced to about 2000 B.C. and centers around the great city of Knossos. We take the name from a legendary king called Minos, who supposedly ruled at Knossos and whose queen gave birth to the dreaded creature, half-human, half-bull, known as the Minotaur. The Minoans, being island dwellers, were a seafaring people, and much of their art depicts sea creatures—fishes and dolphins and octopuses. Usually the art is cheerful, light-hearted, and colorful. It is believed the Minoans worshiped a female deity, and this may be the identity of the *Snake Goddess* (**457**), one of two similar figures discovered at the Palace of Knossos. With her bared breasts, tiny waist, and elaborate skirt, this figure resembles then-fashionable ladies of the court, yet she holds a wriggling snake in each hand. Some writers have suggested she is a priestess associated with a snake-handling cult, or perhaps a queen. In any event, the little terra-cotta statuette is unlike female depictions we would find in any other ancient culture.

Mycenaean culture, so called because it formed around the city of Mycenae, flourished on the south coast of the Greek mainland from about 1600 to 1100 B.C. Like the Minoans, the Mycenaeans built palaces and temples, but they are also noted for their elaborate burial customs and tombs—a taste apparently acquired from the Egyptians, with whom they had contact. It seems probable that Egypt was also the source of the Mycenaeans' great supplies of gold, for they alone among the Aegean cultures were master goldsmiths. Burial places in and

457. *Snake Goddess,* Minoan, from Crete. c. 1600 B.C. Terra cotta, height 17½". Heraklion Museum, Crete.

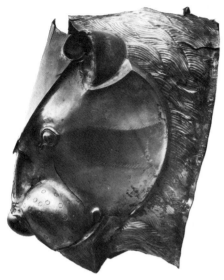

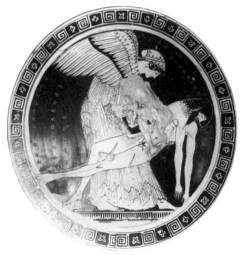

around Mycenae have yielded large quantities of exquisite gold objects, such as the *rhyton,* or drinking cup, in the shape of a lion's head (**458**). The craftsmanship of this vessel is wonderful, contrasting smooth planar sections on the sides of the face with the more detailed snout and mane. The Mycenaeans also used gold for death masks, jewelry, and weapons.

Mycenaean civilization was the last of those we identify as *pre-Hellenic,* or "pre-Greek." Of course, the Aegean peoples lived in or near Greece, but when we speak of "ancient Greece" we do not mean them. We mean a culture that took root on the Greek mainland starting about 1100 B.C., spread through much of the eastern Mediterranean world, survived for only a few hundred years, and created art that remains a standard against which all other art is measured.

Greece

No doubt a major reason we so admire the ancient Greeks is that they seem to have excelled at everything. Their political ideals serve as a model for contemporary democracy. Their poetry and drama and philosophy survive as living classics, familiar to every serious scholar. Their architecture and sculpture have influenced most later periods in the history of Western art and continue to do so. We have seen examples in earlier chapters (**34,72,190,364,409**).

It is assumed the Greeks' genius shone equally in painting, but we know very little about this because most painted works have been lost. We would know even less were it not for the large number of painted clay vases that were produced between the 8th and 5th centuries B.C. In Chapter 11 we noted that terra cotta (baked clay) is an extremely durable material; it can shatter but will not disintegrate, and so the pieces can be reassembled. For this reason a large quantity of Greek art has survived to our day.

Few cultures can match the Greeks in the elaborate painting of vases, which represent a major part of their artistic output. These terra cotta vessels served as grave monuments, storage urns for wine or oil, drinking cups, and so forth. Our illustration (**459**) shows a *kylix* (a drinking cup) representing *Eos and Memnon.* The painting is done in the *red-figure style,* which developed late in the 6th century B.C. A background of black was created from glaze, leaving the figures in the natural red color of the clay. Sometimes details were added with white highlights. Given what sounds like a rather primitive technique, the painting is remarkably fine. Eos, the goddess of dawn, holds the body of her dead son, Memnon, who has been killed by the hero Achilles. There is a suggestion of depth in the overlapping of Memnon's body in front of Eos, as well as in the crossed legs; the dangling arms of the body visually balance Eos' outspread wings. The finely-drawn textures of gown, hair, and wings reveal the great skill of the vase painter's brush. As a mark of the esteem in which vase-painters were held, and the pride they took in their work, this kylix is signed by the painter, Douris.

Despite the Greeks' prolific output of painted vases, most people, at the mention of Greek art, think of sculpture. Between the 6th and 2nd centuries B.C. the Greeks gradually developed a type of sculpture that many succeeding generations have considered the ultimate expression of that medium. Its highest achievement was in the human figure. Although many figures, especially in later decades, were female, the most typical Greek statue is male, a nude superbly proportioned to indicate an ideal of physical perfection.

The Greeks' approach to sculpture was a radical departure from artistic precedents in other parts of the Mediterranean world. Egyptian sculptures generally were attached to a background; Greek figures are freestanding, in the round. Egyptian figures usually were clothed; the Greeks introduced total nudity in the male figure and in later centuries moved toward increasing nudity in female statues (**34**). Most of the Egyptian sculptures we know are of pharaohs, their queens, their children, and other members of the court. The Greeks seem to have been far more interested in physical beauty than in high status. To be sure, some of their finest sculptures represent gods, but they are gods in human form—

magnificent human form. And many are depictions of anonymous young men, to whom scholars have given the name *kouros*, meaning "youth" or "boy."

The reasons for this new approach to sculpture are clear from Greek philosophy and literature. Whereas the Egyptians emphasized continuity of the state, the Greeks sought perfection of the state *through* perfection of the individual. The ideal human body symbolized an ideal divine soul, dedicated to the highest principles. If perfection could be chiseled into marble, then perhaps the sought-after perfection in human affairs could be attained.

Three male figures, made over a period of about 150 years, will show the enormous progress of Greek sculptors in striving toward an ideal of naturalism and physical perfection. The first is a *kouros* dating from the early *Archaic* period, around 600 B.C. (**460**). This sculpture is a fairly crude attempt at freeing the nude body from its original block of stone. We can almost envision the cube of marble the sculptor began with from the square appearance of the form. Although more than 6 feet tall, the figure seems puny and underdeveloped, its torso too small and slender, its shoulders too narrow. The hair is a stylized braid, the eyes blank and staring, the feet featureless slabs with rigid cylinders for toes. Nevertheless, this sculptor has made great strides toward a natural approach, especially when we compare the *kouros* to earlier Egyptian figural statues (**359**). The musculature of arms and legs has been studied carefully, the legs separated from one another, the arms separated from the body.

Another *kouros*, carved some seventy-five years later but still in the Archaic period (**461**), shows considerable progress toward naturalism. This body is far better proportioned, the hips and torso broader, the arms and legs well-developed. We can easily believe a human body might be shaped like this, which is hard to imagine of the earlier *kouros*. In spite of these advances, however, the sculpture retains a blocklike quality, is still imprisoned in the cube of stone. The left foot is set slightly forward to suggest motion, but we do not really believe in that motion because the hips and shoulders are level and the arms held rigidly at the sides. If you try to assume this pose, you will find it almost impossible, for when you take a step forward with one foot, the opposing hip and shoulder go up, and your arms move in counterbalance. There is no indication of this in the statue. On the *kouros'* face is an expression that has been dubbed the "archaic smile"—a rather forced grimace apparently meant to convey animation.

Now let us compare the *Spear Bearer* by the great sculptor Polyclitus (**462**), carved yet another seventy-five years or so later, in the *Classical* period of the 5th

left: 460. *Kouros.* c. 600 B.C. Marble, height 6'1½". Metropolitan Museum of Art, New York (Fletcher Fund, 1932).

center: 461. *Kroisos (Kouros from Anavysos).* c. 525 B.C. Marble, height 6'4". National Museum, Athens.

right: 462. *Doryphorus (Spear Bearer).* Roman copy after a Greek original of c. 450–440 B.C. by Polyclitus. Marble, height 6'6". National Museum, Naples.

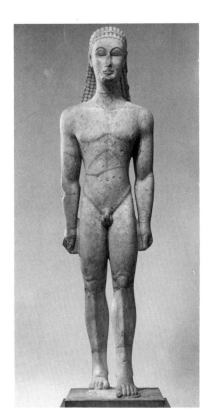

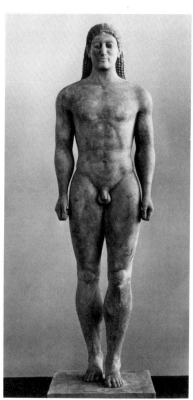

century B.C. (Like so many Greek statues, the original of the *Spear Bearer* has been lost and is known to us only through later, and probably inferior, Roman copies.) Here we find the *contrapposto* of a figure in motion (p. 295). With the weight on the right foot, the left knee is bent, the left hip and shoulder rise, the arms reach outward from the body, and the whole form stands in a relaxed S-curve suggestive of movement. The musculature of a well-developed body has been carefully observed and recorded. Gone is the archaic smile, to be replaced by a natural, pensive expression. We must consider this sculpture in terms of what the Greeks had set out to do. They intended to show a perfectly formed body, at the peak of its youthful strength, rendered in as lifelike a manner as possible. At this they succeeded admirably.

The last phase of Greek art, occurring roughly in the 3rd and 2nd centuries B.C., is known as *Hellenistic*—a term that refers to the spread of Greek culture eastward to Mesopotamia and Egypt. Hellenistic sculpture tends to be more dramatic and emotional than that of the Classical 5th century; it has more of a tendency to push out into space and is more dynamic. One of the best-known examples of this style is the *Laocoön Group* (**463**), dated to the late 2nd century B.C. (see also the Epilogue, **588**).

Laocoön was a priest of the sun-god, Apollo, and his story involves one of the most famous events in Greek mythology. In the last year of the war between the Greeks and the Trojans, the Greeks devised a fabulous ruse to overrun the city of Troy. They built a giant wooden horse, concealed inside it a large number of Greek soldiers, and wheeled it up to the gates of Troy, claiming it was an offering for the goddess Athena. While the people of Troy were trying to decide whether to admit the horse, their priest, Laocoön, suspected a trick and urged the Trojans to keep the gates locked. (Here is the source of the well-known warning about "Greeks bearing gifts.") This angered the sea-god, Poseidon, who held bitter feelings toward Troy, and he sent two dreadful serpents to strangle Laocoön and his sons. The sculpture depicts the priest and his children in their death throes, entwined by the deadly snakes.

Compared to statues from the Classical period, such as the *Spear Bearer*, the *Laocoön Group* seems almost theatrical. Its subject matter, filled with drama and tension, would have been unthinkable three centuries earlier. The Classical sculptor wanted to convey an outward serenity, and thus showed the hero in perfection but not in action, outside of time, not throwing the spear but merely holding it. Hellenistic sculptors were far more interested than their predecessors in how their subjects reacted to events. Laocoön's reaction is a violent, anguished one, and the outlines of the sculpture reflect this. The three figures writhe in

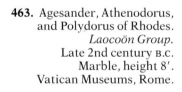

463. Agesander, Athenodorus, and Polydorus of Rhodes. *Laocoön Group.* Late 2nd century B.C. Marble, height 8'. Vatican Museums, Rome.

464. Sarcophagus, from Cerveteri. c. 520 B.C. Terra cotta, length 6′7″. Museo Nazionale di Villa Giulia, Rome.

agony, thrusting their bodies outward in different directions, pushing into space. Unlike the dignified reserve of earlier figures, this sculpture projects a complicated and intense movement.

According to legend, the Trojans disregarded Laocoön's warning and brought the wooden horse into their city. That night the Greek soldiers slipped out of the horse, pillaged Troy, and destroyed it. Only a few of the Trojans escaped, including Aeneas, who sailed away and, after many adventures, landed at the mouth of the Tiber River and founded the city of Rome. Whether or not one chooses to believe the old myths, it is nevertheless true that the history of art and civilization now shifts westward, to the great empire that conquered Greece and virtually all of the Mediterranean world.

Rome

To understand the art of Rome we need to backtrack slightly to a people who inhabited the Italian peninsula from about the 7th century B.C. or earlier—the Etruscans. When the Roman Empire was established and its art began to flower, it drew on not only the traditions of the conquered Greeks but also styles of art nurtured on home soil.

The afterlife is the focus of a large part of Etruscan art—tombs and *sarcophagi* (burial coffins) and funerary vases. From the example illustrated here (**464**) and many others, we can deduce that the Etruscans held a more serene view of death than most cultures before and after. A couple, presumably husband and wife, recline comfortably on the lid of their sarcophagus, their demeanor suggesting that not only their spirits but their bodies are enjoying the hereafter. Their expressions are those of people at a pleasant dinner party, engaged in animated conversation with other guests, whom we cannot see. Part of the appeal of Etruscan sculpture is its material. While contemporary Greek artists to the east were working in marble, the Etruscans preferred terra cotta, which seems warmer than marble and can be modeled into a softer, more fluid sculptural form.

Possibly it was the warmth and humanity of these Etruscan images that inspired a special category of Roman sculpture—one that differentiated Roman

art from Greek. There can be no doubt that the Romans greatly admired the work of their conquered subjects. They made numerous copies of Greek sculptures (including our example of the *Spear Bearer*) and imitated the Greek style for much of their "official" sculpture, such as emperor figures. Sculptures of this sort are interesting historically and some are distinguished, but they pale by comparison to the Greek precedents. Where the Romans truly excelled was in a type of sculpture to which the Greeks had paid little attention—the portrait bust of an ordinary citizen.

One such example (**465**) is a portrait of a Roman husband and wife who are fully realized as individuals. Obviously, we cannot know what these people actually looked like, but it is safe to assume the sculptor made a good likeness, with a minimum of idealizing. The husband is old, the creases in his face well defined, his expression patient; we might read from his image a long experience in the trials of the world and gentle resignation to those trials. His wife seems stronger, less marked by pain, and her supportive clasp of the husband's hand is touching. Scholars have read into this pose the highly esteemed Roman virtues of *fides* (faith or fidelity) and *concordia* (harmony). Whereas the Greek sculptures, and many of the Roman ones (**78**), seem to exist in a world apart, these portrait busts are wonderfully accessible. They allow us to identify with people who have been dead for two thousand years.

Were it not for a tragedy that occurred in A.D. 79, we would know little more about Roman painting than we do about the Greek, so fragile and vulnerable to the elements is this medium. But in that year Mt. Vesuvius, an active volcano, erupted and buried the town of Pompeii, about a hundred miles south of Rome, along with the neighboring town of Herculaneum. The resulting lava and ashes spread a blanket over the region, and this blanket acted as a kind of time capsule. Pompeii lay undisturbed, immune to further ravages of nature, for more than sixteen centuries. Then in 1748 excavations were undertaken, and their findings were made public by the famous German archaeologist Joachim Winckelmann. Within the precincts of Pompeii the diggers found marvelous frescoes that were exceptionally well preserved. Pompeii was not an important city, so we cannot assume that the most talented artists of the period worked there. In fact, there is some evidence to suggest that the fresco painters were not Roman at all, but immigrant Greeks. Nevertheless, these wall paintings do give some indication of the styles of art practiced within the empire at the time.

One fresco, from a house known as the Villa of the Mysteries (**466**), shows a scene believed to represent secret cult rituals associated with the wine-god, Dionysus. The figures stand as though on a ledge, in shallow but convincing space, interacting only slightly with one another. Although the artist has segmented the mural into panels separated by black bands, the figures overlap these panels so freely that there is no strong sense of individual episodes or compartments. Rather, the artist has established two rhythms—one of the figures and another of the dividing bands—both contributing to a strong design unity.

465. *Double Portrait of Gratidia M. L. Chrite and M. Gratidius Libanus.* Last quarter of 1st century B.C. White marble with traces of color, height 23¾". Vatican Museums, Rome.

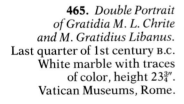

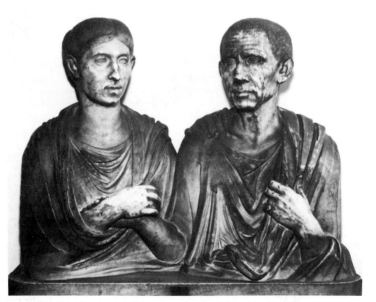

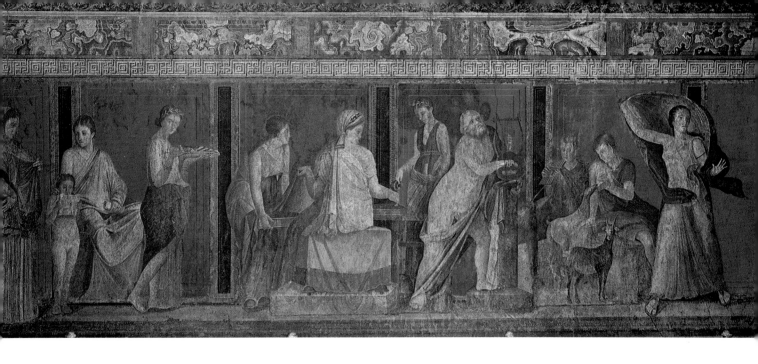

For all their production in painting and sculpture, the Romans are best known for their architecture and engineering. Earlier sections of this book have discussed the Pont du Gard (**410**) and the Pantheon (**413**). But the most familiar monument—indeed, for many travelers the very symbol of Rome—is the Roman Colosseum (**467**).

The Colosseum was planned under the Emperor Vespasian and dedicated in A.D. 80 as an amphitheater for gladiatorial games and public entertainments. A large oval covering 6 acres, the Colosseum could accommodate some fifty thousand spectators—about the same number as most major-league baseball stadiums today. Few of the games played inside, however, were as tame as baseball. Gladiators vied with one another and with wild animals in extraordinarily bloody and gruesome contests, made possible because an extensive system of sewers under the Colosseum could drain away the gore. On special occasions the whole structure could be filled with water for quite realistic naval battles.

While the Colosseum served as headquarters for some rather bloodthirsty activity, its architectural achievement represented the highest ideals of the Romans. Even in its ruined state this structure displays the genius of the Romans as builders. The Colosseum rises on three tiers of arches, each of the levels distinguished from the next by a different style of column between the arches. Around the base are eighty arched openings for entry and exit; it is said that the entire

466. Wall painting,
from the Villa of the Mysteries,
Pompeii. c. 50 B.C. Fresco.

467. Colosseum, Rome.
A.D. 72–80.
Concrete (originally faced
with marble); height 160′.
diameters 620′ and 513′.

building could be emptied in a matter of minutes. Above all, the structure is logical and coherent. Roman architects tell us in visual detail exactly how the building is organized—which parts are separate from other parts, where to enter, where to go, and so on. The exterior view gives us a clear sense of the inside, the walkways, the scheme as a whole. Today the Colosseum seems romantic; tourists dream of exploring it by moonlight. In its prime, with the sides intact and sheathed in marble, it must have been the crown of the empire.

Rome persisted as the capital of the civilized Western world until A.D. 330, when the emperor Constantine moved his government to Byzantium, which he renamed Constantinople (today Istanbul, in Turkey). This change ushered in a new phase in the history of art.

Byzantium

Byzantine art differs from its Greek and Roman precursors in two distinct ways. First, it is an art based on Christianity. Constantine was converted to the Christian faith, and, with a few exceptions, his successors followed that religion. No longer was art diffused into the portrayal of many gods and ideals. One God, one faith, one tradition—these became the standards of Byzantine art. Second, Byzantine art has an Eastern flavor in both style and materials. It seems more closely related to Russian models than to Western European ones. The Byzantine style, even for figurative art, is essentially flat, with an emphasis on elaborate decoration rather than naturalistic depiction. And, whereas the Greek or Roman artist might prefer to work in paint or marble, the Byzantine artist concentrated on the art of *mosaic*—small stones or pieces of tile arranged in a pattern.

We see an excellent example of this mosaic art in the portrait panel of the 6th-century emperor Justinian (**79**) and its companion piece, a mosaic depicting Justinian's queen, Theodora (**468**). The *Theodora* mosaic is especially splendid in its rich, vibrant colors and elaborate decorative details. Many scholars feel it was intended to reinforce the royal status of—perhaps even give religious status to—

468. *Empress Theodora and Retinue.* c. 547. Mosaic. San Vitale, Ravenna.

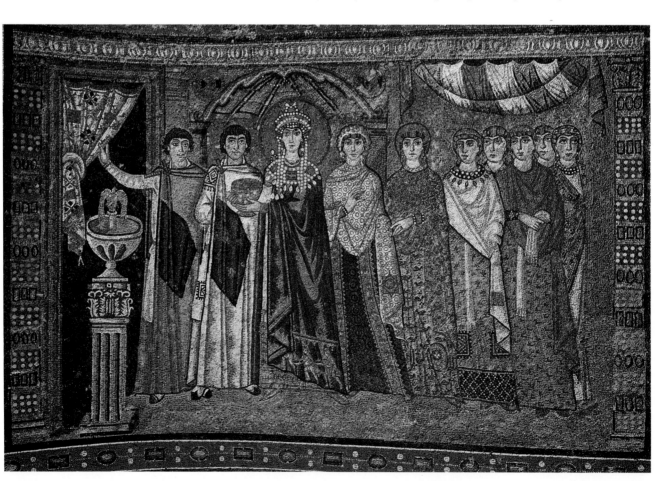

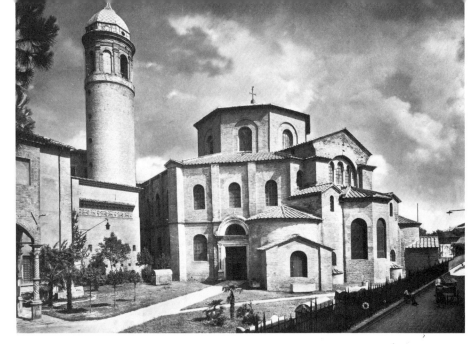

Justinian's queen, who was of low birth and had been an actress before her marriage. The quiet dignity of the figures and elaboration in details seems even more remarkable when we realize this image was put together from tiny pieces, like a giant picture puzzle.

The flatness of Byzantine art is well illustrated by this mosaic. Theodora is supposed to be in procession, with her retinue trailing behind her, but we get little sense of this. Even though the artist has used some overlapping, especially in the figures at right, all the figures appear to be in the same plane, and that plane is identical with the ornately decorated background. Compared to Greek and Roman figures, such as those on painted vases and Pompeiian frescoes, Theodora stands before us as a paper doll. She is, however, one of the loveliest, most sumptuous paper dolls ever.

Both Justinian's and Theodora's mosaics are housed in a building that represents one of the high points of Byzantine art—the church of San Vitale (**469**), built in the early 6th century about the same time that the great cathedral of Hagia Sophia was constructed in Istanbul (**414**). At this point Eastern styles in art and architecture had spread westward; San Vitale is in the Italian city of Ravenna. Its ground plan (**470**) reveals its somewhat unusual spatial organization—unusual, that is, for a church in Western Europe. Most Early Christian churches were simple rectangles; later, churches in the West adopted the cross plan, consisting of a long main section intersected by a shorter section at right angles to the first. In either of these plans one enters through a door at one end, and straight ahead at the other end is the altar. The axis, or main line of sight, is from door to altar, horizontally through the church. San Vitale, with its Eastern character, is not like that. It is a central-plan church, built in the form of an octagon, and so the focus of attention is in the center of the building, immediately under the dome. The major axis, therefore, is vertical, from floor to dome (or earth to Heaven), with the altar off to one side. The central plan remained a feature of Eastern churches long after the cross plan had become firmly established in the West.

The Middle Ages in Europe

Medieval European art is also a Christian art. It would be nearly impossible to understand Western art, from the time of Constantine's historic move of his capital in 330 until well into the 17th century, without taking into account the Roman Catholic faith. Of course, secular art was produced throughout this pe-

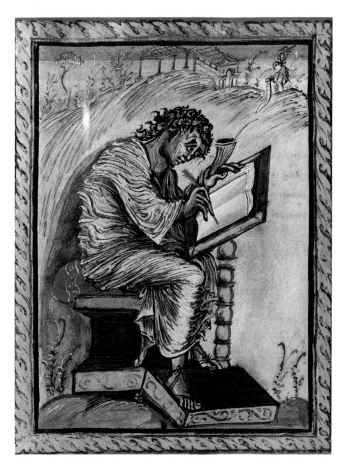

471. *St. Matthew the Evangelist,*
from *The Gospel Book
of Archbishop Ebbo.*
Before 823. Illumination,
10¼ × 7⅞″. Bibliothèque
de la Ville, Epernay.

riod, but a major portion of the art was done in the service of the Church or based
on religious themes. This is not to say that one must *be* a Christian to appreciate
the art. Art is art, and religion is religion. Some of the greatest artists drew freely
upon all the sources available to them, including religion, classical myths, histor-
ical events, literature, and drama. It is natural, though, that artists would turn to
the subjects most familiar to them, and for which they found a ready audience
and patronage. During the Middle Ages and beyond, this meant the Christian
church.

Christianity centers on the Bible, a collection of sacred writings put down
over many centuries and collected into one book (the word "bible" comes from
the Greek and Latin words for "book"), probably in the 8th century. For the
teaching and practice of faith, it was essential to possess a Bible, and in this era,
long before the invention of the printing press, manuscripts had to be copied
laboriously by hand. Most of the work was done by monks, who toiled in special
writing centers known as *scriptoria*. Gradually, the practice evolved of decorat-
ing, or *illuminating*, the prose manuscripts with drawings and paintings. Illumi-
nated Bibles appeared in Western Europe as early as the 8th century, and the
custom prevailed well into the 15th century. These volumes preserved not only
the literary and theological traditions of the Bible and other writings, but also an
artistic heritage. Painting in the sense that we know it—that is to say, a large,
freestanding painted work, such as an easel painting—did not really emerge in
Western Europe until the late 13th century, and even fresco painting was not
widespread. So we rely on these exquisite miniatures—called *illuminations*—to
follow the development of painting during the period.

Many illuminated books concentrated on the gospels of the New Testa-
ment, written by the four Evangelists, Matthew, Mark, Luke, and John. An illu-
mination from the 9th-century *Gospel Book of Archbishop Ebbo* (**471**) shows St.
Matthew hard at work transcribing his Gospel. Everything about him suggests a
frenzy of creative inspiration, from the agitated drapery of his clothing to the

intense concentration on his face. Even his feet and toes seem tensed by the effort of his project. Each of the Evangelists has a traditional symbol, and Matthew's is a winged man, which appears in the upper right corner of the painting. For the most part the monks who made these splendid illuminations were anonymous. We might suspect, however, that the artist of the St. Matthew painting suffered greatly over his arduous task, and felt a certain emphathy with Matthew struggling to get his Gospel written down.

The Middle Ages was the period when most of the great cathedrals of Europe were built. As discussed in Chapter 13 (pp. 328–329), the architectural style favored from about 1050 to 1200 was the Romanesque, based on round arches and vaults. After 1200 and into the 15th century the Gothic style prevailed, with its pointed arches and vaults and its emphasis on large stained-glass windows. The term "Gothic" was actually used by later writers of the Renaissance, who considered this architecture vulgar and used the word to mean "barbarian." Gothic-style architecture originated in France (**412**) and eventually spread to most of Western Europe.

Salisbury Cathedral in England, built in the 13th century, is a splendid example of the developed Gothic style (**472**). Its graceful spire, the tallest in England, rises to 404 feet—or nearly the height of a modern fifty-story apartment building. On the outside, the pointed arch is visible everywhere, and this theme is carried through inside the church. The ground plan (**473**) makes an interesting comparison to that of San Vitale (**470**). Salisbury is a very long church with a true cross plan and the spire located over the exact center. As with most other great churches, Salisbury Cathedral is heavily ornamented with sculpture.

left: 472. Salisbury Cathedral, England. 1220–70.

right: 473. Plan of Salisbury Cathedral.

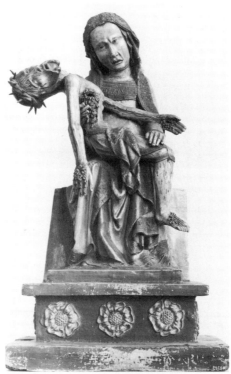

left: **474.** *The Gero Crucifix.*
c. 975–1000. Wood, height 6'2".
Cathedral, Cologne.

right: **475.** *Röttgen Pietà.* c. 1370.
Painted wood, height 10½".
Rheinisches Landesmuseum,
Bonn.

In the sculpture of the Middle Ages, the theme again was usually a sacred one. A life-size work from the 10th century, the *Gero Crucifix* (**474**) shows the enormous skill a medieval carver could attain, as well as the willingness to portray Christ in relatively naturalistic, not symbolic, fashion. Here Christ is shown, not as a deity, but as a suffering flesh-and-blood human. There is great pathos in this figure, especially in the face, which combines the agony of pain with resignation to the fate of violent death. Christ's body pulls downward, its flesh and muscles straining against the hands nailed to the cross. The sculptor of this figure clearly wished to elicit a direct, emotional response from the viewer and identification with Christ's torment and death.

In contrast to the *Gero Crucifix*, a small wooden pietà from the 14th century (**475**) distorts natural appearances for a different effect. Harsh and angular, the *Röttgen Pietà* portrays in ghastly detail the results of Christ's final suffering and the anguish of his mother. If the crucifix was meant to elicit from the viewer a sigh of compassion, the pietà would be more likely to call forth a shriek or a moan. Although less than a foot tall, this little sculpture captures in shocking precision the physical results of crucifixion. Christ's body is shrunken virtually down to the bone, drained of its lifeblood, which pours out from the five wounds in hands, feet, and side. For both compositional and expressive reasons, the sculptor has adjusted proportions in the figures. The Virgin's head is too large for her body, but this is necessary to convey properly the grief on her face, which is a major focal point. Christ's body, on the other hand, is proportionately too small in relation to that of his mother. If it had been carved in correct scale, the effect might have been strange—head and legs jutting out too far in both directions—and the sculpture would lose its compact form and powerful message.

Not all religious sculpture of the Middle Ages has this emotional quality. In the work of Claus Sluter, a Dutch artist who worked in France and who was interested in Greek and Roman sculpture, we find a cool majesty that anticipated the Renaissance. Sluter's most ambitious sculpture was the so-called *Moses Well* (**476**), a six-sided stone pedestal featuring life-size portraits of six Old Testament prophets, carved in very high relief. The view illustrated here shows Moses on the right, Isaiah on the left. Perhaps the word "portraits" seems unusual, since no one really knows what the patriarchs looked like. But Sluter has taken pains to depict them as individual personalities, vibrant and animated, so that we feel he has captured the character of each. The prophets do not stand rigidly, bonded to their background, but instead reach out to interact with one

another and with the viewer. The figures are monumental, seeming especially massive because they are encased in a heavy swirl of drapery. This last point is the key to why the *Moses Well* appears in this chapter rather than the next one. Sluter's work serves as a bridge between the art of the Middle Ages and the art of the Renaissance. In true Renaissance style the sculptor has carved lifelike, mobile figures; yet so profuse is the mountain of drapery that we have little sense of the body underneath. It remained for the next generation of artists to strip away the garments and study the entire human form.

Our two final artists in this chapter could easily be placed in the one that follows, as masters of the Renaissance. Some scholars would insist upon their being accorded this honor for having begun, through their own creative genius, the tremendous artistic outpouring that marked the Renaissance period. Others consider them to represent the last gasp of the Middle Ages. The point is that, like Claus Sluter, both artists were transitional, both were influential in making the leap between two quite different styles of art. We place them here mainly because their major sources of inspiration were the vestiges of Byzantine art to the East and the medieval Gothic tradition to the North. Succeeding generations of artists would look instead to Greece and Rome.

Duccio was an artist of Siena, in Italy. His masterpiece was the *Maestà Altar*, a multisection panel meant to be displayed on the altar of a church, of which we illustrate the part showing *Christ Entering Jerusalem* (**477**). What is most interesting about this painting is Duccio's attempt to create believable space in a large outdoor scene—a concern that would absorb painters of the next century. Christ's entry into the city, celebrated now on Palm Sunday, was thought of as a triumphal procession, and Duccio has labored to convey the sense of movement and parade. A strong diagonal thrust beginning at the left with Christ and his disciples cuts across the picture to the middle right, then shifts abruptly to carry our attention to the upper left corner of the painting—a church tower that is Christ's presumed goal. The architecture plays an important role in defining space and directing movement. This was Duccio's novel, almost unprecedented, contribution to the art of the period, the use of architecture to enclose and demarcate space rather than to act as a simple backdrop.

left: **476.** Claus Sluter.
Moses Well. 1395–1406.
Stone, height of figures c. 6'.
Chartreuse de Champmol, Dijon.

right: **477.** Duccio.
Christ Entering Jerusalem,
detail of *Maestà Altar.*
1308–11. Panel, 40 × 21".
Cathedral Museum, Siena.

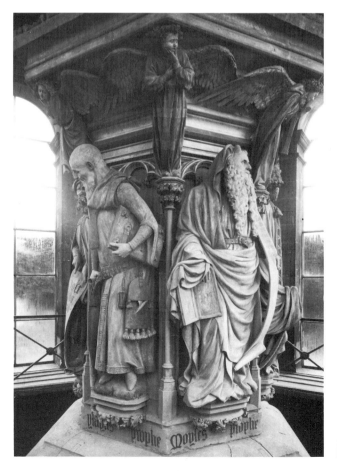

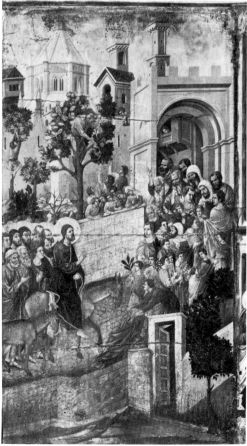

Duccio's contemporary, a Florentine artist named Giotto, made an even more remarkable break with art traditions of the Middle Ages. Most of Giotto's best work was in fresco (Chapter 7), and the most notable examples are in a small church in Padua, called the Arena Chapel. *The Lamentation* (**478**), a work depicting Mary, St. John, and others mourning over the dead Christ, illustrates Giotto's highly original use of space in painting. The scene has been composed as though it were on a stage and we the viewers are an audience participating in the drama. In other words, space going back from the picture plane seems to be continuous with space in front of the picture plane, the space in which we stand. Accustomed as we are now to this "window" effect in painting, it is difficult to imagine how revolutionary it was to medieval eyes, used to predominantly flat, decorative space in painting (**44,471**). Moreover, Giotto seems to have developed this concept of space largely on his own, with little artistic precedent. The figures in *The Lamentation* are round and full-bodied, clustered low in the composition to enhance the effect of an event taking place just out of our reach.

Giotto's grouping of the figures is unusual and daring, with Christ's body half-hidden by a figure with its back turned. This arrangement seems casual and almost random, until we notice the slope of the hill directing attention to Christ's and the Virgin's heads, which are the focal point. Yet another innovation—perhaps Giotto's most important one—was his interest in depicting the psychological and emotional reactions of his subjects. The characters in *The Lamentation* interact in a natural, human way that gives this and the artist's other religious scenes a special warmth.

Neither Duccio nor Giotto had an especially long career. Each did his most significant work in the first decade of the 14th century. Yet in that short time the course of Western art history changed dramatically. Both artists had sought a new direction for painting—a more naturalistic, more human, more engaging representation of the physical world—and both had taken giant steps in that direction. Their experiments paved the way for a flowering of all the arts that would come in the next century and would give us some of the greatest artists of all time—the Renaissance.

478. Giotto. *The Lamentation.* 1305–06. Fresco, 7'7″ × 7'9″. Arena Chapel, Padua.

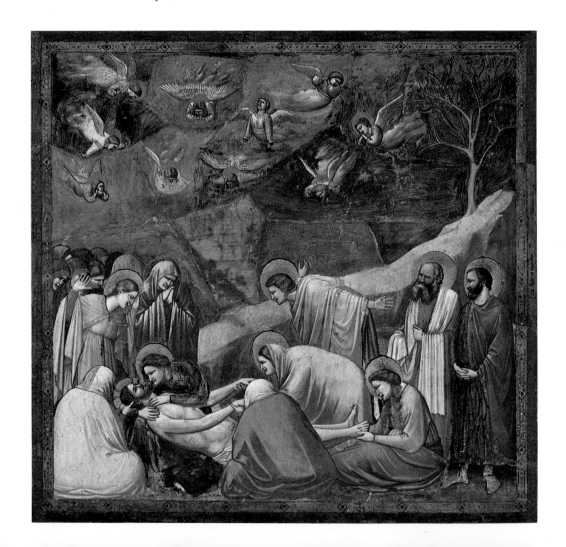

16

Renaissance to Revolution

*T*his chapter encompasses about four hundred years in the history of Western art—from the beginning of the 15th century to near the end of the 18th. The title "Renaissance to Revolution" is appropriate, because the period begins with the emergence of the Renaissance in Italy and concludes with three different revolutions—the French, the American, and the Industrial— all of which occurred at roughly the same time. One could argue, however, that the title "Revolution to Revolution" would have done just as well, for in a very real sense the Renaissance was a revolution in the world of art. Nearly everything about art changed, and changed quickly—the types of art being made, the way works of art looked, the materials used, the role of the artist, the identities and influence of patrons, and the artistic precedents that served as inspiration.

Before discussing the components of this "revolution" that was the Renaissance, we might address the question of why it occurred, especially why it occurred at the time and place it did. Italy in the 15th century offered a perfect combination of circumstances. For one thing, the conditions for artistic patronage were unusually favorable. Italy had developed powerful city-states engaged in extensive trade and banking. The members of the merchant class, at the head of this commerce, had a great deal of money to spend, were well educated, and were highly motivated for reasons of prestige and temperament to invest in art. Also, the Christian church was centered in Italy, and it provided another important source of patronage.

Besides the abundance of customers for art, there was ready inspiration for art. During this period a growing interest in the past led to the excavation of Classical Greek and Roman ruins, which revealed architecture and sculpture that had not been seen for centuries. Many of the leading artists of the Renaissance studied these works and took them as models.

Finally, we might be tempted to say that the Renaissance began in Italy in the 15th century because Michelangelo, Leonardo, Raphael, and others were

there. But perhaps another age with the same social and historical advantages would have spawned artists of equal genius. We cannot know for sure, but the problem is intriguing. Let us now sum up the changes that took place in art; we will refer to them again as they are illustrated in specific examples. Some have already been mentioned in previous chapters.

The types of art made during the Renaissance included all those that had been popular during the Middle Ages—sculpture, architecture, tapestry, and so forth—but there was a much greater emphasis on painting. Throughout the medieval period, painting, except for miniatures and some frescos, had languished. In the Renaissance it came back to life, with an energy perhaps never before seen. The Renaissance has been called "the age of painting"; this may be an overstatement in view of the splendid sculpture and architecture it produced, but the phrase is certainly true when we compare the Renaissance to the several centuries preceding it.

For the first time since the Classical periods of Greece and Rome the quest for "realism"—the faithful representation of the natural world—dominated art. Painters and sculptors dissected corpses to better understand the mysteries of human anatomy. Elaborate studies of perspective were undertaken (p. 131) to create the illusion of accurate three-dimensional space. It was during the Renaissance that the notion of art as mirror of the physical world became established, a notion that persists in some people's minds even today.

Since painting was newly popular, artists took great interest in its physical properties, and the materials of that medium changed radically. Oil paint, which was introduced in northern Europe (perhaps by Jan Van Eyck, **233**), soon eclipsed the more cumbersome tempera (Chapter 7, p. 196). New techniques of fresco painting were perfected. On the whole, there was a great deal of experimentation with materials, some of it rewarding, some of it disastrous. Leonardo da Vinci, whose curiosity about the world seems to have been boundless, was most prone to try new techniques, and some of his best-known works have deteriorated badly (**589**). Nevertheless, the experimentation led to some extraordinary developments.

The changing role of the artist is a fascinating aspect of the Renaissance. Up until that time the vast majority of Western artists had been anonymous. In isolated cases we have a name; we know, for example, that Praxiteles was the great genius of Greek sculpture, and we know what his work looked like (**364**). Beyond that, we have little information about the man himself. Even this much is an advantage over our knowledge of most artists in the 13th and 14th centuries. The medieval artist, in general, was considered a skilled craftsman, little more. A talented wood- or stone-carver might be given the same respect that today is accorded to a first-rate carpenter—valuable, indispensable when needed, forgotten when the job is finished. Of course, there were exceptions, and a few names have come down to us, but not many. It is for this reason that none of the artists' biographies in this book predate the 15th century.

Starting with the great masters of the Renaissance we suddenly have rather complete portraits of the artists—who they were, how they lived and worked, what they thought about art and life in general. For the first time artists were considered a breed apart, comprising a class of their own that transcended the social class determined by birth—not nobility, not bourgeoisie, not clergy, but a separate and elite category of people respected not because of who they were, but because of what they could *do*. They lived in the courts of the nobles and popes, they moved freely in good society, their company was sought after, their services in demand. That role has remained essentially unchanged into the 20th century—except that few patrons today keep an artist in residence.

As mentioned earlier, the character of art patronage reflected the changing times. Before the Renaissance only two groups of people could afford to be art patrons—the nobility and the clergy. Both continued to be active sponsors of art, but they were joined in the 15th century by a new merchant class, very rich, socially ambitious, fully able to support extravagant spending on art. These were the forerunners of today's corporate patrons of the arts. The climate could not have been more fertile for a flowering of art: the best artists were available, and virtually unlimited funds existed to support them.

One more element is needed to complete our picture of the Renaissance artist—the changing sources of inspiration. The Renaissance individual was very much aware of being part of a Golden Age, an age of reason and enlightenment and achievement. Only twice, to anyone's knowledge, had such a situation existed before. Renaissance artists cast their eyes backward to those they considered their natural teachers—the great masters of Greece and Rome. To their everlasting credit these later artists were not satisfied merely to imitate, but forged a new style of art that at least equaled the standards of the Classical world. With this preamble, then, let us look at the artists of the Renaissance.

The Renaissance in Italy

In 1401 the city of Florence announced an artistic competition, the winner of which would be awarded the commission for making sculptured bronze doors to decorate the Baptistry of the Cathedral. At least six artists were invited to submit trial pieces. The subject was to be the sacrifice of Isaac, from the biblical story in which God tested the faith of Abraham by requiring him to slay his son, Isaac. (At the last moment the Lord, convinced of Abraham's obedience, spared the boy.) Among those submitting designs to the competition was a twenty-three-year-old goldsmith, Lorenzo Ghiberti. Ghiberti's trial panel (**479**) shows a strong sense of composition; its action is compact, with a subtle curving rhythm from lower right to upper left, and the figures of Abraham and Isaac at middle right are emphasized to create a focal point. Isaac's nude body reveals Ghiberti's admiration for ancient statues and is a true Renaissance figure. Ghiberti won the prize and spent much of the next two decades working on the doors.

Shortly after the doors were installed, Ghiberti was asked to make another set, this time for the east side of the Baptistry, and this time without any need to prove himself in competition. The east doors were more than twenty-five years in the making, and finally were installed in 1452. So marvelous were their design

479. Lorenzo Ghiberti. *Sacrifice of Isaac.* 1401. Gilt bronze, 21 × 17½″. National Museum, Florence.

left: **480.** Lorenzo Ghiberti. "Gates of Paradise," east doors of the Baptistry, Florence. 1425–52. Gilt bronze, height 18′6″.

right: **481.** Donatello. *St. Mark.* 1411–13. Marble, height 7′9″. Or San Michele, Florence.

and craftsmanship that Michelangelo termed them the "Gates of Paradise," and so they have been called ever since (**480**).

Between the time of the first competition and the completion of the "Gates of Paradise"—half a century—Ghiberti's style had matured considerably. We saw one panel of the later doors in Chapter 11 (**360**). The artist had made extensive studies of perspective, allowing him to create the illusion of spatial depth on the shallow bronze doors. And he is in full control of three-dimensional volumes; some of the figures on the east doors are virtually in the round. The composition is simplified, less cluttered, easier to understand. In the span of time from the trial panel to the "Gates of Paradise," Ghiberti made the transition from the first tentative gropings of the Renaissance to a more assured style that foreshadowed the sculptures of Michelangelo's generation.

While Ghiberti was working on the first set of bronze doors for the Baptistry, he was assisted by, among others, the young sculptor Donatello. Donatello was born in Florence about 1386 and was apprenticed to Ghiberti by the age of seventeen. During his long career he worked in many different styles and in all the sculptural media then available—wood, stone, and metal. An early work, the statue of *St. Mark* in Florence (**481**), depends on Donatello's familiarity with two

sources of inspiration—ancient Greek and Roman sculptures and the Scriptures. The figure is as naturalistic as any of the Greek statues, yet there is a stamp of individual personality in both face and body that may have come from Donatello's reading of Mark's Gospel.

St. Mark shows many of the characteristics that came to typify Donatello's work and helps to explain why some writers consider Donatello to be the founder of modern sculpture. This statue is enclosed within a niche but is by no means dependent on the architectural framework for support. For the first time in centuries we see a sculpture that is totally self-sustaining—fully rounded and capable of standing on its own. Moreover, Donatello's figure is remarkably lifelike. St. Mark seems caught in the act of movement, and his body underneath the garments seems real, substantial, made of flesh and bone. If you compare this statue to the figures on Sluter's *Moses Well* (**476**), carved a mere decade earlier, you will appreciate Donatello's originality. Sluter's prophets are wrapped in massive drapery that has a life of its own, independent of the body. But St. Mark's clothing responds to the form underneath. Where the left knee bends outward, the robe falls back; where the right arm is pressed to the body, the sleeve wrinkles. We know that if St. Mark moved, the garments would move with him.

At the same time that Donatello was exploring the potential for naturalism and animation in sculpture, the first painters of the Renaissance were grappling with the problems of conveying these qualities on a flat surface. Among the first of those who could indisputably be called a Renaissance artist was the young genius known as Masaccio, whose name has been variously translated as "wicked Tom" and "slovenly Tom." Masaccio lived for only twenty-seven years, and there are just four works that can be attributed to him definitely. Nevertheless, his contribution to the development of Early Renaissance art was immense.

Masaccio's best-known painting is *The Tribute Money* (**482**), a fresco in the Brancacci Chapel in Florence. The story related in this fresco is taken from the Gospel of St. Matthew and concerns an event in the life of Christ. Christ's disciples, especially Peter, had questioned whether it was proper to pay taxes to the Roman government, considering that Christ was the Messiah and above such authority. But Christ pointed out the difference between earthly and spiritual obligations and counseled that the taxes be paid, saying "Render therefore unto Caesar the things which are Caesar's; and unto God the things that are God's" (Matthew 22:21). He urged Peter to go and catch a fish, which would have a coin in its mouth and to pay that coin to the tax collector.

To portray this fairly complicated story Masaccio has employed a device known as *continuous narrative*. Three different parts in the sequence of events are shown in the same painting. In the center, Christ is conferring with his disciples and instructing Peter to pay the tax. At left, Peter goes fishing and finds the coin;

482. Masaccio.
The Tribute Money. c. 1427.
Fresco, 8'2⅜" × 19'8¼".
Brancacci Chapel, Sta. Maria del Carmine, Florence.

at right, he turns the coin over to the Roman tax collector. Such a running narrative might have seemed awkward were it not for Masaccio's compositional powers. The most important scene is the conference among Christ and his twelve Apostles, just off center in the composition. Here the figures are drawn together in dramatic tension by their grouping and their gestures. The fishing segment is least important to Masaccio; he thrusts it far to the left in his composition. For the paying of the tribute money, the climax of the event, Masaccio has separated the two key figures—Peter and the tax collector—by an architectural background, with St. Peter framed in an arch.

All of Masaccio's figures are well constructed, standing in relaxed *contrapposto* poses (p. 295). This effect is especially apparent in the legs of the tax collector in his two appearances. Like Donatello's *St. Mark*, the figures have real, living bodies under their garments, bodies that seem to have the muscle and bone to move. A comparison of this work with Duccio's *Christ Entering Jerusalem* (**477**), painted just a little over a century earlier, will show that great strides had been made in using linear perspective to depict architecture in three-dimensional space. Also, Masaccio's shading and treatment of drapery give convincing roundness to the bodies. The figures have a dignity and gravity that mark them as true products of the Renaissance.

Masaccio's art had a profound influence on another Florentine painter, who came into prominence about a generation later—Piero della Francesca. In Piero's fresco, *The Resurrection* (**483**), we can see the artist's debt to Masaccio in the sure handling of linear perspective and the wonderful roundness of the bodies. Piero, however, was a skilled mathematician, and that is one of the things that sets his composition apart from the work of the earlier master. This picture is constructed as a triangle, with Christ's head at the apex. The triangle moves down to the two lower corners of the painting and cuts across the bottom, pulling the figures of Christ and the sleeping soldiers into one coherent group. There is a pronounced vertical axis from Christ's face straight down to the bottom of the painting. In spite of this structure, the picture does not seem rigid. The poses of the soldiers, as they lie sprawled in sleep, are by no means stiff. Also, Piero has introduced elements of asymmetrical balance to offset the predominantly symmetrical balance of the triangle. Christ's upraised arm with the banner juts out to one side of the central axis while his bent left knee pushes out to the other side. At their best, Renaissance painters imposed an order, often a geometrical order, on their compositions, but they did not let that order overwhelm their art.

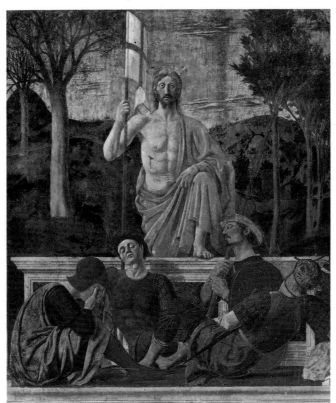

483. Piero della Francesca. *The Resurrection*. c. 1460. Fresco, 9′6″ × 8′4″. Gallery, Palazzo del Commune, Borgo San Sepolcro, Italy.

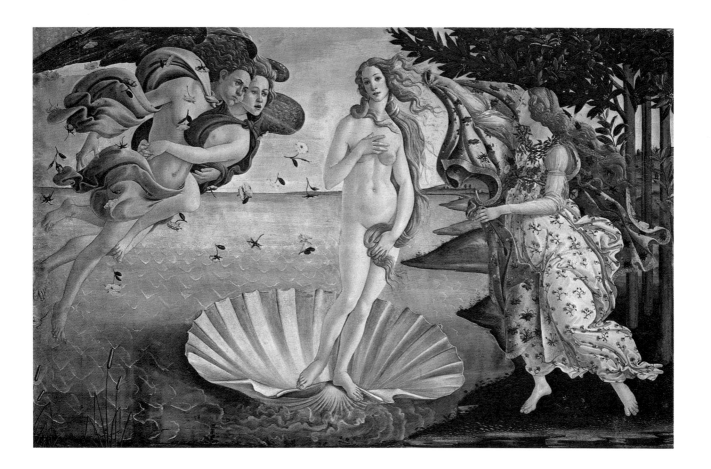

484. Sandro Botticelli.
The Birth of Venus. c. 1480.
Tempera on canvas, 6'7" × 9'2".
Uffizi, Florence.

Yet another Florentine painter, a quarter-century younger than Piero, was Sandro Botticelli. Botticelli was rather more sophisticated and worldly than most of his artist-contemporaries. While he painted many religious subjects, his earlier works took their subjects from Greek and Roman culture and the classical myths. Also, he had a special fascination with detail and with the depiction of women as graceful, exquisite beings, so weightless they often seem about to float out of the paintings. Early in his career Botticelli had the great fortune to enjoy the patronage of the Medici, the ruling merchant family of Florence. At the beginning of this text, in Chapter 1, we pointed out that Botticelli's *Primavera* (**21**) was painted for a villa belonging to the Medici. Apparently, two large works . were commissioned from Botticelli for that same villa, and the other was *The Birth of Venus* (**484**).

Venus was the Roman goddess of love and beauty. According to legend, she was born from the sea, and so Botticelli depicts her floating upward on a shell. Two Zephyrs, or wind gods, blow her gently toward the shore, where a figure representing spring waits ready to clothe Venus in a flowing garment. The portrayal of Venus, a pagan goddess, gave Botticelli a justification for doing what no artist, insofar as we know, had done since classical times—creating a large-scale female nude. Venus' pose is modeled after a Roman sculpture of the goddess, which Botticelli had studied in the Medici collection, but her lightness, her fragile quality, her delicate beauty and billowing hair—these are Botticelli's own.

As we can see in *The Birth of Venus,* Botticelli has mastered the technique of painting round, full-fleshed bodies. However, he is not nearly as interested as later artists would be in depicting deep, three-dimensional space. The space in *The Birth of Venus* is actually quite shallow, with the sea and horizon and trees serving as a backdrop, almost a stage set, and the figures are all set in the same plane. These characteristics mark Botticelli as an artist of the Early Renaissance. Painters of the next generation would strive to set their figures naturally in a deeper landscape.

Leonardo da Vinci
1452–1519

No clues are offered by the scant knowledge about Leonardo's origins to explain what spawned perhaps the most complex imagination of all time. Leonardo was the illegitimate son of a peasant woman known only as Caterina and a fairly well-to-do notary, Piero da Vinci. He was raised in his father's house at Vinci and, when he was about fifteen, apprenticed to the Florentine artist Andrea del Verrocchio, in whose workshop he remained for about ten years.

In 1482 Leonardo left Florence for Milan, where he became official artist to Lodovico Sforza, duke of that city. There the artist undertook many projects, foremost among them his famous painting of the *Last Supper*, for which he used an experimental mural technique that caused the painting to deteriorate badly soon after its completion (Epilogue, **589**). Leonardo remained with Sforza until the latter's fall from power in 1499, after which he returned to Florence.

Sketches and written records indicate that Leonardo worked as a sculptor, but no examples remain. Only about a dozen paintings can be definitely attributed to him, and several of these are unfinished. There are, however, hundreds of drawings, and the thousands of pages from his detailed notebook testify to the man's extraordinary genius. If Leonardo completed relatively few artistic works, this can only be ascribed to the enormous breadth of his interests, which caused him repeatedly to turn from one subject to another. He was a skilled architect and engineer, engrossed in the problems of city planning, sanitary disposal, military engineering, and even the design of weapons. He made sketches for a crude submarine, a helicopter, and an airplane—with characteristic thoroughness also designing a parachute in case the air-plane should fail. He made innovative studies in astronomy, anatomy, botany, geology, optics, and above all mathematics. His contemporaries reported his great talent as a musician—he played and improvised on the lute—as well as his love of inventive practical jokes.

In 1507 Leonardo was appointed court painter to the King of France, Louis XII, who happened to be in Milan at the time. Nine years later the aging artist was named court painter to Louis's successor, Francis I. Francis seems to have revered him for his towering reputation as an artist and his crisp intellect, but to have expected little artistic production from the old man. The king provided comfortable lodgings in the city of Amboise, where Leonardo died.

Solitary all his life, Leonardo did not marry, and he formed very few close attachments. His obsession seems to have been with getting it all down, recording the fertile outpourings of his brain and hand. In his *Treatise on Painting*, assembled from his notebook pages and published after his death, he advised painters to follow his method: "You should often amuse yourself when you take a walk for recreation, in watching and taking note of the attitudes and actions of men as they talk and dispute, or laugh or come to blows with one another . . . noting these down with rapid strokes, in a little pocket-book which you ought always to carry with you . . . for there is such an infinite number of forms and actions of things that the memory is incapable of preserving them."[1]

Leonardo da Vinci. *Self-Portrait.* c. 1512.
Chalk on paper, 13 × 8¼".
Biblioteca Reale, Turin.

We come now to a period known as the *High Renaissance*—a brief but glorious time in the history of art. In barely twenty-five years, from shortly before 1500 to about 1525, some of the most celebrated works of Western art were produced. Many artists participated in this brilliant creative endeavor, but the giants among them were unquestionably Leonardo da Vinci and Michelangelo.

The term "Renaissance man" is applied to someone who is very well informed about, or very good at doing, many different, often quite unrelated, things. It originated in the fact that several of the leading figures of the Renaissance were artistic jacks-of-all-trades. Michelangelo was painter, sculptor, poet, and architect—incomparably gifted at all. Leonardo was painter, inventor, sculptor, architect, engineer, scientist, musician, and all-around intellectual. In our age of specialization these accomplishments seem staggering, but during the heady years of the Renaissance nothing was considered impossible.

Leonardo is the artist who most thoroughly embodies the term "Renaissance man"; many people consider him to have been the greatest genius who ever lived. Leonardo was possessed of a brilliant and inquiring mind that accepted no limits. Throughout his long life he remained absorbed by the problem of how things work, and how they might work. A typical example of his investigations is the well-known *Study of Human Proportions* (**485**), in which the artist sought to establish ideal proportions for the human body by relating it to the square and the circle. Above and below the figure is Leonardo's eccentric mirror writing, which he used throughout his notes and journals.

Despite his vast accomplishments, Leonardo often had difficulty completing specific projects; many of his most ambitious works were left unfinished, including his best-known painting, the *Mona Lisa* (**486**). The *Mona Lisa* has been the object of special fascination ever since it was painted. Songs, poems, and treatises have been written about the sitter's smile, and her image often turns up in remarkably unexpected contexts (**333,531**). Just what is so magical about this painting is hard to define. Certainly the "mysterious" smile on the woman's face contributes to the *Mona Lisa*'s special aura, but it alone is not sufficient to ex-

486. Leonardo da Vinci. *Mona Lisa.* c. 1503–05. Oil on panel, 30¼ × 21″. Louvre, Paris.

485. Leonardo da Vinci.
Study of Human Proportions
According to Vitruvius. c. 1485–90.
Pen and ink, 13½ × 9¾″.
Academy, Venice.

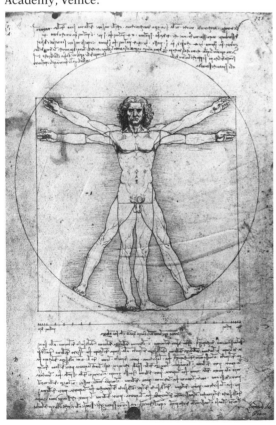

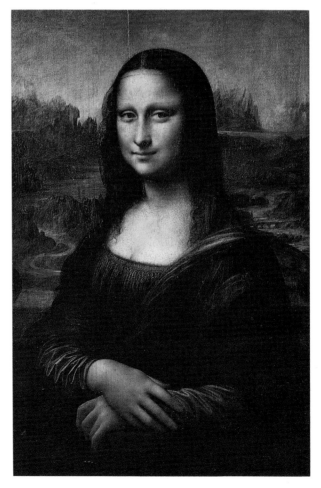

Michelangelo
1475–1564

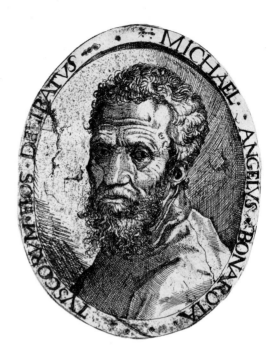

He is beyond legend. His name means "archangel Michael," and to his contemporaries and those who came after, his stature is scarcely less than that of a heavenly being. He began serious work as an artist at the age of thirteen and did not stop until death claimed him seventy-six years later. His equal may never be seen again, for only a particular time and place could have bred the genius of Michelangelo.

Michelangelo Buonarroti was born in the Tuscan town of Caprese. According to his devoted biographer and friend, Giorgio Vasari, the young Michelangelo often was scolded and beaten by his father for spending too much time drawing. Eventually, however, seeing his son's talent, the father relented and apprenticed him to the painter Domenico Ghirlandaio. At the age of fourteen Michelangelo was welcomed into the household of the wealthy banker Lorenzo de' Medici, who operated a private sculpture academy for promising young students. There he remained until Lorenzo's death, after which Michelangelo, just seventeen years old, struck out permanently on his own.

He traveled to Venice and Bologna, then finally to Rome, where he attracted the first of what would become a long list of patrons among the clergy. A *Pietà* (Virgin mourning the dead Christ) made in 1500 and now in the Vatican established his reputation as a sculptor. From that time until his death he never lacked for highly placed patrons. He served—and survived—six popes, and in between accepted commissions from two emperors, a king, and numerous members of the nobility. All his life he struggled to keep a balance between the work he wanted to do and the work demanded of him by his benefactors. His relationships with these powerful figures were marked continually by squabbles about his payment, insults given and forgiven, flight from the scene of a particular commission followed by penitent return to continue the work.

Michelangelo served these masters, at various times, as painter and architect, but he always considered himself above all to be a sculptor. Much of his time was spent supervising the quarrying of superior stones for sculptural projects. His greatest genius lay in depictions of the human figure, whether in marble or in paint. Vasari writes that "this extraordinary man chose always to refuse to paint anything save the human body in its most beautifully proportioned and perfect forms." To this end he made extensive anatomical studies and dissected corpses to better understand the inner workings of the body.

Michelangelo never married, though he formed a number of passionate attachments during his life. These inspired the artist, always a sensitive and gifted poet, to write numerous sonnets. One of his most poignant verses, however, was not addressed to a loved one but to his friend Vasari, a few years before his death:

> The course of my long life has reached at last
> In fragile bark o'er a tempestuous sea,
> The common harbor, where must rendered be
> Account of all the actions of the past....
> Painting and sculpture satisfy no more
> The soul now turning to the Love Divine,
> That oped, to embrace us, on the cross its arms.[2]

Anonymous artist. *Portrait of Michelangelo.* 16th century. Staatliche Museen Preussischer Kulturbesitz, Berlin.

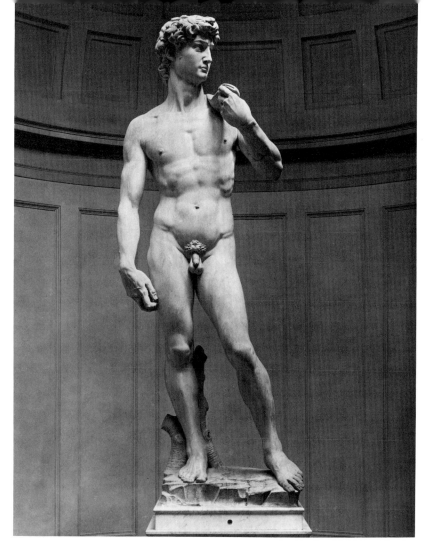

487. Michelangelo. *David.*
1501–04. Marble, height 18′.
Academy, Florence.

plain the painting's fascination. For this work Leonardo was in masterful control of a newly developed technique known as *sfumato* (deriving from the Italian for "smoke"), which involves painting in thin glazes to achieve a hazy, cloudy atmosphere and a sense of three-dimensional form. Behind the model is a fantasy landscape, vague and undefined, another element of the painting's mystery. Some of the intrigue of the *Mona Lisa* must lie in its contradictions. It presents to us a Florentine matron, not at first glance beautiful, posed almost rigidly in the exact center of the painting, showing little of her emotions. Yet further acquaintance with the subject reveals beauty so unique as to ignore conventional ideas of beauty, a pose that is not rigid but serene, and a personality which, though elusive, draws us to her.

During the years when Leonardo was painting the *Mona Lisa,* Michelangelo, a quarter-century younger, also was in Florence, at work on one of the projects for which he is best known. That two such extraordinary figures could live and work in close proximity, surrounded by numerous others of scarcely lower stature, demonstrates how remarkable a time the High Renaissance was.

By the age of twenty-five Michelangelo had established his reputation as a sculptor. A year later he received the commission for, and began work on, a colossal image of the biblical hero David (**487**), the young Hebrew shepherd who killed the giant Goliath with a single stone from his slingshot. The *David* statue reveals Michelangelo's debt to Classical sculptures; we might compare it to the Roman copy of the Greek *Spear Bearer* (**462**). *David* is not, however, a simple restatement of Greek art. The Greeks knew how bodies looked on the outside. Michelangelo knew how they looked on the inside, how they worked, because he had studied human anatomy and had dissected corpses. He translated this knowledge into a figure that seems made of muscle and flesh and bone, though all in marble.

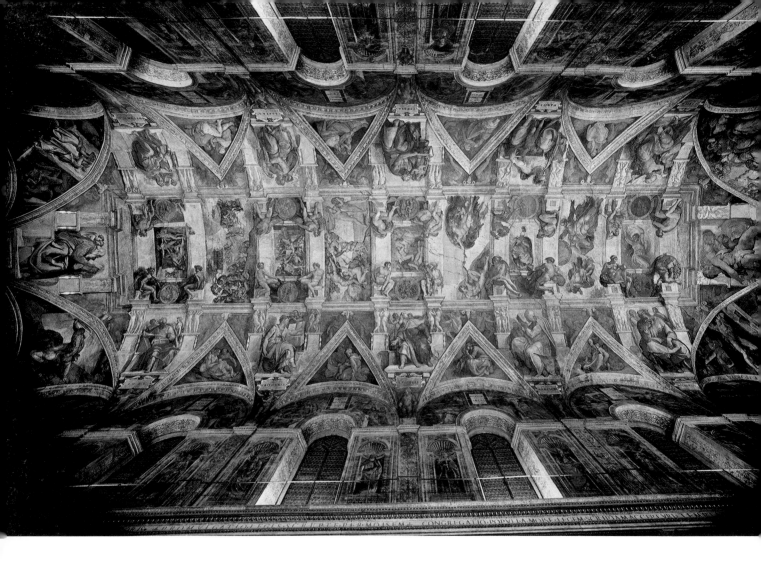

488. Michelangelo.
Ceiling, Sistine Chapel. 1508–12.
Fresco, 44 × 128′.
Vatican, Rome.

There are other characteristics that make *David* a Renaissance sculpture, not a copy of a Greek one. For one thing, it has a tension and energy that is missing from Greek art. Some writers have suggested that the statue is a self-portrait—not so much that it duplicates Michelangelo's features, but that it expresses the creative tension of its maker. The hands especially are taut and strong, held at the ready for action. Another Renaissance quality is the expression on David's face. Classical Greek statues generally bore an expression of beatific calm, showing the subject to be above earthly concerns. But David is young and vibrant—and angry, angry at the forces of evil represented by the giant Goliath. Michelangelo equated perfect beauty with perfect truth and honor; he seems to have found these qualities in the story of David and to have embodied them in his statue of the young conqueror.

Four years after the completion of *David*, Michelangelo was in Rome, working on sculptures for the tomb of Pope Julius II (to be completed in the Pope's lifetime). Julius interrupted this project and persuaded, some would say coerced, his young artist to undertake another commission, the decoration in fresco of the ceiling in the Sistine Chapel at the Vatican (**488**). Such was the power of the Papacy and of patronage in those times that even an artist of Michelangelo's stature could be readily controlled, and Michelangelo writhed under this system.

Chapter 7 explained some of the difficulties of the fresco technique. Paint must be applied to the fresh plaster just when it has the proper degree of dampness; only a small area can be covered at a time; and the painting must be done directly, with no allowance for correction of mistakes. Add to these problems the fact that Michelangelo had to cover an area 44 by 128 feet (700 square yards), working on a scaffolding 68 feet above the floor, lying always on his back in a

489. Michelangelo. St. Peter's, apse and dome. 1546–64. Vatican, Rome.

cramped position with paint and plaster dripping into his face, and you can appreciate how arduous was this task that he undertook.

Even more overwhelming than the physical difficulties was the challenge of making a coherent composition in such a huge area. Because the artist was Michelangelo, the composition is not merely coherent but is one of the great masterpieces of all time. Michelangelo organized the ceiling into a painted architectural framework of squares, rectangles, and triangles. These segments depict Old Testament stories of the creation of the world, the creation of Adam (**40**) and of Eve, the Fall of Man, and other biblical events. The figures have the same anatomical fullness and muscular energy as Michelangelo's sculptures; indeed, many of them have the cool, "stonelike" appearance of painted sculptures (**590**).

Just as Pope Julius II had urged Michelangelo to work as a painter, one of Julius' successors, Pope Paul III, encouraged the sculptor to work as an architect. In 1546 Paul named Michelangelo the official architect of the new St. Peter's—the basilica (or ceremonial cathedral) that is the "headquarters" of the Roman church (**489**). By the time he began work on this project he was an old man, well into his seventies and physically tired, but his creative vigor was undiminished. Michelangelo designed a majestic cross-shaped structure that now comprises the *apse* of St. Peter's (the section containing the altar) and topped it with a towering dome, which he did not live to see completed. (The building was substantially enlarged over the next hundred years; Bernini's colonnade, which we saw in Chapter 14 [**439**], was added in the 17th century.) Even at his advanced age Michelangelo did not relax his lifelong perfectionism. He studied the engineering problems of the huge building, and he mastered them. Today Michelangelo's dome stands as the world symbol for the Roman Catholic Church.

Although Michelangelo could be pressed into service as an architect, other 16th-century artists specialized in this field. Foremost among them was Andrea Palladio, architect of the Villa Rotonda (**490**), near Vicenza—the architect's birthplace. The Villa Rotonda, strange as it may seem to modern tastes, was

490. Andrea Palladio. Villa Rotonda, Vicenza. Begun 1550.

planned as a country house for its owners. Like most of his contemporaries, Palladio looked to ancient Greece and Rome for inspiration, and he apparently believed that the Roman nobility lived in houses of this sort. The villa is absolutely symmetrical all around. Its basic structure is a square, with identical Greek-style porches on each of the four sides, not unlike the entrances to Greek temples (**409**). At the very center is a round salon (the word "rotonda" refers to a round room) reaching up through the building and capped with a low dome. Palladio's architecture epitomizes the "classic" style that would send out echoes for centuries to come. Across the United States, even in small towns, you can see banks and government buildings that resemble the Villa Rotonda.

Besides Leonardo and Michelangelo, three other painters, each just a few years younger than Michelangelo, made far-reaching contributions to the art of the High Italian Renaissance. They are Giorgione, Raphael, and Titian.

The iconography of Giorgione's painting *The Tempest* (**491**) is unknown. Even the artist's contemporaries seem not to have known what story he was depicting or to have been able to identify the nude woman nursing a child at right and the soldier (or shepherd) at left. Most likely Giorgione was making reference to some event in Greek or Latin poetry, or perhaps he was trying to evoke a classical mood. But regardless of the meaning of its subject, *The Tempest* makes an important contribution to Renaissance art in the way it is composed. Artists of earlier generations, even up to Botticelli (**484**), would compose a scene by concentrating on the figures and painting the landscape as a kind of backdrop. Giorgione, however, has started by constructing a landscape and then placing his figures in it naturally. This approach paved the way for the great landscape paintings of the centuries to follow. In *The Tempest*, as the title implies, the subject is really the approaching storm, which closes in dramatically over the city while the two foreground figures are still bathed in sunlight. Giorgione's principal interest seems to have been the contrast of bucolic foreground against the city rendered in careful perspective, with the two drawn together by the

above: **491.** Giorgione. *The Tempest.* c. 1505.
Oil on canvas, 32¼ × 28¾".
Academy, Venice.

right: **492.** Raphael.
Pope Leo X with Two Cardinals.
c. 1518. Oil on wood, 5'⅝" × 3'8⅞".
Uffizi, Florence.

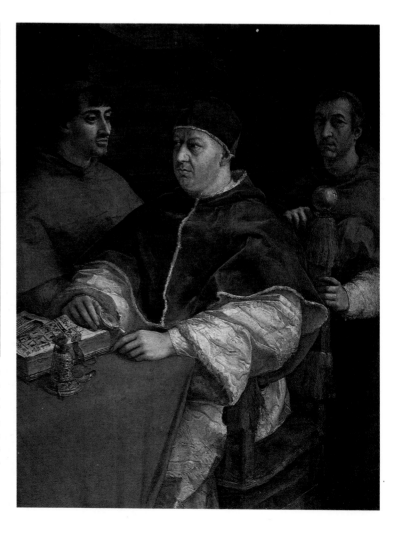

violent effects of nature. The storm and the lush vegetation create a world in which nature dominates, not people, and the painting evokes a powerful, compelling mood of apprehension and anticipation.

Raphael also was capable of placing figures in a believable setting, as we saw in his brilliant fresco *The School of Athens* (**230**). But for the painting illustrated here, *Pope Leo X with Two Cardinals* (**492**), the artist has deemphasized the architectural setting and moved in close to create a true and perceptive portrait. As Julius II had been Michelangelo's great patron, Leo X was Raphael's. Leo was the son of Lorenzo de' Medici (Chapter 1, pp. 17–18), and the cardinals on either side of him are his nephews. Raphael has not flattered the pope. The pontiff we see is seriously overweight and has a puffy face and rather coarse features. Despite its unflinching realism, the portrait conveys Leo's majesty and power, emanating not just from the office but from the man.

Even before Raphael painted the portrait of Leo X, the artist Titian, Raphael's contemporary, had declined to become the pope's official artist. Possibly Titian hoped that a career of greater scope awaited him. If so he was not disappointed, for Titian eventually achieved an international reputation, numbering among his many royal patrons King Philip II of Spain, King Francis I of France, and, above all, the Holy Roman Emperor Charles V.

The term "Roman" here requires some explanation. In the mid-16th century the Holy Roman Empire comprised an area of Europe reaching from the borders of France at the west to Poland and Hungary in the east—roughly the size of modern-day Germany, Austria, and parts of northern Italy. Its ruler, Charles V, was not Roman at all but Austrian, and he reigned as the most powerful monarch in the West. Such was the patron that Titian secured.

After a time the emperor refused to be painted by anyone *but* Titian. In *Charles V at Mühlberg* (**493**) the artist has created the image of a great hero—majestic yet honorable, stalwart yet kind, the defender of the Christian faith on the field of battle. We know that Charles was quite short in stature, and so the

493. Titian.
Charles V at Mühlberg. 1548.
Oil on canvas, 10'10¾" × 9'1⅞".
Prado, Madrid.

artist has cleverly bowed the horse's head to make its rider more imposing. Unlike Raphael, Titian did not limit himself to a strict duplication of his subject's features; he probably improved a bit on nature in drawing the emperor's face. Also, he made sure to pose Charles in splendid royal armor, on a prancing horse, isolated against a vivid sky—all of these factors designed to enhance the ruler's power.

By the time of Titian and his contemporaries, the style that can be identified as Renaissance had begun to spread outward from the Italian peninsula. When Renaissance ideals penetrated the North—Germany, Switzerland, northern France, and the Netherlands—they changed the look of art and swept away the last vestiges of the Middle Ages.

The Renaissance in the North

The first half of the 16th century was a time of tremendous spiritual, intellectual, and artistic upheaval in northern Europe. The Protestant Reformation was in full swing, bringing with it the establishment of new Christian denominations—Anglican, Lutheran, and Calvinist—which would split away large numbers of people from the Church of Rome. Literary and philosophical explorations emphasized the Greek and Roman classics, and gave rise to the movement known as *humanism*. And Renaissance styles in art, which had appeared in Italy a century earlier, now sprang up in the North. All this activity can be traced in part to the new ease of communication. The printing press, developed in the mid-15th century, made possible a dramatic increase in the spread of books and artistic images. Travel throughout Europe became far more common, not just for trade, but for pleasure and study. Many Northern artists made pilgrimages to Rome and Florence to examine the work of their Italian contemporaries.

We have already seen several works by two of the greatest Northern masters, Jan van Eyck (**86,233**) and Albrecht Dürer (**65,175,255,263**). Here we turn to Hans Holbein the Younger, a German artist who was among the first of the true cosmopolitans—well educated, well traveled, at home in many cities. Holbein was born in Augsburg, in southern Germany, but lived for many years in Switzerland. After traveling extensively in France, Italy, and the Netherlands, he eventually settled in London, where he became court painter to King Henry VIII. It is largely through Holbein that we have a visual record of that most intriguing of monarchs (**494**). The painting shows two characteristics of the style that made Holbein one of the greatest portraitists ever. On the one hand, every aspect of the subject's appearance is rendered in careful detail, from the hairs in his beard to the textures of skin, clothing, and fur. On the other, the artist has penetrated surface appearance to give us an imposing character study. He has posed the monarch full front, so that he dominates and fills the picture space, the very image of arrogant kingship at the height of its powers. Henry confronts and overwhelms the viewer—much as he must have confronted the papacy, his own ministers in England, and, for that matter, all six of his wives.

Pieter Bruegel the Elder, an artist who worked in Antwerp and Brussels, also was well educated and well traveled, but his work took an opposite path from that of Holbein. Whereas Holbein concentrated on extravagant portraits of the nobility, Bruegel is best known for his animated genre scenes of the peasantry at work and play. *Peasant Wedding* (**495**) depicts the celebration, held in a barn, after the nuptials of a young couple. Just to right of center a hanging cloth, on which is suspended something like a crown, isolates the bride, who sits looking rather pleased with herself—presumably because she has made a good match. There is disagreement about which figure is the groom; some art historians identify him as the man in dark clothing leaning backward just at the center of the composition.

Bruegel employed an interesting compositional device for this painting. The table, slanting diagonally from lower right to upper left, pulls together a large number of people in conviviality but without confusion. His special genius,

left: **494.** Hans Holbein the Younger.
Henry VIII. 1540. Panel, $32\frac{1}{2} \times 29''$.
National Gallery, Rome.

below: **495.** Pieter Bruegel the Elder.
Peasant Wedding. c. 1565.
Oil on panel, $3'8\frac{7}{8}'' \times 5'4''$.
Kunsthistorisches Museum, Vienna.

however, lies in painting these people as *types*—as "cheerful peasants"—yet also as individuals. If you examine each character, you begin to speculate about emotions, thoughts, reactions. The bagpiper at center left: Surely he wishes he could stop playing and eat some of the delicious food going by. The pair at far right: Are they discussing the details of the marriage contract and assessing the match? The couple immediately to the bride's left, variously identified as her parents or the groom's: They don't look especially happy. In fact, they look downright grim. Have they made a poor bargain, or are they pessimistic about the outcome of this marriage? All in all, *Peasant Wedding* is a marvelous study in personality and in visual organization.

Once the Northern Renaissance caught up with its Italian predecessor, the North never again lagged behind. Starting with the 17th century, although there continued to be special regional styles, art developments throughout western Europe moved forward at the same pace.

17th-Century Europe: Post-Renaissance and Baroque Styles

The Protestant Reformation in northern Europe was extremely successful and drew large numbers of people away from the Roman Catholic Church. Deeply wounded, the Church of Rome regrouped itself and struck back. The Catholic Counter Reformation, begun in the second half of the 16th century and continuing into the 17th, aimed at preserving the strength it still had in the southern countries, and perhaps recovering some lost ground in the North. Spain and Italy were the two major centers of the Counter Reformation, and some artists we shall look at were deeply involved in its activities.

Our first two artists in particular are associated with the Counter Reformation and can serve as a transition from the 16th century to the 17th. They are difficult to categorize, because their styles, while very different from those of the High Renaissance, do not fit either with the Baroque style we shall consider presently. Some writers have labeled their work *Mannerist*—a term that implies a dramatic use of space and light and a tendency toward elongated figures.

The first of the two artists was the Italian master Tintoretto, born in Venice. His *Last Supper* (**496**) makes an interesting comparison with Bruegel's *Peasant Wedding*. Like Bruegel, Tintoretto has organized a large group of people by

496. Tintoretto. *The Last Supper.* 1592–94. Oil on canvas, 12' × 18'8". San Giorgio Maggiore, Venice.

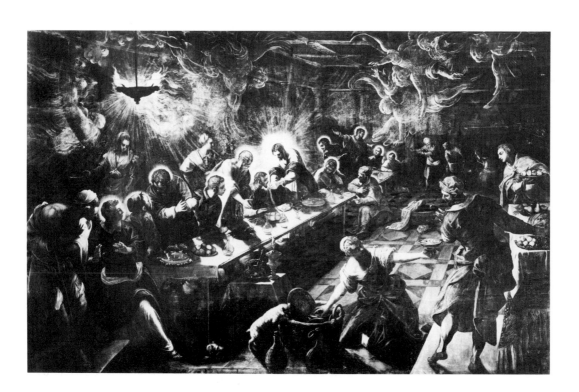

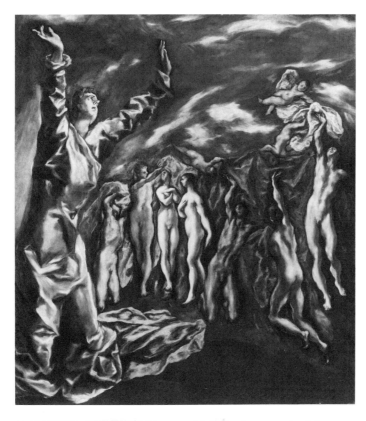

497. El Greco.
The Vision of St. John. c. 1610.
Oil on canvas, 7'3½" × 6'4".
Metropolitan Museum of Art,
New York (Rogers Fund, 1956).

means of a table set in a sharply diagonal composition. The mood of the two paintings, however, could hardly be more different. Bruegel's atmosphere is one of light-hearted—even slightly vulgar—celebration. But Tintoretto's picture portrays a religious subject, and he has given it a dramatic and mystical treatment.

The scene of the *Last Supper* takes place a few days before Christ's death and depicts the moment when Christ breaks bread and gives it to his disciples to eat—the basis for the sacrament of Holy Communion. Christ's head is brilliantly lighted, and clouds of angels waft toward him, making it clear that a supernatural event is taking place in this ordinary setting. The serving attendants, who are tied to earthly concerns, go about their business, oblivious to the spiritual drama, but Christ's disciples are very much caught up in the great mystery. Small halos of light form around all their heads to indicate their holiness— except for the head of Judas, who would soon betray Christ, and who sits alone on the opposite side of the table.

The artist most closely associated with the Catholic Counter Reformation was Domenicos Theotocopoulos, known as El Greco. We saw his *Crucifixion* in Chapter 3 (**76**). Another work from the same period, *The Vision of St. John* (**497**), depicts a scene from the biblical Book of Revelation, when all those martyred for their religion rise up and demand vengeance, and all of them are given white robes. El Greco's figures are extremely elongated; they reach upward in nervous movement like licks of flame. St. John, author of the Book of Revelation, is pictured on the left, transported in visionary rapture, the effect of which El Greco conveys by the turbulent movement of John's robe. Actually, the important point about this painting is that it *is* a vision, and is not meant to be realistic or earthly in any way. El Greco was striving to create an image that transcends this world, that provides a key to the spiritual world.

Tintoretto's and El Greco's works have some elements in common, especially in their emphasis on the spiritual, but we cannot link them with each other or with the products of other artists as constituting a particular style, as we could with the Renaissance. The last half of the 16th century and beginning of the 17th was a period of much experimentation in art, but no single coherent trend. Not until about the second decade of the 17th century can we again identify a definite style and give it a label. That label is *Baroque.*

Gianlorenzo Bernini
1598–1680

Gianlorenzo Bernini falls into a category we find fascinating in all the arts—the youthful prodigy. Born in Naples, he trained with his father, Pietro, a talented sculptor, and by the age of seventeen he had received a commission from the Pope. Too late in history to be a man of the Renaissance, Bernini was nonetheless a Renaissance man—sculptor, painter, architect, stage designer, playwright, composer of music, and, by all accounts, a great wit. He lived into his eighties and displayed throughout his life enough energy and enthusiasm and inventiveness for half a dozen ordinary people.

Nearly all of Bernini's life was spent in Rome, and he outdid even his great predecessor Michelangelo in papal patronage, serving seven popes over a period of half a century. Master always of the grand design, he executed many huge projects, including the Cornaro Chapel group with *St. Teresa in Ecstasy* and the piazza and colonnade of the Vatican. Several outdoor fountains in Rome—elaborate figural sculptures—are also of his design. This last is typical of Bernini, for, grand showman that he was, he loved to incorporate such effects as light, smoke, or in this case water in his creations. Often he was called upon to plan important public events, such as state funerals or celebrations in honor of the saints.

As a sculptor, Bernini excelled at the portrait bust—the head and shoulders likeness in marble of an individual. One of the loveliest of these depicts Costanza Bonarelli (**354**) the wife of Bernini's assistant who was also Bernini's mistress. Sometime in the mid-1630s the current pope, Urban VIII, urged the artist to termi-

nate this relationship and take a wife. So in 1639 Bernini, then forty-one years old, married a young woman half his age, Caterina Tezio. The story is told that Bernini felt compelled to give away the portrait bust of Costanza Bonarelli, which until then he had kept in his home. The artist's wife eventually bore him eleven children, nine of whom survived to maturity.

Bernini's fame as an architect and sculptor spread throughout Europe. In 1665 Louis XIV, king of France, summoned the artist to Paris to work on a new design for the Louvre palace. The trip was not a success. Bernini's plan for the Louvre was rejected, and the artist alienated his hosts by expressing his preference for Italian art and contempt for most French art. He returned to Rome, where he remained until his death.

One major work did result from Bernini's sojourn in Paris—a splendid portrait bust of Louis carved after Bernini had made numerous sketches of the king going about his daily activities. It was in Paris, too, that the artist reportedly explained the problems of portrait sculpture: "If a man whitened his hair, beard, eyebrows and—were it possible—his eyeballs and lips, and presented himself in this state to those very persons that see him every day, he would hardly be recognized by them. . . . Hence you can understand how difficult it is to make a portrait, which is all of one color, resemble the sitter."[3]

Gianlorenzo Bernini. *Self-Portrait.* c. 1625.
Oil on canvas.
Galleria Borghese, Rome.

Baroque art differs from that of the Renaissance in several important respects. Whereas Renaissance art stressed the calm of reason and enlightenment, Baroque art is full of emotion, energy, and movement. Colors are more vivid in Baroque art than in Renaissance, with greater contrast between colors and between light and dark. In architecture and sculpture, where the Renaissance sought a classic simplicity, the Baroque favored ornamentation, as rich and complex as possible. Baroque art has been called dynamic, sometimes even theatrical. This theatricality is clearly evident in the work of the Baroque's leading interpreter, the artist Gianlorenzo Bernini.

Bernini would have been a fascinating character in any age, but if ever an artist and a style were perfectly suited for one another, this was true of Bernini and the Baroque. With a taste for drama and overstatement, a flair for the grand gesture, Bernini found great success in an era that appreciated such expression (**439**). Bernini's background was in the theater, in stage and scene design; he was also an unsurpassed sculptor and architect. All these talents were brought to bear in his masterpiece, the Cornaro Chapel in the church of Santa Maria della Vittoria in Rome (**498**). The chapel itself, shown here in an 18th-century painting, is a brilliantly integrated scheme of architecture, painting, sculpture, and lighting. On the ceiling is painted a vision of heaven, with angels and billowing clouds. At either side of the chapel sit sculptured figures of the Cornaro family, donors of the chapel, in animated conversation, watching the drama before them as though from opera boxes. The whole arrangement is lighted dramatically by sunlight streaming through a concealed yellow-glass window.

The centerpiece of the chapel is Bernini's sculptured group known as *St. Teresa in Ecstasy* (**499**). Teresa was a Spanish mystic, founder of a strict order of nuns, and an important figure in the Counter Reformation. She claimed to be subject for many years to religious trances, in which she saw visions of Heaven and Hell and was visited by angels. It is in the throes of such a vision that Bernini has portrayed her. Teresa wrote:

Beside me, on the left hand, appeared an angel in bodily form, such as I am not in the habit of seeing except very rarely. . . . He was not tall but short, and

left: 498. Anonymous artist. *Cornaro Chapel, Santa Maria della Vittoria, Rome.* 18th century. Oil on canvas. Staatliches Museum, Schwerin, East Germany.

right: 499. Gianlorenzo Bernini. *St. Teresa in Ecstasy.* 1645–52. Marble and gilt bronze, life-size. Cornaro Chapel, Sta. Maria della Vittoria, Rome.

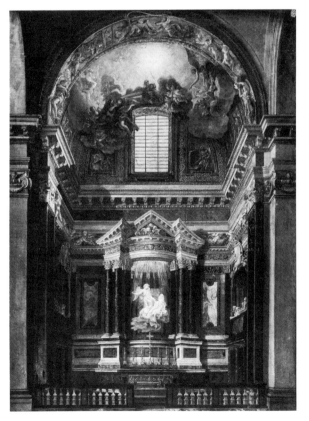

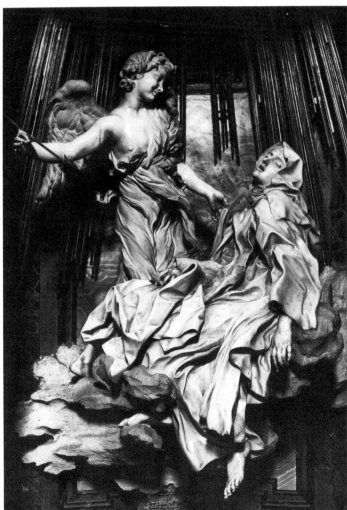

very beautiful; and his face was so aflame that he appeared to be one of the highest rank of angels, who seem to be all on fire. . . . In his hands I saw a great golden spear, and at the iron tip there appeared to be a point of fire. This he plunged into my heart several times so that it penetrated to my entrails. When he pulled it out, I felt that he took them with it, and left me utterly consumed by the great love of God. The pain was so severe that it made me utter several moans. The sweetness caused by this intense pain is so extreme that one cannot possibly wish it to cease. . . . This is not a physical, but a spiritual pain, though the body has some share in it—even a considerable share.

Bernini shows the saint in a swoon, ready for another thrust of the angel's spear. She falls backward, yet is lifted up on a cloud, the extreme turbulence of her garments revealing her emotional frenzy. We can almost hear the moans Teresa spoke of in describing her passionate experience. The angel, wielding his spear, has an expression on his face of tenderness and love; in other contexts he might be mistaken for a Cupid. A work like *St. Teresa in Ecstasy* could never have emerged from the Renaissance. Artists of the Renaissance looked backward to the cool, restrained style of Greece in the Classical period. But the Baroque artist was far more interested in the later Hellenistic period of Greek art, typified by the *Laocoön Group* (**463**). Both in composition and in the intensity of emotion portrayed, there is a kinship between the *Laocoön* and *St. Teresa* sculptures.

The Baroque fondness for dramatic composition and lighting revealed in the Cornaro Chapel also is apparent in works by the painter Caravaggio. His magnificent *Deposition* (**500**) depicts the moment when the dead Christ has been removed from the Cross and is being prepared for burial. The body is lowered by

500. Caravaggio. *The Deposition.* 1604. Oil on canvas, 9′9⅛″ × 6′7¾″. Pinacoteca, Vatican, Rome.

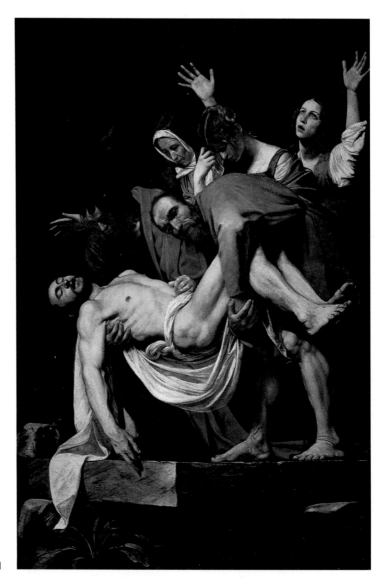

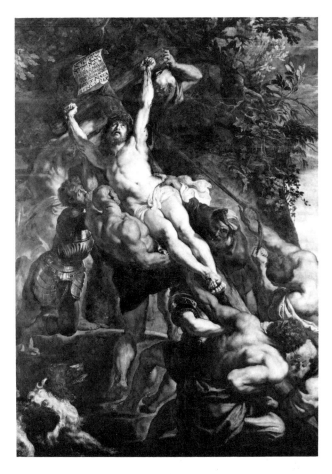

501. Peter Paul Rubens. *The Raising of the Cross.* 1609–10. Oil on panel, 15′2″ × 11′2″. Antwerp Cathedral.

two of Christ's followers—his disciple St. John and the Jewish ruler Nicodemus, to whom Christ had counseled that a man must be "born again" to enter Heaven. The group also includes the three Marys—Christ's mother, the Virgin Mary, at left; Mary Magdalene, center; and Mary Cleophas, at right—who look on in despair. Caravaggio's structure is a strong (though complex and twisting) diagonal leading from the upraised hand at top right down through the cluster of figures to Christ's face. The light source seems to be coming from somewhere outside the top left edge of the picture. Light falls on the participants in different ways, but always enhances the sense of drama. Mary Magdalene's face, for example, is almost totally in shadow, but a bright light illuminates her shoulder to create a contrast with the bowed head. Light also catches the pathetic outstretched hand of the Virgin. Christ's body is the only figure lit in its entirety; the others stand in partial darkness.

When one sees this painting, the most immediate impact comes from the stark dead-white of Christ's form, in contrast to the vivid garments and flesh tones of the others. The viewer's experience of this poignant scene is intensified by the fact that we observe it from "a worm's-eye view," from a position below that of the participants in the drama, who stand on a stagelike slab. Certain elements of the composition almost seem to project forward out of the painting—the corner of the slab, Christ's feet, Nicodemus' elbow. Because the deposition group breaks out of the picture plane, we are drawn into the scene, we become a part of it.

We might compare Caravaggio's *Deposition* to a work painted just a few years later, *The Raising of the Cross* (**501**) by the Flemish artist Peter Paul Rubens. Although he spent most of his life in Antwerp (in modern Belgium), Rubens had traveled to Italy and studied the works of Italian masters, including Caravaggio. There are similarities between these two paintings—in the sharply diagonal composition and dramatic lighting—but we also find several differences in the two masters' styles. Caravaggio's figures seem almost frozen in a moment of anguish, but Rubens' painting teems with movement and energy, each of the participants balanced precariously and straining at his task. While the Caravag-

Peter Paul Rubens
1577–1640

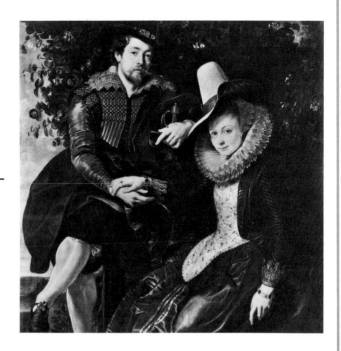

In all the history of art, one of the most civilized figures was the Flemish painter Peter Paul Rubens. Rubens was born in the German town of Siegen, but he returned with his mother at the age of ten to her native Antwerp (then in the Spanish-controlled Netherlands, now a city of Belgium) after the death of his father. There he was placed as a page in a wealthy home—a post that seems to have taught him the tact and courtly manners that would serve him well in the years to come. Coupled with these was an innate intelligence and pleasant disposition, all of which contributed to an enormously productive, rewarding life.

Rubens began his art studies in Antwerp. At the age of twenty-two, however, he set out for Italy, where he was to remain for eight years. During this time he traveled widely through all the major cities, studied the works of the great Italian masters, and was employed as court painter by the Duke of Mantua.

When the final illness of Rubens' mother called him home in 1608, the artist fully expected to return to Italy. But several inducements persuaded him to remain in Antwerp, which became his base for the rest of his life. For one thing, he was immediately successful as an artist and found many lucrative commissions. For another, the political and intellectual climate satisfied him. Perhaps most important, Rubens met, fell in love with, and married a young woman of Antwerp, Isabella Brant. This union lasted for seventeen years, produced three children, and was an extremely happy one. Rubens painted their wedding portrait, shown here.

In an atmosphere of domestic fulfillment, Rubens settled down to work. He became court painter to the Archduke Albert and his wife (also named Isabella), who were at the time rulers of the Netherlands. Over many years he also served them as political emissary and diplomat to foreign courts, often being entrusted with the most secret of negotiations. Artistic commissions poured in from all parts of Europe. Rubens was able to fulfill them mainly because he had a well-organized studio and many assistants. For certain large works, Rubens would make preliminary drawings, assistants would execute routine parts of the canvas, and then the master would make corrections and provide finishing touches.

Rubens' personal life took a stunning blow in 1626, when his wife died suddenly. Four years later, however, the artist remarried. His second wife was Hélène Fourment, and at the time of their marriage she was sixteen, Rubens fifty-three. This marriage, too, seems to have been a most successful one and produced five children. It was cut short by the artist's death, at sixty-three, from heart failure brought on by gout.

The workshop approach perfected by Rubens occasionally got him into trouble. In 1621 he was forced to write this letter to a dissatisfied client: "I am quite willing that the picture painted for My Lord Ambassador Carleton be returned to me and that I should paint another . . . making rebate as is reasonable for the amount already paid, and the new picture to be entirely by my own hand without admixture of the work of anyone else, which on the word of a gentleman I will carry out."[4]

Peter Paul Rubens. *The Honeysuckle Bower (Self-Portrait with Wife)*, detail. c. 1609. Oil on canvas, 5'10½" × 4'5½". Alte Pinakothek, Munich.

gio group projects from the picture plane, its action is contained on four sides within the frame of the canvas. Rubens' figures, in contrast, burst outside the picture in several directions, suggesting that the action continues beyond the painting. In addition, Rubens, like other Northern artists, is far more interested than Caravaggio in textural details—precise rendering of foliage, hair, the curly dog, and so on. Rubens' lifelike treatment of musculature in the bodies recalls Michelangelo's paintings on the Sistine Chapel ceiling (**40,488**), but the writhing S-curve of Christ's body is typically Baroque.

Baroque painting in mid-17th century France seems relatively subdued in contrast to the work of Southern artists of this period and even to that of Rubens. This was due to the French interest in Classical Greek and Roman art, particularly evident in the paintings of Nicolas Poussin. Poussin, born a Frenchman, spent much of his career in Rome, but he struck a different path from that of the Italian artists. His *Rape of the Sabine Women* (**502**) depicts a famous episode in Roman myth. Romulus, the legendary founder and first king of Rome, was concerned that the men of his city had no wives and so could not establish families. To remedy this problem, he announced a festival and invited the people from the neighboring town of Sabina to attend. Poussin shows us the climax of this event. Romulus, standing at upper left on the steps of the temple, gives a signal— opening his cloak—and each of the Roman men seizes a Sabine woman to carry off, killing the Sabine men as necessary.

Despite the violent and dramatic nature of the occasion, Poussin's treatment seems curiously restrained and reflects his admiration for classical art. Poussin based his background on what he believed to be authentic Roman architecture, and he modeled his figures after ancient Greek and Roman sculptures. The two women at left, with their arms upraised, strike us more as carefully posed statues than as terrified maidens about to be carted away into wedlock by rather brutish strangers. There is little sense of continuous action. We almost have the impression that these are actors, arranged into a living tableau with appropriate facial expressions, who will momentarily break the pose and go about their business. Poussin's art is above all rational and intellectual. He wants us to understand the dramatic import of the scene from his careful composition and ordering of the figures, not from any overt display of passion. The "classicizing" tendencies of Poussin had much influence on French artists for the next century.

To grasp fully the flavor of the Baroque in France, we should look once again at a king who for all time exemplifies the term "absolute monarch"— Louis XIV. In Chapter 3 we discussed how his portrait by Rigaud (**80**) both captured and enhanced the ideal of regal power. But in Louis's reign official portrai-

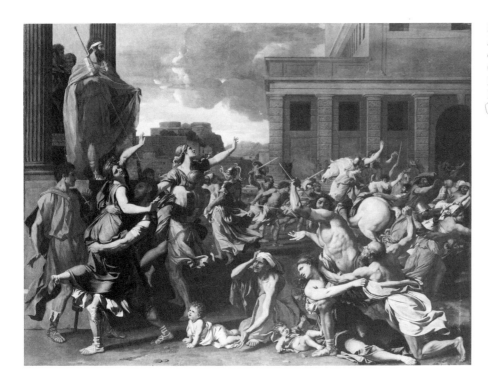

502. Nicolas Poussin.
Rape of the Sabine Women.
c. 1636–37.
Oil on canvas, 5'1" × 6'10½".
Metropolitan Museum of Art, New York (Harris Brisbane Dick Fund, 1946).

ture was, so to speak, just the tip of the iceberg. Every aspect of the king's life and environment was calculated to present the image of divine rule. Louis's statement *"L'Etat c'est moi"* ("I am the state") was not just an expression of ego. It was the truth.

Louis ascended the throne of France in 1643, at the age of four. He assumed total control of the government in 1661 and reigned, in all, for seventy-two years. During that time he made France the artistic and literary center of Europe, as well as a political force to be reckoned with. Showing the unerring instincts of a master actor, he created an aura around his own person that bolstered the impression of divinity. Each day, for example, two ceremonies took place. In the morning half the court would file into Louis's chambers, in full pageantry, to participate in the king's *lever*—the king's "getting up." At night the same cast of characters arrived to play ritual roles in the king's *coucher*—his "going to bed."

A life in which the simple act of climbing in and out of bed required elaborate ceremony must surely also need an appropriate setting, and Louis did not neglect this matter. He summoned Bernini from Rome to Paris to work on completion of the Louvre palace (although the final design of the building was the work of others, **428**). But Louis's real love was the Palace of Versailles, in a suburb of the capital, and it was from this remarkable structure that the power of kingship flowed forth.

In all, Versailles occupies an area of about 200 acres, including the extensive formal gardens. The palace itself (**503**), substantially rebuilt and enlarged during Louis's reign, is an immense structure, more than a quarter of a mile wide. Of the countless rooms inside, the most famous is the Hall of Mirrors, 240 feet long and lined with large reflective glasses. At the beginning of this discussion we said the Baroque style was characterized by ornamentation, dynamism, theatricality, and overstatement. What could better exemplify this style than the reign of Louis XIV and the Palace of Versailles?

The French court clearly was a model of pomp and pageantry, and the Spanish court to the south was eager to emulate that model. King Philip IV of Spain reigned for a shorter time than his French counterpart and could not begin to match Louis in either power or ability. Philip had one asset, however, that Louis never quite managed to acquire—a court painter of the first rank. That painter was one of three great geniuses of Spanish art—Diego Velázquez.

In his capacity as court painter Velázquez created his masterpiece, *Las Meninas (The Maids of Honor)* (**504**). At left we see the artist, working on a very large canvas, but we can only guess at the subject he is painting. Perhaps it is the young princess, the *infanta*, who stands regally at center surrounded by her attendants (*"las meninas"*), one of whom is a dwarf. Or perhaps Velázquez is actually painting the king and queen, whom we see reflected in a mirror on the far wall. Their participation is clear, but where are they standing? Possibly they are outside the picture, standing next to us, the observers. This ambiguity is part of the picture's fascination, as is the dual nature of the scene. Although it shows a formal occasion, the painting of an official portrait, Velázquez has given the scene a warm, "everyday" quality, almost like that of a genre painting. Some experts believe Velázquez is painting the king and queen, and the little *infanta* has just wandered in to disrupt the proceedings.

503. Versailles Palace and gardens. 1661–88.

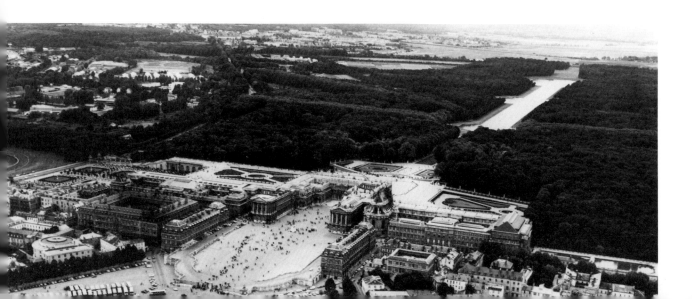

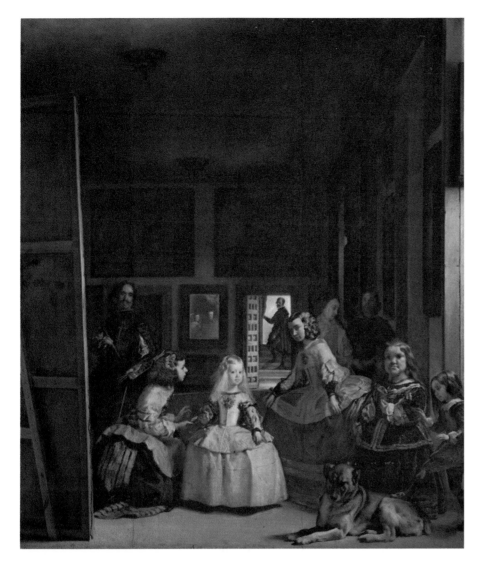

504. Diego Velázquez.
Las Meninas (The Maids of Honor).
1656. Oil on canvas,
$10'5\frac{1}{4}'' \times 9'\frac{3}{4}''$.
Prado, Madrid.

Like Caravaggio, Velázquez uses light to create drama and emphasis, but light also serves here to organize and unify a complex space. The major light source comes from outside the top right corner of the painting, falling most brilliantly on the *infanta*, leaving the others in various degrees of shadow. Another light source illuminates the mysterious figure in the open doorway at back. Velázquez may have put him there to direct attention to the reflected images of the king and queen. Light also strikes the artist's face and the mirror reflection. What could have been a very disorderly scene has been pulled together by the device of spotlighting, much as a designer of stage lighting would control what the audience sees. The theatricality of the Baroque is more subtle in Velázquez than in Bernini, but it is no less skillful.

To end this discussion of 17th-century art, we move north, to the Netherlands. The Dutch Baroque, sometimes called the "bourgeois Baroque," is quite different from Baroque movements in France, Spain, and Italy. In the North, Protestantism was the dominant religion, and the outward symbols of faith—imagery, ornate churches, and clerical pageantry—were far less important. Dutch society, and particularly the wealthy merchant class, centered not on the church but instead on the home and family, the land and the community. We see this focus in the work of two great Dutch artists with very different styles—Rembrandt and Jacob van Ruisdael.

In this book we have already considered several works by Rembrandt (**211,239,267,** p. 200). He was master of so many media that we return to him again and again in discussions of art. For most people, though, Rembrandt's

left: 505. Rembrandt. *Self-Portrait with Saskia.* c. 1634. Oil on canvas, 5'3½" × 4'3½". Gemäldegalerie, Dresden.

right: 506. Jacob van Ruisdael. *Extensive Landscape with a View of the Town of Ootmarsum.* 1660s. Oil on canvas, 23¼ × 28⅞". Alte Pinakothek, Munich.

special appeal lies in his portraits, and especially his self-portraits. He did more of these than practically any other artist. Through them we trace not only his maturation as a painter but his path through life as a human being—from rather humble beginnings to a period of great prosperity and happiness to the disappointments of his later life (p. 200).

The portrait shown here (**505**) represents a high point in the artist's life and is among the most charming of his self-explorations. Rembrandt portrays himself and his wife, Saskia van Uijlenburgh, as an elegant and worldly young Amsterdam couple. Both are dressed in fine clothing (Rembrandt in the guise of a cavalier); they are surrounded by splendid material possessions, and the artist lifts his wine glass high as though to say, "This is the good life!" And so it was for an artist of Rembrandt's incomparable talents.

The 17th century was the great age of landscape painting in the Netherlands. Of course, Rembrandt drew and painted many landscapes (**211**), but his style in this area as in every other was a personal one. More typical of the Dutch landscape painting was the work of Jacob van Ruisdael. Van Ruisdael's *Extensive Landscape with a View of the Town of Ootmarsum* (**506**) shows not only the famed flatness of the Dutch landscape, but also the artist's reaction to that flatness as an expression of the immense, limitless grandeur of nature. The artist makes a contrast between the land—where human order has been established in the form of buildings and cultivation—and the sky, with its billowing clouds, yielding to the wind, which mere people can never tame. The horizon line is set quite low, and, significantly, only the church steeple rises up in silhouette against the sky, perhaps symbolizing that humankind's one connection with the majesty of nature is through the church.

Despite this emphasis on the church building, Van Ruisdael's art is essentially secular, as is that of Velázquez and Rembrandt. Although religious subjects continued to appear in art—and do so even now—never again would religious art dominate as it did in the Renaissance and Italian Baroque periods. No doubt this is largely because of the change in sponsorship; popes and cardinals became less important as patrons, while kings, wealthy merchants, and the bourgeoisie became more so. We can follow this increasing secularization of art as we move out of the 17th century into the 18th.

The 18th Century

The first half to three-quarters of the 18th century is often thought of as the age of *Rococo*—a development and extension of the Baroque style. The term "rococo" was a play on the word "baroque," but it also refers to the French words for "rocks" and "shells," forms that appeared as decorative motifs in architecture, furniture, and occasionally in painting. Like the Baroque, Rococo is an extravagant, ornate style, but there are several points of contrast. Baroque, especially in the South, was an art of cathedrals and palaces; Rococo is more intimate, suitable for the aristocratic home and the drawing room (although there are a number of very grand Rococo buildings). Baroque colors are intense; Rococo leans more toward the gentle pastels. Baroque is large in scale, massive, dramatic; Rococo has a smaller scale and a light-hearted, playful quality. And, as suggested earlier, the Baroque—at least in its origins—was a religious art; Rococo is far more secular and, in its extreme forms, charmingly romantic, more than a little erotic.

The art of Antoine Watteau is typical of the carefree, aristocratic impulse of the Rococo. In *Gersaint's Signboard* (**507**) Watteau gives us a picture of fashionable French society out for a day of shopping—shopping for pictures to decorate the opulent home. All is elegance, verging on the pretentious—the men in their powdered wigs, the women in their silks, everyone maintaining a pose of bored nonchalance. At right the gallery owner, Gersaint, displays a painting to prospective customers, while the adjacent group seems more taken with a smaller work of art. At left, paintings are being crated, presumably for shipment to purchasers. Watteau celebrates in painting a class of people whose most serious concern was maintaining a chic life style.

Somewhat outside this predominant trend toward aristocratic art was another French artist, younger by about fifteen years than Watteau, the painter Jean Baptiste Siméon Chardin. Chardin specialized in the still life (**164**) and the middle-class genre scene. His works have a quiet, meditative appeal and show

507. Antoine Watteau. *Gersaint's Signboard.*
1720–21. Oil on canvas, 5'3⅞" × 10'1".
Staatliche Museen, West Berlin.

ordinary people in ordinary activities. Pictures of children at play, as in *The House of Cards* (**508**), were a favorite theme. Here the boy, dressed in the very proper middle-class attire of the day, is caught up in the concentration of building his card house. There is a tension between his still pose and the precarious balance of the cards. Like the card house, Chardin's picture is perfectly but precariously balanced. The boy leans into his project, and Chardin's masterfully calculated light strikes three areas—the face, the upright cards, and the half-open drawer—to create a tight triangle of interest (**509**). The fact that this triangle is balanced on one of its points adds subtly to the tension of the moment.

Two painters in particular, also French, have become almost synonymous with the Rococo. To admirers their art is sumptuous and delightful; to detractors it is frivolous and decadent. The first is Jean-Honoré Fragonard, whose work we saw in Chapter 4 (**137**). The other is François Boucher. In Boucher's paintings all the people are pretty. The women are frequently nude and, if so, are very pink and voluptuous. (Fragonard's women are more often clothed but equally pink.) If the women are dressed, they are stunningly dressed. Everybody is in love.

Boucher's art suited perfectly the ideals of the French court presided over by Louis XV, great-grandson of the builder of Versailles. Form without substance, beauty without character, extravagance with little regard for paying the bills—such was the reign of Louis XV, and so it was chronicled by Boucher. In 1759 Boucher painted the *Marquise de Pompadour* (**510**), Louis's mistress and influential advisor. How beautiful she looks, how romantic—posed languidly in her lace-frilled dress, resting lightly against a classical statue. Boucher flattered her physically (she was a good deal fatter and less gifted with regular features), and he failed to record the steely political brain that lurked behind the soft face. During the reign of Louis XV, the government of France was on the brink of collapse. The king himself is reputed to have said, *"Après moi, le déluge"* ("After me, the flood"). But for a little while—with Louis XV on the throne, the Marquise de Pompadour at his side, and Boucher at his easel—appearances were kept up.

The lower classes did not participate in this world. They could not afford to wear lace-frilled dresses and had no time to be charmingly in love. Many, in fact,

left: 508. Jean Baptiste Siméon Chardin.
The House of Cards. c. 1741.
Oil on canvas, 32⅜ × 26″.
National Gallery of Art,
Washington, D.C.
(Andrew W. Mellon Collection, 1937).

above: 509. Line analysis
of Chardin's *The House of Cards.*

510. François Boucher. *Marquise de Pompadour.* 1759.
Oil on canvas, $35\frac{7}{8} \times 27\frac{1}{4}''$.
Wallace Collection, London.

were on the brink of starvation. Louis—if he really said it—was right. The flood was coming, and a mere thirty years after Boucher painted his so-lovely portrait of the Marquise de Pompadour, France was engulfed.

Revolution

Repeatedly in this book we have pointed out that art responds to the culture from which it emerges. To get a sense of how dramatic was the revolution that shook France in 1789 (and had implications for much of Western civilization), we might compare Boucher's painting with a work done in France less than three decades later. In 1787, two years before the onset of the French Revolution, Jacques Louis David painted *The Death of Socrates*. Here there is nothing soft, pretty, charming, or romantic. Instead, the mood is somber and speaks of a world in which the good and noble of character (David meant the French lower classes) were sacrificed to satisfy the vanities of the weak in character (the French upper classes). David has skillfully drawn a parallel between the sacrifice of the

511. Jacques Louis David. *The Death of Socrates.* 1787. Oil on canvas, 4′3″ × 6′5″. Metropolitan Museum of Art, New York (Wolfe Fund, 1931; Catharine Lorillard Wolfe Collection).

downtrodden French and the sacrifice of the ancient Greek philosopher Socrates. In the picture (**511**) we see Socrates preparing to die for his ideals. A teacher as well as a philosopher, Socrates was regarded with suspicion by the Athenian state and eventually was convicted by trial of "corrupting the morals of the young" with radical ideas. His sentence was death by poison, and in David's picture he reaches for the cup of hemlock that will kill him, while his followers look away in grief.

The French Revolution was built on goals like those David attributed to Socrates—liberty, equality, fraternity, and participation by all levels of society in the government and economy of France. In practice, however, the noble ideals of the revolution soon disintegrated into wholesale slaughter of aristocrats (including the king and his family) and, in time, of anyone who disagreed with those momentarily in power. Art such as David's projected the *image* the leaders of the revolution wished to have of themselves, just as Boucher's art had projected the image desired by the French monarchs.

Two other revolutions occurred at more or less the same time as that in France. The first was the American Revolution, preceding the French by thirteen years, in which a small group of colonies in an untamed land broke free of England to create what is now the United States. The other was the Industrial Revolution—not a political uprising but an economic and social upheaval. The Industrial Revolution began slowly in the last half of the 18th century and, many would argue, is still going on.

It is difficult to overestimate the impact—social, economic, and ultimately political—of the change from labor done by hand to labor done by machine. Within the space of a few decades the machine drastically altered a way of life that had prevailed for millennia. People who had formerly worked in their homes or on farms suddenly were herded together in factories, creating a new social class—the industrial worker. Fortunes were made virtually overnight by members of another new class—the manufacturers. Naturally, all this upheaval was reflected in art. At the beginning of the 19th century, then, Western civilization faced a totally new world.

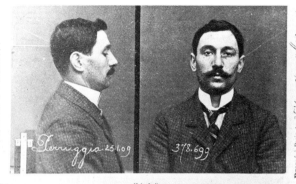

ART PEOPLE
Vincenzo Perugia

At 7:20 on the morning of August 21, 1911, three members of the maintenance staff at the Louvre paused briefly in front of the *Mona Lisa*. The chief of maintenance remarked to his workers, "This is the most valuable picture in the world." Just over an hour later the three men again passed through the Salon Carré, where Leonardo's masterpiece hung, and saw that the painting was no longer in its place. The maintenance chief joked that museum officials had removed the picture for fear he and his crew would steal it. That joke soon proved to be an uncomfortably hollow one. *Mona Lisa* was gone.

Thus begins the story of the most famous art theft in history, of the most famous painting in the world, and of the man who would inevitably become the most famous art thief of all time: Vincenzo Perugia.

French newspapers announced the catastrophe under the banner headline "Unimaginable!" All during the weeks that followed, rumors abounded. A man carrying a blanket-covered parcel had been seen jumping onto the train for Bordeaux. A mysterious draped package had been spotted on a ship to New York, a ship to South America, a ship to Italy. The painting had been scarred with acid, had been dumped in the sea. All clues, however far-fetched, were followed up, but no trace of *Mona Lisa* could be found.

More than two years would pass before the thief surfaced. Then, in November of 1913, an art dealer in Italy received a letter from a man who signed himself "Leonard." Would the dealer like to have the *Mona Lisa?* Would he. Of course it was a joke. But was it? The dealer arranged to meet "Leonard" in a hotel room in Florence. "Leonard" produced a wooden box filled with junk. The junk was removed, a false bottom came out of the box, and there, wrapped in red silk and perfectly preserved, was the smiling face of *Mona Lisa*. The dealer swallowed his shock and phoned for the police.

"Leonard" was actually an Italian named Vincenzo Perugia—a house painter who had once done some contract work in the Louvre. As he told the story of the theft, it was amazingly simple. On the morning in question Perugia, dressed in a workman's smock, walked into the museum, nodded to several of the other workers, and chose a moment when no one else was in the Salon Carré to unhook the painting from the wall. Then he slipped into a stairwell, removed the picture from its frame, stuck it under his smock, and walked out. Stories that Perugia had accomplices have never been proved.

What were the thief's motives? And why, after pulling off what can only be described as the heist of the century, did he so naively offer the painting to the Italian dealer? Perugia claimed he was motivated by patriotism. *Mona Lisa* was an Italian painting by an Italian artist. Believing (mistakenly) that it had been stolen by Napoleon to hang in France, he wanted to restore it to its rightful home. At the same time, however, he expected to be "rewarded" by the Italian government for his heroic act and thought $100,000 would be a good amount. No one shared this point of view.

Perugia was tried, convicted, and sentenced to a year in prison. After his release he served in the army, married, settled in Paris, and operated a paint store. Soon Perugia, who had so briefly captured the world's headlines, settled back into the obscurity from which he had emerged.

And *Mona Lisa?* After a triumphal tour of several Italian museums, she was returned to France. She hangs—at least as of this writing—safely in the Louvre. Romantics say her smile is even more enigmatic than before.

"Mug shot" of Vincenzo Perugia (with the name misspelled) after his arrest in 1913.

17

The Modern World

A chapter covering the art of the 19th and 20th centuries presents certain difficulties, not the least of which is its title. Many writers designate the art of this period as "modern," a term that means "characteristic of the present or the recent past," and so we have chosen to call it. However, this poses a problem: When did "modern" start? There are those who would say that truly modern art did not exist until the Impressionists in the 1870s, or until the period just before World War I, or even until the late 1940s. Moreover, we must remember that people in other periods of history undoubtedly thought of their own art as "modern," and perhaps even called it that.

If modern refers to the present and the recent past, we are faced with another puzzle: When does "modern" stop? In other words, what do we call everything that follows the present? Some writers, obviously at a loss for new labels, have coined the terms "postmodern" and "antimodern," but these are awkward at best. Very likely the period we call "modern" will be given an entirely different name by future generations.

Whatever we call it, we cannot ignore the fact that the art produced during the 19th and 20th centuries offers a variety of expression unprecedented in the history of art. If you flip through the chapter quickly, you will see an amazing range of styles—works so diverse they seem to have little in common with one another. Our discussion begins with a portrait of a woman, to our eyes not markedly different from paintings of the previous four hundred years. It ends with a work _by_ a woman in which there is no tangible substance at all, nothing to hang on the wall or place on a pedestal. No wonder many people find "modern" art bewildering!

Despite the dizzying variety and complexity of modern styles, we have one great advantage in approaching the art of this period. We live now. About three-quarters of the art we shall consider in this chapter was made during the lifetimes of people still alive today. While we can have only limited success in getting "inside" the minds of Michelangelo or Rembrandt—or those of the audiences for whom they worked—we inhabit the same world as contem-

porary artists and, as a result, often share their sensibility. It is not inconceivable that you could meet and talk with several of the artists whose work is illustrated here, could question them about their inspirations, their goals, their reasons for working the way they do. Throughout this text it has been stressed that art is a product of the culture that produces it. In this chapter, then, and especially in the latter part of the chapter, we come to *our* art, the art of our own culture. We see works made by artists who have walked the same streets we have, watched the same television programs, felt the same tides of history washing over us. If we take the trouble to look and study, we may find that this is the art with which we feel the closest connection.

To get to the art of the present we begin at the turn of the 19th century, when the seeds of most modern art movements were sown. The center of Western art was France, and so it remained (with a few digressions) until the onset of World War I.

France, Early 19th Century: Neoclassicism, Romanticism, Realism

As we have seen in earlier chapters, most periods in the history of art had one dominant style—the High Renaissance style or the Baroque style, for instance—that major artists of the time followed. But French art of the early 19th century is not like that. It is customarily divided into three broad categories: classic, romantic, and realist. The fact that artists of the first rank were working in each of these styles gives a hint of the great diversity that was soon to come.

Representing the classic style—or, as it is usually called, *Neoclassical* ("new classical")—was the work of Jean Auguste Dominique Ingres; we saw one of his drawings in Chapter 6 (**204**). Ingres was a pupil of Jacques Louis David (**511**), and he inherited his master's admiration of ancient Greek and Roman art, as well as David's preference for sharp outline, reserved emotions, and studied (often geometric) composition—all characteristics of the Neoclassical style. We see these qualities in *La Grande Odalisque* (**512**). "Odalisque" is a French word derived from the Turkish, meaning a concubine in a harem. It is typical of Ingres that, in

512.
Jean Auguste Dominique Ingres.
La Grande Odalisque.
1814. Oil on canvas,
2'11¼" × 5'3¾".
Louvre, Paris.

513. Eugène Delacroix. *Liberty Leading the People, 1830.* 1830. Oil on canvas, 8'6″ × 10'10″. Louvre, Paris.

portraying the nude figure, he placed it in an exotic situation. (The nude was acceptable to contemporary standards of morality only when separated from everyday life.) This nude, while unquestionably sensual, seems also rather distant and aloof. In Classical Greek art (**462**) and in much art of the High Renaissance (**486**) a cool detachment was deemed ideal. The Neoclassical style followed this trend. Ingres has outlined this figure very clearly, isolating it from its background, and the composition is perfectly balanced—the drape at right offsetting the raised torso on the left. Although a classicist, Ingres was capable of certain romantic touches. Here the figure of the odalisque has been considerably adjusted in its proportions. The long curving spine gives the figure an unearthly elegance, and the graceful arm that connects the two halves of the composition surely outreaches that of any human female.

Ingres's lifelong rival was Eugène Delacroix, champion of the Romantic movement. We can get as clear a picture of the differences between the two men by comparing their drawings (**204,116**) as we can in a comparison of the paintings shown here. The Romantic ideal stressed drama, turbulent emotions, and complex composition, all of which are evident in Delacroix's masterpiece, *Liberty Leading the People* (**513**). In 1830 France was rocked by a brief uprising of the people, an aftershock of the French Revolution forty years earlier. Although not personally involved, Delacroix chose to depict an imaginary moment in this uprising as a statement of sympathy with the democratic ideals of the Revolution. Prominent in the composition is the figure of a woman, symbolizing Liberty and France—powerful, striding across the barricades, holding aloft the tricolor flag of France. Participants in the uprising stream behind her, following her lead— the artist does not tell us where, but presumably to the abstract goal of Freedom.

If we compare this passionate scene to the polished perfection of Ingres, the differences are obvious. Ingres's figure is motionless, languid; Delacroix's composition seethes with energy and violence. Ingres's *Odalisque* is beautifully contained within the frame of the picture, whereas Delacroix's figures marching toward us in a diagonal movement seem about to burst out of the composition, giving the impression of one frame in a continuous drama. Ingres's outlines are clear and refined; Delacroix's free brush strokes give us a sense of blurred mo-

tion, of flickering light and confusion. Yet, in spite of its dynamism, Delacroix's composition is every bit as carefully composed as that of Ingres. The composition is stable, based on a triangle, with the apex in the hand and flag of Liberty, and the two sides moving down through the upraised rifle at left, the boy's arm and pistol at right. In their concern for the structure of painting Ingres and Delacroix were not as far apart as they appeared, but—because of the bitterness of their rivalry—neither would have admitted it.

The Realist movement in French art came somewhat later than Neoclassicism and Romanticism and was, in effect, a reaction against both. Realist artists sought to depict the everyday and the ordinary, rather than the heroic or the exotic. Their concerns were very much rooted in the present. One of the leaders of the Realist movement was Gustave Courbet, who in 1855 exhibited a huge painting, *The Artist's Studio* (**514**), subtitled *A Real Allegory Summing Up Seven Years of My Life as an Artist*. To this day, more than a century later, art historians debate the meaning of the "allegory," or symbolic story.

At the center of the canvas sits Courbet himself, at work on a landscape painting. Although a great many people crowd into the studio, the artist seems aloof from them, as though his aesthetic concerns are all-consuming. A little boy (usually identified as Innocence) gawks up at the work in progress. Behind the artist stands a nude model, whom some consider to be his Muse, or inspiration, others the personification of Truth (that is, the "naked truth"). All the figures to the left of the composition are common people; they are "types," not individuals, derived from Courbet's origins in a rural village. At right are the artist's "intellectual" friends, many of them identifiable figures—his patrons, other artists, writers, and so on. Perhaps Courbet is saying the artist represents a special elite, fed by his origins and by his comrades, but apart from them, alone with Innocence and Truth. We know from Courbet's work as a whole that here the artist was trying to make a particular point—that everyday activities, such as an artist working at his easel or peasants toiling in the fields, were fit subject matter for grand-scale art. In an age when only paintings of religious or historical or mythological scenes were considered "great art," this was indeed a revolutionary idea.

Each of the three paintings we have considered so far in this chapter has included a nude or seminude woman. Why are the women unclothed? Their nudity has a specific, accepted purpose—the exotic (Ingres's odalisque is a harem woman); the heroic (Delacroix's Liberty is bare-breasted as a mythical

514. Gustave Courbet.
The Artist's Studio:
A Real Allegory Summing Up
Seven Years of My Life
as an Artist. 1855.
Oil on canvas.
11'9¾" × 19'6⅝".
Musée d'Orsay, Paris.

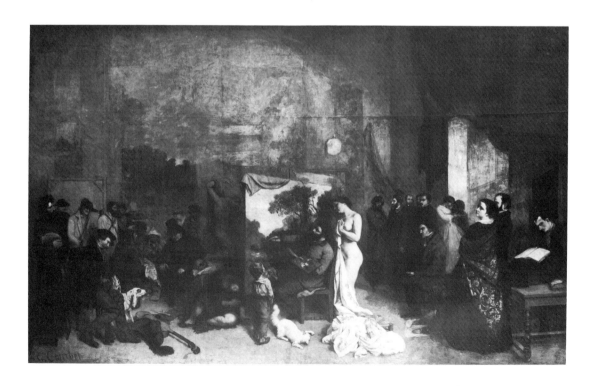

Edouard Manet
1832–1883

Edouard Manet was a gentleman. That old-fashioned word aptly describes one of the most civilized, elegant figures in the history of art. Unfortunately for Manet, through most of his career he was also a gentleman scorned. Few artists have had to endure as much public derision and abuse as Manet did, and few have been as poorly equipped to tolerate abuse as he. To the end of his life he sought popular success for his art, but always it eluded him.

Manet was born in Paris of well-to-do parents. At first he contemplated a naval career, but after two unsuccessful attempts to gain admittance to the naval academy, he turned to painting. He studied at the Ecole des Beaux-Arts and also in the studio of the painter Thomas Couture, but the major influences on his work were Dutch and Spanish art, particularly the paintings of the great Spanish artist Diego Velázquez. In 1859, when he was just twenty-seven, Manet submitted work to the Salon, the annual government-sponsored art exhibition. This submission was rejected, but two years later Manet placed two paintings in the Salon, one of them a portrait of his parents. Then in 1863 came the great scandal of *Le Déjeuner sur l'herbe*, which was rejected by the Salon, hung in the Salon des Refusés, called "immodest" by the French emperor, and heaped with abuse by critics and the public alike. Nevertheless, Manet continued to send paintings to the Salon each year, considering it the only true "field of battle" for an artist.

Surprisingly little is known about Manet's private life. He married Suzanne Leenhoff, who had been his piano teacher, in 1863. Though he earned little money from his art, his private means were sufficient to en-

able him to live comfortably. From time to time he traveled in Europe, but he always returned quickly to Paris, his spiritual as well as actual home. Manet was the quintessential Parisian. The well-dressed, well-mannered, well-spoken artist played an important role in intellectual society of the time. His closest friends were the writer/journalist Emile Zola and the poet Charles Baudelaire. Although he never exhibited with the Impressionist painters—most of whom were younger than he—Manet was considered by the Impressionists to be their natural leader.

Sometime in the early 1880s Manet was struck by a serious illness, the exact nature of which is unknown. This illness resulted in the amputation of a gangrenous leg, and ultimately in his death at the age of fifty-one. As has happened with so many artists, recognition came to Manet just a bit too late. Seven years after his death, his painting *Olympia* was accepted by the Louvre.

Manet never got over his surprise at the public's contempt for his art, nor his bitterness about the rejection. In 1878 he wrote to Edgar Degas: "If there were no rewards, I wouldn't invent them: but they exist. And one should have everything that singles one out . . . when possible. It is another weapon. In this beastly life of ours, which is wholly struggle, one is never too well armed. I haven't been decorated? But it is not my fault, and I assure you that I shall be if I can and that I shall do everything necessary to that end."[1]

Henri Fantin-Latour. *Edouard Manet.*
1867. Oil on canvas, 46 × 35½".
Art Institute of Chicago (Stickney Fund).

Amazon); the allegorical (Courbet's model may be the nude figure of Truth). These conventions satisfied contemporary tastes. But eight years after Courbet exhibited *The Artist's Studio*, a painting was placed on display in Paris that portrayed female nudity without any apparent justification at all. It caused a terrific scandal—the first of many artistic scandals that would shock the art world in the decades to come. The artist responsible for this earthquake was a mild, conventional, well-to-do gentleman: Edouard Manet.

France, Late 19th Century: Impressionism and Post-Impressionism

In 19th-century France the mark of an artist's success was acceptance at the annual "Salon," a state-sponsored exhibition of paintings. Artists submitted their work for consideration by an official jury, whose members varied from year to year but tended to be conservative, if not downright stodgy. Art critic John Russell has described an ideal Salon painting of the period as containing the following ingredients:

> . . . a knight in armor, a group of cardinals, some tropical vegetation, some counterfeit stained glass, a medieval feast with every dish and goblet shown in meticulous detail, a distant view of Constantinople through a window in the background, and in the foreground, three or four naked women, dancing.[2]

Russell wrote this description with tongue in cheek, but there can be no doubt the Salon pictures followed a predictable formula.

In 1863 the Salon jury rejected four thousand of the submitted paintings, which caused such an uproar among the spurned artists and their supporters that a second official exhibition was mounted—the "Salon des Refusés" (showing of those who had been refused). Among the artists who were refused were Whistler and Cézanne. Among the works in the "refused" show—and soon the most notorious among them—was Edouard Manet's painting *Le Déjeuner sur l'herbe* (**515**).

Luncheon on the Grass, as it is usually translated, shows a kind of outdoor picnic. Two men, dressed in the fashions of the day, relax and chat in a woodland

515. Edouard Manet. *Le Déjeuner sur l'herbe.* 1863. Oil on canvas, 7' × 8'10". Musée d'Orsay, Paris.

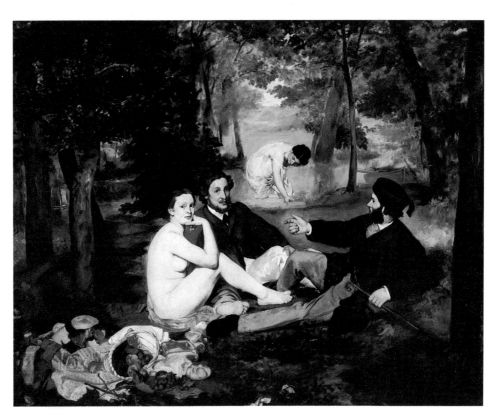

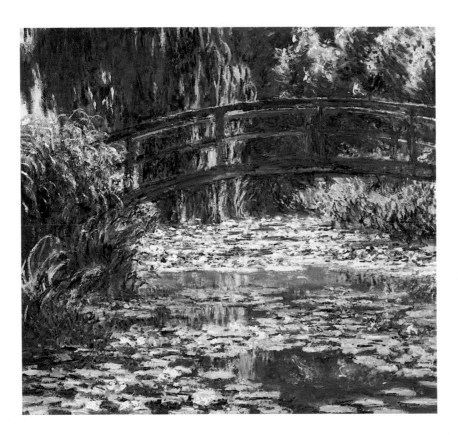

516. Claude Monet. *Pool of Waterlilies.* 1900. Oil on canvas, 35⅜ × 39¾". Art Institute of Chicago (Mr. and Mrs. Lewis Larned Coburn Memorial Collection).

setting. Their companion is a woman who has, for no apparent reason, taken off all her clothes. In the background another woman, wearing only a filmy garment, bathes in a pool. With this one painting Manet had broken several "rules" held dear by French artists and art-lovers alike, and it would be difficult to decide which transgression shocked the viewing public most.

The nude woman is not a goddess, not a harem slave, not an allegorical figure. Then why is she naked, and why sitting nonchalantly with two men who are clothed? Why does she gaze out at the viewer so calmly and matter-of-factly? Nudity in some classical guise was quite acceptable to Manet's audience, but nudity for its own sake was not. With the wisdom of hindsight we can now understand that Manet regarded the nude figure as a study in painted form, an exercise to display his newfound insights into light and shape. His contemporaries had no such understanding. To make matters worse, Manet had "borrowed" certain compositional elements from well-known masterpieces of the past—not at all an unusual practice among artists, but considered presumptuous in the hands of such a "bad" painter as Manet.

Bad, indeed, his technical skills must have seemed to the Salon jurors, for Manet was breaking new ground in the way he interpreted forms on canvas. The artist simplified round, three-dimensional shapes into a series of flat planes. He took a fresh look at the way light strikes a subject, concentrating on brilliant highlights and deep shadow, all but eliminating the middle transitional tones. The image seems to have been caught in an instantaneous flash of brilliant light.

Today's viewer sees *Le Déjeuner sur l'herbe* as one of the first steps toward concerns that would dominate 20th-century art, especially in the use of light and shadow and in the de-emphasis of absolute naturalism. Manet's contemporaries, on the whole, thought him just a clumsy painter. Poor Manet was subjected to a storm of outrage and scorn from critics and the art-viewing public alike. We may find it ironic, therefore, that little over a hundred years later, when a major Manet exhibition was organized in Paris and then moved to the United States, *Le Déjeuner sur l'herbe* was not included in the traveling show. It is considered priceless—and far too precious to leave France.

In the years following Manet's sensation in the Salon des Refusés, young French artists increasingly sought alternatives to the Salon. One group in partic-

ular looked to Manet as their philosophical leader, although he never consented to exhibit with them. The group was formed in 1874 and staged private showings each year until 1886. Because of the diversity of their techniques, the artists had difficulty finding a name for their association. Then a critic, after seeing a painting by Claude Monet (a member of the group) entitled *Impression: Sunrise*, scornfully dubbed the artists "impressionists." Rather than taking offense, the group happily adopted the name; their work was known thereafter as *Impressionism*.

As was mentioned in Chapter 7 (p. 199), Impressionist art sought to capture the fleeting moment, the transitory effects of light. We see this in the work of Monet, the artist who perhaps best typifies the Impressionist style. (Despite the similarity of their names, Manet and Monet were not related.) Monet was far less interested in depicting the solidity of natural forms than in showing how forms look to the eye, how light affects our perception of color and shape. He preferred to work outdoors, in daylight, and labored diligently to record on canvas the exact "impression" created by light striking a surface. Best known of Monet's paintings—and those showing the most developed Impressionist style—were the canvases of the water garden he built outside his home, the famous "water lilies" series (**516**). Although we can identify trees, reeds, a bridge, the floating lily pads, our overall impression is of shimmering light and color, the sparkling effect produced by sunlight reflecting off the water. Monet's technique of combining many small, vivid brush strokes of pure color gives a dazzling brilliance.

Another artist associated with the Impressionist group, and one firmly dedicated to its goals, was Berthe Morisot. Morisot had an early success in the Salon and exhibited in this "establishment" forum several years running, but after she took up with the Impressionists she refused ever again to submit work to the Salon. Like Monet's, Morisot's paintings are suffused with light; they sparkle with the immediacy of the quick glimpse. Morisot, however, was not so committed as Monet to painting outdoors. Often she posed her figures in a charming room or on a balcony, as in *La Lecture* (**517**). Her brushwork is somewhat freer than Monet's, and is sometimes described as "nervous," with its long flamelike flicks of color. But according to Edgar Degas, an artist whose praise was highly valued by his colleagues and followers, Morisot's airy style "conceals the purest draftsmanship."

517. Berthe Morisot. *La Lecture.* 1888. Oil on canvas, 29¼ × 36½". Museum of Fine Arts, St. Petersburg, Fla.

518. Edgar Degas. *The Tub.* 1886. Pastel,
23½ × 32⅛". Musée d'Orsay, Paris.

Degas was well equipped to comment on Morisot's draftsmanship, being
the finest, most sure-handed draftsman of the Impressionist group. Considering
his great interest in line, some critics question whether he can be called an Im-
pressionist at all. Yet Degas's concerns were similar to those of Monet and Mor-
isot—to record the fleeting moment, to capture on canvas an instantaneous per-
ception of the eye. As we have noted in other chapters, Degas was absorbed by
the unusual angle of sight, the "peephole" view of a scene, and his composition
was strongly influenced by the complex spatial relationships in Japanese prints
(**144**). *The Tub* (**518**), a work of the mid-1880s, shows the artist in masterful con-
trol of these effects. We see a nude at her bath, viewed from above. We glimpse
her as though we are quickly looking in a window while passing by. She is
crouched rather awkwardly, scrubbing her shoulder, her body almost filling the
left side of the canvas. On the right is a table or shelf that increases the picture's
spatial ambiguity. We assume that it is above the figure, but the space is so
compressed that the left and right sections might be in the same plane. These
spatial relations appear to be haphazard, but actually they reflect a meticulously
planned composition. To appreciate the originality of Degas's conception, we
might speculate how Ingres or Delacroix might have posed a nude bathing,
barely half a century earlier.

The Impressionists profoundly influenced the major artists who followed
them, especially in the lightness and brightness of colors. However, the work of
the members of this next generation is so diverse in so many respects that no one
stylistic label seems to fit all of them, and they generally are known as the *Post-
Impressionists.* They include Vincent van Gogh, Paul Cézanne, Paul Gauguin,
and Georges Seurat (**135,136,208**).

We have already seen several works by Van Gogh in this book
(**1,28,29,55,212**). His style is characterized by intense, high-key colors; loose
brushwork, often with a heavy impasto; a swirling, agitated composition; and a
subject matter emphasizing those things closest to him—the landscapes he in-

habited, buildings in which he dwelled, his friends, himself. Among his best-known paintings is *The Artist's Room at Arles* (**519**), a study of his own bedroom in the little yellow house shown on the cover of this book. Van Gogh identified so closely with the bedroom that it is virtually a self-portrait. The narrow room, empty except for the bed, two straight chairs, a small table, and, significantly, several paintings on the wall, speaks eloquently of a lonely artist dedicated to his work. The composition is an unusual one. Nearly half the canvas is devoted to bare floor and the blank footboard of the bed. All the main items of interest—Van Gogh's toilet articles on the table, his clothes on a peg, his looking glass, the pillows on his bed, and above all his paintings—are clustered (we might even say crammed) into the top half of the composition. The artist might be showing us that he lived in a tiny, compressed world—the world of his mind, his body, and his extraordinary art.

Paul Cézanne took a different approach in building on the work of the Impressionists. His search was for a solidity and a geometric order in the visual world, and he explored this problem in landscapes (**92**), in figural compositions (**102**), in still lifes, even in portraits (p. 86). A solitary and uncommunicative figure nearly all his life, Cézanne had enormous influence on artists of succeeding generations.

Paul Gauguin worked in the Impressionist style early in his career, but he soon became dissatisfied. Like Van Gogh and Cézanne, he felt the need for more substance, more solidity of form than could be found in optical perceptions of light. Beyond this, Gauguin was interested in expressing a spiritual meaning in his art. All these he sought on the sun-drenched islands of the South Pacific. Gauguin's paintings made in Tahiti have brilliant high-keyed colors; thus revealing his debt to the Impressionists. But to this color effect he has added his own innovations: flattened forms and broad color areas, a strong outline, a taste for the exotic, an aura of mystery, and an interest in the primitive.

519. Vincent van Gogh. *The Artist's Room at Arles.*
1888–89. Oil on canvas, 29 × 36".
Art Institute of Chicago (Helen Birch Bartlett Memorial Collection.)

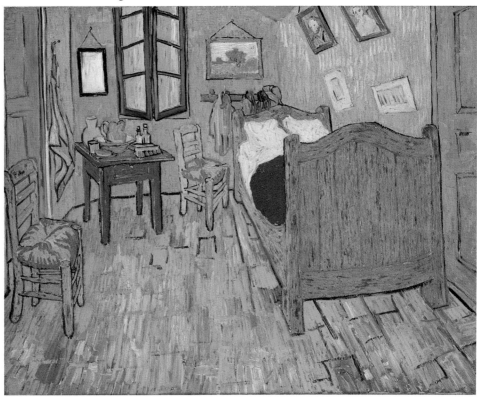

Paul Gauguin
1848–1903

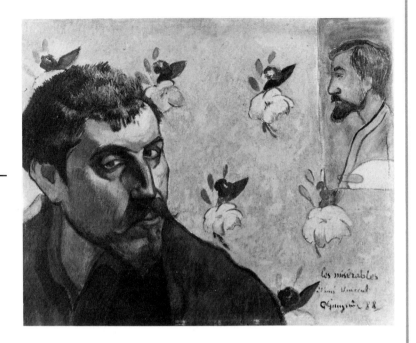

When Gauguin set sail from France in 1891, headed for the remote island of Tahiti in the South Pacific, he wrote a new chapter in the legend of the romantic, bohemian artist. To this day the legend persists. Many people want an artist to be—and Gauguin himself perhaps wanted to be—a dramatic, tormented soul who turns away from the comforts of modern civilization, who is not subject to society's conventions, who thrives in an exotic climate.

Paul Gauguin's origins gave but little hint of what was to come. Born in Paris, he spent part of his childhood in Peru, then returned with his family to France. After a six-year stint in the merchant marine, he settled down and established himself as a stockbroker in Paris. When his career prospered, he married a young Danish woman, Mette Gad, who eventually bore him five children. Sometime in this period he took up painting as a hobby.

Over the years this hobby gradually came to be an obsession. In 1883, when he was thirty-five, Gauguin suddenly announced to his wife that he intended to quit his job and become a full-time painter. His attempts to support himself in this profession were not rewarding; eventually, Gauguin's wife rejoined her family in Denmark, taking the children, and the couple never lived together again. In 1886 Gauguin made the first of three visits to Brittany, the westernmost province of France. By this time he had already begun to establish his style of painting in broad shapes and flat color areas. A year later the artist journeyed to the island of Martinique, in the Caribbean, where the lush tropical colors heightened his palette even further. Late in 1888 Gauguin paid a brief—and disastrously unpleasant—visit to Van Gogh in the south of France.

Finally, disillusioned with Western society and its values, Gauguin departed for Tahiti.

In Tahiti, Gauguin "went native." He lived in a grass hut and took as his *vahine,* or woman, a thirteen-year-old Tahitian girl, who gave birth to his son. At first all seemed idyllic, but even in the tropics one could not live for free, and Gauguin's finances were tight. He returned to Paris in 1893, hoping to sell his paintings and raise money, but the trip was not a success. Two years later Gauguin again set sail for Tahiti—never to return home.

During the second Tahitian period, Gauguin's fortunes went from bad to ghastly. He was wracked by a severe case of syphilis, suffered from a broken ankle that would not heal, and was desperately poor. At lowest ebb he attempted suicide, but the arsenic he swallowed was vomited up, causing him great agony. In 1901 he made his final voyage, to the Marquesas Islands, where—after a series of strokes—he died, penniless and completely alone. Three years after his death a memorial exhibition of Gauguin's work was organized in Paris. The show was a triumph. Gauguin was recognized as one of the great artists of his time.

Through all his ordeals, Gauguin seems to have considered the sacrifice worth it—necessary to achieve the vision he sought in art. As he wrote to his wife, "I am a great artist. . . . I am a great artist and know it. It is because of what I am that I have endured so many sufferings so as to pursue my vocation, otherwise I would consider myself a rogue."[3]

Paul Gauguin. *Les Miserables (Self-Portrait).*
1888. Oil on canvas, 28 × 35".
Rijksmuseum Vincent van Gogh, Amsterdam.

Nafea Faaipoipo (When Are You To Be Married?) (**520**) was painted soon after the beginning of Gauguin's first long stay in Tahiti, and it shows all these characteristics. The figures of the two young women are so flat that we feel we almost could cut around them like paper dolls and pull them out of the painting. Strong outlines define them; this is especially apparent in the skirt and face of the woman at left. The landscape is rendered in broad, flat color areas receding backward: green grass of the foreground, a large yellow middle ground, deep blue shadow under the trees, purple mountain in the background. We know that the women of Tahiti, especially the young girls, were usually slender and lithe. Gauguin has given them a heavy, monumental solidity in keeping with his interest in broad form, and perhaps also because it fulfilled his fantasies about what a "noble savage" ought to look like. Mystery and magic are conveyed by the stylized gesture of the woman at right and the secretive expressions of both women. Perhaps the magic was more in Gauguin's mind than in the subjects he painted. Nevertheless, in the South Pacific he found the ideal environment to foster a unique artistic vision.

When Gauguin moved to this remote island thousands of miles from France, he still kept in touch with his colleagues and dealers in Paris—an indication that we are approaching 20th-century standards of travel and communication. Of course, artists always have traveled. Even the ancient Greek sculptors occasionally set out on the "wine-dark sea" celebrated by the poet Homer. But at the turn of the 20th century, travel across the great oceans had become so convenient and commonplace as to be taken for granted. This ease of movement gave rise to a new phenomenon—transatlantic cultivation of the arts. American artists and

520. Paul Gauguin. *Nafea Faaipoipo (When Are You to be Married?).* 1892. Oil on canvas, 41¼ × 30½". Rudolf Staechelin Foundation, Basel.

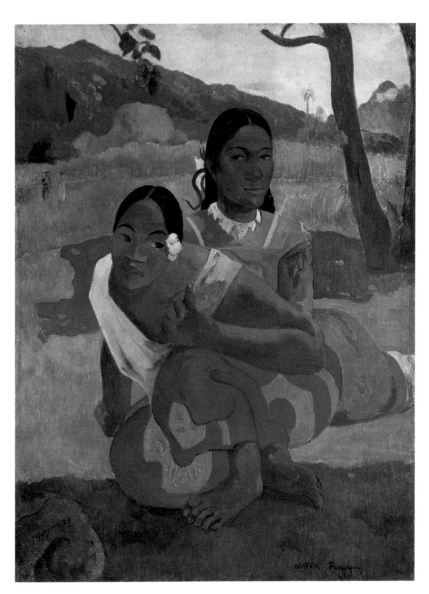

writers flocked to London and Paris to learn from the masters there. European artists and writers flocked to the United States, where they found an eager market among certain discerning collectors. Two worlds were rapidly becoming one.

Bridging the Atlantic: Late 19th Century

Since the early days of the Colonies, American artists had journeyed to Europe, the better to learn their craft. Toward the end of the 19th century, however, the pace of this traveling accelerated. Some artists based in the United States, including Winslow Homer (**261**) and Thomas Eakins (**111,123,124**), made brief visits to Europe and then returned home. Others, born in the United States and considered to be American artists, actually spent much of their working lives in Europe. This latter group includes Mary Cassatt (**210,270**), Maurice Prendergast (**240**), James Abbott McNeill Whistler, and John Singer Sargent.

 Whistler was born in Massachusetts but eventually settled in London. His most famous painting (**521**) has been done a great injustice—and become a cliché—through generations of use on Mother's Day cards, advertisements, and comic posters, thus earning the unfortunate title *Whistler's Mother*. But the artist himself wondered aloud why anyone should care about the identity of the model; his own title, *Arrangement in Gray and Black, No. 1*, speaks far more to Whistler's intent. This image, which has entered the public consciousness as an expression of a son's devotion to his aged mother, actually was meant, and succeeds, as a subtle study of formal composition, light, and color. Whistler's harmony of values—principally soft black and grays—gives the painting a warm, mellow quality. But even more striking is the composition's exquisite visual balance—the elderly woman arranged in profile at right, balanced against the drape at left, the perfect placement of the picture on the wall a bit off center, even the second picture barely visible at upper right. If any of these elements were changed or removed, Whistler's elegant composition would fall apart. (Indeed,

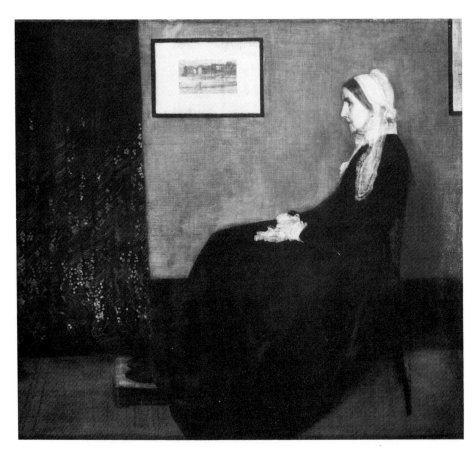

521. James Abbott McNeill Whistler. *Arrangement in Gray and Black, No. 1 (The Artist's Mother).* 1871. Oil on canvas, 4'9" × 5'4½". Musée d'Orsay, Paris.

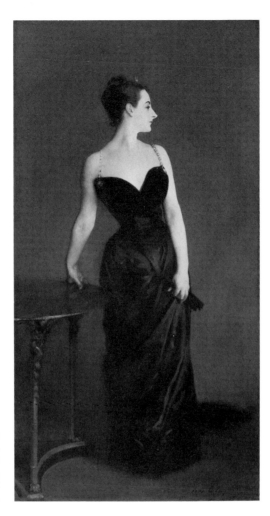

522. John Singer Sargent.
Madame X (Mme Gautreau). 1884.
Oil on canvas, 6'10⅛" × 3'11¼".
Metropolitan Museum of Art,
New York
(Arthur H. Hearn Fund, 1916).

the drape at left is often cropped out in commercial reproductions; you can see how awkward the picture becomes if you cover this portion with your hand.) *Arrangement in Gray and Black* demonstrates a new interest among artists in using the visual elements for their own sake, not just to serve the needs of a particular subject matter.

Although John Singer Sargent was an American citizen, he actually spent very little time in the United States. Born in Italy to American parents, Sargent established his primary studio in London, with only occasional trips to New York and Boston. He made his reputation early as a portrait painter, and throughout his career he remained wildly in demand by the rich and fashionable on both sides of the Atlantic. The best of Sargent's portraits succeed because they create an aura of elegance and aristocratic glamor. A typical example is the notorious *Madame X* (**522**), painted in 1884. This portrait of Mme. Gautreau, an American society woman, caused a scandal when it was exhibited in Paris, in equal parts because of the subject's low cut dress—quite daring for a "nice" woman of the time—and her haughty expression. A century later, however, we see both of these factors as contributing to the effectiveness of the picture. Mme. Gautreau's pose, the essence of grace, is enhanced by the elegant full profile of her head. The abundance of creamy white skin contrasts dramatically with the velvety tones of her dress. Shocking as the portrait might have been, we can well imagine that wealthy women of the period would pay handsomely to be made to look like this.

If Paris was startled by *Madame X*, worse upsets were soon to come. Change was everywhere, signaled by the Impressionists and the Post-Impressionists. How far and how fast art was moving will be obvious when we look at the next "portrait" here, a work painted just twenty-one years after *Madame X*.

France, Early 20th Century: Fauvism, Cubism, and Other Movements

A public that could be shocked by *Madame X*—to our eyes a lovely but rather conventional painting—was hardly prepared for the explosion that shook the art world soon afterward. In 1903 the Salon d'Automne (autumn salon) was organized in Paris as an alternative to the establishment Salon. Two years later the Salon d'Automne exhibited the work of a new group of artists whose style caused a critic to label them *fauves*—"wild beasts"—and the label stuck. Among the artists who elicited this angry characterization was Henri Matisse.

The Matisse painting illustrated here (**523**) is technically a portrait of the artist's wife, but it is usually known by a more descriptive title, *The Green Stripe*. Mme. Matisse is portrayed recognizably, though the contours of her face are flattened and her features abstracted. Most remarkably, the artist, building on precedents Gauguin had explored a generation earlier (**520**), has painted this image in purely arbitrary colors, that is, colors unrelated to the natural appearance of his wife. While the left side of the face is rendered in close-to-normal flesh tones, the right side is a harsh greenish-yellow, and the hair is dark blue. The background is divided into sections of green, red-orange, and rose-violet; these sections do not define a setting, but are simply color patches. Most startling of all, Matisse has drawn a vivid green stripe down the middle of the subject's face, from her hair to her neckline. Three-quarters of a century later, we are accustomed to the use of color for its own sake and can scarcely comprehend how outrageous this painting must have seemed to Matisse's audience. Its clear message is that color need not be subordinated to nature. With *The Green Stripe* color became a tool, one of many tools in the artist's kit, to be used as the artist sees fit for a given composition.

The Fauve movement did not last very long, a mere three years or so. Matisse went on to explore other aspects of painting, as did his fellow exhibitors at the 1905 Salon d'Automne. Yet the Fauve experiment was crucial for the development of modern art, in that it broke once and for all a longstanding taboo

523. Henri Matisse. *The Green Stripe (Mme Matisse)*. 1905. Oil on canvas, 16 × 12¾". Royal Art Museum, Copenhagen.

524. Pablo Picasso.
Les Demoiselles d'Avignon. 1907.
Oil on canvas, 8' × 7'8".
Museum of Modern Art,
New York (acquired through
the Lillie P. Bliss Bequest).

about the boundaries and conventions of art. Never again would artists feel they must confine themselves to replicating the "real" colors of the natural world, although they might do so if they wished. The artistic bag, so to speak, was open.

No sooner had the color rule been broken than artists began to break more daringly than ever before with conventions of shape and space. At the forefront of this experimentation was an artist, just a dozen years younger than Matisse, who broke nearly every rule art had long followed and who emerged as one of the greatest masters of all time: Pablo Picasso. Many consider a painting done relatively early in the artist's career to be pivotal in the development of 20th-century art. That painting is called *Les Demoiselles d'Avignon* (**524**).

Les Demoiselles d'Avignon was not Picasso's title but was given to the painting years later by a friend of his. It translates literally as "the young women of Avignon" and refers to the prostitutes in Avignon Street, a notorious district of Barcelona. In early sketches for the painting Picasso included a sailor entering at left to purchase the prostitutes' services, but in the finished canvas the sailor has been omitted. Picasso had become so involved with the formal components of his painting—the relations of form and space—that he all but forgot its original content.

If these are prostitutes, then how extraordinary they are! They are far from enticing. Picasso has chopped them up into planes—flat, angular segments that still hint at three-dimensionality but have no conventional modeling. Almost as an affront to traditional pictures of curvaceous nude bathers, the artist has defined his nudes in sharp geometric shapes. Figure and ground lose their importance as separate entities; the "background"—that is, whatever is not the five figures—is treated in much the same way as the women's bodies. As a result, the entire picture appears flattened; we have no sense of looking "through" the painting into a world beyond, as with Delacroix (**513**) or even Manet (**515**).

To many people who see *Les Demoiselles* for the first time, the faces cause discomfort. The three at left seem like reasonable enough, if abstract, depictions of faces, except for the fact that the figure at far left, whose face is in profile, has an eye staring straight ahead, much as in an Egyptian painting. But the two faces at right are clearly masks—images borrowed from "primitive" art—and they create a disturbing effect when set atop the nude bodies of European females.

In *Les Demoiselles* Picasso was experimenting with several ideas that he would explore in his art for years to come. First, there was the inclusion of non-traditional elements. Picasso had recently seen sculptures from ancient Iberia (Spain before the Roman Empire), as well as art from Africa. In breaking with Western art conventions that reached back to ancient Greece and Rome, Picasso looked for inspiration from other, equally ancient, traditions. Second, there is the merging of figure and ground, reflecting the assumption that all portions of the work participate in its expression. And third, there is fragmenting of the figures and other elements into flat planes, especially evident in the breasts of the figure at upper right and the mask just below. This last factor proved especially significant for an artistic journey on which Picasso was soon to embark—the movement known as *Cubism*.

Picasso's partner in this venture was the artist Georges Braque. Braque met Picasso in 1907 and saw *Les Demoiselles* in Picasso's studio. By all reports, Braque was at first dismayed and puzzled by the painting, but later he came to understand Picasso's goals. Both artists had been strongly influenced by the late works of Paul Cézanne (**92**) and by Cézanne's idea that natural forms could be reduced to geometric solids—the cone, the sphere, and the cylinder. Picasso and Braque also were interested in the inherent geometry of forms, but they took as their starting point an angular, rather than a curved, solid—the cube.

In 1909 Braque and Picasso began working closely together, and they continued to do so for several years. By 1910 their experiments were so closely intertwined that the two artists' styles became virtually one, and it is sometimes difficult to tell their work apart (Chapter 2, p. 57; **62,63**). Cubism is an art of facets, like the facets in a diamond. As is evident in Braque's painting of 1911, *The Portuguese* (**525**), forms are flattened into planes, broken apart, and reassembled to make a striking visual (but abstract) reality. We see the same form from several angles simultaneously; top, bottom, side, and frontal views may be combined into one image. Figure and ground are treated in the same way and have equal weight in the composition, blending together into a coherent whole. As Cubism developed, both Braque and Picasso began introducing bits of the "real world" into their canvases—stenciled letters and numbers (as here) or even pasted-on newspaper and fabrics. The psychological tension produced in the viewer by merging "real" with "not-real" (the illusory world of paint on canvas) would have important implications for the artists of the Dada movement (p. 436) and for many artists of the later 20th century.

Cubism was a final, dramatic declaration of independence from Renaissance ideals of natural representation and linear perspective (p. 131). Braque's painting is clearly *not* an attempt to show us exactly what his model looked like. Instead, it is a study of forms for their aesthetic possibilities, a statement that a work of art has its own reality and need not be a mirror of the natural world. Neither Braque nor Picasso completely abandoned naturalism. Some of Picasso's works after Cubism (**42**) are as faithful representations of the natural world as anyone could ask for. However, with Cubism the principle was firmly established that a painting is *paint on canvas*—an arrangement of shapes and colors and lines chosen to suit the artist's expressive purpose, whatever that might be.

Early 20th Century: Expressionism

If Picasso and Braque in this period were experimenting with a purely visual reality, some of their contemporaries were more interested in exploring a psy-

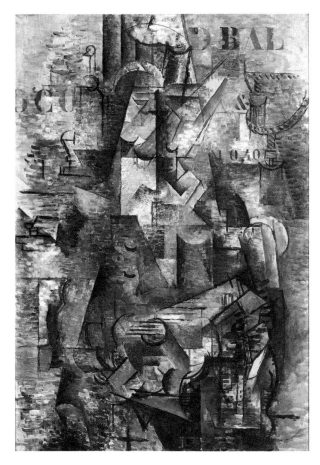

above: **525.** Georges Braque. *The Portuguese.*
1911. Oil on canvas, $45\frac{7}{8} \times 32\frac{1}{8}''$.
Kunstmuseum, Basel.

right: **526.** Ernst Ludwig Kirchner.
Self-Portrait as a Soldier.
1915. Oil on canvas, $27\frac{1}{4} \times 24''$.
Allen Memorial Art Museum, Oberlin College,
Oberlin, Ohio (Charles F. Olney Fund).

chological one. During the first two decades of this century a movement developed in Germany that came to be known as *Expressionism*. Centered around a group of artists based in Dresden who called themselves *Die Brücke* ("the bridge"), Expressionism had many roots. It was strongly influenced by Van Gogh and Gauguin, took its intense color effects from Fauvism, and admired the stark, emotional works of the Norwegian artist Edvard Munch (**274**). At the time when Expressionism flourished, Sigmund Freud was active in Vienna, publishing his new theories about the role of the unconscious, the meaning of dreams, and the practice of psychoanalysis. The Expressionists were entirely in sympathy with Freud's goal of probing the unconscious and hoped to take the process one step further—to translate their inner explorations into a meaningful art.

Ernst Ludwig Kirchner, a leader of *Die Brücke*, painted himself in 1915 as a soldier with an amputated hand (**526**). This canvas has the quality of a dream, a dream in which the separate elements seem to have a psychological connection that we cannot quite identify. The artist presents himself as a gaunt, shrunken

figure, with his cigarette dangling from his mouth and the stump of his hand—his painting hand—offered matter-of-factly for our inspection. In the background, inexplicably, stands a nude woman. In fact, this image *is* a dream—or a waking expression of Kirchner's deepest fears and emotions—for the artist was never actually wounded.

The painting styles of the Expressionist artists are often dissimilar, but their thread of connection is the desire or need to probe their deepest emotions and to express those emotions in their work. Other artists generally associated with the Expressionist movement include Käthe Kollwitz (**56,215**, p. 182), Paula Modersohn-Becker (**88**), Gustav Klimt (**140**), Oskar Kokoschka (**234**), and Emil Nolde (**258**).

Synthesis and Awakening: The Armory Show

European art, by the second decade of the 20th century, had run through a series of "isms"—Impressionism, Post-Impressionism, Fauvism, Cubism, Expressionism. The artists connected with these styles certainly were aware of each other's work and were influenced by one another. But each group tended to exhibit with other members of that group—Impressionists with Impressionists, Cubists with

527. Marcel Duchamp. *Nude Descending a Staircase No. 2.* 1912. Oil on canvas, 4'10" × 2'11". Philadelphia Museum of Art (Louise and Walter Arensberg Collection).

528. Constantin Brancusi. *The Kiss.* 1910. Stone, height 19¾". Musée National d'Art Moderne, Paris.

Cubists, and so on. Never had the various movements been brought together in one place to make the statement that *here* is modern art—or, rather, here are the many directions of modern art. Moreover, this extraordinary activity in European art had gone mostly unnoticed in the United States. Some few American artists and collectors had followed the new styles, but the public at large was unaware of them. All this changed abruptly in 1913. In that year a show of European and American art was organized by a group of progressive American artists. The show opened at the 69th Regiment Armory in New York, and, although there have been many art exhibitions in many armories, this one is still known simply as the Armory Show.

European art of the previous four decades was well represented, and the show caused an immediate sensation. So abusive was the press in its criticism that the general public became intrigued and flocked to the Armory to laugh at the art (and its makers). The critics singled out one work in particular for their greatest scorn, and that work soon became the star attraction. It is a Cubist-derived painting by Marcel Duchamp known as *Nude Descending a Staircase* (**527**).

As in a more "orthodox" Cubist painting, Duchamp has taken an image, here the nude figure, and flattened it into planes, which are then reshuffled and rearranged. However, he has also repeated the image many times over, creating a sharp, choppy rhythm that makes the figure appear to descend the staircase. When we first look at *Nude Descending a Staircase*, we may be tempted to echo the comment of a viewer at the Armory Show, who called the painting "an explosion in a shingle factory." But on closer inspection the forms begin to emerge, although they are abstracted: the rounded shape moving diagonally across the center of the canvas is a hip, the lower section of the painting a series of repeated legs. Duchamp had adopted the rather static forms of Cubism and set them in motion.

Another artist represented in the Armory Show was the Romanian-born sculptor Constantin Brancusi. Brancusi worked briefly in the studio of the great French sculptor Auguste Rodin (**347,362**) but soon departed with the now-famous statement, "No other trees can grow in the shadow of an oak tree." By 1910 Brancusi's work had become very abstract, as evidenced by *The Kiss* (**528**)—one of a long series of sculptures on this theme. *The Kiss* represents two of Bran-

529. Auguste Rodin. *The Kiss.*
1886–98. Marble, height 5'11¼".
Musée Rodin, Paris.

cusi's main preoccupations—fidelity to materials and a search for the essence of form. Here Brancusi's material is stone, and he has carved it in such a way that we are very much aware of its nature as stone, not as an attempt to mimic flesh. So highly simplified is the shape that the kiss itself, the union of two souls and bodies, becomes more important than the individuals who take part in it. Even sex differences between the two are barely suggested (the woman, at right, by longer flowing hair and a rounded breast). Brancusi said: "Simplicity is not an end in art, but one arrives at simplicity in spite of oneself, in approaching the real sense of things."

We can see how far Brancusi has moved from the style of his teacher—how nearly he had arrived at simplicity—by comparing a work of Rodin's, also called *The Kiss*, carved just about a decade earlier (**529**). Rodin's version of the same subject is far more naturalistic, the figures modeled to a smooth perfection and grace. The embrace of the lovers is both romantic and erotic—qualities missing from Brancusi's interpretation.

The Armory Show introduced not only French artists to the United States, but Russian as well, most notably Wassily Kandinsky, whose early gouache painting we saw in Chapter 8 (**242**). Born in Moscow, Kandinsky spent long periods of time in both Paris and Munich. He was influenced by the Post-Impressionists and the Fauves, but by about 1905 he had begun to move toward a much greater abstraction than that attempted by either group. *Picture with an Archer* (**530**), painted in 1909, is roughly contemporary with both Matisse's *Green Stripe* and Picasso's *Les Demoiselles d'Avignon*, yet it is remarkably different in approach. Neither Picasso nor Matisse ever completely abandoned figural references in their work, but Kandinsky strove increasingly to eliminate representa-

tion. His canvases explode with color and energy derived from his own emotional experience—an expression of "inner necessity"—and he considered subject matter "detrimental" to this expression. For this artist, "The harmony of color and form must be based solely upon the principle of proper contact with the human soul."

While the Armory Show attracted much negative criticism, it was a commercial success; about 350 works were sold. Moreover, the show firmly established the position of modern art and introduced its principles to the United States. As we have seen, Marcel Duchamp was the most controversial figure in the show, exhibiting a work influenced by Cubism. Within a very short time, however, Duchamp had shifted his interest to quite a different mode of expression. He became a leader in the first of two movements that, in their own ways, were fully as revolutionary as Cubism.

Europe During and After World War I: Dada and Surrealism

During World War I in Europe there arose an art movement known as *Dada*, which came into being as a reaction against the unprecedented carnage of world war. The artists associated with Dada felt that any civilization that could toler-

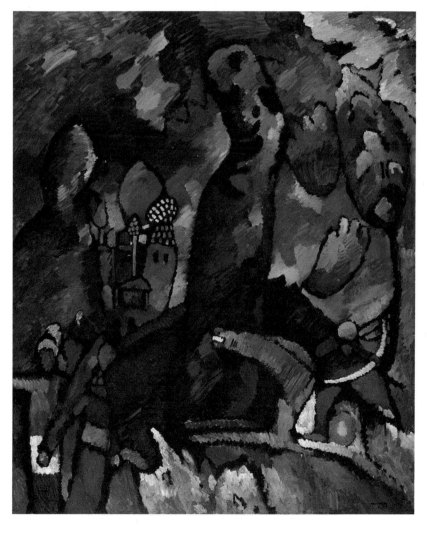

530. Wassily Kandinsky. *Picture with an Archer.* 1909. Oil on canvas, 5'9" × 4'9". Museum of Modern Art, New York (fractional gift of Mrs. Bertram Smith).

ate such brutality must be swept away, and all of its institutions, including traditional art, along with it. Dada, therefore, was anti-everything, even anti-meaning (the name "dada" is said to have been chosen at random from a French dictionary). Representative of Dada's art is Duchamp's work known as *L.H.O.O.Q.* (**531**). Duchamp selected the one painting that for the Western world symbolizes art with a capital *A* and gleefully drew a moustache and goatee on a reproduction of the *Mona Lisa*. As if that irreverence were not enough, he penciled in the letters at the bottom, which, when pronounced in the French way, make a vulgar pun suggestive of nymphomania. *L.H.O.O.Q.* is thus a kind of artistic blasphemy—poking fun at one of the most cherished institutions of art.

Duchamp's friend, the French-Cuban artist Francis Picabia, followed a similar artistic path. He, too, began his career with Cubist-inspired paintings, and he, too, became caught up in the Dada movement. Picabia exhibited several works at the Armory Show, and he journeyed to New York for the exhibition. In the United States Picabia found himself both impressed and amused by Americans' obsession with the machine. The result was a series of works featuring machine symbolism, including *Machine Tournez Vite* (**532**). In true Dada fashion, *Machine Tournez Vite* ridicules a basic human activity—sexual union—by equating it with the meshing of machine gears "turning quickly." A legend at the bottom of the picture identifies the smaller wheel at lower left as "woman," the larger wheel as "man." The Dada world considered nothing sacred; everything was a potential subject for ironic humor.

Surrealism, as we have seen (p. 93), is an art based on the unconscious, often taking its subject matter and its imagery from dreams and fantasies. Conceived

left: **531.** Marcel Duchamp. *L.H.O.O.Q.* 1919. Rectified ready-made, pencil on reproduction of Leonardo's *Mona Lisa*; $7\frac{3}{4} \times 4\frac{7}{8}"$. Private collection.

below: **532.** Francis Picabia. *Machine Tournez Vite*. c. 1916–17. Gouache, $19\frac{1}{4} \times 12\frac{5}{8}"$. Private collection.

533. Salvador Dali.
The Persistence of Memory. 1931.
Oil on canvas, 9½ × 13″.
Museum of Modern Art, New York.
(anonymous gift).

as a reaction to the more "intellectual" art movements, such as Cubism, Surrealism—according to its manifesto published in 1924—aimed at "pure psychic automation by which one intends to express verbally, in writing, or by other method, the real functioning of the mind." Artists who worked in the Surrealist mode are generally separated into two categories—those whose imagery is predominantly figural, including Salvador Dali (**96**) and René Magritte (**187**); and those following a more abstract style, such as Joan Miró (**118**).

Possibly the most famous of all Surrealist works is Dali's *Persistence of Memory* (**533**), a small painting that many people call simply "the melted watches." Dali's art, especially here, offers a fascinating paradox: His rendering of forms is precise and meticulous—we might say *super*realistic— yet the forms could not possibly be real. *Persistence of Memory* shows a bleak, arid, decayed landscape populated by an odd, fetal-type creature (some think representative of the artist) and several limp watches—time not only stopped but melting away. Perhaps in this work Dali's fantasy, his dream, is to triumph once and for all over time. Earlier in this book we have seen images connected with "time running out"—in the egg timer and clock of Audrey Flack's *Marilyn* (**67**) and the bedside clock of a dying Edvard Munch (p. 230). Dali's melted watches cannot move, so the artist may hope to capture time and gain artistic immortality.

While both Dada and Surrealism, as movements, were relatively short-lived, they had great influence on artistic developments in the second half of this century. Meanwhile, another aesthetic—one equally dedicated to altering the course of modern art—had taken root in Germany. It centered on what is perhaps the most famous of all art schools: The Bauhaus.

Between the World Wars:
1918–1938

The Bauhaus was founded as a school of design in 1919 in Weimar, Germany. It moved to Dessau in 1925 and then briefly to Berlin, before being closed by the Nazis in 1933. Throughout its short existence, a mere fourteen years, it had an enormous impact on all the art and design of its time, and the influence of the Bauhaus continues to be felt in many fields. Actually, the Bauhaus was less important as a school than as an *idea*. Although its faculty included some of the most noteworthy names in 20th-century art and architecture, it produced few students of particular talent. But many of the principles that guided its curriculum are alive and well today.

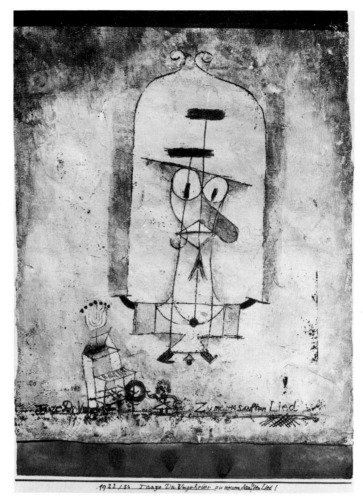

534. Paul Klee. *Dance You Monster to My Soft Song!* 1922.
Watercolor and oil transfer drawing on plaster-grounded gauze
mounted on gouache-painted paper, gauze support; $13\frac{3}{4} \times 11\frac{1}{2}''$.
Solomon R. Guggenheim Museum, New York.

Architect Walter Gropius founded the Bauhaus, and he was also the prime
theorist in the development of the school's philosophy. Briefly, the Bauhaus
hoped to erase the lines separating painters, sculptors, architects, craftsmen, and
industrial designers. All artists and designers, whatever their form of expression,
were considered essentially craftsmen, committed to using materials and forms
in the most straightforward manner, without artificially applied decoration. The
word "Bauhaus" translates roughly as "building house," and its leaders sought
to "build" a new guiding principle of design compatible with 20th-century tech-
nology. In its later years the school focused more and more on architecture and
industrial design, with a view toward reconciling aesthetic design to the capabil-
ities of machine production. Structures, rooms, furniture, and everyday house-
hold objects were stripped of superficial embellishment, pared down to the lines
necessary for functional use.

Despite this emphasis on industrial design, the painting faculty retained a
strong voice. Wassily Kandinsky taught at the Bauhaus for eleven years, and he
is only one of several noted artists whose names are associated with the school.
Another was Josef Albers, who later emigrated to the United States. Albers's
most representative work was done in the 1950s and 1960s, so he will be consid-
ered later in this chapter (**540**).

Also on the painting faculty was the Swiss artist Paul Klee. Klee's work is
among the most difficult to categorize in the history of art. Most art historians
consider him among the great painters of the century, yet he fits no niche or

"ism"; there is really no one like Klee. A common first reaction to a Klee painting is, "That looks like a child's drawing!" And, indeed, the artist took much of his inspiration from the art of children, but behind the childlike imagery is a technique and sensibility of great sophistication. The apparent playfulness masks a deeply complex, subtle imagination. *Dance You Monster to My Soft Song!* (**534**), a mixed-media watercolor, was done two years after Klee joined the Bauhaus staff. Here the delicate line drawing is masterfully controlled to express the idea of a quite friendly monster dancing away to the tune played by a little girl at a transparent piano. Klee's genius lies in combining inventive imagery with a superior command of line, color, and composition.

Except for Dada and Surrealism, few major art movements emerged during the period between the world wars, although individual artists pursued their own styles. Piet Mondrian was at work in Holland (**117,196**), Henry Moore in England (**221,222**), and Marc Chagall in France (**97**). In the United States Edward Hopper painted his lonely, penetrating visions of the American scene (**194**), while the Mexican muralists were creating grand-scale images of the social scene both above and below the border (**231**). Of course, Picasso and Matisse continued to develop their art throughout the period.

Following World War I Europe remained in a state of social and economic turmoil, joined by the United States in 1929, when the entire Western world plunged into the Great Depression. World War II, beginning in 1939 in Europe, 1941 for the United States, brought organized activity in Western art almost to a standstill. Certainly art was made during the war years, but attention was focused on the conflict, and many of the artists were on the battlefield. When the Western nations emerged from war in 1945, it was discovered that the art capital of the Western world had moved—from Paris to New York.

Art Since 1945

NEW YORK: 1945–1960

In the aftermath of World War II most of Western Europe was completely devastated. The United States, while exhausted, was not. No bombs had fallen or battles been fought in New York, as they had in London and Paris and Amsterdam and most of the cities in Germany. When the time came to resume the normal activities of life, New York became the center of a vibrant art revival. Many of the most progressive European artists had immigrated to the United States, and they served as teachers and inspiration for a new generation of artists—most of them American—who gravitated to New York. In fact, painters associated with the first major postwar art movement are referred to as the New York School.

Not a school in the sense of an institution or of instruction, the New York School was a convenient label under which to lump together a group of painters also known as the *Abstract Expressionists*. Primary among them were Jackson Pollock and Willem de Kooning; the group also included Franz Kline, Robert Motherwell (**107**), and Lee Krasner. Abstract Expressionism had many sources—Surrealism, Cubism, the early work of Kandinsky (**530**), and in some cases even Eastern art. The artists involved had less in common than seems apparent at first. One unifying thread is that their paintings, on the whole, are very large in scale, tending to overwhelm the viewer in their dynamic—even violent—presence. Most of the works are entirely nonrepresentational, but de Kooning for one retained figural elements in many of his paintings and thus fits better the technical definition of "abstract." Abstract Expressionism was characterized by bold, passionate painting—sometimes achieved with sweeping brush strokes, at other times produced by hurling paint on the canvas, as Pollock did. The sheer power and energy of this technique caused it to be known as *action painting*.

The quintessential Abstract Expressionist was Jackson Pollock, who had perfected his technique of "drip painting" by the late 1940s (pp. 52–53, and **57**).

Lee Krasner
1908–1984

In October of 1983 the first major retrospective exhibition of paintings by Lee Krasner opened at the Museum of Fine Arts in Houston. Later, the same show toured the United States. Krasner did not live to see it arrive in New York—once the hub of the Abstract Expressionist movement—because she died just eight months after the Houston opening. Amazingly, this remarkable woman, whom critics now consider to be "an artist of the first rank," expressed little bitterness about the fact that she worked so long under the shadow of Abstract Expressionism's "golden boy"—Jackson Pollock.

Krasner, born Lenore, was the sixth child of Russian immigrant parents who had settled in Brooklyn. By the age of thirteen she had decided to become an artist. She enrolled first at Cooper Union, later at the Art Students League in New York. She also studied for several years with the painter Hans Hofmann, from whom she learned the principles of Cubism, and under whose tutelage she took her first steps toward Abstract Expressionism. Like many other young artists of the Depression period, Krasner supported herself by working for the government-sponsored Federal Art Project. Her first exhibition—part of a group show—came in 1937, in New York.

In 1942 Krasner, having heard about the work of Jackson Pollock, went to his studio one day and introduced herself. Soon the couple were living together, and in 1945 they married. This union proved to be a successful working partnership. Wherever they lived, in New York or at their house on Long Island, Krasner and Pollock maintained joint studios. While their painting styles usually remained separate, the two seemed to sustain and encourage each other's work.

Unfortunately for Krasner, the climate of the times was not receptive to a woman who painted in such an assertive style as Abstract Expressionism. Of the New York School of artists she later said, "There were very few painters in that so-called circle who acknowledged I painted at all." Krasner was relegated to the status of "Pollock's wife." Not long afterward, in 1956, she became "Pollock's widow," when her husband was killed in a car crash.

Gradually, after Pollock's death, the critics began to take a fresh look at the work of Lee Krasner, to evaluate it for its own sake. Through it all she continued to paint and to exhibit. And she remained true to the principles of Abstract Expressionism. Other fashions came and went, but this artist continually sought the development of her personal style. By the late 1970s "Pollock's widow" was again Lee Krasner.

Krasner's ideas about painting were her own, not an echo of Pollock's. She has said: "Painting, for me, when it really 'happens' is as miraculous as any natural phenomenon—as, say, a lettuce leaf. . . . One could go on forever as to whether the paint should be thick or thin, whether to paint the woman or the square, hard-edge or soft, but after a while such questions become a bore. . . . The painting I have in mind . . . transcends technique, transcends subject and moves into the realm of the inevitable—then you have the lettuce leaf."[4]

Lee Krasner. *Self-Portrait.*
c. 1930. Oil on linen, 30⅛ × 25⅛".
Courtesy Robert Miller Gallery, New York.

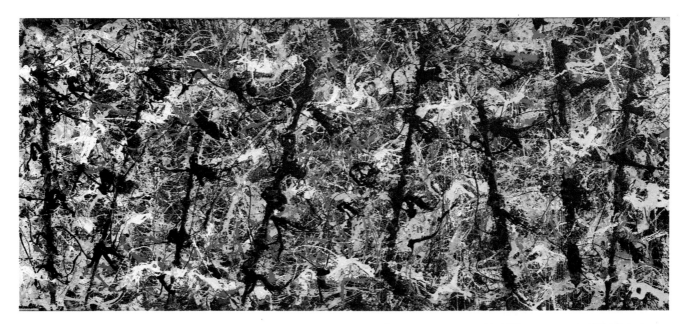

above: **535.** Jackson Pollock.
Blue Poles. 1952.
Oil, enamel, and aluminum paint, glass
on canvas; 6'11½" × 16'½".
Australian National Gallery, Canberra
(purchased 1973).

right: **536.** Lee Krasner. *The Bull.* 1958.
Oil on cotton duck, 6'5" × 5'10⅛".
Courtesy Robert Miller Gallery, New York.

Blue Poles (**535**) shows Pollock's typically dense interweaving of lines and
colors, here punctuated by the almost vertical "poles," which are themselves
criss-crossed with intricate patterns of dripped and spattered paint. Even in re-
production this canvas vibrates with energy, so that one can imagine the impact
of the 7-by-16-foot painting on a viewer standing before it.

Lee Krasner, who was married to Pollock, came to Abstract Expressionism
at about the same time as her husband. Krasner's work, as exemplified by *The
Bull* (**536**), has bolder areas of color and is often characterized by bulbous shapes
that seem to burst out at the viewer. There is a fierce quality in Krasner's work,

deriving from the strong colors and tensely drawn—not spattered—lines. In *The Bull* the rhythms are mostly circular, except for the totem-like image at right.

As mentioned earlier, Willem de Kooning often used figural images in his paintings, especially in his famous "Woman" series (**58**). However, he, too, could work in an entirely nonrepresentational mode, as evidenced by *Composition* (**537**). A saturated blood-red dominates this canvas, seeming to spill out from

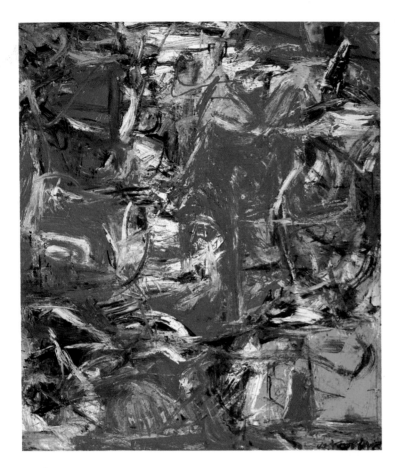

left: **537.** Willem de Kooning.
Composition. 1955.
Oil, enamel, and charcoal on canvas; 6′7⅛″ × 5′9⅛″.
Solomon R. Guggenheim Museum, New York.

below: **538.** Franz Kline. *Chief.* 1950.
Oil on canvas, 4′10⅜″ × 6′1½″.
Museum of Modern Art, New York
(gift of Mr. and Mrs. David M. Solinger).

between the jagged lines and patches of other colors, taking on the intensity of a scream. Abstract Expressionism as interpreted by de Kooning is emotion exploding before your eyes.

Krasner, de Kooning, and Pollock usually worked in color, but two other Abstract Expressionists—Robert Motherwell and Franz Kline—are more closely identified with the bold use of black. Kline's painting *Chief* (**538**), named after a locomotive that passed through the Pennsylvania town where the artist was born, resembles an actual locomotive only in its raw, almost menacing power. Above all, Kline's art is based on the gesture—the tense sweep of a broad brush held at arm's length, the dramatic contrast of black against white in large scale.

Another form of abstraction that came into prominence in the postwar period is known as Color Field painting. As the name implies, imagery is reduced to a large "field" or area of color, in some cases one pure color filling the entire canvas. In contrast to the dynamic emotionalism of Abstract Expressionism, Color Field paintings have a meditative tranquillity that draws the viewer in and invites contemplation. The work of Mark Rothko in the late forties through the sixties (**539**) usually features one or more soft-edged color rectangles floating in the larger color rectangle of the canvas. The inner rectangle has sides parallel to the canvas edges, and its boundaries are blurred and gently blended, causing the

539. Mark Rothko.
Orange and Yellow. 1956.
Oil on canvas, 7'7" × 5'11".
Albright-Knox Art Gallery,
Buffalo, N.Y. (gift of
Seymour H. Knox, 1956).

inner sections to float. Very large scale is also characteristic of Rothko's work, so the viewer is enveloped in an atmosphere of sensuous color.

Superficially the work of Josef Albers (**540**) seems much like that of Rothko, especially when reproduced in a book. In fact, the two artists' paintings have very little in common. Rothko's canvases are huge, Albers' quite small. Rothko's edges are soft and blurred, Albers' precise. Most important, Rothko's expression is emotional, Albers' more intellectual. In the 1950s Albers began a long series of paintings—finally there were hundreds—all entitled *Homage to the Square*. All are "nests" of three or four squares centered in the canvas. What varies is the color, and this was Albers's chief preoccupation. Albers hoped to show the dynamic interaction of colors—how they work together when placed side by side, how some colors advance while others recede, how colors intensify or deintensify each other (pp. 115–124). By restricting himself to the square, he avoided distractions of form, so that the viewer can concentrate on the pure, saturated color. Because it is a series, *Homage to the Square* makes the point that there is no one "best" way a painting can be done, but many different possibilities.

By the time Rothko and Albers painted the works shown here, in the mid-1950s, abstractionism had held sway for more than fifteen years, and the art world was ready for a change of pace. The return of representational art was signaled by two artists who appeared on the scene about 1955—Robert Rauschenberg (**277**) and Jasper Johns.

Jasper Johns chose as his subjects some of the most familiar images one could imagine—the American flag, a map of the United States, numbers, letters of the alphabet. All are rendered accurately, in true proportions, but in a freely brushed, painterly style. His *Target with Four Faces* (**541**) may remind us of a shooting gallery in an amusement park. The inclusion of actual three-dimensional heads with the painting owes a debt to Dada, which often pushed into the third dimension, and to the earlier collage work of Picasso and Braque. Here the target is drawn precisely, the four identical faces seem waiting for bullets to hit them, yet there is no sense of menace in this work. By painting the target so matter-of-factly, Johns has taken away the menace. The target and faces are no longer objects to be shot at, but images to be studied for their own visual interest. This artist seeks the familiar, strips it of its familiar associations, and shows it to us as art. With his targets and other known images, Johns anticipated what would become one of the most important art styles of the 1960s—the movement known as Pop Art.

left: 540. Josef Albers. *Homage to the Square: Ascending.* 1953. Oil on composition board, 43½″ square. Whitney Museum of American Art, New York (purchase).

right: 541. Jasper Johns. *Target with Four Faces.* 1955. Encaustic and newspaper on canvas with plaster casts in wood box, 33⅝ × 26 × 3″. Museum of Modern Art, New York (gift of Mr. and Mrs. Robert C. Scull).

left: 542. Roy Lichtenstein. *Masterpiece.* 1962. Oil on canvas, 4′6″ square. Private collection, New York.

right: 543. Richard Anuszkiewicz. *Splender of Red.* 1965. Liquitex on canvas, 6′ square. Yale University Art Gallery, New Haven, Conn. (gift of Seymour H. Knox).

ART STYLES OF THE SIXTIES

Pop Art was both startling and controversial. As Dada had done nearly half a century earlier, it broke the rules about what constituted fitting material for serious art. Pop drew its subject matter from the most mundane objects of mass-produced culture—billboards, commercial packages, and the like. Andy Warhol's *200 Campbell Soup Cans* (**167**) was but one example of this trend. Another artist, Roy Lichtenstein, based his imagery on the comic book. Many of Lichtenstein's paintings (**542**) are huge, meticulously rendered frames adapted from comic strips, accurate down to the dialogue in "balloons" and the dot pattern of cheap newspaper reproduction. The artist did not hesitate to introduce a touch of irony by poking fun at himself and the art world in proclaiming this work a "masterpiece." Pop Art attempted to show that a detached look at the over-familiar objects of daily life could give them new meaning as visual emblems.

Coexisting with Pop was the movement known as Op Art, or art based on optical principles. Op Art deals in complex color interactions, to the point where colors and lines actually seem to vibrate before the eyes. We have already seen this effect in the work of Bridget Riley (**157**), who was also part of the Op movement. In Richard Anuszkiewicz' painting *Splendor of Red* (**543**) red and blue lines radiate outward from a central diamond shape of intense red. As a viewer looks at the painting, the lines begin to pulsate, and a halo forms around the red diamond. The Op artists were exploring visual phenomena in a wholly new way, generating a clash between what the eye records and the brain perceives. Some critics dismissed the paintings as "just designs," but in fact Op works suggest a new approach to painting—as a challenging optical experience.

A third movement of the sixties was Minimal Art, which reduced the art elements to a "minimum"—simple (often geometric) shapes and sometimes color. Minimal Art can be seen as a kind of celebration of the artist's basic materials. A painting is paint on canvas, a sculpture is metal or stone or wood or similar material. By stripping art down to these substances, the Minimal artist

attempted to reaffirm the worth of art for its own sake, not as a reflection of anything else. In sculpture, an excellent example of the Minimal is Tony Smith's *Die* (**544**), a 6-foot cube of plain black steel that Smith ordered by telephone from the foundry. *Die* cannot be said to have much emotional content. It has no color, no variations of texture, no movement, no rhythm, no focal point. What it does have is *scale*, and that scale gives it a presence, a monumentality. *Die* conveys the idea that form can exist for its own sake in art.

In painting, the Minimal style is often referred to as "hard-edge." Lines are drawn as though with a ruler, colors are pure and unshaded, shapes are precise. Frank Stella's *Sinjerli Variation IV* (**545**) illustrates these characteristics. Its shapes are as regular as those drawn with a compass and a protractor; its rhythms simple and repetitive. Geometric shape in one way or another has been a part of painting for centuries. For example, Raphael based many of his compositions on the triangle (**109**), and Hopper structured a picture around a series of rectangles (**195**). The Minimalists stripped away such figural references and concentrated on geometry alone.

The decade of the sixties was a time of testing, a time of breaking rules, in many spheres—political, social, economic, artistic. Then emerged the sexual revolution, the struggle for racial equality, the peace movement, the feminist movement, the space age, and the computer era. In art a similar kind of testing took place. Merely the fact that there coexisted three art movements—radically different in philosophy and visual effect—demonstrates the vitality of art and the quest for new frontiers. During the following decades, then, artists as well as those in other fields had to confront a basic question: If all the rules have been broken, where does one go next?

CURRENT TRENDS

A good way to introduce the art of the present time is to consider another work by Frank Stella, this one made thirteen years after *Sinjerli Variation IV*. Stella's *Pergusa* (**546**) still shows the artist's preoccupation with interwoven, curvilinear forms, yet he has transformed hard-edged geometry into a more painterly and complicated tracery that is wonderful in its variety. Creative artists, in general, build on what they have done before. Stella has taken his Minimal expressions of

left: 544. Tony Smith. *Die.* 1962.
Steel, 6′ cube.
Private collection, New York.

right: 545. Frank Stella.
Sinjerli Variation IV. 1968.
Fluorescent acrylic on canvas,
diameter 10′. Collection
Mr. and Mrs. Burton Tremaine.

the sixties and developed them into a joyous visual exuberance for the eighties. *Sinjerli's* movement is slow and measured; our eyes move rhythmically around and through its precise curves. But *Pergusa* is alive with movement, a roller-coaster ride of shapes. There is another big difference between the two works. *Sinjerli* of the sixties is two-dimensional—as flat as a bull's-eye. *Pergusa* of the eighties has moved out into the third dimension. It has elements of relief attached to the background surface and projecting to almost 2 feet.

Like many works of contemporary art, *Pergusa* is difficult to categorize. It looks like a painting when reproduced in this book, and sections of it are painted, but it has more depth than many sculptures. Strictly speaking, it is neither a painting nor a sculpture, but a little of both. Similarly, many of Robert Rauschenberg's works (**277**) have areas that are painted, sections that are silkscreened, sometimes applied pieces of fabric, occasionally three-dimensional objects attached to the background. This should not seem surprising in view of the enormous diversity of materials in our lives. A living room, for example, might contain an array of state-of-the-art electronic equipment in a chrome cabinet resting on an antique Oriental rug, and few people would find this combination odd. Just as people select whatever ingredients they wish to support a particular life style, artists choose ingredients to satisfy their expressive needs.

The variety of options extends also to the styles in which contemporary artists work. Earlier periods in the history of art often pitted fashion against anti-fashion. As recently as the 1950s, when Abstract Expressionism held sway, few important museums or galleries would mount shows by contemporary artists working in a naturalistic style, because such work was considered old-fashioned, even trivial. Now the situation has changed dramatically. A tour of the major galleries in New York or San Francisco or Dallas will reveal an astonishing range of styles—all fashionable, all taken seriously by critics and the art-viewing public. The art of the seventies and eighties can be said to offer something for nearly everyone. Abstraction, realism, large, small, painting, sculpture, mixed media, art object, no art object—each has its adherents. Beyond this, the

546. Frank Stella. *Pergusa.* 1981. Mixed media on etched magnesium panel, 6'1" × 7'8" × 2'. Collection Graham Gund, Cambridge, Mass., courtesy M. Knoedler & Co., New York.

individual art-viewer can enjoy a variety of styles, just as one might enjoy having Mexican food one night, Italian food the next night, and so on. The artistic "menu" is a marvelously varied and exciting one. In the next few pages, then, we will look at some of the styles of today.

Jasper Johns is another artist who, like Stella, has developed his style into a new expression for the 1980s. In 1987 he exhibited four large paintings in a series called *The Seasons,* of which we illustrate *Winter* (**547**). Johns is still dealing in what we might call the "givens"—the images and ideas that are so ingrained in our consciousness and our everyday life that we take them for granted. Earlier his "givens" were targets and flags and numbers; now he touches upon the most fundamental rhythms of life itself, as felt through the changing seasons of the year. Depiction of the seasons has many precedents in the history of art; we saw an early example in the Limbourgs' *Très Riches Heures* (**85**). *The Seasons* series is considered to be autobiographical, but, since Johns is a private and introspective person, his allusions to himself are often puzzling. Crowded into the right side of *Winter* is a shadowy figure, surely symbolic of the artist, which may remind you of Edvard Munch's claustrophobic self-portrait (p. 230). The snowman at left is an emblem of winter, and the cut-off circular form at bottom left may serve as an echo of Johns' earlier paintings, such as *Target.* We sense the artist taking stock, sifting through his artistic attic, reworking the imagery that has developed in his art and life for thirty years.

Abstraction is still an important current in present-day art, and among the most innovative of its practitioners is Elizabeth Murray. *Painter's Progress* (**548**) is typical of Murray's exuberant shaped canvases, rather like a brilliantly colored Cubist painting in which the facets have been cut apart and allowed to slip and slide and collide with one another. As in a Cubist work, we can find references to the human figure, but Murray's forms are not only more joyous but more out-ward-turning, seeming to ricochet off each other like a vivid musical animation.

Existing side by side with abstract art is what many would consider its antithesis—art that attempts to duplicate faithfully forms in the natural world. The New Realism, as it is sometimes called, almost certainly derives some of its

left: 547. Jasper Johns. *Winter,* from *The Seasons.* 1987. Oil on canvas, 6′3″ × 4′2″. Courtesy Leo Castelli Gallery, New York.

right: 548. Elizabeth Murray. *Painter's Progress.* 1981. Oil on canvas, in 19 parts; 9′8″ × 7′10″. Museum of Modern Art, New York. (acquired through the Bernhill and Agnes Gund Funds).

549. Philip Pearlstein.
*Model Seated on a Rocking
Rattan Lounge*. 1984.
Oil on canvas, 6 × 5'.
Courtesy Hirschl & Adler Modern,
New York.

inspiration from the Pop Art of the 1960s, but it is more likely to focus on the human figure, and it lacks the association with commercial, mass-produced culture that was so important to Pop. Audrey Flack (**67**) is one of the best-known New Realist painters; Duane Hanson (**367**) is prominent among New Realist sculptors. Some of the painters, including Flack, work from photographs, projecting a photographic image onto a canvas and then painting with an airbrush over the image. The paintings that result have such photographic accuracy that the term *Photorealism* was coined to describe them.

Another prominent artist of the New Realist style is Philip Pearlstein, who in the late 1960s began painting the nude figure in a *super*realistic way that might more accurately be described as "naked" (**549**). Pearlstein's nudes, both male and female, are captured with meticulous, almost brutal accuracy, with all their bulges, wrinkles, warts, hairs, and general imperfections. The "peephole" point of view, in which we see the models at odd angles and oddly cut off by the edges of the canvas, is reminiscent of works by Degas (**518**). In recent years Pearlstein has taken to painting his nudes against elaborate backgrounds, such as intricate, colorful Oriental rugs. The interplay of visual textures becomes extremely important, and one cannot help but marvel at the artist's amazingly naturalistic rendering. Pearlstein's figures are not lovely in the sense that fashion models are lovely, but his pictures fascinate in their stark, uncompromising look at the real.

Relatively few artists aim for such an extreme of realism, but many work in a basically representational style. Of these, one of the most difficult to pin down is Jennifer Bartlett. To get a meaningful sense of her range, the viewer should see a wide selection of her works, and here we can show only one. Bartlett's sources are eclectic—everything from Impressionism to the various styles of the 1960s— and her subjects are equally wide-ranging. She has worked in practically every known medium: oil, pastel, charcoal, fresco, ceramic, enamel, steel plates, wood,

and so on. *Old House Lane #9* (**550**), painted in 1986, is a pastel, and like others of Bartlett's recent paintings it has a large horizontal format. Critics often use the word "mysterious" to describe Bartlett's work, and we may apply this adjective to *Old House Lane #9.* A white picket fence, sun-splashed and viewed from different angles, is its subject. Ordinarily, "white picket fence" comes right behind "Mom" and "apple pie" as symbol of domestic tranquillity, but this fence is painted so aggressively that it stands as a barrier. The house barely seen in each section is on the other side of the fence, but we cannot tell if we are inside the fence looking out, or outside looking in.

Earlier in this book we encountered the work of Sandro Chia (**138**), who is often referred to as one of the "new" Expressionists, or *Neo-Expressionists.* This movement was spearheaded by a group of European artists, principally Germans and Italians, who were young children during and after World War II. Their art reflects the consciousness of nations that fought the great war, lost, and began to pick up the pieces afterward.

Neo-Expressionist art is basically representational and often contains figures, but its intensity of color and form and energy makes it quite different from the New Realist paintings just discussed. Neo-Expressionist works are full of passion, symbolism, and even story line (**551**). According to *New York Times* critic John Russell, "For the first time in many years, people want to say, "And what happened next?' when they look at new pictures."[5] Sometimes there is a jarring, unsettling note, as in the paintings of Georg Baselitz, which may look as though they have been hung upside down.

By the mid-1980s several American (New York–based) artists had become associated with the Neo-Expressionist movement. Whether they would label themselves as Neo-Expressionist remains unclear, but without doubt their work is strong, often disturbing, and expressive. Foremost among the group are Julian Schnabel, David Salle, and Eric Fischl.

Schnabel frequently paints on unconventional surfaces with unconventional materials; we saw his drawing/painting on velvet in Chapter 6 (**227**). For an exhibition in 1986, Schnabel took painted muslin stage backdrops he had

obtained from the Japanese Kabuki theater, stretched them like ordinary plain canvas, and added his own painted touches to produce works like *Rebirth I (The Last View of Camilliano Cien Fuegos)* (**552**). In *Rebirth I* the blossoming trees are from the theater backdrop, turned upside down; Schnabel has painted in the eyes and the horizontal lines. The intense eyes seem to be peering straight at us over a peaceful landscape. In current art we will find two important trends, both manifest in this work of Schnabel's: *reference* to already existing art, and *transformation* of already existing art to make a fresh statement.

Besides "references," two other words you are likely to hear in connection with contemporary art are "quotation" and "appropriation"—that is, quoting from or appropriating images from other types of art or media. Nowhere is this tendency more marked than in the work of David Salle (**553**). Salle's sources are diverse: traditional master artworks, Pop Art, television, magazine layout and graphic design, Dada, photography. Often his images are traced, rather than freely drawn or painted. He may stencil letters onto a painting, as here, or he

left: 552. Julian Schnabel. *Rebirth I: (The Last View of Camilliano Cien Fuegos).* 1986. Oil and tempera on muslin, 12′4″ × 11′2″. Courtesy Pace Gallery, New York.

below: 553. David Salle. *Tennyson.* 1983. Oil and acrylic on canvas with wood, 6′6″ × 9′8″. Courtesy Mary Boone Gallery, New York.

may borrow a fragment from another painting or a photograph for inclusion in his own visual expressions. Not even Salle's dealers profess to understand what his art is all about. Perhaps Salle is closer to Dada than to any other form of art, for in Dada the imposition of the word "Tennyson" over the traced figure of a nude would not *have* any meaning. It would simply be presented as an image to look at.

Quotation is also apparent in the work of Eric Fischl, but Fischl's content is more explicit, his meaning clear—even disturbing—to viewers. A large painting called *Bayonne* (**554**) shows two female figures—a middle-aged nude woman at left, quoted from a photograph by Bill Brandt; and a young girl at right, referring to the dancers of Degas (**144**). Physically the painting is complex. The left side is meant to hang flush against the wall, but the right side juts out at an angle. Only when viewed directly from the front do the two figures seem to be in the same room. From any other angle, they are separate. Head-on, they confront one another. The older woman exhibits a kind of weary sexuality, seeming to look back yearningly to a time of innocence. The girl holds up both hands in a gesture of pushing away, as though to ward off the sexual uncertainties of the future, implicit in the bed behind her. The tension in Fischl's work is the tension caused by small moments of insecurity or pain that many people would choose to forget.

Neo-Expressionist art has no monopoly on references and quotations. Pat Steir, an American artist not associated with the group, has carried the idea of artistic quotation to marvelous heights in a complex work known as *The Brueghel Series* (**555**). Steir, who lives part of the year in Holland, conceived the project after viewing a still-life painting of flowers by Jan Brueghel the Elder in a Dutch museum. Having bought a poster of the Brueghel painting, she then cut the poster into small pieces and used each piece as the basis for a separate painting. When hung together in a prearranged pattern, the sixty-four panels—completed over a period of two years—echo the form of the original flower painting. Each panel, however, is executed in a different style, which explains the work's subtitle, *A Vanitas of Style*. In effect, *The Brueghel Series* is a painting about painting, about all the rich variety of styles that have been practiced by artists for the last several centuries, ranging from Rembrandt to Steir herself. A small book reproduction of this work—which in life is nearly 20 feet tall—makes it difficult to identify the individual styles, but we might recognize the style of Jackson Pollock (far left, third from top); of Franz Kline (top row, second from right); and of Piet Mondrian (top row, third from left). Other artists represented

554. Eric Fischl. *Bayonne.* 1985. Oil on canvas, 8′6″ × 9′1″. Courtesy Mary Boone Gallery, New York.

555. Pat Steir.
*The Brueghel Series
(A Vanitas of Style).*
1982–84. Oil on canvas;
64 panels, each $28\frac{1}{2} \times 22\frac{1}{2}''$.
Courtesy the artist
and Michael Klein, Inc.,
New York.

include Botticelli, Picasso, Watteau, Matisse, O'Keeffe, Degas, and Gauguin. Taken as a piece, *The Brueghel Series* is a wonderful summation of the best in Western art history. Each panel is unique, yet the styles blend into a coherent whole.

It could be said that *The Brueghel Series* was motivated by the underlying *concept* the artist developed while studying the Brueghel flower painting and cutting apart the poster—the concept that many different artistic styles could be quoted and merged into one complex image. Steir's work, however, has physical substance. True *Conceptual Art* has no permanent physical presence, because it is based primarily or solely on an idea. A good example of this type of expression can be found in the work of Sol LeWitt.

We show no illustration of LeWitt's conceptual work *Ten Thousand Lines About 10 Inches (25 cm) Long, Covering a Wall Evenly.* There is nothing to show, no permanent image. The work exists only as an idea, and it is the idea that can be transferred to a gallery or sold to a collector. Suppose a collector decides to "buy" *Ten Thousand Lines* (at a price that may range upward of thirty thousand dollars). What the collector gets is a certificate entitling him or her to have a draftsman—not LeWitt, not necessarily a trained artist—come into the collector's home and draw ten thousand lines on a blank wall, using a ruler and pencil.

If the collector subsequently "sells" the work, the wall must be painted over and the certificate transferred to the new owner. Or, suppose a museum owns the work. It can display the work whenever it wishes to, then simply have the wall painted over to make room for a new exhibit. There is no storage problem. Needless to say, each time the work is redrawn on a wall, it looks different, and that is perfectly compatible with the tenets of conceptual art. The appearance doesn't matter; only the idea matters.

Another artist who has sometimes been associated with Conceptual Art—although he himself disclaims the connection—is Christo. Christo's works *do* have physical substance. What sets them apart from more conventional artworks is that they retain their physical substance for only a short time. In 1969 Christo's workers wrapped and tied a section of the Australian coastline with a million square feet of polypropylene fabric—and then took it down. In 1972 workers strung a huge orange curtain between two mountains in Colorado—and then took it down. In 1976 hundreds of workers installed a 18-foot-high white nylon fence across 24½ miles of the California countryside—and then took it down (**372**). In 1985 a team of three hundred workers transformed the historic Pont Neuf across the Seine in Paris into a giant surprise package by wrapping the bridge in 440,000 square feet of polyamide fabric. And then, inevitably, they took it all down, leaving the bridge as before. All of Christo's works are conceived as *projects*, and the existence of a tangible object is only part of each project. One of the artist's most ambitious projects was the *Surrounded Islands*.

The highlight of the *Surrounded Islands* project (**556**) came in 1983, when eleven small islands in Biscayne Bay, next to Miami, Florida, were "skirted" in pink polypropylene cloth—6.4 million square feet of it. For a few days a string of rather untidy, trash-strewn islands were transformed into bright pink flowers shimmering on the blue water. Then Christo's workers removed the pink fabric, leaving the islands in their previously unsurrounded state. Why would the artist

556. Christo. *Surrounded Islands.* 1980–83. Biscayne Bay, Greater Miami, Florida. Coypright © 1980–83 Christo/C.V.J. Corporation.

557. Christo. *Surrounded Islands, Project for Biscayne Bay, Greater Miami, Florida.* 1983. Drawing in two parts: Pencil, charcoal, pastel, crayon, enamel paint, fabric sample, and aerial photograph; 1′3″ × 5′5″ and 3′6″ × 5′5″. Copyright © 1982 Christo/C.V.J. Corporation.

do this? Why would anyone want to create a large, important work that is doomed to be dismantled?

For Christo, the project is what matters, and the actual time when the installation remains in place—a few days or weeks—is only part of that project. It begins with the first glimmer of an idea about the project and extends indefinitely into the future. After the idea, there is a thinking through of the project. Next come the drawings to test possibilities for what the project's installation will look like (**557**). Then bureaucracy gets involved. For the *Surrounded Islands* it became necessary to deal with the Army Corps of Engineers, the City of Miami, and platoons of local residents, just in order to get the necessary permits to install the work. In the end Christo engaged two lawyers, a marine biologist, a marine engineer, several other engineers, two ornithologists (biologists specializing in the study of birds), and an expert in marine mammals. Again, Christo considers this part of the operation intrinsic to the overall project.

At first the local people were hostile to Christo's project. Soon, however, nearby residents became intrigued with the idea. Not least of the factors responsible for the change of heart was the influx of many, many tourist dollars as the project progressed. By the day of the installation, the *Miami Herald* was cheering, "Go for it, Christo!" As the project took shape, was realized, and was disassembled, practically no one was disappointed.

Yet another part of the project—and one that no doubt prompted the support of local residents—is the fact that Christo's works often leave the natural landscape in better condition than it was in before. Christo's people clean up after themselves. More than 4 tons of trash was carted away in preparation for the *Surrounded Islands,* and the materials of the project were removed without a trace. There were even some surprising results that Christo himself could not have predicted. The manatee, a local mammal that is a species of sea-cow, increased its mating behavior. (Could anyone have anticipated a bumper crop of baby manatees?) Local birds seemed happier; the pink plastic kept people and boats away. Tides were unaffected, because the gossamer fabric allowed the water to ripple underneath.

Finally it was all over but the telling and the showing—and that, too, is part of the project. Christo lectures widely on college campuses and in other forums. Pictures and films of his projects are widely available. And the concept remains—a mental perception of what art can be. As one critic wrote, "Where other artists put nature in a frame, Christo goes boldly to the landscape itself,

bringing to it elegant artistic effects that recall our attention to the splendors of natural environment (or what's left of it) in the same romantic spirit as the painters of the 19th-century West." In a sense, Christo's installations *remind* us to look at the landscape we so often take for granted.

Another important result of Christo's projects is that they get so many people involved—from the volunteers who help construct them to the bureaucrats who must approve them to the onlookers and those who hear about the projects afterward. A huge project like the *Surrounded Islands* cannot help but attract attention, both on the spot and through the media. Thus it reaches more people than could ever see a single painting hanging in a museum. If art is about communication, then clearly Christo has found an effective way to communicate, through art, with an enormous audience.

Involving a broader audience in art has been one of the main concerns of the late 20th century. Christo undertakes this on a grand scale; other artists have attempted, in a somewhat more limited way, to involve people who might not otherwise be connected to art. For the feminist artist Judy Chicago, this means women—long excluded from the mainstream of art history. Chicago takes her concerns a step further by focusing on themes and media that are explicitly woman-centered, and by enlisting women to make the art.

Chicago's most recent large-scale enterprise is called *The Birth Project* (**558**). Its theme—childbirth—is one that has rarely appeared in art because, Chicago maintains, most artists have been men, and men do not have babies. *The Birth Project* was planned to remedy this absence of birth imagery. Its approximately one hundred individual pieces were designed by Chicago, then executed in various forms of fiber craft by 150 volunteer needleworkers, nearly all women. Most forms of traditional "women's craft" are represented—embroidery, quilting, weaving, crochet, petit point—with the needleworkers following Chicago's lushly colored and often anatomically graphic designs. *The Birth Project* is not meant to be exhibited all in one place, but rather is broken down into units for separate display, so that it can reach the widest possible audience.

Art for the artistically "disenfranchised"—for those traditionally cut off from the mainstream of art—is also a concern for Faith Ringgold, a black woman. In recent years Ringgold has exhibited a series of "painted story quilts," which are actually painted canvases with some areas of fiber craft. In the quilts, the artist celebrates not only women's experience but also black experience. Her *Purple Quilt* (**559**) is a tribute to Alice Walker's novel *The Color Purple*. For Ringgold, the quilt format works on a number of levels. It ties contemporary art into the long tradition of (women's) handcraft work, thus breaking down the barrier between "fine" and "applied" arts. It provides a grid format—surprisingly like that of Steir's *Brueghel Series* (**555**)—to unify the rows of people, all staring straight ahead, who inhabit her quilts and who, she reports, are representative of the faces she sees while walking through Harlem. It encourages viewers to per-

558. Judy Chicago. *Birth Trinity,* from *The Birth Project.* 1983. Needlepoint on 6-mesh canvas, from color study; 3'6" × 10'6". Needlework by "The Teaneck Group." Collection Through the Flower, a nonprofit organization.

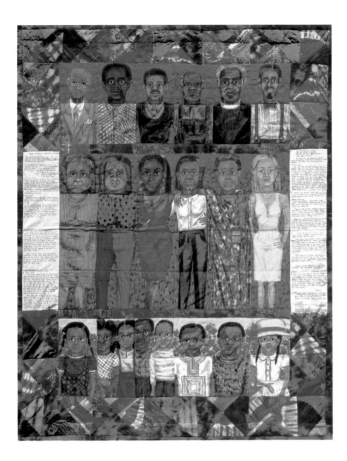

left: 559. Faith Ringgold. *The Purple Quilt.* 1986.
Acrylic on cotton canvas, tie-dyed, printed,
and pieced fabrics; 7'7" × 6'.
Courtesy Bernice Steinbaum Gallery, New York.
Excerpts from *The Color Purple,*
© 1982 by Alice Walker.
Reprinted by permission of Harcourt Brace
Jovanovich, Inc.

below: 560. Laurie Anderson
in performance.

ceive a narrative content, a story line, so that each quilt can be "read" as one
would read a book or play.

Finally, as mentioned at the beginning of this chapter, we come to an artist
whose work has no physical substance at all. During the 1970s the phenomenon
known as *performance art* emerged. Performance art undoubtedly took its inspi-
ration from the "Happenings" of the 1950s and 1960s, one of which is described
on page 234. Happenings are difficult to define; they are visual events in which
some activity occurs, often with several people participating, often with audi-
ence involvement. They may include music, dance, mime, art, reading, or none
of these. Imprecise as it may sound, Happenings are things that happen.

Performance artist Laurie Anderson has developed this idea considerably
in the 1980s (560). Anderson's performances—no two are alike—contain a bewil-
dering array of elements, pulled together in a way that is meaningful to the
artist. She may sing or play the violin or both, and the sounds of voice and
instrument may be distorted. Sometimes she will recite a song or story. Compli-
cated electronic imagery flashes—films, slides, lasers. Occasionally a second
performer will join her—in one case a black man in women's clothing playing

jazz on the bagpipes. There may be sight gags as well; Anderson's lips are made to glow in the dark, or she attaches two extra arms to her body. This artist's work anticipated today's popular music videos (**323**), which also combine images and sounds in a dynamic relationship.

Perhaps it is slightly incorrect to say Anderson's art has no physical presence, although it is certainly true that you could not buy it or hang it on the wall. In performance art the art is the artist. What a far cry this is from the art of the Middle Ages, when artists were often anonymous. Their art endures, but the artist's names have been forgotten. In contrast, performance art places the artist at the very center. If you take away the artist, there is no more art. Performance art is the triumph of the artist.

So that is the scope of modern art—from Ingres to Anderson in less than two hundred years. It should be clear now that the question we addressed in Chapter 2 of this book—what is art?—has no convenient answer. It would be almost impossible to construct a meaningful definition of art that would encompass all fifty of the works discussed in this chapter. Beyond this, we could be almost certain that a definition formulated now would prove inadequate five or ten years hence. It may seem to us that performance artists like Laurie Anderson have broken all the rules, lowered all the barriers to expression in art. But we must remember that the public so outraged by Manet's *Le Déjeuner sur l'herbe* and Matisse's *Green Stripe* also thought that *those* artists had broken all the rules. The trouble is, no one ever really knows what rules are left.

Artists always seem to be one step ahead of everybody else. If we choose to follow them in their explorations—if we choose to live with art—we may sometimes find the experience unsettling, but we will not find it dull. Living with art is an ongoing adventure.

ART PEOPLE
Dorothy and Herbert Vogel

Art collectors are rich. Art collectors are glamorous. Art collectors are members of the upper classes or the nobility, or else they are important business leaders. Everybody knows these facts, but apparently nobody bothered to inform Dorothy and Herbert Vogel of New York City. The Vogels—she a librarian, he a retired postal worker—are not rich, and their life style is modest. They are the sort of people one can't help but call "ordinary." One fact about the Vogels is undeniably *extra*ordinary: They have been collecting contemporary art on an ambitious scale for more than twenty-five years.

Everybody in the fashionable art world of New York, it seems, knows the unfashionable Herbert and Dorothy. The Vogels attend as many openings as possible, they regularly visit several artists' studios, they study the art seriously—and they buy. Their small 3-room apartment in Manhattan is crammed to the ceilings with some fifteen hundred original works of art, emphasizing the Minimal, Conceptual, and Postmodern artists. This staggering collection was acquired almost entirely on Herbert's salary from the post office. Dorothy's salary pays the couple's living expenses.

The odds against two such ... well, *ordinary* ... people becoming important art collectors seem formidable. Herbert, the son of a tailor, grew up in New York and started work for the post office after high school and the army. Dorothy, born in Elmira, New York, earned a master's degree in library science and took a librarian's job in Brooklyn. The couple met at a singles' party, dated for a year, then married in 1962. Their plunge into the art world was led by Herbert, who had taken some art courses at New York University, had made friends with young artists, and aspired to be an artist himself. Soon Herbert got Dorothy involved, and the two decided collecting would be more to their taste.

The Vogels began slowly. Rushing from their respective jobs in the evening, they would rendezvous in a subway station, then go off to a gallery to study the art and consider possible purchases. At first, dealers and gallery habitués wondered, "Who on earth *are* those people?" The Vogels do not look like one's usual image of collectors. Soon, however, their clever and persistent buying attracted attention; soon their appearance in a gallery created a stir. As their collection grew, so did their reputation. Artists accept them as friends because their love of the work is so sincere. In recent years several museums in Europe and the United States have mounted exhibitions of art from the Vogel collection.

No doubt an important factor in the Vogels' success has been their single-mindedness. Dorothy and Herbert have no children, though they have turtles and fish in quantity and—as of this writing—seven cats (Picasso, Renoir, Manet . . .). Nearly all their time is devoted to the collection. They are shrewd buyers, stretching their limited budget to the utmost. Often they buy the work of a particular artist before that artist "hits" and becomes too expensive. Technically, it is no longer true that the Vogels aren't rich. Surely if they sold their collection today, they would be very rich indeed. But the Vogels don't buy to sell or trade. They buy because they love art and want to have it around them.

Most people pretty much live out the lives they were born to, but Herbert and Dorothy Vogel obviously are made of stronger stuff. The postal worker and the librarian—together they invented a special life for themselves, a life with art. Seeing them, talking with them—one cannot doubt they are enjoying every moment of it.

Photograph of Dorothy and Herbert Vogel.

18

Comparative Styles in World Art

*I*n the previous three chapters we focused on the art of Western civilization—
the generally continuous thread of artistic influence stretching from an-
cient Egypt through Greece and Rome down to Western art styles of today.
Here we turn again, as we have often in earlier sections of the book, to a compari-
son of arts from many different cultures. This final chapter concentrates on the
arts in non-Western societies—in the Far East, India, Southeast Asia, Africa,
Persia, and South America.

One of the most fascinating aspects of art history is its diversity. It can be
intriguing to discover what was going on in the world—artistically—at the same
time but at different parts of the globe. Often, works of art contemporary with
one another but separated geographically are very different; occasionally they
are startlingly alike. To get a sense of this cross-cultural diversity, we have se-
lected six periods in the history of art—times when there was significant artistic
activity in widely separated areas. For each time period we have illustrated be-
tween two and four works of non-Western art and usually compared them with a
work of Western art from the same period. And in each case, to make the compar-
ison more interesting, we have chosen works with similar media or themes—
sculpture, precious objects, landscape painting, and so forth.

Whether contemporary works of art are similar or dissimilar, we cannot
help but wonder how they got that way. In other words, did the art trends of one
culture influence those of another, or did certain trends develop independently?
A key to the answer is communication. When a culture is isolated from the rest of
the world, it will not receive artistic ideas from the outside. Many art historians
and others have speculated about possible channels of communication. For ex-
ample, the explorer Thor Heyerdahl has put forth the theory that sailors of an-
cient Egypt could have navigated the Atlantic and crossed to South America. But
for many of the works illustrated in this chapter, it seems more likely that the
creative impulse sprang up without external influence—that artists made won-
derful art unaware of the work of their colleagues around the globe.

10th to 7th Century B.C.: Sculpture

The two objects illustrated on this page (**561,562**) were made at approximately the same time in history but more than ten thousand miles apart—the first in central China, the second in northern Peru, in South America. The possibility of contact between the cultures that produced them is extremely remote. Yet how remarkably similar in design are these sculptures!

We have already seen the *Tiger* from Zhou dynasty China in Chapter 12 (**391**). It was made from bronze, cast in a mold that created not only the basic form but also the imprint of the stylized, geometric motifs that cover the animal's body. The feline figure from South America is carved from stone, and its form is chunkier and more compact, probably because of the limitations of stone-carving tools then available. The tail of the cat does not curve outward quite as jauntily as that of the Chinese tiger, and the feet are much closer to the body. But there is great similarity between the designs on the animals' bodies and in their form. Also, both objects had utilitarian functions. The tiger, as noted earlier, probably served as the support for a post, while the Peruvian vessel was meant as a mortar—a receptacle for grinding.

How can it be that two widely separated peoples developed images that are so much alike? Perhaps like other ideas, the decorated feline figure occurred spontaneously to artists on both sides of the world.

right: 561. *Tiger,* from China. Late Western Zhou period, 9th century B.C. Bronze, length 29⅝". Freer Gallery of Art, Smithsonian Institution, Washington, D.C.

below: 562. Mortar in the form of a feline, Chavin culture, Peru. c. 1000–700 B.C. Stone, length 13". University Museum, Philadelphia.

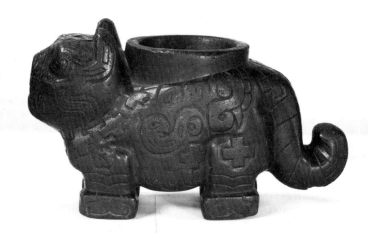

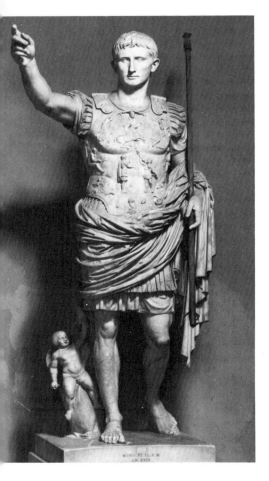

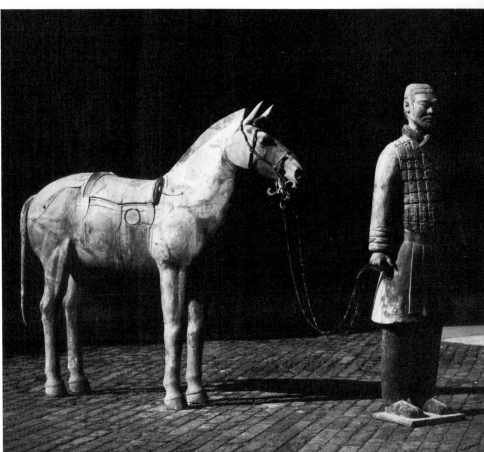

left: **563.** *Augustus of Prima Porta.*
c. 20 B.C. Marble, height 6'8".
Vatican Museums, Rome.

right: **564.**
*Cavalryman and Saddle Horse
from Earthenware Army
of First Emperor of Qin.*
c. 210 B.C. Terra cotta,
height of man 5'10½".
Cultural Relics Bureau, Beijing,
and Metropolitan Museum of Art,
New York.

3rd Century B.C.
to A.D. 3rd Century: Sculpture

Made over a period of some four hundred years, the pieces illustrated in this section (**563,564,565,566**) came from places as far apart as half the circumference of the earth. All four are exquisitely modeled sculptures of figures, two in clay, two in stone. Each represents an important concern for the culture in which it was made, but, because those cultures were very different, the works of art that resulted are unique.

The *Augustus of Prima Porta* (**563**), as we have seen earlier (**78**), was an "official" attempt to glorify the emperor of Rome and endow him with the stature almost of a god—and thus to solidify his legitimacy as a ruler. In ancient China and India no such needs were apparent. In fact, it is unusual to see a sculpture from Asia depicting a political figure. The first emperor of China obviously had no doubts about his political clout. Anyone who could commission (or command) an army of ceramic tomb figures—the cavalryman here (**564**) is but one of thousands of similar figures—clearly wielded enormous power.

Throughout most of the history of Eastern art, religious figures have been the most common subjects for sculpture, and a large portion of this sculpture is connected with the Buddhist religion. Typical is a *Seated Buddha* (**565**) from Gandhara, in India (now in Pakistan), the region where Buddhism originated before spreading to China, Japan, and other countries. This image presents an interesting mixture of Eastern and Western art. The yoga-like pose of the Buddha, as well as his meditative expression, are intrinsic to the Eastern religion; however, the Buddha's draped robe looks very much like a Roman toga (**465**), and his face is reminiscent of naturalistic Greek and Roman statues of gods (**364**).

Indeed, it is generally accepted that North Indian art of this period was much influenced by contemporary Roman art.

By contrast, we find little naturalism in a figure from the Zapotec culture in Mexico (**566**). Most pre-Columbian art—or art made in the Americas before the arrival of Columbus in 1492—is stylized and decorative. The Zapotec people, whose settlement was centered around the temple complex of Monte Albán, near modern Oaxaca, were highly civilized. They built sturdy homes of stone and mortar, practiced agriculture, and refined the arts of weaving, metalwork, and ceramics. In the example shown here facial features are exaggerated, the body is compressed into a symmetrical arrangement of arms and hands and feet, and topping the whole is an ornate, perhaps feathered, headdress. Without the climax provided by the majestic headdress, this sculpture would lose most of its power; this is clear if we imagine it with just a simple, round head.

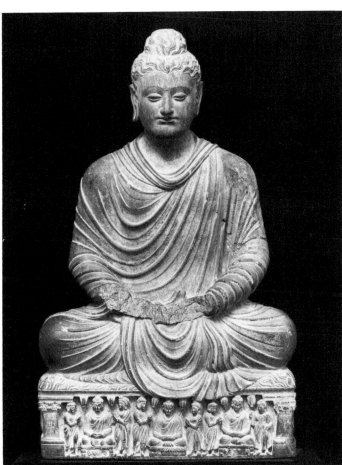

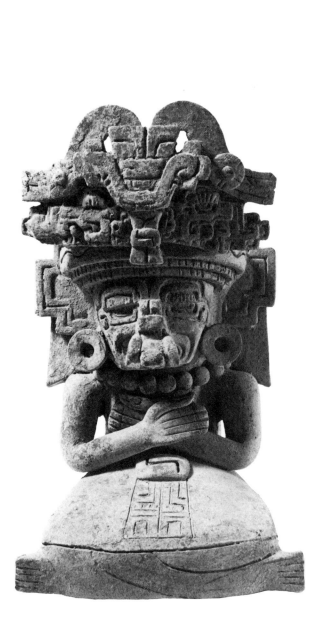

above: 565. *Seated Buddha,*
from Gandhara, India (now Pakistan).
Kushan period, A.D. 2nd–3rd century. Stone, 36 × 22½".
Seattle Art Museum (Eugene Fuller Memorial Collection).

left: 566. Zapotec urn, Mexico,
from Oaxaca. A.D. 100–200.
Clay, height 9".
Dallas Museum of Art.

8th to 12th Century: Sculpture

Sculpture of the period that, in European history, we would call the Middle Ages is extremely varied. By this time sophisticated art styles had evolved in many regions. This section illustrates four pieces—from Asia, Europe, and Africa. All are religious images, but—because of the individual natures of the religions and the cultures that spawned them—they are quite different in their expression.

The earliest figure portrays *Shukongojin* (**567**), a guardian figure known as the "thunderbolt-bearer," who is associated with Buddhism. As noted earlier, depictions of the Buddha himself usually show him in a serene and formal pose (**565**), but lesser personages can be very dynamic. This life-size image of Shukongojin is made of painted terra cotta and stands in the Sangatsu-do (Third Month Hall) of the temple known as Todai-ji at Nara, in Japan. Shukongojin's role is protection. He is meant to ward off demons and evildoers, thus guarding the temple and the faith. His ferocious expression shows that early Japanese sculptors were capable of emotionalism and theatricality, while the S-curve twist of his body demonstrates mastery of the *contrapposto* pose (compare the figure of Laocoön, **463**). Curiously, Shukongojin is not meant to be seen. He is generally hidden behind a screen—acting as a sort of behind-the-scenes guard, ready to strike if the temple should be threatened.

Our next example is a high-relief carving of *Christ in Majesty* (**568**) from the church of St. Sernin in France. The Christ figure is reserved and immobile, with downcast eyes and a solemn, tranquil face. Christ's garments show a stylized, linear pattern that is more decorative than lifelike. Certain stylistic differences separate the Christ figure and the Shukongojin. European sculptors of the Middle Ages seldom ventured into carving fully in the round, most large sculptures are reliefs attached to the walls of churches. Asian sculptors of the period, obviously, were more comfortable with freestanding figures. Also, the Christian religion does not present in its theology any personage as dynamic and fierce as Shukongojin. An image like that of the thunderbolt-bearer would be unthinkable in Western religious art.

left: 567. *Shukongojin*, guardian figure. Nara period, A.D. mid-8th century. Painted clay, height 5'8½". Sangatsu-do of Todai-ji, Nara, Japan.

right: 568. *Christ in Majesty*. Late 11th century. Marble. St. Sernin, Toulouse, France.

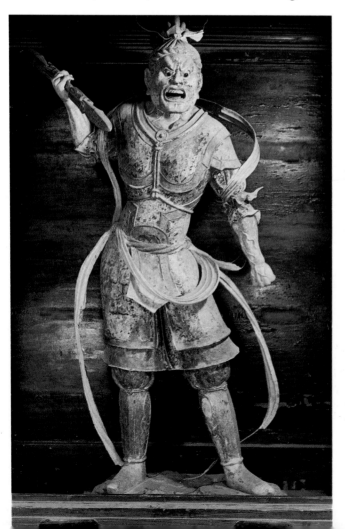

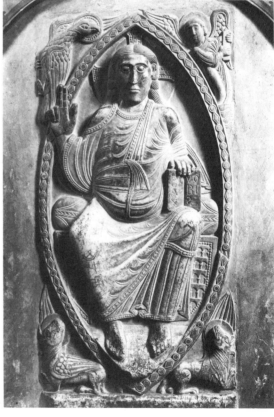

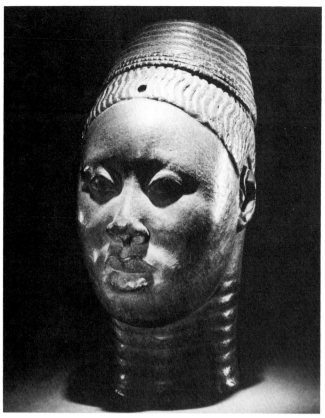

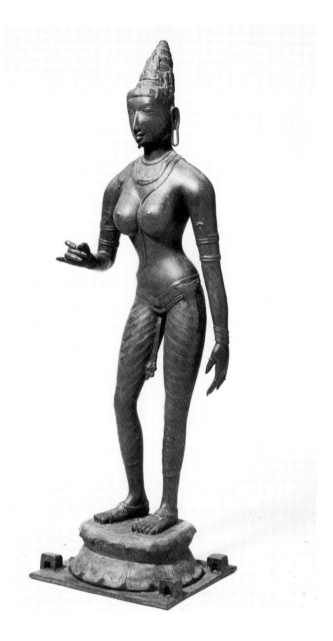

above: 569. Cast of Ife terra cotta head
called *Lajuwa*, from Nigeria. c. 1200–1300.
American Museum of Natural History, New York.

right: 570. *Parvati*, from India.
10th century. Bronze, height 40″.
Freer Gallery of Art,
Smithsonian Institution, Washington, D.C.

Neither the Christ figure nor the Shukongojin is particularly naturalistic in its representation of the human form. For naturalism in this period, we can turn to Africa, where sculptors of the Ife region, in northern Nigeria, were fabricating images of exquisite and lifelike beauty. Ife artists were not only highly skilled in working with terra cotta, as is evident here (**569**), but were also superb metal-casters. Many heads like this one, all of exceptionally high quality, have been found in the area. It is believed that the heads played a role in ancestor-worship, and that each was an individual, true portrait, perhaps made when the person was still alive. After death the sculptured head served as a repository for that person's soul.

A very different approach to depicting the human figure is revealed in the bronze statue of *Parvati*, from India (**570**). Parvati is a goddess of the Hindu religion—another major faith of India. She has many names and many physical guises, but as Parvati she is consort (or wife) of the powerful god Siva. Parvati is a daughter of the mountain, and mother of the war-god. Here she is depicted in characteristic Indian style—full-breasted (to show her procreative powers and strength), narrow-waisted, slender and elegant. The graceful gestures of her hands almost defy the rigid bronze in which this figure was cast.

15th to 16th Century:
Pictorial Arts

The depiction of the natural world has been an important artistic theme in many cultures, especially in Europe, China, and Japan. Sometimes the goal has been to duplicate the physical landscape as closely as possible, to create a mirror of the natural world. Other artistic styles have attempted to *evoke* the sense of the landscape without actually duplicating it. Let us look at four examples of landscape art, made in different parts of the world over a period of not more than one hundred fifty years.

In 15th-century Japan landscape painting reached a pinnacle of stylistic development, and Sesshu was the great master of this style. His *Autumn Landscape* (**571**) is a wonderfully composed arrangement of diagonals—one from the trees at upper right to the ground at lower left, another cutting from middle left to intersect with the first and focus attention on the pagoda near the center of the painting. Sesshu's brushwork is assured, so sharp and definite that he need give only a few strokes to convey the essence of form. Obviously, this is not a naturalistic depiction of the landscape, such as a European Renaissance artist might hope to achieve; it is instead an evocation of the beauty, majesty, and serenity of nature.

Similar goals motivated the Ming dynasty Chinese artist Qiu Ying. His *Lady in a Pavilion* (**572**), which we considered in Chapter 7 (**241**), looks like a dream landscape in which no earthly concerns intrude. The pavilion is perched on a hillside, seeming almost to float above the ground to the music of the barely visible harpist. The clump of trees below might be lightly suspending the pavil-

ion on their branches, like a balloon. Qiu Ying's brushwork is fully as delicate and assured as that of his Japanese colleague.

Now we move west and north, to examine a rendering of landscape almost exactly contemporary with the previous two, but made in Europe, in the German city of Nuremberg (**573**). The *Nuremberg Chronicle*, of which this image was a part, was conceived as a "history of the world" up to that time, and therefore depicted, in woodcut, many important people and places. "Portugalia," shown here, seems at first to have several traits in common with the Japanese and Chinese landscapes of the period. It is decorative, rather than naturalistic, in its depiction of physical features, and it focuses attention on the foreground tree and the building at upper left. But the German artist is far more precise and far more interested in filling the space with linear detail. This is partly because of the needs of the woodcut printing process (Chapter 8), but also because the northern European artists of the time emphasized neatness and order. We might also notice that most of the lines in this woodcut are horizontals and verticals—not the sliding diagonals characteristic of the Eastern paintings.

Our fourth example in this section was painted only about ten years after the scene from the *Nuremberg Chronicle*. Yet in a sense the *Nuremberg* woodcut has more in common with its Chinese and Japanese counterparts than it does with a painting made, so to speak, just down the road, in Italy. Giorgione's *The Tempest* (**574**), as discussed earlier (**491**), was a Renaissance attempt to portray the natural landscape as faithfully as possible, and to capture the effects of an approaching storm. But one factor marks this work as drastically different from landscapes of other cultures during this period, and that is the emphasis on people. Giorgione put two important figures in his foreground. We do not know who they are, but clearly they are an essential part of his composition. No figures intrude on the view of "Portugalia"; and the Eastern landscape artists, if they include figures at all, make them tiny and fit them unobtrusively into the majesty of nature. This is an extremely interesting point in comparing works of art from different cultures: Is nature more important, or are people? And how do they fit together?

below: 573. Shop of Michael Wolgemut. "Portugalia," from the *Nuremberg Chronicle*. 1493. Woodcut, $9\frac{1}{8} \times 9''$.

right: 574. Giorgione. *The Tempest*. c. 1505. Oil on canvas, $32\frac{1}{4} \times 28\frac{3}{4}''$. Academy, Venice.

14th to 16th Century: Precious Objects

Not every culture has made paintings or sculptures; but every culture we know has made precious objects—functional articles raised to the level of art because of their ingenious design and fine craftsmanship. In Chapter 16 of this book we focused on the painting and sculpture in the period of Western culture known as the Renaissance. Here we concentrate on decorative objects of the same period, from Europe, Asia, North and South America, and Africa. The dates of some of these pieces are uncertain, but most of them were created between the 14th and 16th centuries.

Benvenuto Cellini was a goldsmith and sculptor of Florence, perhaps one of the greatest masters of fine gold work who ever lived. His best-known piece is the *Saltcellar of Francis I* (**575**), made for the king of France. Cellini's genius was to capture in miniature the physical perfection and grace of figures such as Michelangelo and his colleagues would have carved on a heroic scale—and to surround them with an opulent decoration to satisfy the tastes of monarchs. Ostensibly, this elegant piece was meant to dispense salt and pepper. Neptune, god of the sea, doles out the salt; the goddess Earth is custodian of the pepper. In fact, the *Saltcellar* probably was intended above all to display the virtuosity of Cellini, and at this it succeeds.

Many people automatically associate fine porcelain—vases and decorative objects—with the word "Ming." The Ming dynasty in China, dating from 1368 to 1644, produced what are unquestionably some of the loveliest specimens of ceramic art ever created. In this example (**576**) the lotus blossoms in the pure white of the base clay gleam through a transparent glaze, surrounded by blue and yellow enamel glazes. The graceful form of the vase is in perfect harmony with the decoration.

Another ceramic vessel (**577**), just as graceful but much simpler in its decoration, was made half a world away, in a portion of the Mississippi Valley now in Louisiana. Very little is known about the culture that made this bottle, which was found in a burial mound. Its swirling, circular decoration, scratched into the clay, is sensitively related to the form. In its simple shape and geometric design, this bottle seems modern enough to have been constructed by a 20th-century craftsman.

Ivory carving has been done in many parts of the world, but we tend to associate it with Africa because the raw material—elephant tusks—has come primarily from that continent. The belt mask illustrated here (**578**) shows the

left: 575. Benvenuto Cellini. *The Saltcellar of Francis I*. 1539–43. Gold, 10¼ × 13⅛″. Kunsthistorisches Museum, Vienna.

right: 576. Mei-ping vase, from China. Ming Dynasty, late 15th century. Porcelain, height 14¾″. Cleveland Museum of Art (bequest of John L. Severance).

flexibility of the material. In its facial features the mask has a full-fleshed naturalism that recalls the Ife terra cotta heads of a century or two earlier (**569**). But the artist of this mask, working in extremely hard and resistant ivory, has also been able to carve in exquisite detail the many tiny heads that surround the face, representing "hair" and "beard."

As a working material, silver is almost the opposite of ivory. It is very soft, easy to mold, and vulnerable to damage. The search for silver and gold was a prime motivation for the *conquistadores,* the Spanish conquerors who overtook the ancient cultures of Central and South America in the 16th century. Many of the precious objects found by the Spaniards were shipped back to Europe, there to be melted down for the metal. The *Figure of a Musician* shown here (**579**) survived. Made by the Chimu culture in Peru, this little figure, hammered from sheet silver, demonstrates the cheerful, light-hearted character that has come to be associated with the Chimu. Almost no historical record exists, so what we know of this culture comes from the wonderful metalwork, ceramics, and weaving that have survived.

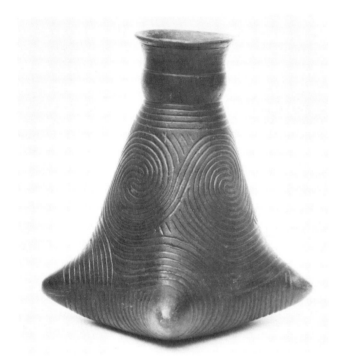

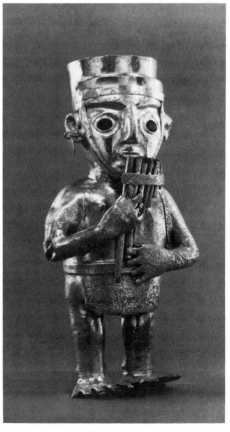

above: 577. Water bottle, from Ouachita Parish, Louisiana. 1300–1700. Ceramic, height 5¾". Museum of the American Indian, Heye Foundation, New York (Clarence B. Moore Collection).

top: 578. Belt mask, from Nigeria. c. 1550. Ivory, height 9⅜". Metropolitan Museum of Art, New York (Michael C. Rockefeller Memorial Collection, gift of Nelson A. Rockefeller, 1972).

right: 579. *Figure of a Musician,* from Peru. Chimu culture, 14th–15th century. Silver, height 8¼". Metropolitan Museum of Art, New York (Michael C. Rockefeller Memorial Collection, gift of Nelson A. Rockefeller, 1969).

16th to 18th Century:
Pictorial Arts

In this final section we look at pictorial art, which by the 16th century was highly developed in many cultures. To make a clear comparison, we have chosen five works, from widely separated parts of the world, that feature a woman and man together.

Thomas Gainsborough, an English artist, was considered one of the great portraitists of the 18th century. The picture illustrated, usually called *The Morning Walk*, (**580**), is not, strictly speaking, a portrait—that is, it is not a portrait of a specific couple so much as a portrait of aristocratic people at leisure. Mr. and Mrs. Hallett are a softly drawn, elegant pair, whose voluptuous forms are just barely defined against the landscape that surrounds them. All parts of the composition are closely integrated: human figures, dog, clouds, background—caught in a swirl of romantic charm.

Gainsborough's work was almost certainly known to, and admired by, a painter of Colonial America—William Williams. (Although the Gainsborough painting illustrated is dated after that of Williams, the English artist's earlier works were familiar in the Colonies.) Williams' painting of *Husband and Wife in a Landscape* (**581**) makes an excellent comparison to Gainsborough's *The Morning Walk*. In subject the two are identical. Each shows a married couple, accompanied by a dog, out for a stroll. But the styles of the two works are not at all alike. Williams has arranged his couple precisely in the center of the canvas, set them apart from the landscape as though they were standing in a stage set, and even placed them in apparent opposition to one another. The husband seems to be pulling one way, the wife the other. All this is in contrast to Gainsborough's

580. Thomas Gainsborough. *"The Morning Walk,"* *Mr. and Mrs. Hallett.* 1785. Oil on canvas, 7'9" × 5'10½". National Gallery, London.

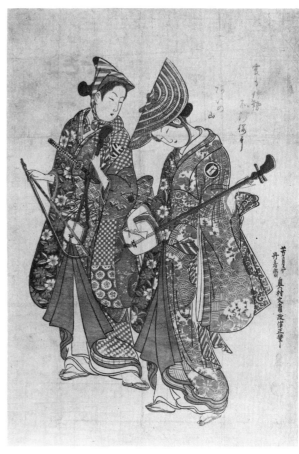

below: **581.** William Williams, Jr.
Husband and Wife in a Landscape. 1775.
Oil on canvas, $33\frac{3}{16} \times 39\frac{1}{8}''$.
Henry Francis du Pont
Winterthur Museum, Winterthur, Del.

right: **582.** Okumura Masanobu.
Lovers. Japan,
Edo period, 18th century.
Woodcut.
Museum of Fine Arts, Boston
(Ross Collection).

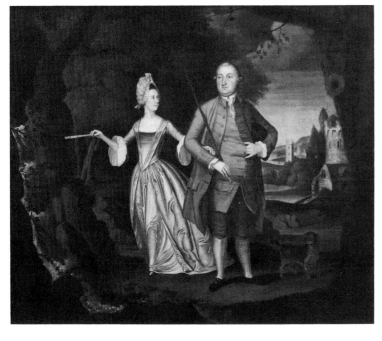

painting, which is one smooth flow of movement, from clouds to feet. It would be too easy to say merely that Gainsborough was a better painter than Williams—although this is undoubtedly true. More important, however, Williams was painting within the fairly austere style of Colonial America, a style that valued a strict presentation of the visual facts. Gainsborough was painting a romantic ideal.

How very different is a work called *Lovers* (**582**) by the Japanese artist Okumura Masanobu, almost exactly contemporary with the previous two. Masanobu includes no landscape. Nothing exists except the two lovers themselves, caught up in their entrancement with each other. The man and woman do not look at each other, but they are drawn together in intimacy and longing. For the viewer this print is delightful in the elaborate decoration of the couple's robes and the sinuous outline of the two figures.

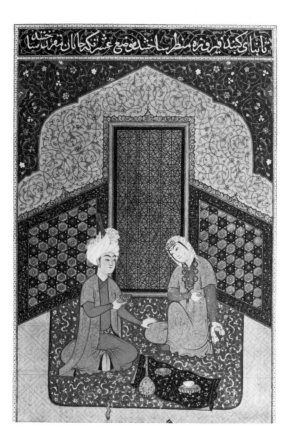

below: **583.** *Krishna and Radha in a Grove.* c. 1780.
Gouache on paper, 4¾ × 6¾".
Victoria & Albert Museum, London (Crown Copyright).

right: **584.** Mahmud Muzahib (?).
Bahram Gur in the Turquoise Palace on Wednesday.
Persian miniature, 16th century.
Metropolitan Museum of Art, New York
(gift of Alexander Smith Cochran, 1913).

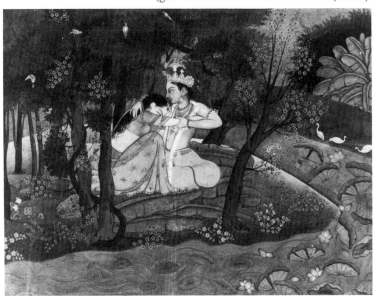

The image of *Krishna and Radha in a Grove* (**583**), contemporary with the previous three but made in India, is much more deliberately sensual. Krishna is an important Hindu god, whom we saw as a child in the guise of "the butter thief" earlier in the book (**365**). As an adult Krishna is often shown in a rendezvous with his beloved, Radha. Indian art contains many examples of meetings, or anticipated meetings, between the couple. There is a passion and intensity in the love between Radha and Krishna—the union of body and soul—that would be unusual in art from other cultures in this period.

Finally, we come to a Persian miniature dated two centuries earlier, *Bahram Gur in the Turquoise Palace on Wednesday* (**584**). Here we see no passion, but only, perhaps, a quiet comradeship. The male and the female figures seem to have been arranged primarily for symmetry, for equal weight in the decorative scheme of the painting, rather than to emphasize any romantic connection between them. Like the background they inhabit, they are flat and ornamental. Persian art strives more for visual appeal than for emotional content.

The temptation to compare the art from here and there, from now and then, is irresistible. We cannot help but be intrigued by the questions: How did it get that way? Why is it so much like other art? Why is it so different? Above all, the study of art from other cultures forces us to set aside preconceived ideas about what art *should* look like. And this openness of mind is valuable for the understanding of all art, from all times and places.

Keeping the Art We Live With: Conservation and Restoration

Torrential rains had fallen on Italy for many days. The earth was wet; rivers were swollen. Just before dawn on the morning of November 4, 1966, the Arno River overflowed its banks, engulfing the countryside. Citizens of Florence awakened to find their city under water—in several places under 14 feet of water and mud. Also under water were thousands of works of art, a large portion of them priceless and irreplaceable masterpieces from the Renaissance. Overnight, Florence, the great repository of Italian art, had become the watery graveyard of Italian art.

The great flood of 1966 woke up not only the Florentines, who survived by clinging to the rooftops and upper stories of their houses, but also awakened art-lovers around the world to a fact that no one likes to dwell on: Art is destructible. Disasters, both natural and unnatural, can take away forever the splendid works of art we consider essential to our cultural heritage. How would our culture be impaired without a *Mona Lisa?* a *Starry Night?* a *David?* Would some necessary piece of our civilization be lost? We already know what it means to live with a badly damaged Parthenon (**409**), because that destruction happened so long ago, three hundred years ago, and we are used to it. The trouble is, most of us tend to be complacent, to assume that works of art will always stay the same as they are now, during our lifetimes. No doubt the citizens of Florence and those who admire the art housed in Florence thought the same thing, but they were wrong. Keeping the art we live with—keeping it in the highest possible state of preservation—requires vigilance and care, and sometimes it requires repair work. That is the subject of this essay.

Artworks at Risk: The Dangers

To begin our discussion, we might pose the question: What *are* the sorts of phenomena that threaten our works of art? The list is a long one:

Item: The caves in southern France and Spain, where the oldest known drawings and paintings from our civilization are found (**2**), have been closed to the public. The paintings had begun to show serious deterioration from crowds of tourists tracking in dust and even from the elevated humidity caused by people breathing. From now on only scholars with special permission will be able to view the cave art.

Item: In 1975 a Dutch mental patient carried a knife into the Rijksmuseum in Amsterdam and managed to gouge twelve deep slashes into Rembrandt's painting *The Night Watch* before a guard was able to pull him off (**585**).

Item: Security at the Taj Mahal in India (**415**) now includes barbed wire, extra guards, and a ban on cameras. The Taj is menaced by the triple threat of air pollution, terrorist bombings (a camera might conceal an explosive device), and vandals who consider it a romantic gesture to scratch their initials deep into the marble walls.

Item: Many of the sculptures on the Acropolis in Athens have been removed to museums and replaced with cheap copies, because that city's devastating air pollution was eating the originals to dust.

Item: The *David* sculpture of Michelangelo (**487**), which is marble, needed only a cleaning after the flood in Florence, but an important work by Donatello, a wood sculpture of *Mary Magdalene*, was badly damaged.

Item: During World War II numerous well-known works of art in Japan, Europe, and elsewhere were destroyed by bombing. A Japanese firm recently paid nearly forty million dollars for a Van Gogh painting of *Sunflowers*, to replace a similar work lost in the war.

Item: Tourist visits to Stonehenge in England (**69**) have been severely restricted, especially at night, for otherwise caretakers would never be able to keep up with the job of cleaning off graffiti from the four-thousand-year-old megaliths.

To sum up, then, the disasters that can befall art divide into two categories: those caused by nature—floods, earthquakes, tornadoes; and those caused by people—wars, pollution, terrorism, vandalism, even simple overexposure. In our time, sad to say, human damage has unquestionably taken the lead.

585. Rembrandt. *Sortie of Captain Banning Cocq's Company of the Civic Guard (The Night Watch)*, detail; photographed the day after it was slashed on September 14, 1975. Rijksmuseum, Amsterdam.

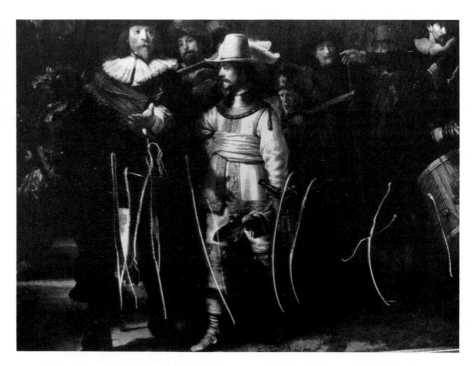

The struggle to protect artworks from damage must rely on two approaches: *conservation,* which means preserving works of art in their present state and preventing any damage or any further damage; and *restoration,* which means employing modern techniques to correct existing damage and put artworks back in their original condition. Both of these activities sound idealistic and sensible, but in practice they frequently open a Pandora's box of troubles. Nearly every decision about conservation or restoration is controversial, and nearly every decision makes *somebody* angry. As often as not, there are at least two sides to every art-preservation issue.

Conservation

Possibly the most famous—or notorious—incident involving art conservation occurred early in the 19th century. At that time Greece, and all the surviving art treasures of ancient Greece, were under the control of the Turks. The British ambassador to the Sultan of Turkey was a man named Thomas Bruce, the seventh Earl of Elgin. With the Sultan's permission, Lord Elgin arranged for the removal of numerous sculptures from the buildings on the Acropolis, including the Parthenon, and had them shipped back to England at his own expense. Although he claimed his motives were pure, that he intended to protect the precious legacy of Greek art, many felt that Lord Elgin's goal was the aggrandizement of Great Britain and (not incidentally) of Lord Elgin. The sculptures ended up in the British Museum, where they remain today and are known as the "Elgin marbles." Even at the time Lord Elgin's act caused a good deal of scandal, and it is still a source of international friction. The Greeks want their sculptures back. The British refuse to give them up. Who is right? A good lawyer could argue either side. On the one hand, the sculptures are undeniably Greek. They were carved *in* Athens *for* Athens, and Lord Elgin's action in cutting them off the architecture could be viewed as vandalism and theft. On the other hand, the sculptures have remained safe in London for nearly two hundred years and are in a high state of preservation (**586**). Anyone who wishes can go to the British Museum and look at them. By contrast, the sculptures Lord Elgin left behind on the Acropolis have deteriorated badly from exposure to the elements.

Fortunately, most issues of conservation are not as dramatic as the controversy over the Elgin marbles, but the problem of keeping artworks intact, especially architecture and outdoor sculptures, becomes increasingly acute as our industrial society progresses. The enemies of outdoor art are almost invisible but nonetheless treacherous: acid rain, automobile emissions, pollutants from factory smokestacks. Our illustration (**587**) shows two photographs of the same sculpture, taken about sixty years apart, in 1908 and 1969. In the later photo, the

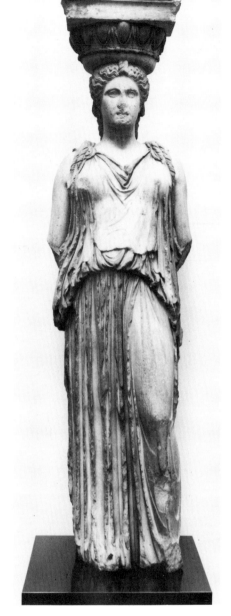

above: **586.** Caryatid from the Erechtheum, Athens, part of the "Elgin marbles." British Museum, London.

left: **587.** Photographs of sandstone sculpture, Herten Castle, Westphalia, West Germany, taken in 1908 and 1969.

sculpture is almost unrecognizable. Chemists have coined the term "stone leprosy" to describe such effects of air pollution, which is no less damaging to buildings than to sculpture. There is no easy answer to this problem. Either we must accept the gradual decay of everything we keep outdoors, or we must accept the urgent need to curtail pollutants in the air.

Artworks housed in museums and other "safe" locations can be considered reasonably immune to destruction. It would be extremely difficult now for a thief to walk off with the *Mona Lisa* (p. 413) or a slasher to attack *The Night Watch*. Most large museums have elaborate systems of temperature, humidity, and light control, as well as tight security. Still, accidents can happen, and there remains the backlog of artworks that have been permitted to deteriorate over the centuries. That is where the restorers come in.

Restoration

Restoration is even more controversial than conservation, and its major area of contention usually revolves around the question: How much? Or, more broadly, how much restoration work should be done, and what kind, and who decides? In a crisis like the slashing of Rembrandt's *Night Watch*, few arguments will arise. Museum curators knew what *The Night Watch* looked like moments before the knife attacked the canvas, and restorers had only to put it back the way it was before. Of course, the word "only" is relative and should not degrade the work of enormously skilled restorers, who took the deeply scarred and torn painting and returned it to a state where inspection from even a few inches away does not reveal the slash marks (**239**).

588. Agesander, Athenodorus, and Polydorus of Rhodes. *Laocoön Group*, with early restorations (now removed). Late 2nd century B.C. Vatican Museums, Rome.

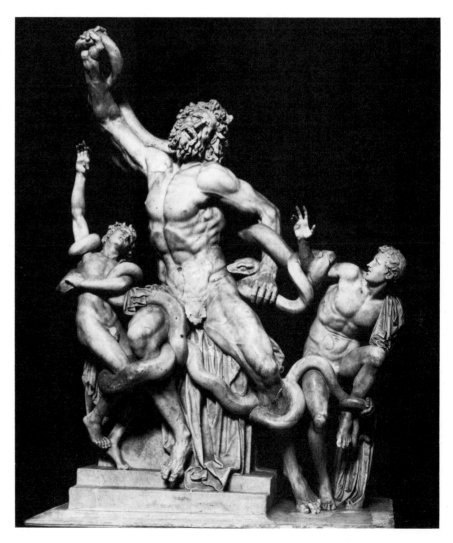

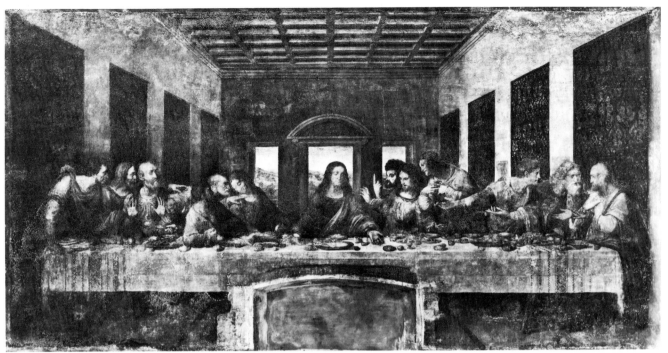

589. Leonardo da Vinci. *The Last Supper,* c. 1495–97.
Fresco, 15′1⅛″ × 28′10½″.
Refectory Santa Maria delle Grazie, Milan.

Arguments are more likely to rage when nobody knows exactly what a particular work of art looked like in its original state. The *Laocoön* statue from 2nd-century B.C. Greece is often given as the extreme example of restoration gone wild, and also of the tendency for restorations to mirror the prevailing fashions of a given period. When the statue was found in Italy in 1506, it was already damaged; the right arms of all three figures in the group were missing. Since then, no fewer than six restorers have, so to speak, taken a crack at repairing the sculpture, with mixed results. The first major restoration was done in 1532–33, at which time the figures were provided with outstretched arms much like those in our illustration (**588**; compare **463**). Art historians generally agree that restorers of the Renaissance thought of themselves as "remodelers," rather than mere repair technicians, so they considered it entirely correct to do over a statue to their own satisfaction. From that point the story becomes complicated.

New plaster arms were made in the 17th century, but they were superseded by marble arms attached in the 18th century. During the 19th century earlier versions of the two sons' arms were replaced, as was a terra cotta version of the 16th-century arm made for Laocoön. To satisfy the prudish sensibilities of the 19th century, "fig leaves" were added to cover the men's nakedness. Finally, in 1954 a thorough study of the statue was undertaken, and all the restorations were removed in 1960. As of that date—that is, as of the mid-20th century—classical experts feel the *Laocoön* is as close as possible to the sculptor's original intent. Naturally, the 21st century may have different ideas.

Unwise restorations have been the plague of many a great work of art, and there can be no better example than Leonardo da Vinci's famous depiction of *The Last Supper* (**589**). Painted to decorate the wall of a monastery in Milan, *The Last Supper,* which shows Christ and the twelve Apostles, has become for Christians around the world as much a religious image as a masterpiece of art. Countless reproductions of the painting have appeared on Bibles, Mass cards, pamphlets, and prints to hang on the wall. These reproductions probably bear little resemblance to Leonardo's original image. And no wonder, considering the painting's checkered history.

Leonardo worked on *The Last Supper* during the years 1495–97. Always a great one for experiment and innovation, he eschewed the established fresco

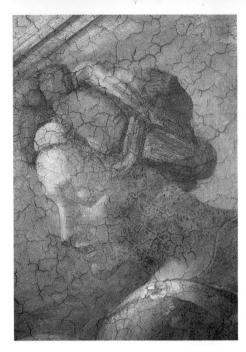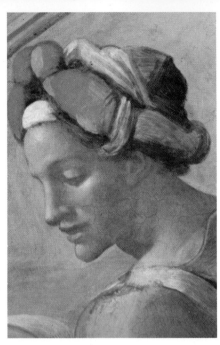

590. Michelangelo. Detail of ceiling frescoes, Sistine Chapel, before and after 1980s restoration. Vatican, Rome.

technique (Chapter 7) in favor of a medium he devised for this project—the details of which will probably never be known. For once, Leonardo's genius let him down. What may have been his greatest work soon became a ruin. Within ten years the painting was said to be flaking badly; within about fifty years the biographer Giorgio Vasari wrote that "Nothing is visible but a dazzling mass of blots." The first major restoration was undertaken in 1726, and five others followed. Each of these restorers did more harm than good. One used a harsh solvent that dissolved Leonardo's colors. Another applied a strong glue that attracted dirt. Yet another restorer managed to give one of the Apostles six fingers on one hand.

To make matters worse, the physical environment of *The Last Supper* could scarcely be more precarious. Sharp variations in heat and humidity all but force the paint off the wall, bringing deep cracks in a surface that is really too thin to support a painting. Sometime in the 18th century well-meaning friars in the monastery installed a curtain across the mural—which had the effect of trapping moisture on the wall and scraping off yet more paint each time the curtain was drawn back. French soldiers of Napoleon occupied the monastery in 1796, and they took turns throwing rocks at the mural and climbing ladders to scratch out the Apostles' eyes. A bomb fell on the monastery during World War II, missing the wall by a yard. It's a miracle that anything is left at all, and little is left.

Now, steps are being taken to save what can be saved. A Milanese restorer, Dr. Pinan Brambilla Barcilon, began a major restoration of the mural in 1977 and expects to finish in about 1990. Dr. Brambilla has three major assets that earlier restorers lacked: modern technology in the form of microscopes, chemicals, and measuring devices; generous financial support (from the Olivetti Corporation); and a sincere respect for Leonardo's creation. Through sensitive probing she can tell what is Leonardo's work and what is somebody else's—and remove the latter. In areas where nothing is left of Leonardo's paint, she does not attempt to reconstruct the imagery. Dr. Brambilla simply paints in a neutral color. When she has finished, the mural surely will not look much like popular reproductions, but it will be *all* Leonardo. Dr. Brambilla is fully aware of the responsibility she bears. She has said, "All the eyes of the world that know Leonardo are watching what I do. Some nights I do not sleep."[1]

These days, Dr. Brambilla might sleep a little easier. The eyes of the art world are not focused on Milan, but on Rome, where another major restoration is in progress. It should be safe to say that no restoration project in history has generated as much controversy as the cleaning of Michelangelo's ceiling frescoes in the Sistine Chapel of the Vatican (**40,488**).

If art were a religion, one of its major deities might well be the Sistine Chapel frescoes of Michelangelo. One cannot overestimate the importance—the

Chronology

Style/Period	Political/Social Events and Personalities	Monuments/Major Artists
30,000–3,000 B.C.		
Old Stone Age, 30,000–10,000 New Stone Age, 10,000–4,000		*Venus of Willendorf*, 30,000–10,000 (**68**) cave paintings, France and Spain, 15,000–10,000 (**2**)
3,000–800 B.C.		
Cycladic culture, Aegean, c. 3000–1100 Sumerian culture, Mesopotamia, c. 2800–c. 1720 Old Kingdom, Egypt, 2686–2181 Middle Kingdom, Egypt, 2133–1991 Minoan culture, Crete, c. 2000–1100 Shang Dynasty, China, 1766–1045 Assyrian Empire, Mesopotamia, c. 1760–612 New Kingdom, Egypt, 1567–1085 Mycenaean culture, Greece, c. 1600–1100	Hammurabi, king of Babylonia, c. 1750–1708 Amenhotep IV, pharaoh of Egypt, 1379–1362 Tutankhamun, pharaoh of Egypt, 1361–1352 Fall of Troy (Trojan Horse), c. 1184	Square Temple, Tell Asmar, Iraq, c. 2900–2600 (**454**) *Great Sphinx*, Egypt, c. 2530 (**451**) Great Pyramids, Egypt, c. 2500 (**77**) Stonehenge, England, c. 2000–1500 (**69**) Temple of Amen-Mut-Khonsu, Egypt, c. 1390 (**407**)
800 B.C.–A.D. 1		
Zhou Dynasty, China, 1045–256 Etruscan style, Italy, 6th cent. Archaic Period, Greece, c. 560–c. 500 Classical Period, Greece, c. 500–c. 400 Hellenistic Period, Greece, c. 400–c. 300	Sargon II, king of Assyria, c. 722–705 Nebuchadnezzar II, king of Babylon, 605–562 Rome founded, c. 753 Buddha, c. 563–483 Confucius, c. 551–479 Great Wall of China begun, c. 228 Augustus, emperor of Rome, 27 B.C.–A.D. 14	Palace of Sargon II, Iraq, c. 721–705 (**455**) Ishtar Gate, Babylon, c. 575 (**456**) Parthenon, Athens, 447–432 (**72, 409, 591**) Great Stupa, India, 3rd cent. B.C.–A.D. 1st cent. (**73**) *Earthenware Army*, China, c. 210 (**346**) Pont du Gard, France, 1st cent. (**410**) *Laocoön Group*, late 2nd cent. (**463**) *Augustus of Prima Porta*, c. 20 (**78**) Praxiteles (c. 390–c. 330)
A.D. 1–800		
Roman Empire, 31 B.C.–c. 500 Maya culture, Mexico & Central America, c. 300–1500 Gupta Period, India, 320–647 Byzantine Empire (Europe–Asia), c. 400–1453 Tang Dynasty, China, 618–907 Islamic Empire, c. 622–900 Nara Period, Japan, 645–794	Jesus Christ (c. 4 B.C.–C. A.D. 29) Pompeii destroyed, 79 Constantine, emperor of Rome, 306–337 Justinian, emperor of Byzantium, 527–565 Mohammed (c. 570–632)	Colosseum, Rome, 72–80 (**467**) Pantheon, Rome, 118–125 (**413**) San Vitale, Ravenna, 527–547 (**469**) Pyramid of the Sun, Mexico, c. 510–660 (**406**) Hagia Sophia, Istanbul, 532–537 (**414**)
A.D. 800–1400		
Middle Ages, Europe Song Dynasty, China, 960–1279 Inca Empire, Peru, c. 1100–1532 Kamakura Period, Japan, 1185–1333	Crusades, Europe, 1096–1270 Magna Carta, England, 1215 Marco Polo journeys to China, 1271–1295 Black Death in Europe, 1348–1357	Li Cheng (d. 967) *Gero Crucifix*, 975–1000 (**474**) *Bayeux Tapestry*, c. 1073–1088 (**402**) Chartres Cathedral, France, c. 1194–1260 (**74, 412**)

Style/Period	Political/Social Events and Personalities	Monuments/Major Artists

1400–1600

Style/Period	Political/Social Events and Personalities	Monuments/Major Artists
Aztec Empire, Mexico, c. 1350–1521 Ming Dynasty, China, 1368–1644 Muromachi Period, Japan, 1392–1573 Renaissance, Italy, c. 1400–c. 1600 Benin "classical" period, Africa, 1550–1680 Renaissance, Northern Europe, c. 1500–c. 1600	Joan of Arc burned at the stake, 1431 Lorenzo de' Medici, ruler of Florence, 1469–1492 Christopher Columbus landed in the Americas, 1492 Henry VIII, king of England, 1509–1547 Martin Luther, beginning of Protestant Reformation in Europe, 1517 William Shakespeare, 1564–1616	St. Peter's, Vatican, Rome, c. 1450–1663 (**439, 489**) Sistine Chapel frescoes, Rome, 1508–1512 (**488**) Jan van Eyck (1370?–1440?) Donatello (1386–1466) Masaccio (1401–1428) Sesshu (1420–1506) Sandro Botticelli (1444?–1510) Hieronymus Bosch (c. 1450–1516) Leonardo da Vinci (1452–1519) Albrecht Dürer (1471–1528) Michelangelo (1475–1564) Raphael (1483–1520) Qiu Ying (d. c. 1560) El Greco (1541?–1614)

1600–1700

Style/Period	Political/Social Events and Personalities	Monuments/Major Artists
Baroque Period, Europe Colonial Period, North America Edo Period, Japan, 1615–1868 Qing Dynasty, China, 1644–1912	Catholic Counter Reformation in Europe *Mayflower* landed on coast of North America, 1620 Louis XIV, king of France, 1643–1715	Taj Mahal, India, 1632–1653 (**415**) Cornaro Chapel, Rome, 1645–1652 (**498, 499**) Versailles Palace, France, 1661–1688 (**503**) Peter Paul Rubens (1577–1640) Gianlorenzo Bernini (1598–1680) Diego Velázquez (1599–1660) Rembrandt (1606–1669) Jan Vermeer (1632–1675)

1700–1800

Style/Period	Political/Social Events and Personalities	Monuments/Major Artists
Rococo Style, Europe Colonial Period, North America Edo Period, Japan, 1615–1868 Qing Dynasty, China, 1644–1912	Louis XV, king of France, 1715–1774 Louis XVI, king of France, 1774–1792 American Declaration of Independence, 1776 American Revolution, 1775–1783 French Revolution, begun 1789	Antoine Watteau (1684–1721) Jean Baptiste Siméon Chardin (1699–1779) François Boucher (1703–1770) Jean Honoré Fragonard (1732–1806) Francisco de Goya (1746–1828)

1800–1850

Style/Period	Political/Social Events and Personalities	Monuments/Major Artists
Neoclassicism, France, early 19th century Romanticism, France, early 19th century Realism, France, mid-19th century Federal style and Greek Revival, United States Edo Period, Japan, 1615–1868 Qing Dynasty, China, 1644–1912	Napoleon I, emperor of France, 1804–1814 War of 1812, United States, 1812–1814 invention of photography by Daguerre, 1837	Jacques Louis David (1748–1825) Katsushika Hokusai (1760–1849) Jean Auguste Dominique Ingres (1780–1862) Théodore Géricault (1791–1824) Ando Hiroshige (1797–1858) Eugène Delacroix (1798–1863) Honoré Daumier (1808–1879)

Style/Period	Political/Social Events and Personalities	Monuments/Major Artists
1850–1900		
Impressionism, France, c. 1875–1900 Post-Impressionism, France, c. 1880–1900	Victoria, queen of England, 1837–1901 Admiral Perry visited Japan, 1853 American Civil War, 1861–1865 First public showing of motion pictures, 1895	Crystal Palace, London, 1851 (**416**) Eiffel Tower, Paris, 1889 (**417**) Statue of Liberty, New York, installed 1886 (**355**) Edouard Manet (1832–1883) James Abbott McNeill Whistler (1834–1903) Edgar Degas (1834–1917) Paul Cézanne (1839–1906) Auguste Rodin (1840–1917) Claude Monet (1840–1926) Berthe Morisot (1841–1895) Pierre Auguste Renoir (1841–1919) Thomas Eakins (1844–1916) Paul Gauguin (1848–1903) Vincent van Gogh (1853–1890) Georges Seurat (1859–1891) Henri de Toulouse-Lautrec (1864–1901)
1900–1945		
Expressionism, Europe, c. 1900–1920 Fauvism, France, begun 1905 Cubism, France, c. 1907–1914 Dada, Europe, c. 1916–1922 Surrealism, Europe, begun 1924	Wright Brothers' first flight, 1903 Armory Show, New York, 1913 World War I, 1914–1918 Russian Revolution, 1917 Bauhaus, Germany, 1919–1933 Tutankhamon's tomb found, 1922 Great Depression, 1929–1941 Spanish Civil War, 1936–1939 Television broadcast from New York World's Fair, 1939 World War II, 1939–1945	Edvard Munch (1863–1944) Alfred Stieglitz (1864–1946) Wassily Kandinsky (1866–1944) Käthe Kollwitz (1867–1945) Frank Lloyd Wright (1867–1959) Henri Matisse (1869–1954) Piet Mondrian (1872–1944) Paul Klee (1879–1940) Pablo Picasso (1881–1973) Edward Hopper (1882–1967) Georgia O'Keeffe (1887–1986) Marcel Duchamp (1887–1968) Norman Rockwell (1894–1978) Alexander Calder (1898–1976) Henry Moore (1898–1986) Alice Neel (1900–1984)
1945–present		
Abstract Expressionism, c. 1945–1960 Op Art, 1960s Pop Art, 1960s Minimal Art, 1960s New Realism, 1970s–1980s Neo-Expressionism, 1980s Conceptual Art, 1970s–1980s Computer Art, 1980s Performance Art, 1970s–1980s	atomic bomb dropped on Japan, 1945 Korean War, 1950–1953 Vietnam War, c. 1961–1973 first walk on moon, 1969	Pablo Picasso (1881–1973) R. Buckminster Fuller (1895–1983) Henry Moore (1898–1986) Louise Nevelson (b. 1899) Willem de Kooning (b. 1904) David Smith (1906–1965) Lee Krasner (1908–1984) Jackson Pollock (1912–1956) Robert Motherwell (b. 1915) Robert Rauschenberg (b. 1925) Andy Warhol (1930–1987) Frank Stella (b. 1936) David Hockney (b. 1937)

Bibliography
and Suggested Readings

General References

Canaday, John. *What Is Art? An Introduction to Painting, Sculpture & Architecture.* New York: Knopf, 1980.

Cummings, Paul. *Artists in Their Own Words.* New York: St. Martin's, 1982.

De la Croix, Horst, and Richard G. Tansey. *Gardner's Art Through the Ages,* 8th ed., 2 vols. New York: Harcourt Brace Jovanovich, 1986.

Fine, Elsa H. *Women and Art: A History of Women Painters and Sculptors from the Renaissance to the Twentieth Century.* Montclair, N.J.: Allanheld & Schram, 1978.

Fleming, William. *Arts and Ideas,* 7th ed. New York: Holt, Rinehart and Winston, 1986.

Goldwater, Robert, and Marco Treves, eds. *Artists on Art: From the Fourteenth to the Twentieth Century.* New York: Pantheon, 1974.

Gombrich, E. H. *The Story of Art,* 14th ed. Englewood Cliffs, N.J.: Prentice-Hall, 1985.

Harris, Ann Sutherland, and Linda Nochlin. *Women Artists: 1550–1950.* New York: Knopf, 1977.

Hartt, Frederick. *Art: A History of Painting, Sculpture, Architecture,* 2d ed., 2 vols. Englewood Cliffs, N.J.: Prentice-Hall, 1985.

Honour, Hugh, and John Fleming. *The Visual Arts: A History,* 2d ed. Englewood Cliffs, N.J.: Prentice-Hall, 1986.

Janson, H. W. *History of Art,* 3d ed. rev. by Anthony Janson. Englewood Cliffs, N.J.: Prentice-Hall, 1986.

Johnson, Ellen H., ed. *American Artists on Art: From 1940 to 1980.* New York: Harper & Row, 1982.

Jones, Lois Swan. *Research Methods and Resources: A Guide to Finding Art Information.* Dubuque, Iowa: Kendall/Hunt, 1985.

Larkin, Oliver. *Art and Life in America.* New York: Holt, Rinehart and Winston, 1960.

Mendelowitz, Daniel M. *A History of American Art.* New York: Holt, Rinehart and Winston, 1970.

Piper, David, ed. *Random House Library of Painting and Sculpture,* 4 vols. New York: Random House, 1981.

Chapter 1
Living with Art

Arnheim, Rudolf. *Visual Thinking.* Berkeley: University of California Press, 1980.

Bishop, Robert. *American Folk Sculpture.* New York: Dutton, 1983.

Edwards, Betty. *Drawing on the Right Side of the Brain.* Los Angeles: Tarcher, 1979.

Fein, Sylvia. *Heidi's Horse,* 2d ed. Pleasant Hill, Calif.: Exelrod Press, 1984.

Four Americans in Paris: The Collections of Gertrude Stein and Her Family. New York: Museum of Modern Art, 1970.

Hemphill, Herbert W., and Julia Weissman. *Twentieth Century American Folk Art and Artists.* New York: Dutton, 1974.

Lipman, Jean, and Tom Armstrong, eds. *American Folk Painters of Three Centuries.* New York: Hudson Hills and Whitney Museum of American Art, 1980.

Mendelowitz, Daniel M. *Children Are Artists.* Stanford, Calif.: Stanford University Press, 1963.

Samuels, Mike, and Nancy Samuels. *Seeing with the Mind's Eye: The History, Techniques, and Uses of Visualization.* New York: Random House, 1975.

Smeets, René. *Signs, Symbols and Ornaments.* New York: Van Nostrand Reinhold, 1982.

Stein, Gertrude. *The Autobiography of Alice B. Toklas.* New York: Random House, 1955.

Chapter 2
What Is Art?

Blocker, H. Gene. *Philosophy of Art.* New York: Scribner's, 1979.

Hammacher, A. M., and Renilde Hammacher. *Van Gogh: A Documentary Biography.* New York: Macmillan, 1982.

Herbert, Robert L. *Modern Artists on Art: Ten Unabridged Essays.* Englewood Cliffs, N.J.: Prentice-Hall, 1964.

Nelson, George. *How to See: A Guide to Reaching Our Manmade Environments.* Boston: Little, Brown, 1979.

Chapter 3
Themes and Purposes of Art

Bradley, William. *Art: Magic, Impulse, and Control: A Guide to Viewing.* Englewood Cliffs, N.J.: Prentice-Hall, 1973.

Clark, Kenneth M. *Civilisation: A Personal View.* New York: Harper & Row, 1970.

Elsen, Albert E. *Purposes of Art,* 4th ed. New York: Holt, Rinehart and Winston, 1981.

Hawkins, Gerald S. *Stonehenge Decoded.* New York: Delta, 1965.

Kris, Ernst, and Otto Kurz. *Legend, Myth, and Magic in the Image of the Artist.* New Haven, Conn.: Yale University Press, 1979.

Lisle, Laurie. *Portrait of an Artist: Georgia O'Keeffe.* New York, Seaview Books, 1980.

Pfeiffer, John E. *The Creative Explosion: An Inquiry into the Origins of Art and Religion.* Ithaca, N.Y.: Cornell University Press, 1985.

Wheat, Ellen Harkins. *Jacob Lawrence: American Painter.* Seattle: Seattle Art Museum, 1986.

Chapter 4
The Visual Elements

and

Chapter 5
Principles of Design in Art

Albers, Josef. *Interaction of Color,* rev. ed. New Haven, Conn.: Yale University Press, 1975.

Arnheim, Rudolf. *Art and Visual Perception: A Psychology of the Creative Eye.* Berkeley: University of California Press, 1974.

Birren, Faber. *Color and Human Response.* New York: Van Nostrand Reinhold, 1978.

Boase, T. S. R. *Giorgio Vasari: The Man and the Book.* Princeton, N.J.: Princeton University Press, 1979.

Ehrenzweig, Anton. *The Hidden Order of Art.* Berkeley: University of California Press, 1976.

Ellinger, Richard. *Color, Structure and Design.* New York: Van Nostrand Reinhold, 1980.

Ernst, Bruno. *The Magic Mirror of M. C. Escher.* New York: Ballantine, 1977.

Gill, Robert W. *Basic Perspective.* London: Thames and Hudson, 1980.

Itten, Johannes. *The Art of Color.* New York: Van Nostrand Reinhold, 1973.

———. *Design and Form: The Basic Course at the Bauhaus and Later.* New York: Van Nostrand Reinhold, 1975.

Lauer, David A. *Design Basics,* 2d ed. New York: Holt, Rinehart and Winston, 1985.

Pile, John F. *Design: Purpose, Form and Meaning.* New York: Norton, 1982.

Richardson, John Adkins, Floyd W. Coleman, and Michael J. Smith. *Basic Design: Systems, Elements, Applications.* Englewood Cliffs, N.J.: Prentice-Hall, 1984.

Zelanski, Paul, and Mary Pat Fischer. *Design Principles and Problems.* New York: Holt, Rinehart and Winston, 1984.

Chapter 6
Drawing

Betti, Claudia, and Teel Sale. *Drawing: A Contemporary Approach,* 2d ed. New York: Holt, Rinehart and Winston, 1986.

Chaet, Bernard. *The Art of Drawing,* 2d ed. New York: Holt, Rinehart and Winston, 1983.

Edwards, Betty. *Drawing on the Artist Within.* New York: Simon & Schuster, 1986.

Goldstein, Nathan. *The Art of Responsive Drawing,* 3d ed. Englewood Cliffs, N.J.: Prentice-Hall, 1984.

Mendelowitz, Daniel M. *A Guide to Drawing,* 3d ed. New York: Holt, Rinehart and Winston, 1982.

———. *Drawing,* repr. of 1967 ed. Stanford, Calif.: Stanford University Press, 1980.

Nicolaides, Kimon. *The Natural Way to Draw: A Working Plan for Art Study.* Boston: Houghton Mifflin, 1975.

Chapter 7
Painting

Blunden, Maria, and Godfrey Blunden. *Impressionists and Impressionism.* New York: Rizzoli, 1980.

Chaet, Bernard. *An Artist's Notebook: Techniques and Materials.* New York: Holt, Rinehart and Winston, 1979.

Cockcroft, Eva, John Weber, and James Cockcroft. *Toward a People's Art: A Contemporary Mural Movement.* New York: Irvington, 1987.

Godley, John. *The Master Forger: The Story of Han van Meegeren.* New York: Wilfred Funk, 1950.

Goldman, Shifra M. *Contemporary Mexican Painting in a Time of Change.* Austin: University of Texas Press, 1981.

Goldstein, Nathan. *Painting: Visual and Technical Fundamentals.* Englewood Cliffs, N.J.: Prentice-Hall, 1979.

Mayer, Ralph. *The Artist's Handbook of Materials and Techniques.* New York: Viking, 1981.

Chapter 8
Prints

Gelman, Barbara, ed. *The Wood Engravings of Winslow Homer.* New York: Bounty Books, 1969.

Hoffman, Detlef. *The Playing Card: An Illustrated History.* Greenwich, Conn.: New York Graphic, 1973.

Lane, Richard. *Masters of the Japanese Print.* Garden City, N.Y.: Doubleday, 1962.

Mayor, A. Hyatt. *Prints and People.* Princeton, N.J.: Princeton University Press, 1980.

Peterdi, Gabor. *Printmaking.* New York: Macmillan, 1980.

Pratt, John Lowell, ed. *Currier and Ives: Chronicles of America.* Maplewood, N.J.: Hammond, 1968.

Saff, Donald, and Deli Sacilotto. *Printmaking: History and Process.* New York: Holt, Rinehart and Winston, 1978.

Salamon, Ferdinando. *The History of Prints and Printmaking from Dürer to Picasso.* New York: American Heritage, 1972.

Chapter 9
The Camera Arts

Bernard, Bruce. *Photodiscovery: Masterworks of Photography 1840–1940.* New York: Abrams, 1980.

Four Screenplays of Ingmar Bergman, trans. Lars Malmstrom and David Kushner. New York: Simon & Schuster, 1960.

Gutman, Judith Mara. *Through Indian Eyes.* New York: Oxford University Press, 1982.

Horan, James D. *Mathew Brady: Historian with a Camera.* New York: Bonanza, 1955.

Mast, Gerald. *A Short History of the Movies.* New York: Macmillan, 1986.

Newhall, Beaumont. *The History of Photography.* New York: Museum of Modern Art, 1982.

Newhall, Beaumont, and Nancy Newhall, eds. *Masters of Photography.* New York: A & W, 1983.

The New York Times Film Reviews, 1913–1970, 1-Vol. Selection. New York: Arno Press, 1971.

Sandler, Martin W. *The Story of American Photography.* Boston: Little, Brown, 1979.

Shipman, David. *The Story of Cinema.* New York: St. Martin's, 1986.

Spoto, Donald. *The Dark Side of Genius: The Life of Alfred Hitchcock.* Boston: Little, Brown, 1983.

Swedlund, Charles. *Photography: A Handbook of History, Materials, and Processes,* 2d ed. New York: Holt, Rinehart and Winston, 1981.

Szarkowski, John. *Looking at Photographs: One Hundred Pictures from the Collection of the Museum of Modern Art.* New York: Museum of Modern Art, 1973.

Truffaut, François. *Hitchcock,* rev. ed. New York: Simon & Schuster, 1983.

Tucker, Anne, ed. *The Woman's Eye.* New York: Knopf, 1973.

Upton, Barbara, and John Upton. *Photography.* Boston: Little, Brown, 1985.

Chapter 10
Graphic Design

Buechner, Thomas S. *Norman Rockwell: A Sixty Year Retrospective.* New York: Abrams, 1972.

Deken, Joseph. *Computer Images: State of the Art.* New York: Stewart, Tabori and Chang, 1983.

Glaser, Milton. *Graphic Design.* Woodstock, N.Y.: Overlook, 1983.

Hall, Jim. *Mighty Minutes: An Illustrated History of Television's Best Commercials.* New York: Harmony, 1984.

Heller, Steven, ed. *Innovators of American Illustration.* New York: Van Nostrand Reinhold, 1986.

Johnson, Stewart J. *The Modern American Poster.* New York: Museum of Modern Art, 1983.

Mayor, A. Hyatt. *Popular Prints of the Americas.* New York: Crown, 1973.

Chapter 11
Sculpture

Goldwater, Robert. *What Is Modern Sculpture?* New York: Museum of Modern Art, 1969.

Gray, Cleve, ed. *David Smith by David Smith.* New York: Holt, Rinehart and Winston, 1968.

Kaprow, Allan. *Assemblage, Environments and Happenings.* New York: Abrams, 1966.

Mili, Gjon. *Picasso's Third Dimension.* New York: Triton, 1970.

Selz, Jean. *Modern Sculpture: Origins and Evolution,* trans. Annette Michelson. New York: Braziller, 1963.

Wilkin, Karen. *Smith.* New York: Abbeville, 1984.

Chapter 12
Crafts

Charleston, Robert J., ed. *World Ceramics.* New York: McGraw-Hill, 1968.

Held, Shirley. *Weaving: A Handbook of the Fiber Arts,* 2d ed. New York: Holt, Rinehart and Winston, 1978.

Morton, Philip. *Contemporary Jewelry,* 2d ed. New York: Holt, Rinehart and Winston, 1976.

Nelson, Glenn C. *Ceramics: A Potter's Handbook,* 5th ed. New York: Holt, Rinehart and Winston, 1984.

Nordness, Lee. *Object U.S.A.* New York: Viking, 1970.

Waller, Irene. *Textile Sculptures.* London: Studio Vista, 1977.

Westbrook, Adele, and Ann Yarowski, eds. *Design in America: The Cranbrook Vision, 1925–1950.* New York: Abrams, 1983.

Chapter 13
Architecture

Fuller, R. Buckminster, and Robert W. Marks. *The Dymaxion World of R. Buckminster Fuller.* New York: Reinhold, 1960.

Hitchcock, Henry Russell. *In the Nature of Materials: The Buildings of Frank Lloyd Wright, 1887–1941.* New York: Da Capo, 1975.

Le Corbusier. *Towards a New Architecture.* New York: Praeger, 1959.

Mansbridge, John. *Graphic History of Architecture.* New York: Viking, 1967.

Risebero, Bill. *Modern Architecture and Design: An Alternative History.* Cambridge, Mass.: MIT Press, 1983.

Safdie, Moshe. *Form and Purpose: Is the Emperor Naked?* Boston: Houghton Mifflin, 1982.

Scully, Vincent J. *Modern Architecture: The Architecture of Democracy.* New York: Braziller, 1982.

Stern, Robert A. M. *American Architecture: Innovation and Tradition.* New York: Rizzoli, 1985.

———. *Pride of Place: Building the American Dream.* Boston: Houghton Mifflin, 1986.

Torre, Susana. *Women in American Architecture.* New York: Whitney Library of Design, 1977.

Chapter 14
Environmental Design

Bacon, Edmund N. *Design of Cities.* New York: Penguin, 1976.

Bennett, Corwin. *Spaces for People: Human Factors in Design.* Englewood Cliffs, N.J.: Prentice-Hall, 1977.

Mehrabian, Albert. *Public Places and Private Spaces: The Psychology of Work, Play and Living Environments.* New York: Basic Books, 1980.

Rudofsky, Bernard. *Streets for People: A Primer for Americans.* New York: Doubleday, 1969.

Chapter 15
The Ancient World to the Middle Ages

Cowen, Painton. *Rose Windows.* San Francisco: Chronicle, 1979.

Edwards, I. E. S. *Tutankhamun: His Tomb and Its Treasures.* New York: Knopf and Metropolitan Museum of Art, 1977.

Hale, William Harlan. *The Horizon Book of Ancient Greece.* New York: American Heritage, 1965.

Mendelssohn, Kurt. *The Riddle of the Pyramids.* New York: Praeger, 1974.

Swann, Wim. *The Gothic Cathedral.* Garden City, N.Y.: Doubleday, 1969.

Chapter 16
Renaissance to Revolution

Chambers, D. S. *Patrons and Artists in the Italian Renaissance.* Columbia: University of South Carolina Press, 1971.

Cuttler, Charles D. *Northern Painting: From Pucelle to Bruegel.* New York: Holt, Rinehart and Winston, 1968.

Hartt, Frederick. *History of Italian Renaissance Art.* Englewood Cliffs, N.J.: Prentice-Hall, 1980.

Leonardo da Vinci. *Notebooks,* ed. E. MacCurdy. New York: Braziller, 1955.

Levey, Michael. *Rococo to Revolution.* New York: Praeger, 1966.

Panofsky, Erwin. *The Life and Art of Albrecht Dürer.* Princeton, N.J.: Princeton University Press, 1955.

Van der Kemp, Gerald. *Versailles.* New York: Park Lane, 1981.

Vasari, Giorgio. *Lives of the Artists,* trans. George Bull. New York: Penguin, 1966.

Chapter 17
The Modern World

Arnason, H. H. *History of Modern Art: Painting, Sculpture, Architecture, Photography.* New York: Abrams, 1986.

Ashton, Dore. *The New York School: A Cultural Reckoning.* New York: Penguin, 1980.

Battcock, Gregory. *Super Realism: A Critical Anthology.* New York: Dutton, 1975.

———. *Minimal Art: A Critical Anthology.* New York: Dutton, 1968.

Chicago, Judy. *The Dinner Party: A Symbol of Our Heritage.* Garden City, N.Y.: Doubleday, 1979.

Diamonstein, Barbaralee. *Inside New York's Art World.* New York: Rizzoli, 1980.

Hughes, Robert. *The Shock of the New.* New York: Knopf, 1981.

Kaprow, Allan. *Assemblage, Environments and Happenings.* New York: Abrams, 1966.

Lippard, Lucy R. *Pop Art.* New York: Praeger, 1966.

Rosenblum, Robert. *Cubism and Twentieth-Century Art.* Englewood Cliffs, N.J.: Prentice-Hall, 1976.

Roskill, Mark, ed. *The Letters of Vincent Van Gogh.* New York: Atheneum, 1977.

Rubin, William, ed. *Pablo Picasso: A Retrospective.* New York: Museum of Modern Art, 1980.

Rubin, William S. *Dada and Surrealist Art.* New York: Abrams, 1969.

Seitz, William C. *Abstract Expressionist Painting in America.* Cambridge, Mass.: Harvard University Press, 1983. Washington, D.C.: National Gallery of Art, 1983.

Chapter 18
Comparative Styles in World Art

Baker, Joan Stanley. *Japanese Art.* London: Thames and Hudson, 1984.

Dwyer, Jane Powell, and Edward B. Dwyer. *The Traditional Art of Africa, Oceania, and the Americas.* San Francisco: Fine Arts Museum of San Francisco, 1973.

Emmerich, André. *Art Before Columbus.* New York: Simon & Schuster, 1983.

Lee, Sherman. *A History of Far Eastern Art,* 4th ed. Englewood Cliffs, N.J.: Prentice-Hall, 1982. New York: Abrams, 1982.

Rawson, Jessica. *Ancient China: Art and Archaeology.* New York: Harper & Row, 1980.

Notes to the Text

Chapter 1

1. Sylvia Fein, *Heidi's Horse,* 2d ed. (Pleasant Hill, Calif.: Exelrod Press, 1984).
2. Adapted from Sidney J. Parnes and Harold F. Harding, eds., *A Source Book for Creative Thinking* (New York: Scribner's, 1962); and Daniel M. Mendelowitz, *Children Are Artists,* 2d ed. (Stanford, Calif.: Stanford University Press, 1963).
3. Jerre Levy, "Right Brain, Left Brain: Fact and Fiction," *Psychology Today* (May 1985), pp. 38–44.
4. Quoted in Dora Jane Hamblin, "A Bright and Happy Four-Hundredth-Birthday Year for the Remarkable Uffizi," *Smithsonian* (November 1982), p. 71.
5. Arthur Schlesinger, Jr., "The Arts' Key Role in Our Society," *The New York Times* (September 20, 1985), p. A31.
6. "More Corporations Becoming Working Museums," *The New York Times* (September 15, 1985), p. 60.
7. Quotation from American Republic Insurance Company: ibid.; quotation from PaineWebber communicated to the publisher in a personal letter from the Chairman.
8. Mark Roskill, ed., *The Letters of Vincent van Gogh* (New York: Atheneum, 1977), p. 188.
9. P. Huisman and M. G. Dortu, *Lautrec by Lautrec* (New York: Viking, 1964), p. 164.

Chapter 2

1. Douglas C. McGill, "Artists and Officials Argue over Removing Sculpture," *The New York Times* (March 7, 1985), p. B1.
2. Ibid.
3. "Intrusive Arc," *The New York Times* (May 31, 1985), p. A26.
4. "A Picture over the Sofa," *The New York Times* (December 1, 1981), p. B2.
5. Michael Brenson, "Art People," *The New York Times* (November 12, 1982).
6. Robert Goldwater and Marco Treves, eds., *Artists on Art: From the Fourteenth to the Twentieth Century* (New York: Pantheon, 1972), p. 417.
7. Ibid., p. 421.
8. Quoted in Irving Sandler, *The Triumph of American Painting: A History of Abstract Expressionism* (New York: Harper & Row, 1976).
9. Goldwater and Treves, p. 82
10. Vincent van Gogh, *The Complete Letters;* quoted in Ronald Pickvance, *Van Gogh in Saint-Rémy and Auvers* (New York: The Metropolitan Museum of Art and Harry N. Abrams, Inc., 1986), p. 219.

Chapter 3

1. Margaret A. Miller, "Alice Aycock at U.S.F.," in *Alice Aycock Projects 1979–1981* (Tampa: University of South Florida), p. 47.
2. Thucydides, *The Peloponnesian War,* trans. Rex Warner (Baltimore: Penguin, 1954), pp. 118, 121.
3. Paul Zanker and John Pollini, quoted in "Scholar-Detectives Learn How Augustus Idealized His Image," *The New York Times* (January 10, 1984), p. C3.
4. Charles Blitzer and the Editors of Time-Life Books, eds., "Age of Kings," *Great Ages of Man: A History of World's Culture* (New York: Time-Life, 1967), p. 62.
5. Black Mountain College Records, 1946; quoted in Ellen Harkins Wheat, *Jacob Lawrence: American Painter* (Seattle: Seattle Art Museum, 1986), p. 73.
6. Gerstle Mack, *Paul Cézanne* (New York: Knopf, 1936), p. 199.
7. Exhibition catalogue statement, Anderson Galleries, January 29, 1923; quoted in Laurie Lisle, *Portrait of an Artist: Georgia O'Keeffe* (New York: Seaview Books, 1980), p. 66.
8. Kathleen Jessie Paine, *William Blake* (New York: Praeger, 1970), p. 148.

Chapter 4

1. Goldwater and Treves, op. cit., p. 74.
2. Peter de Polnay, *Enfant Terrible: The Life and Work of Maurice Utrillo* (New York: Morrow, 1969), p. 190.

Chapter 5

1. John Russell and the Editors of Time-Life Books, eds., *The World of Matisse* (New York: Time-Life, 1969), p. 9.
2. Goldwater and Treves, op. cit., p. 413.
3. Ibid., pp. 203–204.

Chapter 6

1. Martha Kearns, *Käthe Kollwitz: Woman and Artist* (Old Westbury, N.Y.: Feminist Press, 1976), p. 48.
2. Ibid., p. 164.
3. John Russell, "Henry Moore at Eighty—Many Happy Returns," *Smithsonian* (August 1978), p. 75.
4. Carll Tucker, "Henry Moore," *Saturday Review* (March 1981), p. 44.
5. Ibid., p. 46.
6. Grace Glueck, "Leo Castelli Takes Stock of 30 Years Selling Art," *The New York Times* (February 5, 1987), p. C19.

Chapter 7

1. Joan Kinneir, *The Artist by Himself* (New York: St. Martin's, 1980), p. 101.
2. Barbaralee Diamonstein, *Inside New York's Art World* (New York: Rizzoli, 1979), pp. 261–262.
3. John Godley, *The Master Forger: The Story of Han van Meegeren* (New York: Wilfred Funk, 1950), p. 191.

Chapter 8

1. Elizabeth Ripley, *Hokusai: A Biography* (Philadelphia: Lippincott, 1968), p. 24.
2. Ibid., pp. 62, 68.
3. Kinneir, op. cit., p. 107.
4. Piri Halasz, "An Artist's World of Passion, Pain and Weird Beauty," *Smithsonian* (December 1978), p. 94.
5. Diamonstein, op. cit., pp. 308–309. Information in this biography is adapted from *Robert Rauschenberg* (Washington, D.C.: National Collection of Fine Arts, 1976).

Chapter 9

1. John Szarkowski, *Looking at Photographs: One Hundred Pictures from the Collections of the Museum of Modern Art* (New York: Museum of Modern Art, 1973), p. 134.
2. Sue Davidson Lowe, *Stieglitz: A Memorial Biography* (New York: Farrar Straus Giroux, 1983), pp. xxiii, 441.
3. Gerald Marzorati, "Imitation of Life," *ARTnews* (September 1983), p. 80.
4. *The New York Times Film Reviews, 1913–1970* (New York: Arno Press, 1971), p. 6.
5. Donald Spoto, *The Dark Side of Genius: The Life of Alfred Hitchcock* (Boston: Little, Brown, 1983), p. 73.
6. François Truffaut, *Hitchcock,* rev. ed. (New York: Simon and Schuster, 1983), p. 256.
7. Vincent Canby, "Film: Woody Allen's Fond

Remembrances of 'Radio Days,'" *The New York Times* (January 30, 1987), p. C10.
8. Kerry Green, "Nam June Paik," *Video Systems* (July 1982), p. 53.

Chapter 10

1. Donald Walton, *A Rockwell Portrait* (Kansas City: Sheed Andrews & McMeel, 1978), p. 7.

Chapter 11

1. Cleve Gray, ed., *David Smith by David Smith* (New York: Holt, Rinehart and Winston, 1972), p. 25.
2. Ibid., p. 123.
3. Vicki Goldberg, "Louise Nevelson," *Saturday Review* (August 1980), p. 36.
4. Diamonstein, op cit., p. 271.

Chapter 12

1. Susan Peterson, *The Living Tradition of María Martínez* (New York: Kodansha International, 1977), p. 191.

Chapter 13

1. *The New York Times* (July 3, 1983), p. 17.
2. "Symbol and Workplace: An Interview with Kevin Roche," *Architectural Record* (September 1984), p. 106.
3. Frank Lloyd Wright, *A Testament* (New York: Horizon Press, 1957), p. 64.

Chapter 14

1. "Under Glass," *Progressive Architecture* (November 1980), p. 106.

Chapter 16

1. Quoted in Robert Wallace and the Editors of Time-Life Books, eds., *The World of Leonardo* (New York: Time Incorporated, 1966), p. 17.
2. Goldwater, op cit., pp. 60–61.
3. Ibid., p. 134.
4. Ibid., pp. 145–146.

Chapter 17

1. Nicholas Wadley, *Manet* (London: Paul Hamlyn, 1967), pp. 25–26.
2. John Russell and the Editors of Time-Life Books, eds., *The World of Matisse* (New York: Time-Life, 1969), p. 9.
3. Daniel Guérin, ed., *The Writings of a Savage: Paul Gauguin* (New York: Viking, 1974), p. 54.
4. Barbara Rose, *Lee Krasner: A Retrospective* (Houston: Museum of Fine Arts; New York: Museum of Modern Art, 1984), p. 134.
5. John Russell, "The New European Painters," *The New York Times* (April 24, 1983), p. 31.

Epilogue

1. Carlo Bertelli, "Restoration Reveals *The Last Supper,*" *National Geographic* (November 1983), p. 684.

Glossary

Words in *italics* are also defined in the glossary. Numbers in **boldface** following the definitions refer to the numbers of figures in the text that best illustrate the definitions.

abstract Characteristic of art in which natural *forms* are not rendered in a *naturalistic* or *representational* way, but instead, are simplified or distorted to some extent, often in an attempt to convey the essence of form. Compare *nonobjective*. (**50**)

Abstract Expressionism Painting style of the late 1940s and 1950s in which *abstract* or *nonobjective forms* were used to convey emotional *content*. Abstract Expressionism emphasized spontaneity and often employed bold colors and/or strong *value* contrasts; the paintings were usually quite large in *scale*. Because this art often involved energetic physical movement by the artist, it is also referred to as *action painting*. (**535**)

acrylic A plastic substance commonly used as a *binder* for paints and as a *casting* material for sculpture.

action painting Any painting style calling for vigorous physical activity; specifically, *Abstract Expressionism*.

aesthetic Pertaining to the beautiful, as opposed to the useful, scientific, or emotional. An aesthetic response is an appreciation of such beauty.

afterimage An image that persists after the visual stimulus for that image has been removed. In colors, the tendency of the eyes to see a *hue* after having looked for a time at the *complementary* hue. (**134**)

aquatint An *intaglio printmaking* method in which areas of tone are created by dusting resin particles on a plate and then allowing acid to bite around the particles. Also, a *print* made by this method. (**262**)

arch A curving architectural *form* usually made of bricks or other masonry, often in the shape of a semicircle but sometimes rising to a point at the top. (**410**)

Archaic style In Greek art, the style prevalent from the 8th to the 6th century B.C. (**460**)

armature A rigid framework, often of wood or steel, used to support a sculpture or other large work while it is being made.

Armory Show An art exhibition held in 1913 at the 69th Regiment Armory in New York, at which avant-garde European art was introduced to the United States.

Art Deco An art style of the 1920s and 1930s based on modern materials (steel, chrome, glass) and repetitive geometric patterns. (**431**)

Art Nouveau An art style of the 1890s featuring curvilinear shapes based on plant forms.

assemblage The technique of creating a sculpture by joining together individual pieces or segments, sometimes "found" objects that originally served another purpose. Also, a sculpture made by this method. (**358**)

asymmetrical Not *symmetrical*. (**171**)

atmospheric perspective A device for suggesting three-dimensional depth on a two-dimensional surface. Forms meant to be perceived as distant from the viewer are blurred, indistinct, and misty.

auteur A filmmaker who exercises maximum control over a film's production and imparts an individual style to a film, often drawing upon personal imagery, dreams, obsessions, fears, memories, or loves as subject matter.

axis A straight line, often an imaginary vertical line.

Baroque A style dominant in European art during the 17th century, characterized by strong colors and *value* contrasts, bold *scale*, dramatic use of light, elaborate ornamentation, great emotionalism, even theatricality. (**498**)

barrel vault A *vault*, or masonry roof, based on an extension of the round *arch;* in effect, many round arches placed one behind the other. (**411**)

bas relief Also known as low relief, sculpture in which figures project only slightly from a background, as on a coin. (**359**)

Bauhaus A school of design in Germany from 1919 to 1933, best known for its attempts to adapt design principles to machine technology.

binder A substance in paints that causes particles of *pigment* to adhere to one another and to a *support*.

calligraphy The art of "beautiful writing." Specifically, a style of decorative penmanship highly developed in the Orient, featuring a flowing, controlled line, often with gradations from thick to thin.

cantilever A horizontal architectural *form* projecting beyond its supports. (**435**)

cartoon 1. A simple drawing with humorous or satirical *content*. 2. A preparatory drawing for a *mural, tapestry,* or other large work.

casting The process of making a sculpture or other object by pouring liquid material—clay, metal, plastic—into a mold and allowing it to harden.

ceramic Made from fired ("baked") clay.

chiaroscuro Literally, "light-dark." In two-dimensional art, the use of different *values* to create *modeling* and to simulate the effects of light and shadow in nature. (**126**)

chroma See *intensity*.

cire-perdue See *lost wax*.

Classical style In Greek art, the style of the 5th century B.C. Loosely, the term "classical" is often applied to all the art of ancient Greece and Rome, as well as to any art based on logical, rational principles and deliberate *composition*. (**462**)

collage A work of art made by pasting bits of paper, cloth, or other material onto a flat surface. (**165**)

Color Field painting A style of painting prominent from the 1950s through the 1970s, featuring large "fields" or areas of color, meant to evoke an *aesthetic* or emotional response through the color alone. (**539**)

color wheel A circular arrangement of *hues* based on some particular color theory. Often, an arrangement of the hues in a rainbow, plus intermediary colors. (**128**)

complementary colors *Hues* directly opposite one another on the *color wheel* and therefore assumed to be as different from one another as possible. When placed side by side, complementary colors are intensified; when mixed together, they produce a *neutral*. (**128**)

composition The organization of lines, shapes, colors, and other art elements in a work of art. More often applied to two-dimensional art; the broader term is *design*.

computer art Art generated electronically, within the computer. (**216**)

conceptual art An art form in which the underlying idea or concept and the process by which it is achieved are more important than any tangible product.

content The message conveyed by a work of art—its subject matter and whatever the artist hopes to convey by that subject matter.

continuous narrative A device by which two or more episodes in an event are portrayed in the same work of art. (**482**)

contrapposto Literally, "counterpoise." A method of portraying the human figure, especially in sculpture, so that it is apparently relaxed and mobile. The result is often a graceful S-curve. (**364**)

cross-cutting In filmmaking, a technique of alternating two or more scenes or *shots* to advance the action.

cross-hatching An area of closely spaced lines intersecting one another, used to create a sense of three-dimensionality on a flat surface, especially in drawing and *printmaking*. See also *hatching, stippling*. (**104**)

Cubism A style of art pioneered in the early 20th century by Pablo Picasso and Georges Braque. In the most developed form of Cubism, *forms* are fragmented into *planes* or geometric facets, like the facets in a diamond; these planes are rearranged to foster a pictorial, but not *naturalistic*, reality; forms may be viewed simultaneously from several vantage points; figure and background have equal importance; and colors are deliberately restricted to a range of *neutrals*. (**525**)

Dada A movement that emerged during World War I in Europe that purported to be anti-everything, even anti-art. Dada poked fun at all the established traditions and tastes in art with works that were deliberately shocking, vulgar, and nonsensical. (**531**)

daguerreotype The earliest form of photograph, invented by Louis Jacques Mandé Daguerre, in which the photographic image is made permanent on a copper plate.

design The planned organization of lines, shapes and masses, colors, textures, and space in a work of art. In two-dimensional art, often called *composition*.

distemper A painting *medium* in which the *binder* is water-soluble glue; also known as poster paint.

dome An architectural structure generally in the shape of a hemisphere or half globe; theoretically, an arch rotated 360 degrees on its vertical *axis*. (**414**)

drypoint An *intaglio printmaking* technique, similar to *engraving*, in which a sharp needle is used to draw on a metal plate, raising a thin ridge of metal that creates a soft line when the plate is printed. Also, the resultant *print*. (**262**)

earthenware *Ceramic* ware, usually coarse and reddish in color, fired in the lowest temperature ranges.

edition In *printmaking*, the number of images made from a single plate and authorized by the artist.

encaustic A painting *medium* in which the *binder* is hot beeswax. (**229**)

engraving An *intaglio printmaking* method in which a sharp tool called a burin is used to scratch lines into a metal plate. Also, the resultant *print*. (**262**)

entasis In *Classical* architecture, the slight swelling or bulge built into the center of a column to make the column seem straight visually.

environmental art 1. Art that is large enough for viewers to enter and move about in. 2. Art designed for display in the outdoor environment. 3. Art that actually transforms the natural landscape. (**371**)

etching An *intaglio printmaking* method in which lines and image areas are created by first coating a plate with an acid-resistant substance, then scratching through the substance with a sharp needle, and finally immersing the plate in acid, which "bites" depressions into the exposed sections. Also, the resultant *print*. (**262**)

Expressionism Any art that stresses the artist's emotional and psychological expression, often with bold colors and distortions of form. Specifically, an art style of the early 20th century followed principally by certain German artists. See also *Abstract Expressionism*. (**258**)

Fauvism A short-lived painting style in early-20th-century France, which featured bold, clashing, arbitrary colors—colors unrelated to the appearance of *forms* in the natural world. Henri Matisse was its best-known practitioner. The word *fauve* means "wild beast." (**523**)

ferroconcrete Reinforced concrete; a building material that has metal rods or steel mesh embedded in concrete to provide strength. (**422**)

figure-ground relationship In two-dimensional art, the relationship between the principal *forms* and the background. Figure-ground ambiguity suggests equal importance for the two. (**119**)

flashback In filmmaking, a cut to a scene or episode that is supposed to have taken place before the main action of the film.

foreshortening A method of portraying *forms* on a two-dimensional surface so that they appear to project or recede from the *picture plane*. (**151**)

forging Shaping metal with hammers while it is hot; the method for making wrought iron.

form 1. The physical appearance of a work of art—its materials, style, and *composition*. 2. Any identifiable shape or mass, as a "geometric form."

fresco A painting *medium* in which colors are applied to wet plaster, thus bonding the image with the painting surface; most often used for *murals*. (**230**)

Futurism Art movement founded in Italy in 1909 and lasting only a few years. Futurism concentrated on the dynamic quality of modern technological life, emphasizing speed and movement. (**158**)

genre Art that depicts the casual moments of everyday life and its surroundings. (**85**)

geodesic dome An architectural structure invented by R. Buckminster Fuller, based on triangles arranged into tetrahedrons (or four-faceted solids). (**423**)

glaze 1. A coating of glassy, often colored material bonded by heat onto a *ceramic* object. 2. Paint applied in a very thin layer.

golden section Also called the "golden mean," a system of proportions developed by the ancient Greeks in which sections of a line or shape were related to one another according to an "ideal" expressed algebraically as $a:b = b:(a + b)$. (**191**)

Gothic A style of architecture and art dominant in Europe from the 12th to the 15th century. Gothic architecture features pointed *arches*, ribbed *vaults*, and often large areas of stained glass. (**412**)

gouache A painting *medium* similar to *watercolor* but with the addition of an opaque white. (**242**)

groin vault A *vault*, or masonry ceiling, resulting when two *barrel vaults* intersect. Often used in medieval architecture to roof a square area.

ground 1. A substance applied to a painting or drawing *support* in preparation for the *pigmented* material. 2. The preparatory substance used as a coating for a *printmaking* plate. 3. The background in a work of two-dimensional art. See also *primer, figure-ground relationship*.

happening An event performed by artists, usually spontaneous and unrehearsed, that may include music, dance, mime, art, reading, or any combination of these.

hard-edge A style of art, principally painting, of the mid-20th century in which *forms* are depicted with precise, geometric lines and edges. (**246**)

hatching An area of closely spaced parallel lines used to create a sense of three-dimensionality on a flat surface, especially in drawing and *printmaking*. See also *cross-hatching, stippling*. (**104**)

haut-relief Also known as high relief, sculpture in which figures are attached to a background but project substantially from that background, usually by at least half their normal depth. (**361**)

Hellenistic style In Greek art, the style of the 3rd and 2nd centuries B.C., characterized by drama and emotionalism and, in sculpture, a tendency for *forms* to push out boldly into space. (**463**)

hue The property of a color that distinguishes it from others in the *color wheel*; the name of a color. (**128**)

iconography Loosely, the "story" depicted in a work of art; people, places, events, and other images in a work, as well as the symbolism and conventions attached to those images by a particular religion or culture.

illumination Hand-drawn decoration or illustration in a manuscript, especially prevalent in medieval art. (**471**)

impasto A thick application of paint to canvas or other *support*. (**235**)

Impressionism An art style of the late 19th century, principally in France, in which artists tried to capture in paint the fleeting effects—or impressions—of light, shade, and color on natural *forms*. (**516**)

inlay In woodworking, a technique in which small pieces of wood, often with varying grains and colors, are glued together to make a pattern. (**398**)

intaglio Any *printmaking* technique in which the lines or image areas to be printed are recessed below the surface of the printing plate. The intaglio techniques are *aquatint, drypoint, etching, engraving,* and *mezzotint*. (**252**)

intensity The degree of purity or brilliance of a color. Also known as *chroma* or *saturation*. (**129**)

isometric perspective A system for depicting three-dimensional depth on a two-dimensional surface, especially common in Eastern art. Isometric perspective resembles *linear perspective* in some ways, except that parallel lines do not converge. Instead, they are parallel to one another, but at an angle to the *picture plane*. (**150**)

kinetic Of or relating to movement. Kinetic art is art that incorporates movement as part of its expression. (**156**)

kore Greek for "maiden"; an ancient Greek sculpture of a young woman, usually clothed.

kouros Greek for "youth" or "boy"; an ancient Greek sculpture of a nude young man. (**461**)

linear perspective System for depicting three-dimensional depth on a two-dimensional surface. Linear perspective has two main precepts: 1) *forms* that are meant to be perceived as far away from the viewer are made smaller than those meant to be seen as close; 2) parallel lines receding into the distance converge at a point on the horizon line known as the *vanishing point*. (**147**)

linocut Also known as linoleum cut, a *relief printmaking* technique in which a block of linoleum is carved so as to leave image areas raised above the surface of the block; in function, similar to a common rubber stamp. Also, the resultant *print*. (**260**)

lintel A beam; a horizontal architectural member usually supported by vertical posts. See also *post-and-lintel*. (**407**)

lithography A *planographic* (or flat-surface) *printmaking* technique, based on the premise that oil and water do not mix. Image areas are drawn in greasy crayon on a stone or plate, and the greasy ink used in this method adheres to those areas. (**252**)

lost-wax casting Also known by the French term *cire-perdue*, a method for *casting* metal sculptures and other objects. Positive and negative *molds* are built around a layer of wax that exactly duplicates the shape and size of the desired sculpture. When this arrangement is heated, the wax melts out (is "lost") and then molten metal is poured into the mold to replace it. (**349**)

Mannerism A term sometimes applied to art of late 16th and early 17th-century Europe, characterized by a dramatic use of space and light and a tendency toward elongated figures. (**497**)

mass Three-dimensional *form*, often implying bulk, density, and weight.

medium 1. The material used to create a work of art. 2. The *binder* for a paint, such as oil. 3. An expressive art form, such as painting, drawing, or sculpture.

metalpoint A drawing technique, especially popular in the *Renaissance*, in which the drawing material is a thin wire of metal. See also *silverpoint*. (**206**)

mezzotint An *intaglio printmaking* method in which the printing plate is first roughened all over with a sharp tool called a rocker to create a pattern of burrs. *Values* from light to medium dark are created by smoothing away the burrs in relative degree. Also, the resultant *print*. (**262**)

Minimal Art A style of painting and sculpture in the mid-20th century in which the art elements are restricted to an extreme "minimum"—lines, simple (often geometric) shapes, and sometimes color. (**544**)

mixed media Descriptive of any work of art employing more than one *medium*—for example, a work that combines painting, *collage,* and *screenprinting*.

mobile A sculpture that incorporates movement, usually effected by air currents. (**373**)

modeling 1. In sculpture, shaping a *form* in some *plastic* material, such as clay, wax, or plaster. 2. In drawing, painting, or *printmaking*, the illusion of three-dimensionality on a flat surface created by simulating effects of light and shadow. (**126**)

mold A hollow or negative *shape* used for *casting* liquid clay, metal, or *plastic*.

monochromatic Having only one color. Descriptive of work in which one *hue*—perhaps with variations of *value* and *intensity*—predominates.

monotype A *printmaking* method in which only one impression results. (**278**)

mosaic An art form in which small pieces of tile, glass, or stone are fitted together and embedded into a background to make a pattern or image. Often used for floor and wall decoration. (**468**)

mural Any large-*scale* wall decoration in painting, *fresco, mosaic,* or other *medium*. (**231**)

naturalistic Descriptive of a work of art that closely resembles *forms* in the natural world. Synonymous with *representational*.

nave The long central section of a church or cathedral where the congregation stands or sits. (**412**)

Neoclassicism "New" classicism—a style in 19th-century Western art that referred back to the *Classical* styles of Greece and Rome. Neoclassical painting is marked by sharp outline, reserved emotions, deliberate (often geometric) *composition*, and cool colors. (**512**)

Neo-Expressionism "New" Expressionism—a term originally applied to works by some European artists, primarily German and Italian, who came to maturity in the post-World War II era; expanded in the 1980s to include certain American artists. Neo-Expressionist works have much emotion and symbolism, sometimes unconventional *media*, and often intense colors and turbulent composition. (**227**)

neutral Having no *hue*—black, white, or gray; sometimes a tannish color achieved by mixing two *complementary colors.*

New York School See *Abstract Expressionism.*

nonobjective Descriptive of works of art that have no reference to the natural world of images. Composed of lines, shapes, and sometimes colors, chosen and arranged for their own expressive potential. Synonymous with *nonrepresentational.* Compare *abstract, stylized.*

nonrepresentational See *nonobjective.*

Op Art Short for optical art, a style popular in the 1960s and based on optical principles. Op Art deals in complex color interactions, to the point where colors and lines seem to vibrate before the eyes. (**157**)

optical color mixture The tendency of the eyes to blend patches of individual colors placed near one another so as to perceive a different, combined color. Also, any art style that exploits this tendency, especially the *pointillism* of Georges Seurat. (**135**)

painterly Descriptive of paintings in which *forms* are defined principally by color areas, not by lines or edges.

palette 1. A surface used for mixing paints. 2. The range of colors typically used by an artist or group of artists.

pastel 1. A soft, chalky crayon used for drawing; also, the resultant drawing. 2. A light-*value* color.

patina A surface coating that develops on metals, particularly copper and bronze, through exposure to weather and oxides, or by the deliberate application of chemicals.

pediment The triangular area above the porch on a Greek temple, often decorated with sculptures.

pendentive In architecture, a curving, triangular section that serves as a transition between a *dome* and the four walls of a rectangular building. (**414**)

performance art Similar to a *happening,* art in which there is no concrete object, but rather, a series of events performed by the artist in front of an audience, possibly including music, sight gags, recitation, audio-visual presentations, or other elements.

perspective Any system for depicting the illusion of three-dimensional space on a two-dimensional surface. See *atmospheric perspective, isometric perspective, linear perspective.* (**147**)

Photorealism A painting style of the mid-20th century in which people, objects, and scenes are depicted with such naturalism that the paintings resemble photographs.

pictorial space The illusory space in a painting or other work of two-dimensional art that seems to recede backward into depth from the *picture plane;* the "window" effect in a painting.

picture plane An imaginary flat surface that is assumed to be identical to the surface of a painting. *Forms* in a painting meant to be perceived in deep three-dimensional space are said to be "behind" the picture plane. The picture plane is commonly associated with the foreground of a painting.

pigment A coloring material made from various organic or chemical substances. When mixed with a *binder,* it creates a drawing or painting *medium.*

plane A flat surface. See *picture plane.*

planography A *printmaking* technique in which the image areas are level with the surface of the printing plate; *lithography.* (**252**)

plastic 1. Capable of being molded or shaped, as clay. 2. Any synthetic polymer substance, such as *acrylic.*

pointillism An art style of the late 19th century, particularly associated with Georges Seurat, in which small patches or "points" of color are placed close together to build *form.* See also *optical color mixture.* (**136**)

polychromatic Having many colors.

Pop Art An art style of the 1960s, deriving its imagery from the popular, mass-produced culture. Deliberately mundane, Pop Art focused on the overfamiliar objects of daily life to give them new meanings as visual emblems. (**167**)

porcelain A *ceramic* ware, usually white, firing in the highest temperature ranges and often used for fine dinnerware, vases, and sculpture.

post-and-lintel In architecture, a structural system based on two or more uprights (posts) supporting a horizontal crosspiece (lintel or beam). (**407**)

Post-Impressionism A term applied to the work of several artists—French or living in France—from about 1885 to 1900. Although all painted in highly personal styles, the Post-Impressionists were united in rejecting the relative absence of *form* characteristic of *Impressionism.* The group included Vincent van Gogh, Paul Cézanne, Paul Gauguin, and Georges Seurat.

primary color A *hue* that, in theory, cannot be created by a mixture of other hues. Varying combinations of the primary hues can be used to create all the other hues of the spectrum. In pigment the primaries are red, yellow, and blue. (**128**)

primer A preliminary coating applied to a painting *support* to improve adhesion of paints or to create special effects. A traditional primer is gesso, consisting of a chalky substance mixed with glue and water. Also called a *ground.*

print An image created from a master wood block, stone, plate, or screen, usually on paper. Prints are referred to as multiples, because as a rule many identical or similar impressions are made from the same printing surface, the number of impressions being called an *edition.* A print is considered an original work of art and, today, is customarily signed and numbered by the artist. See *relief, intaglio, lithography, screenprinting.* (**252**)

printmaking The art of making *prints.*

proportion Size relationships between parts of a whole, or between two or more objects perceived as a unit. Compare *scale.* (**187**)

radial Projecting outward from a central core like the spokes in a wheel. (**180**)

Realism Broadly, any art in which the goal is to portray forms in the natural world in a highly *representational* manner. Specifically, an art style of the mid-19th century, identified especially with Gustave Courbet, which fostered the idea that everyday people and events are fit subjects for important art. (**514**)

refraction The bending of a ray of light, for example, when it passes through a prism. (**127**)

registration In *printmaking,* the precise alignment of impressions made by two or more printing blocks or plates on the same sheet of paper, as when printing an image in several colors.

relief Anything that projects from a background. 1. Sculpture in which figures or other images are attached to a background but project from it to some degree. See *bas-relief, haut-relief.* 2. A *printmaking* technique in which portions of a block meant to print are raised above the surface. See *woodcut, linocut, wood engraving.* (**252**)

Renaissance The period in Europe from the 14th to the 16th century, characterized by a renewed interest in *Classical* art, architecture, literature, and philosophy. The Renaissance began in Italy and gradually spread to the rest of Europe. In art, it is most closely associated with Leonardo da Vinci, Michelangelo, and Raphael.

representational Descriptive of a work of art that closely resembles *forms* in the natural world. Synonymous with *naturalistic.*

Rococo A style of art popular in Europe in the first three-quarters of the 18th century. Rococo architecture and furnishings emphasized ornate but small-*scale* decoration, curvilinear *forms*, and *pastel* colors. Rococo painting, also tending toward the use of pastels, has a playful, light-hearted, romantic quality and often pictures the aristocracy at leisure. (**510**)

Romanesque A style of architecture and art dominant in Europe from the 9th to the 12th century. Romanesque architecture, based on ancient Roman precedents, emphasizes the round *arch* and *barrel vault*. (**411**)

Romanticism A movement in Western art of the 19th century, generally assumed to be in opposition to *Neoclassicism*. Romantic works are marked by intense colors, turbulent emotions, complex *composition*, soft outlines, and sometimes heroic subject matter. (**513**)

salon 1. A fashionable gathering of artists, writers, and intellectuals held in a private home. 2. In France, a state-sponsored exhibition of art, held in Paris, controlled by the Academy of Fine Arts. Starting in 1863, opposition to the restrictive, overly conservative jurying of the Salon resulted in alternative exhibitions.

sarcophagus A stone or *ceramic* coffin, sometimes decorated with sculpture. (**464**)

saturation See *intensity*.

scale Size in relation to some "normal" or constant size. Compare *proportion*.

screenprinting A *printmaking* method in which the image is transferred to paper by forcing ink through a fine mesh in which the areas not meant to print have been blocked; a stencil technique. (**252**)

secondary color A *hue* created by combining two *primary colors*, as yellow and blue mixed together yield green. In pigment the secondary colors are orange, green, and violet. (**128**)

serigraphy See *screenprinting*.

sfumato From the Italian word for "smoke," a technique of painting in thin *glazes* to achieve a hazy, cloudy atmosphere, often to represent objects or landscape meant to be perceived as distant from the *picture plane*. (**486**)

shape A two-dimensional area having identifiable boundaries, created by lines, color or *value* changes, or some combination of these. Broadly, *form*.

shot In filmmaking, any continuous sequence of movie frames, with the camera rolling.

silkscreen See *screenprinting*.

silverpoint A variation of *metalpoint* in which the drawing material is a thin silver wire.

simultaneous contrast The tendency of *complementary colors* to seem brighter and more intense when placed side by side.

slab construction In *ceramics*, a construction method in which objects are formed from sheets of clay rolled out as with a rolling pin.

solvent Also known as a *vehicle*, the liquid used to thin paints and to clean brushes after painting; for example, water or turpentine.

still life A painting or other two-dimensional work in which the subject matter is an arrangement of objects—fruit, flowers, tableware, pottery, and so forth—brought together for their pleasing contrasts of shape, color, and texture. Also, the arrangement of objects itself. (**164**)

stippling A pattern of closely spaced dots or small marks used to create a sense of three-dimensionality on a flat surface, especially in drawing and *printmaking*. See also *cross-hatching, hatching*. (**104**)

stoneware *Ceramic* ware, usually gray or tan in color, fired in the medium temperature ranges.

style A characteristic, or a number of characteristics, that we can identify as constant, recurring, or coherent. In art, the sum of such characteristics associated with a particular artist, group, or culture, or with an artist's work at a specific time.

stylized Descriptive of works based on *forms* in the natural world, but simplified or distorted for *design* purposes. See also *abstract*. (**44**)

support The surface on which a work of two-dimensional art is made; for example, canvas, paper, or wood.

Surrealism A painting style of the early 20th century that emphasized imagery from dreams and fantasies, as well as an intuitive, spontaneous method of recording such imagery. (**533**)

suspension A structural system in architecture, most common in bridges, in which the weight of a horizontal member is suspended from steel cables supported by uprights called pylons. (**420**)

symbol An image or sign that represents something else, because of convention, association, or resemblance.

symmetrical Descriptive of a design in which the two halves of a composition on either side of an imaginary central vertical *axis* correspond to one another in size, shape, and placement. (**169**)

tapestry A type of weaving in which the crosswise yarns are manipulated freely to create patterned or pictorial effects.

tempera A painting *medium* in which the *binder* is egg yolk. (**232**)

tensile strength In architecture, the ability of a material to span horizontal distances with minimum support from underneath.

terra cotta Italian for "baked earth." A *ceramic* ware, usually reddish, fired in the low temperature ranges and somewhat porous and fragile; *earthenware*. (**379**)

throwing Forming rounded *ceramic* objects on the potter's wheel. (**381**)

triptych A three-part work of art; especially a painting, meant for placement on an altar, with three panels that fold together.

trompe-l'oeil French for "fool-the-eye." A painting or other work of two-dimensional art rendered in such an extremely *naturalistic* manner that the viewer is "tricked" into thinking it is three-dimensional. (**49**)

truss In architecture, a structural system, used principally with wood and metal, based on the triangle. (**421**)

value The relative lightness or darkness of a *hue*, or of a *neutral* varying from white to black. (**125**)

vanishing point In *linear perspective*, the point on the horizon line where parallel lines appear to converge. (**147**)

vault A masonry (brick or concrete) roof or ceiling, especially in medieval architecture. See also *groin vault, barrel vault*. (**411**)

vehicle See *solvent*.

video art Any art form based on television. (**324**)

volume Similar to *mass*, a three-dimensional *form* implying bulk, density, and weight; but also a void or empty, enclosed space.

wash Ink or *watercolor* paint thinned so as to flow freely onto a *support*.

watercolor A painting *medium* in which the *binder* is gum arabic.

woodcut A *relief printmaking* method in which a block of wood is carved so as to leave the image areas raised from the background. Also, the resultant *print*. (**252**)

wood engraving Similar to *woodcut*, a *relief printmaking* process in which the image is cut on the end grain of a wood plank, resulting in a "white-line" impression. (**261**)

Index

All references are to page numbers. Numbers in **boldface** indicate an illustration on that page.

Photographic Credits

All references are to figure numbers. The following abbreviations have been used throughout:
AR: Art Resource, New York.
ARS: Artists Rights Society, New York.
PR: Photo Researchers, New York.
RMN: Service de Documentation Photographique de la Réunion des Musées Nationaux, Paris.

Chapter 1: 2, Jean Vertut, Issey-les-Moulineaux, France; **9,** Gjon Mili/Life Magazine © Time, Inc., Life Picture Service, New York; **10,** Rod Bauer, courtesy Pratt Institute Gallery, Brooklyn, New York; **11,** © Craig Aurness/West Light, Los Angeles; **13,** AR; **15,** Douglas Keister, Oakland, California; **18,** Chevojon Freres/ARS; **19,** © M.C. Escher Heirs c/o Cordon Art, Baarn, Holland; **21,** Scala/AR; **22,** Steve Kagan/NYT Pictures; **23,** Pepsico, Inc.; **27,** From *Perception* by Irwin Rock © 1984 Scientific American Books, Inc.; **p. 24,** Service Photographique; **p. 30,** © Juliet Man Ray, 1988.

Chapter 2: 34, 36, Alinari/AR; **37,** Jack Manning/NYT Pictures; **38,** Tony Jerome/NYT Pictures; **39,** Jörg P. Anders; **40,** Alinari/AR; **42, 46,** RMN; **49,** Dan Lecca, New York; **62,** Robert E. Mates; **63,** Oeffentliche Kunstsammlung Kunstmuseum, Basel; **64,** Jörg P. Anders.

Chapter 3: 69, Fritz Menle/PR; **72,** George Holton/PR; **73,** Archeological Survey of India, Janpath, New Delhi; **74,** French Government Tourist Office, New York; **75,** O. Zimmermann, Colmar. **77,** Hirmer Fotoarchiv, Munich; **79,** Alinari/AR; **80,** Caisse Nationale des Monuments Historiques et des Sites, Paris/ARS. **84,** Courtesy Barbara Gladstone Gallery, David Reynolds; **85,** Giraudon/AR; **89,** Allan Finkelman, New York; **91,** © The Frick Collection, New York.

Chapter 4: 98, Museum of Modern Art, New York; **101,** Rudolf Burckhardt; **105,** Giraudon/AR; **107,** Ken Cohen, New York; **113, 116,** Giraudon/AR; **119,** © M.C. Escher Heirs c/o Cordon Art. Baarn; **120,** © George W. Gardner, Hillsdale, New York; **122,** Christopher Springman/TIME Magazine; **126,** Giraudon/AR; **137,** RMN. **139,** Courtesy Maxwell Davidson Gallery, New York; **140,** Reproduced by permission Gallery Welz, Salzburg; **141,** Robert E. Mates; **142,** Françoise Legrand, Buckingham, England; **145, 148, 151,** Alinari/AR; **154,** Doisneau/PR; **155,** French Government Tourist Office, New York; **156,** Rob Cornfelder; **p. 102,** Alinari/AR; **p. 120,** Le Fevre Gallery, London; **p. 140,** Alinari/AR.

Chapter 5: 160, Courtesy the artist; **163,** George Holton/PR; **165,** George Holzer; **166,** Courtesy Elizabeth Benton; **169,** Reproduction authorized by the Instotuto Nacional de Bellas Artes y Literatura; **172,** Robert E. Mates; **173,** From *Prairie Fires and Paper Moons* by Hal Morgan and Andreas Brown, pub. David Grodine, Boston; **176,** Library of Congress, Washington, D.C.; **177,** Philip L. Molten, Tilburon, California; **179,** Otto E. Nelson, New York; **180,** Alinari/AR; **185,** Courtesy Toni Mendez, Inc., New York; **186,** VAGA; **190,** Hirmer Fotoarchiv, Munich; **194,**

Geoffery Clements, New York; **198,** Courtesy Michael Klein Gallery, Inc., New York; **p. 148,** Magnum Photos, New York.

Chapter 6: 203, The Pierpont Morgan Library, New York, M.500, f.16v.; **211,** Courtauld Institute of Art, London; **220,** Mira Godard Gallery, Toronto; **p. 188,** Sanford H. Roth, Rapho/PR.

Chapter 7: 229, Giraudon/AR; **230,** Scala/AR; **246,** Collection Mrs. Harry Davidson, courtesy Andre Emmerich Gallery, New York; **251,** Courtesy Robert Miller Gallery, New York; **p. 208,** Courtesy Robert Miller Gallery, New York; **p. 210,** Yale Joel, Life Magazine, © Time, Inc.

Chapter 8: 264, The Bettmann Archive; **267,** Giraudon/AR; **278,** Karen Bell.

Chapter 9: 285, 286, Library of Congress, Washington D.C.; **287,** Berenice Abbott/Commerce Graphics Ltd., Inc.; **289,** Library of Congress, Washington D.C.; **292,** For the estate of Diane Arbus, Ellis J. Freedman; **294,** PR; **298,** UPI/Bettmann Newphotos; **300,** Library of Congress, Washington D.C.; **309,** Museum of Modern Art Film Stills Archive; **310,** Museum of Modern Art Film Stills Archive; **311,** Courtesy Turner Entertainment Company; **312,** Museum of Modern Art Film Stills Archive; **313,** Janus Films; **314,** Museum of Modern Art Film Stills Archive; **315,** Courtesy Turner Entertainment Company; **316,** Brian Hamill, from Jack Rollins and Charles H. Joffe Productions; **317,** Museum of Modern Art Film Stills Archive; **321,** CBS Entertainment, a Division of CBS, Inc.; **322,** CBS Entertainment, a Division of CBS, Inc.; **323,** David Plastik/Retna, Ltd.; **p. 246,** Philadelphia Museum of Art; **p. 260,** The Bettmann Archive.

Chapter 10: 330, Courtesy the artist; **331,** The Pushpin Group; **337,** Courtesy Bascove; **342,** © 1987 Capital Cities/ABC Inc.

Chapter 11: 346, Seth Joel; **348,** Anne Kohs and Associates, Inc., San Francisco; **350, 354,** Alinari/AR; **355,** Stuart Cohen/Stock, Boston; **357,** Ken Cohen Photography; **359,** Egyptian Expedition, Metropolitan Museum; **360,** Alinari/AR; **361,** Courtesy Metro Pictures, photo D. James Dee; **364,** Hirmer Fotoarchiv, Munich; **367,** D. James Dee; **370,** David Heald; **371,** Gian Franco Gorgoni © 1984/Contact Press; **372,** Jeanne-Claud Christo; **375,** Chad Slattery; **p. 290,** Courtesy Conde Nast Publications; **p. 292,** Lynn Gilbert, courtesy Pace Gallery, New York.

Chapter 12: 377, Bruce Handelsman, San Francisco; **380,** Jerry Jacka, Phoenix; **381,** Ellen Grossman; **384,** Bill Scott; **389,** Sherman Howe; **392,** Bruce Miller; **394,** Robert Boni; **395,** Larry Stein; **402,** Giraudon/AR; **p. 308,** Jerry Jacka, Phoenix; **p. 322,** Jerry Cooke.

Chapter 13: 405, Marc Treib, Berkeley, California; **406,** Carl Frank/PR; **407,** Hirmer Fotoarchiv, Munich; **409,** William Katz/PR; **410,** French Government Tourist Office, New York; **411,** Jean Roubier; **412,** Rapho/PR; **414,** Hirmer Fotoarchiv,

Munich; **415,** George Holton/PR; **417,** French Government Tourist Office, New York; **418,** Hedrich-Blessing, Chicago; **419,** Ezra Stoller, ESTO; **420,** Chris Minerva/FPG International; **421,** Joe Aker; **422,** Dennis Halinan/FPG International; **423,** David Maclean/Shostal Associate, New York; **424, 425,** Library of Congress, Washington D.C.; **426,** Brown Brothers; **428,** RMN; **429,** Robert E. Mates; **430,** French Government Tourist Office, photo François Darras; **431,** Brown Brothers; **432,** © 1958 Ezra Stoller, E.S.T.O.; **433,** Robert Livieri; **434,** Harold Meeker, San Carlos, California; **435,** Bill Hedrich, Hedrich-Blessing; **436,** Timothy Hursley; **p. 338,** Theo Westenberger/Liaison, New York; **p. 346,** UPI/Bettmann Newsphotos.

Chapter 14: 438, Dimitri Kessel, Paris; **439,** Alinari/AR; **440,** Ewing Galloway; **441,** The Bettmann Archive; **443,** Jack Mellott; **444,** Edward V. Souza, courtesy of Stanford University, News and Publications Service; **445,** U.S. Air Force; **446,** Richard Wood/The Picture Cube; **447,** Gregory Glass; **448,** Courtesy Citicorp; **449, 450,** Enrico Ferorelli/DOT.

Chapter 15: 451, Hirmer Fotoarchiv, Munich; **455,** Oriental Institute, University of Chicago; **457, 458,** Hirmer Fotoarchiv, Munich; **459,** RMN; **462, 464, 465,** Alinari/AR; **466,** Scala/AR; **467,** Alinari/AR; **468,** Scala/AR; **469,** Alinari/AR; **472,** Georgia Engelhard/FPG International; **474,** Bildarchiv Foto, Marburg/AR; **476,** RMN; **477,** Alinari/AR; **478,** Scala/AR.

Chapter 16: 479, Alinari/AR; **480,** Scala/AR; **481, 482, 483,** Alinari/AR; **484,** Scala/AR; **485,** Alinari/AR; **486,** Scala/AR; **487,** Alinari/AR; **488,** Scala/AR; **490, 491,** Alinari/AR; **492,** Scala/AR; **494,** Giraudon/AR; **496, 498,** Alinari/Ar; **499, 500,** Scala/AR; **501,** © Frans Claes, Antwerp, courtesy Belgian National Tourist Office, New York; **503,** Le Coguen, Rapho/PR; **p. 388, p. 400,** Scala/AR; **p. 413,** The Bettmann Archive.

Chapter 17: 512, 513, 514, 515, RMN; **517,** RMN; **517,** Hirschl and Adler Galleries, Inc., New York; **518,** RMN; **520,** Hans Hinz, Allschwil; **521,** RMN; **523,** Hans Petersen, Copenhagen; **534,** Robert E. Mates, New York; **537,** Robert E. Mates, New York; **542,** Courtesy Leo Castelli Gallery, New York; **544,** Courtesy Xavier Fourcade, Inc., New York; **545,** Courtesy Leo Castelli Gallery, New York; **550,** Geoffrey Clements; **551,** Bruce C. Jones, New York; **556, 557,** Wolfgang Volz/photo Eeva-Inkerti, © Christo; **558,** Michele Maier; **560,** Lynn Goldsmith/LGI © 1982; **p. 459,** Duane Michals.

Chapter 18: 565, Seattle Art Museum, catalog number 33.180; **567,** Courtesy Sakamoto Photo Research Laboratory; **568,** Marburg/AR; **570,** The Smithsonian Institution, accession number 29.84; **574,** Alinari/AR.

Epilogue: 585, UPI/Bettmann Newsphotos; **587,** Schmidt-Thomsen, Landschafts-Verband Westfalen-Lippe, Munich; **588,** Anderson/AR; **589,** Alinari/AR; **590,** courtesy NTV-Tokyo; **591,** Ecole nationale supérieure des Beaux-Arts, Paris.